GATEWAYS TO ART

GATEWAYS TO ART

Understanding the Visual Arts

With 1013 illustrations, 865 in color

Gateways to Art copyright © 2012 Thames & Hudson

Text copyright © 2012 Debra J. DeWitte, Ralph M. Larmann and M. Kathryn Shields

All Rights Reserved. No part of this publication may be reproduced or transmitted in any form or by any means, electronic or mechanical, including photocopy, recording or any other information storage and retrieval system, without prior permission in writing from the publisher.

First published in 2012 in paperback in the United States of America by Thames & Hudson Inc., 500 Fifth Avenue, New York, New York 10110

thamesandhudsonusa.com

Reprinted 2015

Library of Congress Catalog Card Number 2011922637

ISBN 978-0-500-28956-3

Designed by Geoff Penna

Printed and bound in Canada

FRONT COVER

Henri Matisse, *Icarus*, Plate VIII from *Jazz*, 1943–47. The Museum of Modern Art, New York. The Louis E. Stern Collection. 930.1964.8. Digital image, The Museum of Modern Art, New York/Scala, Florence. © Succession H. Matisse/DACS 2012

BACK COVER

Above, left to right:

Katsushika Hokusai, "The Great Wave off Shore at Kanagawa," from *Thirty-Six Views of Mount Fuji*, 1826–33 (printed later). Library of Congress, Washington, D.C.

Artemisia Gentileschi, Judith Decapitating Holofernes, c. 1620. Uffizi Gallery, Florence

Raphael, The School of Athens, 1510–11. Stanza della Segnatura, Vatican City

Dorothea Lange, Migrant Mother, Nipomo, California, 1936. Library of Congress, Washington, D.C.

The Great Pyramid of Khufu, Giza, c. 2,500 BC. Photo Heidi Grassley © Thames & Hudson Ltd, London

Francisco De Goya, The Third of May, 1808, 1814. Museo Nacional del Prado, Madrid

Below:

Colossal Head, Olmec, Basalt, 1500–1300 BCE. Museo de Antropología, Veracruz, Mexico. Photo Irmgard Groth-Kimball © Thames & Hudson Ltd, London

Contents

How to Use *Gateways to Art: Understanding the Visual Arts* **13** Gateway Features for *Gateways to Art* **16**

Introduction 26

What Is Art? 26
Where Is Art? 29
Who Makes Art? 30
The Value of Art 34
Censorship of Art 39
Why Do We Study Art? 41

FEATURES:

Line 46

Shape 57

Contrast 58

Conclusion 61

Robert Wittman: What Is the Value of an Artwork? 36 Tracy Chevalier: Art Inspires a Novel and a Movie 38

PART 1 FUNDAMENTALS 44

Chapter 1.1

Art in Two

Dimensions: Line,

Shape, and the

Principle of

Contrast 46

FEATURE:

LATONE

Gateway to Art: Goya, The Third of May, 1808: Using Line to Guide the Viewer's Eye 54

Chapter 1.2

Three-Dimensional

Art: Form, Volume,

Mass, and Texture 62

Form 62

Form in Relief and in the Round 66

Volume 68 Mass 70

Texture 72 Conclusion 75

FFATURES:

Gateway to Art: The Great Pyramid of Khufu: The Importance of Geometric Form 64

Gateway to Art: Colossal Olmec Heads: Mass and Power 70

The Guggenheim Museum, Bilbao 74

Chapter 1.3

Implied Depth: Value and Space 76

Value 77 Space 80

Perspective 84
Conclusion 91

	Gateway to Art: Hokusai, "The Great Wave off Shore at Kanagawa": Methods for Implying Depth 81
	Gateway to Art: Raphael, <i>The School of Athens:</i> Perspective and the Illusion of Depth 89
Chapter 1.4 Color 92	Light and Color 92 Dimensions of Color 93 Color Schemes 96 Our Perceptions of Color 99 Color in Design 101 Color and the Brain 103 Conclusion 105
	FEATURE: Gateway to Art: Matisse, Icarus: The Artist's Fascination with Color 97
Chantar 1 5	Time 106
Chapter 1.5 Time and Motion 106	Motion 108 Natural Processes and the Passage of Time 115 Conclusion 115
	FEATURE: Gateway to Art: Lange, Migrant Mother: Time and Motion in Photography 114
Chapter 1.6 Unity, Variety, and Balance 116	Unity 116 Variety 122 Balance 124 Conclusion 127 FEATURE: Gateway to Art: Hokusai, "The Great Wave off Shore at Kanagawa": A Masterpiece of Unity
	and Harmony 117
Chapter 1.7 Scale and Proportion 128	Scale 128 Proportion 131 Conclusion 135 FEATURE: Gateway to Art: Raphael, The School of Athens: Scale and Proportion in a Renaissance Masterpiece 133
Chapter 1.8 Emphasis and Focal Point 136	Emphasis and Subordination 136 Focal Point 138 Emphasis and Focal Point in Action 140 Conclusion 141 FEATURE: Gateway to Art: Gentileschi, Judith Decapitating Holofernes: Emphasis Used to Create Drama 139
Chapter 1.9 Pattern and Rhythm 142	Pattern 142 Rhythm 146 Conclusion 151 FEATURE: Gateway to Art: Goya, The Third of May, 1808: Visual Rhythm in the Composition 150
Chapter 1.10 Content and Analysis 152	Content 152 Modes of Analysis 154 Imitation and Individual Style 162 Conclusion 163

FEATURES:

	PART 2 MEDIA AND PROCESSES 164
Chapter 2.1 Drawing 166	Functions of Drawing 166 The Materials of Drawing: Dry Media 169 The Materials of Drawing: Wet Media 174 Paper 176 The Drawing Process 177 Conclusion 179 FEATURES: Gateway to Art: Raphael, The School of Athens: Drawing in the Design Process 168 Gateway to Art: Matisse, Icarus: Line and Shape 178
Chapter 2.2 Painting 180	Encaustic 180 Tempera 181 Fresco 183 Oil 185 Acrylic 188 Watercolor and Gouache 188 Ink Painting 189 Spray Paint and Wall Art 190 Conclusion 191 FEATURES: Melchor Peredo: Fresco Painting Inspired by the Mexican Revolution 184 Gateway to Art: Gentileschi, Judith Decapitating Holofernes: Paintings as Personal Statements 187
Chapter 2.3 Printmaking 192	Context of Printmaking 193 Relief Printmaking 193 Intaglio Printmaking 195 Planographic Printmaking 199 Editions 202 Monotypes and Monoprints 202 Conclusion 203 FEATURES: Gateway to Art: Hokusai, "The Great Wave off Shore at Kanagawa": Using the Woodblock Printing Method 195 Gateway to Art: Goya, The Third of May, 1808: Prints as Art and as Creative Tools 198
Chapter 2.4 Visual Communication Design 204	The Early History of Graphic Arts 204 Graphic Design 206 Layout Design 210 Web Design 211 Conclusion 211
Chapter 2.5 Photography 212	Recording the Image 212 The History of Photography 212 Photographic Genres 215 Photojournalism 219 The Art of Photography 221 Conclusion 227 FEATURES: Diagram of Film Photography Darkroom 215

	Gateway to Art: Lange, <i>Migrant Mother</i> : How the Photograph Was Shot 216 Steve McCurry: How a Photographer Captures a Moment 220
Chapter 2.6 Film/Video and Digital Art 228	Moving Images before Film 228 Silent and Black-and-White Film 230 Sound and Color 231 Animation and Special Effects 232 Film Genres 235 Film as Art 236 Conclusion 239 FEATURE: Bill Viola: How Did Video Become Art? 238
Chapter 2.7 Alternative Media and Processes 240	Context of Alternative Media 240 Performance Art 241 Conceptual Art 243 Installation and Environments 246 Conclusion 247 FEATURE: Mel Chin: Operation Paydirt/Fundred Dollar Bill Project 245
Chapter 2.8 The Tradition of Craft 248	Ceramics 248 Glass 253 Metalwork 255 Fiber 256 Wood 258 Conclusion 259 FEATURES: Hyo-In Kim: Art or Craft: What's the Difference? 249 Gateway to Art: Colossal Olmec Heads: Sculpture in Stone and Clay 251 Faith Ringgold, Tar Beach, 1988 257
Chapter 2.9 Sculpture 260	Approaches to Three Dimensions in Sculpture 260 Methods of Sculpture 263 Light and Kinetic Sculpture 270 Installations 273 Conclusion 273 FEATURES: Gateway to Art: Colossal Olmec Heads: How Sculptors Made the Colossal Heads 263 Michelangelo 264 Antony Gormley: Asian Field 272
Chapter 2.10 Architecture 274	The Context of Architecture 274 The Engineering and Science of Architecture 276 Traditional Construction in Natural Materials 276 The Emergence of Modern Materials and Modern Architecture 284 Contrasting Ideas in Modern Architecture 289

Gateway to Art: The Great Pyramid of Khufu: **Math and Engineering 277** Le Corbusier's Villa Savoye and Frank Lloyd Wright's Fallingwater **286**

The Future of Architecture 291

Zaha Hadid: A Building for Exciting Events 290

Conclusion 291

FEATURES:

PART 3 HISTORY AND CONTEXT 292	Chapter 3.1	Prehistoric Art in Europe and the I	Med
		PART 3 HISTORY AND CONTEXT	292

The Prehistoric and Ancient

diterranean 295 Mesopotamia: The Cradle of Civilization 298

Ancient Egypt 300

Mediterranean 294 Art of Ancient Greece 304

Roman Art 309

Discussion Questions 312

FEATURES:

Gateway to Art: The Great Pyramid of Khufu: Belief in the Afterlife 301

Hieroglyphs 302

Zahi Hawass: The Golden Mask of King Tutankhamun 303

Classical Architectural Orders 306 Sculpture throughout Ancient Greece 308

Chapter 3.2 Art of the Middle

Art of Late Antiquity 315 Byzantine Art 318 Ages 314

Manuscripts and the Middle Ages 320 Pilgrimage in the Middle Ages 322 Symbolism in Medieval Churches 325

The Rise of the Gothic 327

From the Gothic to Early Renaissance in Italy 328

Discussion Questions 328

FEATURE:

Three Religions of the Middle Ages 316

Chapter 3.3 Art of India, China, and Japan 330

India 332 China 336 Japan 340

Discussion Questions 346

FEATURES:

Philosophical and Religious Traditions in Asia 331 The Three Perfections: Calligraphy, Painting, Poetry 337

Sonoko Sasaki: Art and Tradition in Japan 341

Japonisme: The Influence of Ukiyo-e on French Artists 345

Gateway to Art: Hokusai, "The Great Wave off Shore at Kanagawa": Mount Fuji: The Sacred

Mountain of Japan 346

Chapter 3.4 Art of the

Americas 348

The Americas: When's the Beginning? 348

South America 348 Mesoamerica 353 North America 359 Discussion Questions 362

FEATURES:

How Do We Know? 349 The Importance of Wool 352

Gateway to Art: Colossal Olmec Heads: The Discovery of Monumental Portraits at

La Venta 354

Chapter 3.5

Art of Africa 364

Art of Africa and the Pacific Islands 364

African Architecture 368 Art of the Pacific Islands 370 Discussion Questions 374

FEATURE:

Paul Tacon: Australian Rock Art 371

Chapter 3.6Art of Renaissance and Baroque Europe

(1400-1750) **376**

The Early Renaissance in Italy 377
The High Renaissance in Italy 380
The Renaissance in Northern Europ

The Renaissance in Northern Europe 384
Late Renaissance and Mannerism 388

The Baroque 393

Discussion Questions 396

FEATURES:

Gateway to Art: Raphael, The School of Athens: Past and Present in the Painting 382

Pieter Bruegel: A Sampling of Proverbs 386

Depictions of David 392

Gateway to Art: Gentileschi, Judith Decapitating Holofernes: The Influence of Caravaggio 394

Chapter 3.7

Art of Europe and America (1700–1900) 398 Rococo 398

Neoclassicism 403 Romanticism 405 Realism 408 Impressionism 411

Post-Impressionism and Symbolism 415

Fin de siècle and Art Nouveau 417

Discussion Questions 420

FEATURES:

European and American Art Academies: Making a Living as an Artist 400
Gateway to Art: Goya, *The Third of May, 1808*: **The Artist and the Royal Family** 406
Madaga Saylatura Avaraga Padia and Carailla Olay III.

Modern Sculpture: Auguste Rodin and Camille Claudel 414

The Museums of Paris 419

Chapter 3.8

Twentieth and Twenty-First Centuries: The Age of Global Art 422 The Revolution of Color and Form 422

Expressionism 427

Dada 429 Surrealism 431

The Influence of Cubism 433 Abstract Expressionism 437

Pop Art 438 Minimalism 441 Conceptual Art 442

Postmodernism, Identity, and Multiculturalism 443

Discussion Questions 450

FEATURES:

Gateway to Art: Matisse, Icarus: Cutouts as Finished Art 424

Gertrude Stein as an Art Patron 427
Religion and Symbolism in *The Throne* 440
Modern and Postmodern Architecture 444
The Complexity of Today's (Art) World 449

PART 4 THEMES 452

Chapter 4.1 Art and

Civic and Ceremonial Places 454
Manmade Mountains 459

Art and Manmade Mountains 45
Community 454 Ritual: Performance, Bal

Ritual: Performance, Balance, and Healing 464

Art in the Public Sphere 466
Discussion Questions 469

FEATURES:

Art in Public Spaces 456

Gateway to Art: The Great Pyramid of Khufu: Community Art: The Building of

the Pyramids 460

Richard Serra: A Sculptor Defends His Work 466

Chapter 4.2

Spirituality and Art 470

Deities 470

Spiritual Beings and Ancestors 472

Connecting with the Gods 474

Sacred Places 477

Discussion Questions 483

FEATURES:

What Makes a Place Sacred? 478

Gateway to Art: Matisse, Icarus: Designs with Cutouts 482

Chapter 4.3

Art and the Cycle of Life 484

Life's Beginnings and Family Ties 484

Sacrifice, Death, and Rebirth 487

The Power of Nature 490

Judgment 492

Discussion Questions 495

FEATURE:

Gateway to Art: The Great Pyramid of Khufu: Astronomical Alignments of the Pyramids 493

Chapter 4.4

Art and Science 496

Astronomical Knowledge in Art 496

Art Celebrating Science 498

Using Science to Create Art 500

The Science of Perception and the Senses 501

Science of the Mind 503

The Scientific Restoration of Artworks 506

Discussion Questions 507

FEATURE:

Martín Ramírez: Art Inspired by Insanity 505

Chapter 4.5

Art and Illusion 508

Art as an Illusionistic Window 508

Illusionism as Trickery 512

Illusion and the Transformation of Ideas 516

Discussion Questions 519

FEATURES:

Gateway to Art: Raphael, The School of Athens: Architectural Illusion 509

Satirizing Illusionism: Hogarth's False Perspective 518

Chapter 4.6

Art and Rulers 520

Regal Portraits 520

Art to Demonstrate Absolute Power 523

The Power to Command 526
Art and Societal Control 528
Discussion Questions 529

FEATURES:

Gateway to Art: Colossal Olmec Heads: Portraits of Powerful Rulers 522

The Extravagance of the French Monarchy 524

Chapter 4.7

Art and War 530

Documenting War: Unbiased Facts or Biased Judgments? 530

Warriors and Scenes of Battle 534 The Artist's Response to War 537

Discussion Questions 541

FEATURES:

Gateway to Art: Goya, The Third of May, 1808: Two Views of a Battle 532

Michael Fay: Storm and Stone: An Artist at War 538

Wafaa Bilal: Domestic Tension: An Artist's Protest against War 540

Chapter 4.8

Art of Social Conscience **542**

Art as Social Protest 542
Art as the Object of Protest 546
Memorials and Remembrance 551

Discussion Questions 553

FEATURES:

Dan Tague: Art Made from Dollar Bills 543

Gateway to Art: Lange, Migrant Mother: The Impact and Ethics of Documentary

Photography 547

Iconoclasm: Destruction of Religious Images 550

Chapter 4.9

Archetypal Images of the Body 554

The Body in Art 554

Ideal Proportion 556
Notions of Beauty 557

Performance Art: The Body Becomes the Artwork 562

The Body in Pieces 565
Discussion Questions 567

FEATURES:

Reclining Nudes 560

Spencer Tunick: Human Bodies as Installations 564

Gateway to Art: Matisse, Icarus: The Blue Nude: Cutouts and the Essence of Form 566

Chapter 4.10

Art and Gender 568

Gendered Roles 568

Feminist Critique 572

Blurring the Lines: Ambiguous Genders 575

Discussion Questions 577

FEATURES:

Gateway to Art: Lange, Migrant Mother: The Image of Motherhood 570

Cindy Sherman: The Artist and Her Identity 571

Gateway to Art: Gentileschi, Judith Decapitating Holofernes: Professional Painter

of Women 573

Chapter 4.11

Expression 578

Making a Self-portrait 578

Finding an Artistic Voice 582
Borrowing an Image 588
Discussion Questions 589

FEATURES:

Gateway to Art: Gentileschi, Judith Decapitating Holofernes: Self-Expression in the Judith

Paintings 583

Mona Hatoum: Art, Personal Experience, and Identity 585

Glossary 590

Further Reading 598

Sources of Quotations 602

Illustration Credits 605

Image Numbering/Acknowledgments 611

Index 612

How to Use *Gateways to Art: Understanding the Visual Arts*

Gateways to Art is a new introduction to the visual arts, divided into four parts: Fundamentals, the essential elements and principles of art that constitute the "language" of artworks; Media, the many materials and processes that artists use to make art; History, the forces and influences that have shaped art throughout the course of human history; and Themes, the major cultural and historical themes that have motivated artists to create. Each of these parts is color coded to help you move easily from one section to the next.

Gateways to Art gives you complete flexibility in finding your own pathway to understanding and appreciating art. Once you have read the Introduction, which outlines the core knowledge and skills you will need to analyze and understand art, you can read the chapters of our book in any order. Each chapter is entirely modular, giving you just the information you need when you need it. Concepts are clearly explained and definitions of terminology in the margins ensure that you are never at a loss to understand a term.

This means that you can learn about art in the order that works best for you. You can, of course, read the chapters in the order that they are printed in the book. This will certainly tell you all you need to know to

appreciate art. But you can also choose your own path. For example, in the Introduction we discuss how art can be defined and what it contributes to our lives. This might be a great time to read chapter 2.8, "The Tradition of Craft," which deals with media that artists have used for centuries to create artworks, but which in our Western culture have sometimes been considered less important than "fine art." You could also read the discussion of Japanese art in chapter 3.3, "Art of India, China, and Japan," where you will discover that in Japan an expertly made kimono (an item of traditional clothing), for example, is appreciated as much as a painting or a print that in our culture are usually considered more prestigious. After considering the contrast between human proportion in the art of Ancient Greece and of Africa in chapter 1.7," Scale and Proportion," you could next read chapter 4.9, "The Body in Art," to understand how some artists have attempted to devise rules to portray the "perfect" body, while others have represented the human body as they see it in daily reality, challenging traditional notions of beauty.

Gateways to Art aims to demonstrate how rewarding it is to look at a great work of art many times and always discover

something new because there are many ways of seeing and analyzing an artwork. That is why our book takes its title from a unique new feature, not found in any other art appreciation textbook: what we call the "Gateways to Art." Through eight iconic works of world art (introduced on pp. 16–25), we will invite you to come back to these Gateways and look again to discover something new: about the design characteristics of the work; the materials with which it was made; the historical era and culture that influenced its creation; or how the work expressed something personal (for example the artist's character, gender, or political views). These discussions also sometimes provide a comparison with another work on the same subject, or consider what the artwork tells us about the great mysteries of our existence, such as spirituality or the cycle of life and death. We hope this will encourage you to revisit not only our Gateways, but also other works, and continue to enjoy them for years to come.

Our Gateways to Art boxes are just one of numerous features we provide to help you in your studies. In many chapters you will find Perspectives on Art boxes, in which artists, art historians, critics, and others involved in the world of art explain how diverse people involved in art think and work. Other boxes will, for example, help you to focus in depth on a single artwork, or alternately to compare and contrast artworks that deal with a similar subject or theme.

The Authors

Debra J. DeWitte has studied art history at the University of Texas Arlington, Southern Methodist University, and the University of Texas at Dallas. She has devised an award-winning online art appreciation course at UT Arlington.

Ralph M. Larmann
has a BFA from the University of
Cincinnati and an MFA from James
Madison University. He currently teaches
at the University of Evansville and is a past
President of Foundations in Art: Theory
and Education.

M. Kathryn Shields has a PhD in art history from Virginia Commonwealth University and has taught at the University of Texas Arlington and at Guilford College.

Resources for Instructors

• The authors of *Gateways to Art* have written an Instructors' Manual that is

1 Fifteen media and process videos made by art educators at Bowling Green State University demonstrate how art is made.

2 Twenty videos examine individual artworks in depth or set a work in a broader context.

available in print and digital form. In addition, they have created a test bank that is available in print, on disk with free software, and also as a download from our instructors' website.

- Images from the book are available as Jpegs and PowerPoint slides. Contact your W. W. Norton representative for details.
- The authors have worked with a team of art educators and digital art specialists at the Bowling Green State University to create a range of high-quality media to enrich your teaching:
 - 50 multimedia animations to demonstrate key elements and principles of art
 - 15 videos demonstrating how art is made
 - 20 video presentations that provide a multimedia presentation of key works of world art.

For full details of all instructors' resources go to thamesandhudsonusa.com/college.

Resources for Students

Our student website offers a wide range of review materials designed to improve your understanding and your grades: self-test quizzes; flash cards; chapter summaries; a glossary; multimedia demonstrations of key concepts; and videos that explain how art is made. Other content-rich resources for students include an audio glossary of foreign-language terms and artists' names.

For full details of our student resources go to http://www.wwnorton.com/college/art/gate waystoart.

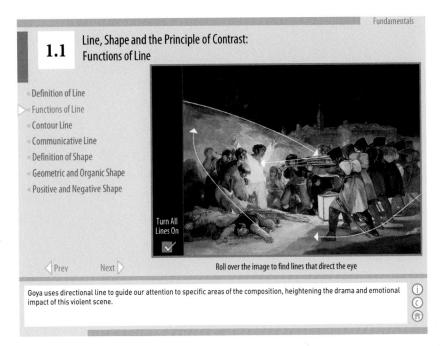

- **3** Fifty-one Interactive Exercises help students to understand the elements and principles of art.
- **4** A free and open student website presents an array of review opportunities, using the analytical framework of the text throughout

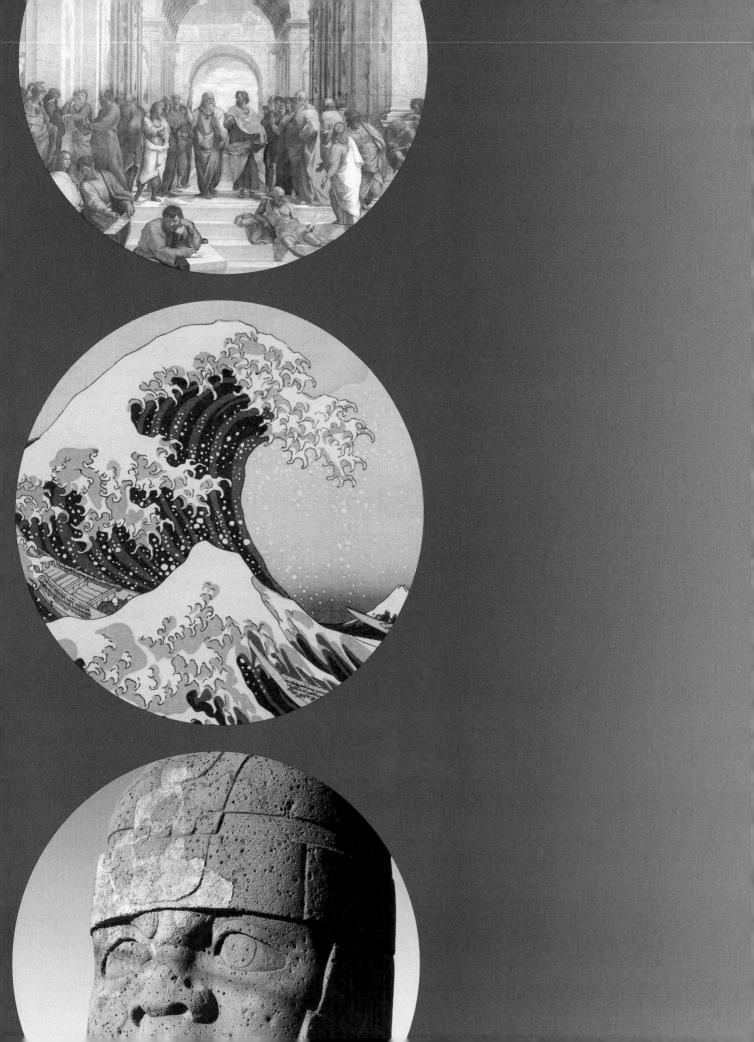

Gateway Features for Gateways to Art

One of the important lessons you will learn from this book is that every time you look at a great work of art, it will have something new to say to you. If you consider, for example, the way an artist designed the work, you may notice something about the use of color or contrast that had not struck you before. When you study the medium the artist chose (such as the particular choice of paint or the printing method selected), you will appreciate how it contributed to the overall impact of the work.

Another approach that we can take to an artwork is to look at it from a historical point of view: how does this work reflect the circumstances and the society in which it was created? Does it express the values of those who held political and economic power, or could it tell us something about the status of women at the time? Alternately, you could ask yourself whether the work addresses issues that have absorbed the attention of artists ever since humans began to paint, draw, and make sculpture. Does it touch on very big questions, such as the nature of the universe, or life and death? Or is it engaged with more personal concerns, such as gender, sexuality and our own identities?

You can appreciate a work of art by examining it closely from one or more of these perspectives. You can also learn more about one work by studying another and comparing the two. For example, consider how an artist might depict a famous event, such as a battle, or render the dramatic plight of sailors whose boat is caught in a terrible storm, or the poignancy of a family ruined by an economic disaster. The artist might choose a large-scale work that shows the enormous impact of events on a large number of people. But an alternative would be to create a work on a much more intimate scale, showing how such events affect a single person or a family, or even portraying that family in a moment of rest and quiet before the enormity of events becomes apparent.

There are many possible approaches to art, and to help you develop the important skills of looking at, analyzing, and interpreting works of art, we have selected eight iconic works—the "Gateways to Art"—which you will encounter repeatedly as you read this book. Each time you see one, you will learn something new about art and how to appreciate it. Let's begin by taking our first look at the Gateways in the pages that follow.

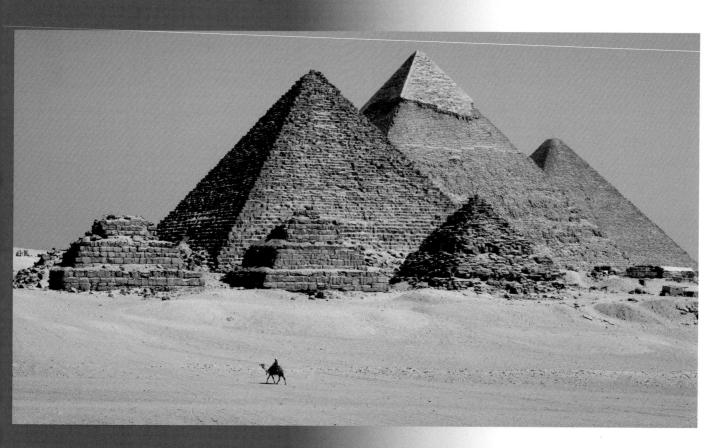

The Giza Pyramids

Three pyramids on the Giza plateau in Egypt, southwest of Cairo, Egypt's modern capital, are great monuments to the civilization of ancient Egypt. They were built to house the tombs of three Egyptian kings, or pharaohs: Khufu, his son Khafre, and Menkaure, son of Khafre. Construction of the first pyramid began about 2551 BCE and all three were completed over three generations.

The pyramids, built of stone clad in fine white limestone, were also temples to the gods worshiped by ancient Egyptians. The pharaohs who were buried there were believed to be representatives of the gods. The Great Pyramid of Khufu stands 481 feet high. The central pyramid built by King Khafre is 471 feet tall, slightly smaller than his father's. The height of Menkaure's pyramid is 2131/4 feet.

FUNDAMENTALS

1.2 (p. 64) Understand how the massive geometric forms of the pyramids reflect the formality and order of ancient Egyptian art.

MEDIA AND PROCESSES

2.10 (p. 277) Learn how the ancient Egyptians used their mathematical and engineering skills to build the pyramids.

HISTORY AND CONTEXT

➤ **3.1** (p. 301) Discover how the bodies of Egyptian pharaohs were prepared for burial in their tombs deep inside the pyramids.

THEMES

4.1 (p. 460) See how these great structures were achieved through a huge communal effort.
4.3 (p. 493) Learn how the ancient Egyptians used their mathematical and astronomical skills to align their pyramids with the points of the compass and with the stars.

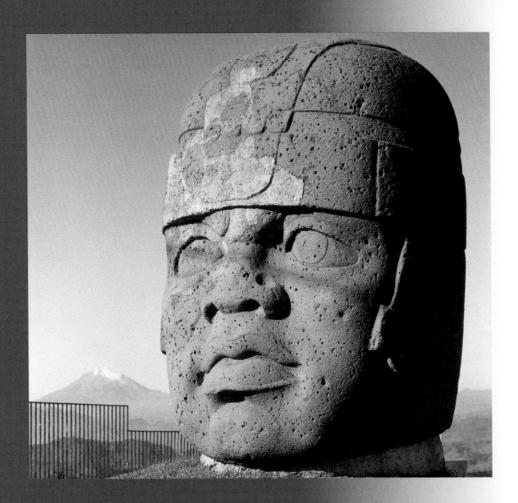

The Colossal Olmec Heads

The Olmecs, a people who lived on the Gulf Coast of eastern Mexico from about 2500 BCE to 400 cE, were great sculptors of stone. Probably sometime around 900 BCE they made colossal heads like the one shown here. These are amongst the most impressive sculptures of ancient Mexico. Seventeen such heads have been discovered at four sites. They range in size from five to twelve feet tall and weigh approximately six to twenty-five tons each. All portray mature males with flat noses, large cheeks, and slightly crossed eyes. Many scholars believe that the heads depict individual Olmec rulers.

FUNDAMENTALS

1.2 (p. 70) See how Olmec artists used the sheer mass of colossal heads to create a sense of power.

MEDIA AND PROCESSES

2.8 (p. 251) Compare the colossal heads with an Olmec ceramic sculpture.

2.9 (p. 263) Learn how the colossal heads were sculpted.

HISTORY AND CONTEXT

3.4 (p. 354) Experience the discovery and excavation of four colossal heads found buried at La Venta, Mexico.

THEMES

4.6 (p. 522) Examine how the evidence suggests that the colossal heads were portraits of Olmec rulers.

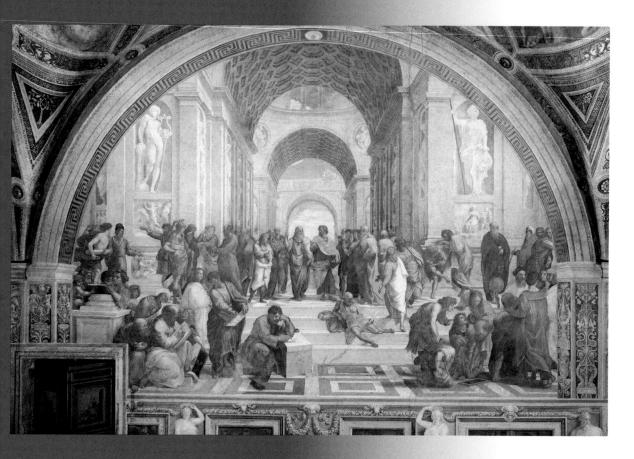

Raphael, The School of Athens

In 1510–11 the Italian artist Raphael (1483–1520) painted one of the great works of the Italian Renaissance, *The School of Athens*. This was one of four wall paintings commissioned by Pope Julius II to decorate the Stanza della Segnatura (his private library) in the Vatican Palace in Rome, Italy. *The School of Athens* measures 16 ½ feet high by 25 feet wide.

The School of Athens derives its name from the reputation of Athens, Greece, as the great center of Classical learning, and from the painting's subject matter: the work depicts an imaginary gathering of the great scholars of ancient Greece and Rome.

FUNDAMENTALS

1.3 (p. 89) Understand how the illusion of three-dimensional depth is created on a flat surface.
1.7 (p. 133) Discern how the artist drew the attention of the viewer to the figures in the center of the painting.

MEDIA AND PROCESSES

➤ 2.1 (p. 168) Study how Raphael used drawings to plan and design this large wall painting.

HISTORY AND CONTEXT

→ **3.6** (p. 382) See how Raphael used famous artists of his time as models for portraits of great thinkers from ancient Greece and Rome.

THEMES

▶ **4.5** (p. 509) Visualize how the other paintings in Pope Julius's library work in harmony with *The School of Athens* to create the illusion of an architecturally compelling space.

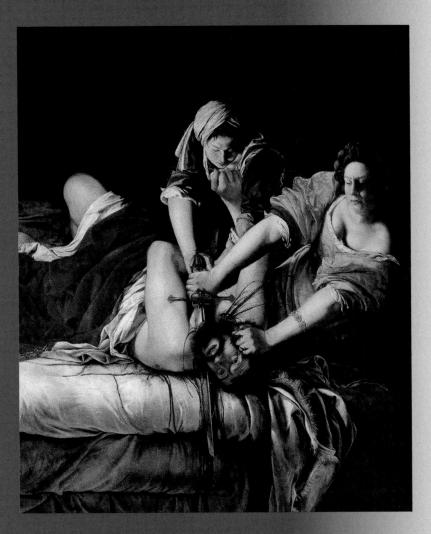

Artemisia Gentileschi, Judith Decapitating Holofernes

Around 1613–14, the Italian artist Artemisia Gentileschi (1593–c. 1656) made a dramatic painting of the story from the Old Testament of the Israelite heroine Judith killing the Assyrian general Holofernes, who had been sent by his king to punish the Israelites for not supporting his reign. Gentileschi's dramatic work, executed in oil paint on canvas, and measuring 6 feet 6 inches by 5 feet 4 inches addressed a subject that was popular among painters of the Baroque era. The artist is remarkable, however, as a woman who was determined to succeed in the maledominated art world of her time.

FUNDAMENTALS

• 1.8 (p. 139) Observe how the artist directs the viewer's eye toward the decapitated head.

MEDIA AND PROCESSES

➤ 2.2 (p. 187) Examine Gentileschi's paintings as personal statements.

HISTORY AND CONTEXT

➤ 3.6 (p. 394) Compare Gentileschi's style with that of a leading male painter of her time.

THEMES

► **4.10** (p. 573) Discover how Gentileschi focused her art on portraying women.

4.11 (p. 583) Interpret this painting as a response to Gentileschi's experience as a victim of rape.

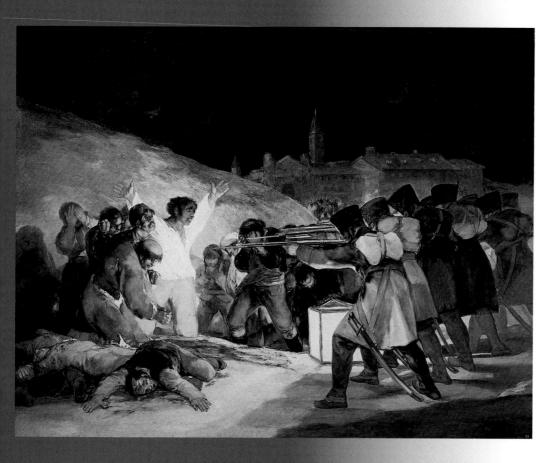

Francisco Goya, The Third of May, 1808

In 1814 the Spanish artist Francisco Goya (1746–1828) painted a dramatic depiction of war, *The Third of May, 1808*. Goya's work shows Spanish patriots being executed by invading French troops. This large oil painting (it measures 8 feet 4 inches by 11 feet 4 inches) was commissioned by King Ferdinand of Spain, who had recently returned to the throne after the defeat of the French. Goya's work is generally considered one of the finest portrayals of the horrors of war.

FUNDAMENTALS

- **1.1** (p. 54) Analyze Goya's use of line to guide the viewer's eye through his painting.
- **1.9** (p. 150) Understand how Goya uses visual rhythm to direct our attention to the victims of the French troops.

MEDIA AND PROCESSES

2.3 (p. 198) Study the connection between Goya's famous print series *Disasters of War* and his painting.

HISTORY AND CONTEXT

► **3.7** (p. 406) Examine Goya's relationship with Spain's royal family through his paintings.

THEMES

► 4.7 (p. 532) Consider how Goya's painting of Spanish resistance to the French invaders might add to your views of the war depicted in *The Third of May, 1808*.

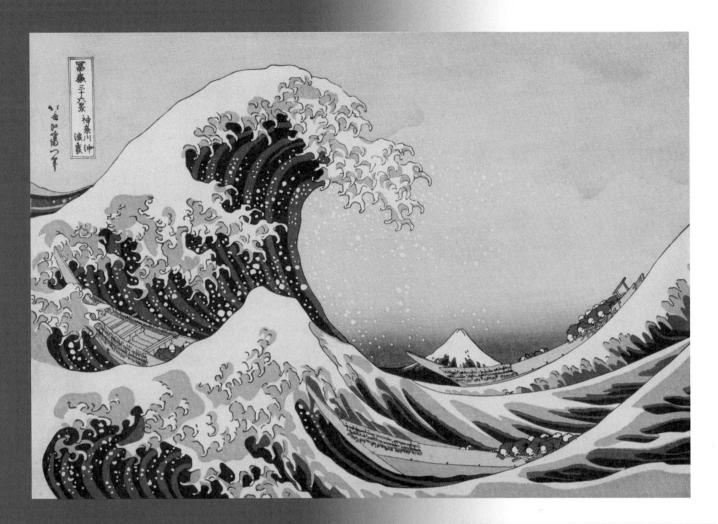

Katsushika Hokusai, "The Great Wave off Shore at Kanagawa"

Katsushika Hokusai (1760-1849) is regarded as one of the greatest Japanese printmakers. In 1831 he published a series of woodblock prints titled Thirty-Six Views of Mount Fuji: the prints were so successful that in fact he made 46 of them. All feature a view of Japan's sacred mountain, Fuji. One of the prints, "The Great Wave off Shore at Kanagawa," measuring around 9 inches by 14 inches, portrays a dramatic scene of fishermen caught in a storm at sea. Interestingly, Hokusai's work became popular in Europe before it did in Japan.

FUNDAMENTALS

► 1.3 (p. 81) Examine the techniques Hokusai used to give the illusion of depth on a flat surface. 1.6 (p. 117) Study how Hokusai arranges the elements of his composition to create a harmonious design.

MEDIA AND PROCESSES

2.3 (p. 195) Investigate the process Hokusai used to make this woodblock print.

HISTORY AND CONTEXT

- 3.3 (p. 346) Learn about the importance of Mount Fuji in Japanese culture.

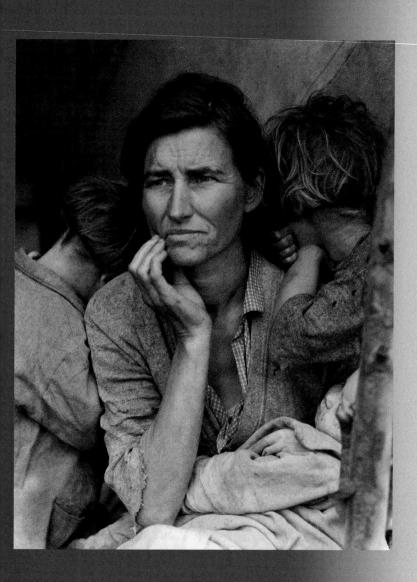

Dorothea Lange, Migrant Mother

The black-and-white photograph of a homeless and hungry family, *Migrant Mother*, is widely recognized as an iconic image of the hardships of the Great Depression of the 1930s in America. The documentary photographer Dorothea Lange (1895–1965) took the picture in 1936. She had been hired by a government agency, the Farm Security Administration, to record social and economic conditions in California. Since then, *Migrant Mother* has been frequently reproduced as a record of American social history.

FUNDAMENTALS

- **1.5** (p. 114) Study the sequence of images taken by Lange to see how time and motion are captured even in a still photograph.

MEDIA AND PROCESSES

➤ **2.5** (p. 216) Read Dorothea Lange's own account of how and why she took photos of this family.

THEMES

■ 4.8 (p. 547) Understand how the image became a symbol of society's responsibility toward the poor, and how the work and its reception affected the family it portrayed.

4.10 (p. 570) Analyze the presentation of motherhood in Lange's portrait.

un moment Me dibres.

Re divraitem

pas faire ac.

complir un

grand voyage

en avion aux

jeunes gens

ayantterminé

ceurs études.

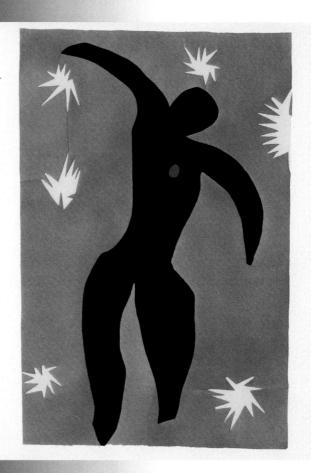

Henri Matisse, Icarus

Frenchman Henri Matisse (1869-1954) is recognized as one of the most important artists of the twentieth century for his interest in the vivid use of color, his exploration of the treatment of the human figure, and his work in an impressive range of media. His work includes painting, drawing, printmaking, sculpture, and graphic and interior design. He is also well-known for his "cutouts," works made from pieces of painted cut paper.

The bold use of color and shape in Icarus, a work published in 1947 in a book called Jazz, is characteristic of Matisse's work. This piece is also an example of the way Matisse could work across different media. Icarus (the title refers to a young man in Greek mythology who made wings so that he could fly) was designed as a cutout, and then made into a stencil to be printed in the book.

FUNDAMENTALS

1.4 (p. 97) Appreciate what *Icarus* tells us about Matisse's explorations of color.

MEDIA AND PROCESSES

2.1 (p. 178) Study how Matisse used line and shape to create form.

HISTORY AND CONTEXT

3.8 (p. 424) Learn what led Matisse to begin creating cutouts.

THEMES

4.2 (p. 482) Understand how Matisse used cutouts to design in many media, including creating the entire interior of a chapel.

4.9 (p. 566) Read Matisse's own words as he explains how he distilled forms to their simple essential truth.

Introduction

What Is Art?

The Japanese artist Katsushika Hokusai (1760–1849) is said to have created a painting, titled *Maple Leaves on a River*, by dipping the feet of a chicken in red paint and letting the bird run freely on a sheet of paper he had just covered in blue paint. Although we know that Hokusai

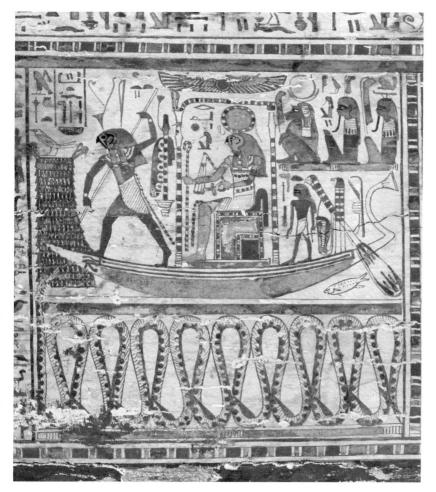

was an unconventional character, we cannot be certain that the story is true, because *Maple Leaves on a River* no longer exists. If we think about this curious story for a while, however, we can begin to understand the most basic question addressed in this book: What is art? This question is not an easy one to answer, because people define art in many individual ways. In Hokusai's case, he wanted to make viewers of his work feel the peaceful sensations of a fall day by a river, without actually showing them what a real river and real leaves look like. In this instance, art communicated a sensation to its audience.

In nineteenth-century Japan, art could be a means to encourage the quiet contemplation of nature, but to an Egyptian artist almost 3,000 years earlier, art would have meant something very different. The Egyptian who in the tenth century BCE decorated the wooden coffin of Nespawershefi with a painting of the Sun god Re had a quite different idea of rivers in mind from the one Hokusai conceived. For ancient Egyptians, rivers were important for survival. The Egyptians depended on the flooding of the River Nile to grow their crops. Rivers also had religious significance. Egyptians believed that during the daytime Re sailed across a great celestial ocean in his day boat. By night, the Sun god traveled in his evening boat along a river in

0.1 The Journey of the Sun God Re, detail from the inner coffin of Nespawershefi, Third Intermediate Period, 990–969 BCE. Plastered and painted wood. Fitzwilliam Museum, Cambridge, England

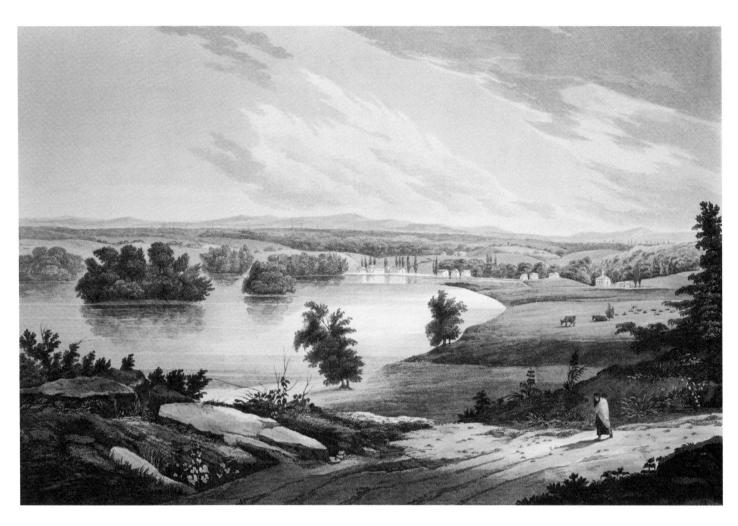

0.2 William G. Wall, Fort Edward, from The Hudson River Portfolio, 1820. Hand-colored aquatint, $14^{1}/2 \times 21^{3}/8$ "

the underworld, but before he could rise again he had to defeat his enemy, the serpent Apophis, which in **0.1** can be seen swimming in the river. Here the river is again suggested rather than being realistically portrayed. It is a place of danger, not of contemplation, and if Re does not emerge victorious, the world will be deprived of the life-giving light of the Sun. Re, who in the image is seated, is protected by another god carrying a spear. He travels with several attendants, including a baboon. The choice of this subject was appropriate for a coffin: no doubt Nespawershefi hoped to emerge from the underworld to live a happy afterlife, just as Re rose again every morning. For the painter of this coffin, art was a way to express profound religious ideas and to invoke beliefs in a happy life after death.

Both of the works we have examined so far are paintings, even though they were painted on different materials for different purposes. If we consider another **medium**, a **print**, we can see how another artist from a different era and

continent could depict a river in yet another way. For William Wall (1792-1864), working in the United States in the early nineteenth century, rivers and the landscape of which they formed part were a vehicle for expressing nationalistic sentiment and a way of celebrating the expansion and development of America. Wall published the first book that made Americans aware of the sublime beauty of their own scenery. The work shown here is Fort Edward (0.2). Wall produced an attractive scene. but this was not all he wanted to communicate to his audience. His print recalls the struggles of empire- and nation-building that took place on this site. As the artist noted: "The ploughshare now peacefully turns up the soil moistened by the blood of thousands: the dust of the merciless Indian and the ambitious European repose in awful amity together." As if to remind us that the time of the Indian has been replaced by new ways of life, a lone Indian woman passes in front of prosperous European farmsteads. Although

Medium: the material on or from which an artist chooses to make a work of art

Print: a picture reproduced on paper, often in multiple copies

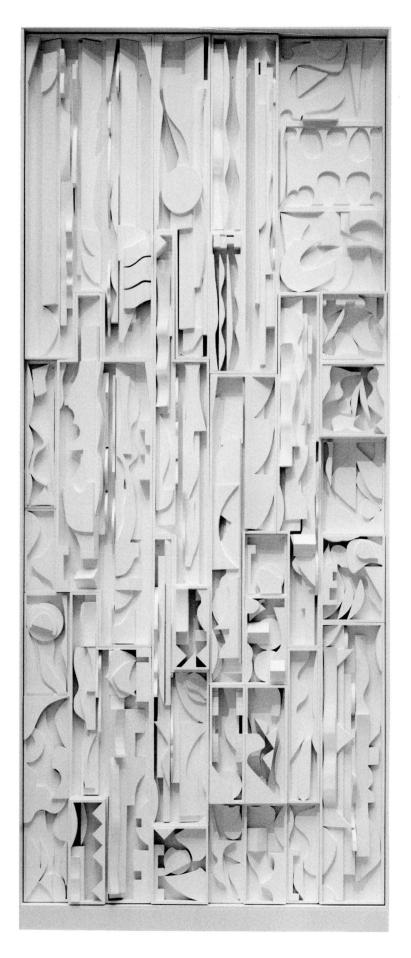

Wall painted an original **watercolor** of this scene, the print was made by another artist, John Hill.

Finally, before we try to come to some conclusions about the definition of art, consider a work by Louise Nevelson (1899-1988) that also features a river, or, more precisely, a waterfall (0.3). Nevelson constructed twenty-five painted rectangular and square wooden sections inside an overall rectangular frame, measuring 18×9 ft. Inside some of the rectangles we can see undulating curved forms that suggest a cascading waterfall or the froth of white water. Other forms in the upper right of the square resemble squirming fish. Clearly, Nevelson's purpose in this artwork is not to show to us an instantly recognizable likeness of a waterfall full of fish. Instead we are invited to examine closely her carefully constructed work and to feel the sensations of watching water cascade and fish swimming.

If we go back to our original question, what is art?, can our consideration of these four very different works help us to find a quick and simple definition that will tell us whether we are looking at something called art? These four works certainly do not have much in common in terms of their appearance. The definition also cannot include a common range of materials (in fact, art can be made from almost anything). We cannot define art in terms of the kind of choices an artist makes: very few artworks involve a live chicken, but Hokusai used one to make his painting. Nor do these works have a common purpose. The Egyptian coffin painting has a clear religious message. Wall's print portrays a beautiful landscape but also carries a powerful message of nationalism and colonial conquest. Hokusai's painting used very simple means to convey restful sensations. Nevelson's work also focuses on communicating the sensations of being by a river, but in her case with a meticulously constructed geometric suggestion of one.

Perhaps the works do have some things in common, however. We can see that artworks

0.3 Louise Nevelson, White Vertical Water, 1972. Painted wood, 18 × 9°. Solomon R. Guggenheim Museum, New York

communicate ideas and emotions (religious feelings or the sensation of watching beautiful fall foliage, for example). The communication of ideas by visual means can help us see the world in new and exciting ways and strengthen our understanding. In other words, art is a form of language. In our contemporary world, some people hold the opinion that art has no boundaries, and that anything can be a work of art. In this book we will examine about 750 artworks made over thousands of years and in all parts of the world, but there will still be many kinds of art that we will not have space to include. The language of art is a living entity that is constantly evolving and changing. Perhaps the most important qualities an artwork can possess are the ability to move the spectator; to convey a message; or to inspire thoughts a person would not otherwise have had.

Where Is Art?

Although so far we have examined only four works of art, you have probably already figured out that there is no single place in which we can find art. We can discover it in a coffin, a book, or a museum. In the modern world we go to museums and art galleries—institutions established specifically to display and care for artworks. If we visit a major museum, such as the Metropolitan Museum of Art in New York or the British Museum in London, we will see that visitors have come from just about every country in the world. But if we consider only works that are displayed in museums and galleries, we will ignore many works that are certainly art. In fact, a great deal of art exists outside such institutions.

You almost certainly have some art in your home: perhaps a painting in the living room, a poster in your bedroom, or a beautifully made flower vase. In parks or other public spaces in most cities there are sculptures and memorials. From 1921 to 1954 Simon Rodia built seventeen interconnected structures on a residential lot in a neighborhood of Los Angeles (0.4). Rodia's work is now known as the Watts Towers, although he named it *Nuestro Pueblo* (Spanish for "our

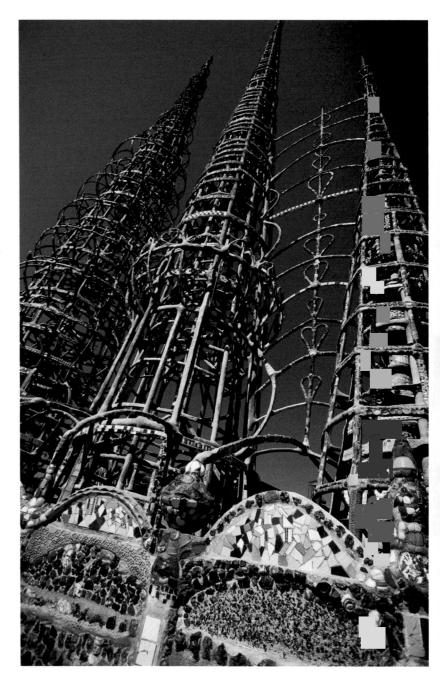

town"). Rodia, a construction worker, made his structures out of materials he found or that local people brought to him. The towers are made of steel rods and pipes, wire mesh, and mortar, and decorated with bits of broken glass and pottery. Rodia's neighbors and the City of Los Angeles did not approve of his work, and efforts were made to destroy it, but in 1990 it was named a National Historic Landmark.

In most American cities there are civic buildings (such as the courthouse or the Capitol) that were designed to impress and to communicate something about the strength of

0.4 Simon Rodia, Watts Towers, 1921–54. Seventeen mortar-covered steel sculptures with mosaic, 99½' high at tallest point. 1761–1765 East 107th Street, Los Angeles, California

Watercolor: transparent paint made from pigment and a binder dissolved in water

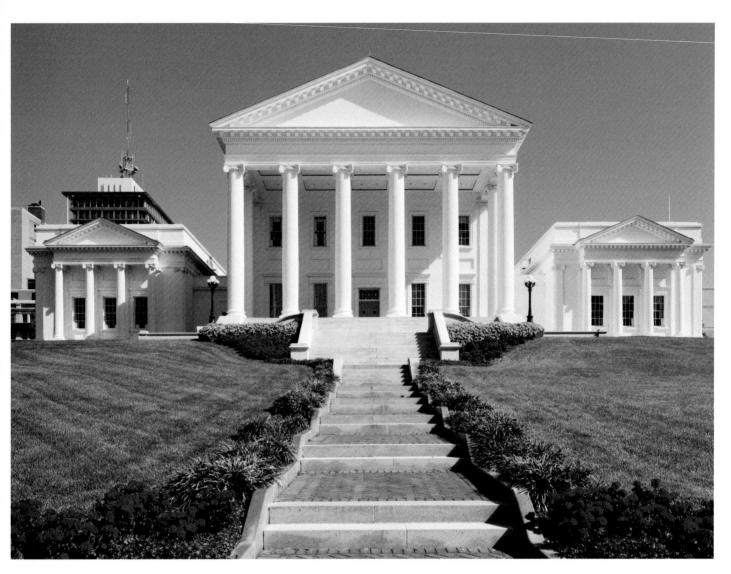

0.5 Thomas Jefferson, Virginia State Capitol Building, 1785–8, Court End District, Richmond, Virginia

the Republic and its institutions. The Virginia State Capitol (**0.5**), designed by Thomas Jefferson, was modeled closely on a famous ancient Roman temple in Nîmes, France, built 1,800 years before Jefferson's building. It thereby drew on the symbolic power of ancient Rome.

Who Makes Art?

Who decides what an artwork looks like? The simple answer might seem to be the artist who makes it. We know that art has been made for thousands of years: at least since humans first painted images on the walls of caves, and probably long before then. Much artwork made in the past has not survived, however, so we do not know what it looked like. Even when art did survive, we often have no idea who made it.

The great temples of ancient Egypt, Greece, and Rome were certainly not the work of one person, and in some cases, we cannot tell if their overall design was the idea of a single individual. Archaeologists have discovered in the Valley of the Kings in Egypt an entire village, Deir el-Medina, which was occupied by artisans who made the great monuments that we admire today. The cathedrals of **medieval** Europe were the result of the skills of many different artists and artisans: stone carvers, the makers of stainedglass windows, and carpenters who made the furniture. These skilled workers remain mostly anonymous, except for a very few whose names have been found in manuscripts or carved on works of art—for example, the sculptor Gislebertus carved his name on sculptures that adorn the cathedral of Autun, France. But though we may never identify most of these

early artists, it is clear that humans have always wanted to make art. This urge is part of our nature, just like our need to eat and sleep.

In the nineteenth and twentieth centuries in the Western world, the popular idea of the artist was of a lone individual creating his or her own work to express something very personal. In these centuries it became more common for artists to create their own work, and, in their search for new forms of self-expression, to make art that was often very controversial. But for many centuries before this, very few artists worked alone. **Renaissance**

artists created workshops staffed by artist assistants who carried out most of the work involved in turning their master's design into a work of art. In nineteenth-century Japan, the eccentric Hokusai was famous around the world for his prints, but he could not have made them alone. A wood carver cut his designs into blocks from which a printer manufactured copies. Even today, some famous artists, such as Jeff Koons, employ other artists to realize their ideas (0.6).

In other words, there is no simple definition to enable us to tell who is an artist and who is

0.6 Jeff Koons, *Rabbit*, 1986. Stainless steel, $41 \times 19 \times 12^{\circ}$. Edition of 3 and artist's proof

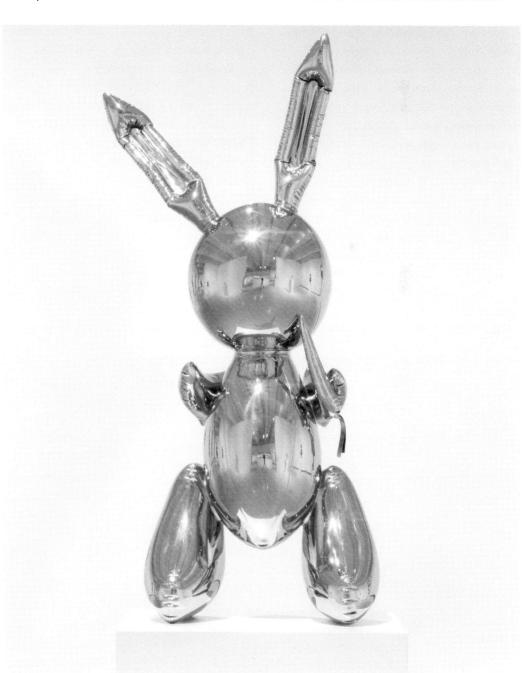

Medieval: relating to the Middle Ages; roughly, between the fall of the Roman Empire and the Renaissance

Renaissance: a period of cultural and artistic change in Europe from the fourteenth to the seventeenth century

not. If we take a global view, we certainly cannot define an artist by what he or she made. In Western culture during some eras of history, particularly since the Renaissance, painting and sculpture have been considered to be the most important categories of art ("high art"), while others, such as ceramics and furniture, have been considered less important. The term craft was usually applied to such works, and their makers were considered less skilled or of lower status than painters and sculptors. This distinction arose partly because the cost of producing a fine painting or a beautifully carved marble statue was high. Therefore, those became status symbols of the rich and powerful. In other cultures the relative importance of different forms of art was quite different. The people of ancient Peru seem to have placed special value on wool, and those who made fine woolen textiles were likely considered as skillful as a painter would be in our society. In China the art of calligraphy (elegantly painted lettering) was considered one of the highest forms of art. A Chinese encyclopedia of 624 CE included calligraphy and painting in "Skills and arts," alongside, for example, archery and chess.

For centuries, in Japan, such **ceramic** objects as tea bowls have been highly esteemed for their beauty. The bowl seen in **0.7** would have been prized for its subtle variations of color, the pleasant tactile sensations of its slightly irregular

surface, and its shape. It was designed to be appreciated slowly as the user sipped tea. The artist who made this bowl worked at roughly the same time as the Italian Renaissance artist Leonardo da Vinci (1452–1519), but the two had different ideas of what it meant to be an artist. The Japanese maker of the tea bowl worked in a society that valued tradition. Japanese artists followed with supreme skill the established methods of working and making. Leonardo, however, became famous in an era in Europe that valued individual ingenuity. He was a supremely talented artist whose visionary interests and inventions extended far beyond the visual arts, to engineering and science. Between 1500 and 1503 he created a portrait that is probably the most famous painting in the world. Leonardo was not content to create a likeness of the subject (Lisa Gherardini, wife of a silk merchant in Florence). The Mona Lisa smiles and looks out at the viewer, inviting us to seek in her face, her pose, and the surrounding landscape a meditation on the human soul (0.8). Both the tea cup and the portrait are great works of art, but they display very different ideas of what it means to be an artist.

We must also consider that artworks are not only the result of the work of those who made them, but are also influenced by the input of others: the **patrons** who employ an artist

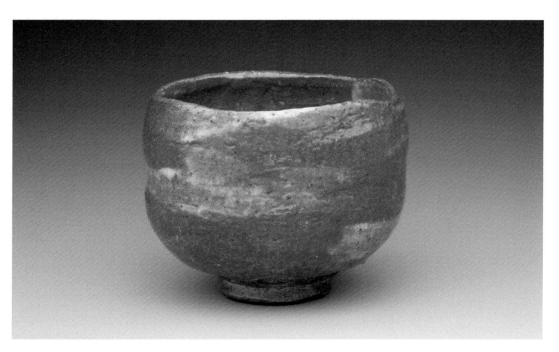

0.7 Tea bowl, 16th century. Stoneware with red glaze [Karatsu ware], 3 × 19⁷/₈". Indianapolis Museum of Art

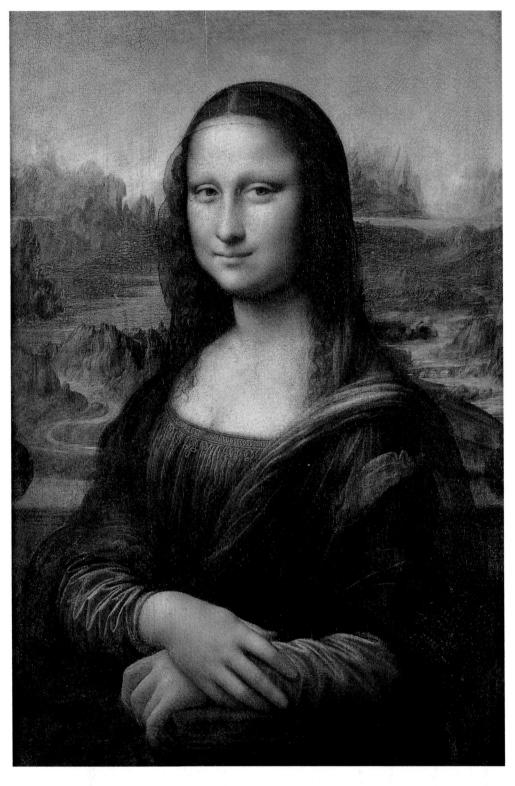

Calligraphy: the art of emotive or carefully descriptive hand lettering or handwriting **Ceramic:** fire-hardened clay,

often painted, and normally sealed with shiny protective coating

Patron: an organization or individual who sponsors the creation of works of art

0.8 Leonardo da Vinci, *Mona Lisa*, 1503. Oil on wood, $30\% \times 20\%$. Musée du Louvre, Paris, France

to make a work; the collectors who buy it; and the dealers and gallery owners who sell it. In contemporary times, both the publicist who presents artworks and the critic who reviews them in a newspaper, on TV, or on the Internet help to make an artist's work well known and desirable. All of these people, not just the artist,

help to determine what art we see, and to some extent they can influence what we consider to be art. By controlling access to those who buy art, the places where art is displayed, and the media that inform the public about art and artists, they also often influence what kind of art an artist actually produces.

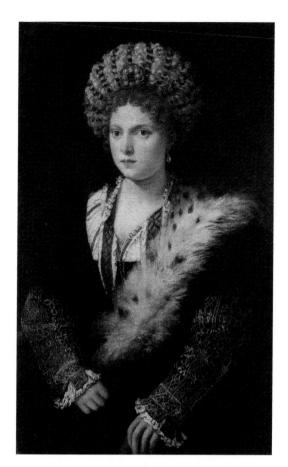

0.9 Titian, *Isabella d'Este*, 1536. Oil on canvas, $40\% \times 25\%$. Kunsthistorisches Museum, Vienna, Austria

One individual who greatly impacted the production and presentation of art was Isabella d'Este (1474–1539), Marchesa of the city of Mantua, Italy, and the wife of the ruler of the city, which she governed in her husband's absence. As an influential patron of the arts, Isabella funded a variety of artists to create luxurious objects for her collections, including such things as gems, musical instruments, manuscripts, and ceramics. Her money and tastes therefore played an important part in determining what art was produced in Mantua. Titian's (1485–1576) portrait of the Marchesa presents her as a formidable woman who enjoys the finer things in life (0.9). This elegant woman wears a turban she designed, fine embroidered clothes, and a white ermine stole (a sign of wealth and refinement) over her shoulder. Although the Marchesa was in her sixties when she commissioned this painting, Titian portrays her as a youthful beauty.

Fame and success do not always come in an artist's lifetime. Perhaps the most famous example of this is the Dutch painter Vincent van

Gogh (1853–1890). In his ten years as an active artist, Van Gogh produced about 1,000 drawings, sketches and watercolors, as well as around 1,250 other paintings. Very few people saw his work in his lifetime, however; he received only one favorable notice in a newspaper; his work was shown in only one exhibition; and he sold only one painting. Yet today his work is extraordinarily famous, it sells for millions of dollars, and in his native Netherlands an entire museum is devoted to his work.

The training of artists also helps to determine who makes art and what art is shown in galleries and museums. For example, traditional training for painters in China focused on the passing of artistic skill from a master to his students, who learned by copying his works and those of other famous artists. Only scholars and government officials could become professional painters. Other painters were considered to be just craftspeople whose work was of lower status. In medieval Europe, only those trained in associations of craftsmen called guilds were allowed to make works of art. For example, there were guilds of carpenters, glassmakers, and goldsmiths. The system in Europe changed in the sixteenth century. Schools called **Academies** were organized (first in Italy) to train artists in a very strict curriculum devised by specialized teachers. It was very difficult to succeed as an artist without being trained in an Academy. In modern Europe and North America, most practicing artists are trained in art schools. which are sometimes independent schools, but often part of a university or college that teaches many different subjects. It is possible, but more difficult, for artists who have not been formally trained in this way to succeed in having their work displayed and sold.

The Value of Art

On November 8, 2006 a sale at Christie's auction house in New York City broke records by selling 491 million dollars' worth of artworks. The most expensive item for sale that evening was a portrait, *Adele Bloch-Bauer II* (**0.10**), painted in 1912 by the Austrian artist Gustav Klimt (1862–

1918). It sold for \$87.9 million. Klimt made a comfortable living from painting portraits of the wives and sisters of wealthy Austrian businessmen, but in his own lifetime he was certainly never paid anything like the enormous sum for which his portrait of Mrs Bloch-Bauer

sold in 2006. One reason for the painting's increase in price was its controversial history. In 1938 it had been looted by the Nazis, who had occupied Austria, and the work later became the subject of a lawsuit by the heirs of the Bloch-Bauer family.

0.10 Gustav Klimt, *Adele Bloch-Bauer II*, 1912. Oil on canvas, 6'2⁷/8" × 3'11¹/4". Private collection

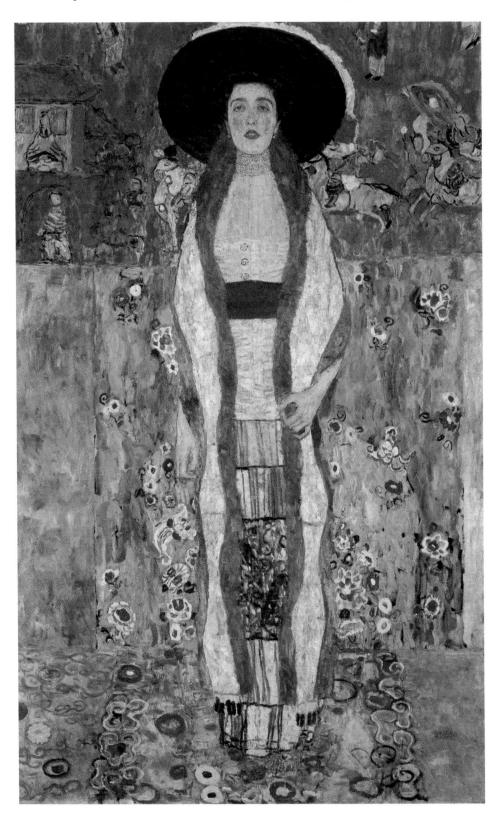

Manuscripts: handwritten texts Guilds: medieval associations of artists, craftsmen, or tradesmen Academies: institutions training artists in both the theory of art and practical techniques

Perspectives on Art: Robert Wittman What Is the Value of an Artwork?

A work of art will usually attract a high price if works by the artist who made it are rarely Special Agent Robert Wittman is a former FBI investigative expert for stolen artworks. Here he explains how criminals valued a self-portrait by Dutch artist Rembrandt van Rijn (1606-69).

Value can be defined as the price that a willing buyer will pay to a willing seller. But that value 0.11 Rembrandt van Rijn, changes as a result of the circumstances surrounding an artwork. One needs only to look at auction records to determine the value of a painting. These prices are records of what

available for sale. Some artists' works are so rare that thieves will go to great trouble to steal them.

a willing buyer paid to a willing seller to obtain a work of art that had a good provenance and title that could be transferred on the market.

These are the legitimate prices in the art world, but there are other prices that have no basis in legitimacy. These others are the prices that are paid when an artwork is stolen and sold on the black market. Even criminals need a basis to place a value on their ill-gotten gains and that is usually about ten percent of the legitimate market value of the stolen artwork; but even that sum is usually not paid.

For example, in December 2000 a Rembrandt self-portrait (0.11) was stolen from the Swedish National Museum in Stockholm. Three men entered the museum wielding machine guns. After placing the guards, visitors, and guides on the floor, two of the men raced around the museum and stole three paintings: two by Auguste Renoir, and the Rembrandt. The Self-portrait was painted in 1630 and is very rare: it is the only known portrait by the Dutch master painted on copper. Its market value is \$35 million. The men had set two car bombs off in the city to snarl traffic and prevent the police from responding. They made their escape in a motorboat moored to a pier near the entrance of the museum.

It was not until nearly five years later, in September 2005, that the Rembrandt selfportrait was recovered in a multi-national police undercover operation in Copenhagen, Denmark. The thieves attempted to sell it to me when I posed as an art expert working for the Mafia. The price was \$250,000, or less than one percent of the market value of the artwork. Stolen art has no real value: the lack of good title, improper provenance, and inability of a buyer to sell the painting in the future all decrease the value of an artwork. As most thieves eventually learn. the true art in an art theft is in the selling, not the stealing.

Self-portrait, 1630. Oil on copper. $6\frac{1}{8} \times 4\frac{3}{4}$. Nationalmuseum, Stockholm, Sweden

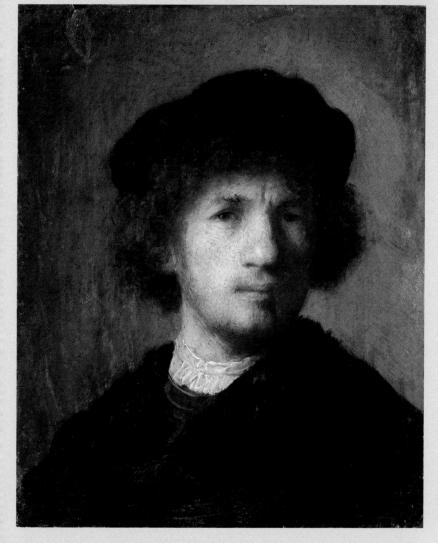

When we read that some works of art sell for large amounts of money while others do not, we quite reasonably ask ourselves why such a high financial value is placed on a single work. Works of art by famous artists of the past tend to be valued at a high price, especially if they are very rarely available.

In our modern society art is often valued by its sale price, but there are many other ways of valuing it. When we visit art museums and see artworks displayed inside glass cases or at a distance from the viewer who must not touch, the care to preserve them in perfect condition is an indication that these works are highly valued. Sometimes a work is valued because it is very old or rare, or indeed unique.

In many societies, however, artworks were not made to be sold or displayed where they cannot be touched. As we have seen, the Japanese made fine tea bowls. These bowls were to be used as part of a ceremony, involving other fine objects, good conversation, and, of course, excellent tea. The tea bowl was valued because it formed part of a ritual that had social and spiritual significance. Similarly, in the African art section of many museums we can see masks displayed that were originally made to form part of a costume that, in turn, was used in a ceremony involving other costumed figures, music, and dancing. In other words, the mask often had some kind of spiritual or magic significance for its original creators: but they would have regarded it as holding this value only when used as intended, not when displayed in isolation in a museum.

So we see that price is, of course, not the only measure of the value of an artwork. We might place a high value on a work because it is aesthetically pleasing or because its creation involved great skill. This can be true even if there is no possibility of our owning it. Many museums organize large exhibitions of the work of famous artists because they know that great numbers of people will pay to see the work. Enthusiasts will travel long distances, even to other continents, to visit such exhibitions. In 2007, for example, 796,000 people visited an exhibition of the work of Leonardo da Vinci at the Tokyo National Museum, Japan.

Artworks can also acquire great religious, cultural, or political significance. For example, the Lincoln Memorial in Washington, D.C., was dedicated in 1922 to honor a president who had become a symbol of American values and identity. The memorial was the work of three artists. Architect Henry Bacon (1866–1924) designed in the form of an ancient Greek temple the building that houses Lincoln's statue (0.12). Daniel Chester French (1850–1931) made the over-life-sized statue of Lincoln, while Jules Guerin (1866–1946) painted the **murals** (*Reunion* and *Emancipation*) on the interior walls.

Provenance: the record of all known previous owners and locations of a work of art Mural: a painting executed directly on to a wall

0.12 The Lincoln Memorial statue by Daniel Chester French, 1920. Marble, 19' high. The Mall, Washington, D.C.

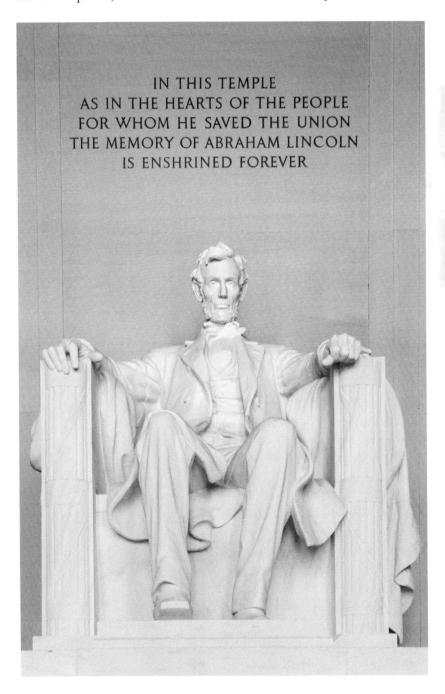

Perspectives on Art: Tracy Chevalier

Art Inspires a Novel and a Movie

Art can have value as a source of inspiration.
Tracy Chevalier is the author of the bestselling
novel Girl with a Pearl Earring (1999), which in
turn inspired a movie (2003) starring Scarlett
Johansson and Colin Firth. Tracy tells how her
novel was inspired by a poster of the famous
painting by the Dutch painter Johannes Vermeer.

I first saw the painting *Girl with a Pearl Earring* (0.13) when I was nineteen and visiting my sister in Boston for spring break. She'd hung a poster of it in her apartment. I was so struck by it—the

color! the light! the girl's look!—that the next day I bought a poster of it myself. That same poster has accompanied me for twenty-nine years, hanging in my bedroom or—as it does now—in my study.

Over the years I've hung many other paintings on my walls. But most art, even great art, loses its punch after a while. It becomes part of the space designated for it; it becomes decorative rather than challenging. It turns into wallpaper. Occasionally someone will ask a question about one of the paintings in my house, or I'll notice one's crooked and straighten it, and I'll look at it again and think, "Oh yeah, nice painting. I forgot about you."

Girl with a Pearl Earring is not like that. She has never become wallpaper. I have never grown tired or bored of her. I notice her all the time, even after twenty-nine years. Indeed, you'd think I'd have nothing left to say about the painting. But even after writing a whole novel about her, I still can't answer the most basic question about the girl: Is she happy or sad?

That is the painting's power. *Girl* with a Pearl Earring is unresolved, like a piece of music that stops on the

penultimate chord. Vermeer draws us in with his technique—his remarkable handling of light and color—but he holds us with her. He has somehow managed the impossible, capturing a flickering moment in a permanent medium. You would think that, with the paint static, the girl would be too. But no, her mood is always changing, for we ourselves are different each time we look at her. She reflects us, and life, in all its variations. Few paintings do that so well, which is why *Girl with a Pearl Earring* is a rare masterpiece.

0.13 Johannes Vermeer, *Girl with a Pearl Earring, c.* 1665.
Oil on canvas, 17½ × 15¾...
Mauritshuis, The Hague,
Netherlands

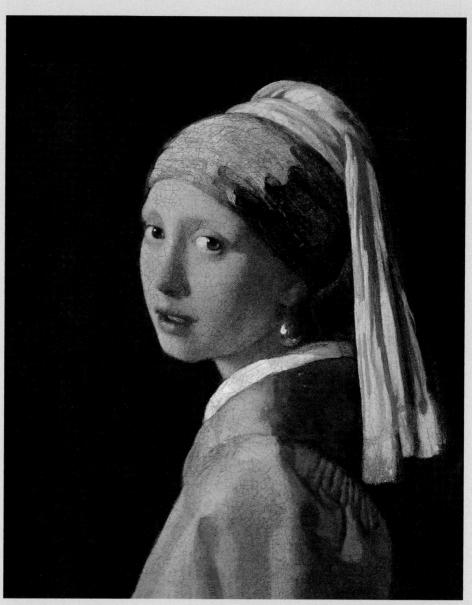

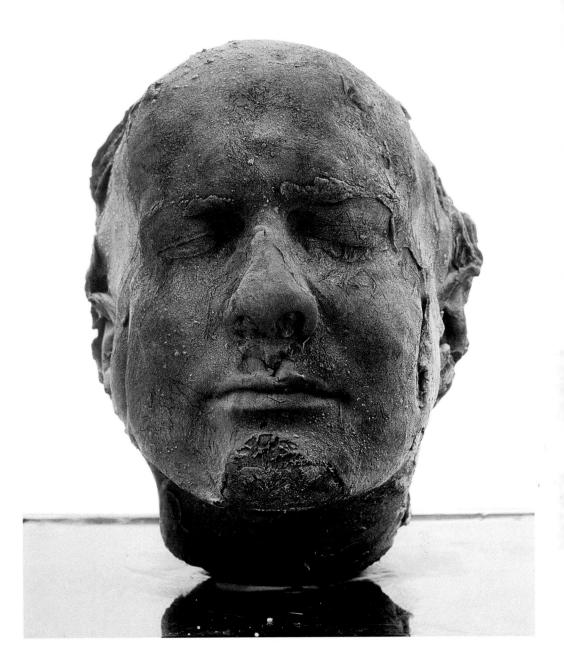

0.14 Marc Quinn, *Self*, 1991. Blood (artist's), stainless steel, perspex, and refrigeration equipment, $81\% \times 24\% \times 24\%$. Private collection

Censorship of Art

Art can be a form of expression and communication so powerful that those who are challenged or offended by it wish to censor it. If we examine the history of the censorship of art, we find many reasons for attacking, destroying, or preventing the display of artworks. Art may be censored because some consider it pornographic; because it offends religious beliefs; because of objections to the political message of a work; or because it represents values that somebody considers offensive or improper. For example, in 1999 the Brooklyn Museum held an exhibition of contemporary British art titled

Sensation. The mayor of New York, Rudolph Giuliani, objected to a painting by Chris Ofili, The Holy Virgin Mary. When the museum refused to remove the work from public display, the mayor attempted to evict the Brooklyn Museum from the building it had occupied for 106 years and to withhold city funding. He then objected that the exhibition included many works that offended religious sensibilities, were sexual in nature, or were in some other way offensive. One, titled Self, was a self-portrait by Marc Quinn made from nine pints of his frozen blood (0.14). The city argued that the museum had violated the terms of its lease by holding an exhibition that was not appropriate for the citizens of New York, and in particular young

people. A federal court protected the museum's right to hold the exhibition and prevented the city from evicting it or from withdrawing funding.

In Germany in the 1930s, the Nazi regime of dictator Adolf Hitler launched a systematic and large-scale attack on modern art that did not conform to Nazi party goals. The Nazis initially confiscated around 5,000 works of art from museums; they subsequently took a further 16,500 from private collections. Some 4,000 of these were then burned, while others became the property of Nazi collectors, or were sold to foreign collectors for Nazi profit. The artists who had made them were banned from working. The Nazis also dismissed museum directors, closed art schools, such as the famous Bauhaus, and burned books. On July 19, 1937 the Nazis opened an exhibition of "Great German Art." The next day they opened a display of 730 works labeled "Degenerate Art" to suggest that these were the work of mentally deficient artists. Works were deliberately displayed awkwardly and labels on the walls ridiculed the artworks. One read: "We

act as if we were painters, poets, or whatever, but what we are is simply and ecstatically impudent. In our impudence we take the world for a ride and train snobs to lick our boots!"

One of the artists whose work was ridiculed in the exhibition was Otto Dix (1891–1969). Dix had been a machine-gunner in the German army during World War I from 1914 to 1918. He made many sketches of war scenes, and the experience of war became the main subject of his work until the 1930s. The Nazis dismissed him from his teaching position at the Prussian Art Academy in 1933. They then confiscated his paintings from museums and banned him from exhibiting his work because his paintings were "likely to adversely affect the military will of the German people." Dix's drawing War Cripples (0.15) was one of the works that was included in the Degenerate Art Exhibition. Dix was then forced to join the government's Chamber of Fine Arts and to promise to paint only landscapes. He was drafted into the German army in 1945 and taken prisoner by the French.

0.15 Otto Dix, *Kriegeskrueppel* (War Cripples), 1920. Drypoint, 12³/₄ × 19¹/₂" (sheet size). MOMA. New York

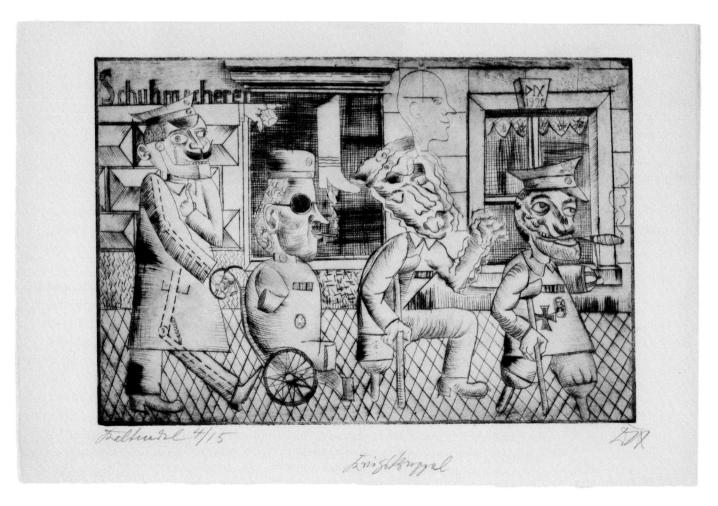

Thus the Degenerate Art Exhibition not only affected the lives of artists, but also restricted what art Germans were allowed to see and how they would view it. Ironically, however, Hitler's attempt to censor art backfired: five times as many visitors attended the Degenerate Art Exhibition as the show of Great German Art. Very few records survive to reveal what viewers really thought of the art in this propaganda spectacle.

Why Do We Study Art?

Finally, why take a course that teaches you how to look at art? Surely we all have eyes and we all see the same thing when we look at a work of art, so we can decide what we like or dislike about it. In fact, it is not quite that simple. Our interpretations of works of art may differ from other people's according to our perceptions, beliefs and ideas. Art is also a form of language; one that can communicate with us even more powerfully than written language. Art

communicates so directly with our senses (of sight, touch, even smell and sound) that it helps us to understand our own experiences. By learning to see, we experience new sensations and ideas that expand our horizons beyond our daily lives.

Let us consider an artwork and the fact that we may not see the work the way it was seen when it was first made. Prisoners from the Front (0.16) by American artist Winslow Homer was painted in 1866. We can tell immediately that the subject is war and that it involves men from two armies. But there are many ways in which we can discover and learn more from this painting: how really to look at it. We can begin by examining the way Homer organizes different aspects of the painting to direct our eyes and to communicate with us. How has he placed the figures in the painting and what first attracts our attention? Perhaps we look first at the group of soldiers dressed in gray (especially the one standing in the center of the work)—but does the gaze of this group then direct us to the officer standing alone on the right? What colors did Homer

Bauhaus: design school founded in Weimar, Germany, in 1919

0.16 Winslow Homer, *Prisoners from the Front*, 1866. Oil on canvas, 24 × 38". Metropolitan Museum of Art, New York

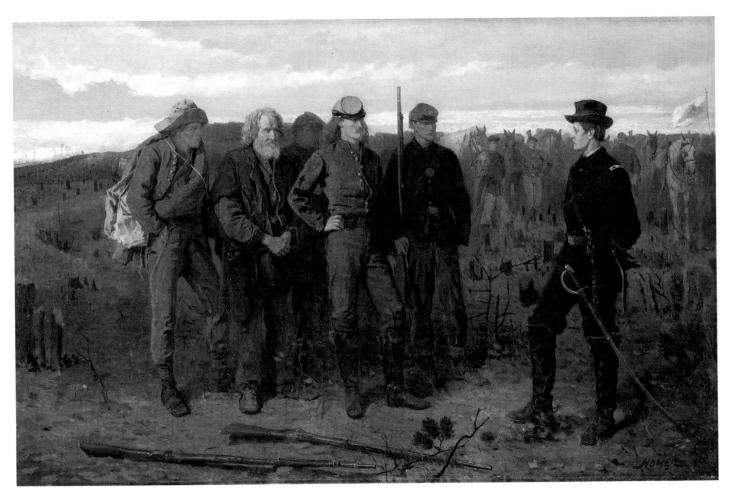

choose, why, and what impact do they have? What medium did the artist select? In this case, Homer chose **neutral tones** of **oil paint**, which has the advantage that it dries very slowly and allows the artist to make alterations almost without limit. Scientific studies have shown that Homer made many changes to his work. Is the date of the painting (1866) significant? This was one year after the end of the Civil War. Homer had witnessed and recorded the war personally. This painting was made during the period of Reconstruction, when the victorious Union troops forced changes on the slave-owning South, represented here by Confederate soldiers

in gray uniforms. The officer standing to the right is Homer's distant cousin: once we know this, it causes us to ask whether all these men are real historical figures. In other words, Homer was not simply showing his audience a dramatic scene, but was also commenting on the important issues that arose after the end of the war. Finally, what is the painting about in a more general sense? It is a painting about war and history, but also about social concerns, and the artist's desire for reconciliation after a devastating conflict. If we study other paintings that address these themes, we will see that some aspects of the way Homer depicted this event are

0.17 Eugène Delacroix, *The Massacre at Chios*, 1824. Oil on canvas, 13'8" × 11'73/8". Musée du Louvre, Paris, France

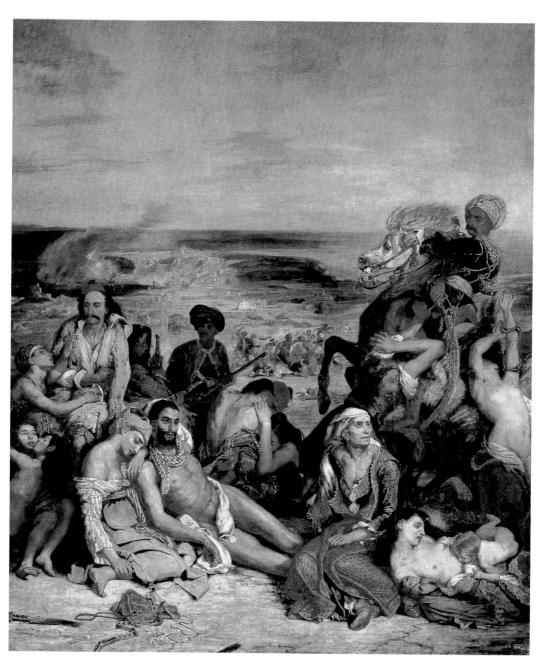

Neutral tones: colors (such as blacks, whites, grays, and dull gray-browns) made by mixing complementary hues
Oil paint: paint made of pigment suspended in oil
Ivory: hard, creamy-colored material from the tusks of such mammals as elephants

similar to paintings by other artists. If we compare such works with *Prisoners from the Front* we might learn more about portrayals of history and war in general and about Homer's works in particular.

A very contrasting view of war and the treatment of prisoners is found in a painting by Eugène Delacroix (1798–1863) (0.17). The island of Chios was ruled by the Ottomans of Turkey, but for centuries the majority of the population had been Greek. In 1822 Greeks from a nearby island attacked the Turks on Chios and destroyed mosques. The Turks responded by killing thousands of Greek residents of Chios. Delacroix portrays the victims as helpless: most are women and are partially nude, which emphasizes their helplessness. As in Homer's painting, a victorious soldier is seen to the right, but in Delacroix's painting he shows no pity, cutting down a woman with his curved sword. He and the faceless Turkish soldier behind the Greek civilians wear exotic turbans, as if to make them even more fearsome to Delacroix's European audience.

0.18 Carved ivory mask-shaped hip pendant, mid-16th century. Ivory inlaid with iron and bronze, $9^{5/6} \times 5 \times 2^{9/6}$ ". British Museum, London, England

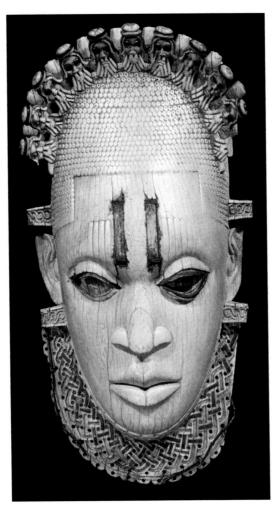

Thus, if we know what questions to ask about a work of art, we can learn more about it than we probably expected when we first saw it. What happens if a work is several centuries old and comes from a completely different culture? The head of an African woman shown here (0.18)was made in the mid-sixteenth century and comes from Benin in West Africa. The artist has made the woman's face a perfect and pleasing oval shape. Everything in the figure, from the faces on the woman's headdress to the eyes that look down and the shape of the nose and mouth, seems to direct our eyes downward. The effect is to concentrate on the beauty of the woman's features. The artist chose as materials **ivory**, iron, and bronze, rare items in Benin, so presumably the head was made for someone wealthy. Although we now see this work in a glass case in a museum, this was not how it was used in Benin. Research into its history tells us that this was a decoration worn on the belt of a king. Therefore, it formed part of the presumably impressive finery of the king: the artist did not design it to be seen alone in a glass case. We know that the king maintained groups of specialist artists (including ivory-carvers) and paid them in food, slaves, and wives. Anybody who made ivory objects without the king's permission was severely punished. Therefore, we can tell that this was an object of great luxury intended to show the wealth and power of a ruler. Finally, the head also tells us something about the history of Africa and the religion of Benin. Those odd-looking heads around the top of the headdress represent the faces of men from Portugal, which was then a powerful European trading nation that had conquered some parts of Africa. The Portuguese were important in Benin because they had worked with the king, whose power had grown as a result. Alternating with the Portuguese heads are mudfish that had sacred significance, and were symbolically connected to the god of the sea, Olukun. This pendant from Benin means much more to us if we take the time and effort to understand and analyze it.

Similarly, if we learn how to look at art, we will discover how exciting it can be. This book aims to help you not just to get a good grade in your course, but also to begin a lifetime of enjoying and being inspired by art.

FUN

Art is a form of visual language, and much as we use vocabulary and grammar to communicate verbally, artists use a visual vocabulary (the elements of art) and rules similar to grammar (the principles of art.) When we study an artwork, we can use the same elements and principles to analyze the work: a process called visual analysis. In this part you will learn about the elements and principles and will be shown how to apply them in a visual analysis. You will also learn how to use two other concepts when you analyze a work of art: style and content.

PART 1

DAMIENTALS

The ten elements of art are:

The ten principles of art are:

Color

Form

Line

Mass

Shape

Space

Texture

Time and Motion

Value

Volume

Balance

Contrast

Emphasis

Focal Point

Pattern

Proportion

Rhythm

Scale

Unity

Variety

1.1

Art in Two Dimensions: Line, Shape, and the Principle of Contrast

Just as we use the principles of grammar to turn vocabulary into sentences, so the language of art consists of **elements** (the basic vocabulary of art) and **principles** (the "grammar" that artists apply to turn the elements into art). The principles of design are a set of rules that explain how the elements of a work of art are organized.

Two-dimensional art is a remarkably elegant way to express ideas and share our mental pictures of the world. A two-dimensional object, such as a drawing of a triangle, is flat. It has height and width, but not depth. It can be made very simply, for example with a pencil on paper. The first plans for the grandest of designs can be drawn up on a cocktail napkin with a few squiggles of a pen. As well as drawing and painting, two-dimensional arts include the graphic arts: printmaking, graphic design, and photography.

In this chapter we will look at **line** and **shape**, basic elements of any kind of two-dimensional artwork. We will then see how to apply them to the understanding of works of art by using the principle of **contrast**.

Line

Lines are the most fundamental element artists use. They are there in almost every work of art or design. Lines organize the visible world. Without line, an artist hardly knows where to begin.

The ancient designs known as the Nazca Lines, located on the high desert plains of Peru, include some of perhaps the most unusual drawings in the world. They can show us much about line and shape.

In the spider "drawing," lines define the shape onto the landscape at such an enormous scale that it can only be seen from the sky (1.1). (In fact, the Nazca Lines were first discovered in modern times by overflying commercial aircraft.) Unlike most drawings, the Nazca Lines cannot be rolled up in a tube or carried off in a portfolio. First of all, they are too huge: the spider shown here is 150 feet long; side by side, two such spiders would nearly fill up a football field. Second, they are hardly "drawings" at all. Instead, they were made by scraping off the layer of dark gravel that covers the flat Nazca plain, to expose the white gypsum that lies just beneath the surface. In this sense, they are a sort of incision or engraving.

The lines are mysterious. Why would such huge designs, so huge they can hardly be understood at ground level, be made? What was their purpose? The designs resemble symbolic decorations found on local pottery made at least 1,300 years ago. We do not know what they were used for, but their size suggests they played an important part in the lives of the people who made them. How were they made? There are postholes found at intervals along their edges—perhaps strings from post to post formed guidelines for the scraping of the pathway. Notably, the Nazca Lines do not cross over themselves—in the photo, the parallel tracks intersecting with the spider were made

Elements: the basic vocabulary of art—line, form, shape, volume, mass, color, texture, space, time and motion, and value (lightness/darkness) Principles: the "grammar" applied to the elements of artcontrast, balance, unity, variety, rhythm, emphasis, pattern, scale, proportion, and focal point Two-dimensional: having height and width Line: a mark, or implied mark, between two endpoints Shape: the two-dimensional area the boundaries of which are defined by lines or suggested by changes in color or value

Contrast: a drastic difference

between such elements as color or value (lightness/darkness)

1.1 Spider, *c*. 500 BCE-500 CE, Nazca, Peru

Outline: the outermost line of an object or figure, by which it is defined or bounded Plane: a flat surface

by off-road vehicles. The lines define the **outline** of a shape.

Definition and Functions of Line

A line can be a mark that connects two points, like the strings that must have run from post to

post at Nazca. Artists can use lines to define the boundaries between **planes** in a two-dimensional work of art: notice how the lines at Nazca divide one area of the gravel surface of the land from another. In two-dimensional art, line can also define shapes (in this case the shape of a giant spider). A line may direct our eyes to look at

1.2a (left) A modern photo of the Ducal Palace and Piazzetta in Venice; 1.2b (below) Canaletto, The Maundy Thursday Festival before the Ducal Palace in Venice, 1763/6. Pen and brown ink with gray wash, heightened with white gouache, 15½8 × 21¾". National Gallery of Art, Washington, D.C. Lines drawn on the Canaletto image indicate his use of line to define planes

something the artist particularly wants us to notice. Finally, line can convey a sense of movement and energy, even the movement of a giant spider. We can see many of these uses of line in two very different artworks, one from eighteenth-century Italy and the other from modern Japan.

In Figs. 1.2a and 1.2b we see a modern photograph of the Ducal Palace in Venice, Italy, and a drawing, The Maundy Thursday Festival before the Ducal Palace in Venice, by Italian artist Canaletto (1697–1768). Canaletto uses line both to differentiate one part of the building from another and to mark the boundary between the building and its surroundings. Although line is two-dimensional, with line the artist points out where one plane meets another, and creates an impression of three dimensions. Line is thus a tool for describing, in a simple way and in two dimensions, the boundaries and edges of threedimensional surfaces. For example, in the photo we see the division between the top of the building and the blue sky, but there is no line as such. Canaletto uses line to define where the pointed tracery at the top of the building ends and the sky begins.

Some of Canaletto's lines also give the viewer a sense of the surface. The artist accentuates the patterned surface (which can barely be seen in the photograph) with diagonal lines that fall across the **facade** of the building. Canaletto uses line to emphasize surface information that perhaps we overlook at first glance.

Besides demarcating boundaries and surface changes, line can also communicate direction and movement. The page from the manga (Japanese comic/cartoon book) *Tsubasa RESERVoir CHRoNiCLE* (1.3) is divided into two major sections. A close-up sketch of a character is compressed into the bottom, and a larger action scene occupies the upper two-thirds of the page. In this section directional lines converge on a light area in the upper right of the page, then our attention is redirected to the left, where a figure is being blasted away by an explosion. The mangaka (group of manga artists) CLAMP has cleverly used the strong diagonals to add an intense feeling of movement to the page.

Lines to Regulate and Control

The variety of different types of line is virtually infinite. Whether straight or curved, a line can be regular and carefully measured. Regular lines express control and planning and impart a sense of cool-headed deliberation and accuracy. Such lines are effective for communicating ideas that must be shared objectively by groups of people, such as the plans an architect provides to guide builders.

American **conceptual artist** Mel Bochner (b. 1940) uses ruled line in his work *Vertigo*

1.3 CLAMP, page from the *Tsubasa RESERVoir CHRoNiCLE*, volume 21, page 47

Facade: any side of a building, usually the front or entrance Conceptual art: a work in which the ideas are often as important as how it is made

1.4 Mel Bochner, *Vertigo*, 1982. Charcoal, Conté crayon, and pastel on canvas, 9' × 6'2". Albright-Knox Art Gallery, Buffalo, New York

(1.4). By using a regular line drawn with the aid of a straightedge, Bochner speaks in the language of mechanical planning. However, he seems to contradict the use of regular line to convey a sense of control. The repetitious diagonal movement and hectic crossing and overlapping of his lines impart a sense of motion in disarray, as if his machine has somehow gone out of whack.

The British sculptor Barbara Hepworth (1903–75) utilized regulated line in the preliminary drawings she made for her sculptures. The lines she uses are crisp and clear. They combine to represent feelings or sensations that Hepworth wants to make visible in her sculpture. Hepworth said, "I rarely draw what I see. I draw what I feel in my body."

In **1.5**, the artist has projected four views of a future sculpture. As she rotates this imaginary sculpture in her mind's eye, the precision of her line helps her comprehend the complexity of her sensations. Like a dancer who responds to the

1.5 Barbara Hepworth, Drawing for Sculpture (with color), 1941. Pencil and gouache on paper mounted on board, 14 × 16". Private collection

rhythm of music, Hepworth has revealed the kind of lines that she feels, rather than sees, and has translated them into a visual "dance." Like an architect preparing the blueprints of a real building, Hepworth uses regulated line to translate her feelings into drawing and then, finally, into a real sculpture.

Lines to Express Freedom and Passion

Lines can also be irregular, reflecting the wildness of nature, chaos, and accident. Such lines—free and unrestrained—seem passionate and full of feelings otherwise hard to express.

Some artists decide to use irregular lines to reflect their drawing and thinking process. French artist André Masson (1899-1987) wanted to create images that expressed the depths of his subconscious. Sometimes he would go for days without food or sleep in an attempt to force himself to explore deeper-rooted sources of creativity and truth. His automatic drawings look spontaneous and free, and also perhaps unstructured and rambling (1.6).

The drawings of French artist Jean Dubuffet (1901–85) are uninhibited in style. Their lines

1.6 André Masson, Automatic Drawing, 1925–6. Ink on paper, 12 x 91/2". Musée National d'Art Moderne. Centre Georges Pompidou, Paris, France

appear irregular and loose. At first sight, his Suite with 7 Characters may seem chaotic and unpredictable, even scribbled, but the overall composition is controlled and orderly (1.7).

Regular and Irregular Lines

Although line can be either regular or irregular, most art exhibits a combination of both. American artist George Bellows (1882–1925) uses both varieties of line in his work Woodstock Road, Woodstock, New York, 1924 (1.8). He contrasts

1.7 Jean Dubuffet, Suite avec 7 Personnages, 1981. Ink on paper, 133/4 × 167/8". Private collection

Automatic: suppressing conscious control to access subconscious sources of creativity and truth Style: a characteristic way in which an artist or group of artists uses visual language to give a work an identifiable form of visual expression

the natural and organic lines of landscape and sky with the restrained and regular line of the man-made and architectural features. It seems that Bellows made this drawing as a preliminary sketch for another work. In the center at the bottom is the inscription, "all lights as high as possible / get color out of shadows." He wrote this to remind himself later of ideas he had while sketching the scene.

Implied Line

The lines we have discussed so far can be clearly seen as continuous marks. We can call these lines

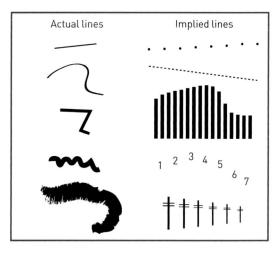

1.9 (above) Actual and implied lines

1.10 (left) Franco-German hand, *Pentateuch with Prophetical Readings and the Five Scrolls*, 13th–14th century. Illustrated manuscript. British Library, London, England

1.11 (above) Detail of *Pentateuch with Prophetical Readings and the Five Scrolls*

1.12 Sauerkids, *The Devil Made Me Do It*, 2006. Digital image, $16\frac{1}{2} \times 8\frac{1}{4}$ "

Actual line: a continuous, uninterrupted line

Implied line: a line not actually drawn but suggested by elements in the work

Rhythm: the regular or ordered repetition of elements in the work

Etching: a printmaking process that relies on acid to bite (or etch) the engraved design into the printing surface

actual lines. But line can also be implied by series of marks. An **implied line** gives us the impression we are seeing a line where there is no continuous mark (1.9).

Implied line is important in the Jewish art of micrography, the creation of designs using very small writing. At first glance, the text border in **1.10** appears to be an ornate line drawing that has been used to help embellish the text. In fact, the ornate frame is made from tiny Hebrew letters and words. If we look at the detail in **1.11** it becomes more obvious there is no line at all, but an implied line created by the skillful arrangement of the lettering. The "microscopic" text has been added as a guide (called a masorah) that provides advice about pronunciation and intonation.

Implied line is used in a more freeform way in the work by Sauerkids, the Dutch graphic designers Mark Moget (b. 1970) and Taco Sipma (b. 1966). *The Devil Made Me Do It* uses implied line to influence visual **rhythms** that add to the excitement of the design (1.12). The many dashes and the grid of dots at the bottom of the work imply vertical and horizontal lines. Even the title of the work is spelled out using implied line.

Directional Line

An artist can use line to direct our attention to something he or she wants us to notice (see Gateway Box: Goya, **1.13**, p. 54). An example of directional line occurs in the American artist James Allen's (1894–1964) **etching** of Depression-era construction workers. They are depicted working in New York City on the Empire State Building, which was to become the tallest building in the world. In *The Connectors*, the steel girders are closer together at the bottom

Gateway to Art: Goya, *The Third of May, 1808* **Using Line to Guide the Viewer's Eye**

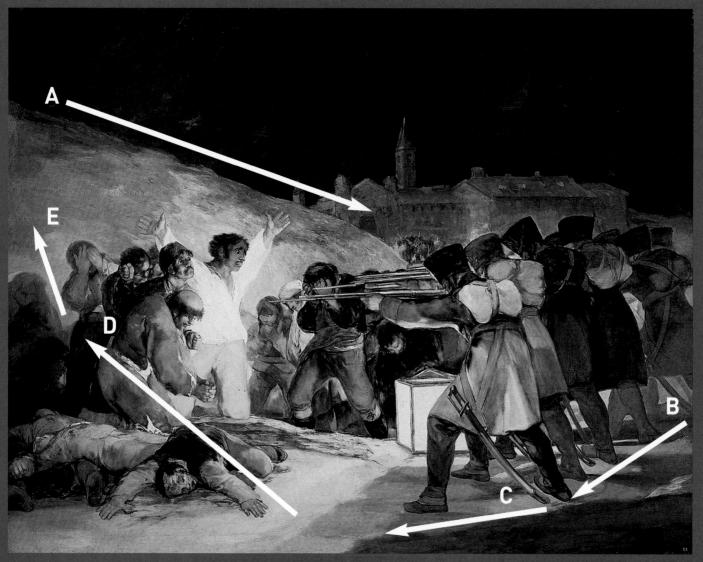

1.13 Francisco Goya, *The Third of May, 1808*, 1814.
Oil on canvas, 8'4%" × 11'3%".
Museo Nacional del Prado,
Madrid, Spain

Directional lines can be either actual or implied. Painters often use implied line to guide a viewer's eye as it scans the canvas. In Goya's *Third of May, 1808*, the artist portrays the execution of Spaniards who had resisted the occupation of their country by the French army of Emperor Napoleon (1.13). Goya uses contrast to draw our attention to a particular line (A)—created in the place where the dark background sky meets and contrasts with the lighted hillside—that separates the two areas of value. Our attention is drawn downward and to the right toward an area where there is more visual activity. Goya

holds our attention by using other directional lines; (B), for example, follows the line implied by the feet of the soldiers. Then a shadowed area (C) at the bottom of the page directs our eye to the left, where other lines such as (D) and (E) draw our gaze up toward the area of high contrast (A). Goya is keen to keep our attention on the atrocities committed by the army of Napoleon. The strong horizontal of the rifles is so distinct that our eye is pulled toward the group of victims: we identify not with the line of executioners, but with the victims.

1.14 James Allen, *The Connectors*, 1934. Etching, $12\% \times 9\%$. British Museum, London, England

of the picture than at the top; they direct the viewer's eye downward in order to accentuate great height (1.14). The narrowing lines showing the buildings in the **background** of the print help reinforce the same effect.

Contour Line

A contour is the outer edge or profile of an object. Contour lines can suggest a **volume** in **space** by giving us clues about the changing character of a surface.

Portrait of the Artist's Wife, Standing, with Hands on Hips, by Austrian painter Egon Schiele (1890–1918), is drawn almost entirely using contour lines (1.15). The lines of the fingers and shirtsleeves express the pose with utmost economy; their simplicity is a sign of Schiele's superb drafting skills. Compare the regularity of lines that indicate the clothing with those depicting the contours of the hair. The lines in the hair vary in thickness and regularity. They suggest an organic surface that contrasts with the machine-like print of the clothing.

Communicative Line

The directions of lines (whether they go up, across, or diagonally) both guide our attention and suggest particular feelings. Vertical lines tend to communicate strength and energy; horizontal lines can suggest calmness and passivity; diagonal lines are associated with action, motion, and change.

Graphic designers use the communicative qualities of directional line when creating logos (1.16, p. 56). To convey the strength of government or the stability of a financial

1.15 Egon Schiele, *Portrait of the Artist's Wife, Standing, with Hands on Hips*, 1915. Black crayon on paper, 18 × 111/4". Private collection

Background: the part of a work depicted furthest from the viewer's space, often behind the main subject matter

Volume: the space filled or enclosed by a three-dimensional figure or object

Space: the distance between identifiable points or planes

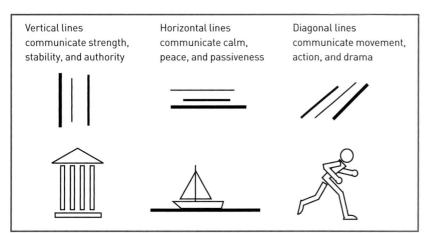

1.16 Communicative qualities of line

institution, they may choose verticals. Logos for vacation resorts often have horizontal lines to communicate peaceful repose. Diagonals can express the excitement of athletic activity. For example, Carolyn Davidson's (b. c. 1943) distinctive Nike "swoosh" conveys action with a shape comprising a stylized, diagonal line (1.17).

Line gives an unsettling energy to a painting of the bedroom (1.18) of the Dutch artist Vincent van Gogh (1853–90). Most of the lines that make

1.17 Carolyn Davidson, Nike Company logo, 1971

up the room are strong verticals. This suggests that van Gogh's bedroom was not a calm place of rest, as horizontal lines might imply. The floor also nervously changes **color** and value. The varying width of the vertical lines communicates the anxiety van Gogh may have felt in the months leading up to his suicide in 1890. The strength of the verticals combined with the agitation of the emphatic diagonals makes for a powerful sense of unease. Yet van Gogh may also have been trying to ground himself in the here-and-now by painting the simple room in which he slept.

1.18 Vincent van Gogh, *The Bedroom*, 1889. Oil on canvas, 28³/₄ × 36¹/₄". Art Institute of Chicago

Color: the optical effect caused when reflected white light of the spectrum is divided into a separate wavelength

Shape

A shape is a two-dimensional area the boundaries of which are defined by lines or suggested by changes in color or value.

Geometric and Organic Shapes

Shapes can be classified into two types: geometric and organic. Geometric shapes are composed of regular lines and curves. Organic shapes, however, as the examples in the right-hand part of **1.19** show, are made up of unpredictable, irregular lines that suggest the natural world. Organic shapes may seem unrestrained and sometimes chaotic, reflecting the never-ending change characteristic of living things.

Geometry is a branch of mathematics dating back more than 2,000 years. It is concerned with space, area, and size. Traditionally defined, a geometric shape is mathematically regular and precise. The simple shapes we know—circle, square, triangle—are all examples of geometric shapes. Geometric shapes can be created by plotting a series of points and connecting them with lines, or simply enclosing a space using regulated and controlled line. Although artists can draw by hand something similar to a geometric shape, they often use tools to control and regulate the preciseness of the line. For example, an artist may use a ruler to create perfectly straight lines, or alternatively a computer graphics application can be used to generate a clean sharp edge. In both cases the artist adds a layer of control that gives the shape greater predictability.

While line may be the most fundamental element of art, often shape is the element we see. The **collage** by Canadian-born feminist artist Miriam Schapiro (b. 1923) illustrates differences between geometric and organic shapes (1.20).

1.19 Geometric and organic shapes

In *Baby Blocks*—also the name of a traditional quilting pattern—images of flowers and children's clothes overlap a tiling of orange, blue, and black diamond shapes. The work's title suggests a **pattern** of diamond shapes creating an illusion of cubes. The organic shapes of the flowers are clearly distinct from the hard geometric shapes of the "blocks" and the red frame; they overflow the boundaries of both.

The stylized floral designs, derived from oldfashioned wallpaper and upholstery patterns, are simplified representations of real flowers. Even so, the shapes have an irregularity that reflects the kind of shapes we find in living things.

The interlocked blue and yellow blocks are so predictable and regular that we can even envision the pattern where it disappears behind the flowers. This geometric regularity acts as a foil to the organic shapes casually arranged "on" it.

By incorporating doll clothes, home decorations, and sewing materials into her "femmages" (homages to the work of women), Schapiro opens our eyes both to the remarkable artistry of much traditional "women's work," and to the cultural forces that undervalue it.

1.20 Miriam Schapiro, Baby Blocks, 1983. Collage on paper, 29% × 30". University of South Florida Collection, Tampa

Collage: a work of art assembled by gluing materials, often paper, onto a surface. From the French *coller*, to glue

Pattern: an arrangement of predictably repeated elements

Implied Shape

Most shapes are defined by a visible boundary, but we can also see a shape where no continuous boundary exists. Just as line can be implied, so too can shape (1.21).

The AT&T logo, created in the 1980s by American graphic designer Saul Bass (1920–96), uses horizontal lines to imply a sphere or globe (1.22). Twelve horizontal lines are trimmed to form a circle. By constricting the width of nine of these lines, a **highlight** appears on the circular shape, implying the swell of a globe. This logo communicates the idea of an expansive telecommunication network operating all over the globe. The image is simple, creating an appropriately meaningful and readily recognizable symbol for a global company.

Contrast

When an artist uses two noticeably different states of an element, he or she is applying the principle of contrast. For example, lines can be both regular and irregular, or shapes can be both geometric and organic. Strong differences in the state of an element can be a very useful effect for an artist to use; it is especially effective to use opposites.

Positive and Negative Shapes

In everyday life, positive and negative are opposites: one needs the other for contrast and comparison. Without positives, negatives would not exist and vice versa. When we speak of positive and negative in visual form it is most often represented by black and white. The words on this page, for example, are **positive shapes** of printed black ink that we can see on the **negative space** of the white paper. The space supports the solidity of the placement of the word or shape. Although black and white are common examples

of positive and negative, any color combination can work the same way. Sometimes, too, the lighter color becomes the positive shape.

We can see the interlock of positive and negative shape in the work of American Shepard

1.22 Saul Bass, Bass & Yager, AT&T logo, 1984

Highlight: an area of lightest value in a work

Positive shape: a shape defined by its surrounding empty space Negative space: an empty space given shape by its surround, for example the right-pointing arrow between the E and x in FedEx

1.23a and 1.23b (left) Shepard Fairey, Obey, 1996. Campaign poster and a view of the posters as they were installed in public

1.24 Georgia O'Keeffe. Music—Pink and Blue II. 1919. Oil on canvas, $35 \times 29\%$ ". Whitney Museum of American Art, New York

Fairey (b. 1970). The black features and the blank white space contrast with and complement each other, intensifying the design of this poster (1.23a and 1.23b). Fairey wants strong impact because, as a street artist, he needs to catch his audience's attention quickly as they pass by. In this case, the image is of the professional wrestler Andre the Giant (Fessick in the movie The Princess Bride), captioned by the word "Obey." Without seeking prior permission, Fairey posts these images in public spaces as an expression of guerrilla marketing and street theater. The

tension between contrasting positive and negative shapes draws our attention, while the cryptic slogan makes us wonder what it is all about.

The works of the American artist Georgia O'Keeffe (1887–1986) often play upon the relationship between positive and negative shape. Her **abstract** shapes derive from a close observation of organic objects. In the painting Music—Pink and Blue II, O'Keeffe puts emphasis on the negative blue shape in the bottom right of the picture (1.24). That negative shape initially draws our attention into a deep interior

Abstract: art imagery that departs from recognizable images from the natural world so that the positive shape of the pink arc above it carries us back to the surface through a maze of tender folds. O'Keeffe's paintings use landscape and flower shapes to make associations to the female body. The interplay of positive and negative space becomes symbolic of the erotic and life-giving nature of womanhood.

Sometimes graphic designers use negative shape to convey information subtly. For example, when the Big Ten Conference—ten major universities competing in many different sports—expanded to eleven teams, they needed a logo that announced the change. The only problem was that they wanted to retain the name, "Big Ten," rather than use eleven and change the conference title. The graphic designer Al Grivetti ingeniously inserted the number "11" in the negative space on either side of the capital "T"

1.25 Al Grivetti, Big Ten logo, 1991

(1.25). We can discern both messages (Big Ten and 11) as we view the logo. The alternation of positive and negative shape communicates the new and old titles of the conference in a single image.

In the **woodcut** *Sky and Water I* the Dutch artist M. C. Escher (1898–1972) applies many of the concepts we have been exploring in this chapter (**1.26**). The negative shape changes from white in the upper part of the picture to

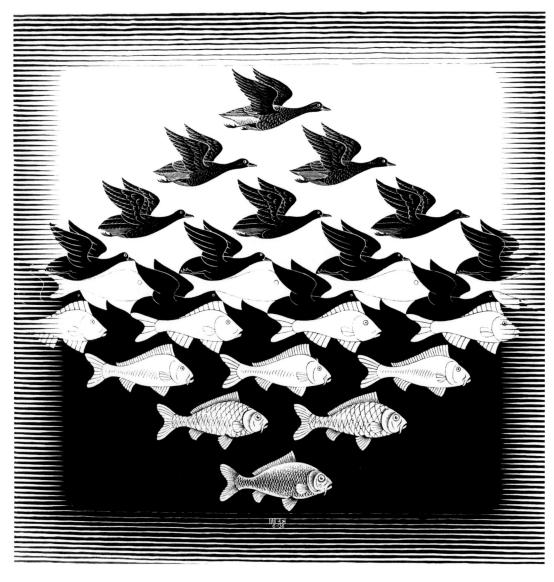

black in the lower. The most refined version of each animal occurs at the top and bottom extremes of the image. As we follow each transition upward or downward, each animal becomes more simplified until it forms part of the background negative shape. Strong geometric patterns change into the organic shapes of animals. The woodcut, where removed material prints white and preserved material prints black, is conducive to exploring **figure**—**ground reversal**, which is the very essence of Escher's technique here.

Conclusion

Artists use line, shape, and contrast to communicate in two dimensions. By combining these different characteristics, artists can communicate visual ideas with elegance and razor-edged efficiency. They can describe the beautiful and ugly details of our world, and express the deepest emotional experiences of the human soul. Within two dimensions we can communicate nearly every interaction in mankind's history of understanding.

The Banner of Las Navas de Tolosa (1.27), a thirteenth-century Islamic tapestry, exemplifies the themes of this chapter. Made during the time when Spain was under Islamic rule, it is supposed to have been captured in battle from the Muslim occupying forces. To this day, patterns from Islamic art can be found in the designs and architecture of Spain.

The banner is composed of a central medallion surrounded by several **concentric** shapes. Within the circular medallion, squares are rotated to create a series of concentric eight-pointed stars. These star shapes are encircled by a large round shape with a border of smaller circles. These circles in turn are surrounded by a square that sits inside another square.

Along the margins at the top and bottom are inscriptions in ornate Arabic calligraphy. The free-flowing and vigorous letterforms create strong horizontal implied lines. This ornamental writing style is often used in Islamic art to communicate words—in this case from the Koran—richly and expressively.

The banner also uses contrasting positive and negative shapes as a series of patterned organic shapes weave in and out of the enclosed central spaces. The line, principal shape, and contrasting shapes are used to great effect. A central square that meets the left and right edges of the banner encloses a series of other shapes. Just inside the edges of the square is a series of round medallions that create another implied square. That same implied square spills into a centered circular shape that subdivides the square and leaves almost-triangular shapes in the corners. Centered within the circle is another series of shapes that are superimposed and subdivided again. This multitude of simple shapes combines to create a masterpiece of complexity that attests to the power and majesty of Allah. From humblest simplicity to the boldest intricacies, the basics of two dimensions provide us with great visual communicative power.

1.27 Banner of Las Navas de Tolosa, 1212-50. Silk and gilt thread tapestry, 10'10" × 7'25%". Monasterio de las Huelgas, Museo de Telas Medievales, Burgos, Spain

Woodcut: a print created from an incised piece of wood
Figure—ground reversal: the reversal of the relationship between one shape (the figure) and its background (the ground), so that the figure becomes background and the ground becomes the figure
Concentric: identical shapes stacked inside each other sharing the same center, for example the circles of a target

1.2

Three-Dimensional Art: Form, Volume, Mass, and Texture

In 1802 a French artist and archaeologist described his impression of the great pyramids of Egypt:

On approaching these colossal monuments, their angular and inclined form diminishes the appearance of their height and deceives the eye...but as soon as I begin to measure ...these gigantic productions of art, they recover all their immensity...

(Vivant Denon, Travels in Upper and Lower Egypt)

The massive structures that so impressed Denon have three dimensions, like every object in our world, which can be expressed as their height, width, and depth (1.28). Because the pyramids can be measured in these three dimensions they are classified as **three-dimensional** works of art, and like all the art discussed in this chapter they possess four of the visual **elements**: form, volume, mass, and texture. We need to understand these terms in sequence so that we can analyze and understand three-dimensional art.

Three-dimensional: having height, width, and depth Elements: the basic vocabulary of art—line, form, shape, volume, mass, color, texture, space, time and motion, and value (lightness/darkness)
Two-dimensional: having height and width
Shape: the two-dimensional

area the boundaries of which are defined by lines or suggested by changes in color or value

Form: an object that can be defined in three dimensions (height, width, and depth)

Scale: the size of an object or

artwork relative to another object or artwork, or to a system of measurement

Volume: the space filled or

enclosed by a three-dimensional figure or object

Mass: a volume that has, or gives the illusion of having, weight, density, and bulk

Space: the distance between identifiable points or planes **Texture:** the surface quality of a work, for example fine/coarse, detailed/lacking in detail

Form

A **two-dimensional** object, such as a drawing of a triangle, is called a **shape**. Shapes are flat. A three-dimensional object, such as a pyramid, is called a **form**. Forms are tactile; we can feel them with our hands. Some forms are so tiny they cannot be seen with the naked eye, while others are as large as a galaxy. When artists and designers

create forms, they consider how we will experience them in three dimensions. Architects usually make buildings that accord with our physical size, in proportions that are convenient and easy to live in, but sometimes they might build to a larger **scale** in order to leave us in awe. A jeweler makes objects at a small scale that few people can experience at once: we are drawn closer to examine the work more intimately.

Forms have two fundamental attributes: **volume** and **mass**. Volume is the amount of **space** a form occupies. Mass is the expression that a volume is solid and occupies space, whether it is enormous like a pyramid or relatively small like a piece of jewelry.

The surface of a form can be cool and slick, rough and jagged, soft and warm. Such sensations arise from the **texture** of the form. Texture can be experienced directly, but we can also imagine how the surface of a form may feel simply by looking at it. Some hand-made objects, like ceramics or basketry, attract our touch naturally. They were touched by the hands that formed them, and they fit in our hands just as they used to fit in the hands of the artist. Some machine-made forms reflect the crisp precision of mechanical perfection; their smooth, shiny forms seduce our senses. Artists and designers create forms with full knowledge that they can evoke our memories of other three-dimensional objects in the world and allow us to experience our own world in a richer way.

The forms created by artists in the ancient world reflected the everyday experiences of people of that time. For example, stone was a common material in ancient Egypt, easily accessible and so durable that artists must have thought it would last for a very long time—a correct assumption, as we can still see.

The Great Sphinx of Giza guards the tombs of the Egyptian kings at Giza, near Cairo (1.29). The Great Sphinx is the largest carving in the

world made from a single stone. The sculpture stands as a symbol of the power to change our surroundings. The Egyptians who created this work changed the very earth by sculpting the living rock. We do not know what the Egyptians called this half-man, half-lion, but we have come to call it a "sphinx" after the creature from Greek

1.28 (above) Three dimensions: height, width, and depth

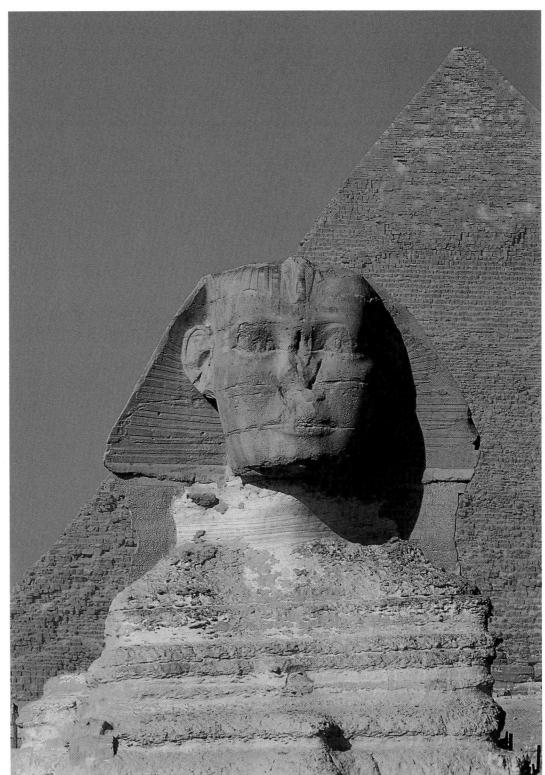

1.29 Great Sphinx of Giza, c. 2650 BCE, Giza, Egypt

mythology with the body of a lion, the wings of an eagle, and the head of a woman.

There are two types of form: geometric and organic.

Geometric Form

Geometric forms are regular and are readily expressible in words or numbers: cubes, spheres,

cylinders, cones, and pyramids are simple examples. The Great Pyramid of Khufu is a stunning example of geometric form in architectural design (see Gateway Box: The Great Pyramid of Khufu, **1.30**).

Like the ancient Egyptians, the American sculptor David Smith (1906–65) also relied on geometric forms to create his compositions. In *Cubi XIX*, made of stainless steel, Smith

Gateway to Art: The Great Pyramid of Khufu **The Importance of Geometric Form**

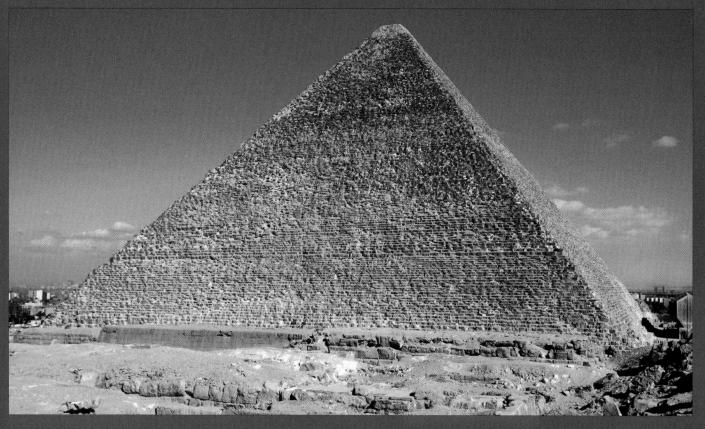

1.30 Great Pyramid of Khufu, c. 2560 BCE, Giza, Egypt

The regulated and controlled geometric form of the Great Pyramid at Khufu in Giza, Egypt, stands as a monument to the engineering and construction skills of the ancient Egyptians (1.30). The base of Khufu's pyramid is level to within less than an inch, and the greatest difference in the length of the sides is 1¾ inches. The pyramids at Giza (there are three) were originally encased in fine white limestone: the simplicity of their geometry must have stood out like gigantic crystals in

the desert sands. They point to the sky, the realm of the sun god. Just as we can calculate the result of a mathematical equation, if we view a pyramid from its eastern side, we can predict what its northern, southern, and western sides will look like. Egyptian art and architecture exhibit carefully ordered and controlled characteristics. The work of these artists was governed by a canon, or set of rules, that is also expressed in the strict formality of ancient Egyptian art.

uses cubes, cuboids, and a thick disk (1.31). Smith learned welding in an automobile factory and became expert while fabricating tanks of thick armor plate during World War II. The late works of his Cubi series combine geometric

1.31 David Smith, *Cubi XIX*, 1964. Stainless steel, 113½ × 215/8 × 205/8"

forms in angular relationships. The diagonal angles imply movement, giving these basic geometric forms a visual energy. Smith burnished their surfaces to create a counterpoint between industrial and natural form.

Organic Form

The form of most things in the natural world is organic: it is irregular and unpredictable. Living things, such as plants and animals, change constantly, and their forms change too. Artists accentuate the irregular character of organic form for expressive effect.

The human figure gives an artist a subject that can communicate the rich experience of humanity and organic form in a way we can all understand. The human body, like other organic forms, constantly changes in concert with its surroundings. Forms representing the human figure can provide the artist with a subject conveying symmetry and balance. But by visually contradicting such order, an artist can make a work seem uncomfortable or uneasy to look at. The unknown artist who carved the work *Vesperbild* in the fourteenth century expresses the agony of death and grief by making the bodies of Jesus and Mary irregular, awkward,

1.32 Vesperbild (Pietà), Middle Rhine region, c. 1330. Wood, 34½" high. Rheinisches Landesmuseum, Bonn, Germany

1.33 Lino Tagliapietra, *Batman*, 1998. Glass, 11½ × 15½ × 3½"

Abstract: art imagery that departs from recognizable images from the natural world Color: the optical effect caused when reflected white light of the spectrum is divided into a separate wavelength Relief: a raised form on a largely flat background. For example, the design on a coin is "in relief" In the round: a freestanding sculpted work that can be viewed from all sides

The expression of vigor and uplift in Italian glass artist Lino Tagliapietra's Batman (1.33) contrasts with the expression of death and despair in Vesperbild. Tagliapietra (b. 1934) wanted to convey the idea of "a creature who emerges from his dark cave to share goodness and light." He has enhanced the positive emotion of this abstract image by using bright color and stretching the extreme edges upward as if this were a growing, living object. Rather than having hard, angular distortions, the artist uses a form that is lively and organic. The natural energy of light is captured in the glowing transparency of the glass. Tagliapietra, a master of glassblowing technique, wants the form to allude, without making a literal reference, to the idea behind the character Batman. Thus we are free to revel in the life.

energy, and power of the superhero through an expressive form, rather than a carefully depicted, lifelike representation. Tagliapietra says of the work, "I imaged pieces that allow the viewer to see both the reality and fantasy of Batman's world."

Form in Relief and in the Round

An artist who works with three-dimensional form can choose to create a work in **relief** or **in the round**. A relief is a work in which forms project from a flat surface. It is designed to be viewed from one side only. A form in the round can be seen from all sides.

1.34 Imperial Procession, from the Ara Pacis Augustae, 13 BCE. Marble altar. Museo dell'Ara Pacis, Rome, Italy

Facade: any side of a building, usually the front or entrance
Foreground: the part of a work depicted as nearest to the viewer
High relief: a carved panel where the figures project with a great deal of depth from the background

Bas-relief: a sculpture carved with very little depth **Stela** (plural **stele**): upright stone slab decorated with inscriptions or pictorial relief carvings

Plane: a flat surface **Composition:** the overall design or organization of a work

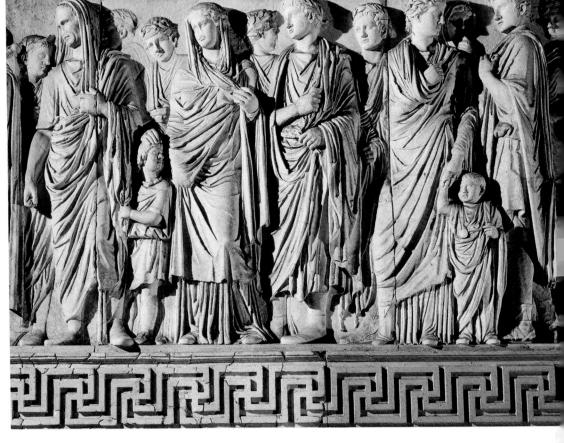

Forms in relief combine aspects of twodimensional and three-dimensional works of art. Like a two-dimensional work, a relief can be mounted on a wall or other surface.

> Although relief may appear to limit the work's potential visual impact, in fact the sculptor can create the illusion of a three-dimensional space, with dramatic results.

In the relief sculptures on the south **facade** of the Ara Pacis (Latin for Altar of Peace) in Rome, Italy, a sculptor chose to fit many figures into a limited space (**1.34**). The unknown artist uses the depth of the carvings to suggest that some areas of the composition are further away from us than others. The figures in the **foreground** are deeply carved (in **high relief**) so that the

1.35 Stela with supernatural scene, Mexico or Guatemala, 761 cE. Limestone, $92 \times 42 \times 3$ ". Fine Arts Museums of San Francisco

folds in their togas are strongly delineated by shadows. But the artist wanted to imply a large crowd rather than just a line of people. The figures behind those in the foreground are also carved in relief, but not quite so deeply. They appear to be further away because there is less shadow defining their shape. The artist suggests even greater depth by using a third group of figures who are carved in shallow relief, so that there is no shadow at all to make them stand out. This effect is clear in the upper left-hand corner, where the carving overlaps and diminishes in height.

The Maya artist who carved **1.35** in **bas-relief** worked in a tradition quite different from that of the Roman sculptor of the Ara Pacis, with its deeply incised figures. On the Maya **stela** all the carving is carefully arranged on the same **plane**. The sculptor has created a large figure of a Maya ruler, shown wearing a highly detailed and elaborate costume. The Mayan writing to the left of the figure seems to be of equal visual weight; the sculptor intended the viewer to read every element of the **composition**.

1.36 Volume and mass

Volume

Three-dimensional objects necessarily have volume. Volume is the amount of space occupied by an object. Solid objects have volume; so do objects that enclose an empty space. Mass, by contrast, suggests that something is solid and occupies space (1.36). Architectural forms usually enclose a volume of interior space to be used for living or working. For example, some hotel interiors feature a large, open atrium that becomes the **focal point** of the lobby. Some sculptures accentuate weight and solidity rather than openness. Such works have very few open spaces that we can see. The presence of mass suggests weight, gravity, a connection to the earth. The absence of mass suggests lightness, airiness, flight. Asymmetrical masses—or masses that cannot be equally divided on a central axis can suggest dynamism, movement, change.

Open Volume

When artists enclose a space with materials that are not completely solid, they create an open volume. In *Ghostwriter*, Ralph Helmick (b. 1952) and Stuart Schechter (b. 1958) use carefully suspended pieces of metal to make an open volume that, when looked at as a whole, creates the image of a large human head (1.37a and 1.37b). The small metal pieces, which represent letters of the alphabet and other objects, are organized so that they delineate the shape of the head but do not enclose the space. In the stairwell where the piece hangs, the empty space and the "head" are not distinct or separate, but the shape is nonetheless implied.

1.37a (top right) Ralph Helmick and Stuart Schechter, *Ghostwriter*, 1994. Cast metal/stainless cable, $36 \times 8 \times 10^{\circ}$. Evanston Public Library, Illinois

1.37b (right) Detail of Ghostwriter

The Russian artist Vladimir Tatlin's (1885–1953) Monument to the Third International was intended to be a huge tower with rooms housing the offices and chamber of delegates of the Communist International. It was going to commemorate the triumph of Russia's Bolshevik Revolution. Never built, it would have been much higher than the Eiffel Tower in Paris, France. In its form as we see it in 1.38, the spiraling open volume of the interior, and its proposed novel use of such materials as steel and glass, symbolize the modernism and dynamism of Communism.

Tatlin believed that art should support and reflect the new social and political order.

Open volume can make a work feel light. *In the Blue*, a collaborative work by American sculptors Carol Mickett (b. 1952) and Robert Stackhouse (b. 1942), was created to imply the presence of water (1.39). By creating **negative space** (the openings between the wooden slats) with crowds of horizontal members, the artists make the work seem to float. Mickett and Stackhouse also curve the pieces and place them at irregular intervals to create many subtle changes in direction. This arrangement gives a

1.38 Vladimir Tatlin, Model for *Monument to the Third International*, 1919

feeling of motion like the gentle ripples of flowing water. The artists hope that viewers will experience a feeling of being surrounded by water as they walk through the passage.

Focal point: the center of interest or activity in a work of art, often drawing the viewer's attention to the most important element

Axis: an imaginary line showing the center of a shape, volume, or composition

Negative space: an empty space given shape by its surround, for example the right-pointing arrow between the E and x in FedEx

Mass

Mass suggests that a volume is solid and occupies space. Every substance has mass. Our perception of mass influences how we react to and what we feel about that substance (see Gateway Box: Colossal Olmec Heads, **1.40**). We can feel the weight of a pebble in the palm of our hand, or the heaviness of a chair as we pull it away from a table. Our perception of mass in large objects is

derived from our imagination, our previous experience with smaller objects, and our understanding of the forces of nature. Artists tap into these various intuitions when they create a work of art.

Mass can suggest weight in a three-dimensional object. Some artists imply mass (without it necessarily being there) to give us the impression that the object we are looking at is very heavy. In movies, special-effect artists use boulders made of foam to give the impression of great weight.

Gateway to Art: Colossal Olmec Heads **Mass and Power**

The monumental quality of some artworks is directly related to their mass. The eight-foothigh Olmec sculpture of a Colossal Head has an imposing physical presence (1.40). The sheer size of the work was almost certainly intended to impress and overwhelm. At La Venta, in Mexico, three heads were positioned in a "processional arrangement" requiring the viewer to walk from one head to another, which must have increased their visual impact. Some of the Olmec colossal heads are flat at the back because they had been carved out of earlier monuments known as "altars," although they may in fact have been thrones. The flat back to the head was the base of the altar. While a similar head could be carved on a pebble that would fit in the palm of the hand, the massive scale of this head makes an imposing statement. Its intimidating size suggests the power of a mighty ruler or an important ancestor. The full lips and nose amplify the head's massive scale.

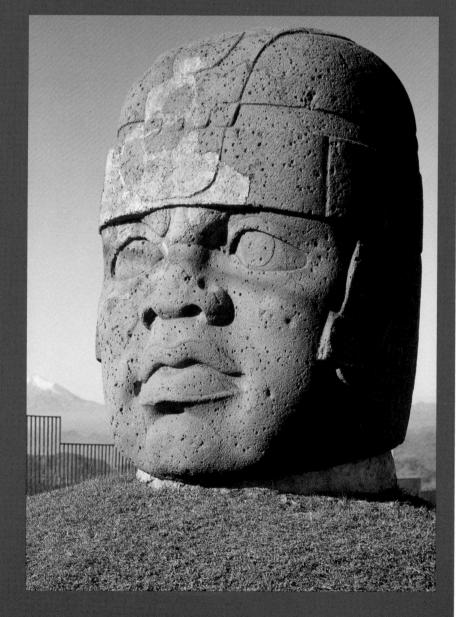

1.40 Colossal Head, Olmec, 1500–1300 BCE. Basalt. Museo de Antropología, Veracruz, Mexico

1.41 Rachel Whiteread, *House*, 1993. Concrete. Bow, London, England (demolished 1994)

Mass does not necessarily imply heaviness, only that a volume is solid and occupies space.

The mass of British sculptor Rachel Whiteread's *House* suggests great weight and solidity (1.41). To create this work, Whiteread (b. 1963) filled the interior space of a house with tons of concrete before demolishing the exterior walls and windows. The empty volume that was once filled with the happy and sad moments of ordinary domestic life has been turned into a

memorial of its former self. Whiteread has taken the volume of this building's interior and transformed it into a lasting memorial of the lives of the people who used to live in it, and in other houses just like it. We not only comprehend the weight of the concrete, but the related associations of life and death, memory and change.

The sculpture of Father Damien by the Venezuelan-born artist Marisol (b. Maria Sol Escobar, 1930) stands as an immovable object against an irresistible force (1.42). It depicts

1.42 Marisol (Escobar), *Father Damien*, 1969. Bronze. State Capitol Building, Honolulu, Hawaii

1.43 Nam June Paik, *TV Buddha*, 1974. Closed circuit video installation with bronze sculpture, monitor, and video camera, dimensions vary with installation. Stedelijk Museum, Amsterdam, Netherlands

the courage of a humanitarian hero. Father Damien was a Catholic missionary who supervised a leper colony on the Hawaiian island of Molokai during the nineteenth century. His steadfast compassion is suggested by the four-square mass of Marisol's work, while his upright correctness is reflected in its vertical lines—in the cane, in the cape, and in the straight row of buttons. The stout form communicates stability and determination. Father Damien, who himself died of leprosy while serving its victims, exemplified such heroism that the Hawaiian legislature voted to place this memorial to him in front of the State Capitol Building in Honolulu.

Texture

Any three-dimensional object that can be touched and felt has texture, the tactile sensation we experience when we physically encounter a three-dimensional form. Textures vary, from the slick, cold surface of a finely finished metal object, to the rough-hewn splintery character of a broken branch, to the pebbly surface of a rocky beach.

When you hold this book in your hands, you feel the surface of the pages and feel its weight. We mostly rely on the impressions we receive from our hands when we think of texture, and

these tactile experiences influence the way we look at art.

Even if we do not touch three-dimensional works of art, we can still think of them as having "actual texture." We know what polished stone feels like (cool and smooth), so when we look at a highly polished marble sculpture we can imagine how its texture feels, based on our past experience. Our experience of it will be different, though, if we look at a picture of it in a book or if we stand next to it in the same room.

Viewers of Korean artist Nam June Paik's sculpture TV Buddha experience actual texture when they see and touch the work (1.43). We understand the tactile sensations of touching a bronze sculpture, or a television screen, or a video camera. Paik (b. 1932) presents us with a visual image of the Buddha contemplating the world and meditating through modern electronics. The artist successfully draws on our past tactile experiences to give us a fuller experience of the artwork. The low-tech sense of touch contrasts with the high-tech process of capturing a visual image and projecting it onto a screen. A camera installed in the work shoots video of the actual texture and translates it into an image that can only be experienced from our

tactile memory. The texture can then be implied by the two-dimensional image on the screen.

Subversive Texture

A subversive texture contradicts our previous tactile experience. Some types of cactus appear to have a soft, furry covering, but touching them will be painful. Artists and designers use the contradictions and contrasts of subversive texture to invite viewers to reconsider their preconceptions about the world around them.

In the early twentieth century, artists calling themselves **Surrealists** created work that drew on ideas and images from dreams and the unconscious mind. The Swiss Surrealist Méret Oppenheim (1913–85) used texture to contradict the conscious logical experiences of viewers. In her sculpture *Object*, Oppenheim takes a cup, saucer, and spoon, normally hard and cool to the touch, and instead makes them soft and furry (1.44). The idea of sipping tea from this object conjures up an unexpected sensation of fur tickling our lips. The artist is counting on our tactile memory to conflict with the actual experience of sipping tea from a shiny teacup. In this case, the form is recognizable, but the associated experience is not.

Surrealist: an artist belonging to the Surrealist movement in the 1920s and later, whose art was inspired by dreams and the subconscious

1.44 Méret Oppenheim, *Object*, 1936. Fur-covered cup, saucer, and spoon, 27/8" high. MOMA, New York

The Guggenheim Museum, Bilbao

The American architect Frank Gehry (b. 1929) designed the Guggenheim Museum, located between a river and a motorway, in Bilbao, Spain; it was completed in 1997 (1.45). Bilbao was once a center for ship-building, and the undulating surfaces of Gehry's creation suggest ships and ship construction. Gehry's design uses contrasts in geometric and organic form. Historically, architectural design has relied on geometric form. Organic forms, by comparison, are more difficult to visualize and plan in advance; curved and irregular structures are difficult to survey, measure, plumb, and level. But Gehry used computer programs originally invented for aerospace design to plan buildings that contradict our preconceived ideas about architecture as geometric form. Most of the walls of the Guggenheim Museum consist of irregular, curving organic forms that rise and fall unpredictably. The undulating surfaces give a sense of movement and life to the structure.

This could make some visitors feel disoriented, but Gehry counters this at critical junctures by using strongly geometric form. At the entrance, for instance, the reassurance of geometric form encourages even the most apprehensive visitor to enter the building.

Gehry employs both sculptural relief and in-the-round forms. The surfaces of the organic portion of the building are covered with titanium tiles. The subtle changes to the surfaces of this material resemble an abstract bas-relief. But the entire building is also like a sculpture in-the-round that the viewer can stroll around to appreciate its unexpected juts and curves.

Gehry's museum has reshaped its location.
The interior space, designed to meet the changing needs of art and artists in the future, can also be extended or reduced, creating interesting exhibition opportunities. The complex shapes of the building extend out into space like a huge boat, emphasizing its relationship to the

1.45 Frank Gehry, Guggenheim Museum, 1997, Bilbao, Spain

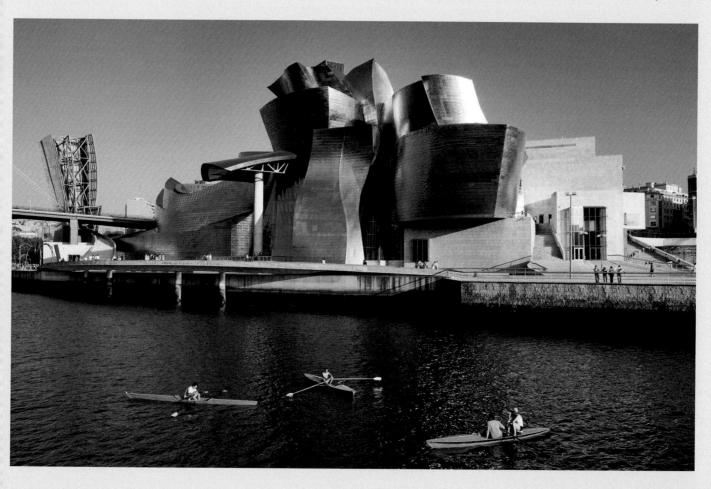

1.46 Louise Bourgeois, *Maman*, 1999 (cast 2001). Bronze, stainless steel, and marble, 29'4%" × 32'91%" × 38'1". Guggenheim Museum, Bilbao, Spain

nearby River Nervión. The building stands in stark contrast to the surrounding urban landscape, offering an optimistic vision in a deteriorating industrial district of Bilbao.

The shimmering titanium tiles of Gehry's building are complemented by a sculpture that stands beside the museum, Maman (1.46; meaning "Momma" in French), by French artist Louise Bourgeois (1911-2010). The Guggenheim's apparently solid mass is contrasted with the spindly form and open volume of Maman. The negative space surrounding its legs and body imparts lightness. The subtle variations of angle in the legs imply movement. The wobbly vulnerability of the spider contrasts with the massive solidity of the building. Even though this spider is made of bronze, the effect is one of lightness. And by suspending below the central body a container of marble spheres like an egg sac, Bourgeois wants to suggest both the tenderness and fierce protectiveness of motherhood.

Conclusion

We see a three-dimensional work of art in terms of its height, width, and depth. The term form is used to describe any three-dimensional work. Three-dimensional forms can be geometric or organic. They also have volume (the amount of space occupied by the form) and mass (the impression that the volume is solid and occupies space). The surface of the form can be described in terms of its texture. Artists can use the language of three-dimensional art to express many ideas and emotions. Méret Oppenheim playfully tests our assumptions about everyday objects with a furry teacup and saucer. On a much larger scale, the creators of the Colossal Olmec Heads express the power of their rulers or ancestors, while the fourteenth-century sculptor of Vesperbild communicates the terrible sorrow of Mary as she holds the lifeless form of Jesus.

FUNDAMENTALS

1.3

Implied Depth: Value and Space

Three-dimensional: having height, width, and depth
Two-dimensional: having height and width
Value: the lightness or darkey

Value: the lightness or darkness of a plane or area

Space: the distance between identifiable points or planes
Perspective: the creation of the illusion of depth in a two-dimensional image by using mathematical principles

Surrealist: an artist belonging to the Surrealist movement in the 1920s and later, whose art was inspired by dreams and the subconscious

1.47 René Magritte, *The Treachery of Images ("This is not a pipe")*, 1929. Oil on canvas, $23^3/4 \times 32^{\circ}$. LACMA

Reality is merely an illusion, albeit a very persistent one.

(Albert Einstein, physicist and Nobel Prize winner)

When Albert Einstein suggested that not everything we see is real, he probably did not have art in mind. But artists readily understand his remark, because when they create a picture of real space on a flat surface they know they are creating an illusion. When we watch a magician perform a trick, we instinctively wonder how the magic was achieved. In this chapter we will reveal some of the secrets that artists rely upon to create the appearance of **three-dimensional** depth in a **two-dimensional** work of art.

The techniques artists use to imply depth—value, space, and perspective—evoke our past

visual experiences and the way we see. **Value**, the lightness or darkness of a surface, emulates the effects of light and shadow, and can be used to suggest solidity. Artists have a variety of techniques based on the optics of vision that enable them to create the illusion of pictorial space. One of these is called atmospheric perspective, a method that mimics our visual perceptions of color, clarity, and form at a distance. Linear and isometric perspective are drawing methods that can express the idea of three-dimensional space on a two-dimensional surface. In this chapter we will introduce these methods of creating the illusion of space and discuss why some artists choose to use them.

In *The Treachery of Images*, Belgian **Surrealist** artist René Magritte (1898–1967)
uses value and perspective to imply depth (1.47).
The pipe is painted in varying values (light and dark tones), which gives the appearance of shadows that suggest depth. The top of the pipe bowl (where the tobacco would be stuffed) is composed of two concentric ellipses, which is how circles appear in perspective. We know what a real pipe looks like in real space, and Magritte understands our habits of visual perception.
He paints a picture of a pipe that "feels" solid, but then playfully invites us to re-examine our habits of mind.

In this painting, Magritte tells us that painting is a visual trick. By writing "Ceci n'est pas une pipe" ("This is not a pipe"), Magritte wants us to recognize that what appears to be a pipe is not really a pipe: it is an illusion, nothing more than paint on a flat surface.

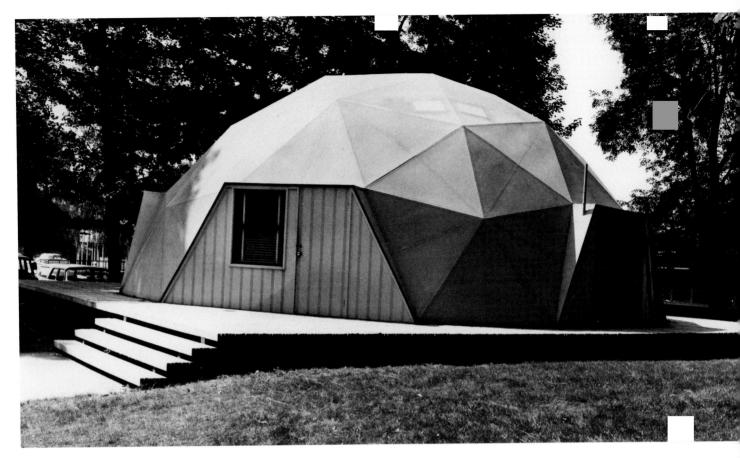

Value

Value refers to lightness and darkness. An artist's use of value can produce a sense of solidity and influence our mood. For example, detective movies of the 1940s were filmed in such dark tones that they had their own **style** called *film noir*, French for "dark film." The serious mood of these mysteries was enhanced by the filmmaker's choice of dark values. Artists use dark and light values as tools for creating depth.

Artists learn to mimic the appearance of things by observing the effects of light as it illuminates a surface. The Art Dome, formerly used as a sculpture studio at Reed College in Portland, Oregon, demonstrates the effect of light on planes in varying locations (1.48). Many triangular flat planes make up this surface. Each of these planes has a different value, the relative degree of lightness or darkness of the plane according to the amount of light shining on it. The light source (high and to the left of the dome) hits some of the triangular planes of the Art Dome more directly than others. The planes

that have a lighter value are facing the light source; the darker ones are facing away.

Value changes often occur gradually. If you look at the Art Dome, you will notice that the relative dark values increase as the planes get further away and face away from the light (see also 1.49). These changes occur on any object. There are subtle value changes even in a white object.

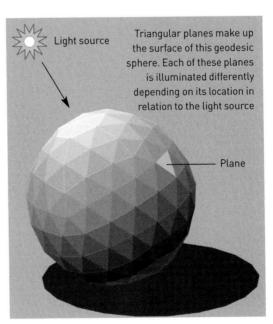

1.48 Buckminster Fuller, Geodesic Dome (Art Dome), 1963–79, Reed College, Portland, Oregon

1.49 Values and planes of a geodesic sphere, vector graphic

Style: a characteristic way in which an artist or group of artists uses visual language to give a work an identifiable form of visual expression

Plane: a flat surface

A value range refers to a series of different values. In the image of the geodesic sphere (see p. 77) there is a value range of black, white, and eight values of gray. Black and white are the values at the extreme ends of this value range.

Chiaroscuro

Chiaroscuro (Italian for "light-dark") is a method of applying value to a two-dimensional piece of artwork to create the illusion of a three-dimensional solid form (1.50).

The illusion of solidity and depth in two dimensions can be achieved by using an approach devised by artists of the Italian Renaissance. Using a sphere as their model, Renaissance artists identified five distinct areas of light and shadow. A **highlight** marks the point where the object is most directly lit. This is most often depicted as bright white. From the highlight, moving toward the shadow, progressively less light is cast on the object until the point is reached where the surface faces away from the light. Here there is a more sudden transition to darker values, or core shadow. At the bottom of the sphere a lighter value is produced by shadow mixed with light reflected from the surrounding environment. This lighter value defines the bottom edge of the sphere. In contrast, the sphere casts a shadow

1.50 Diagram of chiaroscuro

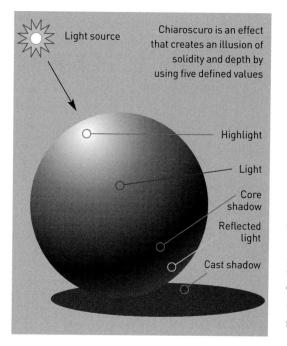

away from the direction of the light source. Near the edge of the cast shadow, as light from the surrounding environment increases, the shadow becomes lighter.

Highlight

Core shadow

Reflected light

Cast shadow

Light

In *Study for La Source*, the French artist Pierre-Paul Prud'hon (1758–1823) uses chiaroscuro in the drawing of a female figure (**1.51**). If you look carefully at the figure's upper left leg (the leg on the viewer's right), you

1.51 Chiaroscuro graphic applied to Pierre-Paul Prud'hon, *Study for La Source*, c. 1801. Black and white chalk on blue paper, 21³/₄ × 15¹/₄". Sterling and Francine Clark Art Institute, Williamstown, Massachusetts

Renaissance: a period of cultural and artistic change in Europe from the fourteenth to the seventeenth century

Highlight: an area of lightest value in a work

can see that the chiaroscuro is being used just as it is in **1.50**. There is an area of highlight on the knee transitioning to the lighted thigh. Under the knee and thigh there is a strong core shadow: reflected light can be seen on the calf and the underside of the thigh. The reflected light is accentuated by the dark cast shadow behind the calf. Prud'hon's use of black and white chalk on a gray paper allows him to accentuate the lightest and darkest areas, the chiaroscuro.

Dramatic effects can be achieved through the use of chiaroscuro, especially if it is exaggerated. *The Calling of St. Matthew* by the Italian artist

Caravaggio (1571–1610) uses strongly contrasting values to convert a quiet gathering into a pivotal and powerful event (1.52). The intense difference between lights and darks places extra **emphasis** on Christ's hand as he singles out Matthew, who points to himself in response. The light also frames Matthew and highlights the surprised looks of the others in the room as Matthew is called to become one of Christ's disciples.

1.52 Caravaggio, *The Calling of St. Matthew, c.* 1599–1600. Oil on canvas, 11'1" × 11'5". Contarelli Chapel, San Luigi dei Francesi, Rome, Italy

Emphasis: the principle of drawing attention to particular content in a work

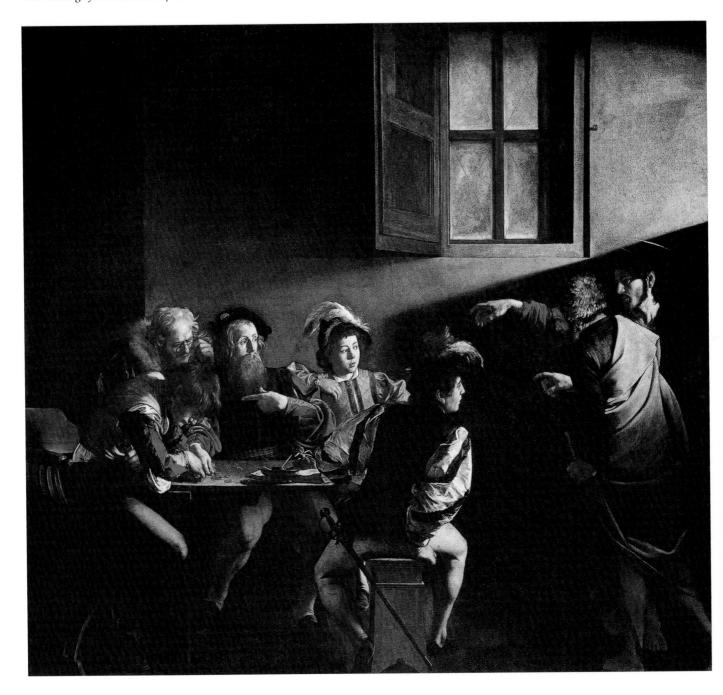

Hatching: the use of nonoverlapping parallel lines to convey darkness or lightness Medium (plural media): the material on or from which an artist chooses to make a work of art, for example canvas and oil paint, marble, engraving, video, or architecture

Cross-hatching: the use of overlapping parallel lines to convey darkness or lightness
Shape: the two-dimensional area the boundaries of which are defined by lines or suggested by changes in color or value

1.53 Creating value using hatching and cross-hatching

1.54 Michelangelo, *Head of a Satyr*, c. 1520–30. Pen and ink on paper, $10^{5/8} \times 7^{7/8}$ ". Museé du Louvre, Paris, France

Hatching and Cross-Hatching

Artists also use a method called **hatching** to express value (**1.53**). Hatching consists of a series of lines, close to and parallel to each other. **Media** that demand a thin line, for example engraving or pen-and-ink drawing, do not allow much variation in the width of the line. Here an artist may choose hatching or **cross-hatching** (a variant of hatching in which the lines overlap) to suggest values that create a greater sense of form and depth.

The Italian artist Michelangelo (1475–1564) uses cross-hatching in his pen-and-ink drawing *Head of a Satyr* (1.54). Cross-hatching gives the face of the satyr solidity and depth. By building up layers of brown ink, Michelangelo overcomes the restrictions created by the thin line of the pen. For example, if we look carefully at the cheekbone of the satyr it appears to be jutting out toward us. This effect is created by hatching and cross-hatching. The bright white highlight uses no lines; the surrounding hatch lines define the transition from bright light to a darker value. As we move our gaze downward and to the right of the highlight we notice that a second layer of overlapping hatching lines intersects the diagonals bordering the highlight. Then, as we continue to scan downward and to the right we see more layers of hatching lines crossing over the previous. As the hatching lines cross over and over, the value appears to get darker. Michelangelo communicates three-dimensional depth by using narrow and two-dimensional lines.

Space

Value is just one of a variety of strategies artists use to communicate the idea of depth in a work of art. The strategies are techniques whereby an artist creates a sense of depth and the illusion of space.

Size, Overlapping, and Position

In a work of art, the size of one **shape** compared to another often suggests that the larger object is closer to us. Another way to create the illusion of depth is to overlap shapes. If one shape appears to

Gateway to Art: Hokusai, "The Great Wave off Shore at Kanagawa" Methods for Implying Depth

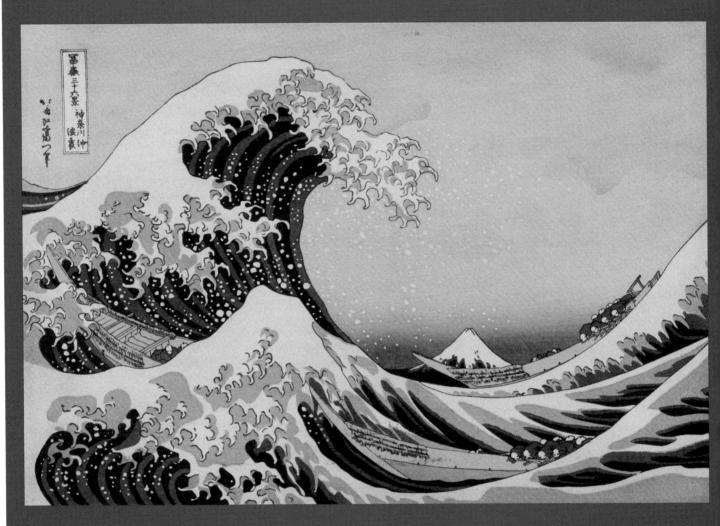

1.55 Katsushika Hokusai. "The Great Wave off Shore at Kanagawa", from Thirty-Six (printed later). Print, color woodcut. Library of Congress, Washington, D.C.

The Japanese artist Katsushika Hokusai (1760-1849), one of the great masters of drawing and printmaking, uses several devices to indicate depth in "The Great Wave off Shore at Kanagawa" (1.55). The artist makes one boat shape smaller than the others, so by size comparison we see the boat that is smallest as furthest. Hokusai also gives us other clues about depth. The shape of the wave overlaps the two largest boat shapes (on the bottom). In this way, the artist tells us that the water is closer to us than the boat shapes. The relative positions of the shapes in the print also imply depth. By placing the wave shape at the lowest point on the page, the artist suggests that it is closest to the viewer. As the shapes get higher in the composition, they appear to be further

away. Hokusai then draws our attention back to the foreground with the enormous whitecapped wave shape that gives the piece its title. The placing of Mount Fuji lower than the top of the waves deliberately confuses the composition of the picture space, but it also adds to our sense of the size of the wave that towers over it. At first glance the mountain seems like just another wave, but once we realize it is the far-off Mount Fuji we get a sense of distance. We can then assume the boats are far off shore, and this contributes to our feeling of unease regarding the fate of these mariners in a churning, violent sea.

Picture plane: the surface of a painting or drawing **Rhythm:** the regular or ordered repetition of elements in the work

1.56 Fan Kuan, Travelers among Mountains and Streams, Northern Sung Dynasty, 11th century. Hanging scroll, ink and colors on silk, $81^{1}/_{4} \times 40^{5}/_{8}$ ". National Palace Museum, Taipei, Taiwan

overlap another, the shape in front seems closer than the shape that is partially covered. Position in the **picture plane** is also an effective device for implying depth. A shape lower in the picture plane appears to be closer.

Alternating Value and Texture

The illusion of depth in two dimensions is often influenced by the arrangement of value and texture. Artists intersperse value and visual texture to create a sense of rhythm. Look at Travelers among Mountains and Streams (1.56), by Chinese painter Fan Kuan (c. 990–1020). From the bottom up, we first confront a large boulder, followed by a light opening (a road with travelers), and then some trees and foliage clinging to a rocky landscape. After this section there is another light area, after which the values gradually darken as our view climbs the face of a mountain. Finally, the sky is lighter, although somewhat darkened, completing the alternating rhythm from bottom to top. Each area of light and dark occupies different amounts of space, making the design more interesting. We can also note the change in visual texture from bottom to top. The texture appears to be extremely rough and detailed near the bottom. From this point it progressively becomes less precise. As Fan Kuan's landscape rises it also appears to recede. These visual layers create a sense of depth.

Brightness and Color

Brightness and color can both be used to suggest depth in a work of art. Lighter areas seem to be closer as dark areas appear to recede. This is especially true of color. For example, we are more likely to think that a green that is very pure and intense is closer to us than a darker green. American painter Thomas Hart Benton (1889–1975) used brightness and color to create a sense of distance in his painting The Wreck of the Ole '97 (1.57). In the green areas we see the bright pure greens come forward as the darker, less intense greens fall away. The greens in the lower central portion of the work are more intense than the greens on the far left. Because

we perceive color that is more intense as being closer, this difference in color intensity helps us to feel we are at a safe distance from the terrible train wreck.

Atmospheric Perspective

Some artists use atmospheric perspective to create the illusion of depth. Distant objects lack contrast, detail, and sharpness of focus because the air that surrounds us is not completely transparent. The effect makes objects with strong color take on a blue-gray middle value as they get farther away: the atmosphere progressively veils a scene as the distance increases. Contemporary filmmakers use this atmospheric effect to give the illusion of great depth, just as traditional artists have always done.

In 1.58 the Greek temple to the left appears to be closer to the viewer than the other temples because its colors are brighter and its shape is more sharply defined. The smallest temple lacks detail and is tinged blue-gray, making it seem the

1.57 Thomas Hart Benton, The Wreck of the Ole '97, 1943. Egg tempera and oil on canvas, $28\frac{1}{2} \times 44\frac{1}{2}$ ". Hunter Museum of Art, Chattanooga, Tennessee

1.58 The effects of atmospheric perspective

1.59 Asher Brown Durand, Kindred Spirits, 1849. Oil on canvas, 44 × 36". Crystal Bridges Museum of American Art, Bentonville, Arkansas

farthest away. American Asher Brown Durand (1796–1886) used comparable effects in his painting *Kindred Spirits* (1.59). The trees in the foreground are detailed and bright green, but as the trees recede into the landscape behind the two figures they become a lighter gray and increasingly out of focus. Lines and shapes also become less distinct as the illusion of distance increases. By using atmospheric perspective, Durand conveys an impression of the vastness of the American landscape.

Perspective

Artists, architects, and designers who wish to suggest the illusion of depth on a two-dimensional surface use perspective. They have the choice of several ways to do this, of which two are the most common. **Isometric perspective** uses diagonal

parallels to communicate depth, while **linear perspective** relies on a system where lines appear to converge at points in space. Both forms of perspective tap into some of the ways we see the world and think about space.

Isometric Perspective

Isometric perspective arranges parallel lines diagonally in a work to give a sense of depth. The word isometric derives from the Greek meaning "equal measure." The system has been used by artists in China for more than a thousand years. It was particularly suitable for painting on scrolls, which can be examined only in sections. Since Chinese landscape painters were never really interested in portraying space from a single viewing point—they preferred to convey multiple viewpoints simultaneously—isometric perspective was their chosen technique to convey the illusion of space in the structural lines of architecture and other rectilinear objects. A section from the painting The Qianlong Emperor's Southern Inspection Tour, Scroll Six: Entering Suzhou and the Grand Canal by Xu Yang shows this system in action (1.60). The parallel diagonal lines that define the small L-shaped building in the center of the work suggest a three-dimensional object (1.61). Xu Yang, a Chinese artist working in the 1770s, uses this method to give the architecture along the Grand Canal the illusion of depth. This method of implying depth is not "realistic" according to the Western tradition, but the artist makes use of other spatial devices to help us understand how the space is structured. For example, the diminishing size of the trees as they recede into the distance reinforces the sense of depth.

Isometric perspective is now common in contemporary computer graphics as well.

The computer game *The Sims* (1.62) is designed to express depth with a perspective method similar to the one Xu Yang used in 1770. The designers have created the architecture of the game using parallel diagonal lines to make "tiles." The tiles allow uniform objects to remain the same size, yet as they move around the game field they still imply depth. The game designers' choice

Isometric perspective: a system using diagonal parallel lines to communicate depth
Linear perspective: a system using converging imaginary sight lines to create the illusion of depth

1.60 Xu Yang, The Qianlong Emperor's Southern Inspection Tour, Scroll Six: Entering Suzhou and the Grand Canal, Qing Dynasty, 1770 (detail). Handscroll, ink and color on silk, $2'3^{1/8} \times 65'4^{1/2}$ ". Metropolitan Museum of Art, New York

1.61 (above) Graphic detailing isometric perspective in scroll image

1.62 Screenshot from *The* Sims, a computer simulation game, 2000

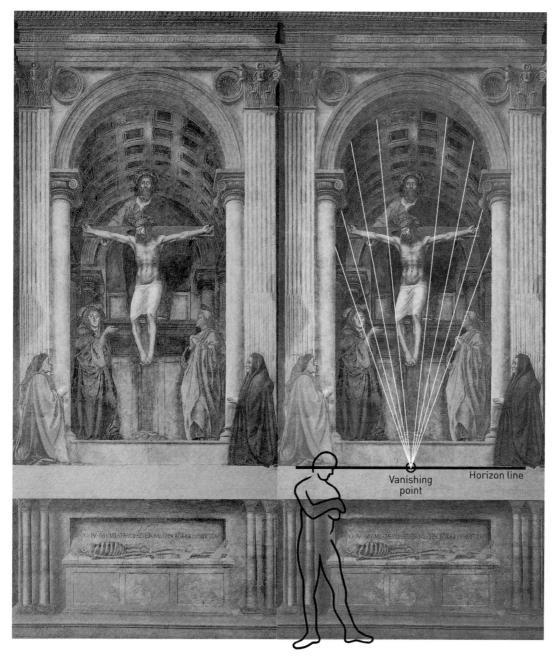

1.65 Use of one-point perspective: Masaccio, *Trinity*, c. 1425–6. Fresco, 21'10½" × 10'4½". Santa Maria Novella, Florence, Italy

of direct sight and it is not as easy to see the recession of space.

One of the first artists to use one-point perspective was the Italian Masaccio (1401–28). In his **fresco** of the *Trinity*, Masaccio places the horizon line, an imaginary line that mimics the horizon, at the viewer's eye level (note the figure) and centers the vanishing point in the middle of that line (1.65). The horizon line represents our eye level and is the basis for the setting-out of a perspective drawing. The orthogonals create an illusion that the background is an architectural setting. The end result is an effective illusion of depth on a two-dimensional surface that must

have amazed visitors at the church of Santa Maria Novella in Florence, Italy.

Two-Point Perspective

The one-point perspective system worked for Masaccio because his composition relied on the viewer standing directly in front of the vanishing point. But if the vanishing point is not directly (or near directly) in front of a viewer, or if the objects in the work are not all parallel, one-point perspective does not create a believable illusion of depth. The Italian artist Raphael (1483–1520) dealt with this problem in his famous painting *The School of Athens* [1.66a and 1.66b].

Fresco: a technique where the artist paints onto freshly applied plaster. From the Italian *fresco*, fresh

Gateway to Art: Raphael, *The School of Athens* **Perspective and the Illusion of Depth**

1.66a Raphael, *The School of Athens*, 1510–11. Fresco, 16'8" × 25'. Stanza della Segnatura, Vatican City

In *The School of Athens* Raphael combines one-point perspective and two-point perspective in one composition (1.66a and 1.66b). The figure in the foreground is leaning against an object set at an angle that is not perpendicular and parallel to the rest of the architectural setting. Consequently, it cannot depend on the central

vanishing point that has been determined following the rules of one-point perspective, or it will be distorted. Raphael deals with this situation by introducing two additional vanishing points. Notice that both these new vanishing points fall on the horizon line, following the established rules of perspective (vanishing points must fall on the horizon line). One vanishing point is positioned to the left of the central vanishing point that anchors the architecture, and the right vanishing point is outside of the picture. The block in the center is the only object in the composition that uses these two vanishing points, because the viewer is not perpendicular or parallel to it. Since it is turned at an angle, Raphael had to integrate another level of perspective into the work. All of the objects and architectural spaces depicted in this painting rely on one of these two perspective points.

1.66b (below) Applying two-point perspective: detail from Raphael, *The School of Athens*

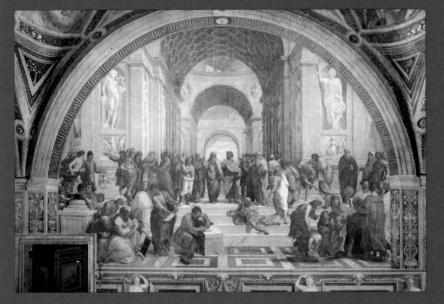

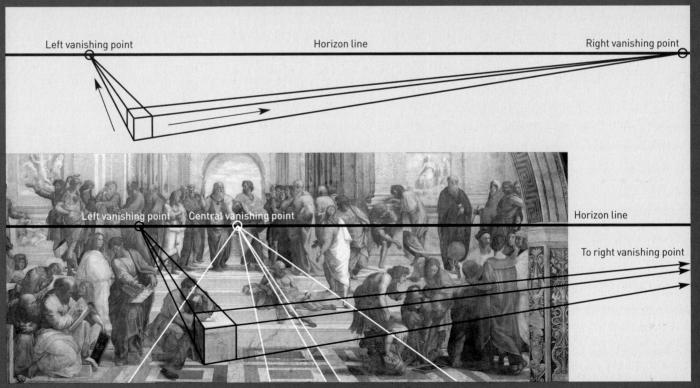

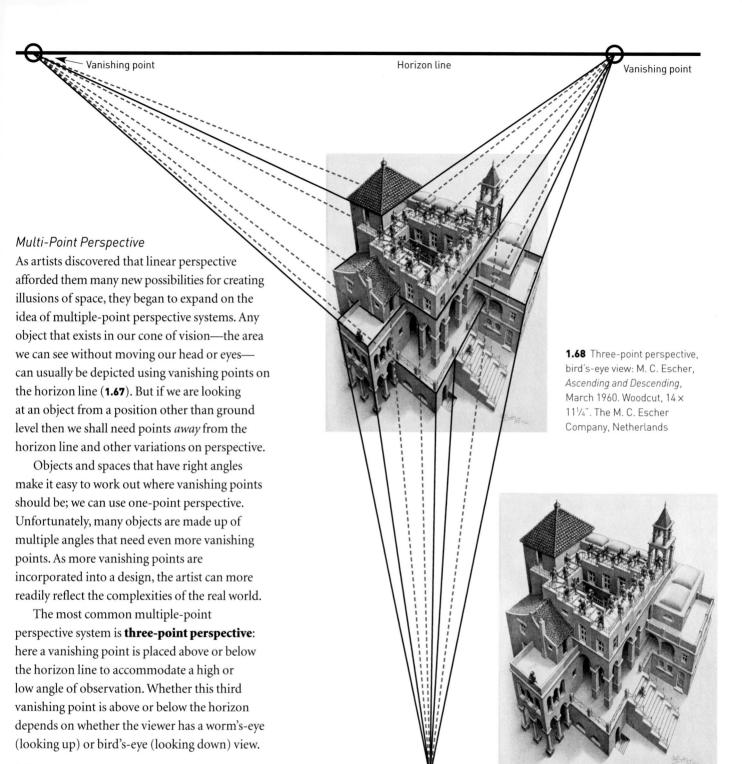

1.67 Cone of vision

Dutch graphic artist M. C. Escher (1898–1972) uses a third vanishing point in *Ascending and Descending*; we can see three distinct vanishing points (1.68). Two of the vanishing points are placed on the horizon line, but one is well below it. This gives us a bird's-eye view of the building that allows us to see the sides of the structure while looking down on it as if from above.

Vanishing point

Three-point perspective: a perspective system with two vanishing points on the horizon and one not on the horizon

1.69 Albrecht Dürer, *Draftsman Drawing a Recumbent Woman*, 1525. Woodcut. Graphische Sammlung Albertina, Vienna, Austria

Foreshortening: a perspective technique that depicts a form at a very oblique (often dramatic) angle to the viewer in order to show depth in space

Woodcut: a print created from an incised piece of wood

1.70 Andrea Mantegna, The Lamentation over the Dead Christ, c. 1480. Tempera on canvas, $26^3/4 \times 31^7/8^\circ$. Pinacoteca di Brera, Milan, Italy

Foreshortening

Foreshortening results when the rules of perspective are applied to represent unusual points of view. The German artist Albrecht Dürer (1471–1528), in his woodcut Draftsman Drawing a Recumbent Woman, portrays an artist at work drawing a figure (1.69). At this oblique angle the usual proportions of different parts of the body do not apply. The artist has a fixed lens or aperture in front of him to make sure he always views from the same point. As he looks through the gridded window he can see the coordinates, in relation to the grid, of the different parts of the model's body. He can then transfer those coordinates onto the similar grid marked on the piece of paper in front of him. The gridded screen in the illustration helps the artist to translate a

three-dimensional form into a foreshortened two-dimensional composition.

A painting by the Italian artist Andrea Mantegna (1431–1506), *The Lamentation over the Dead Christ*, also illustrates foreshortening (1.70). The figure of Christ is oriented so that the wounded feet are placed in the extreme foreground, with the rest of the body receding away from the viewer back into space. Mantegna only slightly enlarges the feet, and depicts the body in shortened sections. Like perspective in general, foreshortening has the effect of grabbing our interest. In this work, we feel as if we are standing at the foot of the slab where they have put down Christ's dead body.

Conclusion

The depiction of space in a work of art is more than just an illusion, trick, or device. By means of a rich and creative variety of techniques, artists through the ages and across the world have given us clues we can connect with things we have seen and the ways in which we have seen them.

Artists anticipate the effects of light on an object by subtle variations in value. By noting how we see light and shadow the artist can use chiaroscuro or hatching to remind us of solid objects similar to those we have seen.

When an artist overlaps different shapes, or contrasts their sizes in a particular way, we begin to imagine something that is not there. The artist, from observation of the real world, mimics variations in texture, brightness, color intensity, and atmospheric perspective. These effects create an illusion that increases our ability to perceive space. The right method can help even the simplest graphic convey depth.

Different systems of perspective organize and distribute lines and forms in two-dimensional space, allowing artists to create a new and convincing sense of depth.

Implied depth has been a powerful tool for artists since the first created image. The ability to make a two-dimensional surface look as if it opens up into a new space expands our imagination and enhances our experience of the world.

1.4

Color

Color: the optical effect caused when reflected white light of the spectrum is divided into a separate wavelength

Primary colors: three basic colors from which all others are derived

Secondary colors: colors mixed from two primary colors

Pigment: the colored material used in paints. Often made from finely ground minerals

Hue: general classification of a color; the distinctive characteristics of a color as seen in the visible spectrum,

such as green or red **Value:** the lightness or darkness
of a plane or area

Tint: a color lighter in value than its purest state

1.71 White light can be separated into the visible spectrum using a prism

The first colors that made a strong impression on me were bright, juicy green, white, carmine red, black and yellow ochre. These memories go back to the third year of my life. I saw these colors on various objects which are no longer as clear in my mind as the colors themselves.

(Vasily Kandinsky, Russian painter)

Color is the most vivid element of art and design. By its very essence, color attracts our attention and excites our emotion. Just as personality and mood vary from one person to the next, our perceptions of color are personal and subjective. Few other phenomena touch our innermost feelings as deeply and directly.

Ancient Greek philosophers speculated that color was not a state of matter but a state of mind. Today, physicists tell us that an object's color is determined by the wavelengths of light it reflects. The refraction of light through a prism shows that we can think of white light as composed of constituent colors of different wavelengths (1.71). The colors we see are those portions of the light spectrum that a surface fails to absorb, and reflects instead. Physiologists, meanwhile, explain that this reflected light excites nerve cells that line the back of our eyes, and that their nerve signals are reprocessed and interpreted as color

in our brains. In natural sunlight, the color of an object we see is, in fact, a reflected fraction of light. When we see someone wearing a blue sweater, the blue we see is the portion of the spectrum that is reflected back to our eyes; the rest of the light is absorbed by the sweater.

Because color is so essential to our experience of seeing, it is deeply associated with the psychological and expressive aspects of our lives. That simple blue sweater may have many complex associations. We will explore and explain the complexities of color in this chapter.

Light and Color

The colors of the color wheel are the building blocks of most color combinations (1.72). The traditional **primary colors**—red, yellow, blue—cannot be mixed from any other two colors. The **secondary colors** are colors, such as orange (a blend of red and yellow) and green (a blend of yellow and blue), which can be mixed from two primary colors. In the color wheel the secondary colors are located between the primary colors because they naturally fall between them in the visible spectrum.

Colors of light and colors of **pigment** behave differently. You see this in action when you mix all the colors of paint together and get a muddy middle gray instead of white. There are two ways of working with color mixtures, known as subtractive and additive. When subtractive colors are mixed they make a darker and duller color because more of the visible spectrum is

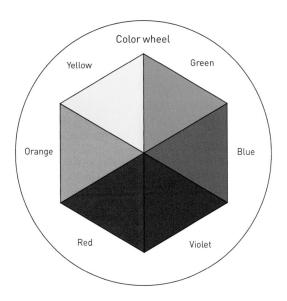

1.72 Traditional color wheel (red, yellow, blue primaries)

absorbed. When additive colors are mixed they make colors even lighter.

Dimensions of Color

All colors have three basic properties: hue, value, and saturation. By manipulating these three properties painters can achieve an endless range of visual effects.

1.73 Kane Kwei, *Coffin in the Shape of a Cocoa Pod, c.* 1970. Polychrome wood, 2'10" × 8'6" × 2'5". Fine Arts

Museums of San Francisco

Hue

Hues are the basic colors of the spectrum, the same as those in a rainbow: red, orange, yellow, green, blue, and violet. In addition, there are a

number of other hues we can see when white light is divided into the spectrum, for example blue-green or yellow-orange.

Color is such an important aspect of a coffin created by the African sculptor Kane Kwei (1922–92) that it is sometimes known as Coffin Orange (1.73). Kwei's coffin is painted with a brilliant middle-orange hue, the color of a halfripened cocoa pod. Although cocoa pods are orange, the brightness of color used for this coffin is exaggerated. In Ghana, Kwei's native country, funerals are celebratory, loud affairs where bright color adds to the festive mood. Ghanaians believe that having lots of happy people at a funeral gives solace to the family of the deceased, reminding them that they still have many friends. Kwei got started in his career when his dying uncle asked Kwei to build him a boat-shaped coffin. It was such a hit in the community that others began to ask for coffins made in interesting shapes. Coffin in the Shape of a Cocoa Pod was commissioned by a cocoa farmer who wanted to tell everybody about his lifelong passion at his last party on earth.

Value

Each hue has a **value**, meaning its relative lightness or darkness compared to another hue. For example, a pure yellow has a light value and a pure blue has a dark value. Similarly, different colors of the same hue vary in terms of their value: there are light reds and dark reds. **Tints** are

1.74 Color-value relationships

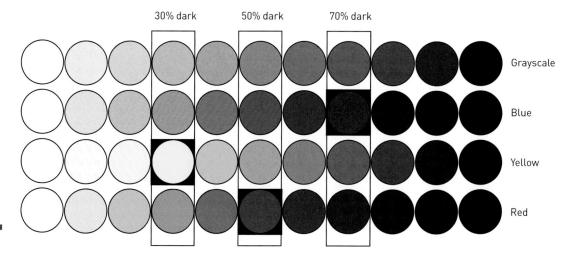

Shade: a color darker in value than its purest state
Neutral: colors (such as blacks, whites, grays, and dull graybrowns) made by mixing complementary hues
Monochromatic: having one or

more values of one color **Cubism:** a twentieth-century art movement that favored a new perspective emphasizing geometric forms

Collage: a work of art assembled by gluing materials, often paper, onto a surface. From the French *coller*, to glue **Palette:** the range of colors used

by an artist

colors that are lighter than their basic hue; **shades** are colors that are darker. **1.74** shows relative values of red, blue, and yellow. The purest values, compared with those visible in the spectrum, are indicated by the black outline. **1.74** also shows the grayscale values; these are described as **neutral**, meaning there is an absence of color.

A work that uses only one hue is called **monochromatic**. An artist can give variety to such a work by using a range of values. Creating dramatic differences in the values of a color allows for ordered transitions from one value

to another. Many of American Mark Tansey's (b. 1949) large paintings are monochromatic. In *Picasso and Braque*, Tansey depicts two figures, whom he refers to as "Orville and Wilbur," a reference to aviators the Wright Brothers (1.75). He is also referring wryly to Pablo Picasso's (1881–1973) and Georges Braque's (1882–1963) habit of referring to each other as Orville and Wilbur during the pioneering days of **Cubism**. The two figures here have created a flying machine that resembles an early Cubist **collage**. The monochromatic **palette** is

1.75 Mark Tansey, *Picasso and Braque*, 1992. Oil on canvas, 5'4" × 7'

reminiscent of the black-and-white photos of the Wright Brothers' experiments with flight, and the blue tone refers to an early **style** of Picasso's known as his Blue Period. Tansey uses humor to comment on historic discoveries in art and flight within a single monochromatic composition.

Saturation

When we think of the color yellow, we often imagine something strong, bright, and intense. Many shades of yellow exist, but we tend to associate a color with its purest state, or its highest level of **saturation**. A color at its most intense is said to have a high saturation. The color mustard yellow, which has a brownish tone, is said to have a lower level of saturation.

Saturation describes the purity of a hue as it is derived from pure white light. A red at the height of saturation is closest to its pure state in the spectrum (1.76). There are no tints or shades when a color is fully saturated. A color that is almost gray has a low saturation. Therefore a muted color, whatever its value, is less saturated as it gets further from the purity of its color in the spectrum. A pastel tone and a dark tone would each have a low saturation of color, but a grayed middle value of red would also have a low saturation of color; saturation is not related to value.

Works such as *Vir Heroicus Sublimis* (Latin for "heroic sublime man") by the American painter

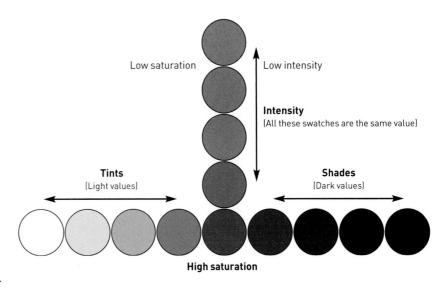

1.76 High and low saturation in a red hue

Barnett Newman (1905–70) rely for their visual impact on the value and saturation of color (1.77). The alternating colors of the narrow vertical lines (which Newman calls "zips") break up a broad red **plane**. The white zip makes a gap, while the maroon zip seems to meld into the red field. Subtle variations in the saturation of the red tones create the sensation that parts of the painting are separately lit. Newman wants viewers to stand close to the canvas, engulfed by color, meeting the artwork as one might another person. The square area in the center of this painting suggests

Style: a characteristic way in which an artist or group of artists uses visual language to give a work an identifiable form of visual expression

Saturation: the degree of purity of a color

Plane: a flat surface

1.77 Barnett Newman, *Vir Heroicus Sublimis*, 1950–51. Oil on canvas, 7'11³/₈" × 17'8¹/₄". MOMA, New York

1.78 André Derain, The Turning Road, L'Estaque, 1906.
Oil on canvas, 4'3" × 6'43/4".
Museum of Fine Arts,
Houston, Texas

Newman's idealistic vision of the perfectibility of humankind.

The French painter André Derain (1880– 1954) was a great advocate of highly saturated color. In his work The Turning Road, L'Estaque, his use of strong bright color makes the entire scene glow with energy and vitality (1.78). Derain was a member of the **Fauves** (French for "wild beasts"). The Fauves delighted in the new and brighter colored pigments made available by advances in industrial manufacturing. They used colors in their purest and strongest states as an act of defiance against the Academy, a statesponsored school of art that set rigid rules for acceptable standards for art and artists at the turn of the century. The Fauves' fierce colors challenged the Academy and Western artistic conventions generally and earned the artists their nickname. Derain's painting is energized by deeply saturated color and color opposites, colors that intensify each other when seen close together.

Color Schemes

The color wheel displays important color relationships. It is a kind of color "map" that allows us to assess quickly the attributes of colors as they relate to each other. Colors opposite each other on the color wheel are called **complementary colors**. Complementary colors contrast strongly with each other. Colors adjacent to each other on the color wheel are called **analogous colors**. These colors do not contrast strongly with each other.

Complementary Color

When complementary colors are mixed, they produce gray; they tend to desaturate one another. However, when two complementary colors are painted side by side, these "opposite" colors create visual anomalies: they intensify one another, and each seems more saturated. This happens because complementary colors have markedly different

Fauves: a group of early twentieth-century French artists whose paintings used vivid colors. From the French *fauve*, wild beast

Complementary colors: colors opposite one another on the color wheel

Analogous colors: colors adjacent to each other on the color wheel

wavelengths, creating an illusion (in the photoreceptors of the eye) of vibrating movement where their edges meet (1.79).

When the eye tries to compensate for the different wavelengths of two complementary colors, we tend to see color more intensely than when we see the colors separately. So when red is present, greens tend to appear more vibrantly green. Henri Matisse was a Fauve (like Derain) and explored the bold contrasts of black and

1.79 Color combinations, color complements, and vibrating boundaries

Primary/secondary analogous combinations

Primary/secondary and tertiary complements

Vibrating boundaries

Gateway to Art: Matisse, *Icarus* **The Artist's Fascination with Color**

Throughout the whole of his career, the French artist Henri Matisse (1869–1954) explored the expressive potential of color. He often painted in southern France, and the kind of bright light he experienced there seems to emanate from his paintings. As a Fauve he used colors so bright that some viewers considered them violent. Much later, in the 1940s, Matisse began to excel in creating artworks by using scissors to cut out pieces of brightly painted paper. In part this was a response to his ill-health—he could not hold a brush up to a canvas for hours at a time. As he commented:

Paper cutouts allow me to draw in color.

For me, that simplifies matters. Instead of drawing an outline and then adding color—which means that line and color modify one another—I can draw directly with color ... the simplification means that the two means of expression can be united.

(Matisse, 1951)

Matisse was interested in using vibrant colors to evoke an emotional response. To make his cutouts, he had his assistants prepaint the paper in vivid colors. He found many creative ways to use these cutouts. In the case of *Icarus* (1.80), Matisse made a stencil of the cutout to print the image in his artist's

book Jazz. Subsequently, he used some of the images in Jazz as an inspiration for large tapestries that he designed by arranging cutouts on the wall of his apartment. Matisse found the process of designing with cutouts an ideal way to study different color relationships.

In Jazz, Icarus is accompanied by handwritten text, which reads: "At this moment we are so free, shouldn't we make young people who have finished their studies take a grand trip by plane." Matisse uses the myth of youthful exuberance to encourage young people to experience the world first hand—if not with wings, as the mythological young Icarus did, then by airplane.

1.80 Henri Matisse, *Icarus*, from *Jazz*, 1943–7. Page size $16\% \times 12\%$ ". MOMA, New York

un moment
di libres.

ne devraiten
pas faire ac.
complir un
grand voyage
en avion aux
jeunes gens
ayanttermini
ceurs études.

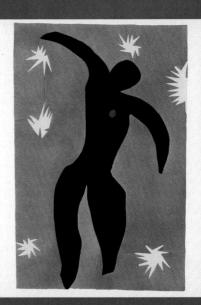

1.81 Frederic Edwin Church, *Twilight in the Wilderness*, 1860. Oil on canvas, 40×64 ". Cleveland Museum of Art, Ohio

white against the intensity of primary colors (see Gateway Box: Matisse, **1.80**, p. 97).

American landscape painter Frederic Edwin Church (1826–1900) used complementary colors for dramatic effect. In *Twilight in the Wilderness*, the intense red-orange clouds complement swathes of the blue-green evening sky, giving magnificence to a quiet landscape (1.81). The powerful color of the sky and its reflection in the water below reveal Church's awe and respect for the American landscape.

Analogous Color

Analogous colors are similar in wavelength, so they do not create optical illusions or visual vibrations the way complementary colors do. Painters use analogous color to create color unity and harmonies to steer viewers toward a particular attitude or emotion. By keeping the color within a similar range, artists avoid jarring, contrasting combination of colors and moods.

In *The Boating Party* by Mary Cassatt (1844–1926), her color palette creates a harmonious effect (**1.82**). This is the result of using analogous colors that are next to one another on the

1.82 Mary Cassatt, The Boating Party, 1893–4. Oil on canvas, $35\% \times 46\%$. National Gallery of Art, Washington, D.C.

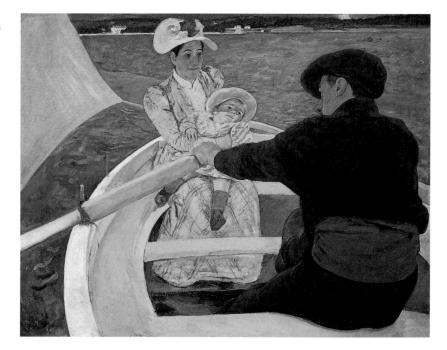

color wheel. In this painting, yellows, greens, and blues predominate. These colors have relatively similar wavelengths and do not intensify each other when placed in close proximity. Cassatt's color seems relaxed, reinforcing her theme. Cassatt was one of the few female (and only American) members of the **Impressionists**, a group of artists who shared an interest in the effects of light and color on the natural world, which they depicted in their paintings of everyday life.

In *Interior with Figures*, by British artist Howard Hodgkin (b. 1932), pinkish verticals on each side of the scene make a frame of analogous colors for the saturated reds in the space between (1.83). Deep crimsons, fleshy pinks, and countless dabs of scarlet fill this scene with heat. Red is dominant here and heightens our response to an enigmatically erotic encounter.

Our Perceptions of Color

Our experiences of color are sometimes evocative or physical. Some colors are associated with emotional states: if we say we are feeling "blue," we are describing a psychological state of mind. Blue is also associated with cold, and red with hot: an association known as color **temperature**.

1.83 Howard Hodgkin, Interior with Figures, 1977–84. Oil on wood, 54 × 60". Private collection

Impressionism: a late nineteenth-century painting style conveying the impression of the effects of light

Temperature: a description of color based on our associations with warmth or coolness

Ground: the surface or background onto which an artist paints or draws Pointillism: a late nineteenthcentury painting style using short strokes or points of differing colors that optically combine to form new perceived colors

Color can also affect the way we see. Because of color saturation, our eyes cannot fully comprehend all the colors we see, so our brain translates (or distorts) the incoming information. This is the basis of an illusion known as optical color, when boundaries between complementary colors seem to "vibrate" as our eyes struggle to compensate for differences between them.

Color Temperature

We associate color with temperature because of our previous experiences. We may have been burned by something red-hot, or chilled by cool blue water. Our perception of the temperature of a color can be altered if it is placed next to an analogous color. For example, green, a color we might associate with coolness, can be warm if we see it next to a cooler color like blue. A yellowgreen would be warmer than a blue-green. Color temperature is relative to the other colors nearby. Artists use such associations to communicate physical and emotional states.

The colors chosen for the underglazepainted lamp from the Islamic shrine the Dome of the Rock, in Jerusalem, are blue and green, on a white **ground** for contrast (1.84). They reflect the kind of color influence valued in the meditative atmosphere of a holy place. The choice of colors is cool and peaceful. Many people associate green and blue with water, plant life, a clear sky. Our life experiences with blue and green things can easily be associated with passive environments. The color green has positive associations in Islamic art and supports the peacefulness of prayer.

Optical Color

Sometimes our brains receive so much information that they simplify it. Optical colors are colors our minds create based on the information we can perceive. In 1.85 the square on the left contains so many red and blue dots that our brain mixes them so that we see a purple color. In the square on the right, red and yellow dots create an orange tone.

The French painter Georges Seurat (1859–91) used the optical qualities of color to create a

1.85 (above) Two squares, one filled with red and blue dots and the other with red and yellow dots to create optical color mixing effect

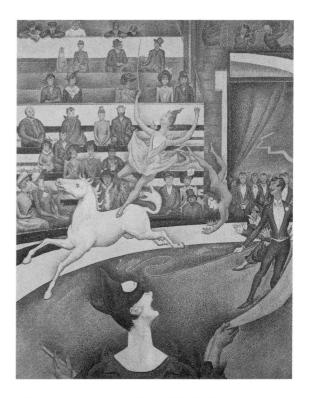

1.86 Georges Seurat, The Circus, 1890-91. Oil on canvas, 6'7/8" × 4'117/8". Musée d'Orsay, Paris, France

new style of painting, called **pointillism** because it relied on small dots (or points) of color. In The Circus Seurat paints a scene of lively entertainment, imbued with bright color and texture through the use of small dots (1.86, 1.87). Because these dots are so close together, the colors we see are different from the actual colors of the dots. This optical mixing makes the colors more intense because they have retained their individual saturation, whereas if they were mixed

1.84 Mosque lamp from

the Dome of the Rock in Jerusalem, 1549. Iznik

pottery, 15" high. British

1.87 Detail of Georges Seurat, The Circus

on the palette they would appear more subdued. The Circus's jewel-like diffusion of light and vibration of color make it visually exciting.

Color in Design

Artists who design images for commercial printing or to display on videoscreens take a different approach to color than such painters as

Seurat and Hodgkin. In this section we will look at how color is used in print and electronic displays.

Color in Print

Most printed color images—from posters, to magazines, to this book—rely on four separate colors to create the range of colors that we see. Commercial printers use three primary colors cyan (a kind of light blue-green), magenta (a light Medium (plural media): the material on or from which an artist chooses to make a work of art, for example canvas and oil paint, marble, engraving, video, or architecture

red-violet), and yellow—plus black, or key; the color wheel for printing is referred to as CMYK (1.88). An image is scanned and separated into the four colors. 1.89 shows a typical set of color separations. The image is re-created when the separated colors are printed in sequence, overlapping each other. The four colored inks are printed on paper as dots in a regular pattern ("screen"): the smaller the dot, the less of each color is printed. In the darkest colors the dots are nearly joined together. If you look very closely (using a magnifying lens) at the pictures in this book, you will be able to see the dots. Because the

pictures are divided into tiny dots of color, optical color mixing also plays a role in the control and perception of CMYK color, in a similar way to Seurat's Pointillist paintings.

Color in Electronic Displays

A computer-generated image produces color very differently. First, the digital display is illuminated by three different colored light cells, called phosphors, which project the primary colors of red, green, and blue (the color wheel is referred to as RGB) (1.90). Then, the electronic monitor turns a combination of phosphors on or off to produce the colors the designer wants. If the red and blue phosphors are on, the color on the display will be magenta, a secondary color. If all three of the primaries are on, the combination will result in white light (1.91). Complex combinations of these color lighting cells will result in millions of color possibilities.

The brilliant illuminated color of a video display is a seductive **medium** for computer artists. The digital artist Charles Csuri (b. 1922) has been creating imagery on computers since 1963. In Wondrous Spring, the RGB primaries create a dazzling illuminated array of colors reminiscent of a modern-day stained-glass window (1.92). A pioneer in the merging of art with scientific innovations in computer

Red Cyan Magenta Blue **Primaries**

1.90 Color wheel for light using red, green, and blue primaries

1.89 Subtractive color mixtures using CMY primaries, CMYK color separation, and image with exaggerated color print screen

1.88 Color wheel for

commercial printing inks

1.91 Additive color mixtures using RGB primaries

1.92 (above) Charles Csuri, Wondrous Spring, 1992. Computer image, $4' \times 5'5''$

technology, Csuri has explored and helped develop the digital realm as a viable art medium. The organic flow and brilliant color of Wondrous Spring remind us of growth and positive change. Digital works have a glow and rich color that bring new dimensions of color to art and design, and they attract a growing number of artists. This is a medium that will surely continue to prosper.

Color and the Brain

Color affects how we think and feel. Studies by Faber Birren, a color psychologist, have shown that when people are constantly exposed to red light they become loud, grow argumentative, and eat voraciously: red seems to bring out aggression in our behavior. We also make associations between colors and language—calling a coward "yellow," telling "white" lies—that can make our meaning clearer and affect how we feel about those colors.

Advertisers can reach their audience better by knowing how people respond to color. The most visible color is lime yellow because it lies near the middle of the visible spectrum. For this reason some advertisers use lime yellow in designing product packaging, to attract the attention of consumers.

Colors also have traditional symbolic values. Green has positive associations for Muslims; Confucius and Buddha wore yellow or gold; Jews and Christians associate the color blue with God. Our cultural beliefs about color also affect the way we think and feel.

The Psychology of Color

Color affects us physiologically because it alters our psyche. In Western cultures we associate love with red and sadness with blue. Some ancient cultures, like the Egyptians and Chinese, engaged in chromotherapy, or the use of colors for healing.

Artists understand that color affects the way we think and react to the world. Some of these reactions are culturally based: brides wear red in Asia, but white in the West. But there do appear to be some universal psychological associations. As we have seen, red (which we can easily associate with blood) can arouse feelings of anxiety, aggression, passion, eroticism, and anger. Green, a color we associate with growing plant life,

encourages restfulness, but it also suggests decay and illness.

The Dutch painter Vincent van Gogh (1853-90) was enormously affected by color, and studied its psychological effects. Van Gogh was plagued by periods of deep depression and was hospitalized on many occasions; through his treatment he learned a great deal about psychology. The colors in his painting The Night Café are carefully chosen to elicit emotional responses from viewers (1.93). In a letter to his brother Theo, van Gogh writes about the work, "I have tried to express with red and green the terrible passions of human nature." The color intensifies the psychological implications of the scene, in a seedy nightspot in Arles, France, as we wander into this menacing place as an outsider.

1.93 Vincent van Gogh, The Night Café, 1888. Oil on canvas, $28\frac{1}{2} \times 36\frac{1}{4}$ ". Yale University Art Gallery, New Haven, Connecticut

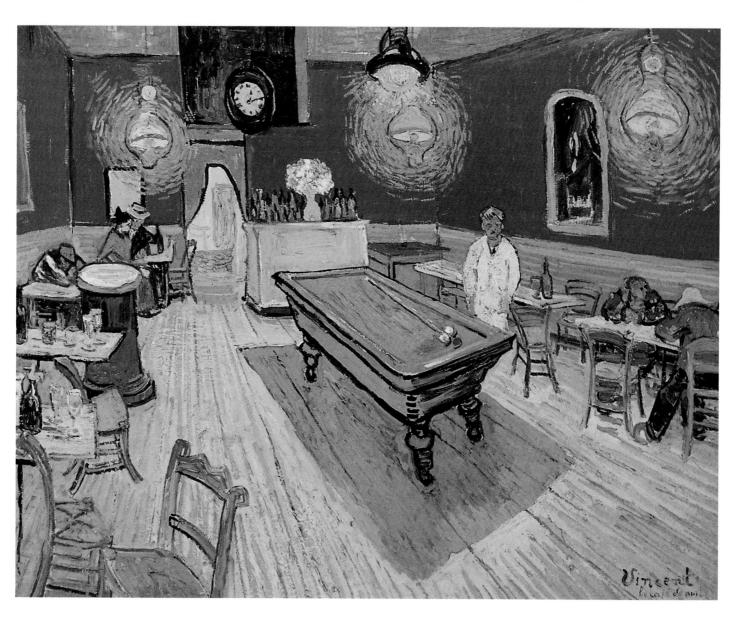

Expressive Aspects of Color

Artists like van Gogh wanted a viewer of a work to "feel" an artwork, rather than merely to understand it. Color in particular can express a wide range of emotions. Artists and designers know that the bright yellow of a happy-face symbol attracts our attention and lifts our spirits. They can use color to engage the viewer, whether it is the use of blue around the image of a political candidate to suggest traditional values, or green as an identifier of environmental awareness.

The French painter Paul Gauguin (1848–1903) used yellow for its uplifting associations when he painted The Yellow Christ (1.94). Gauguin painted this scene—a deliberately populist portrayal of folk spirituality—while in Brittany, France. In it, three women in traditional Breton dress appear to attend the crucifixion. Although Gauguin is known to have been inspired by a woodcarving in a local chapel, his choice of color is primarily symbolic. Through color he connects the crucifixion of Christ to the seasons of Earth and the cycle of life. Here, yellows and browns correspond to the colors of the surrounding autumnal countryside, harvested fields, and turning leaves. Gauguin's color palette relates the background natural world to the body on the cross, so that our gaze too is drawn in and upward. By using bright color, Gauguin creates a simple and direct emotional connection with the viewer. While depicting death, Gauguin chose colors that yet express the optimism of rebirth.

Conclusion

Artists must understand color. The terms hue, value, and saturation are essential. Other attributes of color, such as complementary and analogous color, allow artists to control how colors combine. Some colors seem warm or cool to us: we refer to this as their temperature. Sometimes, our physiological ability to perceive color can be challenged when there is too much color information. Optical color is our mind's response to this kind of sensory overload.

"Artists' color" is the name for the basic theory about color based on the three primary colors

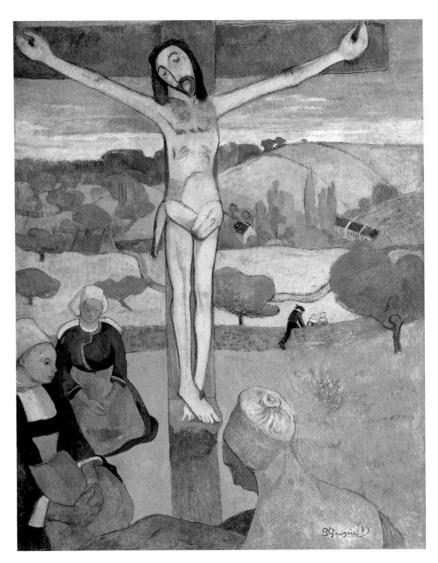

1.94 Paul Gauguin, The Yellow Christ, 1889. Oil on canvas, 361/4 × 277/8". Albright-Knox Art Gallery, Buffalo, New York

(red, yellow, and blue). It was developed to help artists paint. However, modern four-color printing is based on the mixing of four inks: cyan, magenta, yellow, and black: CMYK color. In both artists' color and CMYK color, hues and values are mixed by adding pigments together. Modern video, digital cameras, and liquid crystal diode (LCD) computer monitors operate in yet another color space mixing red, green, and blue light, called RGB color. In RGB color, hues and values are modulated by controlling tiny projectors of red, green, and blue light. Interestingly, when all the hues of RGB color are mixed, white light is the result; whereas when all the pigments of artists' color or CMYK color are mixed, the theoretical result is black.

Artists have used color to express feelings and have been exploring the human response to it—for thousands of years.

1.5

Time and Motion

Moving images are part of our daily experience of life in the twenty-first century. We see them on our TV and computer screens, on displays in stores, and on the street. But if we could travel back in time little more than a century, our visual experience would be quite different: all art images were still.

Time and **motion** are closely linked elements in art. Most of the traditional art media are inherently motionless and timeless. Paintings, for example, are static, holding a moment so that it can be experienced through the ages. But artists who work in static media have found imaginative ways to indicate the passage of time and the appearance of motion. And film and video have gradually overturned the conventions of traditional art, as new technology and media have evolved that allow artists to capture and express time and motion.

Time

Since events necessarily take place over time, any artwork that deals with events must show how time goes by. Stories of gallant deeds and heroic moments—and stories of life's ordinary moments too—unfold over time in chronologies of events. Writers use chapters, episodes, and other tools to give us a sense of how events unfold. Artists also find ways to communicate

1.95 Workshop of the Master of Osservanza (Sano di Pietro?), The Meeting of St. Anthony and St. Paul, c. 1430–35. Tempera on panel, $18\frac{1}{2} \times 13\frac{1}{4}$ ". National Gallery of Art, Washington, D.C.

the passage of time and to remind us of its influence on our lives.

The Passage of Time

Artists often seek to tell a story. When painters in the workshop of the fifteenth-century artist known as the Master of Osservanza illustrated The Meeting of St. Anthony and St. Paul, they solved the problem of how to tell a story in a single painting by merging a series of episodes into one picture (1.95). The story begins in

Motion: the effect of changing placement in time

Medium (plural media): the material on or from which an artist chooses to make a work of art, for example canvas and oil paint, marble, engraving, video, or architecture

the upper left-hand corner, where St. Anthony sets out across the desert to seek the hermit St. Paul. In the upper right, St. Anthony encounters a mythical creature called a centaur: half-man, half-horse, it was associated with the Greek god of wine, Bacchus. This symbol of earthly temptation does not deter St. Anthony. He continues on his lone journey through thick forest until he finally meets and embraces St. Paul: their meeting is the culminating incident in the foreground. The entire painting signifies a pilgrimage on the long and winding road of time, rather than merely a single moment. This linear method is still used by artists, comic-book writers, and designers who want to tell a story or express the passing of time.

The American artist Nancy Holt (b. 1938) examines cycles of time in her works. Many of Holt's sculptures intertwine the passage of time with the motion of the sun. Her Solar Rotary, at the University of South Florida, Tampa, is

designed to express meaning from shadows cast by the sun throughout the year (1.96). The work features an aluminum sculptural "shadow caster" perched on eight poles high above the center of a circular concrete plaza. The shadow caster a circular ring with eight serpentine arms—is oriented so that shadows cast by its central ring encircle notable dates set into the surrounding concrete plaza. The different angles of the sun at different times of the year make shadows at different locations in the sculpture. For example, on March 27 a circle shadow surrounds a marker that recounts the day in 1513 when the Spanish explorer Juan Ponce de León first sighted Florida. In the center, a concrete circular bench, into which a meteorite has been set, is encircled by the shadow at noon on the summer solstice, the longest day of the year (in the northern hemisphere), when the sun reaches its northernmost point. The meteorite symbolizes the connection between our world and the larger universe.

1.96 Nancy Holt, Solar Rotary, 1995. Aluminum, concrete, and meteorite, approx. height 20', approx. diameter 24'. University of South Florida

The Attributes of Time

Time-based arts, such as film, embody six basic attributes of time: duration, tempo, intensity, scope, setting, and chronology. All these attributes exist in one of the first American movies, Fred Ott's Sneeze, made by Thomas Edison and W. K. Dickson in 1894 (1.97). The duration, or length, of this film is 5 seconds. The tempo, or speed, is 16 frames per second. The intensity, or level of energy, is high because the activity is sudden and strong. This film has a limited scope, or range of action, because it is confined to a simple activity. The setting, or context, is Thomas Edison's studio. The chronology, or order of events, can be seen in the still frames as Fred Ott appears to be placing some snuff in his nose, recoiling, then jerking forward as he sneezes.

1.97 Thomas Edison and W. K. Dickson, Fred Oll's Sneeze, 1894. Still frames from kinetoscope film. Library of Congress, Washington, D.C.

By the end of the nineteenth century, many visual artists had created their own techniques that made time part of the language of visual art.

Motion

The aim of every artist is to arrest motion, which is life, by artificial means and hold it fixed so that a hundred years later, when a stranger looks at it, it moves again since it is life.

(William Faulkner, American novelist)

Faulkner tells us that an artist can make even a still image move and come to life. Motion occurs when an object changes location or position. Because this process occurs as time passes, motion is directly linked to time. To communicate motion without actually making anything move, artists can choose to imply time or, alternatively, create the illusion of it.

Implied Motion

When artists imply motion, they give us clues that a static work of art portrays a scene in which motion is occurring or has just occurred. In the case of implied motion, we do not actually see the motion happening, but visual clues tell us that it is a key aspect of the work.

The seventeenth-century Italian sculptor Gianlorenzo Bernini (1598-1680) emphasizes implied motion in many of his marble sculptures. Apollo and Daphne illustrates a story from ancient Greek mythology in which the sun god Apollo falls madly in love with the wood nymph Daphne (1.98). Terrified, she runs from him and begs her father, the river god Peneius, to save her. As Apollo reaches Daphne, Peneius transforms his daughter into a bay laurel tree. To convey the action, Bernini uses diagonal lines in the flowing drapery, limbs, and hair. Daphne's fingers sprout leaves as bark encases her legs. At the pivotal moment in the story, the scene is suddenly frozen in time. Thereafter, since she could not be his wife, Daphne became his tree, and Apollo made the laurel wreath his crown.

Futurism: an artistic and social movement, originating in Italy in 1909, passionately in favor of everything modern

Implied line: a line not actually drawn but suggested by elements in the work

Composition: the overall design or organization of a work

1.99 Giacomo Balla, Dynamism of a Dog on a Leash, 1912. Oil on canvas, $35\% \times$ 431/4". Albright-Knox Art Gallery, Buffalo, New York

The Italian Futurist Giacomo Balla (1871–1958) uses a different method of implying motion in his painting Dynamism of a Dog on a *Leash* (1.99). Balla paints a series of repeating marks to give the impression that we are seeing motion as it happens, as if we are viewing several separate moments at once. He paints the dog's tail in eight or nine different positions to communicate movement. Its feet are merely indicated by a series of strokes that give a sense of very rapid motion. The leash, a white **implied line**, is also repeated in four different positions. The **composition** gives viewers a sense of ongoing forward motion even though the paint on the canvas is perfectly still.

The Illusion of Motion

In the works by Bernini and Balla, the artists imply motion: we do not actually see it occurring, but visual clues tell us that the works, although static, portray motion. Artists can also communicate the idea of motion by creating an illusion of it. Artists create this illusion through visual tricks that deceive our eyes into believing there is motion as time passes, even though no actual motion occurs.

The American artist Jenny Holzer (b. 1950) uses the illusion of motion to enhance her

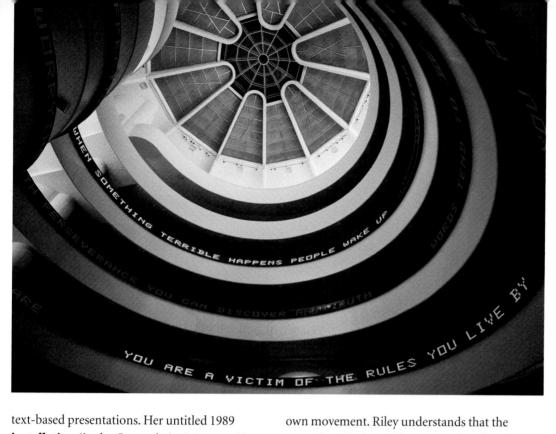

1.100 Jenny Holzer, Untitled (Selections from Truisms, Inflammatory Essays, The Living Series, The Survival Series, Under a Rock, Laments, and Child Text), 1989. Extended helical tricolor LED. electronic display signboard. site-specific dimensions. Solomon R. Guggenheim Museum, New York

text-based presentations. Her untitled 1989 installation (in the Guggenheim Museum, New York, which was designed by Frank Lloyd Wright) displays messages as text (1.100). Although the text does not actually move, it appears to spiral up the ramped circular atrium of the museum as the tiny light-emitting diodes (LEDs) are illuminated and then switched off in an automated sequence. Thus the impression is created that the text is moving as time elapses. The intermittent flashing of lights creates a scrolling series of letters and words, like the flashing lights of the casinos on the Las Vegas Strip. Holzer uses this illusion to invigorate her messages and critiques of society.

Another illusion of motion that deceives the eye forms the basis for **Op art** (short for Optical art). During the 1960s, painters in this style experimented with discordant positive**negative** relationships. There is a noticeable sense of movement when we look at Cataract 3 (1.101), by British artist Bridget Riley (b. 1931). If we focus on a single point in the center of the work, it appears there is an overall vibrating motion. This optical illusion grows out of the natural physiological movement of the human eye; we can see it because the artist uses sharp contrast and hard-edged graphics set close enough that the eye cannot compensate for its

own movement. Riley understands that the natural oscillation of the eye combined with the passage of time makes us feel a sense of motion.

1.101 (below) Bridget Riley, Cataract 3, 1967. PVA on canvas, $7'3^{3}/4'' \times 7'3^{3}/4''$. British Council Collection

1.102 Zoetrope, 19th century. Bill Douglas Centre for the History of Film and Popular Culture, University of Exeter,

Stroboscopic Motion

When we see two or more repeated images in quick succession they tend visually to fuse together. Many early attempts to show moving images were based on this effect, known as stroboscopic motion. One was the zoetrope, in which a series of drawings was placed in a slotted cylinder (1.102). A viewer who looked through the slots as the cylinder was spun could see an image appearing to move and repeat, even though the drawings that made up the series were, of course, static. Inventions like the zoetrope were early forms of animation.

Cartoon animation grew out of these early stroboscopic experiments, and today's computer animation follows the same principle. Disney's Finding Nemo is compiled from individual frames that were computer-generated using 3-D modeling software (1.103). The animator can make changes to the images and then produce all the individual frames in a sequence that the computer plays in rapid succession. This succession of images is combined with other scenes and eventually committed to film—or, increasingly, digital media—for distribution to movie theaters.

"Movie" is an abbreviation of "moving picture," and movies became the dominant mode of artistic expression in motion during the twentieth century. Billy Wilder's Double Indemnity was one of the first films that used sharply contrasting modeling, angled shadows, and lighting effects to give a sense of emptiness.

1.103 Walt Disney Pictures, frame from Finding Nemo, 2003

Op art: a style of art that exploits the physiology of seeing in order to create illusory optical effects

Style: a characteristic way in which an artist or group of artists uses visual language to give a work an identifiable form of visual expression

Positive-negative: the relationship between contrasting opposites

1.104 Still from Double Indemnity, Billy Wilder, 1944

The stark contrasts in lighting influenced an entire genre of movies called film noir (French for "dark film"). In the still shown in 1.104, the two main characters walk through a darkened railway station as they prepare to murder the woman's husband. Notice the crisp long shadows behind them: the shadows create a sense of tension and foreboding by getting us to focus on each of

the couple's deliberate movements. Wilder uses this kind of strong lighting effect throughout the film to enhance the drama of the plot.

Film relies on individual frames played in quick succession. Similar advanced forms of stroboscopic motion have been developed to stream digital video for the Web. Files with a series of multiple images (and sound files) are electronically transferred to a computer where they are played in rapid succession, much like a film movie. Internet users experience this when they view Flash animations posted on YouTube.

Actual Motion

We perceive actual motion when something really changes over time. We see it in performance art and in kinetic art when objects physically move and change in real space and time. Performance art is theatrical; the artist's intention is to create not an art object, but an experience that can exist only in one place and time in history. Kinetic art plays out the passage of time through an art object, usually a sculpture, that moves.

Performance art emerged as a specific form of visual art during the twentieth century when

1.105 Blue Man Group perform at the Venetian Hotel, Las Vegas, Nevada, September 17, 2005

Performance art: a work involving the human body, usually including the artist, in front of an audience Kinetic art: a work that contains moving parts **Space:** the distance between identifiable points or planes

such artists as the German Joseph Beuys (1921-86) began performing his works, which he called Actions. Following his traumatic experiences in the German Air Force in World War II, Beuys incorporated everyday objects—such as animals, fat, machinery, and sticks—into his Actions, a series of self-performed situations in which the artist would interact with these things in a defined space and time. By putting common items in new situations Beuys conjured up different ways of thinking about our world so that we might question past practices.

Performance artists need not focus on a social or political issue. For example, from the 1980s the Blue Man Group performed in ways that integrated humor and music for passersby on the streets of New York (1.105). They used sound and mime, relying on bodily movements to communicate ideas without speech.

Kinetic sculpture has evolved during the twentieth century and is a notable example of art that moves. The earliest kinetic artwork is credited to French artist Marcel Duchamp (1887-1968), who mounted a bicycle wheel on a barstool so that the wheel could be spun. Later, the American sculptor Alexander Calder (1898–1976) invented the **mobile**, taking the name from a suggestion by Duchamp. The mobile relies on air currents to power its movement. Calder's kinetic sculptures were so finely balanced that even the smallest breeze would set them in motion. His final sculpture is the huge aluminum-and-steel mobile suspended in the National Gallery of Art in Washington, D.C. (1.106). It resembles its predecessors in being made up of counterbalanced abstract elements that move independently of each other. The result is a constantly changing visual **form**.

1.106 Alexander Calder, Untitled, 1976. Aluminum and steel, $29'10^3/8'' \times 75'11^3/4''$. National Gallery of Art. Washington, D.C.

Mime: a silent performance work; actors use only body movements and facial expressions Kinetic sculpture: threedimensional art that moves, impelled by air currents, motors, or people Mobile: suspended moving sculptures, usually impelled by natural air currents Abstract: art imagery that departs from recognizable images from the natural world Form: an object that can be defined in three dimensions (height, width, and depth)

Gateway to Art: Lange, Migrant Mother Time and Motion in Photography

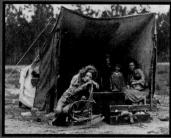

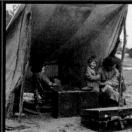

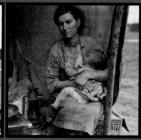

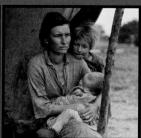

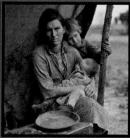

Although photography is a still medium, the work of a photographer is deeply concerned with motion and time. Photographers move around their subject, choosing the right focus for the shot and putting the camera in the best position to capture the image they seek. We can get a sense of how a still photographer captures a moment in time in the sequence of photographs Dorothea Lange took of Florence Thompson and her children (1.107a-f). In the span of a few minutes, Lange went from showing the family in the environment in which they lived—a tent—to an intimate portrayal of an individual. The first frame Lange shot includes the barren landscape of the farm and the lean-to in which the family lived. In the second shot, Lange has moved her camera closer to the tent, but the image does not give us much information about the people. In the third through the sixth shots, Lange zooms in on the woman and the children around her.

Still photographers must make decisions about the images they create. If we look at this series, the process of selection becomes clear. Lange chose specific moments to capture, and from those moments she further selected the one she felt most effectively communicated what she thought was most true (1.107f). Lange's careful composition of her image of the family did not end with shooting her photographs. Further changes were made to the negative in the dark room. Lange's original shot included the mother's hand holding onto the tent pole; Lange retouched the negative to crop out the hand. Because this photograph was meant to be an objective portrayal, the change was kept secret at the time, and has since been considered controversial.

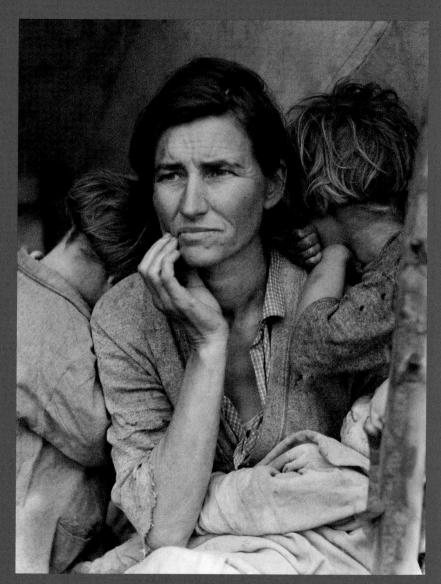

1.107a-e (top of page) Dorothea Lange, Destitute Pea Pickers in California. Mother of Seven Children. Age Thirty-two. Nipomo, California, 1936. Images a, c-e: Library of Congress, Washington, D.C. Image b: Oakland Museum of California

1.107f (above) Dorothea Lange, Migrant Mother, 1936. Library of Congress, Washington, D.C.

Natural Processes and the Passage of Time

Motion is not the only indicator of the passage of time in art. Some artists use biology and organic materials to create their artwork. Organic materials grow and degrade with the passage of time, so work by "bioartists" is always changing. Adam Zaretsky (b. 1968) has "grown" and performed works, such as Workhorse Zoo, that include living things. In this performance piece, he and Julia Reodica (b. 1970) lived for a week in an 8 × 8 ft "clean" room with an assortment of organisms: bacteria, yeast, plants, worms, flies, frogs, fish, and mice (1.108). During the week all the organisms were either growing or deteriorating. The artists' intention was to draw attention to the pros and cons of animal research.

Natural processes also dominate the work of American sculptor Ron Lambert (b. 1975), for

1.109 Ron Lambert, Sublimate (Cloud Cover), 2004. Water, vinyl, humidifiers, steel, aluminum, and acrylic, dimensions variable

whom the water cycle illustrates the passage of time. For Sublimate (Cloud Cover) he created a large transparent plastic environment in which water endlessly evaporates and condenses (1.109). Lambert draws attention to our immediate environment as he shows how the rhythms of nature become a measure of natural time that we gauge by how long we have to wait

1.108 Adam Zaretsky and Julia Reodica, Workhorse Zoo, 2002. Performance at the Salina Art Center, Salina, Kansas

Conclusion

for the next rain.

Movement and change are the essence of life and time. The traditional visual arts, although inherently static, have always been inventive and creative in finding ways to try to reflect, distill, and mimic the ceaseless flux of a world in motion. By means of illusion (Op art) or imitation (performance, kinetic, or "bioart"), in the last hundred years or so artists have been able to incorporate the passage of time and movement into their works using a variety of modern media. With the technological advances of the twentieth century, artists acquired new tools to capture time and create works that represent time and motion. Through film and video, we can appreciate the motion of life and have come to experience time in new ways. Television, movies, the Internet, and a multitude of other technologies use movement as an important visual element.

1.6

Unity, Variety, and Balance

Unity: the imposition of order and harmony on a design

Elements: the basic vocabulary of art—line, form, shape, volume, mass, color, texture, space, time and motion, and value (lightness/darkness)

Composition: the overall design or organization of a work

Variety: the diversity of different ideas, media, and

elements in a work

Medium (plural media): the
material on or from which an
artist chooses to make a work of
art, for example canvas and oil
paint, marble, engraving, video,
or architecture

Grid: a network of horizontal and vertical lines; in an artwork's composition, the lines are implied

Gestalt: complete order and indivisible unity of all aspects of an artwork's design

Principles: the "grammar" applied to the elements of art—contrast, balance, unity, variety, rhythm, emphasis, pattern, scale, proportion, and focal point

Unity—creating order or wholeness, the opposite of disorder—is central in the creation of a work of art or design. Unity refers to the imposition of order and harmony on a design. It is the sense of visual harmony that separates the work of art from the relative chaos of the surrounding world. Unity refers to the "oneness" or organization of similarities between **elements** that make up a work of art. Artists use the principle of unity to make choices that link visual elements to each other in a **composition**.

By comparison, **variety** is a kind of visual diversity that brings many different ideas, **media**, and elements together in one composition. Sometimes artists will use the discordance of variety to create uneasy relationships between visual elements. Sometimes this lack of similarity between elements can actively create a sense of unity when an artist imposes on the work a **grid** or other visual structure.

Balance refers to the distribution of elements, whether unified or varied, within a work. The number and distribution of different elements influence the composition. Balance in visual art is much like the balance we experience in real life. If we carry a large heavy bucket in one hand it pulls us to one side and we orient our body to

offset its weight. In art, the visual elements in one half of a work are offset by the elements on the opposite side. By making sure that the elements are distributed in an organized way, artists create balance.

Unity

Unity provides an artwork with its cohesiveness and helps communicate its visual idea. Artists face a communication challenge: to find a structure within the chaos of nature and to select and organize materials into a harmonious composition. An artist will identify specific elements in a scene and use them to create unity (see Gateway Box: Hokusai). Artists are concerned with three kinds of unity: compositional, conceptual, and **gestalt**.

Compositional Unity

An artist creates compositional unity by organizing all the visual aspects of a work. This kind of harmony is not easy to achieve. Too much similarity of shape, color, line, or any single element or **principle** of art can be monotonous and make us lose interest. Too much variety can lead to a lack of structure and the absence of a central idea. Experienced artists learn to restrict the range of elements: working within limitations can be liberating. The three similar diagrams in **1.110** illustrate the idea of compositional unity. Although A is unified, it lacks the visual interest of B. While C is a unified work, its visual variety feels incoherent and chaotic.

1.110 Three diagrams of compositional unity

Gateway to Art: Hokusai, "The Great Wave off Shore at Kanagawa" A Masterpiece of Unity and Harmony

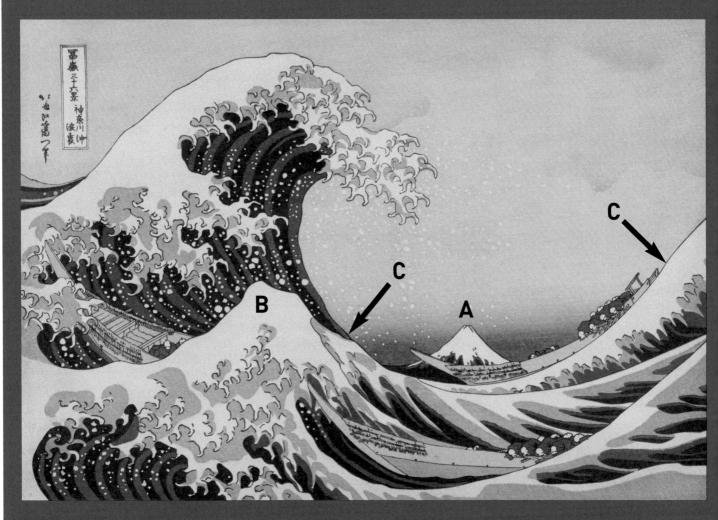

1.111 Katsushika Hokusai. "The Great Wave off Shore at Kanagawa," from Thirty-Six Views of Mount Fuji, 1826-33 (printed later). Print, color woodcut. Library of Congress, Washington, D.C.

In his print "The Great Wave off Shore at Kanagawa," Japanese artist Katsushika Hokusai created a unified composition by organizing repetitions of shapes, colors, textures, and patterns to create a visual harmony even though the scene is chaotic (1.111). These repetitions visually link different parts of the picture. Even Mount Fuji (A), in the middle of the bottom third of the work, almost blends into the ocean: because whitecaps on the waves (B) mimic the snow atop Mount Fuji, the mountain's presence is felt and reiterated throughout the composition. The shape and placement of the boats also creates a pattern among the waves. Because the great wave on the left is not repeated, it has a singular strength

that dominates the scene. Hokusai has also carefully selected the solids and voids in his composition to create opposing but balancing areas of interest. As the solid shape of the great wave curves around the deep trough below it (C), the two areas compete for attention, neither one possible without the other.

The words unity and harmony suggest peaceful positive coexistence in a chaotic world. A skillful artist can depict unity and harmony even in a work that portrays a scene that in reality would be chaotic and threatening. Here, Hokusai has organized a group of visual elements into a structure that makes sense because it has been simplified and ordered.

1.112 (right) Interior design, I. Michael Interior Design, Bethesda, Maryland

1.113 (far right) Linear evaluation of elements in interior design by I. Michael

The interior designed by I. Michael Winegrad (1.112) closely reflects the design in 1.113. The interior has a balance of curved and straight lines that complement each other. The linear patterns of curved lines repeat (red), as do the other directional lines. Shapes are distributed throughout the scene (green). The composition appears harmonious without being boring.

In the work of Russian artist Marie Marevna (1892–1984), the unifying features are the angular lines and flat areas of color or pattern (1.114). Marevna was one of the first female members of the Cubist movement; here her Cubist style breaks apart a scene and re-creates it from a variety of different angles. In this image she shows us the seltzer bottle

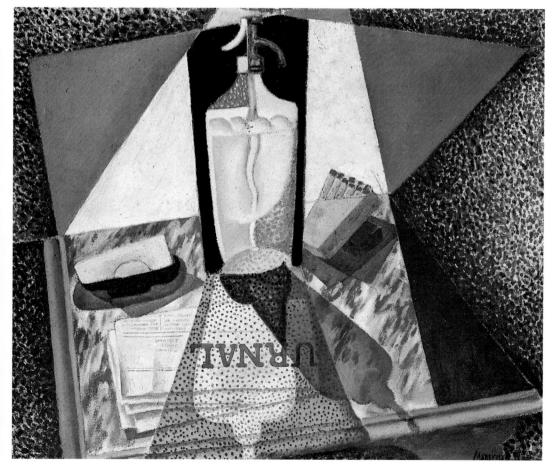

1.114 Marie Marevna (Marie Vorobieff-Stebelska), Nature morte à la bouteille, 1917. Oil on canvas with plaster, $19^{3}/4 \times 24"$

Cubism: a twentieth-century art movement that favored a new perspective emphasizing geometric forms **Style:** a characteristic way in which an artist or group of artists uses visual language to give a work an identifiable form of visual expression

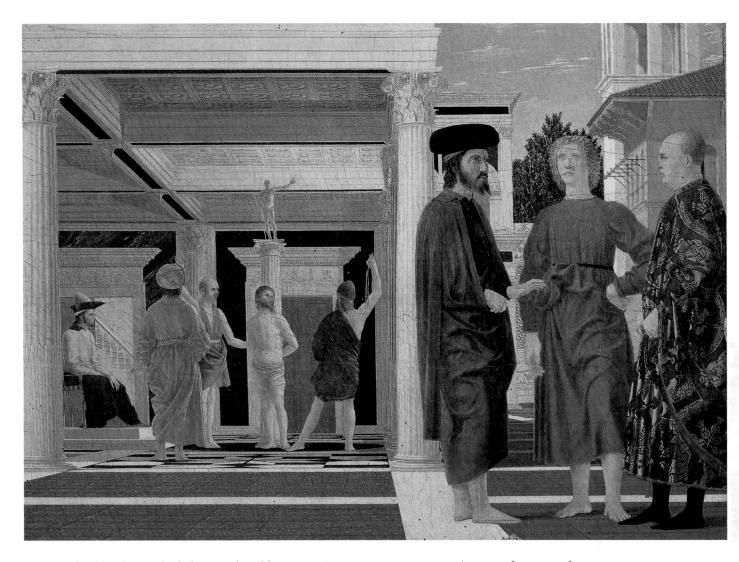

from the side while we look down at the tabletop from above. The entire work becomes unified. however, because the artist paints a variety of different viewing angles using flat areas of color and pattern throughout, rather than relying on a more realistic representation. Even though we view the still life from many different angles, the artist was able to unify the composition by using similar elements. The texture of the paint, the hard diagonal angular lines, and the dominant gray-brown color all work together to counteract the potentially excessive variety that could have come from the many points of view presented.

The great masters of the **Renaissance** understood the importance of unity in their works. They also appreciated the value of putting limits on the number of different elements they introduced into a design, as Piero della Francesca (c. 1415–92) does in *The Flagellation* (1.115).

He concentrates on two major areas, **foreground** and background, where stand two different groups of figures. The organic human shapes in the foreground are balanced against the geometric lines of the background. The two groups complement each other and create an order that is reinforced by the strong horizontal and vertical lines throughout the work. This scene depicts Christ, before his crucifixion, being flogged by his captors. The figures in the foreground—whose identities are not known seem oblivious to what is going on behind them. Rather than communicating a feeling of tension and violence, the composition is quiet and logical, emphasizing the mood of detachment and contemplation.

Some artists create compositional unity while gathering together bits and pieces of visual information. The African-American artist Romare Bearden (1911–88) captures the unity

1.115 Piero della Francesca, The Flagellation, c. 1469. Oil and tempera on panel, 23 x 32". Galleria Nazionale delle Marche, Urbino, Italy

Still life: a scene of inanimate objects, such as fruits, flowers, or motionless animals Renaissance: a period of cultural and artistic change in Europe from the fourteenth to the seventeenth century Foreground: the part of a work depicted as nearest to the viewer **Background:** the part of a work depicted furthest from the viewer's space, often behind the main subject matter

1.116 Romare Bearden, The Dove, 1964. Cut-and-pasted printed papers, gouache, pencil, and colored pencil on board, $13\% \times 18\%$ ". MOMA, New York

of New York in the bits that make up his **collage** *The Dove* (1.116). In this work we see snippets of faces and hands, city textures of brick walls and fire escapes, and other associated images assembled into a scene that, at first glance, seems frenetic and chaotic. We may feel this pace of life when we visit a big city, but if we look beyond our first impressions we often notice the orderly grid of streets and the organization that underpins city life. Bearden reflects this order with an underlying grid of verticals and horizontals in the street below and in the vertical streetposts and buildings in the upper section of the work. The hectic composition is subtly coordinated by an implied triangular shape that runs from the cat in the lower left and the woman's feet in the lower right to the dove (hence the title) at the top center. These three points create a sense of depth while stabilizing the lively image of a hectic street scene.

Conceptual Unity

Conceptual unity refers to the cohesive expression of ideas within a work of art. Ideas can come to us in haphazard and unpredictable ways. Sometimes the expression of these ideas may not look organized, but an artist can still communicate them effectively by selecting images that conjure up a single notion. For example, an artist wishing to communicate the feeling of flight can use such symbols as feathers, kites, or balloons. Each of these has different visual attributes, but they all have an idea in common. That common idea is emphasized when they are placed together in the same work. The artist links images that, although different perhaps even drastically different—in their appearance, have an idea, symbol, aspect, or association in common. Sometimes, on the other hand, an artist may deliberately break or contradict linkages between ideas to freshen up our tendency to find conventional—even boring—connections between them.

Artists bring their own intentions, experiences, and reactions to their work. These ideas—conscious and unconscious—can also contribute to the conceptual unity of a work and are understood through the artist's style, attitude, and intent. In addition, the conceptual links that artists make between symbols and ideas derive from the collective experiences of

Collage: a work of art assembled by gluing materials, often paper, onto a surface. From the French coller, to glue

their culture: this too influences both the means that artists use to create unity and the viewer's interpretation of the work.

American Surrealist sculptor Joseph Cornell (1903-72) created boxes that contain compositions of **found objects**. His works seem to suggest mysterious ideas and elusive feelings. The disparate shapes, colors, and other characteristics of everyday things come together to form distinctive images. Cornell's works are like a complex game with the viewer, a game that reveals and conceals—just as in a dream or psychoanalysis—the artist's personality. In Untitled (The Hotel Eden), Cornell has collected objects from life and sealed them in a box (1.117). Although the interior of the box is a protected place, the bird is caged and unable to get out. A yellow ball sits trapped on two rails that limit its freedom of movement to roll back

and forth. Neither the bird nor the ball is free. Placed together, all the different objects in the box make an idea greater than any one of them could create on its own. The artist has fused (and deliberately confused) his memories, dreams, and visualizations; the resulting artwork is a rich and complex visual expression of Cornell's personality and methods.

Gestalt Unity

Gestalt, a German word for form or shape, refers to something (here a work of art) in which the whole seems greater than the sum of its parts. The composition and ideas that go to make a work of art—as well as our experience of it—combine to create a gestalt. We get a sense of gestalt when we comprehend how compositional unity and conceptual unity work together.

1.117 Joseph Cornell, Untitled (The Hotel Eden), 1945. Assemblage with music box, $15^{1}/_{8} \times 15^{1}/_{8} \times 4^{3}/_{4}$ ". National Gallery of Canada, Ottawa

Surrealist: an artist belonging to the Surrealist movement in the 1920s and later, whose art was inspired by dreams and the subconscious

Found object: an object found by an artist and presented, with little or no alteration, as part of a work or as a finished work of art in itself

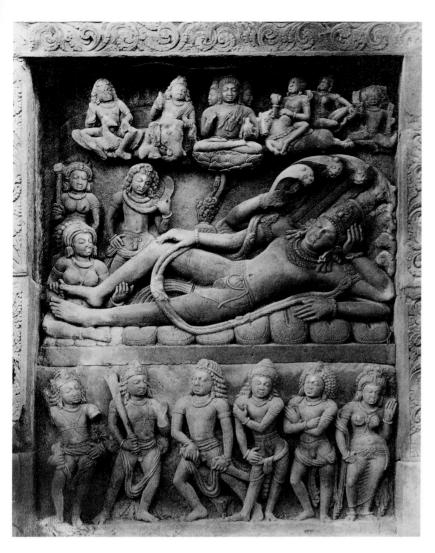

1.118 Vishnu Dreaming the Universe, c. 450-500 cE. Relief panel. Temple of Vishnu. Deogarh, Uttar Pradesh, India

We can discover the many faces of gestalt by examining the ancient Hindu relief Vishnu *Dreaming the Universe* (1.118). In this stone carving, an abundance of human figures surrounds a much larger reclining figure; this is Vishnu dreaming. The repetition of the human shapes that attend Vishnu creates compositional unity: these similar shapes link to each other visually.

According to some texts written in the ancient Indian language known as Sanskrit, the existence of the universe, and its creation, are directly dependent on the god Vishnu, who is sheltered by the great serpent Ananta and sleeps on the Cosmic Sea. Through his sleep, the universe is reborn over and over into eternity. Hindu pantheism (the unity of many gods as one) is elegantly illustrated in this work. Brahma is the upper figure seated on a lotus that has sprouted from Vishnu's navel. Here he becomes the active agent of creation. The god Shiva, riding a bull

(Nandi), is at Brahma's left. Lakshmi, Vishnu's wife, attends her sleeping husband. Their unity of male and female creates a partnership that results in the birth of a new universe and many other universes into eternity. The dualities of male/female, life/death, good/evil are illustrated in the complex stories of the gods. Shiva, for example, is both creator and destroyer, destruction being necessary for creation—yet another unifying duality.

As is often the case, a religious idea provides profound conceptual unity. The image, the religious idea that the image illustrates, and the fervent belief of the artist who created the work interconnect through a symbolic representation in carved stone. As we come to appreciate how these aspects combine so completely in an artwork, we experience a sense of gestalt, an awakened understanding of the whole. This is a goal in any artwork.

Variety

If "variety is the spice of life," it is also the spice of the visual world. In art, variety is a collection of ideas, elements, or materials that are fused together into one design. Inasmuch as unity is about repetition and similarity, variety is about uniqueness and diversity. Artists use a multiplicity of values, textures, colors, and so on to intensify the impact of a work. It is unusual to see a good composition that has just one type of **value**, shape, or color. Variety can invigorate a design. The example in 1.119 shows a composition of shapes set into a rectangle on a grid. Even though

1.119 Variety of shapes and values set into a grid

Value: the lightness or darkness of a plane or area

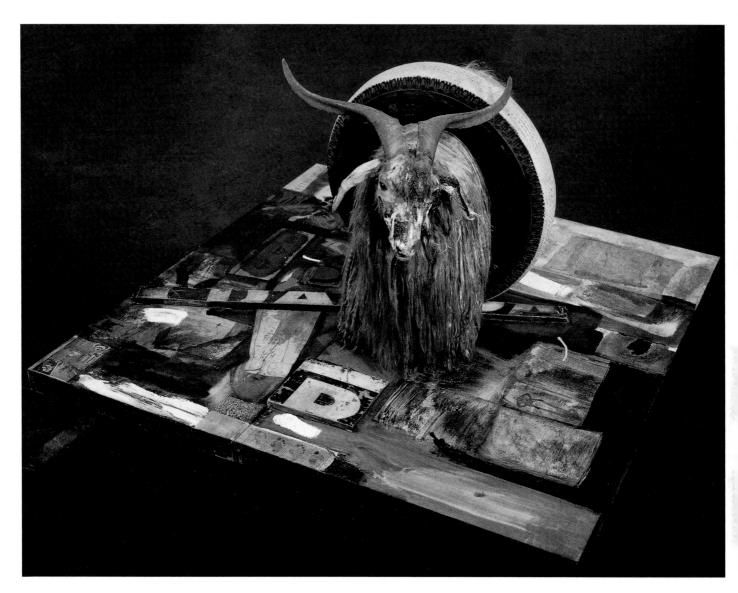

1.120 Robert Rauschenberg, Monogram, 1955-9. Mixed media with taxidermy goat, rubber tire, and tennis ball, $42 \times 63^{1/4} \times 64^{1/2}$ ". Moderna Museet, Stockholm, Sweden

the grid structure is predictable, the variety of shapes and values counteracts the rigid structure. Many artists use this kind of variety to express an energy that would be lost if there were too much unity. Variety is the artist's way of giving a work of art a jolt.

The American Robert Rauschenberg (1925– 2008) used variety to energize his artwork and challenge his viewers. In the work Monogram, Rauschenberg has used all kinds of different things to form his composition (1.120). The work features a stuffed goat with a tire around its middle standing on a painting. By combining these objects, Rauschenberg creates an outlandish symbol of himself as a rebel and outcast. The goat, an ancient symbol of male lust and a Christian symbol of souls cast out from salvation, becomes the totem of Rauschenberg's own provocative

behaviors and his violation of art-world conventions. The stuffed goat penetrates the tire and stands atop a symbol of the established art world (painting) while defecating a dirty tennis ball on it. For the first time in modern art, too, Rauschenberg breached the divide between painting and sculpture and took painting "off the wall." By using a variety of non-traditional art materials and techniques, the work becomes a transgression against traditional art and morals.

Using Variety to Unify

Although it might seem contradictory, variety can be unifying. Even while using a variety of different shapes, colors, values, or other elements, an artist can create visual harmony. This can be

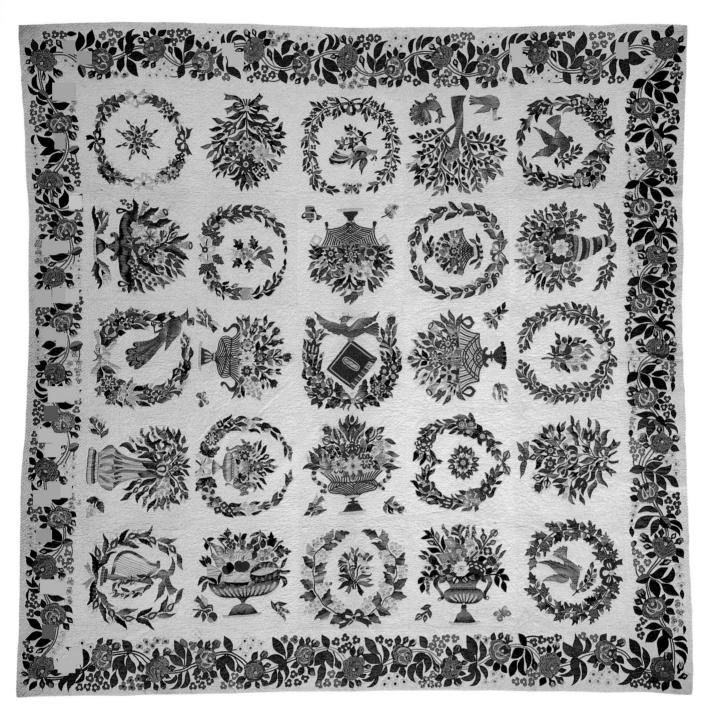

1.121 Album quilt, probably by Mary Evans, Baltimore, Maryland, 1848. Appliquéd cottons with ink work, 9 x 9'. Private collection

seen in Baltimore album quilts, created by Maryland artists in the nineteenth century (1.121). These carefully sewn quilts are named after the scrapbooks kept by Baltimore girls. Rather than being constructed from scraps of leftover material, as many quilts are, these fiber works were made from new pieces of fabric, a reflection of the wealth of this port city. Like a scrapbook, these quilts use a variety of images and fuse them together into a finished work. Because a strong structure is imposed on the many different shapes through the use of a grid,

the work holds together as a unified whole. The quilted surface is an arrangement of shapes that form a unified composition.

Balance

Just as real objects have physical weight, parts of a work of art can have visual weight, or impact; these need to be balanced to achieve a sort of visual equilibrium. We can identify visual balance in a form or composition, the same as we can

with weighted objects, by noting differences between the two halves we are looking at. If the amount of visual weight does not have a reasonable counterweight on the opposite side, the work may appear to be unsuccessful or unfinished. If there are reasonable visual counterweights the work seems complete, and balance has been achieved. Even placing a visual weight in the center of a composition can impose a strong balance on a design.

Finding visual weight and counterweight is a challenge for the artist; balance in a work is not always easy to define. But there are some situations that often arise. For example, dark and light, although opposites, can act as counterbalances. Large shapes or forms can be countered by groups of smaller shapes or forms. For many artists this process is intuitive; they make decisions about the work based on what looks right, rather than on a rigid set of rules.

Symmetrical Balance

If a work can be cut in half and each side looks exactly (or nearly exactly) the same, then it is symmetrically balanced. Near-perfect symmetry exists in the human body. For example, each side of our face has half a nose, half a mouth, half a chin, and so on. The same is true for most animals and a number of geometric shapes, such as circles and squares. Because it is a part of our physical body, symmetry can seem very natural and we can make natural connections to it.

Artists of ancient China designed a creature born of symmetry called the t'ao t'ieh. The image of the creature in an artwork is not immediately apparent, because its form is "hidden" amongst many separate symmetrical shapes and forms. It is as if a symmetrical collection of elements coalesce to reveal a monster mask. The image of the t'ao t'ieh has been used widely in Chinese art since the Shang Dynasty (1766–1122 BCE), when it appeared on ceremonial bronze objects. The meaning of this **motif** is mysterious, but it may symbolize communication with the gods. According to some accounts, the t'ao t'ieh mask represents a monster that, through its own gluttony, is devouring itself: a warning against overindulgence.

1.122 Ritual container from Gui, China, Shang Dynasty, 1600-1100 BCE. Bronze, $6^{1}/4 \times 10^{3}/4$ ". University of Hong Kong Museum

The t'ao t'ieh can be found on the bronze ritual container in **1.122** by identifying a pair of perfectly round "eyes" on either side of the central vertical ridge. On each side of this central ridge are patterns that mirror each other. Some of these signify horns, claws, fangs, ears, and even smaller images of animals. If you look carefully you may see two rhinoceros heads jutting out at the top of the left and right handles. The "monster" of symmetry lurks amongst the many parts of the image and waits for us to discover its hiding place.

Asymmetrical Balance

On an old-fashioned scale, the kind with a long arm centered on top of a vertical support, a single heavy object on one side can be balanced by several lighter objects on the other side as long as the weight on both sides is the same. Similarly, when artists organize a composition they often use different visual "weights" on each side of the composition. This is asymmetrical balance, also called dynamic balance; it applies when the elements on the left and right sides are not the same, but the combination of elements counters each other.

Chinese artists have used asymmetrical balance to reflect on life and spirituality. The thirteenth-century Zen Buddhist monk

Motif: a design or color repeated as a unit in a pattern

1.123 Muqi, *Six Persimmons*, Southern Song Dynasty, *c*. 1250. Ink on paper, 14¹/₄ × 15". Ryoko-in, Dailoxu-ji, Kyoto, Japan

Muqi expresses balanced asymmetry in his work Six Persimmons (1.123). In this work, dark, light, and the subtle differences in shape are not distributed evenly between the left and right sides of the work. Muqi creates subtle variations in the placement of the persimmons on each side of the central axis. On the right are two large dark shapes with a heavy visual weight, one of which partially overlaps a light shape. On the left there is one light shape and two dark shapes, one of which is placed lower in the picture. Muqi brilliantly counteracts the visual "heaviness" of the right side by placing one shape lower on the left. The lower placement of the smallest persimmon in the picture adds visual weight to the left side and counters the visual weight of the largest fruit just above it. For Muqi, the use of brush and ink was a form of meditation, through simple, thoughtful actions, in search of higher knowledge. Although this work may look simple, the thoughtful arrangement of the shapes cannot be changed without undermining the "perfect" asymmetry.

Axis: an imaginary line showing the center of a shape, volume, or composition

Facade: any side of a building, usually the front or entrance Mandala: a sacred diagram of the universe, often involving a square and a circle

Radial Balance

Radial balance (or symmetry) is achieved when all elements in a work are equidistant from a central point and repeat in a symmetrical way from side to side and top to bottom. Radial symmetry can imply circular and repeating elements. Artists can employ this kind of balance when it is necessary to depict an element more than twice. It is sometimes used in religious symbols and architecture where repetition plays an important role in the design.

Although the term "radial" symmetry suggests a round shape, in fact any geometric shape can be used to create radial symmetry. Italian architect Andrea Palladio (1508–80) decided to use the same elements on four sides of the Villa Capra (also called the Villa Rotonda) to achieve a perfect radial balance and allow the owner of this villa to take advantage of four views (1.124). Palladio referred to this symmetry in this way:

The place is nicely situated and one of the loveliest and most charming that one could hope to find; for it lies on the slopes of a hill, which is very easy to reach.

The loveliest hills are arranged around it, which afford a view into an immense theatre...; because one takes pleasure in the beautiful view on all four sides, loggias were built on all four facades.

Palladio wants people who live in this building to be able to experience four views of the surrounding countryside from a single vantage point. If we were to open all four sets of doors we could look in four separate directions as we turned on the villa's center point. Palladio's plan repeats the loggias, or porch-like entrances, on all four **facades**; they are all equidistant from the center of the building.

The Tibetan sand painting in **1.125** is a diagram of the universe (also known as a **mandala**) from a human perspective. The Tibetan Buddhist monks who created this work have placed a series of symbols equidistant from the center. In this mandala the colors vary

1.124 Andrea Palladio, Plan and part elevation/section of the Villa Rotonda, Vicenza, Italy, begun 1565/6. From the Quattro Libri, Book II

1.125 (below) Amitayas mandala created by the monks of Drepung Loseling Monastery, Tibet

but the shapes pointing in four different directions from the center are symmetrical. The creation of one of these sand paintings is an act of meditation that takes many days, after which the work is destroyed.

Conclusion

Unity, variety, and balance are central principles that artists use to create visual impact. Unity gives a work a certain oneness or cohesion. So powerful is the force of cohesive oneness that even a fragment of a work—for example, a broken piece of a ceramic pot—may have aesthetic unity. An artist may unify a work in one or more of three ways: through the arrangement of its elements, such as shape, line, and color; through its subject matter or the ideas it describes; and by drawing us in so that we become intensely aware of what the artist intends to communicate—a perception of wholeness sometimes known as gestalt.

The other two fundamental principles that affect the visual impact of a work are variety and balance. Variety is expressed in contrast and difference, which create visual interest and excitement; artists may use extreme variety quite deliberately to give an artwork a sense of chaos and lack of control. Variety can be created by the use of different kinds of lines, shapes, patterns, colors, or textures, or even by intentionally distinguishing many separate brushstrokes or chisel marks.

Balance is imposed on a work when the artist achieves an appropriate combination of unity and variety. We appreciate balance by "weighing up" the organization of the visual elements in our minds, as we consider and examine an artwork; our comprehension of balance is primarily intuitive, and our intuitions are based on an instinctive ability to discern symmetries and patterns in the world around us. This innate awareness of symmetry is reflected in the abundance of symmetrical artworks, but artists also exploit it when they create artworks that rely for their effect on the disturbing feelings caused by asymmetry.

1.7

Scale and Proportion

The nineteenth-century French poet Charles Baudelaire wrote that "All which is beautiful and noble is the result of reason and calculation." Baudelaire was speaking of cosmetics and makeup, and not referring specifically to works of art, but his statement neatly summarizes the care with which artists determine scale and **proportion**. Artists use these key **principles** of design to control how they implement the basic **elements** of art, just as grammar controls how words work in a sentence.

We perceive scale in relation to our own size. Art objects created on a **monumental** scale appear larger than they would be in normal life. This monumentality imposes itself on us. In a work created on a human scale, its size corresponds to the size of things as they actually exist. Work at this scale often surprises us. Small-scale objects appear smaller than our usual experience of them in the real world. Often scale is used to indicate importance. Even so, scale does not always indicate significance; sometimes the smallest thing is the most significant.

Proportion is a core principle in the **unity** of any art object. Usually, an artist ensures that all the parts of an object are in proportion to one another. Alternatively, an artist can create a contradiction by portraying objects or figures out of proportion. For example, a cartoonist may portray a figure with disproportionately large nose or ears to exaggerate the prominent facial features distinctive to a famous personality. Careful proportion is a sign of technical mastery; discordant proportions can express a wide range of meanings.

Scale

The scale of a work of art communicates ideas. A small work of art communicates something very different than a larger work. Small-scale pieces force viewers to come in close to experience the artwork. A small-scale work implies intimacy, like whispering in someone's ear or admiring a ring on their finger. Large-scale works can be experienced by groups of viewers and usually communicate big ideas directed at a large audience. Artists and designers make conscious choices about the scale of a work when they consider the message they want to put across.

Artists may also consider scale as they make more practical choices about a work. Considerations of cost, the time it will take to execute the piece, and the demands that a specific location may place on the work: all come into play in decisions about scale.

Scale and Meaning

Usually a monumental scale indicates heroism or other epic virtues. War monuments, for example, often feature figures much larger than life-size in order to convey the bravery of the warriors. However, the Swedish-born artist Claes Oldenburg (b. 1929) uses monumental scale to poke fun while expressing admiration for the little things of everyday life. Oldenburg believes that the items of mass culture, no matter how insignificant they might seem, express a truth about modern life. So he restyles small, often

Scale: the size of an object or artwork relative to another object or artwork, or to a system of measurement

Proportion: the relationship in size between a work's individual parts and the whole

Principles: the "grammar"

applied to the elements of artcontrast, balance, unity, variety, rhythm, emphasis, pattern, scale, proportion, and focal point **Elements:** the basic vocabulary of art-line, form, shape, volume, mass, color, texture, space, time and motion, and value (lightness/darkness) Monumental: having massive

or impressive scale

Unity: the imposition of order and harmony on a design

1.126 Claes Oldenburg and Coosje van Bruggen, Mistos (Match Cover), 1992. Steel, aluminum, and fiberreinforced plastic, painted with polyurethane enamel, $68' \times 33' \times 43'4"$. Collection La Vall d'Hebron, Barcelona, Spain

overlooked objects on a monumental scale, giving clothes-pins and ice-cream cones a grandeur and significance they do not usually have. In the process, Oldenburg transforms the essence of these everyday things as he magnifies their sculptural form. Look at, for example, the enormous book of matches in 1.126, a collaboration between Oldenburg and his wife, the Dutch-born sculptor Coosje van Bruggen (1942–2009).

The American Robert Lostutter (b. 1939) uses small scale to enhance the character of his work. Lostutter likes to create his works on the scale not of a human but of a bird. He paints the plumage

of exotic birds in great detail onto human faces, while the tiny size evokes the bird from which the plumage was copied (1.127). The small scale of Lostutter's work—only one person at a time can see it properly—forces us to come closer; looking at it becomes an intimate experience.

1.127 Robert Lostutter, The Hummingbirds, 1981. Watercolor on paper, $1\frac{3}{4} \times 5\frac{5}{8}$ ". Collection of Anne and Warren Weisberg

Relief: a raised form on a largely flat background. For example, the design on a coin is "in relief" Gothic: western European architectural style of the twelfth to sixteenth centuries, characterized by the use of pointed arches and ornate decoration

1.128 Hierarchical scale: Relief from the northern wall of the hypostyle hall at the great temple of Amun, 19th Dynasty, c. 1295-1186 BCE. Karnak, Egypt

Hierarchical Scale

Artists can use size to indicate the relative importance of figures or objects in a composition: almost always, larger means more important, and smaller means less important. Hierarchical scale refers to the deliberate use of relative size in a work in order to communicate differences in importance. 1.128 shows the use of hierarchical scale in a relief sculpture from ancient Egypt. In the art of ancient Egypt, the king, or pharaoh, was usually the largest figure depicted because he had the highest status in the social order. Here, the largest symbol (A) represents the pharaoh; the figure is visually

1.129 Jan van Eyck, Madonna in a Church, 1437-8. Oil on wood panel, $12^{5}\% \times 5^{1}\%$. Gemäldegalerie, Staatliche Museen, Berlin, Germany

more dominant than the others. This scene depicts the military campaign of Seti I against the Hittites and Libyans.

The Flemish artist Jan van Eyck (c. 1395–1441) uses hierarchical scale to communicate spiritual importance. In his painting Madonna in a Church, van Eyck enlarges the scale so that the enormous mother and child fill the massive space of a Gothic church (1.129). In his effort to glorify the spiritual importance of Mary and the Christ child, van Eyck also separates them from normal human existence. Their gigantic appearance, relative to the interior, makes these figures appear to be larger than normal human beings. Van Eyck has scaled them to symbolize their central importance in the Christian religion.

Distorted Scale

An artist may deliberately distort scale to create an abnormal or supernatural effect. In the twentieth century, artists known as Surrealists created works that use dreamlike images to subvert our conscious experiences. The American Surrealist artist Dorothea Tanning (1910–2012), in Eine Kleine Nachtmusik, paints a sunflower at a scale that contradicts its surroundings (1.130). The sunflower seems huge in relation to the interior architecture and the two female figures standing on the left. By contradicting our ordinary experience of scale, Tanning invites us into a world unlike the one we know. This is a world of childhood dreams and nightmares where odd things happen, like the strangely alive sunflower and the unexplained wind that lifts the hair of one figure. The title, Eine Kleine Nachtmusik ("A Little Night Music"), is borrowed from a lighthearted piece of music by the eighteenth-century Austrian composer Wolfgang Amadeus Mozart, but ironically Tanning's scene exhibits a strange sense of dread.

Proportion

The relationships between the sizes of different parts of a work make up its proportions. By controlling these size relationships an artist can enhance the expressive and descriptive characteristics of the work.

As size relationships change, proportions change. For example, 1.131 shows the profile of a Greek vase. If we change the width (B) or the height (C) the overall proportions change. Each of these vase profiles communicates a different

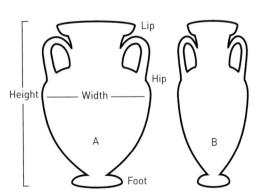

1.130 Dorothea Tanning, Eine Kleine Nachtmusik, 1943. Oil on canvas, $16^{1/8} \times 24^{\circ}$. Tate, London

Surrealist: an artist belonging to the Surrealist movement in the 1920s and later, whose art was inspired by dreams and the subconscious

1.131 Examples of how proportion changes on vertical and horizontal axes

feeling simply because the ratio of height to width is different. When the width is reduced the vase seems elegant and light. Reducing the height makes the opposite true: the vase seems clumsier and weightier than the original profile (A).

For a two-dimensional work the artist chooses an area, or **format**, on which to make a drawing, painting, print, or design. The format's dimensions—its height and width—dictate a great deal about what kind of image can be created. For example, a format that is only 2 inches tall and 10 inches across will require that the artist create an image that is short and wide. Artists must plan ahead and choose the format that best fits their intended image.

Human Proportion

As we saw when discussing **1.131**, carefully chosen proportion can make an art object seem pleasing to the eye. As it happens, the parts of a vase are given names based on the human body: the lip, body, and foot. Just as the body of a vase can have agreeable or disagreeable proportions, the same is true of the human body.

In ancient Egypt the palm of the hand was a unit of measurement (1.132). Six palm widths equaled a unit of measurement called a cubit. The height of an average man was estimated at 4 cubits or 24 palms: the proportion of the man's palm to the height of his body was therefore 24:1.

The ancient Greeks were especially interested in proportion. Greek mathematicians investigated, in the visual arts and in other forms of art, such as music, the mathematical basis of beauty and of ideal proportions. The Greek sculptor Polykleitos wrote a treatise describing how to create a statue of a human being with ideal or perfect proportions. In the first century BCE the Roman writer Vitruvius wrote his book *On Architecture*, in which he claimed to set out the rules that Greeks and Romans applied to the design of architecture.

The Greeks sought an ideal of beauty in the principle of proportion. Figures made during the **Classical period** of Greek sculpture share similar proportions. To the Greeks, these proportions embodied the perfection of the gods. In contrast, fifteenth-century African sculptors preferred to

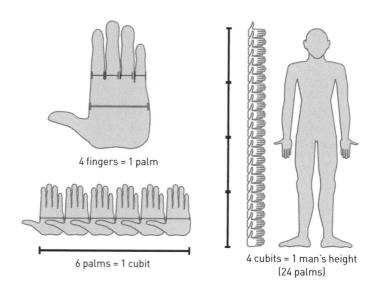

1.132 Ancient Egyptian system using the human hand as a standard unit of measurement

show status and individuality. Pictured in 1.133 is a sculpture of the Oni of Ife in cast brass. The Oni, or Monarch, of the Ife dynasty of the Yoruba people is shown standing in full regalia (ceremonial clothing and adornments). The Oni is the most powerful and important figure in this culture, yet his proportions here are neither realistic nor idealized. The head—about a quarter of the entire figure—is large; the Yoruba believe that the head is the seat of a divine power from whence a life source emanates to control personality and destiny. This figure, like Ife kings, represents a direct descendant of Oduduwa, the heroic leader whose children became the great leaders of the Yoruba. The facial features are idealized, suggesting that a personal heritage shapes one's destiny as a great leader. Many African sculptures exaggerate the head and face as a way to communicate status, destiny, and a connection to the spiritual. Both the Yoruba and the Greeks were concerned with creating a connection to the spiritual world, but African artists celebrated the importance of history (inheritance) and one's unique affiliation or office, while the Greeks sought an impersonal, ideal model.

The models used by the Greeks for calculating human proportion were later adopted by artists of ancient Rome and then by the artists of the **Renaissance**. Raphael used them in *The School of Athens* (see Gateway Box: Raphael) to ensure that the figures in his composition had the ideal human proportion used in the ancient world.

Format: the shape of the area an artist uses for making a two-dimensional artwork

Classical period: a period in the history of Greek art, *c.* 480–323 BCE

Cast: a sculpture or artwork made by pouring a liquid (for example molten metal or plaster) into a mold

Renaissance: a period of cultural and artistic change in Europe from the fourteenth to the seventeenth century

1.133 Nigerian Ife artist, Figure of Oni, early 14th–15th century. Brass with lead, 183/6" high. National Museum, Ife, Nigeria

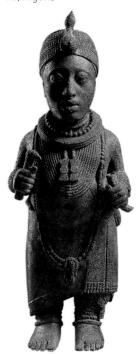

Gateway to Art: Raphael, The School of Athens Scale and Proportion in a Renaissance Masterpiece

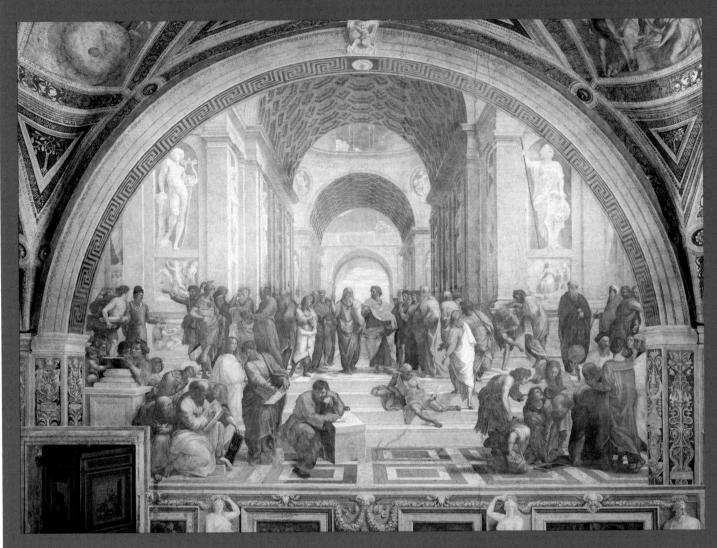

1.134 Raphael, The School of Athens, 1510-11. Fresco, 16'8" × 25'. Stanza della Segnatura, Vatican City

The Italian painter Raphael's sensitivity to proportion reflects his pursuit of perfection, an ideal of Renaissance artists. Raphael indicated the importance of his masterpiece by creating it on a magnificent scale: it measures 17×25 ft (1.134). The figures inhabit a wellproportioned interior that makes them seem human despite the large size of the work.

The figures in this work are particularly important because Raphael is showing us a gathering of great scholars from Classical antiquity. Raphael composed the individual figures so that the parts of each figure are harmonious in relation to each other and portray an idealized form. We notice two of these ideal human figures immediately

because Raphael has positioned them in the center of the work to draw our attention to them. In addition, Raphael has oriented the perspective, used to give the architectural elements a sense of depth, so that our eyes are drawn to the center of the work. This double emphasis on the center brings our attention to the opposing gestures of two famous Greek philosophers (Plato points to the heavens while Aristotle holds the palm of his hand down to the earth, a reference to their differing philosophical positions). Raphael's deft use of proportion and emphasis ensures that he is able to communicate his admiration for the ideas of the great minds of antiquity and the Renaissance.

Golden Section: a unique ratio of a line divided into two parts so that a + b is to a as a is to b. The result is 1:1.618

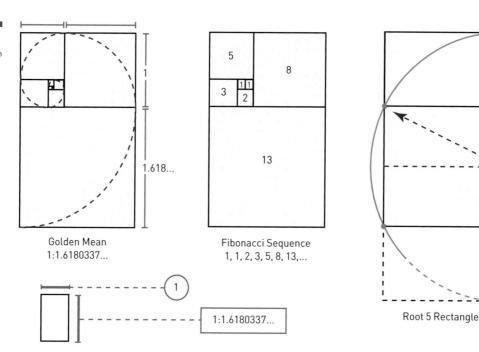

1.135 The Golden Section

The Golden Section

The Greeks' interest in the use of mathematical formulas to determine perfect proportions has fascinated artists ever since. One of the bestknown formulas is what has become known since the Renaissance as the **Golden Section** (1.135). a proportional ratio of 1:1.618, which occurs in many natural objects. It turns out that real human bodies do not have exactly these proportions, but when the ratio 1:1.618 is applied to making statues, it gives naturalistic results. It is likely that Greek sculptors used much simpler methods than the Golden Section to calculate the proportions of their sculptures, but the resulting proportions are often very close to the Golden Section. The sculpture of Poseidon

(some art historians say it is Zeus) is a famous example (1.136). Poseidon, a Greek god, had to have perfect proportions. The Greek sculptor applied a conveniently simple ratio, using the head as a standard measurement. In 1.136 and **1.137** you can see that the body is three heads wide by seven heads high.

√5 2

1/2

1.618...

2.236.

Proportional Ratios

Artists have learned other ways to apply proportional formulas to organize their compositions and ensure that their work is visually interesting. One such technique is known as "Golden Rectangles," because it is based on nesting inside each other a succession of rectangles based on the 1:1.618 proportions of the Golden Section. The shorter side of the outer rectangle becomes the longer side of the smaller rectangle inside it, and so on. The result is an elegant spiral shape. In 1858 the English photographer Henry Peach Robinson (1830-1901), one of the great innovators of the photographic arts, used this idea to compose a photograph titled Fading Away (1.138a and **1.138b**). Robinson was well known for his work in fusing many different negatives to create a new image. This image shows his attention to the coordinated ratios in artistic composition. Notice how the right-hand drape divides the photograph

1.136 Poseidon (or Zeus). c. 460-450 BCE. Bronze, 6'101/2" high. National Archaeological Museum, Athens, Greece

1.137 (below, right) Diagram of proportional formulas used in the statue

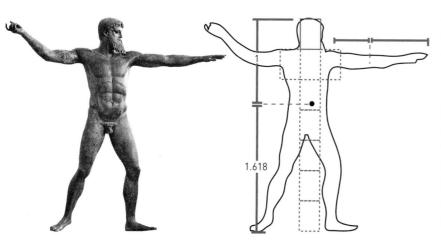

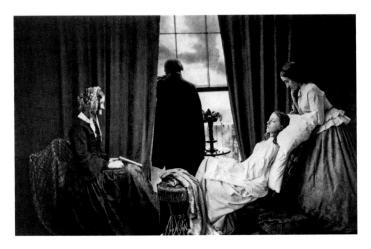

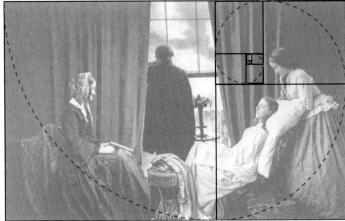

1.138a (above left) and 1.138b (above right) Proportional analysis: Henry Peach Robinson, Fading Away, 1858. Combination albumen print. George Eastman House, Rochester, New York

into two Golden Rectangles and how the spiral draws our eye to the dying young woman.

The Greeks applied their proportional systems to architecture as well as to sculpture. By applying the idealized rules of proportion for the human body to the design of the Parthenon, a temple of the goddess Athena, the Greeks created a harmonious design. As it happens, the proportions correspond quite closely to the Golden Section (1.139). The vertical and horizontal measurements work together to create proportional harmony (1.140).

Scale—whether monumental, human, small, hierarchical, or distorted—carries meaning and communicates a part of an artwork's message. It also sets the tone for proportion, the size relationships between the various parts of a work. When proportion conforms to scale, all the parts of the work look the way we expect them to; they seem proper and harmonious. In other times and places, the proportions of the representations of human figures have reflected the values of the societies that produced them. Scale and proportion are basic to most works; size choices influence all the other elements and principles in the design. Because scale and proportion have such an impact on the whole artwork, they are essences of the artwork's unity.

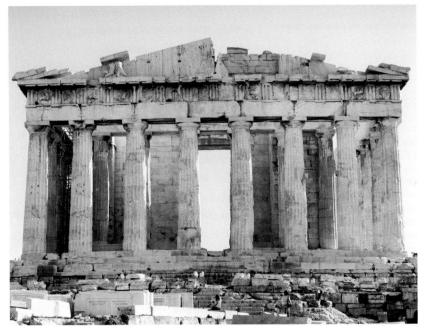

1.139 Iktinos and Kallikrates, Parthenon, 447–432 BCE, Athens, Greece

1.140 The use of the Golden Section in the design of the Parthenon

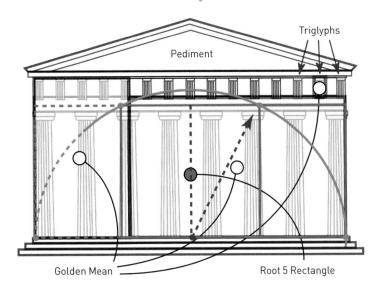

1.8

Emphasis and Focal Point

Emphasis: the principle of drawing attention to particular content in a work

Focal point: the center of interest or activity in a work of art, often drawing the viewer's attention to the most important element

Principles: the "grammar" applied to the elements of artcontrast, balance, unity, variety, rhythm, emphasis, pattern, scale, proportion, and focal point Elements: the basic vocabulary of art-line, form, shape, volume, mass, color, texture, space, time and motion, and

value (lightness/darkness) Subordination: the opposite of emphasis; it draws our attention away from particular areas of a work

Abstract: art imagery that departs from recognizable images from the natural world Color field: a term used by a group of twentieth-century abstract painters to describe their work with large flat areas of color and simple shapes Color: the optical effect caused when reflected white light of the spectrum is divided into a separate wavelength

Positive shape: a shape defined by its surrounding empty space Negative space: an empty space given shape by its surround, for example the right-pointing arrow between the E and x in FedEx

Implied texture: a visual illusion expressing texture

Emphasis and **focal point** are **principles** of art that draw attention to specific locations in a work. Emphasis is the principle by which an artist draws attention to particular content. A focal point is a specific place of visual emphasis in a work of art or design.

Most works of art have at least one area of emphasis and multiple focal points. Those few artworks that do not have areas of emphasis or focal points usually have little or no variation. An artist can emphasize focal points through the use of line, implied line, value, color—in fact, any of the **elements** of art can help focus our interest on specific areas. Like the bull's-eye on a target, focal points concentrate our attention. Even though our field of vision is fairly wide, at any given moment we can only focus our vision on a small area. The physiology of vision underlies the principle of focal point.

Emphasis and focal point usually accentuate concepts, themes, or ideas the artist wants to express: they signal what the artwork is about.

Emphasis and **Subordination**

When an artist emphasizes different elements in a work of art, he or she creates visual relationships and connections between them. The artist activates our visual and conceptual linkages and connects up new thoughts for us; he or she expands the scope of the work and highlights its main ideas. This is the essence of emphasis.

The opposite of emphasis is **subordination**: subordination draws our attention away from certain areas of a work. Artists choose carefully in both two- and three-dimensional workswhich areas to emphasize or subordinate.

We can see how emphasis works in 1.141: a double-chambered vessel with mouse, by an ancient Peruvian artist. The mouse on the top left side of the work attracts our attention because it is so detailed, both in its three-dimensional modeling and its painted pattern. (Its eyes are a particularly strong focal point; in fact, eyes are primal focal points that fascinate us from early infancy.) The spout of the vessel also stands out, not only because of its color but also because of its geometric simplicity, which contrasts with the organic modeling and painting of the mouse. We find third and fourth areas of emphasis in the

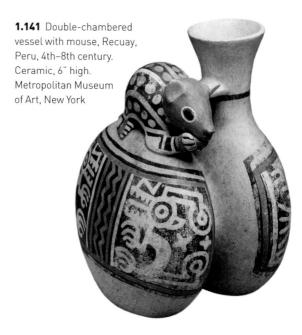

1.142 Jules Olitski, Tin Lizzie Green, 1964. Acrylic and oil/wax crayon on canvas, $10'10'' \times 6'10''$. Museum of Fine Arts, Boston, Massachusetts

1.143 (right) Mark Tobey, Blue Interior, 1959. Tempera on card, 44×28 "

decorations on the two chambers of the vessel. Although these areas have a great deal of variety, they connect because they share common shapes, coloration, and texture that draw our attention away from the undecorated—subordinated areas of the vessel. The playful variations of emphasis create a sense of humor and imagination.

Because abstract works can never directly evoke our memories of things or people, they frequently rely on compositional principles, such as emphasis. The American color field painter Jules Olitski (1922-2007) was primarily concerned with the optical effects of **color**. In his work Tin Lizzie Green, Olitski frames our attention on the color field in the center of the work with three colored dots on the right, red horizontal strokes on the top and bottom, and a tan-colored stroke on the left (1.142). These color shapes support the real focus of this work, which is the blue-green color in the center. Olitski surrounds this with other colors so that we repeatedly alternate our view from the edges to the center and back again. The artist emphasizes the central area and subordinates the edges through the use of contrast between the **positive shapes** on the edges and the **negative space** of the center.

When a work does not have areas of emphasis, that changes the way we respond. For example, the painting Blue Interior by Mark Tobey (1890-1976) has an overall **implied texture** so uniform that we are hard-pressed to find places where our eye can rest (1.143). Tobey, who grew up in the Pacific Northwest, was inspired by the landscape near his native Seattle. He wishes to provide us with a sense of the Puget Sound area, with (as the artist says) its "virginal winds, air currents, and intermingled seasons." He is especially interested

Composition: the overall design or organization of a work

in creating a meditative response to the landscape. Because Tobey does not use areas of emphasis, we are free to roam visually in his painting, without encumbrance. We can immerse ourselves in the work, as if it were an ocean.

Focal Point

In any **composition**, a focal point is that specific part of an area of emphasis to which the artist draws our eye. He or she can do so by using line, implied line, or contrast. These techniques focus our gaze on that point in the work (see Gateway Box: Gentileschi).

In the painting Landscape with the Fall of Icarus the artist diverts our attention so that we barely notice Icarus plunging to his doom (1.144): a fine example of subordination. Flemish artist Pieter Bruegel the Elder (c. 1525–69) illustrates a story from Greek mythology. Icarus and his father Daedalus had been imprisoned on the island of Crete by its ruler, Minos. In order to escape,

Daedalus fashioned two sets of wings from feathers and wax. As father and son flew away from their prison, Icarus became overly exuberant. Although his father had warned him not to, Icarus, recklessly enjoying his new wings, flew too high and close to the sun. The wax in his wings melted, and he fell to his death in the sea below. In Bruegel's version of this story our attention is drawn to the figure in the foreground, plowing his field, unaware of the tragedy. Several other areas of emphasis—the tree on the left, the sunset, the town in the distance, the fanciful ships—also capture our interest. We hardly notice poor Icarus, whose legs are disappearing into the sea just in front of the large ship on the right. Because Bruegel has gone to such lengths to draw attention away from the plight of his subject, art historians think he is illustrating the Flemish proverb, "No plough stands still because a man dies." Or, as we might say, "Life goes on." Either way, it is a brilliant example of using emphasis to divert the viewer's attention away from a particular point in the work.

1.144 Pieter Bruegel the Elder, Landscape with the Fall of Icarus, c. 1555-8. Oil on canvas, mounted on wood, 29 x 441/8". Musées Royaux des Beaux-Arts de Belgique, Brussels, Belgium

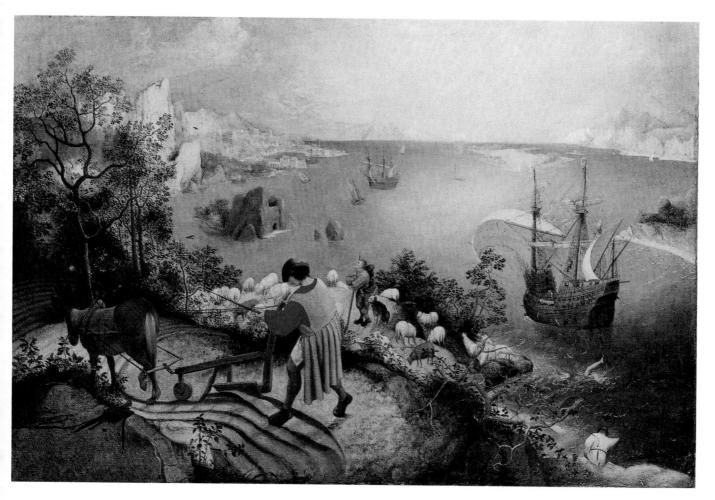

Gateway to Art: Gentileschi, Judith Decapitating Holofernes **Emphasis Used to Create Drama**

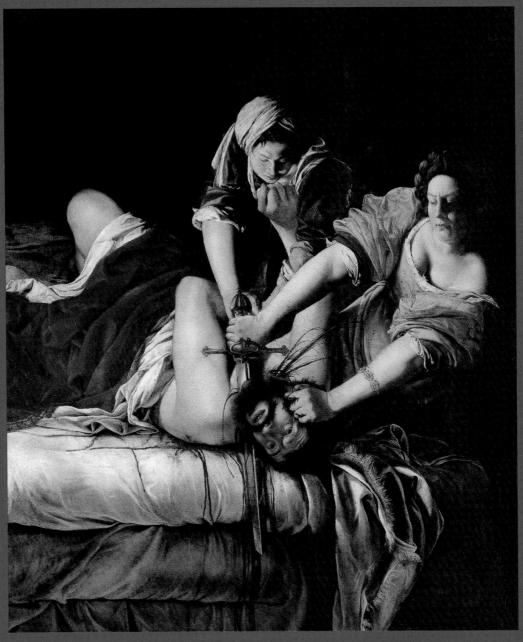

1.145 Artemisia Gentileschi, Judith Decapitating Holofernes, c. 1620. Oil on canvas, $6'6\frac{3}{8}" \times 5'3\frac{3}{4}"$. Uffizi Gallery, Florence, Italy

Artists often take advantage of the strength of a single focal point to force us to give our attention to the crux or pivot of the work. Although a composition can have several focal points, the Italian Baroque painter Artemisia Gentileschi uses just one in her Judith Decapitating Holofernes (1.145). Through Gentileschi's use of directional line and contrasting values we are drawn irresistibly to the point where the climax of the story is unfolding. Bright light

emphasizes Judith's arms and those of her maidservant (visually connected to the sword itself) as they stretch toward the dark values of their victim's head. The light values of the five bare arms create strong directional lines that lead to the focal point where blood spurts from the violent attack on Holofernes' neck. This double emphasis (contrast of values and directional line) freezes our stare upon the fatal blow, even as it obscures it in darkness.

Rhythm: the regular or ordered repetition of elements in the work

Emphasis and Focal Point in Action

Artists can use direction, dramatic contrasts, and placement relationships to organize the elements in a work and draw our attention to areas of emphasis and focal points.

Line

Line is an effective way to focus our attention in an artwork. In Mughal India (the period from 1526 until the mid-nineteenth century), a garden was considered a work of art, one that symbolized the promise of paradise. Zahir ud-Din

1.146 The Emperor Babur Overseeing his Gardeners, India, Mughal period, c. 1590. Tempera and gouache on paper, $8\frac{3}{4} \times 5\frac{5}{8}$ ". Victoria and Albert Museum, London, England

Muhammad bin Omar Sheikh, nicknamed Babur, founded the Mughal Empire in India when he conquered most of Central Asia and northern India. In 1.146, the gardener/artist Babur is pointing to a feature that channels water in four directions. The life-giving properties of water and the four cardinal directions were important symbols of life and eternity. Because the garden was based on the perfect geometry of a square, it could be expanded an infinite number of times without disturbing the original plantings. In this image of the garden, water is the focal point both conceptually and visually.

We tend to notice diagonal lines because they appear to be more visually active than either horizontal or vertical lines. The strong diagonal of the channel draws our attention to the water as it runs toward us. The central cross-shaped confluence of the waters in the middle of the garden becomes the focal point of the composition.

Contrast

Artists look to create effects of contrast by positioning elements next to one another that are very different, for example areas of different value, color, or size. Value is an effective and frequently used means of creating emphasis and focal point. It also has the advantage that it can be used in subtle ways. In The Funeral of St. Bonaventure, a painting by Spanish artist Francisco de Zurbarán (1598–1664), most of the lightest values are reserved for the clothing adorning the dead body of St. Bonaventure (1.147). They create a central focal point that stands out in contrast to the surrounding dark values. We are drawn to the whiteness (symbolic of Bonaventure's chaste and spotless reputation) before we look at the surrounding characters. Enough light value is distributed to the other figures to allow our eyes to be drawn away from Bonaventure's body, making the composition more interesting.

Placement

The placement of elements within a composition controls **rhythm** and creates multiple focal points.

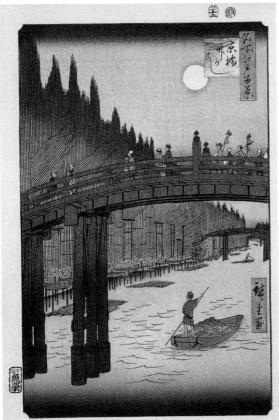

1.147 (above) Francisco de Zurbarán, The Funeral of St. Bonaventure, 1629. Oil on canvas, 8'2" × 7'4". Musée du Louvre, Paris, France

1.148 (left) Ando Hiroshige, "Riverside Bamboo Market, Kyōbashi," from One Hundred Famous Views of Edo, 1857. 15×10^3 /8". James A. Michener Collection, Honolulu Academy of Arts, Hawaii

Outline: the outermost line of an object or figure, by which it is defined or bounded Woodcut: a print created from an incised piece of wood Actual and Implied lines: actual lines are solid lines. Implied lines are impressions of lines created from a series of points that orient our gaze along a visual path

In the print "Riverside Bamboo Market, Kyōbashi," the Japanese artist Ando Hiroshige (1797–1858) has oriented three shapes; all of them are visually independent of each other (1.148). The positions of the moon, the bridge, and the figure in a boat form three separate focal points. Each shape commands our attention and draws more of our focus to the right side of the work. Even though the bridge is the largest shape, and so naturally catches our attention, the light value and hard geometry of the moon divert our gaze, and the moon becomes a secondary focal point. We look at the figure under the bridge because of its careful placement under the moon, and because it has a definite outline that contrasts strongly with the flat color of the water. The varying distances between the placements of the three focal points also create rhythm that adds visual interest. Hiroshige, a master of **woodcut** printing, uses placement to emphasize specific points in the work and enliven the composition.

Conclusion

Emphasis and focal point give a work of art punch. They announce important content in an artwork and call attention to the concepts the artist wishes to communicate. Artists rely on emphasis and focal point to give their work visual and conceptual impact.

All the elements and principles of art can serve to create emphasis. Both actual and implied lines shape our examination of a work of art by directing the movement of our gaze. Contrasts between different values, colors, or textures can sometimes be so dramatic and distinct that we cannot help but feel drawn to that area of a work. Our vision keeps coming back to these focal points; they are places where our thoughts linger for a while. During the process of artistic design, artists are constantly adjusting the elements of composition, calculating how they are going to influence the focus and duration of these pauses. The placement of these "centers of attention" generates rhythmic sequences while emphasizing the core significance of the artwork: its ideas, feelings, and images.

1.9

Pattern and Rhythm

Space: the distance between identifiable points or planes Pattern: an arrangement of predictably repeated elements Elements: the basic vocabulary of art-line, form, shape, volume, mass, color, texture, space, time and motion, and value (lightness/darkness) Unity: the imposition of order and harmony on a design **Rhythm:** the regular or ordered repetition of elements in the

Composition: the overall design or organization of a work **Shape:** the two-dimensional area the boundaries of which are defined by lines or suggested by changes in color or value Value: the lightness or darkness of a plane or area

Color: the optical effect caused when reflected white light of the spectrum is divided into a separate wavelength

Contrast: a drastic difference between such elements as color or value (lightness/darkness)

Each day the sun rises and sets; we believe it will do so again tomorrow. Patterns and rhythms in nature help us make sense of the world. They express the order and predictability of our lives. Artists use pattern and rhythm to bring order to **space** and to create a dynamic experience of time.

When events recur, this creates a **pattern**. But other patterns are more regular, more predictable. In art, we can see patterns as the recurrence of an art element. In a work of art the repetition of such patterns gives a sense of unity.

Rhythm arises through the repetition of pattern. It adds cohesiveness in artistic **composition** because it links elements together. Rhythm affects our vision as we study a work of art. The rhythm of a series of linked elements guides the movement of our eyes across and through a design. The artist can also use rhythm to add variety.

Pattern

The use of repetition in a work of art usually results in the creation of a pattern. These patterns are sometimes based on occurrences in nature, such as the regular repetition of fish scales or the pattern created by the cracks that open as mud dries in the desert. Other patterns may be derived from the repeated shapes of mass-produced human-made objects, such as stacked tin cans or the warp and weft of woven cloth. Artists often create unity in works of art by repeatedly using a similar **shape**, **value**, or **color**, for example.

An artist can use repetition of a pattern to impose order on a work. But simple repetition can become more complex and make a work even more interesting when the pattern changes. Sometimes artists use alternating patterns to make a work more lively. The area covered by pattern is called the field; changes in the field can invigorate visual forms. The pattern in **1.149** shows a series of star shapes set on alternating black and white backgrounds on a rectangular field. The drastic difference in value combined with the active shape causes a visual vibration.

A variety of different colors and patterns enlivens work by the French painter Suzanne Valadon (1865-1938). In The Blue Room, Valadon includes three **contrasting** patterns (1.150). In the blue bed covering, in the lower portion of the painting, Valadon has used

1.149 Horizontal alternating pattern

1.150 Suzanne Valadon, The Blue Room, 1923. Oil on canvas, $35\frac{1}{2} \times 45\frac{5}{8}$ ". Musée National d'Art Moderne, Centre Georges Pompidou, Paris, France

an organic pattern of leaves and stems. The green-and-white striped pattern in the woman's pajama bottoms dominates in direct contrast to the blue bed covering. Above the figure is a mottled pattern that again contrasts with the other two. The differences in these patterns energize the work.

Motif

A design repeated as a unit in a pattern is called a motif. Motifs can represent ideas, images, and themes that can be brought together through the use of pattern. An artist can create a strong unified design by repeating a motif.

A single motif can be interlaced with others to create complex designs. Many Islamic works use complex interlaced motifs, as two objects created in seventeenth-century India demonstrate. The huqqa base (a huqqa is a water pipe used for smoking) in 1.151 may at first glance appear

Abstract: art imagery that departs from recognizable images from the natural world

1.152 Pashmina carpet with millefleur pattern, northern India, Kashmir or Lahore, second half of 17th century. Ashmolean Museum, Oxford

to use little repetition. Nevertheless, as we study the overall design we discover that elements, such as the flowers and leaves of the plants, recur at intervals. Similarly, in the detail of a carpet (1.152), repeated flower-like motifs are arranged in a pattern in the center. Islamic artists delighted in the detail of pattern, as these two works show.

The American artist Chuck Close (b. 1940) uses motif to unify his paintings. Close uses a repeated pattern of organic concentric rings set into a diamond shape as the basic building blocks for his large compositions. These motifs, which appear as **abstract** patterns when viewed closely, visually solidify into realistic portraits of the model. In his *Self Portrait*, there is a distinct

Texture: the surface quality of a work, for example fine/coarse, detailed/lacking in detail

1.153a Chuck Close, Self Portrait, 1997. Oil on canvas, $8'6" \times 7'$. MOMA, New York

1.153b Chuck Close, Self Portrait, detail

1.153c Chuck Close, Self Portrait, detail

difference between a close-up view of the painting and the overall effect when we stand back from this enormous canvas (1.153a-1.153c). The motif unifies the work and allows Close the freedom to control the color, texture, and value. In this case, the motif that Close uses is the result of a technical process. When applied to the larger image, however, it almost disappears because of

each unit's tiny size. A grid that subdivides the entire image organizes the placement of each cell.

Randomness

Although nearly all artists have used pattern in their work, some have consciously tried to eliminate it. If pattern imposes order, then

Automatic: suppressing conscious control to access subconscious sources of creativity and truth

Dada: anarchic anti-art and anti-war movement, dating back to World War I, that reveled in absurdity and irrationality

Picture plane: the surface of a painting or drawing

Foreground: the part of a work depicted as nearest to the viewer

Middle ground: the part of a work between the foreground and background

1.154 Hans Arp, *Trousse d'un Da*, 1920–21. Assemblage of driftwood nailed onto wood with painting remains, $15 \times 10^{1}/_{2} \times 1^{3}/_{4}$ ". Musée National d'Art Moderne, Centre Georges Pompidou, Paris, France

the introduction of chance metaphorically symbolizes anti-order. Artists who introduce randomness to a work try to avoid predictable repetition. Works made in this way purposely contradict widely used traditional methods. Some artists consciously fight against order, while others have relied on their subconscious and a kind of **automatic** reaction to the art materials.

Dada reveled in absurdity, irrationality, the flamboyantly bizarre, and the shocking. Nearly all the Dada artists had moved to neutral Switzerland by 1916 to avoid the draft. They vehemently opposed the so-called "rationality" of treaties and alliances that led to the horrific slaughter in the trenches of World War I. They also detested art and art movements—Dada was "anti-art": "Use a Rembrandt as an ironing board," said Marcel Duchamp. Dada design, writing, and theater were also expressly "irrational." Hans Arp (1886—1966), a German-

French Dada sculptor and artist in Zürich, worked on creating "chance" arrangements. The shapes were derived from nature, but Arp made a point not to copy directly. Arp claimed that the arrangement of the shapes happened by random placement, as he dropped shaped wooden pieces onto the **picture plane** and glued them where they landed (1.154).

Rhythm

Rhythm is something you either have or don't have, but when you have it, you have it all over.

(Elvis Presley)

Rock and roll icon Elvis Presley might as well have been speaking about visual art when he was talking about musical rhythm. Rhythm is something that visual art has "all over." Rhythm gives structure to the experience of looking, just as it guides our eyes from one point to another in a work of art. There is rhythm when there are at least two points of reference in an artwork. For example, the horizontal distance from one side of a canvas to the other is one rhythm, and the vertical distance from top to bottom another. So, even the simplest works have an implicit rhythm. But most works of art have shapes, colors, values, lines, and other elements too; the intervals between them provide points of reference for more complex rhythms.

In Flemish painter Pieter Bruegel's work we see not only large rhythmic progressions that take our eye all around the canvas, but also refined micro-rhythms in the repetition of such details as the trees, houses, birds, and colors (1.155). All these repetitive elements create a variety of rhythms "all over."

In *Hunters in the Snow*, the party of hunters on the left side first draws our attention into the work. Their dark shapes contrast with the light value of the snow. The group is trudging over the crest of a hill that leads to the right; our attention follows them in the same direction, creating the first part of a rhythmic progression. Our gaze now traverses from the left **foreground** to the **middle ground** on the right, where figures

1.155 Pieter Bruegel, Hunters in the Snow, 1565. Oil on panel, $46 \times 63^{3}/4^{\circ}$ Kunsthistorisches Museum, Vienna, Austria

Background: the part of a work depicted furthest from the viewer's space, often behind the main subject matter Focal point: the center of interest or activity in a work of art, often drawing the

viewer's attention to the most

important element

appear to be skating on a large frozen pond. Thereafter, the color of the sky, which is reflected in the skaters' pond, draws our attention deeper into the space, to the horizon. We then look at the background of the work, where the recession of the ridgeline pulls the eye to the left and into the far background. As a result of following this rhythmic progression our eye has circled round and now returns to re-examine the original focal point. We now naturally inspect details, such as the group of figures at the far left making a fire outside a building. As our eye repeats this cycle, we also notice subsidiary rhythms, like the receding line of trees. Bruegel masterfully orchestrates the winter activities of townspeople in sixteenth-century Flanders (a country that is now Belgium, the Netherlands, and part of northern France) in a pulsating composition that is both powerful and subtle at the same time.

Simple Repetitive Rhythm

Artists create repetition by using the same shape, color, size, value, line, or texture over and over again. A repeating "pulse" of similar elements sets up a visual rhythm that a viewer can anticipate. Such regularity communicates reassurance.

The design of buildings is often intended to reassure us about the stability and durability of the structure. Stability was so important to the ancient Romans that when the builders finally removed the temporary support structures for archways, the architects who had designed them were made to stand underneath. If the arch failed, the architect would be crushed. Like Roman architects, we want reassurance that our structures will endure. For this reason, architectural designs often incorporate simple repetition.

The main hall of the Great Mosque of Córdoba in Spain is full of seemingly endless rows of identical columns and arches made from alternating red and white voussoirs (stone wedges that make up the arch) (1.156). Each of these repeating elements—columns, arches, and voussoirs—creates its own simple rhythm. The accumulation of these simple repetitions also enhances the function of the space and becomes a part of the activity of worship, like prayer beads, reciting the Shahada (profession of faith), or the five-times-a-day call to prayer. Our trust in the permanence of architecture is combined with the timelessness of prayer in the repetitions of the Great Mosque of Córdoba.

Progressive Rhythm

Repetition that regularly increases or decreases in frequency creates a progressive rhythm as the eye moves faster or slower across the surface of the work. In the photograph Artichoke Halved, by American Edward Weston (1886–1958), the

1.156 Great Mosque of Córdoba, prayer hall of Abd al-Rahman I, 784-6, Córdoba, Spain

1.157 Edward Weston, Artichoke Halved, 1930. Silver gelatin print, $7\frac{3}{8} \times 9\frac{3}{8}$ ". Collection Center for Creative Photography, University of Arizona, Tucson

outer layers (bracts) of the artichoke bud are closer together nearer the center (1.157). Then, as they form the triangular center of the bud, a second progressive rhythm begins and the small bracts below the triangle form a third rhythm. The highly focused close-up view and strong photographic contrasts of black and white accentuate the sense of speeding up.

Alternating Rhythm

Artists can intertwine multiple rhythms until they become quite complex. The addition and alternation of rhythms can add unpredictability and visual excitement. On the island of Belau in the western Pacific, a traditional men's long house, called the bai, serves as a place for meeting and ritual (1.158). The imagery above the entry of this bai begins, at the bottom, with the regular rhythms of horizontal lines of fish, but the images above become increasingly irregular as they change to other kinds of shapes. The edges of the roof display a regular series of symbolic icons that, together with the building's horizontal beams, frame the composition and give the building **facade** a dynamic feel.

An alternating rhythm can also communicate chaos and make viewers feel uncomfortable.

1.158 Bai-ra-Irrai, originally built c. 1700 and periodically restored, Airai village, Airai State, Republic of Palau

Facade: any side of a building, usually the front or entrance

Emphasis: the principle of drawing attention to particular content in a work

In Spanish painter Francisco Goya's Third of May, 1808, the alternating rhythms help define our ideas about humanity and inhumanity (see Gateway Box: Goya).

Rhythmic Design Structure

The idea of rhythmic structure helps us understand how artists divide visual space into different kinds of sections to achieve different kinds of effects. In her painting of 1849 Plowing in the Nivernais: The Dressing of the Vines, the French artist Rosa Bonheur (1822–99) creates a horizontal structure that leads our eye in sequence from one group of shapes to the next (1.160a and 1.160b). Bonheur expertly organizes the composition, emphasizing the cumulative effect of the rhythm of the groupings as they move from left to right. Because the

composition is so horizontal, the design emphasis directs our gaze sideways using a linear direction and rhythm. By changing the width of the gaps between the animals, Bonheur suggests their irregular movement as they plod forward, drawing the heavy plow. Each group also has a different relative size and occupies a different amount of space, creating a visual rhythm and energy that pulls our attention from left to right.

The careful composition and rhythmic structure in such paintings give an air of respectability and nobility to laborers of the field. Bonheur may have been sympathetic toward those who worked outside of the stuffy social order of the time, since her gender may have been a disadvantage in a traditionally male profession. Her effort to bring respectability to hard work also reminds us of the slow physical rhythms created by the brute strength of these beasts and

Gateway to Art: Goya, The Third of May, 1808 Visual Rhythm in the Composition

Spanish painter Francisco Goya's Third of May, 1808, shows an image of Napoleon's troops executing Spanish citizens during the French occupation of Madrid in 1808 (1.159). It can be divided up into two distinct rhythmic groups. Each side of the work has almost the same number of victims as executioners. Goya does not allow the "good" victims to overpower the "bad" occupiers in number, but keeps a visual balance to steady the work. Although the number of figures in each group is the same, they are distributed very differently. The group of French soldiers on the right stands in a pattern so regulated it is almost mechanical. Each of the soldiers adopts the same stance, and the strong horizontal barrels of the guns repeat uniformly. On the left side, the rhythms are much more irregular and unpredictable. The figures are not organized so rigidly: some figures are lying on the ground, some are standing, and some are kneeling. The pose (with arms held high) of the standing figure in white is repeated in the

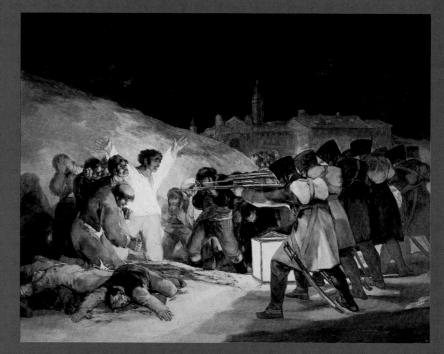

dead figure on the ground. The alternating rhythm in this painting leads our eye from the figure in white through a group of figures downward to the victims on the ground.

1.159 Francisco Goya, The Third of May, 1808, 1814. Oil on canvas, 8'4%" × 11'3%". Museo Nacional del Prado, Madrid

1.160a Rosa Bonheur. Plowing in the Nivernais: The Dressing of the Vines, 1849. Oil on canvas, $4'4^{3}/_{4}" \times 8'6^{3}/_{8}"$. Musée d'Orsay, Paris, France

1.160b Rhythmic structural diagram of 1.160a

the irregularity of the plowman's steps as both of them work together to turn the weighty soil.

Conclusion

Artists frequently rely on rhythms and patterns to ground their work. Just like a great theater production, a blockbuster movie, a brilliant ballet, or a catchy tune, a well-composed work of art with visually exciting patterns and rhythms can thrill an audience. In works of art, good composition articulates patterns and rhythms in a way that grabs our attention.

Because the visual rhythm of pattern is predictable, it often tends to unify a work of art. By alternating the rhythm, the artist can reinforce the visual emphases of a work and make its composition visually stronger. The repetition of motifs such as those found in certain pottery and carpets can add the richness we associate with

the finer things in life. But some artists try to contradict pattern by imposing randomness and chance to free a work from what they see as suffocating orderliness.

Good works of art, like Elvis as he gyrated on stage, have rhythm "all over." That rhythm dictates how elements visually relate to one another. These relationships make up a work's composition. Rhythm is a core part of any visual composition.

Simple repetitions can give a work a welcoming predictability that makes us comfortable. Progressive rhythm builds like a musical crescendo or diminishes like a fading echo, and can suggest growth or ebbing power. Alternating rhythm can create a dynamic sense of energy and add visual interest, because we may not be able to predict what the rhythm will do next. Irregular rhythm can make a work seem unpredictable or make us feel uneasy. If the elements of art are its life's blood, rhythm is like the beating of its heart.

artwork to others made at the time and find that female nudes were often depicted as objects of desire and beauty. The woman is dressed as an odalisque (a woman in a harem), and so a feminist analysis might study the French view of women in Near Eastern society, who were considered fascinating for their exotic sensuality. Feminist analysis could seek an explanation for the interest in harem women in art during this period, and might find that women in France were demanding equal rights, causing men to pine for docile females.

A feminist might also study this subject's demure gaze, whereby she accepts her status as an object of beauty. At the time when the picture was painted, critics complained that the figure's body parts were disproportionate: her back was too long, and her hips too wide. A feminist analysis would point out that Ingres believed that the back was a very sensual part of a woman's body, and claimed he could not stop himself, when painting, from adding what appear to be extra vertebrae.

Contextual Analysis

Art is shaped by the historical context in which it is made. In 1934, German dictator Adolf Hitler commissioned filmmaker Leni Riefenstahl (1902–2003) to film a four-day Nazi Party rally in Nuremberg. Riefenstahl created a propaganda film, *Triumph of the Will* (1.167), designed to promote the Nazi ideology and create an impression that Hitler was wholeheartedly supported by the entire German nation.

This film cannot be understood without recognizing its historical context. Riefenstahl's concluding scenes, of a speech by Hitler, are filmed from below, visually emphasizing his importance. At several points in the film the crowd is seen to be cheering wildly, but instead of the cheers we hear dramatic music by the German composer Richard Wagner. In the scenes that film Hitler speaking we can see that the crowd is noisily excited, but there is no sound other than Hitler's voice—an effect that gives his words greater authority. In the film still shown

1.167 Leni Riefenstahl, still from *Triumph of the Will*, 1934

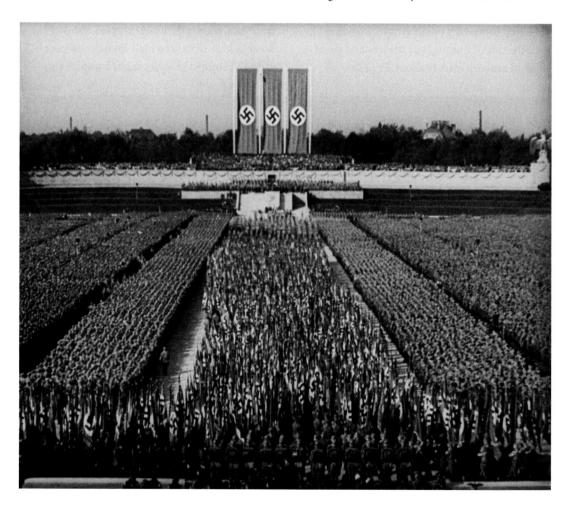

1.168 Edward Hopper, Nighthawks, 1942. Oil on canvas, $33\frac{1}{8} \times 60$ ". Art Institute of Chicago

here, three large banners carrying the Nazi symbol are given **emphasis**, and are echoed in the three groups of followers shown underneath. The platform on which Hitler will speak is front and center. Triumph of the Will, while considered a pioneering work of modern filmmaking, is also political propaganda; as such it must be viewed as part of the Nazi Party's attempts to consolidate its power and to promote its ideology of German superiority over those it considered inferior, such as Jews, homosexuals, the mentally ill, and other groups (including many modern artists) that the Nazis defined as outside of their "Aryan" norm.

Psychological Analysis

Psychological analysis considers the artist's state of mind when creating an artwork. Nighthawks, by the American artist Edward Hopper (1882-1967), reflects the solemn mood many felt in the United States at the beginning of America's entry into World War II (1.168). Hopper began this painting immediately after the attack on Pearl Harbor, which had left many Americans shocked and distraught. The artist captured this feeling in his painting. The scene shows a café, which

Hopper based on a restaurant in New York's Greenwich Village. Hopper himself was a model for the man seated at the counter whose face can be seen; he used his wife for the figure next to him. Even though the scene takes place in the middle of New York City, the streets are devoid of people, activity, even light. The people seated inside are still and quiet, and the decor is reduced to essentials. The café is the only lit place; no light emanates from windows on the other side of the street. The artist remarked later, "Unconsciously, probably, I was painting the loneliness of a large city."

Despite gathering together in the all-night diner, these individuals appear to be alone in their own thoughts; little interaction takes place between them. A large glass window separating the viewer from the figures leaves the viewer alone as well.

Formal Analysis

Formal analysis considers the way in which the elements and principles of art are applied in an artwork. The famous painting Las Meninas (The Maids of Honor) by Diego de Silva y Velázquez

Emphasis: the principle of drawing attention to particular content in a work

1.169 Diego de Silva y Velázquez, Las Meninas, c. 1656. Oil on canvas, $10'5\frac{1}{4}" \times 9'\frac{3}{4}"$. Museo Nacional del Prado, Madrid, Spain

Implied line: a line not actually drawn but suggested by elements in the work

Vanishing point: the point in a work of art at which imaginary sight lines appear to converge, suggesting depth

Linear perspective: a system using converging imaginary sight lines to create the illusion of depth

Depth: the degree of recession in perspective

Volume: the space filled or enclosed by a three-dimensional figure or object

Color: the optical effect caused when reflected white light of the spectrum is divided into a separate wavelength

Neutral tones: colors (such as blacks, whites, grays, and dull gray-browns) made by mixing complementary hues

Palette: the range of colors used by an artist

(1599–1660) shows members of the court of Spanish King Philip IV gathering in a room in the Alcázar Palace (1.169). The painter depicts himself on the left, painting a large canvas. The Princess Margarita is posed in the center, with her ladiesin-waiting ("las meninas") surrounding her. Court workers, including dwarfs, are present as well.

The **implied lines** suggested by the black frames on the right wall and the ceiling fixtures converge on the chest of the man standing in the doorway. This is the **vanishing point** required in **linear perspective** to create an illusion of **depth**, as if the viewer is looking into a real room. All the figures in the painting have a realistic sense of volume and are arranged to emphasize further the illusion of looking into a real space. Notice how they overlap one another, and that those toward the back of the room are smaller than those at the front. The painting is more than 10 feet tall, which allows Velázquez to make the figures life-size, further reinforcing the illusion of three-dimensional space. Finally, most of the colors in the painting are neutral. The color palette of brown, grey, beige, and black creates

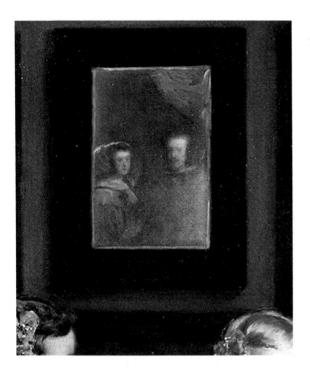

1.170 Detail of Diego de Silva y Velázquez, Las Meninas

the impression of a dark space the depth of which is emphasized by the light coming in from a window on the right and the door at the back.

Velázquez highlights several areas he wants to emphasize. The young princess is in the central **foreground**, the part of the painting nearest to us, well lit, and shown attended by her maids. In the **background**, the mysterious male figure is emphasized because his black form contrasts with the light coming through the doorway. The painter himself stands proudly at his work. And we notice the mirror on the back wall because of its blurry shiny surface: whom does it reflect? (1.170). Touches of red lead our eye around the painting to significant points of interest: from Margarita's flowers, to the cross on Velázquez's chest, to the red curtain in the mirror on the back wall.

The painting is **balanced** in various ways. All of the figures are placed in the bottom half of the canvas, balanced by the sparseness of the wall and ceiling that take up the top half. While the figures at first appear to be arranged chaotically, they are actually placed in several stable pyramidal arrangements. One triangle highlights three of the composition's **focal points**: the mirror, Margarita, and the man in the doorway. The frames on the back and side walls form a framework of rectangles that stabilize the space of the room. The figures are of different heights and arranged so that our eye is led from Velázquez on

the left to the right of the painting in a rhythmic line: if you trace the heads of the figures in the foreground with your finger you will sense the visual rhythm.

Combined Analysis of Las Meninas

A formal analysis tells us how the artist has communicated using a visual language. The use of other approaches, however, often enhances our understanding of a work of art. While it is rare to be able to use every method discussed in this chapter on every artwork, we can often consider one artwork in many ways. Using three more of the modes of analysis discussed earlier, we can arrive at a better and more rounded understanding of the painting Las Meninas.

A contextual analysis gives us a better understanding of the time in which this work was made. The young girl is the Spanish princess Margarita Hapsburg; the couple in the mirror are her parents, King Philip IV and Marianna of Austria. The mysterious man in the doorway is Nieto, the queen's chamberlain. Through the use of the mirror and his portrayal of an essential aide to the queen, Velázquez has subtly indicated the presence of the royal couple without violating etiquette by showing the king and queen in a portrait with lesser court members.

A biographical analysis suggests why Velázquez placed himself in a painting that subtly shows the presence of the king. One reason was that he was the king's favorite painter and assistant. It was extremely bold of him to paint himself into a scene with the royal family; by doing so, he wished to show his closeness with the king, and to raise his own status.

An iconographic analysis tells us that the cross on Velázquez in Las Meninas is the cross of the Order of Santiago. Velázquez had a lifelong ambition to become a knight of the order, but the order challenged his membership for decades. Their bylaws stated that: (1) only those from families of nobility could join, (2) members may have no Moorish (Muslim) ancestry, and (3) a craftsman could not become a member. The members saw painting as simply a manual craft rather than a liberal (or highminded) art.

depicted as nearest to the viewer **Background:** the part of a work depicted furthest from the viewer's space, often behind the main subject matter Balance: a principle of art in which elements are used to create a symmetrical or asymmetrical sense of visual

Foreground: the part of a work

weight in an artwork Focal point: the center of interest or activity in a work of art, often drawing the viewer's attention to the most important

Rhythm: the regular or ordered repetition of elements in the work

In truth, Velázquez did not meet any of these criteria, but after hundreds of supportive interviews, and with the support of both the king and the pope, Velázquez was finally knighted in 1659, three years after he painted *Las Meninas*.

Why, then, is the cross painted here when Velázquez was not knighted until after this painting was completed? Historians have found evidence that the king ordered the cross painted on after Velázquez's death, to honor the artist for having achieved his lifelong goal.

What Is the Meaning of Las Meninas?

After considering the various methods of analysis discussed above, scholars have arrived at a hypothesis as to what Velázquez wanted to say. They suggest that the artist was defending the nobility of painting itself. In order to be accepted as a knight, he needed to prove that his skill was not mere craft, but an intellectual endeavor. Therefore Velázquez created a brilliant illusion of **space** through his mastery of atmosphere and perspective. Even more boldly, he included the king in a painting that also included a selfportrait of the artist, demonstrating the king's clear support for the painter. Velázquez's painting is an intentional effort to raise the status of painters, and to raise his own status in Spanish society.

Imitation and Individual Style

Artists often study and copy the work of artists they admire, and may use such studies to create works in their own individual style. The Spanish painter Pablo Picasso (1881-1973) did not come to admire Velázquez until late in his own career, when he began to set his skills against the great artists of the past. At the age of seventy-six, Picasso locked himself in a room with a poster of Las Meninas and created forty-five paintings in response to Velázquez's masterpiece.

In the first painting in the series, Picasso alters the size of the canvas (1.171). While mimicking Velázquez, he uses the elements and principles differently. For example, although Picasso does not use linear perspective, he does create a sense

1.171 Picasso, Las Meninas, first in a series, 1957. Oil on canvas, $6'4^{3}/_{8}" \times 8'6^{3}/_{8}"$. Museo Picasso, Barcelona, Spain

Space: the distance between identifiable points or planes Style: a characteristic way in which an artist or group of artists uses visual language to give a work an identifiable form of visual expression

1.172 Thomas Struth, Museo del Prado 7, Madrid 2005. Chromogenic print, $5^{17}/8^{11} \times 7^{12}$.

of depth by making Nieto small in scale and placing his dark figure in the bright doorway. Velázquez now appears to be stretched or floating up to the ceiling, leaving his paintbrushes and palette below. Is Picasso removing the old master to make room for himself?

Other figures are mere suggestions of the forms they had been in the original painting. Picasso has broken them down into abstract parts. Margarita is outlined with no sense of volume, and the heads of the figures on the right are just black lines on white circles. The play of light on the figures is similar to the original, but Picasso's approach is more abstract: on the right, he lines up a row of windows that shine a bright white on the figure there (which correlates to the child dwarf in the original). Margarita, highlighted in Velázquez's painting, is of a much lighter value than the other figures in Picasso's painting, emphasizing that she is the most important person in the group. The majority of the rest of the series, in fact, are studies of Margarita specifically. This may relate to Picasso's own life. The first time he saw Las Meninas as a boy was just after his younger sister had died; she had been about the same age as the young Margarita here. Picasso has totally reinterpreted this artwork to make it his own; he has even replaced the large mastiff in Velázquez's painting with his own dog.

Scale: the size of an object or artwork relative to another object or artwork, or to a system of measurement

Abstract: art imagery that departs from recognizable images from the natural world

German photographer Thomas Struth (b. 1954) used photography to create his own view of Las Meninas. In 1.172, he shows a group admiring the painting at the Prado Museum in Madrid, Spain. There are multiple ways to interpret Struth's artwork. We might study his use of lighting and composition. We might consider which image is the "true" artwork, the photograph of the visitors to the Prado or the painting Las Meninas. We might take notice of the boy sketching on the right, creating his own work of art. Finally, we might pay more attention to the multiple layers of looking and reflecting in Struth's photograph. The photograph portrays people looking at art—which is exactly what we are doing when we look at the photograph. In this way, the artwork can be seen as a portrait of art appreciation. In 2007, Struth exhibited this photograph at the Prado, hanging it right next to Las Meninas.

Conclusion

The tools of formal analysis are the starting point for understanding any work of art; this will help you realize how it was made. When you see a work of art, take a long look and use the elements and principles of art as your guide. But the other methods of analysis discussed in this chapter can help you to understand why an artwork was made, and what its message is.

You have been introduced to several approaches for doing this. Consider the artist's life when the artwork was created. Delve into the time and place in which he or she lived. What symbols did the artist use, and what was his or her state of mind? Recognize that some artworks are meant to convey distinct messages, which were clear to their contemporary audiences. Many artworks convey more subtle messages, filled with layers of meaning. Some artworks are intentionally subjective, which means that artists expect us to infuse meaning into the work from our own experiences; subjective artworks are often mirrors of the person who looks at them.

Using a variety of methods of analysis, you can endlessly explore both the minds of great artists and the furthest reaches of your own!

MEDIA

Art is a form of visual communication: artists make art because they want to express something. Just as writers consider carefully the form that best expresses what they want to say (a long novel, a brief poem, a play or film script, for example), artists consider carefully the materials and processes available to communicate their visual ideas. In fact, art can be made from almost anything: one contemporary artist uses elephant dung in his paintings. There are certain media and processes that have been commonly used by artists, some of them for thousands of years, but others that have been developed more recently. In this part you will learn how most of the art that you will encounter has been made.

PART 2

AND PROCESSES

The main media and processes of art are:

Drawing

Painting

Printmaking

Visual Communication Design

Photography

Film/Video and Digital Art

Alternative Media and Processes

Craft

Sculpture

Architecture

MEDIA AND PROCESSES

2.1

Drawing

Shape: the two-dimensional area the boundaries of which are defined by lines or suggested by changes in color or value Form: an object that can be defined in three dimensions (height, width, and depth) Line: a mark, or implied mark, between two endpoints Sketch: a rough preliminary version of a work or part of a work

He who pretends to be either painter or engraver without being a master of drawing is an imposter.

(William Blake, English artist and poet)

As William Blake suggests, drawing—defined as the depiction of **shapes** and **forms** on a surface, primarily by means of **lines**—is a fundamental artistic skill. Even before we learn to write, we learn to draw; we draw the shape of a cat before we can write the word. Drawing is spontaneous, a convenient way for us to "make our mark" on the world. Like the instinctive crayon marks children make as they explore and develop their fine motor skills, drawing provides a primal outlet for artistic energy and ideas.

Artists draw for many reasons: to define their ideas, to plan for larger projects, to

resolve design issues in preparatory sketches, and to record their visual observations. Of course, drawings can also be finished works of art.

Drawing is the basis of all visual communication. Most artists and designers continue to develop their drawing skills throughout their lives.

Functions of Drawing

Leonardo da Vinci (1452–1519) used drawing to examine the world. His sketchbooks are full of fresh ideas and images, illustrating both his speculative thought and his careful observations. Amongst his explorations, Leonardo dissected human bodies and then drew what he saw. He also studied the works of other writers and artists, and observed the effects of light and shadow on a form. He investigated the mechanics of a bird's wing, and considered whether humans might also be able to fly if the same mechanics were re-created on a human scale. His drawing of a flying machine illustrates a concept that had never been considered in this way before (2.1). Drawing provided Leonardo with a way to express his ideas beyond what could be said in words.

Some of Leonardo's most revolutionary drawings depict the interior anatomy of the human body (2.2). These drawings are especially

2.2 Leonardo da Vinci, Studies of the foetus in the womb, c. 1510-13. Pen and ink and wash over red chalk and traces of black chalk, 12 × 83/4". Royal Collection, England

desecrated the body, including dissection. Leonardo may have been allowed to record his observations because he practiced his drawing **Fresco:** a technique where the methodically and with great care. Some speculate that the Church was interested in Leonardo's observations as possible evidence

rare because the Church banned all acts that

of how the human soul resides in the body.

All artists draw for the same reasons as Leonardo: as an end in itself, to think, and to prepare and plan other works. Drawing played an essential role in Raphael's planning of his **fresco** The School of Athens (see Gateway Box: Raphael, p. 168, **2.3a** and **2.3b**).

artist paints onto freshly applied plaster. From the Italian fresco, fresh

Gateway to Art: Raphael, The School of Athens **Drawing in the Design Process**

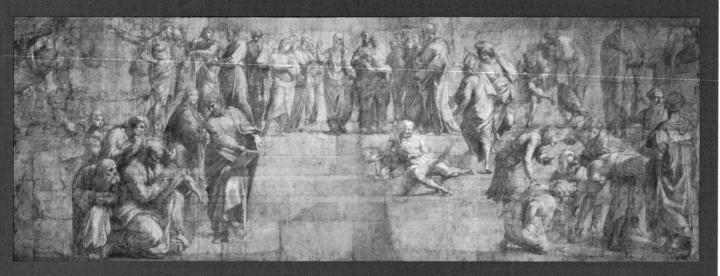

2.3a Raphael, Cartoon for The School of Athens, c. 1509. Charcoal and chalk, 9'41/4" × 26'45/4". Biblioteca Ambrosiana, Milan, Italy

When the Italian painter Raphael (1483-1520) prepared to paint The School of Athens, he drew the image in advance (2.3a), practicing before he tackled the larger work (2.3b). His preliminary drawings allowed Raphael to refine his ideas and perfect the image in smaller scale before investing in the more expensive painting materials he used for the final version.

The artist began the painting process by creating a large drawing of the work, almost the same size as the final painting, to use as the design for a wall mural. This design, called the cartoon, was perforated with small pinholes all along where the lines were drawn. It was then positioned on the wall where Raphael intended to paint the work, and powdered charcoal dust was forced through the small holes in the cartoon's surface, leaving behind an impression of the original drawing. These marks would aid Raphael in drawing the image onto the wall. He applied a thin layer of plaster, repowdered the charcoal dust through the cartoon if necessary, and then began to paint The School of Athens.

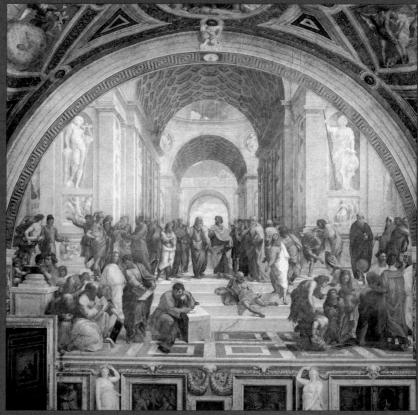

2.3b Raphael, The School of Athens, 1510-11. Fresco, 16'8" × 25'. Stanza della Segnatura, Vatican City

The Materials of **Drawing: Dry Media**

When creating a drawing, an artist must first choose whether to draw using dry **media** or wet media. Dry media offer the artist some unique and versatile properties.

Pencil

Everyone knows what pencils are. We like them because we can erase and correct errors. This makes the pencil a valuable tool for artists as well. Most artists' pencils differ from those used for writing and are categorized by their relative hardness or softness.

A deposit of solid graphite—which looks and writes like lead, but without its weight—was discovered in the mid-1500s and gave rise to the manufacture of the basic pencil we know today.

Pencils have different degrees of hardness (2.4). The softer the pencil, the darker the mark, or grade, and the quicker the pencil loses its point. The B or black graphite pencils are softer and darker than the H series. Number 2 (2B to be precise) pencils are the writing tools used by nearly every American elementary-school student. The H or hard graphite pencils create a relatively light mark. This type of pencil is useful when an artist is doing layout work and does not want pencil lines to show in the final product. Artists carefully choose the grade of the pencil lead they use.

The self-portrait by Hungarian artist Ilka Gedö (1921–85) shows how an artist can vary the pressure of a pencil line to suggest texture and create **emphasis** in a drawing (**2.5**). Gedö has used thick dark lines to imply darkness and thin light lines to suggest lightness. The dark value of the eye and wavy hair, where the pencil has been pressed hard, concentrates our attention on the

2.5 Ilka Gedö, Self-portrait, 1944. Graphite on paper, 115/8 × 83/8". British Museum, London, England

artist's face, while the different sets of straight horizontal and vertical lines recede into the **background**. In further contrast, notice how softly the artist handles the graphite in the areas representing the skin compared with the hair or clothing. Gedö was a survivor of the Holocaust; this drawing records her gaunt features shortly after her internment.

Medium (plural media): the material on or from which an artist chooses to make a work of art, for example canvas and oil paint, marble, engraving, video, or architecture

Texture: the surface quality of a work, for example fine/coarse, detailed/lacking in detail

Emphasis: the principle of drawing attention to particular content in a work

Value: the lightness or darkness of a plane or area

Background: the part of a work depicted as behind the main figures

2.4 Pencil hardness scale from 9H to 9B

2.6 Birgit Megerle, Untitled, 2003. Pencil and colored pencil on paper, $16\frac{3}{4} \times 11\frac{3}{4}$ ". MOMA, New York

Color Pencil

Color pencil is manufactured much like the traditional graphite pencil, but the mixture that makes up the lead has higher amounts of wax and **pigment**. Color pencils are used just like graphite pencils, although their marks may be harder to erase or alter. In 2.6, the German artist Birgit Megerle (b. 1975) applies the colored pencil lightly, allowing the whiteness of the paper to dominate. These pale tones of **color** give the drawing a light overall appearance. Megerle's highly regarded style communicates a sense of stillness.

Silverpoint

Almost every metal will leave a mark on a fibrous surface. Artists during the Italian Renaissance used lead, tin, copper, and silver to draw images. The most common of these drawing metals was silverpoint.

Silverpoint is a piece of silver wire set in some type of a holder, usually wood, to make the wire easier to hold and control. The artist hones the end of the wire to a sharp point. Because of the hardness of the silver, artists can create finely detailed drawings. Historically, artists have drawn with silverpoint on wood primed with a thin coating of bone ash. This creates a white **ground** for the light value of the silver. Because silver tarnishes, the drawing becomes darker and the image more pronounced over time. Working on colored paper creates distinctive effects and was particularly popular in Renaissance Italy (*c.* 1400–1600).

In Heads of the Virgin and Child, a silverpoint drawing by Raphael, the artist uses hatching to create a stronger dark value (2.7). Because silverpoint has such a light value and is usually drawn with very thin lines, much of the white paper is exposed. By closely overlapping many parallel lines across each other, Raphael covers more of the paper, creating the illusion of a darker value. Many artists use this technique to darken values and create the effect of shading.

2.7 Raphael, Heads of the Virgin and Child, c. 1509-11. Silverpoint on pink prepared paper, 5\% \times 4\%". British Museum, London, England

2.8 Käthe Kollwitz, Selfportrait in Profile to Left, 1933. Charcoal on paper, $18^{3}/4 \times 25^{\circ\prime}$. National Gallery of Art, Washington, D.C.

Charcoal

Charcoal has long been an important material in the history of drawing: samples from cave drawings in France have been dated back to 30,000 BCE. Unlike pencils and silverpoint, charcoal smudges easily, creates lines that can be easily shaped and altered, usually has strong dark value, and is soft compared to metal-based drawing materials. Artists choose charcoal as a drawing material when they want to express strong dark tones, add interest to a surface, and make something look solid rather than linear.

Two types of charcoal are common. Vine charcoal is made from thin vine branches and is very soft and easily erased. Compressed charcoal, to which a binding agent such as wax is sometimes added, is much denser.

To make charcoal, finger-length pieces of wood (often dried willow) are placed inside an airtight container (to prevent the loss of important binding chemicals) and heated in an oven until all the wood has been burned.

To draw with charcoal, an artist drags the stick across a fibrous surface, usually paper, leaving a soft-edged line. By using just the end an artist can create thin strokes; by using the side he or she can cover a lot of surface quickly. The amount of pressure an artist exerts while drawing controls the lightness or darkness of the stroke. Sandpaper can be used to sharpen the stick for more detail.

An artist can achieve a soft visual effect by rubbing the newly charcoaled drawing surface with a bare finger, some tissue paper, or a rolled-paper cone called a tortillion, made expressly for this purpose.

Charcoal is so soft that the texture of the paper surface—even the drawing board's texture below the paper—profoundly affects the image. Charcoal works best on paper with a fairly rough texture (known as tooth), which catches the charcoal better in its fibers.

Charcoal portraits by German artist Käthe Kollwitz (1867-1945) and French artist Léon Augustin Lhermitte (1844–1925) show how artists work with the characteristics of the medium (2.8 and 2.9).

In her self-portrait we feel a sense of energy from the way Kollwitz applies the charcoal. Although she renders her own face and hand realistically, in the space between we see the nervous energy connecting the eye to the hand. Kollwitz draws with a spontaneous burst of charcoal marks along the arm, in expressive contrast to the more considered areas of the head and hand.

In An Elderly Peasant Woman Lhermitte works with the characteristics of charcoal to

2.9 Léon Augustin Lhermitte, An Elderly Peasant Woman, c. 1878. Charcoal on wove paper, $18\frac{3}{4} \times 15\frac{5}{8}$ ". National Gallery of Art, Washington, D.C.

Pigment: the colorant in art materials. Often made from finely ground minerals Color: the optical effect caused when reflected white light of the spectrum is divided into a separate wavelength Style: a characteristic way in which an artist or group of artists uses visual language to give a work an identifiable form of visual expression Renaissance: a period of cultural and artistic change in Europe from the fourteenth to the seventeenth century Ground: the surface or background onto which an

artist paints or draws

Hatching: the use of nonoverlapping parallel lines to

convey darkness or lightness

Expressive: capable of stirring the emotions of the viewer

Subject: the person, object, or space depicted in a work of art Contrast: a drastic difference between such elements as color or value (lightness/darkness) Highlight: an area of lightest value in a work

Binder: a substance that makes pigments adhere to a surface Cross-hatching: the use of overlapping parallel lines to convey darkness or lightness

describe his subject carefully. Each line and blemish on this woman's face has been carefully rendered. The charcoal's dark value accentuates the contrast between the highlights in the face and the overall darkened tone of the work. It even carefully preserves the light reflected in her eye. Lhermitte has controlled charcoal's inherent smudginess to offer an intimate view of the effects of aging.

Although there is precise detail in both drawings, each artist allows the "personality" of the charcoal into the softened background through smudges and irregular soft marks.

Chalk, Pastel, and Crayon

Sticks of chalk, pastel, and crayon are made by combining pigment and binder. Traditional

binders include oil, wax, gum arabic, and glues. The type of binder gives each material a unique character. Chalks, pastels, and crayons can be prepared in any color. Chalk is powdered calcium carbonate mixed with a gum arabic (a type of tree sap) binder. Pastel is pigment combined with gum arabic, wax, or oil, while crayon is pigment combined with wax. Conté crayon, a variation invented by Nicolas-Jacques Conté, who was a French painter and army officer, is a heavily pigmented crayon sometimes manufactured with graphite.

For their preparatory sketches, artists of the Renaissance used colored chalks, in particular a red chalk known as sanguine. The Italian artist Michelangelo Buonarroti (1475-1564) used this red chalk for his Studies for the Libyan Sibyl (2.10), which he made in preparation for painting the Sistine Chapel ceiling in Rome. Michelangelo uses hatching and cross-hatching to build up the values and give the figure depth. The artist's study concentrates on the muscular definition of the back and on the face, shoulder, and hand, and gives repeated attention to the detail of the big toe. These details are essential to making this twisting pose convincing, and Michelangelo spent extra time deciding them.

The French artist Edgar Degas (1834–1917) is noted for pastel studies that stand as finished works of art. In The Tub, Degas lays down intermittent strokes of different color pastel (2.11). He takes advantage of the charcoal-like softness of the material to blend the colors together, thus giving them a rich complexity and creating a variety of contrasting textures. In pastel as in painting, Degas was a master at re-creating the effects of light and color seen in nature.

In the Conté crayon drawing Trees on the Bank of the Seine, the French artist Georges Seurat (1859–91) uses hatching and cross-hatching to

2.10 Michelangelo, Studies for the Libyan Sibyl, 1510-11. Red chalk, $11\% \times 8\%$ ". Metropolitan Museum of Art, New York

2.11 Edgar Degas, *The Tub*, 1886. Pastel, $23\% \times 32\%$ ". Musée d'Orsay, Paris, France

2.12 Georges Seurat, Trees on the Bank of the Seine (study for La Grande Jatte), 1884. Black Conté crayon on white laid paper, $24\frac{1}{2} \times 18\frac{1}{2}$ ". Art Institute of Chicago

build up value and create depth (2.12). He designates the **foreground** by using darker values; he allows the color of the paper to be more dominant in areas he wants to recede into the distance. Because this drawing was a study for a subsequent work, Seurat also took special care in organizing the **composition**. For example, the darkest large tree on the left is the focal point of this drawing and leads our eye to the right, where Seurat places a curved tree to direct our attention to the nearby river in the background.

Foreground: the part of a work depicted as nearest to the viewer **Composition:** the overall design or organization of a work Focal point: the center of interest or activity in a work of art, often drawing the viewer's attention to the most important element

Conceptual art: a work in which the ideas are often as important as how it is made

2.13 Robert Rauschenberg,

Erased de Kooning Drawing, 1953. Traces of ink and

crayon on paper, in gold leaf

frame, $25^{1}/4 \times 21^{3}/4 \times \frac{1}{2}$ ".

Modern Art

San Francisco Museum of

Erasers and Fixatives

Erasers are not only used for correction but also to create light marks in areas already drawn. In this way the artist can embellish highlights by working from the dark to light.

Erasers can be used to create works of art by destroying the marks made by an artist. In 1953 the artist Robert Rauschenberg created a new work of art by erasing a drawing by Willem de Kooning (2.13). Rauschenberg, a young unknown artist at that time, approached the famous de Kooning and asked if he could erase one of his drawings. De Kooning agreed, understanding what the younger artist had in mind. But, in order to make it more difficult, de Kooning gave Rauschenberg a drawing made with charcoal, oil paint, pencil, and crayon. It took Rauschenberg nearly a month to erase it, but he did so, leaving a drawing on the back of the work intact. Some in the art world dubbed him "L'Enfant Terrible," which means a young person who behaves badly, but Rauschenberg's idea was to create a performed work of conceptual art and display the result.

Because most dry media are prone to smudging, contemporary artists often use fixative in a spray can to hold the dry media to the surface of the paper.

The Materials of **Drawing: Wet Media**

The wet media used in drawings are applied with brushes or pens. Wet media dry or harden as the liquid evaporates.

Ink

Ink is a favorite of artists because of its permanence, precision, and strong dark color. There are many types of ink, each with its own individual character.

Carbon ink, made by mixing soot with water and gum, has been in use in China and India since around 2500 BCE. This type of ink tended to discolor over time and could become smudged in moist or humid environments. A contemporary version of carbon ink, called India (or Indian) ink, is a favorite of comicbook artists.

Most European ink drawings from the Renaissance to the present day are made with iron gall ink. Gall ink is prized for its nearpermanence and rich black color. It is manufactured from a mixture of tannin (from oak galls—parasitic growths on oak trees), iron sulfate, gum arabic, and water. Gall ink is not entirely lightfast, however, and tends to lighten to brown after many years.

Other types of fluid media include bistre, which is derived from wood soot and usually a yellow-brown color, and sepia, a brown medium that is derived from the secretions of cuttlefish.

Quill and Pen

Traditionally a quill—the shaft of a bird's feather, or a similarly hollow reed—is carved to a point to apply the ink. A slit, running parallel to the shaft, helps control its rate of flow. The modern version is a pen with a metal nib. The artist can control the flow of the ink by pressing harder or more softly. Apart from choosing different widths of nib, the artist can further increase or decrease the width of the drawn line by holding the pen at different angles. Often, pen-and-ink drawings employ

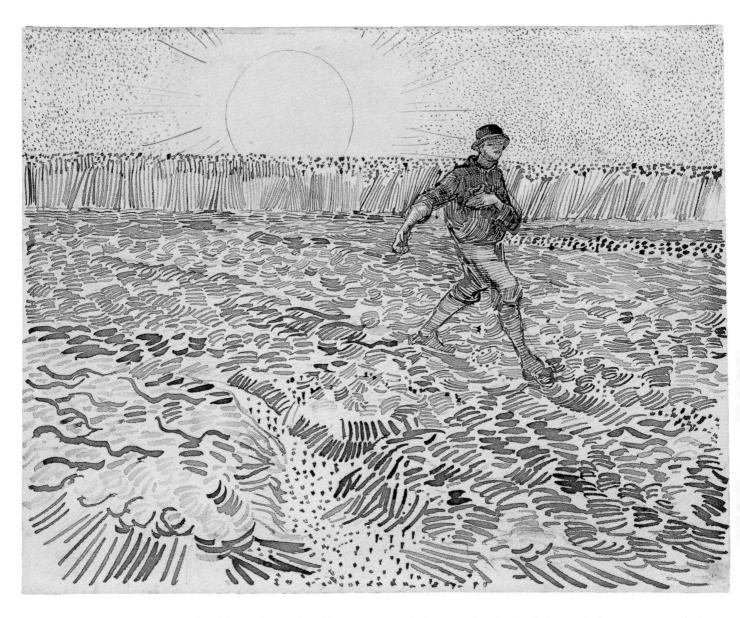

2.14 Vincent van Gogh, Sower with Setting Sun, 1888. Pen and brown ink, $9\% \times 12\%$ ". Van Gogh Museum, Amsterdam, Netherlands

hatching and cross-hatching to create variations in value.

Dutch artist Vincent van Gogh (1853–90) uses a reed pen and brown ink for his Sower with Setting Sun (2.14). By changing the way he applies his pen strokes and by controlling their width, he creates an undulating, restless design. Van Gogh's emphatic direction of line expresses the characteristic energy of his work.

Brush Drawing

Because ink is a liquid medium it can also be applied with a brush. The ancient Chinese used brush and ink for both writing and drawing. Even today, children throughout east Asia who are learning to write must learn to control a

brush effectively, much the same way students in the West learn to use pens and pencils.

East Asian artists use the same brush for writing and drawing. These brushes are made with a bamboo shaft and either ox, goat, horse, or wolf hair. Traditionally, Asian artists use a stick of solid ink that they hold upright and grind on a special ink stone with a small amount of water. As the ink reaches the desired consistency, it is pushed into a shallow reservoir at the rear of the stone. Artists wet the brush by dipping it into this reservoir, and then adjust the shape and charge of the brush by stroking it on the flat of the grinding stone. They can readily adjust the dilution of the ink with water to create an infinite range of grays. This is called a wash, and it allows the artist to control value and texture.

2.15 Wu Zhen, Leaf from an album of bamboo drawings, 1350. Ink on paper, 16×21 ". National Palace Museum, Taipei, Taiwan

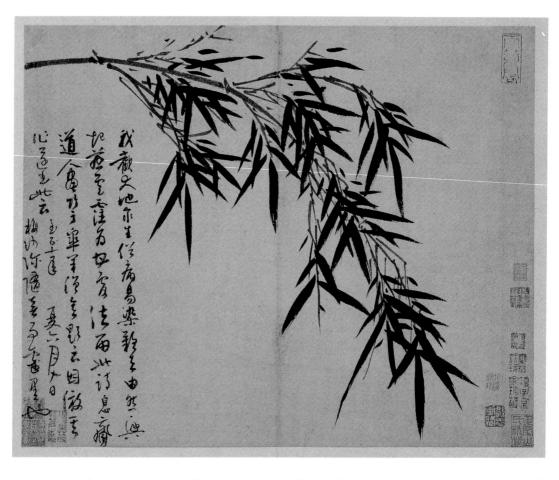

2.16 Claude Lorrain, The Tiber from Monte Mario Looking South, 1640. Dark brown wash on white paper, 7^{3} / $\times 10^{5}$ %". British Museum, London, England

In 2.15 the fourteenth-century Chinese artist Wu Zhen (sometimes spelled Wu Chen) (1280– 1354) uses brush, ink, and wash to create a masterpiece of simplicity. This finely planned design contains carefully controlled brushstrokes as well as loose, freer ink applications, thereby bringing together two opposing influences and

In his image of the landscape just north of Rome, The Tiber from Monte Mario Looking South, the French artist Claude Lorrain's (1604/5-82) thoughtful brushstrokes give us a feeling of the great expanse of the Italian countryside (2.16). The wash that Lorrain uses gives a sense of depth by making the values of the foreground areas both the darkest and lightest of the whole drawing.

Paper

Before the invention of paper, drawings were made on papyrus (a plant material), cloth, wood, and animal hide (parchment and vellum). Paper was invented in China by Cai Lun, who manufactured it from pounded or macerated plant fibers, at around the end of the first century CE. The image in 2.17, even though it was made more than 1,500 years later, shows how this was done. The fibers are suspended in water and then scooped up into a flat mold with a screen at the bottom, so that the water can escape. The fibers are now bonded enough to each other to keep their shape when they are taken out. The sheet is then pressed and dried.

Over the centuries improvements were made to the construction of the mold to speed up times for papermakers to flip out molded sheets of paper and reuse the mold. Handmade papers are still manufactured this way in many countries, mostly from cotton fiber, although papers are also made of hemp, abaca, flax, and other plant fibers.

In addition to their fiber content, papers are classified by their surface texture and weight. Depending on the construction of the mold, the paper usually has a surface texture described as

2.17 Hishikawa Moronobu, Papermaking in Japan, showing the vatman and the paper-drier, from the Wakoku Shōshoku Edzukushi, 1681. Woodblock print.

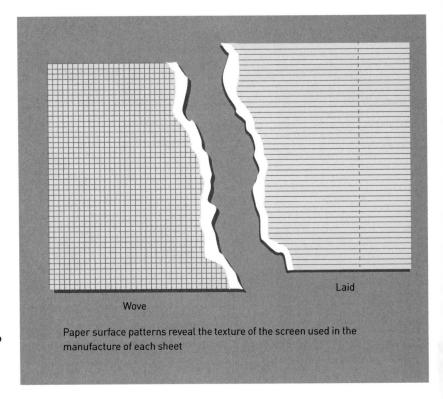

either wove or laid. The laid texture derives from a screen (bottom of the mold) composed of many parallel rods, like a bamboo mat, whereas the wove texture derives from the use of a grid-like

mesh of metal wire or cloth (see 2.18).

Paper in bulk is normally measured by the ream (a quantity of 500 sheets). The standard measurement for defining the character of paper is its weight per ream in the paper's basic sheet size. (For cotton rag paper, the sheet size is usually 17×22 in.) For example, if 500 sheets of 17×22 in. paper weigh 20 lbs., the paper is referred to as "20 lb." Heavier papers are stronger and usually better to work with, but they are more expensive.

2.18 Surface texture of wove and laid paper

The Drawing Process

Life drawing is the practice of drawing from a live model, as opposed to using photographs, plaster casts, or other existing artworks as source material. We associate this process with nude models, but life drawing can also involve animals, plants, and architecture. Life drawing is one of the core skills that art students learn. In addition to the extended study of live models, two types of introductory drawing methods are popular in the teaching of life drawing: gesture and contour.

Cast: a sculpture or artwork made by pouring a liquid (for example molten metal or plaster) into a mold Contour: the outline that

defines a form

Gateway to Art: Matisse, Icarus Line and Shape

un moment me moment
di libres.

Pre devraitem
pas faire ac.
complir un
grand voyage
en avion aux
jeunes gens
ayanttermine
ceurs études.

Contour lines provide linear clues about the surface of an object. In his pen-and-ink line drawing of a woman, Henri Matisse pays close attention to the lines that define the woman's face and clothing (2.19). The outer profile and undulating surfaces of the figure are depicted in a long continuous line. Matisse also uses contours to give the suggestion of shape, rather than choosing more traditional methods, such as cross-hatching or shading. His interest in economically defining a shape can be seen not only in his contour drawings but also in his "cutouts," such as Icarus (2.20). Matisse enjoyed working with pieces of solid painted paper and cutting them to create the contours of a shape. In effect, the edges of the paper shapes formed the equivalent of contour lines in his drawings. Matisse described his cutouts as "drawing with scissors," implying that to him there was no great difference between working with contour lines and paper cutouts.

Matisse loved simplicity and proclaimed that he wanted his paintings to be like "a comfortable chair." The process of contour drawing has the kind of spontaneity that such artists as Matisse use to give a work a fresh, simple, and "comfortable" feeling. In Matisse's paper cutout work Icarus, the pleasant organic lines and colorful shapes are derived from his careful observation of contour lines. Thus, the simple clarity present in the contour lines of Woman Seated in an Armchair is used to create a feeling of "comfort" that is also found in the bold shapes of Matisse's paintings and paper cutouts.

2.19 (top left) Henri Matisse, Themes and Variations, Pen and ink, $19^{3}/4 \times 15^{3}/4$ ". Musée des Beaux-Arts, Lyons, France

2.20 (left) Henri Matisse, Icarus, from Jazz, 1943-7. Page size $16\% \times 12\%$ ". MOMA, New York

Rhythm: the regular or ordered repetition of elements in the work

Three-dimensional: having height, width, and depth Outline: the outermost line of an object or figure by which it is defined or bounded

2.21 Umberto Boccioni. Muscular Dynamism, 1913. Pastel and charcoal on paper, $34 \times 23^{1/4}$ ". MOMA, New York

Gesture Drawing

Gesture drawing aims to identify and react to the main visual and expressive characteristics of a form. Since artists often confront changing subjects and situations, capturing the energy of the moment is the essential goal of gesture drawing.

The energy of the human figure is evident in Muscular Dynamism (2.21), by the Italian artist Umberto Boccioni (1882-1916). In this drawing the movement of the body is implied by the undulating strokes of the chalk and charcoal. The **rhythms** of the composition lead our eye through a series of changing curves and values that give us a feeling of the energy of the figure.

Contour Drawing

Contour drawing aims to register the essential qualities of **three-dimensional** form by rendering the outline, or contour, of an object. An artist uses contour drawing to sharpen hand-eye coordination and gain an intimate understanding of form, increasing his or her sensitivity to essential detail. For example, contour drawing can help an artist copy the shape of a leaf as faithfully as possible. The French artist Henri Matisse was an excellent draftsman who used elegant contour line to extract the essence of a shape (see Gateway Box: Matisse). In his work Woman Seated in an Armchair the essence of the portrait is captured by the organic curves of the contour lines.

Conclusion

Drawing, like writing, is something we all do. As an innate part of our humanity, we may have the urge to draw in order to record, visualize, and express ourselves. Artists are exactly the same, but they also want to refine their skills, to think, and to prepare and plan other works.

With regard to how drawing is done, artists use a variety of dry media, including pencil, silverpoint, and charcoal, and chalks, pastels, and crayon. Each technique lends itself to a different range of expressive effects. Artists achieve the rich blackness or softly subtle washes in their wet media drawings by applying a variety of inks with either quills, pens, or brushes. The "tooth" or character of the paper (or other material) is an important part of the final result.

The drawing process can start from the life drawing of a variety of subjects, from nude models to plants; in the teaching of drawing, gesture and contour drawing are two techniques that aim to capture the essence of the subject. Drawing has economy, immediacy, and simplicity. It is the gateway through which nearly every work of art first enters the world.

MEDIA AND PROCESSES

Painting

When most of us think of art, painting is the medium that most often comes to mind. Perhaps this is not surprising, since artists have painted surfaces of many kinds for tens of thousands of years. In prehistoric times, artists painted on the walls of caves. The temples of ancient Greece and Mexico were painted in bright **colors** that look, to our contemporary tastes, garish. Modern muralists and graffiti artists also paint on walls. Of course, artists also paint on a much smaller and more intimate scale, on a stretched canvas or a sheet of paper. The artistic possibilities paint offers are almost limitless, and the effects achieved are often amazing.

There are many kinds of paints, suitable for different purposes, but they all share the same components. Paint in its most basic form is composed of **pigment** suspended in a liquid **binder** that dries after it has been applied. Pigment gives paint its color. Traditionally, pigments have been extracted from minerals, soils, vegetable matter, and animal by-products. The color umber, for example, originated from the brown clay soil of the Umbria region in Italy. Ultramarine—from the Latin ultramarinus, beyond the sea—is the deep, luxurious blue favored for the sky color in some Renaissance painting; it was ground from lapis lazuli, a blue stone found in Afghanistan. In recent times, pigments have been manufactured by chemical processes. The bright cadmium reds and yellows, for instance, are by-products of zinc extraction.

Pigments by themselves do not stick to a surface. They need a liquid binder, a substance that allows the paint to be applied and then dries,

leaving the pigment permanently attached. Just as there are many kinds of pigments, there are many binders, traditionally beeswax, egg yolk, vegetable oils and gums, and water; in modern times, art-supply manufacturers have developed such complex chemical substances as polymers. Painters also use solvents for different reasons, for example adding turpentine to oil paint to make it thinner.

Artists use many kinds of tools to help them paint. Although historically brushes have been the most popular, some artists have used compressed air to spray paint on to their chosen surface; others have spread it around with a palette knife as if they were buttering toast. Sometimes they have poured it from buckets, or have ridden across the canvas on a bicycle the wheels of which were covered in it; others have dipped their fingers, hands, or entire body in it so they can make their marks.

Paint is an attractive and versatile material that has been used to create artworks ever since prehistoric people first applied pigment to the walls of their caves. This chapter will survey its most common forms, and the methods and tools used in the painting process. It will also introduce some notable painters and paintings.

Encaustic

Encaustic is an attractively semi-transparent paint medium that was used by the ancient Greeks and Romans, and which continues to be chosen by some artists today. To use encaustic an artist must mix pigments with hot wax and then apply the mixture quickly. He or she can use

Medium (plural media): the material on or from which an artist chooses to make a work of art, for example canvas and oil paint, marble, engraving, video, or architecture

Color: the optical effect caused when reflected white light of the spectrum is divided into a separate wavelength

Scale: the size of an object or artwork relative to another object or artwork, or to a system of measurement

Pigment: the colored material used in paints. Often made from finely ground minerals Binder: a substance that makes

pigments adhere to a surface Renaissance: a period of cultural and artistic change in Europe from the fourteenth to the seventeenth century

2.22 Palette knife, a tool that can be used by the painter for mixing and applying paint

brushes, palette knives (2.22), or rags, or can simply pour it. A stiff-backed support is necessary because encaustic, when cool, is not very flexible and may crack. The Greeks and Romans typically painted encaustic on wood panel.

Ancient Roman painters showed great ability in controlling encaustic paint and produced beautiful results. The image of a boy in 2.23 was made by an anonymous artist during the second century CE in Roman Egypt. This type of portrait would have been used as a funerary adornment that was placed over the face of the mummified deceased or on the outside of the sarcophagus in the face position. The artist took great care to create a lifelike image and probably captured a fairly **naturalistic** image of the deceased boy.

2.23 Portrait of a boy, c. 100-150 cE. Encaustic on wood, $15^{3}/8 \times 7^{1}/2$ ". Metropolitan Museum of Art, New York

Encaustic portraits from this era are referred to as Fayum portraits after the Fayum Oasis in Egypt where many of them were found.

Tempera

If you have ever scrubbed dried egg off a plate while washing dishes, you know how surprisingly durable it can be. Painters who use egg tempera have different ideas about what parts of the egg work best for tempera painting, but artists during the Renaissance preferred the yolk. Despite its rich yellow color, egg yolk does not greatly affect the color of pigment; instead, it gives a transparent soft glow. Tempera is best mixed fresh for each painting session.

As in many Italian paintings of the fifteenth century, the paint of The Virgin and Child with Angels (2.24, by an unknown artist) consists of pigment and egg yolk. It also incorporates oil and gold leaf, a common combination at this time.

Support: the material on which painting is done Naturalism (adjective naturalistic): a very realistic or lifelike style of making images

2.24 The Virgin and Child with Angels, Ferrarese School, c. 1470–80. Tempera, oil, and gold on panel, 23×17^{3} %". National Gallery of Scotland, Edinburgh

2.25 Riza Abbasi, Two Lovers, Safavid period, 1629-30. Tempera and gilt paint on paper, $7\frac{1}{8}$ × 43/4". Metropolitan Museum of Art, New York

The image has been painted onto a wood panel, but the artist has chosen to paint an illusionistic frame that makes us think we are looking at the back of a damaged canvas. The tattered cloth and tacked binding-even the fly in the lower left-hand

corner—are painted with careful attention to texture and realistic appearance. Tempera is normally painted with short thin strokes and lends itself to such careful detail.

Tempera is usually applied with a brush and dries almost immediately. The earliest examples of egg tempera have been found in Egyptian tombs. From the fifth century CE onward, painters of icons (stylized images of Jesus and saints) in modern-day Greece and Turkey perfected the use of the medium and transmitted the technique to early Renaissance painters in Europe and the Middle East. Islamic artists enjoyed the sensitive detail that can be achieved with tempera, and some used tempera with gold leaf to create rich images for the ruling class. In Two Lovers by the Persian miniaturist Riza Abbasi (1565-1635) we see the rich gold-leaf finish combined with the high detail of tempera (2.25). Riza, who worked for Shah Abbas the Great, has used the transparency of the medium to make the plant life look delicate and wispy. The intertwined lovers stand out proudly from the softness of the plants in the **background**.

The appeal of tempera painting continues today. It has been used to create some of the most recognizable works in American art. Andrew Wyeth (1917–2009), loved by Americans for his sense of realism and high detail, chose tempera to

2.26 Andrew Wyeth, Christina's World, 1948. Tempera on gessoed panel, $32\frac{1}{4} \times 47\frac{3}{4}$ ". MOMA, New York

Stylized: art that represents objects in an exaggerated way to emphasize certain aspects of the object

Background: the part of a work depicted as furthest from the viewer's space, often behind the main subject matter

create works that provide a glimpse into American life in the mid-twentieth century. The subject of Christina's World (2.26) is a neighbor of Wyeth's in Maine who had suffered from polio and could not walk. Wyeth has chosen to place her in a setting that expresses (in Wyeth's words) her "extraordinary conquest of life." The scene appears placid and bright, reflecting Wyeth's great admiration for her. The high degree of detail gives a sense of mystery that stimulates our imagination.

Fresco

Fresco is a painting technique in which the artist paints onto freshly applied plaster. The earliest examples of the **fresco** method come from Crete in the Mediterranean (the palace at Knossos and other sites) and date to c. 1600–1500 BCE. Frescoes were also used later, to decorate the inside of Egyptian tombs. The technique was used extensively in the Roman world for the decoration of interiors, and its use was revived during the Italian Renaissance. The pigment is not mixed into a binder, as it is in other painting techniques. Instead, pigment mixed with water is applied to a lime-plaster surface. The plaster absorbs the color and the pigment binds to the lime as it sets. Once this chemical reaction is complete the color is very durable, making fresco a very permanent painting medium.

There are two methods of fresco painting: buon fresco (Italian for good fresco) and fresco secco (dry fresco). When artists work with buon fresco they must prepare the wall surface by rendering undercoats of rough plaster containing sand, gravel, cement, and lime. The artist adds a further (but not final) layer of plaster and allows it to dry for several days; he or she then transfers onto it the design from a full-scale drawing (referred to as a cartoon) in preparation for the final painting. Next, the artist applies the last finishing layer of plaster, re-transferring onto it the required part of the cartoon. Onto this he or she will paint pigment suspended in water. Because there are only a few hours before the lime plaster sets, only a portion of the wall is freshly plastered each day. If the artist makes a mistake, the plaster must be chiseled away and the

procedure repeated. These technical challenges are offset by the brilliance of color for which fresco is renowned.

Many of the Renaissance fresco paintings were made to decorate the interiors of churches. The Italian artist Michelangelo Buonarroti (1475–1564) used the buon fresco method to decorate the ceiling of the Sistine Chapel in Rome. For this monumental undertaking, requiring four years to complete, Michelangelo needed to craft a strategic approach in order to disguise the seams between separate days' work. For example, in one section called the Libyan Sibyl he only plastered the area where the leg in the **foreground** was to be painted (2.27). This was probably a day's work, and the seam of the plaster could be camouflaged because the surrounding edges (the purple drapery in particular) change color and value.

If an artist cannot finish painting a section within a day of plastering, or needs to retouch a damaged fresco, he or she employs the dry fresco method. Wet rags moisten the lime plaster that

2.27 Michelangelo, The Libyan Sibyl, 1511-12. Fresco. Detail of the Sistine Chapel Ceiling, Vatican City

Subject: the person, object, or space depicted in a work of art Fresco: a technique in which the artist paints onto freshly applied plaster. From the Italian fresco, fresh

Foreground: the part of a work depicted as nearest to the viewer Value: the lightness or darkness of a plane or area

Perspectives on Art: Melchor Peredo

Fresco Painting Inspired by the Mexican Revolution

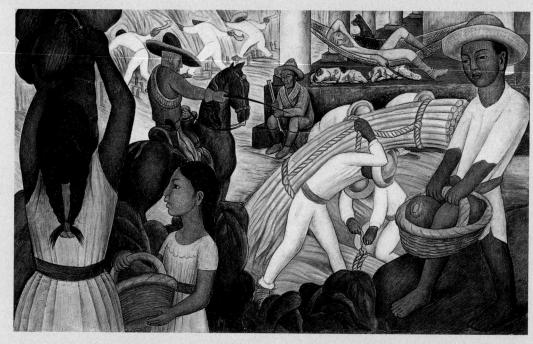

2.28 Diego Rivera, Sugar Cane, 1931. Fresco on plaster, 4'10" × 7'11". Philadelphia Museum of Art

2.29 Melchor Peredo, Remembrance Fresco, 1999. Fresco, each panel 4 x 8'. Harton Theater, Southern Arkansas University, Magnolia

During the twentieth century, Mexican mural artists painted the walls of public buildings with works that expressed their aspirations for social justice and freedom. The Mexican painter Melchor Peredo (b. c. 1929) studied with the great mural painters and has painted murals throughout Europe and North America. Here he explains how the revolutionary traditions of his

country inspired a mural at Southern Arkansas University in Magnolia.

For more than thirty years Porfirio Díaz ruled Mexico as a dictator. This was a time of injustice and great divisions between the powerful rich and the poor masses. In 1911, the Mexican people rebelled and forced Díaz to resign. For

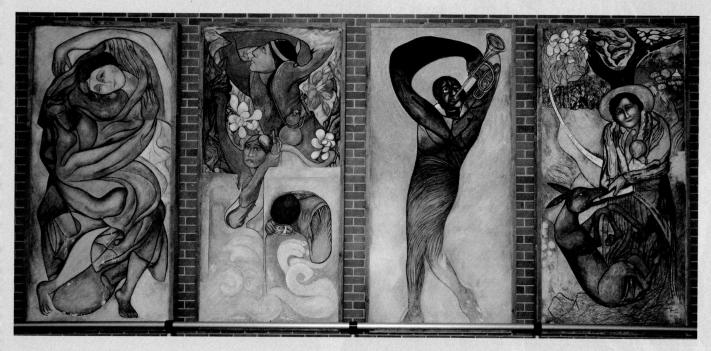

ten years revolutionary groups led the fight for social justice.

In the 1920s a group of artists decided to champion the struggles of ordinary Mexicans and express the ideals of the Mexican Revolution by reviving the art of fresco painting. Diego Rivera, José Clemente Orozco, David Alfaro Siqueiros, Juan O'Gorman, and others covered the walls of public buildings with murals that were painted as a gift that could be enjoyed by all the people of Mexico. The mural painters were political radicals who were influenced by the ideas of socialist and communist leaders. The Russian revolutionary Leon Trotsky was exiled to Mexico and lived in the home of Diego Rivera.

When I was a student at La Esmeralda art school in Mexico, I went to the National Palace in downtown Mexico City where Diego Rivera was painting murals, to invite him to give a lecture at our school. Rivera seemed disturbed by my interruption and came down off the scaffold, looking at me with his protruding eyes. "Yes, I will go," he said, "because that is a revolutionary school."

One of Rivera's works I admire is Sugar Cane (2.28). It portrays the exploitation of workers on the large sugar farms in Morelos, south of Mexico City. Rivera painted this work at the Palace of Cortés (the Spanish conqueror of Mexico) in Cuernavaca. He also made a portable version in 1931 to be exhibited at the Museum of Modern Art in New York City.

In 1999 I completed Remembrance Fresco at Southern Arkansas University (2.29). I began by making a drawing. The design focuses on important historical figures and local folklore, based on ideas given to me by students and members of the local community. This is a portable fresco, like Rivera's, painted on a large wooden container mounted on the wall, so next I layered cement, sand, gravel, and lime plaster on the wooden support, adding more lime with each application. When I reached the secondlast layer, using a perch (a long stick), I drew the images from my sketch onto the wall. After applying a final thin, slick layer of plaster over the drawings I painted the final colors for the mural. The work still hangs at the Harton Theater on the campus.

has already set to encourage absorbency, and the wall is then painted. The once-dry lime surface soaks up some of the pigment. Frescoes painted using the fresco secco method tend to be less durable than buon fresco because the surface is less absorbent.

Oil

Painting with oil is a relatively recent invention compared to encaustic, tempera, and fresco. Artists used oil paint during the Middle Ages, but have only done so regularly since the fifteenth century, particularly in Flanders (modern-day Belgium, Netherlands, and northern France). The oil used as a binder there was usually linseed oil, a by-product of the flax plant from which linen cloth is made. Giorgio Vasari, an Italian Renaissance writer and artist, credits the fifteenthcentury Flemish painter Jan van Eyck (c. 1395– 1441) with the invention of oil paint. In fact, van Eyck did not invent oil paint, but he is its most astonishing early practitioner: see 2.30.

2.30 Jan van Eyck, *The Madonna* of Chancellor Rolin, 1430-34. Oil on wood, 26 × 24 3/8 ". Musée du Louvre, Paris, France

2.31 Joan Brown, Girl in Chair, 1962, Oil on canvas. 5 × 4'. LACMA

Because it is so flexible, oil paint readily adheres to a cloth support (usually canvas or linen)—unlike encaustic, which is usually painted onto a stiff panel. Painters like oil paint because its transparency allows the use of thin layers of color called glazes. In the hands of such artists as van Eyck, glazes attain a rich luminosity, as though lit from within. Because oil paint is slow drying, artists can blend it and make changes days after the initial paint has been applied, thereby achieving smooth effects and a high level of detail.

Modern and contemporary artists have used oils to achieve quite different **expressive** effects. The San Francisco artist Joan Brown (1938–90) used oil in an **impasto** (thickly painted) fashion (2.31). Because oil paint is normally thick enough to hold its shape when applied to a surface, the paint can pile up, giving Brown's work a threedimensional presence.

The Chinese-born artist Hung Liu (b. 1948), who grew up in Communist China before emigrating to the United States, utilizes the different qualities of oil paint to achieve her own unique style. Hung's images express her Chinese roots. Her work Interregnum juxtaposes images and styles (2.32). The traditional Chinese style is

Luminosity: a bright, glowing quality

Expressive: capable of stirring the emotions of the viewer **Impasto:** paint applied in thick lavers

Three-dimensional: having height, width, and depth Style: a characteristic way in which an artist or group of artists uses visual language to give a work an identifiable form of visual expression

Baroque: European artistic and architectural style of the late sixteenth to early eighteenth centuries, characterized by extravagance and emotional intensity

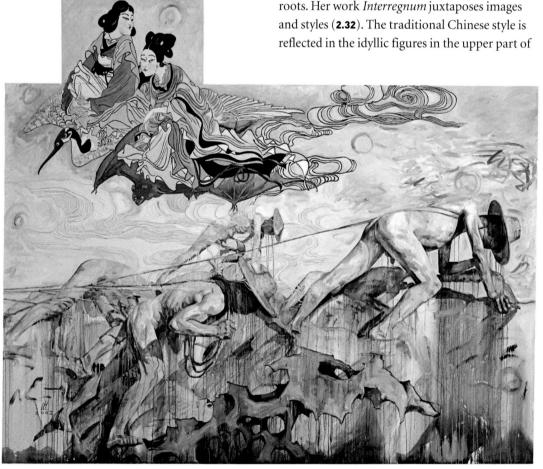

2.32 Hung Liu, Interregnum, 2002. Oil on canvas, $8' \times 9'6''$. Kemper Museum of Contemporary Art, Kansas City, Missouri

Gateway to Art: Gentileschi, Judith Decapitating Holofernes **Paintings as Personal Statements**

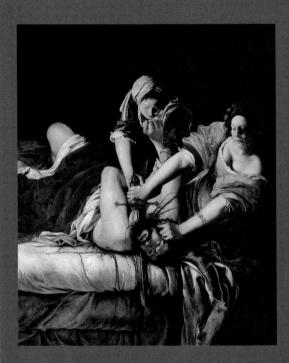

2.33 Artemisia Gentileschi, Judith Decapitating Holofernes, c. 1620. Oil on canvas, $6'6\frac{3}{8}" \times 5'3\frac{3}{4}"$. Uffizi Gallery, Florence, Italy

At a time when there were very few women working as professional artists, Italian Baroque artist Artemisia Gentileschi (1593-c. 1656) earned a reputation as a talented and accomplished painter. Women were not allowed to follow the traditional avenues of apprenticeship to complete their training as painters, but Gentileschi was the daughter of an artist, and her talent was recognized and fostered by her father. Unlike her male contemporaries, Gentileschi often depicted strong female figures with emotion, intensity, and power, as exemplified in Judith Decapitating Holofernes (2.33); but she also painted many portraits, some of which were in oil paint, including the self-portrait shown here (2.34).

Artists have always made self-portraits to show off their skill and define themselves as they wish others to see them. In Allegory of Painting—"allegory" here meaning an image of a person that represents an idea or abstract quality—Gentileschi depicts herself at the moment she begins to paint, holding a brush in one hand and her palette in the other. The mask pendant around her neck signifies that painting is an illusion only an inspired master can produce. She shows painting as a physical, energetic act; she is about to be inspired to paint upon the blank canvas before her. Just as Judith Decapitating Holofernes portrays strong female figures, Gentileschi's selfportrait shows her succeeding in the maledominated world of the professional artist.

2.34 Artemisia Gentileschi. Self-portrait as the Allegory of Painting (La Pittura), 1638-9. Oil on canvas, 38 × 29". Royal Collection. London, England

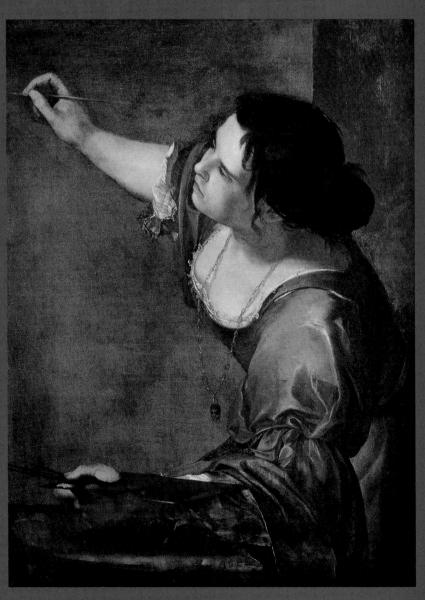

the work, in contrast with the back-breakingly hard reality of life under the Communist leader Mao Zedong in the lower part. Hung's work shows the discontinuity between reality and the ideal.

Acrylic

Acrylic paints are composed of pigments suspended in an acrylic polymer resin. They dry quickly and can be cleaned up with relative ease. Latex house paint is made of acrylic polymer. These paints have only been in use since about 1950. Unlike oil paints, which dissolve only in turpentine or white spirit, acrylics can be cleaned up with water. When dry, however, they have similar characteristics to those of oil paint.

Many professional artists, including the contemporary Japanese-American artist Roger Shimomura (b. 1939), prefer acrylics as their primary painting medium. Shimomura uses them to create works that investigate the relationships between cultures. He merges traditional Japanese imagery, such as a shogun warrior, with popular

culture and typically American subjects, such as Superman. This combination of styles reflects the mixing of cultures resulting from communication and contact between nations. In *Untitled* (2.35) Shimomura refers to the internment of Japanese-Americans during World War II. The painting explores the effects of conflict between two cultures.

Watercolor and Gouache

Watercolor and gouache suspend pigment in water with a sticky binder, usually gum arabic (honey is used for French watercolor), which helps the pigment adhere to the surface of the paper when dry. Watercolor is transparent, but an additive (often chalk) in gouache makes the paint opaque. Usually watercolor and gouache are painted on paper because the fibers of the paper help to hold the suspended pigments in place. The portability of watercolor (all the artist needs is brushes, small tubes or cakes of paint, and paper) has made it vastly appealing.

2.35 Roger Shimomura. Untitled, 1984. Acrylic on canvas, $5^{1}/2^{2} \times 6^{1}/4^{2}$. Kemper Museum of Contemporary Art, Kansas City, Missouri

2.36 Albrecht Dürer, A Young Hare, 1502. Watercolor and gouache on paper, $9\% \times 8\%$. Graphische Sammlung Albertina, Vienna, Austria

2.37 (right) Sonia Delaunay, Prose of the Trans-Siberian Railway and of Little Jehanne of France, 1913. Watercolor and relief print on paper, support $77 \times 14"$

Watercolor's ease of use poses one inherent challenge. Watercolor is transparent, but there is no white transparent pigment; any white area in a watercolor is simply unpainted paper. If an artist paints a white area by mistake, one solution is to paint it over with opaque white gouache.

The watercolors of the German Albrecht Dürer (1471–1528) are noted for their masterful naturalism. Dürer's works, such as A Young Hare, reflect direct observation of a natural subject (2.36). Above all, the artist conveys a sense of the creature's soft, striped fur through a combination of watercolor with opaque white heightening.

French artist Sonia Delaunay (1885–1979), the first woman to have her work shown at the Louvre Museum in Paris, France, during her lifetime, mastered the art of watercolor. Prose of the Trans-Siberian Railway and of Little Jehanne of France (2.37), an artist's book, was part of a collaboration with the poet Blaise Cendrars (1887–1916). If all 150 copies of the first edition were placed end to end, it was intended they would stretch the height of the Eiffel Tower. The book was also meant to be folded like a roadmap, and it recounts a trip from Russia to Paris. Delaunay's work is a "simultaneous book" in which her watercolor illustration on the left is set next to the Cendrars poem on the right. She used the bright colors that watercolor affords to create an illustration that progressively changes as the reader advances down the page.

Ink Painting

Although artists often use ink with a pen on paper, they also use it for painting. Different surfaces require differences in ink. If you are drawing on a surface that is not fibrous enough, you need to modify the ink. Ink is commonly used on paper because the fibers hold the pigment, but a slicker surface needs an additional binder. Painting inks

Opaque: not transparent Artist's book: a book produced by an artist, usually an expensive limited edition, often using specialized printing processes

are slightly different from drawing inks because they have a binder, usually gum arabic, rather than simply being suspended in water. Ink can be painted in much the same way as watercolor; artists

2.38 Suzuki Shōnen, Fireflies at Uji River, Meiji period, 1868-1912. Ink, color, and gold on silk; hanging scroll, 13³/₄ × 50". Clark Family Collection

sometimes incorporate it into their watercolor paintings to give extra richness and darker values.

Japanese artist Suzuki Shōnen (1849–1918) makes good use of the expressive rich blackness of ink in his *Fireflies at Uji River* (2.38). The luscious darkness of the ink on silk scroll supports the retelling of a night scene from the eleventhcentury Japanese novel The Tale of Genji, when a young man tries to overhear the conversation of two young women. The rushing waters of the Uji obscure their words from the eager ears of the would-be suitor. The artist emphasizes the power of the rushing water with strong brushstrokes and powerful diagonals.

Mask: in spray painting or silkscreen printing, a barrier the shape of which blocks the paint or ink from passing through **Stencil:** a perforated template allowing ink or paint to pass through to print a design

Spray Paint and Wall Art

Believe it or not, spray painting is one of the oldest painting techniques. Researchers have discovered that some images on the cave walls of Lascaux, France, were applied by blowing a salivaand-pigment solution through a small tube. Although today's spray paint comes in a can, the technique is essentially the same as it was 16,000 years ago. Because the spray spreads out in a fine mist, the ancient spray-paint artist, like today's spray painters, would **mask** out areas to create hard edges. Ancient artists may even have done this with the edge of their hand, covering the wall where they did not want the paint to fall.

2.39 John Matos, a.k.a. "Crash," Aeroplane 1, 1983. Spray paint on canvas, $5'11\frac{1}{4}" \times 8'7"$. Brooklyn Museum, New York

2.40 Blek le Rat, *David with the Machine Gun*, 2006. New York

Nowadays, spray paint can be applied using a spray gun or spray can, a favorite of tag and graffiti artists. Graffiti artists prefer to use spray enamel, a commercially produced paint, packaged in an aerosol can and generally used for applying an even coating on a slick surface. A propellant forces the paint out in a fine mist when the user pushes down on the valve button. Graffiti artists often cut into the spray nozzle with a knife to alter the spray stream, for example to spread a wider mist.

Practitioners of spray-painted graffiti art are considered vandals and criminals by local governments when they paint places without the permission of the property owners. Because of this, many keep their identity secret and sign their work with an alias, called a tag. Even so, many graffiti artists have become known, even celebrated. John Matos (b. 1961), whose tag is "Crash," is considered a founder of the graffiti art movement. He began spray painting New York City subway cars at the age of thirteen. Crash exhibited *Aeroplane 1* at the Brooklyn Museum in 2006 (2.39).

The French graffiti artist known as Blek le Rat (b. Xavier Prou, 1952) uses **stencils** as a quick way of transferring his designs to surfaces. (Speed of application is important to graffiti artists, who often risk being arrested for defacing private property.) In *David with the Machine Gun*, Blek le

Rat ironically juxtaposes an image of Michelangelo's famous statue *David* with a superimposed machine gun (2.40). Blek le Rat is considered an artivist, an artist/activist whose work is part of a larger movement, called culture jamming, that draws attention to social or political issues. This unauthorized rendering was spray painted on a building in support of Israel and was not well received by the European public, who hold a wide array of opinions regarding the relationship between Israeli Jews and the Palestinians.

Conclusion

In the 18,000 years between the spray painters of the Lascaux caves and their graffiti counterparts today, painters have continued to turn to the spectacular effects of different kinds of paint. The wax of encaustic, the egg of tempera, and the wet plaster of fresco have all offered artists technically demanding ways of combining pigment with a binder to depict subjects in durable and vivid color. Additionally, the invention of oil paint helped Renaissance artists achieve astonishing naturalism and luminosity of light effects. The strength, flexibility, and versatility of oil paint have continued to make it a favorite medium for artists right through to the present day. Its modern variant, acrylic, is a water-based medium and gives similar results, and artists can simply clean their brushes under the faucet. Watercolor, gouache, and inks are other kinds of water-based paint. Watercolor needs the minimum of equipment, and so has long been popular with professionals and amateurs alike, particularly for direct observation of nature outside of the studio.

By selecting a paint suitable for the chosen support, an artist can make images on areas as large as a wall or even an entire building, or at a much smaller scale, such as on a canvas or sheet of paper. Artists achieve many kinds of visual effects by changing the consistency of the paint with solvents or by working creatively with a variety of tools. Yet paint is actually a quite simple medium that for thousands of years has provided artists with a versatile means for communicating their thoughts, dreams, feelings, ideas, and experiences.

Printmaking

Before the invention of printing, artists who wanted to have multiple copies of their work needed to copy it over by hand, one reproduction at a time. Printing with inks, first used in China to print patterns on fabrics in the third century CE, changed all that. Printing allowed the same designs to be more easily reproduced and distributed to many people. In the world of art, however, printmaking is much more than a way of copying an original. There are many different techniques, and each one gives a unique character to every work it creates. Artists may well choose a particular technique because they think it will suit the kind of effect they want to achieve.

Although artists may not always do the production work themselves, if they create the master image, supervise the process, and sign the artwork, it is considered an original print. This differs from a commercial reproduction of an artwork, where the artist may not be involved in the process. The production of two or more identical images, signed and numbered by the artist, is called an **edition**. When an artist only produces one print, it is called a monoprint. The method used to create a print may dictate the number of works that can be produced. There are three main printing processes: relief, intaglio, and planography.

In relief printmaking, the artist cuts or carves into a workable surface, such as wood or linoleum, to create the image. The printmaker rolls ink onto the raised surface that remains and presses a sheet of paper or similar material onto the image to make what is known as an **impression**.

Intaglio printing requires the artist or printmaker to cut or scrape (in many different ways) into what is usually a metal plate. Ink is applied and then wiped off the surface, leaving ink in the lines or marks made by the artist. The pressure of the printing press transfers the image from the plate to the paper.

In the kind of planographic printing known as lithography, the image is drawn with an oily crayon onto a special kind of limestone. The non-image area of the stone absorbs a little but enough water so that when the printmaker applies oil-based ink to the whole stone, the ink only remains on the image area. In the printing press the image transfers to the paper. Silkscreen printing physically blocks out non-image areas so that ink only passes through the screen where required.

Context of Printmaking

Ancient civilizations in Egypt and Mesopotamia reproduced images by rolling cylindrical incised stones across clay or pressing them into wax. These very earliest prints were used as a tamperproof seal to show if the contents of a sack had been opened or interfered with. Chinese craftspeople in Ancient China used wooden stamps to print patterned designs into textiles.

The earliest existing printed artworks on paper (itself invented in China in the second or first century BCE) were created in China and date back to the eighth century CE. By the ninth century, printed scrolls containing Buddhist sutras (scriptures or prayers) were being made across east Asia. Over the ensuing centuries,

Edition: all the copies of a print made from a single printing **Relief:** a print process where the inked image is higher than the non-printing areas

Intaglio: any print process where the inked image is lower than the surface of the printing plate; from the Italian for "cut into"

Planography: a print process lithography and silkscreen printing-where the inked image area and non-inked areas are at the same height Impression: an individual print,

or pull, from a printing press

paper technology spread across the Islamic world, until papermaking workshops were common throughout Europe by the beginning of the fifteenth century, and paper was no longer an expensive, exotic commodity.

While the **woodblock** print remained the primary vehicle for the development of the print in Asia (especially Japan), in the West a number of additional techniques developed over time.

Relief Printmaking

Relief prints are made by carving away from a block of a suitably workable material, such as wood or linoleum, a certain amount of it, to create a raised image. The artist then applies ink to the raised surface and transfers the image to paper or similar material by applying pressure in a printing press (see 2.41). The areas of the block that remain print the image because the carved areas are recessed and are not inked.

2.41 (below) A brief overview of the relief printing

- 1 An image is designed and is prepared for transfer to the block surface.
- 2 The image is now transferred to the block.
- 3 The surface area that will not be printed is carved away.
- 4 The remaining protruding surface is carefully inked.
- 5 The raised inked area is transferred to the surface to be printed.

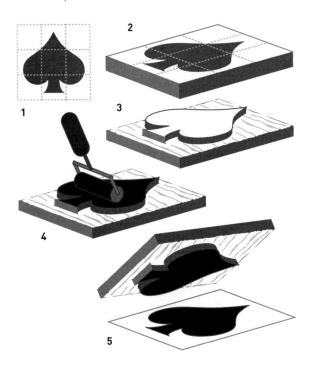

Traditionally, wood has been used for relief prints because it is readily available, familiar to work with, and holds up under the pressure exerted by the printing process; these prints are known as woodcuts. Today, for linocuts, printmakers use linoleum, an inexpensive material which cuts easily and can produce a clean, sharp image.

Woodblock

The German artist Albrecht Dürer (1471–1528) combined images and the printed word (with text printed on the reverse) when he illustrated the final book of the Bible, the Book of Revelation. Four Horsemen of the Apocalypse (2.42) is the most famous image in this series of fifteen illustrations and was made from a specially

Woodblock: a relief print process where the image is carved into a block of wood Woodcut: a print created from an incised piece of wood

2.42 Albrecht Dürer, Four Horsemen of the Apocalypse, c. 1497-8. Woodcut, 15^{3} /s × 11"

2.43 Kitagawa Utamaro, Lovers in an Upstairs Room, from Uta makura (Poem of the Pillow), 1788. Color woodblock print, $10 \times 14^{1/2}$ ". British Museum, London, England

prepared woodblock. In this process, unlike cutting from a solid block of wood, a print craftsman stacks and glues a series of thin, sliced layers of wood to create a more stable printing block (similar to plywood) that will be less likely to splinter or crack. Dürer commissioned professional block cutters to perform the layering, and they also cut the highly detailed lines of his original drawing into the block. This technique resulted in thin lines and detail that could withstand the compression of repeated printings. Because it required expert craftsmen, the labor was very expensive. But the series of works was so popular it made Dürer wealthy. The Book of Revelation is a symbolic piece of writing that prophesies the Apocalypse, or end of the world. The horsemen represent Death, Plague, War, and Famine.

Many great masters of woodblock printing were active in eighteenth- and nineteenthcentury Japan. Kitagawa Utamaro's (1753–1806) print, entitled Lovers in an Upstairs Room, uses multiple colors and shows great graphic skill in controlling the crisp character of the print and the interplay of multiple blocks in different colors (2.43). To create a color woodblock print an artist must produce a separate relief block for every color. Utamaro uses at least three colors to create Lovers in an Upstairs Room: red ochre (a shade of red-brown), black, and green. In color woodblock printing, each block must be accurately carved and planned because each individual color is printed in sequence on the same sheet of paper.

Care must be taken to align each print color perfectly (called registration); this is done by carving perfectly matching notches along two sides of each block to guide the placement of the paper. Utamaro is regarded as one of the greatest Japanese printmakers. He made images for the Japanese middle and upper classes of figures, theatres, and brothels, in a **style** known as *ukiyo-e* printmaking. Ukiyo-e means "pictures of the floating world," a reference to a young urban cultural class who separated themselves from the agrarian life of traditional Japan by indulging in a fashionable and decadent lifestyle. The people of the "floating world" were the celebrities of their time.

In his woodcut Prophet the German artist Emil Nolde (1867–1956) uses the natural character of the wood to suggest the hardships and austerity of the life of his **subject** (2.44). The crude carving of the block has produced splintering, and the printing has revealed the grain of the wood. The print's lack of refinement reflects the raw hardness of the life of a prophet.

2.44 Emil Nolde, Prophet, 1912. Woodcut, printed in black, composition $12\% \times 8\%$ ". MOMA, New York

Color: the optical effect caused when reflected white light of the spectrum is divided into a separate wavelength Style: a characteristic way in which an artist or group of artists uses visual language to

Subject: the person, object, or space depicted in a work of art

of visual expression

give a work an identifiable form

Gateway to Art: Hokusai, "The Great Wave off Shore at Kanagawa" Using the Woodblock Printing Method

Katsushika Hokusai's woodblock print "The Great Wave off Shore at Kanagawa" uses multiple colors and shows great graphic skill. It is a fine example of the printmaker's art. Hokusai (1760-1849) was not solely responsible for the production of this print: he relied on skilled craftsmen. Hokusai made a drawing of his subject, which a print craftsman then transferred face down onto a block of cherry wood. When the drawing was peeled away, the image remained, and the craftsman then carved the image into the wood. To create a color woodblock print a printer must produce a new relief block for each separate color. (Incidentally, "The Great Wave" was one of ten prints in the series Thirty-Six Views of Mount Fuji to use a new blue color, imported from Europe, known as Prussian blue. Nine blocks were used to print "The Great Wave." Each block had to be carefully carved, and the printmaker had to carry out the sequence of printing skillfully because each new color was printed directly on top of the same sheet of paper. If all nine blocks were not printed in exactly the

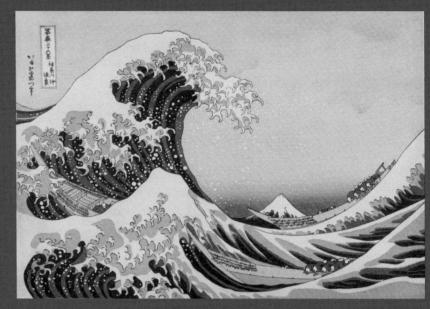

correct position, the print would be discarded because it did not match the others in the edition. The blocks of wood were used so many times that the carving eventually deteriorated. Although it is unknown how many prints were made, it is estimated there were more than 5,000.

2.45 Katsushika Hokusai. "The Great Wave off Shore at Kanagawa", from Thirty-Six Views of Mount Fuji, 1826-33 (printed later). Print, color woodcut. Library of Congress, Washington, D.C.

Intaglio Printmaking

Intaglio is derived from an Italian word that means "cut into" a surface. Usually the artist uses a sharp tool (a burin) to cut or gouge into a plate made of metal (or sometimes acetate or Plexiglas). Intaglio printing differs from relief printmaking because little of the base material is removed. The ink on the raised surface is also wiped away before printing, leaving ink in the scarred surface of the plate. The pressure of the printing press squeezes the plate against the paper, transferring the ink. There are several variations of intaglio printing, all of which give the resulting artwork a different visual character (see 2.46).

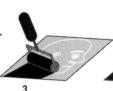

- **2.46** A brief overview of the engraving process (intaglio):
- 1 An image is designed for the plate.
- 2 Using a sharp tool, the artist incises the image into the plate.
- 3 The plate is inked.
- 4 The surface of the plate is wiped, removing all ink except in the grooves.
- **5** Paper is placed on the plate and it is pressed.
- 6 The paper lifts the ink out of the grooves and the ink is imprinted on the paper.
- 7 The final image is complete. (In most printmaking methods the final image is reversed from the plate or block.)

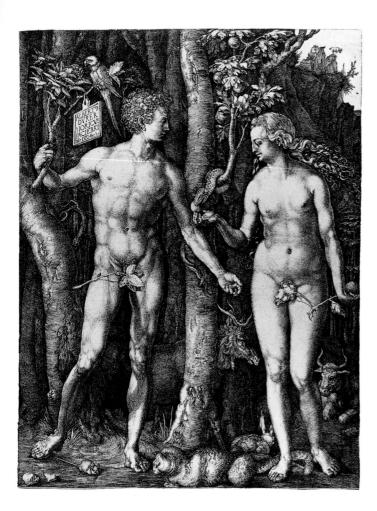

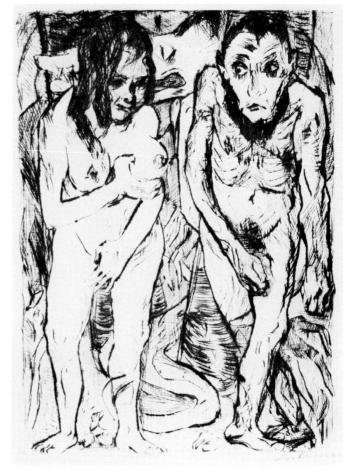

Engraving

Albrecht Dürer printed from a woodblock for his Four Horsemen of the Apocalypse but chose a different technique, engraving, for Adam and Eve (2.47). The intaglio engraving method is based on the careful scoring of a metal plate so that clean gouges are created in the surface. An engraving can achieve fine detail, making the resulting print more like the artist's original drawing. Dürer also had a business reason for choosing to engrave his work. He had to pay engravers to make his printing plate, and because the metal plate is much more durable than the woodblock, he could make and sell many more copies.

Drypoint

For his Adam and Eve, Max Beckmann (1884–1950) chose the **drypoint** intaglio method rather than engraving (2.48).

2.47 (above left) Albrecht Dürer, Adam and Eve, 1504. Engraving on paper. Victoria and Albert Museum, London, England

2.48 (above, right) Max Beckmann, Adam and Eve, 1917, published 1918. Drypoint, 9\% x 7". Private collection, New York

In engraving the burin is pushed across the surface, but in drypoint it is pulled, leaving a rough edge, or burr. When the plate is wiped the ink is caught under the burr. The result is a less precise line that has more irregularities. Artists can use this irregularity to add new dimensions to a work. For example, in Beckmann's Adam and Eve the lines appear to be more irregular than those in Dürer's version of the same subject. Beckmann, a German **Expressionist** artist, probably chose drypoint because of its slightly uneven quality of line.

Engraving: a printmaking technique where the artist gouges or scratches the image into the surface of the printing plate

Drypoint: an intaglio printmaking process where the artist raises a burr when gouging the printing plate

Expressionism (adjective: Expressionist): an artistic style, at its height in 1920s Europe, which aimed to portray the world in terms of vivid extremes of personal experience and feeling

2.49 Rembrandt van Rijn, Adam and Eve, 1638. Etching. Kupferstichkabinett, Museen Preussiches Kulturbesitz, Berlin, Germany

Etching: an intaglio printmaking process that uses acid to bite (or etch) the engraved design into the printing surface

Value: the lightness or darkness of a plane or area

Aquatint: an intaglio printmaking process that uses melted rosin or spray paint to create an acid-resistant ground **Rosin:** a dry powdered resin that melts when heated, used in

Organic: having forms and shapes derived from living organisms

the aquatint process

Etching

Dutch artist Rembrandt Harmenszoon van Rijn (1606-69) was a master of intaglio printmaking, especially **etching**. Etching is a process in which a metal plate is covered with an acid-resistant coating, into which the artist scratches the design. The plate is then immersed in a bath of acid. The acid "bites" into the metal where the covering has been removed, making grooves that hold the ink. Unlike engraving and drypoint, the artist does not score a hard metal plate but makes small incisions, which allows for greater control in incorporating subtle changes of dark or light lines that affect value. In his etching Adam and Eve Rembrandt brings out details by marring the plate surface more in the areas that will appear darker in the print (2.49).

Aquatint

Another process that requires the use of an acid bath to etch the surface of the plate is

aquatint (from its Italian name acqua tinta, meaning dyed water). Despite the name, water does not play a role in aquatint printmaking. The image is created in a coating of powdered **rosin** (a tree sap), or spray paint, on the surface of the plate. When heated, the rosin melts onto the surface of the plate, creating a mottled, acidresistant barrier into which the design is etched. Since the rosin leaves irregular areas of the plate exposed, a soft **organic** texture (similar to that created when one uses brush and ink) dominates the image. The artist can even use a brush to push around the dry rosin (before heating) to draw the original design, adding to the watery effect. Francisco Goya utilizes the wash-like appearance of aquatint in his print Giant (2.50). Goya probably used a rosin box, a device that allows the artist to control the distribution and amount of powder that falls onto the plate, then he scraped away the heated rosin in the areas where he wanted the dark values of the final printed image to appear. The artist can progressively scrape more and

2.50 Francisco Goya, Giant, c. 1818. Burnished aquatint, first state, sheet size 111/4 × 81/4". Metropolitan Museum of Art, New York

Gateway to Art: Goya, The Third of May, 1808

Prints as Art and as Creative Tools

The Spanish artist Francisco Goya (1746–1828) painted The Third of May, 1808 (2.51a) in 1814, six years after the event it memorializes. During the French occupation of Spain (1808-1814), Goya also **sketched** scenes of the occupation by Napoleon's troops. These sketches were published in 1863 as a series of prints called Disasters of War. The Third of May, 1808 is often considered to be the most dramatic of Goya's studies of the Spanish War of Independence. In it, we can see aspects of the compositions of the prints in Disasters of War.

Compositionally, there are similarities between the print and the later painting. In "And There Is No Remedy" (2.51b), the firing squad about to shoot its helpless targets is arranged in a strikingly similar way to the firing squad in The Third of May, 1808. The light area on the left is echoed in the small hill behind the

martyr in Third of May. The vertical post to which the victim is tied in the print also draws the viewer toward the center of the work; this device was repeated with the church tower in the painting. The horizontal rifles on the right side of the print create a directional line

drawing attention toward the victim, a technique Goya repeats in Third of May. "And There Is No Remedy" is a good example of the way in which an artist re-works a visual idea over a period of time to develop ideas and refine the composition. Goya's masterpiece evolved after years of trial and practice in his prints.

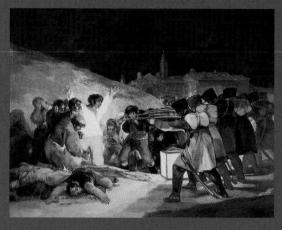

2.51a Francisco Goya, The Third of May, 1808, 1814. Oil on canvas, 8'4\%" × 11'3%". Museo Nacional del Prado, Madrid

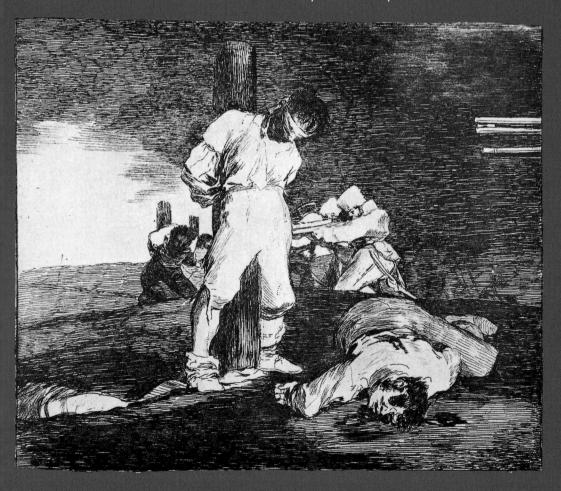

2.51b Francisco Goya, "And There Is No Remedy", from Disasters of War, c. 1810

Sketch: a rough preliminary version of a work or part of a work

Composition: the overall design or organization of a work Directional line: implied line within a composition, leading the viewer's eye from one element to another

Implied texture: a visual illusion expressing texture Mezzotint: an intaglio printmaking process based on roughening the entire printing plate to accept ink; the artist smoothes non-image areas

2.52 Dox Thrash, Defense Worker, c. 1941. Carborundum mezzotint over etched quidelines, 93/4 × 8". Print and Picture Collection, Free Library of Philadelphia

more to get darker values. The **implied texture** of the aquatint print is soft and rich, giving a softness and subtlety to the contours of the giant's body.

Mezzotint

Because each intaglio method leaves its own unique mark on the plate, many artists have opted to use more than one method when making a print. In his Defense Worker, the African-American artist Dox Thrash (1893-1965) uses **mezzotint** over etched guidelines (2.52). Mezzotints often produce dark, rich values because the ink has many places to settle. To make a mezzotint the entire surface is roughened with a heavy spiked rocking tool, which is a metal object with a spiked, curved bottom. This can be rocked back and forth across the surface of the plate so that it is completely covered in burrs. The burrs are

then smoothed in the areas where the printmaker wants the light tones. Ink is removed from the smoothed areas when the plate is wiped: the inked areas create dark tones and the smoothed areas hold less ink to create light tones. Thrash wanted to use this dark mood to reflect the drama and seriousness of the war effort at home. This work was sponsored by the Works Projects Administration, a government program originally created during the Great Depression to employ Americans at a time when jobs were hard to find. Artists, writers, musicians, and others contributed to American culture and infrastructure by applying their skills, first in support of rebuilding America and then, during World War II, in support of the war effort. Thrash, like other artists of the time, uses the dark values afforded by the medium to express the spirit and strength of the American worker.

Planographic Printmaking

Unlike relief (which cuts away non-printing areas) and intaglio (which cuts away the printing areas), planographic prints are made from an entirely flat surface. The printmaker treats parts of the surface so the ink adheres only to selected areas. The planographic forms, lithography and silkscreen printing, use very different techniques.

Lithography

Lithography (from the Greek for stone writing) is traditionally done on stone. Out of money and looking for a cheaper method to print his newest play, German author Alois Senefelder (1771-1834) devised the lithographic printing process in 1796. The complex presses used nowadays by commercial printers for producing newspapers, magazines, and brochures ("offset lithography") use thin sheets of zinc or aluminum instead of stone, but the basic principles are the same as Senefelder's original discovery.

Contemporary artists' lithographic prints are still made on the kind of stone used by Senefelder.

2.53 A brief overview of the lithography process:

- 1 The artist designs the image to be printed.
- 2 Using a grease pencil, the design is drawn onto the limestone, blocking the pores.
- 3 The stone is treated with acid and other chemicals that are brushed onto its surface. Then the surface is wiped clean with a solvent, such as kerosene.
- 4 The stone is sponged so that water can be absorbed into the pores of the stone.
- 5 Oil-based ink is repelled by the water and sits only on areas where the oil crayon image was drawn.
- 6 Paper is laid on the surface of the stone and it is drawn through a press.
- 7 The print is removed from the stone.
- 8 The completed image appears in reverse compared with the original design.

Some artists like lithography because it allows them to draw a design in the same way they do a drawing. Successive stages in the process are illustrated in 2.53. An artist first draws a design, using a grease pencil or other oil-based drawing material, directly onto a piece of specially selected, cleaned, and prepared limestone. Next, the artist applies a number of materials to the stone, including a gum arabic and nitric acid solution that makes the image more durable. Then he or she wipes the surface clean using kerosene. Even though the image appears to have been obliterated by the kerosene (this is a most unnerving moment for novice printmakers!), the stone is now ready to be printed. The surface is sponged with water, which is repelled by the

greasy areas of the drawing, and rolled with oilbased ink. In the ungreased regions the water repels ink, leaving only the image covered with ink. At this point the artist carefully places paper over the stone and lightly presses down, usually by passing it through a printing press.

In 1834, the French artist Honoré Daumier (1808–79) used his skills combined with the lithographic process to tell the citizens of Paris about an incident of police brutality. Daumier, who worked for the monthly magazine L'Association Mensuelle, depicted the aftermath of a horrible incident that took place at Rue Transnonain on April 15, 1834 (2.54). That night, police responded to a sniper attack. Thinking the attack had come from a residence at 12 Rue

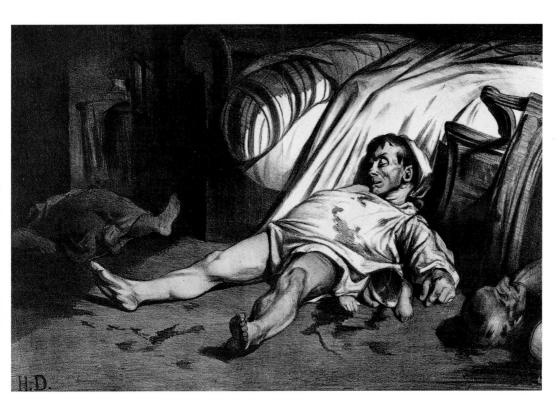

2.54 Honoré Daumier, Rue Transnonain, April 15, 1834. Lithograph, $11\frac{1}{2} \times 17\frac{5}{8}$ ". Private collection

Transnonain, the authorities entered the house and ruthlessly killed everyone inside. Daumier, a great critic of the French government's treatment of workers, drew the images of the massacred in gruesome detail. A father and child lie in the center, flanked by the mother and an elderly family member.

Silkscreen Printing

Silkscreen printing is one of the most versatile printing processes, capable of placing a heavy coverage of ink on a wide variety of surfaces, from printed circuit boards to packaging, from solar panels to T-shirts. Artists value, amongst its many other virtues, its potential for printing strong colors.

Unlike all the other printing processes discussed in this chapter, only silkscreen printing produces "right-reading" reproductions of the original artwork. Relief, intaglio, and litho prints

all make mirror images, so an artist making such a print needs to think in reverse.

Silkscreen printing was first developed in China during the Sung Dynasty (960–1279) and uses a **stencil** process. It can be used to create a large number of prints. The silkscreen itself is nowadays a fine mesh usually made out of nylon. The image area of the screen is open and allows ink to pass through, while the rest of the screen is **masked** off. As the printmaker moves the squeegee (like a heavy flat windshield wiper) over the screen, the mask prevents ink from passing through in unwanted areas. The mask can be a kind of thick glue painted on with a brush, or it can be a physical barrier, such as tape. Photographic silkscreen prints can be produced using a photosensitive masking material.

The American artist Andy Warhol (1928–87) utilized photographic silkscreen techniques over aluminum paint to create a distinctive style, seen in his work Double Elvis (2.55). Warhol reproduces

2.55 Andy Warhol, Double Elvis, 1963. Silkscreen ink and silver paint on canvas, $17^{3}/4^{2} \times 6^{9}/8^{2}$. Stiftung Sammlung Marx, Hamburger Bahnhof-Museum für Gegenwart, Berlin, Germany

Stencil: a perforated template allowing ink or paint to pass through to print a design Mask: in spray painting or silkscreen printing, a barrier whose shape blocks the paint or ink from passing through

a cowboy-like image of Elvis Presley from a photo taken at the height of the singer's career. Warhol deliberately repeats the image of Elvis to comment on the nature of mass-produced images in advertising. Public figures market their image the same way food companies promote cans of soup. Silkscreen printing is particularly suited to printing large areas of flat, heavy color, and by using this technique, Warhol emphasizes the flatness and lack of depth in the character played by Elvis. The doubling "clones" of Elvis accentuate the degeneration that occurs when an original is copied.

Editions

Prints are produced in limited numbers of identical impressions, called editions. The printmaker has the ethical responsibility of making sure each print is similar enough to the others so that each person who buys a print has a high-quality image. When a print is deemed identical to others in the edition it is assigned a number in the production sequence. For example, a print marked 2/25 is the second print in an edition of twenty-five. Some

unnumbered prints bear the letters A/P. These prints, called artist's proofs, are used by the printmaker to check the quality of the process and are not intended to be part of the edition. Even though they could create more prints than they do, most artists decide to print a set number of prints: a limited edition. The artist afterwards destroys the original plates so it is impossible to make any more copies.

Monotypes and **Monoprints**

Monotypes and monoprints are print techniques where the artist means to produce a unique image.

A monotype image prints from a polished plate, perhaps glass or metal. The artist puts no permanent marks on it. He or she makes an image on it in ink or another medium, then wipes away the ink in places where the artist wants the paper to show through. The image is then printed. Only one impression is possible.

Hedda Sterne (1910-2011) was the sole woman in a group of abstract painters called the

2.57 Kathy Strauss, Kepler Underneath 1, 2007. Monotype over India-inked calculations, Somerset velvet paper, each panel 30×23 ". Collection of the artist

Irascibles. Although abstract, Sterne's Untitled monotype makes associations with architectural and mechanical images (2.56). Sterne probably employed a straightedge to maintain the regularity of line in the print.

Monoprints can be made using any print process. The artist prepares the image for printing as described previously in this chapter, but will ink or modify each impression in a unique way. This includes varying colors, changing the spread of the ink across the image area, and adding features by hand. The individual modifications possible are as infinite as for any handmade work of art. Artists choose to make monoprints, however, because they may want to explore "themes and variations," where some elements of the work remain the same but others are different. If two prints are identical, they are not monoprints.

Kathy Strauss's (b. 1956) monoprint Kepler Underneath 1 painstakingly depicts the Milky Way Galaxy (2.57). The artist has first incised a series of calculus problems into the metal plate. As with any other intaglio print, the plate was then completely covered with ink and wiped. Ink stayed in the incised grooves. Strauss has then painted the image of the Milky Way in ink directly onto the same plate; when the inking was complete, she centered the paper over the image and ran it through the press. Because Strauss painted the ink on by hand, she cannot re-create the result exactly in a second print, so it is not part of an edition.

Conclusion

To create prints, artists have to work with all the technical steps required by the different

printing processes. While most printmaking requires slow and careful preparation, multiple images are usually the reward for the time invested. Prints can be published as unique single artworks or in editions, allowing the artist to reach a wide public.

Printmakers choose the printing process that best fits the kind of image they want to achieve. For relief prints they have to carve into a flat, comparatively soft surface (often wood or linoleum) to leave an image on the surface of the block. Comparatively quick to make, relief prints favor dark images with great **contrast**, but the amount of detail can be limited.

Intaglio processes, such as engraving, drypoint, and etching, require artists to cut or gouge into a hard surface, such as metal, to make crisp thin lines that lend themselves to great detail. Removing metal to create dark areas is hard work, however. Marring surfaces with acid or heavy gouging tools in aquatint and mezzotint can provide rich dark values and textures similar to those in watercolors.

Planographic printing by lithography allows artists to use their familiar drawing skills with an oily crayon on a specially prepared stone. Using stencils to block out non-image areas, silkscreen printing is particularly suited to laying down flat areas of heavy color.

Although printmaking can lend itself to the publishing of editions, some artists choose to create prints one at a time, just as if creating a drawing or a painting. Whatever method an artist chooses, and whether he or she makes monotypes or monoprints, the way artists work with the character of their chosen printmaking process is integral to (all part of) the final artwork.

Abstract: an artwork the form of which is simplified, distorted, or exaggerated in appearance. It may represent a recognizable form that has been slightly altered, or it may be a completely non-representational depiction Contrast: a drastic difference between such elements as color or value (lightness/darkness)

2.4

Visual Communication Design

The essence of visual communication design is the use of symbols to communicate information and ideas. Traditional communication design was known as graphic design: the design of books, magazines, posters, advertising, and other printed matter by arranging drawings, photographs, and type. Advances in printing processes, television, the computer, and the growth of the Web have expanded graphic design to include many more design possibilities. A better and more complete term for it now is visual communication design. Furthermore, while graphic design was the responsibility of specialists, the typographical power of the computer—both for print and the Web—means almost anyone can be a visual communication designer, provided they understand the principles of visual communication design.

This chapter will discuss the development of the **media**, systems, and processes used in visual communication design. While based on simple ideas, visual communication design enables us to express our ideas with increasing clarity, style, and sophistication—valuable qualities in a rapidly changing world.

The Early History of **Graphic Arts**

The graphic arts probably started when a prehistoric person spat pigment through a reed to **stencil** a handprint on the wall of a cave. The ancient Mesopotamians in what is now

Iraq were the first people (c. 3400 BCE) to employ picture symbols in a consistent language system. The ancient Egyptians created their own version of picture symbols, known as hieroglyphics, as a written form of communication. In particular, the Egyptians wrote them on scrolls made of a paper-like substance created from the pith of the papyrus plant (see, for example, **2.58**). Later forms of picture writing became

2.58 Section of papyrus from Book of the Dead of Ani, c. 1250 BCE. British Museum, London, England

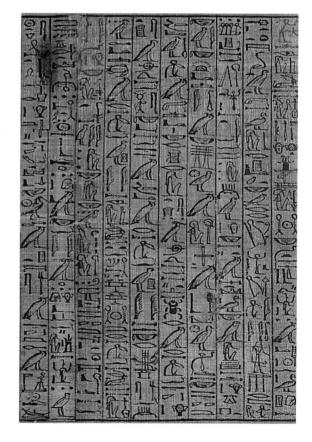

Medium (plural media): the material on or from which an artist chooses to make a work of art, for example canvas and oil paint, marble, engraving, video, or architecture

Stencil: a perforated template allowing ink or paint to pass through to print a design

2.59 Rubbing of stele inscription, Preface of the Lanting Gathering, Ding Wu version (Inukai version), original by Wang Xizhi, Eastern Jin Dynasty, dated 353. Album, ink on paper, 95/8 × 87/8". Tokyo National Museum, Japan

increasingly abstract, for instance Chinese written characters. While originally (for example) the letter A was supposed to be derived from the shape of a house, and B from a cow, the contemporary Western alphabet has now lost any of its earliest connections with representations of things.

Wherever literacy takes hold, **calligraphy** usually develops as a form of art concerned to express layers of meaning and feelings by means of the shape of written letterforms. For example, handwritten wedding invitations are created using calligraphy because the flowing line and distinctive character of the lettering communicates the upcoming event in an elegant and romantic way. In oral communication, changes in tone, volume, and even hand gesture and body movement work together; in calligraphy, the physical act of writing, the thought expressed, and the visual form of the text become one. Chinese culture particularly exalts calligraphy executed in black ink with a brush. The Chinese calligrapher Wang Xizhi defined the art of calligraphy in China during the Jin Dynasty (265-420 CE). Although none of Wang's originals still exists, other calligraphers copied his work through the ages, perpetuating his ideal of perfect form. In ancient China, fine

specimens of writing were carved on large standing stone tablets, from which visitors could take copies by making rubbings—a rudimentary printing technique (2.59).

During the Middle Ages, European artists combined calligraphy and illustration to craft illuminated manuscripts (for example 2.60). Illuminated manuscripts were executed in monasteries on prepared animal skins, called parchment. After being painted and lettered by hand, they were bound as books. This kind of design was very time consuming and produced only one copy of the book. The invention of printing technology simplified the design process and made it possible to print multiple copies. In other words, printing made graphic design possible.

Abstract: art imagery that departs from recognizable images from the natural world Calligraphy: the art of emotive or carefully descriptive hand lettering or handwriting Illuminated manuscript: a hand-lettered text with handdrawn pictures

2.60 Dutch History Bible, copied by Gherard Wessels van Deventer in Utrecht, 1443, fol. 8r. National Library of the Netherlands, The Hague

Graphic Design

Graphic design is the art of improving visual communication design. As you read this text you may have noticed the way the information is organized. Headings, page numbers, illustrations, and the definitions of terms in the margin have all been carefully considered with you in mind. The use of **boldface** type and columns of text helps you read and understand. In other visual arts it may be preferable to invite a viewer to consider and contemplate. But in graphic design, the communication is intended to be instantaneous, clear, and direct.

Typography

The visual form of printed letters, words, and text is called **typography**. Type, a word derived from a Greek word meaning to strike, first came into existence with Johannes Gutenberg's (c. 1398–1468) invention of the printing press in Germany around 1450. Gutenberg also created a technique for producing small castmetal letter shapes, known as letterforms, that could be set next to each other in a row, inked. and then printed in relief on paper using his press. Gutenberg's letterforms have angled thick and thin strokes that copy the pen calligraphy used in illuminated manuscripts (called Black Letter). Scholars believe his intention was to emulate handwritten texts; his first bibles used the exact same letterforms as those used in manuscripts, and the pages even included illustrations drawn by hand.

The German master printmaker Albrecht Dürer (1471-1528) wrote systematically on the subject of typography in order to teach others. In The Painter's Manual: A Manual of Measurement of Lines, Areas, and Solids by Means of Compass and Ruler (1525), Dürer sought to create a set of rules for the design of letter shapes (2.61). His was the first text to standardize how to create each letter using such geometric elements as squares, circles, and lines. Through these careful instructions a typographer could create letterforms similar to those used by the ancient Romans.

Dürer's Roman alphabet is notably different from Gutenberg's letterforms. A complete alphabet of letterforms and matching punctuation is called a font. A font is a group of letterforms designed to have a unified appearance. Roman-style fonts were derived directly from the letters chiseled into stone on the buildings and monuments of ancient Rome. Those characters had a vertical or horizontal mark at the edges of some letters. These marks, called serifs, were integrated into many early

2.61 Albrecht Dürer. pages from Course in the Art of Measurement with Compass and Ruler, 1538 Victoria and Albert Museum. London, England

2.62 Some font styles:

1 Replica of Black Letter style used in Gutenberg's 1454 Bible

Hütenberg Bible

2 Times New Roman with some serifs circled

Roman Serif Font

3 Helvetica font with no serifs (sans serif)

Sans Serif Font

typefaces. The differences between these kinds of fonts are shown in 2.62.

In books and newspapers, serif fonts are traditionally used in the main text because they are considered easier to read. Typographers often use a sans serif font, or a font without serifs, in headings. (Sans serif derives its name from the French word sans, meaning without, and perhaps from the Dutch word schreef, meaning a stroke of a pen.) In the twenty-first century, sans serif has become the standard font style in electronic media, as tiny serifs may not fully appear in comparatively low-resolution electronic displays.

Typographers follow some simple rules to make sure a written message is clear. When using multiple fonts, the fonts must be different enough to avoid confusion between the typefaces. The visual weight, or thickness, of the letters can be used for **contrast** and to emphasize a section of the text simply by changing type to bold. The choice of larger or smaller font sizes also adds another level of contrast and **emphasis**. Finally, even more emphasis and contrast can be gained through the choice of **color**. Typographers use these options carefully to "keep it simple" and to create a message that is clear, concise, and easily understood.

Logos

Businesses and other organizations use logos as communication tools. A logo is often simply a carefully designed piece of type, called a logotype,

2.63 Ford Motor Company logo, c. 1906

that is unique and easily identified. The logo design of the Ford Motor Company has become universally recognized (2.63). In 1903 an engineer and Ford executive named Harold Wills created the original logo, which read "Ford Motor Company Detroit, Mich.", from the lettering style used on his business cards. His original design was later simplified into a plainer writing style that was common at the time. This particular font, known as Spencerian script, was derived from the style of handwriting that was practiced in America in the nineteenth century.

Sometimes a designer communicates an idea using a pictorial symbol instead of type. The Chevrolet logo was first used in 1913 and has been an identifying mark for the company ever since. Originally, the name "Chevrolet" was written across the simple stylized cross (called the "bowtie"). Over time, the symbol became associated in people's minds with the name, which was then removed from the design. It now communicates the company name without using one letter of the alphabet (2.64). 2.64 Chevrolet logo, first used in 1913

Boldface: a darker and heavier typeface than its normal instance Typography: the art of designing, arranging, and

choosing type Contrast: a drastic difference

between such elements as color or value (lightness/darkness)

Emphasis: the principle of drawing attention to particular content in a work

Color: the optical effect caused when reflected white light of the spectrum is divided into a separate wavelength

Illustration

Illustrations are images created to inform as well as to embellish the printed page. Good illustration is critical in such fields as medicine and science, where it may communicate essential information more effectively than text or a photograph.

The nineteenth-century English artists and designers William Morris (1834-96) and

Edward Burne-Jones (1833–98) believed society should reject rampant industrialization and restore hand craftsmanship. Their illustrated book of the works of the medieval poet Geoffrey Chaucer was handcrafted so that each page contained illustrations, illuminated characters, and patterns (2.65). The illustrations allow readers to experience and understand the works of Chaucer more richly. They support and enhance the written words.

2.65 William Morris and Edward Burne-Jones, page from Works of Geoffrey Chaucer, Kelmscott Press. 1896. British Museum, London, England

Illuminated characters: highly decorated letters, usually found at the beginning of a page or paragraph

2.66 Norman Rockwell, Rosie the Riveter, 1943. Oil on canvas, $52 \times 40^{\circ}$. Crystal Bridges Museum of American Art, Bentonville, Arkansas

The American illustrator Norman Rockwell (1894–1978) drew covers for the Saturday Evening Post magazine for forty-seven years, from the end of World War I until the 1960s. His good-humored images of national stereotypes captured how "middle America" viewed itself. One of Rockwell's most effective and memorable images is a character he created to support the war effort on the home front during World War II. Rosie the Riveter, a female construction worker, symbolizes the contribution American women were making, working in jobs traditionally held by men (2.66). Rockwell's Rosie sits defiantly and confidently as she looks down from her lunchtime perch. The facial expression, body language, and

demeanor of this figure send a message of strength about the American spirit in times of adversity.

Digital illustration has become a popular way for designers to incorporate illustrations into a printed design. Digital drawings are produced through the use of computer applications that use mathematical formulas dependent on the relative placement of points. In these math-based applications, the computer generates an image, called a vector graphic, from a series of lines plotted from the relationship between individual points. Since points and lines are the basic units of this system, it bears a resemblance to drawing processes. Most of the line art in this book was created using this type of digital illustration application.

The Malaysian designer Kok Cheow Yeoh (b. 1967) creates drawings digitally. His images, such as Kiddo, can easily be distributed via many different mass-media channels (2.67). He controls color so that his work is relatively inexpensive to print and uses less disk space on a computer.

2.67 Kok Cheow Yeoh, Kiddo, c. 1994. Computergenerated vector drawing

Yeoh creates his unique graphics by hand, scans them, and re-creates them in digital form, but makes sure to keep the handmade appearance.

Layout Design

Layout design is the art of organizing type, logos, and illustrations in traditional print media. Good layout design is essential if information is to be easily understood. One of the main considerations in layout design is spacing. Designers are very aware of white spacethe voids that lie between text areas and images—and are careful in its organization and distribution in their layouts.

If you examine the way this page is designed, you will notice the relationships between columns of text, images, and other features, such as page numbers. The designer responsible

2.68 Henri de Toulouse-Lautrec, La Goulue at the Moulin Rouge, 1891. Lithograph in black, yellow, red, and blue on three sheets of tan wove paper, 6'21/2" × 3'95/8". Art Institute of Chicago

2.69 Hill, Holliday, Connors, Cosmopulos advertising agency, Boston, Massachusetts, Tyco—A Vital Part of Your World, 2005

for this page has made sure each feature has enough white space around it to be easily identified and understood, but is close enough to related elements, such as the pictures, so that the text and images complement each other.

The French artist Henri de Toulouse-Lautrec (1864–1901) created posters for his favorite Parisian nightspot, the Moulin Rouge. In La Goulue at the Moulin Rouge, Toulouse-Lautrec uses a free, rounded writing style that is as casual as the spectators in the nightclub scene, as they watch La Goulue (the nickname, meaning "The Glutton," of the dancer Louise Weber) dance the can-can (2.68). Here, the text is calligraphy rendered by hand directly (in mirrorwriting) on the lithographic stone from which it is printed. Toulouse-Lautrec's great skill as an illustrator and typographer is apparent in the excellent hand-rendered text and images.

Effectively controlling type and layout can have amazing results. In the Tyco "Vital" advertising campaign, the designer carefully controls the color and size of the fonts so that the list of Tyco products and services reveals the face of a young child (2.69). The designer effectively communicates the suggestion that Tyco's products and services are vital to her and others' survival.

White space: in typography, the empty space around type or other features in a layout Void: an area in an artwork that

seems empty

Expressive: capable of stirring the emotions of the viewer

2.70 Carolina

Photojournalism Workshop, Seth Moser-Katz (design) and Emily Merwyn (programming). Photo Eileen Mignoni. School of Journalism and Mass Communication at the University of North Carolina at Chapel Hill, 2008. http://www.carolinaphotojour nalism.org/cpjw/2008/

Web Design

In the past twenty years, visual communication design has been dramatically influenced by the Internet. The use of text and image in mass communication has evolved from the motionless design of print publications to the interactive designs used on the World Wide Web. The Web allows designers more freedom to add interactivity so that text and image can change as the reader progresses through the information presented.

In a website design created at the 2008 Carolina Photojournalism Workshop, the communicated message is enhanced by the integration of text, image, and interactivity (2.70). The artist, Seth Moser-Katz (b. 1984), has placed a large photographic background image, illustrating the important issue of beach erosion, into the page design. The central location of the gray text box combined with the open space around it draws attention to the written message. Moser-Katz has also cleverly created a series of rectangular images as hyperlinks at the bottom of the design. When a user moves a cursor over one, new text appears in the gray text box. When clicked, a new page opens that plays a recorded message and presents a series of photos related to an important issue for those who live in the region. By employing good visual communication design Moser-Katz makes the message more direct, clear, and engaging.

HOME ABOUT CREDITS EMAIL CAPE FEAR TO DOWN HERE

Conclusion

Visual communication design has been a part of society since picture symbols were first invented. Leaving behind their original purpose as pictures, letterforms became increasingly abstract and easier to use for general written communication. Calligraphy is the sophisticated art of **expressive** handwriting and influenced the first Black Letter machine-made typeforms. With the advent of the printing press, the new art of typography focused on refining the attributes of movable type, leading to new Roman-inspired letterforms. Serif and (later) sans serif fonts provided more varieties of type. Typographers further enhanced the communicative possibilities of their medium by developing the use of bold, italics, varying sizes, and color.

Logos and logotypes identify millions of organizations quickly, powerfully, and memorably. Illustrations are ideas presented as pictures that complement and broaden the communicative power of the written text. Just like the illuminated drawings in medieval handwritten texts, images are still used to clarify and embellish modern printed materials. The advent of computers has influenced typography and made vector graphic illustration an important part of visual communication design.

Visual communication designers organize type, text, logos, and illustrations in their layouts. They work to budgets, using the technical constraints of the medium to make beautiful and communicative designs. Their books, advertisements, posters, and other printed matter are stronger and more coherent when they consider the white space connecting yet separating each part of their layouts. Every day on our computer screens we can see the results of their skills on the World Wide Web.

The work of visual communication designers is for everyone. It must therefore appeal to and be understood by the widest public possible, not just an elite few. In many ways visual communication design is the most democratic of all the arts because it is shared by so many and touches our lives every day. After all, every image and word in print or on screen was put there by a designer—and you are looking at an example now.

Photography

Recording the Image

The word photography derives from two Greek words, photos, meaning "light," and graphein, meaning "to draw": together, they mean "drawing with light." Before the digital era, a photograph was an image recorded onto a light-sensitive material, usually film, that darkened when it was exposed to light. The lights and darks on a film **negative** are the opposite of what we see in life: the tones are reversed. This negative can be reversed again, with chemicals or by re-exposure to light, to make an infinite number of **positive** prints, called photographs. In addition, ever since the 1970s, digital cameras can record images in the form of pixels which can then be stored as files on a computer.

The mechanics of the camera are similar to those of the human eye. Just as light enters the eye through the pupil, light enters the camera through a small opening, the aperture. In both eye and camera the lens changes shape, flattening to bring far-away things into focus and thickening to make close-up objects clear.

When photography was invented in the nineteenth century, its reliance on mechanical and chemical processes led many to refuse to consider it an art form. Photography seemed to be a simple recording of the real world by a machine, not the result of an artist's creative imagination. In fact a photographer can express ideas in many ways, for example by deciding the way the **subject** is photographed, by manipulating the image after it has been

captured, or by combining the photograph with other images.

The History of **Photography**

The basic principles of photography were known long before modern photographic processes were invented. A simple kind of camera called the camera obscura (Latin for dark room) had been used by artists for several centuries as an aid to drawing. However, it was not until the nineteenth century that inventors discovered a number of ways to make permanent camera images that could be reproduced: in other words, photography.

The first cameras were indeed room sized, and the projections they created were used as guides for making drawings. A sixteenth-century illustration of a camera obscura shows the basic principles of all cameras today (2.71). When a small hole, or aperture, is placed in an exterior wall of a darkened room, light rays project the outside scene onto the opposite wall inside the room. A person could stand inside a camera obscura and trace over the image projected onto the wall. Inside the camera the image, no matter what size it was, continued to appear in **color**, but upside down and back to front, unless it was reversed using mirrors. Smaller, portable models became widely available in Europe in the eighteenth century.

Negative: a reversed image, in which light areas are dark, and dark areas are light (opposite of a positive)

Positive: an image in which light areas are light and dark areas are dark (opposite of a negative)

Subject: the person, object, or space depicted in a work of art Color: the optical effect caused when reflected white light of the spectrum is divided into a separate wavelength

Fixing: the chemical process used to ensure a photographic image becomes permanent

2.71 Rainer Gemma-Frisius, first published illustration of a camera obscura, 1544. Gernsheim Collection, London

The images projected in a camera obscura are not permanent, but we can see what a camera obscura image looks like because the contemporary Cuban-American photographer Abelardo Morell (b. 1948) recorded a camera

obscura image in 1999. He turned an entire hotel room into a camera obscura to project an upsidedown image of the dome of the Panthéon, a building in Paris, France (2.72). The image projected in Morell's hotel room was only temporary until he took a picture of it, showing that the principles of the camera obscura are the same as those relating to the photographic camera.

Previously, images in the camera obscura were limited because they were not permanent and could be recorded only when traced over by hand. Photography could not exist until the image could be **fixed** (as photographers say).

2.72 Abelardo Morell, Camera Obscura Image of the Panthéon in the Hotel des Grands Hommes, 1999. Gelatin silver print, 20×24 "

2.73 Anna Atkins, *Halydrys Siliquosa*, 1843–4. Plate 19 from Volume 1 of *Photographs of British Algae*. Cyanotype, 5×4". British Library, London, England

In 1839, English scientist John Herschel (1792– 1871) discovered a chemical compound that could do this. Using another of Herschel's processes, English botanist and photographer Anna Atkins (1799–1871) made cyanotype images in 1843-4. She placed pieces of algae on paper that had been treated with a special lightsensitive solution and exposed the sensitized paper to direct sunlight (2.73). The areas of the paper exposed to the light turned the paper dark, but in the places where the plant's stems and leaves created a shadow, the paper remained white. Although Atkins made this image without a camera, the same principles are at work when a film camera is used, and her images look exactly like film negatives.

A few decades before Herschel's pioneering work, two Frenchmen—the painter and stage designer Louis-Jacques-Mandé Daguerre (1787–1851) and a chemist, Joseph Nicéphore Niépce (1765–1833)—worked together to invent a method of producing and fixing an image, which came to be known as the daguerreotype. A polished metal plate, made light-sensitive by silver iodide, was placed inside the camera. The camera's shutter was opened to expose the plate

to sunlight and record an image on its surface. Mercury vapors revealed the image before it was chemically fixed, or made permanent with table salt (later with Herschel's sodium thiosulfate or hypo).

While the daguerreotype process created very detailed images captured through a camera, these positive images could not be readily reproduced (see **2.79** on p. 218).

At about this time, the Englishman William Henry Fox Talbot (1800-77) captured on a light-sensitive surface a negative image of a window at his home (2.74). These images, known as calotypes, resembled Atkins's botanical specimens. Talbot eventually discovered how to reverse the negative to make numerous positive prints. In other words, the places that appeared light in the negative, such as the window frames, would be dark in the print, while the dark areas, such as the sky, would change to light. The resulting print contained shades of gray that matched the values of the original scene. This negative/ positive process is the basis of film photography (see Box: Diagram of Film Photography Darkroom).

These early processes were central to photography until the invention of digital cameras, first available around 1985, that record images not on film but in the form of pixels (tiny square dots arranged in a grid). Images

Value: the lightness or darkness of a plane or area

2.74 William Henry Fox Talbot, *The Oriel Window,*South Gallery, Lacock Abbey,
1835 or 1839. Photogenic drawing negative, 3½ × 4½". Metropolitan Museum of Art, New York

Diagram of Film Photography Darkroom

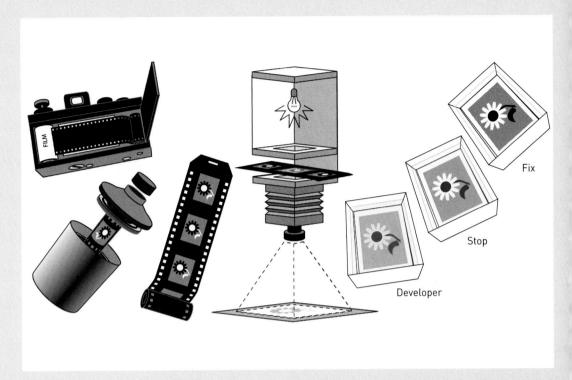

2.75 Diagram of film photography darkroom

> Once a photographer captures an image on film in a camera, he or she must develop the film to produce a negative, and can then make photographic prints. A darkroom prevents any further light from reaching the light-sensitive materials and wiping out the image previously captured in the camera. Shining a light from an enlarger through the negative reverses the tones and projects a positive image onto light

sensitive paper. At this point the photographer chooses what size to make the image, but it is not yet visible on the paper. The paper then goes through a series of chemical solutions: first, the developer reveals the image; next, the action of the developer is stopped in the stop bath; then fix, or fixer—a compound that also stops and stabilizes the photographic image—makes it permanent. Finally, the print is washed and dried.

recorded as pixels can be stored as digital files, and either printed on paper or projected on a screen or computer monitor. Some photographers present these images as they were originally taken, but many make alterations to them on a computer.

Photographic Genres

As photography became widely used in the nineteenth century, the English art critic John Ruskin argued in the 1850s that "a photograph is *not* a work of art" because only art "expresses the personality, the activity, the living perception of a good and great human soul." Photographers create images in the same genres as painters, however, making **portraits**, landscapes, and still lifes; although some photographs are factual records, others clearly explore ideas similar to the more traditional ones favored by Ruskin.

Portraiture

From the earliest days of photography, portraiture has been one of its most popular uses. Before photography was invented, the only way to get a portrait was to have an artist paint

Genre: categories of artistic subject matter, often with strongly influential histories and traditions

Portrait: image of a person or animal, usually focusing on the face

Still life: a scene of inanimate objects, such as fruits, flowers, or motionless animals

Gateway to Art: Lange, Migrant Mother How the Photograph Was Shot

In 1936 Dorothea Lange (1895-1965) was working as a photographer for the federal Farm Security Administration when she took a photograph that would become a symbol of the hardships of the Great Depression. Lange later described how she came to take six photographs of Florence Thompson, one of which is known as Migrant Mother. The most famous of the six photos has been the subject of debate ever since. Lange wrote about the experience in the following passage:

I saw and approached the hungry and desperate mother, as if drawn by a magnet. I do not remember how I explained my presence or my camera to her but I do

2.77 Dorothea Lange, Migrant Mother, 1936. Library of Congress, Washington, D.C.

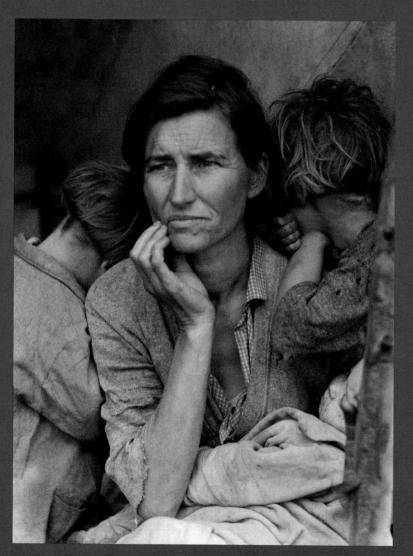

remember she asked me no questions. I made five exposures, working closer and closer from the same direction. I did not ask her name or her history. She told me her age, that she was thirty-two. She said that they had been living on frozen vegetables from the surrounding fields, and birds that the children killed. She had just sold the tires from her car to buy food. There she sat in that lean-to tent with her children huddled around her, and seemed to know that my pictures might help her, and so she helped me. There was a sort of equality about it.

The pea crop at Nipomo had frozen and there was no work for anybody. But I did not approach the tents and shelters of other stranded pea-pickers. It was not necessary; I knew I had recorded the essence of my assignment.

Shooting documentary photographs involves many ethical issues, and Lange's photograph has been the subject of much discussion of the ethics of photography. For example, did Lange consider Thompson's feelings when she had the photograph published? Should the photograph have been published without identifying the mother and her children? In addition, the newspapers never mentioned that Thompson was a Native American who became a migrant when she was displaced from her tribal land at a young age. However, Lange was doing the job the federal government had hired her to do, and her photo made a difference to the lives of many poor and hungry people: after the picture was published, food was rushed to the migrant camp.

Because photographs can be reproduced and manipulated, such an image as Migrant Mother also raises the ethical question of how the image should be used later. Lange's photograph continues to be a symbol of people struggling against poverty and deprivation. It has been published many times since in books and newspapers, and has twice featured on U.S. postage stamps.

2.76 (above) Nadar, Sarah Bernhardt, 1865. Albumen print, Bibliothèque Nationale, Paris, France

one—an expensive and time-consuming process. Photography changed all that. Eventually, camera technology allowed people to take their own pictures and to select and capture their own memories. Many photographic portraits follow the conventions for portraiture established in painting, while others take advantage of the camera's immediacy and its documentary potential to make new styles of portraits.

French photographer Nadar (1820–1910) made portraits of many well-known artists, writers, and politicians. His photograph of the actress Sarah Bernhardt illustrates his distinctive style (2.76). Rather than showing the actress posed with elaborate props, which was the norm for portraits at the time, Nadar placed her in the **foreground**, surrounded only by luxurious fabric and leaning on a plain column. By focusing his attention on the sitter, his image highlights the actress's elegance and an introspective aspect of her personality.

Landscape

While portrait photographers capture images of individuals, landscape photographers take

pictures of the land and its natural features. American Ansel Adams (1902-84) is known for his landscape photographs of the American West. In Sand Dunes, Sunrise—Death Valley National Monument, California, Adams arranges black, white, and gray tones to achieve a balanced effect (2.78). For Adams, a balanced photograph contains a range of tones that help us see the subject the way the artist wants us to, with everything in the picture clearly in focus. He was also deeply involved with the Sierra Club, which was dedicated to preserving America's wilderness. Such landscape photographs as these can raise awareness of nature's grandeur.

artists uses visual language to give a work an identifiable form of visual expression **Foreground:** the part of a work

Style: a characteristic way in

which an artist or group of

depicted as nearest to the viewer

2.78 [below] Ansel Adams, Sand Dunes, Sunrise—Death Valley National Monument, California, c. 1948

2.79 Louis-Jacques-Mandé Daguerre, The Artist's Studio. 1837. Whole-plate daguerreotype. Collection of the Société Française de Photographie

2.80 Edward Weston, Pepper No. 30, 1930. Gelatin silver print, 93/8 × 71/2". Collection Center for Creative Photography, University of Arizona

Still Life

One of the earliest surviving photographs is of a collection of objects in the photographer's studio. Daguerre, who was a painter as well as a photographer, used the genre of still life in much the same way that he did when he painted. A still life, or artistic arrangement of objects, allowed him to study the formal relationships of light, shadow, and texture. At this time many artists worked with live models in their studios, but in The Artist's Studio Daguerre used plaster casts instead, because his exposure times were then generally more than eight minutes, much too long to photograph a living person (2.79).

In the early twentieth century, photographers took a slightly different approach to still lifes. By focusing so closely on an object that it became almost abstract, such photographers as the American Edward Weston (1886-1958) were able to create a new visual experience. Weston believed in photographing a subject as he found it, creating sharply focused prints on glossy paper, and framing images with white mats (cardboard surrounds in which a window for the image was cut) and simple frames. Weston's Pepper No. 30 concentrates the viewer's attention on the form and texture of the vegetable, so it begins to look like something other than itself, taking on qualities

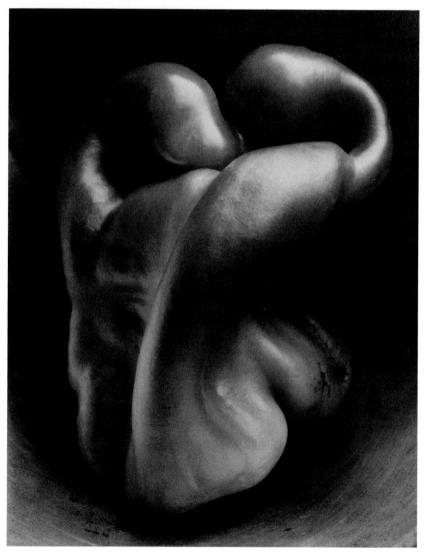

similar to those of a human form; at the same time it clearly represents what it is, a pepper (2.80).

Photojournalism

Photojournalism is the use of photography to tell a news story. Some of the earliest examples of photojournalism date back to the Civil War, when photographic equipment was portable enough to be used in the field. Although we now readily accept that photographs can distort, exaggerate, and even lie—because they can be manipulated, altered, cropped in particular ways, and only ever give a partial view—the medium was once believed to be inherently truthful. This credibility, even today, is crucial for news reportage.

American Lewis Wickes Hine (1874–1940) used photography to expose the injustice of child labor in the early 1900s (2.81). He went into factories and mines under the guise of a salesman, repairman, or safety investigator, and then took photographs as well as detailed notes about the ages of the children he found there. When he later published his findings, the public was shocked by his photos of these children and

their often grueling and dangerous working conditions. His efforts eventually led to the establishment of laws preventing children from working at such young ages.

American Steve McCurry (b. 1950) took his photograph called Afghan Girl in a refugee camp in 1984 after the Soviet invasion of Afghanistan (2.82a). At twelve years old, this young girl had

2.81 Lewis Wickes Hine, Ten Year Old Spinner, Whitnel Cotton Mill, 1908. Photographic print. Library of Congress, Washington, D.C.

2.82a Steve McCurry, Afghan Girl at Nasar Bagh Refugee Camp. Peshawar, Pakistan, 1984

2.82b Steve McCurry, Sharbat Gula. Peshawar, Pakistan, 2002

Texture: the surface quality of a work, for example fine/coarse, detailed/lacking in detail Cast: a sculpture or artwork made by pouring a liquid (for example molten metal or plaster) into a mold Abstract: art imagery that departs from recognizable images from the natural world Form: an object that can be defined in three dimensions (height, width, and depth)

Perspectives on Art: Steve McCurry

How a Photographer Captures a Moment

2.84 Steve McCurry, Dust Storm. Women Take Shelter from Strong Dust-Laden Winds, Rajasthan, India, 1983

Steve McCurry is a photographer who launched his career by entering Afghanistan disguised in native clothing shortly before the Russian invasion in 1978. A photographer needs to be constantly alert for an opportunity to take a great image. Here he describes how he took a photograph of a group of Indian girls in a dust storm in 1983.

As we drove down the road, we saw a dust storm grow—a typical event before the monsoon rain arrives. For miles it built into a huge wall of dust, moving across the landscape like a tsunami, eventually enveloping us in thick fog. As it arrived, the temperature dropped suddenly and the noise became deafening. Where we stopped, the women and children who worked on the roadsomething they are driven to do when the crops fail-were barely able to stand in the driving winds. They clustered together to shield themselves from the sand and dust. I tried to make pictures; they didn't even notice me. In the strange dark-orange light and howling wind, battered by sand and dust, they sang and prayed. Life and death seemed to hang in precarious balance. I took this picture with a wide-angle lens so that I could capture the whole scene at this angle.

The monsoon is the earth's most awesome climate event, and is deeply embedded in the Indian psyche. Some believe that to understand the Indian people one must first understand the effect the monsoon has on the Indian soul.

Covering the monsoon meant total immersion. For months there is no rain, then there is too much. Half the world's people survive at the whim of the monsoon winds. Photographing in this environment is as difficult as it gets. You continually have to wipe away dust or rain from the lens, which takes about half the time. The monsoon rains are accompanied by winds that continually try to wrestle away the umbrella that is tightly wedged between head and shoulders.

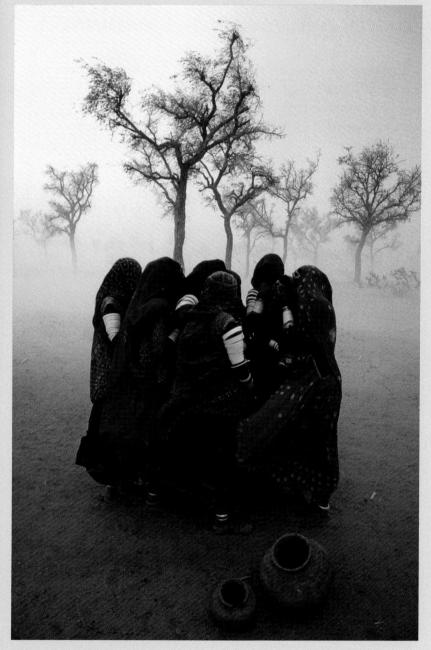

2.83 Hiroko Masiuke, Here Is New York: A Democracy of Photographs, exhibition at the New York Historical Society, September 2007

already lost both parents, fled from her home with her grandmother, brother, and sisters, and walked over snow-covered mountains to Pakistan. For McCurry, pictures of individuals tell the story of conflict. This girl was just one of the people McCurry encountered on his trip, but her eyes made her unforgettable. In 2002, using the original photograph, McCurry again found Sharbat Gula, then in Afghanistan, and confirmed her identity by iris-pattern identification. When they met for the second time, custom dictated she could not smile or even look at a man who was not her husband. Both times their encounter was through the lens of the camera (2.82b).

Today, photojournalism communicates events almost immediately on television and the Internet, but those same images can also be used to record events for posterity. Still images freeze a moment in time. Photographs made during the attack on the World Trade Center on September 11, 2001, were published all over the world right after the event. In the days following 9/11, a group of photographers organized an exhibition called Here Is New York: A Democracy of Photographs on the streets of SoHo in New York City (2.83). The collection of photos gave voice to almost 800 people who had experienced the attack first hand, whether they were professional photographers

or people who just happened to be carrying a camera that day. The exhibition traveled all over the world and was later donated to the New York Historical Society.

The Art of Photography

Photojournalists often focus on documenting a real event, while art can be considered to express an artist's creative interpretation of a subject. As we have seen, photography has not always been regarded as one of the fine arts, such as painting, sculpture, and drawing. Soon after it was invented there were heated debates about whether photography worked best for recording reality or as a way to make works of art. But a walk through today's galleries in any major city will show that photography is a favored medium of many contemporary artists. It was not until as recently as the 1980s, however, that photographs were collected in major fine art museums.

Making "Artistic" Photographs

Swedish photographer Oscar Gustav Rejlander (1813–1875) worked in a labor-intensive, time-consuming way, just like traditional artists.

2.85 Oscar Gustav Rejlander, The Two Ways of Life, 1857. Albumen silver print, 16×31 ". Royal Photographic Society, Bath, England

By emulating the appearance and process of painting, Rejlander hoped his photographs would earn the respect that at that time was reserved for painting. His Two Ways of Life was made with thirty separate negatives, which were cut out like puzzle pieces (2.85). He exposed the negatives one at a time, covering the rest of the print every time he exposed another negative. The resulting image, which took him six weeks to make, looks like one seamless scene.

While Reijlander used manual methods to create his images, German photographer Loretta Lux (b. 1969) uses digital technology to assemble the elements in her compositions. She takes pictures of her friends' children and then subtly manipulates the colors and **proportions**, making the subjects look as if they just stepped out of a fairy tale. Sometimes she also paints backgrounds, which she then photographs and retouches digitally to contribute to the otherworldly effect. She works on each photograph for anywhere from several months to a year. The Waiting Girl shows a little girl and a cat on a vintage sofa (2.86). The girl's severely knotted hair, her uniform-like dress with its prim collar, and the emptiness of the background give the impression she spends her time in a confined environment, likely with people much older than herself. This picture, like the one Rejlander created, shows a scene that did not exist before the artist made it. Lux's subtle use of digital technology, though, allowed her to alter certain attributes, such as **scale** and proportion, to create the effect she wanted.

2.86 Loretta Lux, The Waiting Girl, 2006. Ilfochrome print. $11\frac{7}{8} \times 15\frac{7}{8}$

Recording Detail and Stopping Time

At a time when other photographers were trying to imitate traditional painting, the American Alfred Stieglitz (1864–1946) was among the first to emphasize what he considered to be the particular strengths of the photographic medium: its clarity and realism. In addition to making artistic photographs, Stieglitz actively promoted photography as a fine art medium in

the journal Camera Work (first published in 1902) and in his New York galleries. The Steerage, taken on a trip to Europe, shows the decks of a passenger ship in the cheapest accommodations, separate from the first-class passengers, including Stieglitz himself (2.87). Stieglitz was struck by the **composition** of **shapes** and **rhythms** in the photograph, including the straw hat on the upper deck near the center, the crossed suspenders on the man below, the funnel leaning left, the stairway on the right, and the shapes

2.87 Alfred Stieglitz, The Steerage, 1907. Chloride print, 4^3 /s \times 3^5 /s". Alfred Stieglitz Collection, Art Institute of Chicago

Proportion: the relationship in size between a work's individual parts and the whole Background: the part of a work

depicted furthest from the viewer's space, often behind the main subject matter

Scale: the size of an object or an artwork relative to another object or artwork, or to a system of measurement

Composition: the overall design or organization of a work

Shape: the two-dimensional area the boundaries of which are defined by lines or suggested by changes in color or value

Rhythm: the regular or ordered repetition of elements in the work

2.88 Garry Winogrand, Central Park Zoo, New York City, 1967. Gelatin silver print, 11 × 14"

of round machinery, draping chains, and the triangular mast. This kind of composition seemed thoroughly modern and reminiscent of the abstract paintings of that era.

In contrast to Stieglitz's concern with sharp focus and formal composition, American Garry Winogrand (1928–1984) was more interested in photographic candor and telling the truth. Winogrand used a small camera he could easily carry around with him. He generally did not pose his subjects or set up shots beforehand. Many of his photographs seem spontaneous, as in *Central Park Zoo, New York*: he walked around the city's streets and captured what he found there (2.88). Winogrand's approach, known as the snapshot aesthetic, seems casual and non-professional, but he intended his photographs to be serious and artistic.

Photocollage and Photomontage

A **collage** is a composition created by gluing together fragments of separate materials to form an image. Collage is the name for both the technique and the resulting artwork. Collage can include photo-based images and pre-printed materials. Sometimes collages combine photographs and text. A collage is a unique

artwork, like a drawing or a painting, that is not generally reproduced. By contrast, a **photomontage** is made to be reproduced. In photomontage, the artist combines and overlaps smaller photographic images (using prints or negatives) and then rephotographs or scans the result.

German artist Hannah Höch (1889–1978) was one of the first to make photomontages. She used them as a way to protest social conditions, especially during and after World War I. In *Cut with the Kitchen Knife through the Last Weimar Beer-Belly Cultural Epoch of Germany*, Höch's **Dada** combination of text and images is at once complex and nonsensical (2.89). The disorder of the image effectively reflects the chaos of life at that time.

The American photographer Stephen Marc (b. 1954) manipulates and juxtaposes images so they take on new meaning. In *Untitled—Passage on the Underground Railroad* he interweaves pictures from various sources to create layers that are visually interesting (2.90). They also communicate complex ideas about how the past informs the present. Highlighting the dark and powerful history of the Cedar Grove Plantation in Vicksburg, Mississippi, Marc photographed the slave quarters there; he also includes an

Collage: a work of art assembled by gluing materials, often paper, onto a surface. From the French *coller*, to glue

Photomontage: a single photographic image that combines (digitally or using multiple film exposures) several separate images

Dada: anarchic anti-art and anti-war movement, dating back to World War I, that reveled in absurdity and irrationality

2.89 Hannah Höch, Cut with the Kitchen Knife through the Last Weimar Beer-Belly Cultural Epoch of Germany, 1919-20. Photomontage, $44^{7}/8 \times 35^{1}/2$ ". Nationalgalerie, Staatliche Museen, Berlin, Germany

extract from a slave-owner's letter defending his decision not to emancipate his slaves. The rhythms of the iron fence, antique hoe, and cotton plants are punctuated by the young man who stands, prominently displaying his Phi Beta Sigma fraternity brands, a voluntary celebration of fraternal commitment. The artist sees these markings as a contemporary crossover of African scarification and body marking, and the branding of livestock and slaves. The historical backdrop for this contemporary African American makes the image more intriguing.

2.90 Stephen Marc, Untitled-Passage on the Underground Railroad, 2002. Digital photomontage, archival pigment inkjet print, 9 × 26". Arizona State University, Phoenix

Black and White versus Color

Although color processes were invented around the end of the nineteenth century, they were not used widely in photography until much later. Some artists hand-tinted their photographs or used complicated methods to make color photographs before color film became commercially viable in the 1930s. Even after that, some preferred to use black and white because it makes elements of the composition clearer. Today, so many of the images we see are in color that black-and-white photographs sometimes give the impression of being old-fashioned.

British artist Roger Fenton (1819-69) was hired by a publisher to photograph the Crimean War (1853–6). Because his mission was to help counteract unfavorable public perceptions about the British government's involvement in the war, none of his photographs shows casualties or dead bodies. Valley of the Shadow of Death was titled after a passage from Psalm 23 in the Bible referring to the comfort God offers for the miseries and suffering of life (2.91). In black and white, the cannonballs littering the battlefield seem eerie, and even look like human skulls. Fenton captures the emptiness and desolation of the aftermath of combat in a poetic and thought-provoking scene.

The series *Immediate Family* by American photographer Sally Mann (b. 1951) uses black and white to help transform ordinary moments into nostalgic and provocative statements. Parts of childhood experience and family interactions that might have passed by without note are captured in honest and refreshing ways. The images also reveal how children sometimes predict later adult behaviors in their innocent mannerisms and actions. Mann collaborated with her children to make the photographs: sometimes she came up with the ideas, sometimes they did. The New Mothers shows the artist's daughters at play, believably taking on the guise of women much older than themselves (2.92).

The color photograph Radioactive Cats by American Sandy Skoglund (b. 1946) is a

2.91 (above left) Roger Fenton, Valley of the Shadow of Death, 1855. Gernsheim Collection, Harry Ransom Humanities Research Center, University of Texas at Austin

2.92 (above) Sally Mann, The New Mothers, 1989. Gelatin silver print, 8×10 "

2.93 Sandy Skoglund. Radioactive Cats © 1980. Cibachrome or pigmented inkjet color photograph, $25\% \times 35$ "

2.94 Edward Burtynsky, Manufacturing #17, Deda Chicken Processina Plant. Dehui City, Jilin Province, China, 2005

carefully organized narrative tableau, or arrangement (2.93). Skoglund makes all the objects in her photographs, arranges them herself, then hires actors to pose with them, and records the resulting scene. Sometimes she also exhibits the tableau. In Radioactive Cats the outlandish color contributes to a surreal combination of factual and fictional elements that make us question whether seeing really should be believing.

Canadian Edward Burtynsky (b. 1955) prints his powerful color photographs on a large scale, about 3 × 4 ft., so that small details create an impression of the vast scale of urban landscapes and the relative smallness of humankind. His series called *Manufacturing* focuses on factories in China where raw and recycled materials are brought to be turned into commercial products and shipped all over the world. Manufacturing #17 shows a vista of workers in a chickenprocessing plant (2.94). The vivid pinks of the uniforms, the white pants and boots, and the bright-blue aprons punctuate the industrial grimness of the warehouse. Without passing judgment, Burtynsky's arresting images call attention to things not usually in our consciousness. Burtynsky has said he wants viewers to come to their own conclusions about civilization's impact on the planet because "it's

not a simple right or wrong. It needs a whole new way of thinking."

Conclusion

With the invention of the artificial eye of the camera and the chemistry of film, artists had a new way to record the world. Like other artists, photographers decide what to include and what to leave out, how to compose the image, and how to balance the elements within a scene. Photographers may choose to make portraits, landscapes, or still lifes. Perhaps they may decide to tell news stories; if so, what choice of image tells "the truth"? Some photographers—even using digital images—choose to work using time-consuming craft skills, similar to the tradition of painting. Others prefer the feeling of spontaneity and directness that comes from an apparently casual working method, even if hundreds of photos were needed to choose just one. No matter what kind of image results, the medium of photography is unique because it contains a direct connection to both a particular moment in time (a reality existing in the external world captured by the camera) and the creative and **expressive** choices in the mind of the artist.

Narrative: an artwork that tells a story

Tableau: a stationary scene arranged for artistic impact Surreal: reminiscent of the Surrealist movement in the 1920s and later, whose art was inspired by dreams and the subconscious

Expressive: capable of stirring the emotions of the viewer

2.6

Film/Video and Digital Art

Of all the **media** chosen by artists, the moving image is one of the youngest. For most of its history to date, the dominant process for making movies has been film: flexible, celluloid, and light-sensitive. A movie camera captures movement by taking many separate frames per second, all exposed in sequence onto the same strip of film. After being developed and edited, the moving film passes in front of a bright light in a projector that shines the image onto a screen.

Today, because of the high costs of the medium, making a movie with film requires serious, usually commercial, investment. Film is expensive because it requires many materials, highly specialized equipment, and includes development costs. By contrast, because digital technology does not require such development expenses, once the initial investment in the equipment and software has been made, the overhead for making films digitally is comparatively low. It was not long ago, though, that home movies, artworks, independent films, and major motion pictures were all made and presented on film.

Analog videos, by contrast, are generally made with small, hand-held cameras. Recordings, usually on tape, can be shown on the camera's screen or a television. Like films, videos can be edited by splicing (joining) together separate recordings for a variety of effects. The analog nature of films and videos requires them to be viewed from beginning to end, although sections can be skipped by fast forwarding, or replayed by rewinding. Digital video cameras, which were developed more recently, record images as files

on a DVD disk or computer hard drive. They are shown on a computer monitor, or on a screen using a digital projector. Often, moving images are recorded on film and transferred to a digital format for the purposes of editing and presentation.

Moving Images before Film

How is the illusion of movement created? The principle was understood long before the invention of still or moving film images. An antique child's toy called a zoetrope (2.95) contains a rotating cylinder with a sequence of images on the inside. By looking through the outer ring of the cylinder, which has slots cut into it, and spinning the zoetrope, the viewer gets the impression of a single image in continuous motion. The illusion of movement created in this way is the basis of modern film and video technique.

A theory known as persistence of vision explains that this illusion results from the presentation to the eye of separate images at regular intervals so that they appear to be a continuous sequence. Because visual sensations persist even after the seen object is no longer there, the mind connects them together. This concept is illustrated in a rudimentary way by a flip book with separate still images in a sequence that, when flipped, become visually connected and appear to move. Images captured in the camera use the same concept. The faster the succession of images, the smoother the

Medium (plural media): the material on or from which an artist chooses to make a work of art, for example canvas and oil paint, marble, engraving, video, or architecture

IMAX: a format for film presentation that records at such high resolution that it allows presentation of films at far larger sizes than the conventional one

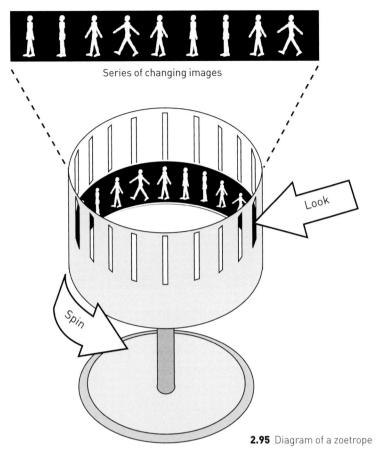

impression of movement. In the earliest film projectors there was a visible "blink" between frames. A modern movie will show images at twenty-four frames per second; IMAX highdefinition films show forty-eight.

As strange as it may seem, in order to make moving pictures it was first necessary to freeze movement in the form of still images. After many failed attempts, the English photographer Eadweard Muybridge (1830-1904) arranged a line of twelve cameras to take a sequence of twelve pictures of a running horse. The cameras, connected to cables stretched across the racetrack, were tripped as the horse passed.

Muybridge was paid about \$42,000 to resolve a wager that a galloping horse has all four of its legs off the ground at once. The camera proved what the naked eye could not see: the horse does (see the third frame of 2.96). Before then, people thought the legs of the horse were

2.96 Eadweard Muybridge, The Horse in Motion, June 18, 1878. Albumen print. Library of Congress, Washington, D.C.

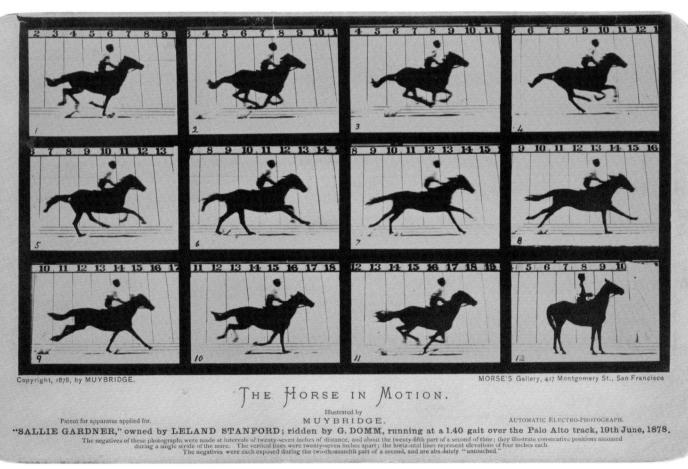

extended, like those of a rocking horse, when they were off the ground. When prints of Muybridge's photographs were published in Scientific American magazine, they were accompanied by instructions to cut them out and place them in a zoetrope.

Silent and Black-and-White Film

The very earliest films were short clips usually documenting single instances of everyday occurrences—feeding the baby, doing a dance, leaving the factory gate at closing time, watching the arrival of a passenger locomotive. The earliest motion pictures were black and white and silent: they had no soundtrack. They were shown in nickelodeons, small storefront movie theaters popular in the early years of the twentieth century. Nickelodeons provided musical accompaniments with live piano and drums, and some provided lecturers to explain the action as the moving pictures, or movies, played. As movies grew into a business, they were shown in huge, ornate movie palaces that might also feature a pipe organ.

By 1896, movies were being shown all over Europe and the United States. Georges Méliès (1861–1938), a French magician and filmmaker, began showing films as part of his theatrical magic show. His silent science fiction and fantasy films were known for their trick effects and humor. In A Trip to the Moon (1902), Méliès's most famous film, a group of astronomers flies to the moon in a spaceship launched from a cannon (2.97). Their vessel crashes into the man-in-themoon's right eye, and then the astronomers encounter wondrous sights and moon inhabitants called Selenites. Méliès was one of the first to use multiple settings, repeated scenes, and cuts to establish a sense of time moving forward.

The American filmmaker D. W. Griffith's (1875–1948) silent film *Birth of a Nation* (1915) was Hollywood's first blockbuster and one of the first films to tell an epic story (2.98). The film introduced a number of new techniques, including original editing styles to make transitions between scenes and vary the sense of

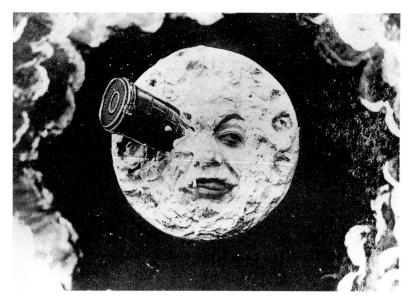

pace. Birth of a Nation uses symbolism, gesture, and intertitles (onscreen text), rather than spoken dialogue, to move the story along. The film is now controversial for its reinforcement of racist views and stereotypes of the Old South; in fact, the Ku Klux Klan used it for recruitment. Despite this unpleasant history, Birth of a Nation is important for the epic scale of its production, its stylistic and technical innovations, and its use of the film medium as a propaganda tool.

2.97 Georges Méliès, scene from A Trip to the Moon (Le Voyage dans la Lune), 1902, 14 minutes, Star Film

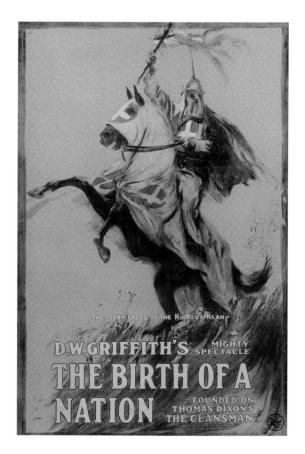

2.98 D. W. Griffith, Birth of a Nation, 1915, publicity poster

Style: a characteristic way in which an artist or group of artists uses visual language to give a work an identifiable form of visual expression

Propaganda: art that promotes an ideology or a cause Color: the optical effect caused when reflected white light of the spectrum is divided into a separate wavelength

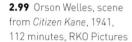

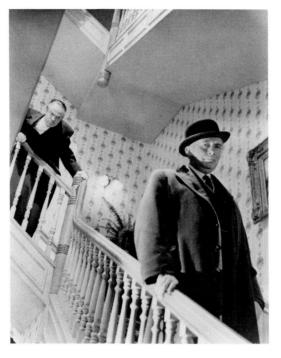

Another American filmmaker, Orson Welles (1915–85), wrote, directed, and starred in Citizen Kane (1941), a film that was a box-office failure but hailed by critics as brilliant (2.99). It is now widely considered one of the most important films of all time. Welles's film tells the story of Charles Foster Kane, a character modeled on the

real-life newspaper tycoon William Randolph Hearst. To tell Kane's story, Welles used what were then highly innovative techniques, including fabricated newspaper headlines and newsreels that give the impression of following a factual story. Other parts of the plot are told using flashbacks. Citizen Kane also features techniques that were revolutionary for the time, such as dramatic lighting, innovative editing, natural sound, elaborate sets, moving camera shots, deep focus, and low camera angles. The movie questions the values of the American Dream and was controversial for its criticism of Hearst, a powerful public figure.

Sound and Color

From the late 1920s, movie studios promoted color as a novelty to attract audiences. One of the first popular films to make use of color combined both the new and old approaches. In The Wizard of Oz (1939), Dorothy Gale is transported by a cyclone from Kansas to the Technicolor Land of Oz (2.100). The story's two separate locales are distinguished by the use or

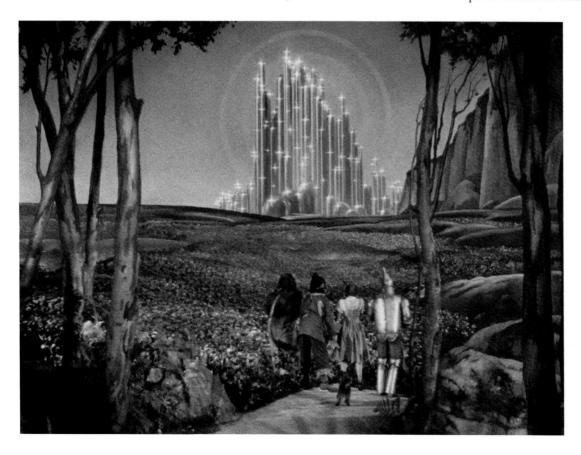

2.100 Victor Fleming, scene from The Wizard of Oz, 1939, 101 minutes, Metro-Goldwyn-Mayer (MGM)

Background: the part of a work depicted furthest from the viewer's space, often behind the main subject matter

2.101 Stanley Donan and Gene Kelly, still from Singin' in the Rain, 1952, 103 minutes, produced by Loew's Incorporated, distributed by MGM

absence of color. The film opens with Dorothy in the black-and-white world of her home on a Kansas farm. Later, the brilliant colors of the Land of Oz transport us into a fantasy world clearly far removed from Kansas. Color features prominently throughout the film: Dorothy wears ruby slippers as she travels with her companions—her dog Toto, the Scarecrow, the Tin Man, and the Lion—along the yellow-brick road to the Emerald City to find the wizard.

Before 1927, any sound in cinemas was performed live by musicians in the theater building. After that, integrated sound made it possible to build dialogue, background noise, and music into the film itself. Singin' in the Rain, made in 1952, looked back to the silent era by telling the story of a silent-film company making

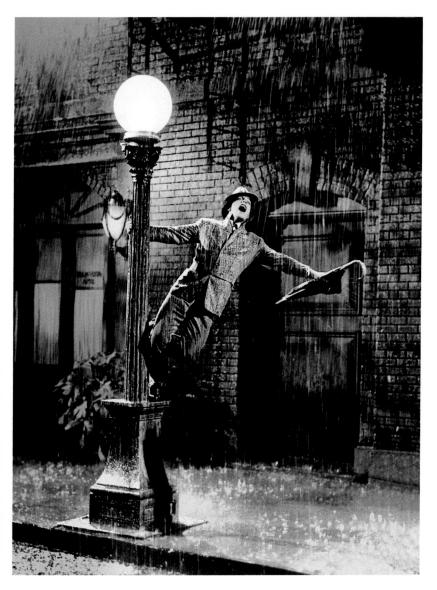

the difficult transition to sound. Synchronizing sound with the actors' lip movements and dubbing was one of the great technical challenges of early sound movies, as songs could not be performed on camera by the actors, but had to be recorded separately. Singin' in the Rain finds much humor in this situation. In the movie's most famous scene, actor Gene Kelly jubilantly performs the title song in the rainy streets. All musicals tell their story in a combination of dialog, songs, and dance. Frequently, as in this scene, dialog stops completely, and song and dance move the story along (2.101).

Animation and Special Effects

Animation creates the illusion of movement in films by taking a still image of an object or drawing, changing it slightly for each new frame, and then projecting all the images in sequence. The many thousands of images in modern animations, such as those from Pixar Studios, are generated and manipulated on computers.

Special effects can be created by using models, props, or makeup during filming, or by the use of digital technology.

Some of the earliest film animations were made using puppets or dolls. In stop-action animation, the figures are photographed in a pose, moved very slightly, and then photographed again; the process is repeated until the desired sequence of movements has been acted out. Russian animator Wladyslaw Starewicz (1882-1965) created a stop-action animation movie about infidelity, with a twist: the characters in The Cameraman's Revenge (1912) are bugs (2.102). Mr. Beetle has gone to the city on business. He meets a dancer at the Gay Dragonfly, a burlesque parlor. A grasshopper cameraman at the burlesque also has designs on Miss Dragonfly. He is so jealous that he films Mr. Beetle and the dancer. When Mr. Beetle returns home, he finds his wife in the arms of an "artist" cricket. Mr. Beetle, after beating up the lover, forgivingly takes his wife to the movies, where his own

2.102 Wladyslaw Starewicz, Mest Kinematograficheskogo Operatora (The Cameraman's Revenge), 1912, produced by Khanzhonkov Company, Moscow, Russia

2.103 Hayao Miyazaki with Kirk Wise (English version), still from Spirited Away, 2001, 125 minutes, Studio Ghibli

indiscretions are projected onto the big screen. This film is surprising for the physical expressiveness of the bugs as well as for the wit that gives the plot a slapstick quality. Like many animated films, The Cameraman's Revenge was made more for adults than children.

The most common technique for making animated films is called cel animation, which uses a sequence of drawings called cels. The Oscar-winning film Spirited Away (2001),

written and directed by Hayao Miyazaki (b. 1941), tells the story of a ten-year-old girl named Chihiro who is unhappy about moving to a new town with her family. After her parents are transformed into pigs, she is introduced to a world filled with spirits from Japan's mythology (2.103). She must go on a quest to conquer her fears in order to find the strength to bring her family back together.

Miyazaki personally created detailed storyboards, or series of drawings, to be used as the basis for the animations, which were then completed by a team of artists. Backgrounds were drawn on transparent sheets that could be used for an entire scene, but a separate drawing had to be made for each stage in the movement of any moving object. At least twelve drawings, and sometimes thirty, were required for every second of Spirited Away. Thus a film of this length (125 minutes) requires a minimum of 90,000 drawings, and perhaps as many as 200,000.

American film director George Lucas's (b. 1944) Star Wars (1977) set a new standard for blockbuster films by earning \$194 million at the box office and bringing science fiction into the mainstream. It offered a timeless tale of

2.104 (above) George Lucas, still from Star Wars Episode IV-A New Hope, 1977, 121 minutes, Lucasfilm

good versus evil in a fantasy setting peopled with bizarre creatures. The Star Wars series of films is known for its elaborate and imaginative special effects. The fantastical and dramatic scenes, cosmic battles, and otherworldly environments combine footage shot on location in Tunisia, Guatemala, and Death Valley, California, with imagery created in the studio using super-realist paintings, detailed models, and computer-generated and digitally timed effects (2.104).

The French director Jean-Pierre Jeunet (b. 1953) adds animation and special effects to live-action film to tell the story of Amélie (2001), a shy twenty-three-year-old waitress (2.105). Amélie's heart beats out of her chest at one point; in another scene, when her crush Nino walks away, she melts into a puddle on the floor. Inanimate objects, such as the Impressionist artist Pierre-Auguste Renoir's painting Luncheon of the Boating Party, take on so much significance that they almost function as additional characters. Jeunet creates an environment in which fantasy, reality, and rich color are mixed together to reveal the magical qualities of ordinary life.

2.105 (below) Jean-Pierre Jeunet, still from Amélie (The Fabulous Destiny of Amélie Poulain), 2001, 122 minutes, Claudie Ossard Productions

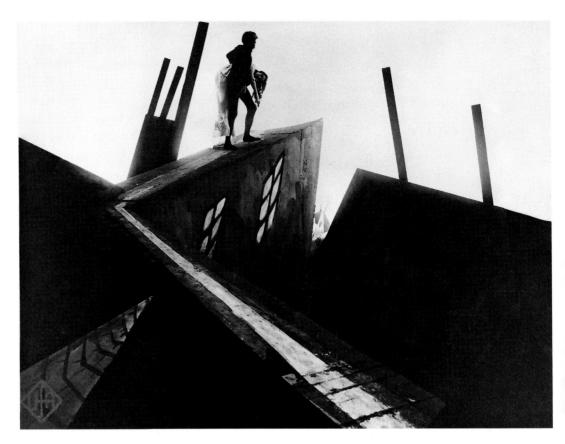

2.106 Robert Weine, still from The Cabinet of Dr. Caligari, 1919, 80 minutes, Steiner

Film Genres

Over time, certain genres, or categories, of film have developed their own conventions, plot lines, and stock characters. As we have seen, musicals interweave singing and dancing into the narrative flow; science-fiction films explore fantasy in a context of space and time beyond the everyday. Romantic comedies and Westerns have evolved to explore changing views of relationships and U.S. history. Some other familiar film genres include horror and documentary films.

One of the earliest horror films, The Cabinet of Dr. Caligari (1920), creates a creepy, nightmarish world. Directed by Robert Wiene (1873–1938), the film tells the story of a psychiatrist, Dr. Caligari, and his servant Cesare, who can foretell the future. Another character, Francis, suspects Caligari and Cesare of a series of murders, including that of his friend. In one scene Cesare abducts Francis's fiancée, Jane. (He is shown carrying her onto the bridge in **2.106.**) The film ends with a twist when Francis turns out to be a patient of Dr. Caligari, and the entire film is apparently one of his delusions.

The Cabinet of Dr. Caligari is famous for its plot development, its character types, the strange, shifting mood of the film, and the way its scenic design expresses this psychology. The costumes, makeup, gestures, and music combine to create a dark and mysterious atmosphere. The film's **Expressionist** sets were designed by German artists and include crooked walls, angular buildings, and jarring plant forms that mimic the narrator's tortured mind.

Documentaries seek to inform us about actual subjects, events, or people. Some documentaries present the story directly, filming events as they occur through people's own voices and actions. Other documentaries edit past, present, and future events together to tell a story. Some documentaries use voiceover commentary to narrate or interpret the action or events. Most documentary films combine such approaches, shaping factual information to express a point of view.

An Inconvenient Truth (2006), directed by Davis Guggenheim (b. 1963), presents startling facts about global warming. The film interweaves former Vice President Al Gore's public lectures on climate change with narratives about his life, family, and political career (2.107).

Genre: category of artistic subject matter, often with a strongly influential history and tradition

Expressionism: an artistic style, at its height in 1920s Europe, which aimed to portray the world in terms of vivid extremes of personal experience and feeling

Form: an object that can be defined in three dimensions (height, width, and depth) Documentary: non-fiction films based on actual people, settings, and events

2.107 Davis Guggenheim. still from An Inconvenient Truth, 2006, 95 minutes. Lawrence Bender Productions

With graphs, charts, and photographs, Gore describes the impact of pollution and carbon emissions on our planet. In one of the most startling examples of global climate change, photographs show the recession of glaciers and the melting of the ice shelves of Antarctica. Animated maps of Florida, San Francisco, Beijing, Bangladesh, and Manhattan show the projected effects on shorelines if the sea level rises twenty feet, as it will if the ice masses of major sections of Antarctica continue to melt.

Film as Art

Experimental Films

Experimental films analyze and extend the medium of film by using new technology or subject matter, and by exploring new aesthetic ideas. They tend to be visually compelling and poetic, notable for their unusual content and idiosyncrasy. They are often the production of a single person or small group, and experimental filmmakers use inexpensive equipment and lowbudget formats to create desired effects. They frequently do not have integrated sound, or use it in unnatural ways. Experimental filmmakers tend to adopt innovative approaches, including dream sequences and fantastic imagery created by manipulating the filmstrip. Such films are also often autobiographical.

American dancer, choreographer, and filmmaker Maya Deren (1917-61) wrote Meshes

of the Afternoon (1943) and co-directed it with her husband, cinematographer Alexander Hammid. The film follows a woman's experience of an afternoon, shuffled together with her dreams after she has drifted off to sleep in a chair (2.108). Two sequences are repeated: in one, a cloaked woman with a mirror over her face walks down the road; in the other, the woman (played by Deren) enters a house and walks up the stairs. These sequences appear to be replaying themselves in the woman's mind rather than representing actual events. Several objects are shown again and again: a flower, a key, a telephone, a large knife, a record player, billowy curtains, rumpled sheets. Elements change each time the sequences are shown. For instance, one moment the flower is placed on the pillow, the next the knife appears in the same position. Toward the end of the film a man replaces the female figures, one moment entering the house and the next walking on the road.

Time is circular in this film, and the overall effect mimics a dream in which events that make sense to the dreamer seem illogical to others. Each object seems to have an unnamed symbolic significance, and it is impossible to separate actual occurrences from memories or fiction. Ultimately, the film reflects a state of mind, and can be best understood as visual poetry.

American Sadie Benning (b. 1973) began making videos at the age of fifteen. Like all of her work, Flat is Beautiful challenges societal perceptions while using innovative techniques

2.108 Maya Deren, still from Meshes of the Afternoon, 1943, 16mm black-and-white silent film, 18 minutes

2.109 Sadie Benning, still from Flat Is Beautiful, 1998, Pixelvision video with sound, 56 minutes

(2.109). Benning used a toy camera, the Fisher Price PixelVision camera, along with Super-8 film and animated collages to make Flat Is Beautiful. The sections shot with PixelVision are grainy, black-and-white images, emphasizing the handmade and personal quality of the video. Based on Benning's own experiences growing up as a lesbian, this story focuses on the isolation and persecution of an adolescent named Taylor. Taylor is undergoing a difficult transition into adulthood as she tries to come to terms with issues of identity and sexuality in a world of rigidly defined gender distinctions. The video's title refers both to the hand-drawn paper masks the characters wear and to an appreciation of the flat-chested figure.

Video

Typically, video artworks are made to be presented in art galleries or at art events. They may be shown on television monitors or projected onto walls. Sometimes artists incorporate video displays (along with other media) in a darkened area in ways that transform the space and create a total environment of sight and sound. Because high-quality video equipment is relatively inexpensive, artistic experimentation with video is widespread.

Korean-American artist Nam June Paik (1932-2006) was a pioneer of video art. In 1969 Paik worked with Shuya Abe, an engineer from Tokyo, to modulate video signals with a device called the Paik-Abe Synthesizer. The results

combined both recognizable and distorted pictures that were recorded and could be replayed later. Paik's Global Groove (1973), a thirty-minute video recording, comments on the increasing role of media and technology in daily life.

Global Groove replicates the variety of topics available on television at the time the video was made, from Pepsi commercials to news footage to game shows to President Richard Nixon's face. All these scenes are interspersed like glimpses of changing channels. Most of the clips integrate music and visuals, consisting of either performers or dancers. For example, Charlotte Moorman is shown playing several experimental cellos designed by Paik. The close-up of her face (2.110) is surrounded by visual noise, static translated into changing designs that correspond to the rhythms of the music she is playing. Global Groove draws on contemporary culture, and foreshadows music video by integrating visual and musical inputs.

Interactive Digital Media

Recent developments in digital technology have allowed artists to involve viewers as active participants in the artwork by, for example, determining the appearance of the work or choosing different paths to follow.

Fantastic Prayers (1999) is the creation of three artists: Constance DeJong (writer, b. 1950),

2.110 Nam June Paik and John J. Godfrey, still from Global Groove, 1973, singlechannel videotape, color with sound. Courtesy Electronic Arts Intermix (EAI), New York

Aesthetic: related to beauty, art, and taste Collage: a work of art assembled by gluing materials, often paper, onto a surface. From the French coller, to glue

Perspectives on Art: Bill Viola

How Did Video Become Art?

Bill Viola, one of the world's leading video artists, has been working in video since the 1970s. Here he explains why many contemporary artists prefer video as an art form.

I first touched a video camera in 1970 as a firstyear art student. In those politically charged times, making art took on a renewed urgency, and the new electronic communication technologies played a central role in re-imagining not only what a work of art could be but also how it could reach beyond the art world to engage life and society directly and transform the world.

2.113a (above) Bill Viola, Going Forth by Day, 2002. Installation view, video/sound installation, five-part projected image cycle

2.113b Bill Viola, The Raft, May 2004. Video/sound installation, color highdefinition video projection on wall in darkened space, screen size 13' x 7'37/8"

2.113c Bill Viola (on the right) in production for The Raft. Downey Studios, Downey, California, 2004

By the early 1970s, political and social activists, documentary filmmakers, and artists of all disciplines were using video and showing their work together in art museums, film festivals, community centers, universities, and on television.

Video as art exists somewhere between the permanence of painting and the temporary existence of music. Technically, the video system of camera and recorder mimics the human eye and memory. The so-called video "image" is actually a shimmering energy pattern of moving electrons vibrating in time. To exist, the fabric of the image needs to be in a constant state of motion. The electronic image is not fixed to any material base, and as digital data it is infinitely reproducible. It can be copied, stored, and transferred onto new formats in a continuous chain of eternal life. As an electronic signal it can travel at the speed of light around the Earth and beyond, and it can appear in multiple places at the same time. As an international technical standard, the image exists in the same form as the dominant mass media, allowing artists the potential to address the global culture. Since the production and distribution of images is now accomplished by the same technological system, today's artists have the freedom to work within existing institutions or become their own producers and distributors.

Technology is the imprint of the human mind onto the material substance of the natural world. Like the Renaissance, today's technological revolution is fueled by a combination of art, science, and technology, and the universal human need to share our individual ideas and experiences in ever-new ways. The medium of video, where images are born and die every instant, has brought a new humanism to contemporary art. The digital image has become the common language of our time, and through it living artists are once again emerging from the margins of the culture to speak directly to the people in the language of their experience.

Tony Oursler (visual artist, b. 1957), and Stephen Vitiello (musician/composer, b. 1964). This project, which started as a performance, is especially well suited for the virtual environment of the Web (2.111). In it, fragments of text, images, and sounds constantly shift and change rather than being restricted by fixed boundaries.

Fantastic Prayers combines eight environments that visitors explore like archaeologists to uncover fragmentary narratives, memories, objects, and places: Place Where Lost Things Go, Ludlow Street, Graveyard, Hair, Natatorium, Empathy Wheel, Walls that Speak, and Jacket. Actions vary for each environment, including locating items, embarking on journeys, and discovering embedded video and audio works. Some environments are like detective mysteries, while others can be played like games. For example, Empathy Wheel incorporates fourteen videos that give visitors the opportunity to manipulate actress Tracy Leipold's emotions. Like the rest of the environments, Empathy Wheel is driven by the user's choices and experience rather than having a beginning, middle, and end.

The Road Movie was an interactive Web project consisting of a bus called MobLab ("Mob" for mobile and for crowd; "Lab" for laboratory) in which German and Japanese artists traveled across Japan in the fall of 2005. Their trip was tracked by Global Positioning System (GPS); five cameras mounted on the bus recorded the journey and uploaded to the Web every five minutes. The five camera shots (front, back, right, left, and top) were

2.111 Constance de Jong, Tony Oursler, Stephen Vitiello, Fantastic Prayers, 2000. Screenshot from CD-ROM. Courtesy Dia Art Foundation

configured into image files in the form of patterns that allowed Internet viewers to print out and fold digital **origami** replicas of the bus and its exterior views to make their own road movie (2.112).

2.112 exonemo, The Road Movie, 2005. Mobile installation system (MobLab on the road in Japan, October 18-November 6, 2005) and online artwork

Conclusion

Film and video evolved from the sequencing of still images to replicate the appearance of life moving in front of our eyes. Such elements as sound, color, animation, and special effects have added to the believability and appeal of movies made for both entertainment and artistic purposes. Film also has the power to re-create dreamlike effects and to make a big impression on us through its glamour and immediacy. As it has developed into a major industry, popular cinema usually produces and markets films belonging to different genres that promote desired—if at times predictable kinds of characters and storylines. Documentaries step outside of the imaginary world to tell us about reality, generally from the filmmaker's point of view. In the world of art movie-making and video, artists have extended the medium in ways that are often visually compelling and poetic. Artists have also used the low cost of accessible digital and Internet technologies to create new kinds of reflections of our world.

Moving images are all around us. Knowing about the history and technology of film, video, and digital movies enriches our experience of them.

Origami: the Japanese art of paperfolding

2.7

Alternative Media and Processes

Artworks made using alternative media and processes break down the traditional boundaries between art and life. They draw our attention to actions or ideas rather than to a physical product. The creative process produces events, ideas, and experiences that are artworks in and of themselves. Many artworks that are interactive or involve the viewer in unusual and significant ways fall into this category.

Performance art has some similarities to theater because it is performed in front of a live audience. Performance art includes varying amounts of music, dance, poetry, video, and multimedia technology. Unlike traditional theater, however, there is rarely an identifiable story and the performance takes place in consciously artistic venues. The actions of the artist, or individuals chosen by the artist, become the focus. These actions, which occur in a gallery, on a stage, or in a public place, may last from a few minutes to a few days and are rarely repeated.

In **conceptual art**, the idea behind an artwork is more important than any visible subject or material product. Artists generally plan the piece and make all of the major decisions beforehand; the execution of the piece itself is secondary. Conceptual art often produces no permanent artwork and very little that can be promoted and sold: sometimes a set of instructions, a documentary photograph, or nothing at all remains as evidence that the piece existed.

For example, if an artist printed a set of instructions for the viewer, the actual, tangible result of the piece would be the actions that person performed. Yoko Ono's Wish Tree (2.119see p. 244) existed only in a potential state when the artist first made it. The piece requires the viewer's participation to be realized. In Vito Acconci's Following Piece (2.115—see p. 242), there was no audience at the time, but the artist took pictures of each 'following' that he made.

When artists design an entire exhibition space as an artwork, usually in a gallery or museum, it is called an installation. Installations might consist of props and sets to transform the space into a room in a house or a place of business; they might incorporate electronic displays or video projections; or they might involve artworks arranged in relation to one another in a sequence or series. Often installations are designed to fit the dimensions or environment of a particular location: these installations are called "sitespecific." The artist plans the space, considers how people will move through it, and arranges the elements to create a certain effect. Whether they are designed for an interior or exterior space, installations immerse viewers in the artwork.

Context of Alternative Media

During the twentieth century, a way of making art emerged that focused on modes of creation, such as actions, texts, and environments. These approaches differed from the traditional Western practices of "fine art," narrowly defined as paintings on canvas and sculptures on pedestals. American artist Jackson Pollock's (1912–56)

Medium (plural media): the material on or from which an artist chooses to make a work of art, for example canvas and oil paint, marble, engraving, video, or architecture

Performance art: a work involving the human body, usually including the artist, in front of an audience Conceptual art: a work in

which the ideas are often as important as how it is made **Installation:** an artwork created by the assembling and arrangement of objects in a specific location

action paintings of the 1950s brought the canvas off the easel and onto the floor to become a surface around which the artist moved as he splashed, dripped, and flung his paint. His unusual and exciting painting techniques galvanized public interest in "difficult" modern art. Pollock rocketed to popular fame following an article of August 8, 1949 in Life Magazine that even asked, "Is he the greatest living painter in the United States?" Not long after Pollock's early death in a car crash, though, there was a sense that artists had exhausted all they could say with paint on canvas. Artists began to turn to performance, conceptualism, and installations to explore radical new ideas about art.

Because this chapter focuses on the ideas expressed in the making of artworks rather than the finished objects themselves, we shall also look at the documentation about them—instructions used to plan an activity, notes taken by the artist related to a piece, or photographs or video made during a performance. The works themselves tend to last for a relatively short period of time.

Performance Art

During the 1960s and 1970s artists all over the world began exploring theatrical actions or performances as a new form of creative activity they termed performance art. American composer John Cage (1912–92) incorporated into his music chance operations, experimental techniques, and even silence. Heavily influenced by Zen Buddhism, Cage wanted to jolt his audiences into paying attention to the life all around them. He was one of the first artists to conduct **happenings**, or impromptu art actions. Theater Piece No. 1 (1952) was an unrecorded collaboration in poetry, music, dance, and paintings by the faculty and students at Black Mountain College in North Carolina. The performers mingled with the members of the audience, and the piece relied for its outcome on improvisation and chance rather than a script or musical score. Its lasting influence comes from its emphasis on performance rather than documentation. Happenings expanded the scope of art to include the lived moment actions as they happen, here and now.

2.114 Joseph Beuys, Coyote, I Like America and America Likes Me, May 1974. Living sculpture at the René Block Gallery, New York

The work of German artist Joseph Beuys (1921–86) explores his own German heritage and wider issues of social identity. Beuys's early life under the Nazis, especially his compulsory membership of the Hitler Youth and volunteer service as a fighter pilot in the German Air Force, strongly influenced his artwork. After his plane crash in World War II, Beuys's artworks often recalled the nomads that rescued him and prevented him from freezing to death by wrapping him in fat and felt. The materials used to save his life became symbolic elements in many of his sculptures and performances. A large piece of felt was one of the major props in his piece Coyote, I Like America and America Likes Me (2.114). The piece is mysterious. Because Beuys did not speak or interact with anyone during the five-day performance, a sense of myth surrounds the events that actually took place. Upon arrival in America, Beuys was transported from the airport to the gallery in an ambulance. He was wrapped in felt, covered in hospital blankets, and carried on a gurney so he could not see his surroundings or touch American soil. During the performance he was confined in the gallery with a coyote, a trickster or mischievous figure in native American mythology, and symbolic of the spirit world. Beuys's action (as he called his performances) was intended to activate a process of spiritual healing and reconciliation, to make amends for the desecrations caused by the coming of Europeans

to the New World.

Action painting: application of paint to canvas by dripping, splashing, or smearing that emphasizes the artist's gestures Happening: impromptu art actions, initiated and planned by an artist, the outcome of which is not known in advance

When he was finished with his performance, the artist was wrapped up and whisked away by ambulance in the same manner as he had come. Beuys saw his actions as a way to make art more connected to society, incorporating commitments to activism and political reform.

Early in his career, American artist Vito Acconci (b. 1940) was known for art actions and performances. These works consisted of situations he set up for himself, and records of how he completed them. His stated intentions for Following Piece (2.115) were: "Choosing a person at random, in the street, a new location, each day. Following him wherever he goes, however long or far he travels. (The activity ends when he enters a private place—his home, office, etc.)." Acconci performed this activity for twenty-three days; the longest following lasted nine hours. An exhibition of Following Piece includes documents of the events, such as the artist's handwritten note cards, and photographs of Acconci walking behind the person being followed. Following Piece examines both the relationship between the artist and the viewer and the way an artist's actions create interactions with another person. In this sense Acconci's work is a conceptual performance: it is about ideas and a set of actions as much as about the production of a work of art. It is interesting to note how our view of such works can change through time. In 1969, when the piece was first developed, it was regarded as a new idea, but nowadays, we might look on the artist's actions in following and photographing someone without their knowledge as disturbing or even menacing.

Some performances put the body through extremes of endurance, as Serbian artist Marina Abramović (b. 1946) has done in a number of works dating back to the 1970s. In one piece she lay in a ring of fire until she fainted from asphyxiation (and had to be rescued by onlookers). In another, one of her longest pieces

2.115 Vito Acconci, Following Piece, 1969. Street Works IV. 23-day activity

2.116 Marina Abramović, The House with the Ocean View, 2002. Performance at Sean Kelly Gallery, New York

(it took almost three months), she and her partner Ulay started at opposite ends of the Great Wall of China and met in the middle after walking over 1,242 miles. In 2002 Abramović performed The House with the Ocean View at a gallery in New York City. For twelve days she did not eat, speak, read, or write while she was isolated and on public view. The rungs of the ladders leading to the raised sitting room, bedroom, and bathroom were made of large butcher knives, reinforcing the idea of confinement (2.116). For the duration of the piece Abramović performed some of her everyday activities—sleeping, drinking, going to the bathroom, dreaming, looking, and thinking—in ways that were highly conscious and deliberate. Because she did not allow herself to talk, the artist spent her time interacting with the members of her audience visually, looking at them, being looked at, and relating to them without speaking. As an art performance carried out in public, The House with the Ocean View calls attention to the simplicity and meaningfulness of everyday life.

Conceptual Art

Conceptual art is a form of art that emphasizes ideas and radically downplays the importance of the work of art as craft object. It has flourished from the 1960s onwards. In some ways conceptual art is similar to **Dada** absurdist events in Zürich in 1916, where artists performed nonsense poetry as a release from and savage commentary on the events of World War I. Dadaist Marcel Duchamp (1887-1968) also made artworks that challenged traditional notions of art. One of his works, Fountain, was rejected for an art exhibition in New York in 1917 because it was simply a factorymade white porcelain urinal, signed "R. Mutt." Duchamp was very influential for many artists later in the twentieth century, and opened up possibilities of making art with everyday things and materials, imagery from popular culture, or even simply ideas.

Many examples of conceptual art consist of words on a page or background. These words cut to the chase, not only directing our attention

2.117 Barbara Kruger, Untitled (Your Gaze Hits the Side of My Face), 1981-3. Photograph, 55 x 41"

to the core concept but also allowing us to make the words meaningful for ourselves. American artist Barbara Kruger (b. 1945) uses her training and experience as a graphic designer to combine found images and words to give them new meanings. Her pieces address the powerful institutions of society and stereotypes that are often seen in graphic design and museum display. As in Untitled (Your Gaze Hits the Side of My Face) (1981–3), there is often a feminist overtone to her work, taking the institutions to task for their treatment of women (2.117). Because the text is written in the first person, the sculpture in the picture seems to be speaking, addressing the viewer directly. In this piece, beauty is shown to be just a coating or surface, and the viewer realizes that when we gaze at beauty we become voyeurs.

Like Kruger, American artist Bruce Nauman (b. 1941) uses words as the basis for some of his artworks, though he employs the text directly, without an accompanying image. Nauman shapes neon, an unconventional artistic medium more commonly used for commercial signs, into

Dada: anarchic anti-art and anti-war movement, dating back to World War I, that reveled in absurdity and irrationality Found image: an image found by an artist and presented with little or no alteration as a work of art

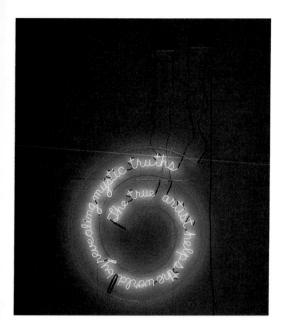

2.118 Bruce Nauman, The True Artist Helps the World by Revealing Mystic Truths (Window or Wall Sign), 1967. Neon tubing with clear glass tubing suspension frame, $59 \times 55 \times 2$ ". Philadelphia Museum of Art

a message, for example: "The true artist helps the world by revealing mystic truths" (2.118). He made this piece while working in a studio in San Francisco that had formerly been a grocery store. Inspired by a beer sign he found, the work addresses metaphysical concerns about the role of the artist in a way that does not initially look like art. The flashy appearance of the spiral of handwritten text draws us in and confronts us with a statement that is both serious and funny.

Yoko Ono (b. 1933), a Japanese-born American artist and musician, began making conceptual artworks in the early 1960s. Her first pieces were poetic instructions to be performed or just imagined. Sometimes they were typescripts framed and put on the wall. Other times, Ono painted right on the museum or gallery wall (again highlighting the transient nature of some of these pieces, because when the exhibition ended, those instructions would disappear).

She then started to ask viewers to complete her pieces by, for example, burning or walking on the paintings. Eventually she made "Instruction Paintings," consisting of typed instructions, rather than finished works of art. The instructions are open-ended and serve as a beginning point rather than a final product. They rely heavily on the interaction and participation of the viewer. The instructions for Wish Tree for Washington D.C. (2007) state: "Make a wish, Write it down on a piece of paper, Fold it and tie it around the branch of a Wish Tree, Ask your friends to do the same, Keep wishing Until the branches are covered with your wishes." Inspired by the Japanese practice of tying prayers to a tree, Ono has made Wish Trees like the one in **2.119** all over the world.

2.119 Yoko Ono, Wish Tree for Liverpool, 2008. Bluecoat Arts Centre, Liverpool, England

Perspectives on Art: Mel Chin

Operation Paydirt/Fundred Dollar Bill Project

Mel Chin (b. 1951), an American conceptual artist, challenges the traditional role of the artist and the expected outcomes of artworks. Here Chin describes how a collective work of art (2.120 and 2.121) made by children and adults across the United States (and interested people from other countries) can be used to raise awareness and support for an important environmental initiative.

Following Hurricane Katrina, I was invited to contribute to rebuilding the social, cultural, and physical infrastructure of New Orleans. Researching the impact of the storm and the pre-existing conditions in the city, I found New Orleans to be the second most lead (Pb)contaminated city in the United States, and that the elevated levels had existed in the soil before the storm. The contamination exists in thousands of properties and contributes to the high percentage of the inner-city childhood population that suffers from lead poisoning. Scientific studies have linked lead poisoning to elevated rates of violent criminal activity and poor academic performance in schools. The presence of polluted soil and the absence of capital to respond to the situation motivated the creation of this dual-layered project. Paydirt/Fundred is a method to respond to this condition—through art—and to transform through science—an environment that compromises human health.

Operation Paydirt offers a pragmatic, scientifically proven method to neutralize hazardous lead that contaminates soil and compromises the health of children. This plan, focused on solution, has the potential for creating a model for all cities and counteracting an environmental factor that undermines the health of society.

Supporting Operation Paydirt is the Fundred Dollar Bill Project, a collective artwork, created by children and adults across the country, of three million original interpretations of the U.S. \$100 bill. Through Fundred, a childhood

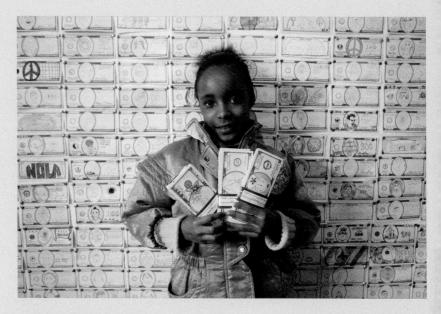

population most threatened has a means to respond. These unique artworks will be delivered to the steps of Congress where an even exchange of this "creative capital" will be requested to obtain funding for implementation of Operation Paydirt.

The Paydirt/Fundred project seeks to facilitate the complete transformation of New Orleans into a city with lead-safe soil, through the delivery of a scientific solution to the problem of lead contamination, while calling for action through a nationwide drawing project designed to engage all. The approach extends across the disciplines of art, science, and education, and is sensitive to aspects of community development and urban infrastructure.

2.120 Mel Chin, Operation Paydirt/Fundred Dollar Bill Project. Devion Charlot, a resident of the 7th ward in New Orleans, shows some of the thousands of fundreds on display at Safehouse

2.121 Mel Chin, Operation Paydirt/Fundred Dollar Bill Project. Examples of the fundreds drawn by students in New Orleans, Louisiana (top left and right); Marfa, Texas (bottom left); and Collowhee, Tennessee (bottom right)

Installation and **Environments**

The Store by the Swedish-born American sculptor Claes Oldenburg (b. 1929) helped break down barriers between art and life (2.122). Oldenburg created and sold hand-made painted plaster replicas of food and ordinary objects in a rented storefront at 107 E. Second Street, New York City. The goods in Oldenburg's Store were painted with gestural paint marks that made it clear they were art objects. The Store created an active space where people could have experiences and interact. It combined the familiarity of a conventional grocery store with the mystique of an art gallery while creating a fun and inviting environment.

American (with African, native American, and European ancestry) Fred Wilson (b. 1954) draws on his background as an art educator to rearrange objects in museum collections. He takes on the role of the **curator**—the person

2.122 Claes Oldenburg, The Store, installation view, 107 East 2nd Street, New York, December 1, 1961-January 31, 1962. Photo Robert McElroy

2.123 (below) Fred Wilson, Portraits of Cigar Store Owners, from Mining the Museum, installation April 4, 1992-February 28, 1993

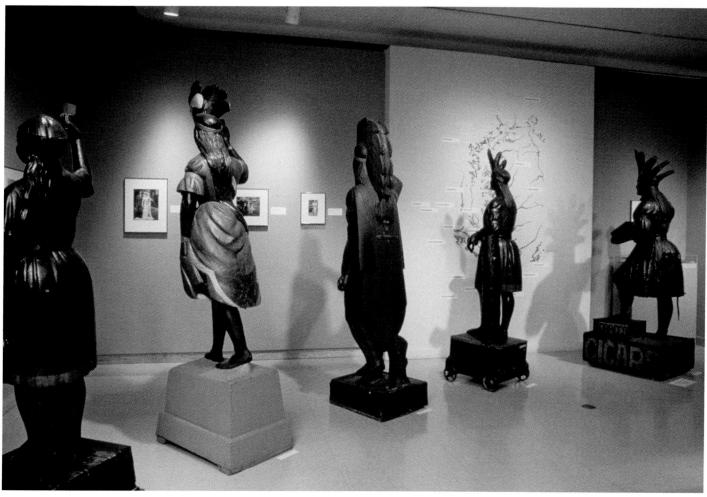

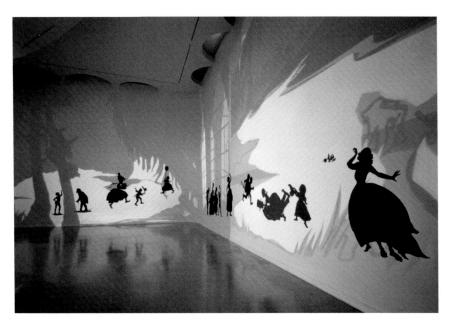

2.124 Kara Walker, Insurrection! (Our Tools were Rudimentary, Yet We Pressed On), 2000. Projection, cut paper, and adhesive on wall, 4'8³/₄" × 29'1⁷/₈". Solomon R. Guggenheim Museum, New York

responsible for overseeing, preserving, and exhibiting objects in a particular collection, and converts the role into an art action. Wilson's work at the Metropolitan Museum of Art, the American Museum of Natural History, and the American Crafts Museum gave him insight into the ways in which museum displays create certain experiences that have specific effects on audiences. In his own art, Wilson looks critically at the assumptions behind the ways museum exhibitions work.

In Mining the Museum, Wilson selected and presented objects only from the collection of the Maryland Historical Society (2.123). He arranged them in unusual ways and included objects rarely seen because they were usually in storage. He also provided provocative wall labels, and installed audio loops to accompany certain pieces. One section of the installation displayed five "cigar store Indians" with their backs to the viewer. (Since the nineteenth century, "cigar store Indians" have been used as sidewalk displays for tobacco shops in America.) The title, "Portraits of Cigar Store Owners," is ironic because native Americans would never have owned cigar stores at that time; it is also critical of the degradation of the dignity of native Americans that is involved in turning them into advertising signs. Throughout Mining the Museum the museum's unconscious racial biases are exposed. As a result of this installation the Maryland Historical Society realized it had never staged an exhibition about slavery or institutionalized

racism, although eight out of ten Baltimore residents are African American.

The installations of American artist Kara Walker (b. 1969) also address overlooked history: the pre-Civil War South. Walker adopts the nineteenth-century technique of silhouette cutouts, in which an artist makes a likeness of the sitter by tracing the shadow cast from a strong light source. The silhouettes in Walker's installations provide a glimpse of the **subject** in an indirect way, a trace of history that seems to have existed. She has recently incorporated overhead projectors in her installations to cast additional shadows on the walls, including those of viewers in the room. As the viewer's shadow appears on the wall, he or she is included and even implicated in the events unfolding there. The combined projections and silhouettes can be seen in Insurrection! (Our Tools Were Rudimentary, Yet We Pressed On), which presents a story that combines fact and fiction (2.124). Walker explains that this scene is intended to show "a slave revolt in the antebellum South where the house slaves got after their master with their instruments, their utensils of everyday life." Each grouping of figures highlights the bodies of the individuals, the stories they represent, and the scenarios of which they become a part.

Conclusion

The art in this chapter emphasizes the lived moment, or actions as they are happening, by focusing on the processes involved. Artworks made using alternative media and alternative processes draw our attention away from art that tells a story, or that seems to be a picture of something, and toward the acts of making, thinking, and experiencing. Performance art enlivens moments that were once frozen in paintings and sculptures, conceptual art concentrates on ideas, and installations arrange an environment for the viewer to engage with. These types of artwork celebrate the perceptions and understanding of those who respond to them as much as the skills of the artists who made them. They inspire us to expand our understanding of art and see it all around us in the life we are living.

Curator: a person who organizes the collection and exhibition of objects/artworks in a museum or gallery Silhouette: a portrait or figure represented in outline and solidly colored in Subject: the person, object, or

space depicted in a work of art

2.8

The Tradition of Craft

Life is so short, the crafts so long to learn. (Geoffrey Chaucer, English poet)

In Geoffrey Chaucer's (c. 1340–1400) time, the makers of the fine objects we can see today in the world's great art museums learned their trade in associations called guilds. Fourteenth-century aspiring craftsmen trained with masters, a process that lasted many years, as Chaucer's comment suggests. In medieval Europe, painting (for example) was not considered to be of higher status than the work of either turning ceramics into fine vessels or weaving exquisite tapestries. Things gradually changed after 1400 during the **Renaissance**, and by the eighteenth century, certain **media**, notably painting and sculpture, came to be considered as art, while ceramics, weaving, and embroidery were termed crafts. Other materials, such as metals, were used to make fine sculpture (which was "art") as well as practical and household objects ("craft"). Crafts came to mean items made to be used rather than simply looked at. This view was generally accepted, even though utilitarian objects require technical skill to produce, and craftspeople devote years to mastering their craft. Indeed, some craft objects, because of their ingenuity and refinement, stand out as artworks that transcend mere utility.

The distinction between art and craft was unique to Western culture, and it has now broken down in the twentieth and twenty-first centuries, as this chapter will show. As for the rest of the world, the maker of a bronze vessel in China during the Shang Dynasty (1300-

1045 BCE), the maker of a fine embroidered wool tunic in Paracas, South America (600-175 BCE), and the **ceramist** who made lamps for the Dome of the Rock in Jerusalem (sixteenth century) probably did not consider themselves any less skillful or "artistic" than painters or sculptors.

In this chapter we will examine both craft objects and works of art made with the same materials. If we try to define precisely the difference between art and craft we will discover it is difficult, perhaps impossible. As you read this chapter, ask yourself whether you think the objects discussed can be considered art or craft. At the same time, think about whether the makers of the objects, and the people they made them for, could tell the difference either. In the hands of skillful designers, great craft objects possess artistry equal to great works of art.

Ceramics

Our word ceramic comes from the Greek word keramos, meaning pottery, which was probably derived from a word in Sanskrit (a language of ancient India) meaning to burn. The accepted interpretation of the word, burnt earth, aptly describes the ceramic process. The manufacture of a ceramic object requires the shaping of clay, a natural material dug from the earth, which is then baked at high temperatures to make it hard.

We know that the basic techniques used to make ceramics date back thousands of years

cultural and artistic change in Europe from the fourteenth to the seventeenth century Medium (plural media): the material on or from which an artist chooses to make a work of art, for example canvas and oil paint, marble, engraving, video, or architecture

Ceramist: a person who makes

Renaissance: a period of

ceramics

Perspectives on Art: Hyo-In Kim

Art or Craft: What's the Difference?

2.125 Hyo-In Kim, To Be Modern #2, 2004. Metal screen, wire, porcelain, acrylic paint, and found objects, slightly over life-size

When we look at a fine painting we will almost certainly describe it as being art. But is a fine example of clothing, for example, art or craft? If craft is something that has a useful function, then presumably a dress is craft. Here, however, Professor Howard Risatti, an art historian at Virginia Commonwealth University, examines a work based on a traditional Korean dress that transforms a practical piece of clothing to comment on our modern globalized world (2.125). He asks: What makes something a work of art rather than a work of craft?

Only by understanding something essential about a work of art can we begin to appreciate its richness and complexity as an aesthetic object. So to begin, we must ask, "What is essential to a work of craft?" To my thinking, it is that craft is an object constructed around the idea of function, say the way a container functions to hold water, or a chair to support

a person, or clothes to cover someone's body. The work shown here is from a series by the young Korean-American artist Hyo-In Kim. It is a hanbok, a traditional Korean dress worn with shoes and a hairpin by women of the upper and royal classes. Its gold-colored decoration indicates its prestige; such expensive materials were costly and well beyond the means of commoners, who mostly wore plain white garments.

However, the title, To Be Modern #2, suggests the artist has something more in mind than simply a fondness for traditional Korean clothes. Kim is faithful to the original dress design; she wants it to be correct to tradition. But she also wants it to indicate something important about tradition. That is why she has subtly transformed it by making it out of silver-colored wire mesh (instead of cloth) and by molding the decorative details out of porcelain, which she has then painted gold. And in keeping with the idea of transformation, instead of displaying it on a manikin like a dress in a store window, like something to be bought and sold, she decided to suspend it with its sleeves outstretched so that its transparency and weightlessness would be emphasized.

Kim intends us to see through the material so that the dress, like the hairpin, appears to float like a ghostly, disembodied figure—something almost there and yet not quite. This apparitional effect, enhanced by the glittering gold of the decoration, is then undercut when, upon close-up inspection of the dress, the decoration turns out to be tiny versions of fashionable Western clothing: jeans, skirts, shoes, purses. What Kim wants us to see and appreciate, both literally and figuratively, is that those traditional cultural values that give structure and form to people's lives, including our own, are fading away and disappearing as globalization spreads.

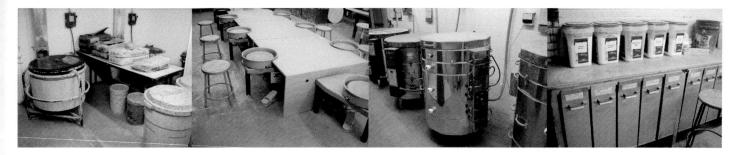

2.126 Ceramics studio equipment (left to right):

- 1 Clay mixer, dry clay, and wet clay storage bins.
- 2 Electric ceramic wheels for pottery production.
- 3 Kilns for firing the ceramic objects.
- 4 Bins and containers of chemicals used in ceramic glazes.

because archaeologists investigating the earliestknown civilizations have found potsherds, small pieces of ancient ceramics.

The first step in making a ceramic object is to choose a clay, often a mixture ceramists have developed that fits their own working methods. Then, in a process called wedging, the clay is kneaded to work out pockets of air (which can destroy a piece of ceramic ware when it is heated) and make the clay easier to work. Next, the ceramist uses one of a number of hand methods to shape the clay into the form of the finished object. For example, the artist can build up an object using slabs or coils of clay, or by modeling a lump of clay into the desired shape. Another method is to shape the clay as it turns on a rapidly turning potter's wheel, a process known as throwing.

Once it has been shaped, the clay is left to dry. At this point it is very fragile. The dry clay is fired in an oven called a kiln at a high temperature (between 2,000 and 3,000°F). The object is now very hard. It must be left to cool to avoid cracking.

To add the finishing touches to a ceramic object, artists apply a glaze, a liquid (known as a slip) made with a material that will give the object a glass-like finish and that adds color, texture, and protection to the object's surface. (A glaze can also make an object more watertight.) The artist usually applies the slip with a brush. The object is again placed in the kiln and fired to melt and harden the glaze, which fuses with the clay.

Ceramists choose from a variety of clays, each with unique characteristics. Clay used to make earthenware has good plasticity, or pliability, but it can be somewhat brittle after firing. Earthenware is often red in color and hardens at a lower temperature than other clays. Stoneware clays are less plastic than earthenware clays. Stoneware (as its name implies) is much harder than

earthenware and is fired at a higher temperature. Stoneware is a good clay for the creation of items for everyday use, like mugs and bowls. Porcelain, a durable, high-temperature ceramic commonly used for fine dinnerware, is made of a mixture of three clays: feldspar, kaolin, and silica. Porcelain is strong but sometimes hard to manipulate. Fine white china, bathroom fixtures, and dental crowns are made of porcelain.

Coil Method

The art of using coils to create a clay object has been a common hand-building method since ancient times. A coil is created by rolling the clay on a flat surface so that it extends into a long rope-like shape. When making a round vessel, the artist wraps the coil around upon itself and then fuses the sections together by smoothing.

Seated Figure, a work from the Zapotec culture of Mexico, was made using the coil method (2.127). This figure was made to be buried

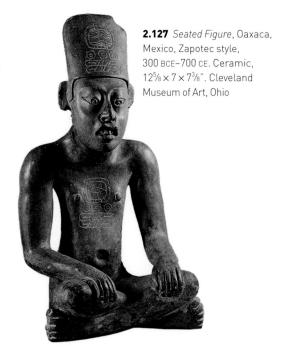

Color: the optical effect caused when reflected white light of the spectrum is divided into a separate wavelength

Texture: the surface quality of a work, for example fine/coarse, detailed/lacking in detail

Plastic: referring to materials that are soft and can be manipulated

Gateway to Art: Colossal Olmec Heads Sculpture in Stone and Clay

2.128a Baby Figure, between 12th and 9th centuries BCE. Ceramic, cinnabar, red ocher, 13%" high. Metropolitan Museum of Art, New York

The Olmec were experienced potters as well as being skilled stone carvers. Along with carving colossal stone works, they made sculptural figurines in clay. One well-known ceramic sculpture is called Baby Figure (2.128a).

One of the most striking differences from the colossal heads is the scale of this figure. At just over a foot tall, it is closer to the size an actual baby would be. By contrast, a person's head is about the size of one of the eyes on a colossal head. The Baby Figure shows the whole body instead of focusing only on the head. The rolls of flesh and the gesture of putting the hand to the mouth seem very intimate and personal, with a careful attention to detail. Another major difference between the colossal heads and this figurine is the materials used to make them. The fine, white clay, called kaolin, was molded while it was still wet. The ceramist was able to take advantage of the softness of the clay to add and take away material to create the desired

form: the figurine is an example of both additive and subtractive sculpture. The stone carver, on the other hand, was working with an extremely hard material and was only able to carve away from the existing block of basalt to create the overall shape of the head and the details of the facial features: the head is a subtractive sculpture. The ceramic sculpture is also hollow, while the stone head is solid. Finally, a noticeable similarity between the two figures is the helmet-like headgear they both wear. It is believed that this kind of helmet was important for protection during the ritual ballgame played throughout Mesoamerica. The Baby Figure could be a representation of an actual baby or a supernatural figure related to the fertility and prosperity of the Olmec.

2.128b Colossal Head, Olmec, 1500-1300 BCE. Basalt. Museo de Antropología, Veracruz, Mexico

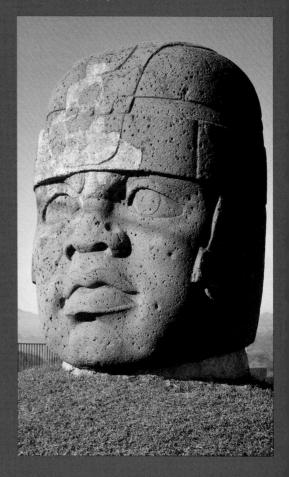

Gothic: western European architectural style of the twelfth to sixteenth centuries, characterized by the use of pointed arches and ornate decoration

Stained glass: colored glass used for windows or decorative applications

Contrast: a drastic difference between such elements as color or value (lightness/darkness) **Aesthetic:** related to beauty, art, and taste

2.133 Rose window and lancets, north transept, 13th century, Chartres Cathedral, France

The designers of the **Gothic** cathedrals of medieval France adopted a type of colored glass, known as **stained glass**, which had been used previously on a smaller scale in northern Europe. But the French did something extraordinary with stained glass by using it to make enormous decorative windows that bathed the cathedral in

colored light. The windows of the cathedral in the northern French town of Chartres are magnificent examples of stained glass (2.133). The large (43 feet in diameter) circular windows are accented by the **contrast** with smaller, tall thin windows with pointed tops. The brilliant blue color in these windows stands apart as one

2.134 Dale Chihuly, Fiori di Como, 1998. Handblown glass and steel, $27.6^{3}/4^{\circ} \times$ $11''9''_4$ " × $4''8''_4$ ". Bellagio Hotel, Las Vegas, Nevada

2.135 Death mask from

Shaft Grave V, Grave Circle

of the most extraordinary achievements of the early thirteenth century. They are so valued that to prevent them from being damaged during World War II they were removed and placed in storage until after the war had ended.

The contemporary American glass artist Dale Chihuly (b. 1941) makes comparable use of the kind of **aesthetic** experience that glass can bring to an interior. To enhance the reception area at the Bellagio Hotel in Las Vegas, Chihuly has created a dazzling chandelier made of 2,000 individually blown glass flowers (2.134). The strong color, reminiscent of stained glass, enlivens and invigorates the interior and becomes an inviting and memorable symbol of the hotel. The effect is mesmerizing.

Metalwork

As with ceramics, the use of metal in the creation of objects goes back to ancient times. Metal has been so important in human history that some archaeological periods, such as the Bronze Age (more than 5,000 years ago) and Iron Age (more than 3,000 years ago), are named for the metal most commonly used at that time. The working of metal has been a measure of human

development and, like most traditional crafts, an important medium for utilitarian purposes.

Metal can be heated to a liquid state and poured into molds. It can also be heated and then hammered into shape, or it can be worked (usually, again, by hammering) when it is cold. Most metals are strong but malleable and can be bent or stretched to fit the needs of the artist. Gold is particularly well suited for decorative metalwork because it is comparatively soft (for a metal) and easy to shape.

A, Mycenae. Also known as Mask of Agamemnon. Gold, 12" high. Greece, c. 1550-1500 BCE. National Archaeological Museum, Athens, Greece The gold mask in 2.135 was

created by laying a thin piece of metal over an object carved to resemble a human face. The artist then carefully hammered the surface of the thin metal until the shape and texture of the design was imprinted in the metal. The artist has deftly given us the impression of a human face by placing objects, like cowrie shells for the eyes, under the surface of the

metal and forcing the gold sheet into its final shape. This process would

2.136 Benvenuto Cellini, Salt Cellar of Francis I, 1540-3. Gold, enamel, ebony, ivory, $11\frac{1}{4} \times 8\frac{1}{2} \times 10\frac{3}{6}$ " Kunsthistorisches Museum, Vienna, Austria

have been repeated with different textures and objects to create the ears, eyebrows, beard, and so on. This type of mask was used as a burial mask to cover the face of the departed.

An artist with good technical skills can control metals to make almost any object he or she can imagine. The Italian goldsmith Benvenuto Cellini (1500–71) created the Salt Cellar of Francis I as an extremely elaborate object to go on the dining table of the king of France (2.136). To make this salt cellar Cellini first sculpted wax models of Neptune (the Roman god of the salty sea) and Mother Earth (whence table salt was extracted) in harmony and at rest. Cellini then covered the wax model with a strong material, perhaps sand and lime, to make a mold. The mold was then heated so that the wax melted and left the center of the mold empty. Once the metal had reached the required 2,000°F, Cellini poured the molten gold into the mold. When it was cool, the artist could remove the mold and then carefully finish off the piece to its splendid conclusion. The salt was held in the small bowl shape next to Neptune, and the pepper inside a small triumphal arch next to the symbolic image of Earth. This magnificent example of Renaissance metalwork took more than two years to make.

Fiber

Fibers are threads made from animal or vegetable materials (such as fur, wool, silk, cotton, flax, or linen) or, more recently, synthetic materials (for example nylon or polyester). Fiber art is most often associated with the creation of textiles. The fibers can be spun into yarn, string, or thread, then woven or knitted into lengths of textiles. In the case of embroidery, the thread, string, or yarn is applied using stitching techniques. Relatively stiff fibers, such as grass and rushes, can be woven together to make baskets and similar objects. Processing plant fibers begins with separating the fiber from the plant, then preparing it for use by spinning the fiber into a long thread. In the case of cotton, once the cotton bolls are collected, the fibers are separated and washed; then the individual fibers are spun, or twisted, into thread. Wool is sheared from sheep in the spring, washed and separated, then spun into yarn. Silk fibers are very fine and are the product of silkworms that

2.137 Tilleke Schwarz. Count Your Blessings, 2003. Handembroidery on linen, 26\% × 251/4". Collection of the artist

spin cocoons. Once the cocoons are complete, they are harvested. They are softened in warm water to loosen the gum that binds the fibers together. The silk can then easily be removed and spun into an exquisite fabric.

The Dutch artist Tilleke Schwarz (b. 1946) uses thread in her embroidered works the way another artist might use a pencil. In the work Count Your Blessings, she stitches mostly images of memories from trips to the Unites States and Australia (2.137). The artist explains that her work aims to be humorous and is "a mixture of contemporary influences, graffiti, icons, texts and traditional images from samplers." In this work

there are images from the cover of a disposable coffee cup, a receipt from a fried-chicken restaurant, and a cartoon of the character Butthead. The artist is expressing her fascination with how and what people communicate. For example, the writing at the top right is quoted from the Museum of Contemporary Art in Sydney, Australia, and reads: "Do not jump when leaving the vessel. Members of aboriginal communities are respectfully advised that a number of people depicted in photographs in this room have now passed away." Schwarz includes this phrase because she feels it emphasizes just how sensitive these subjects are in Australia.

Faith Ringgold, Tar Beach, 1988

There once was a little girl named Cassie who lived in an apartment in New York. On warm summer evenings she and her family would lay out blankets and have picnics under the stars on their tar beach. The roof was a wonderful place to lie back and look at the city and its lights and dream about wonderful things like flying through the sky. She could dream that her father, who had helped to build the building where she lived, could join the union even though being half-Black and half-Indian made it impossible. She could dream that her mother owned an ice-cream factory and was able to eat ice cream every night for dessert.

In this artwork, the African-American artist Faith Ringgold (b. 1930) tells a story of a child called Cassie (2.138). Ringgold relates the African-American experience, her personal history, and her family life by presenting her own childhood memories in a work that combines painting on canvas with the quilting skills of her family and ancestors. Ringgold began to paint on fabrics in the 1970s. As she did, the works evolved into a collaborative effort with her mother, who was a dressmaker and fashion designer. Ringgold would create the painted part of the work, and her mother would stitch the edges and sew patches of cloth and quilted areas together to form a border. Her great-great-grandmother had been a

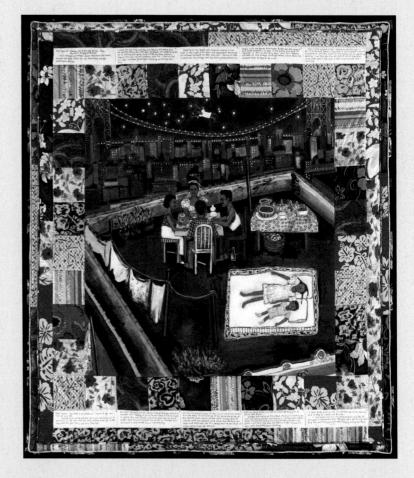

slave who made quilts for plantation owners in the South. Ringgold's works thus possess many layers of meaning that relate to this history and these craft skills. Together these layers communicate the richness of human experience.

2.138 Faith Ringgold, Tar Beach, 1988. Acrylic on canvas, bordered with printed, painted, quilted, and pieced cloth, 6'25%" × 5'81/2". Solomon R. Guggenheim Museum, New York

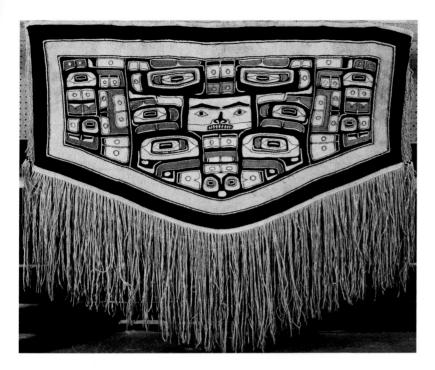

2.139 Tlingit Chilkat dancing blanket, 19th century

The Tlingit people, who live on the western coast of Canada and Alaska, combine both animal and plant material in their fiber art. The blanket shown in **2.139** has been woven entirely by hand (without a loom) from goat wool and

cedar bark. Tlingit use symbols to identify their tribe or family. In many cases these designs are abstract depictions of animals. The central figure here looks like a bear or raccoon. Note the large eyes on either side of the central image that imply the presence of even bigger creatures. Blankets like this were worn on ceremonial occasions. They were very expensive, and the prized possessions of anyone wealthy enough to own one.

Wood

Wood, an organic plant-based material, deteriorates over time, so we have few ancient examples of art objects made from wood. But we know that wood has been utilized for objects and architecture throughout history. Wood has an innate beauty that can be brought out by cutting

2.140 Detail of *studiolo* from the Ducal Palace in Gubbio. Italy, Giuliano da Maiano, after a design by Francesco di Giorgio Martini, c. 1480. Walnut, beech, rosewood, oak, and fruit woods in walnut base, $15'11'' \times 16'11'' \times 12'7'/4''$. Metropolitan Museum of Art, New York

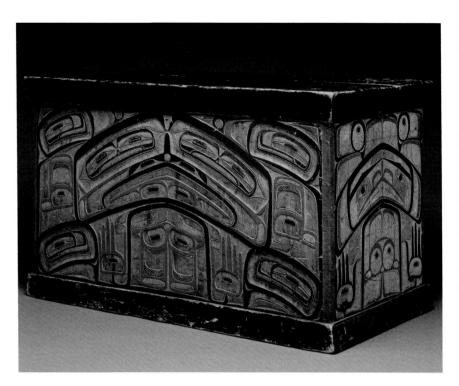

2.141 Captain Richard Carpenter (Du'klwayella), Bent-corner chest, c. 1860. Yellow cedar, red cedar, and paint, $21\frac{1}{4} \times 35\frac{3}{4} \times 20\frac{1}{2}$ ". Seattle Art Museum

wood technique called intarsia in his design for a studiolo (a private room, often a library or study) in Gubbio, Italy. Intarsia is a kind of wood mosaic using woods of different colors. Guiliano

and carving. Sanding and polishing a piece of

wood gives its surface a mesmerizing beauty.

Around 1480, the Italian artist Francesco di

Giorgio Martini (1439–1501) used a decorative

da Maiano, who executed the work, took very thin, shaped pieces of wood and organized them to create a masterpiece of illusionistic depth and value (2.140). To the casual viewer, because the artists employed such skill, it is not clear where reality ends and the illusion begins. Federico da Montefeltro, the duke of Urbino, who commissioned Martini to create this work, wanted the symbols in this magnificent design to reflect his achievements as a ruler, military commander,

A native American artist of the Heiltsuk tribe worked with wood to make the bent-corner chest shown in **2.141**. To create this vessel, a plank of cedar was smoothed, notches known as kerfs were cut at three corners, and then the wood was made flexible by exposing it to steam created by firebaked rocks and water. The plank was then bent at the kerfs and joined at the juncture of the last corner. After that, the chest was carved and painted with an elaborate, symmetrical design

collector of books, and patron of the arts.

that fills the whole surface. A separate base and top were then fitted to the whole.

Conclusion

Functional crafts are still practiced and remembered as a part of American history and culture, and sometimes as part of a region's identity. The pioneers, migrating westward, faced the challenges of survival and made their own utilitarian objects. They fashioned objects not only out of need, however. They added their own aesthetic touches to make the hardships they faced seem a little more bearable.

The makers of functional items refined and improved them until they became objects of art. By experimenting with and refining such raw materials as stone, clay, metal, wood, sand, and fibers, workers with craft skills developed objects that both fulfilled needs and were interesting to look at. Making things by hand, the artist responded to the unique character of each medium in the same intimate space.

The artist of hand-made objects understands the attributes of various materials and chooses those that fit the function he or she needs the object to fulfill. Ceramic artists use the plasticity of the clay and their knowledge of technique to model a lump of wet earth into a solid vase, jug, or pot. Weavers twist fibers derived from plants and animals to create thread, which can then be embroidered or woven into textiles. Tree bark can be made into fibers, and wood can be crafted into almost limitless shapes for almost any function. In the hands of a skillful artist, these objects may have a practical function; or they may have no immediately useful purpose at all, but be prized principally for their great beauty.

Not all crafts are considered art. Some craft objects are mass-produced from an artist's or designer's original design, or emphasize utility rather than aesthetic form. But many craft works have been recognized for their excellence and attention to design and originality. The American Craft Museum in New York is an excellent place to see craft that goes beyond utility and extends traditional materials into the realm of fine art.

Abstract: an artwork the form of which is simplified, distorted, or exaggerated in appearance. It may represent a recognizable form that has been slightly altered, or it may be a completely non-representational depiction **Intarsia:** the art of setting pieces of wood into a surface to create a pattern

Illusionism: the artistic skill or trick of making something look real

Value: the lightness or darkness of a plane or area

Sculpture

A great sculpture can roll down a hill without breaking.

> (Michelangelo Buonarroti, Italian sculptor, painter, and architect)

being immersed in an environment created by the sculptor, including sights, sounds, textures, and other sense experiences.

Michelangelo is generally regarded as one of the finest sculptors in the Western tradition some would say the greatest. When the **Renaissance** Italian artist made the humorous remark above, he probably had in mind most of his own sculptures: statues chiseled out of durable marble. This might be the first response of most of us when asked to define what we mean by sculpture, although we might broaden our definition to include other materials, such as metal, ceramics, and wood. But, as we will see in this chapter, sculpture can be made from many materials: for example, glass, wax, ice, plastic, and fiber. In fact, the materials of modern sculpture can include, for example, neon lights and even animals. Sculptors' methods today still include chiseling (as Michelangelo did), carving, molding, assembling, and constructing, but inventive sculptors are finding new ways to create their art, and new materials to make it with.

It is probably because artists are so inventive that it is difficult to define sculpture exactly. Look up the word in a dictionary and then check whether the definition fits all the works in this chapter; it probably will not. But we can agree on a few things that are true of all sculptures. They exist in three dimensions and occupy physical space in our world. And they invite us to interact with them: by looking at them, by walking round them, or by entering them and

Approaches to Three **Dimensions in Sculpture**

Sculptors planning new sculptures have two basic options for displaying them. The first approach invites us to examine them on all sides; sculpture made to be enjoyed in this way is known as freestanding, or sculpture in the round. Many freestanding sculptures are made so that we can move around them, but sculptures in the round can also be displayed in a way that prevents a viewer seeing every side of them. Sculptures can be made, for example, to be placed in a niche or standing against a wall. In such cases, the location of the statue determines the vantage points from which it can be viewed, and the sculptor will design his or her work with the viewer's position in mind.

The second fundamental approach to the three-dimensional nature of sculpture is relief, a type of sculpture specifically designed for viewing from one side. The image in a relief either protrudes from or is sunk into a surface. It can have very little depth (bas-relief) or a great deal (high relief).

Freestanding Sculpture

Some freestanding sculpture is not intended to be experienced from every point of view. The

Renaissance: a period of cultural and artistic change in Europe from the fourteenth to the seventeenth century In the round: a freestanding sculpted work that can be viewed from all sides

Three-dimensional: having height, width, and depth Relief: a raised form on a largely

flat background. For example, the design on a coin is "in relief" Bas-relief: a sculpture carved with very little depth

High relief: a carved panel where the figures project with a great deal of depth from the background

Plane: a flat surface, often implied by the composition

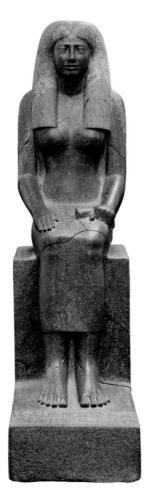

2.142 (above) Sculpture of the Lady Sennuwy, 1971-1926 BCE. Granite, $67 \times 45^{3}/_{4} \times 18^{1}/_{2}$ ". Museum of Fine Arts, Boston. Harvard University-Boston Museum of Fine Arts Expedition

Egyptian sculpture (1971–1926 BCE) of the Lady Sennuwy, wife of the very powerful governor of an Egyptian province, was designed to be seen from the front (2.142). (Many Egyptian sculptures were made to be displayed with their backs to a wall or a pillar.) In this work we can get a sense of the original block of granite from which the work was chiseled. Egyptian figure sculptures often sit, as this one does, very straight and upright on the stone from

which they were carved, with the arms and legs drawn in close to the body.

Giambologna (1529–1608), a Flemish artist working in Florence, Italy, designed the Rape of a Sabine as a kind of spiral that draws the viewer around to view its many changing planes (2.143a and 2.143b). With each step the viewer can discover unexpected details as the surfaces spiral upward. This is a powerful and beautiful work, but Bologna had more in mind when he created it

2.143a, 2.143b Giambologna, Rape of a Sabine, 1583. Marble, 13'6" high. Loggia dei Lanzi, Piazza della Signoria, Florence, Italy

than just a dramatic design. His statue was a piece of political propaganda. It re-creates an ancient story about the foundation of Rome around 753 BCE. Most of the early founders of Rome were male. For the city to grow, the Romans needed wives. They solved this problem by inviting their neighbors the Sabines to a festival, during which the Romans seized the Sabine women and forced them to marry. This story symbolized the ability of a small community to become the most powerful city in Italy, as Rome was by Giambologna's time. This message was useful to Francesco de' Medici, who ruled Florence and who paid Giambologna for the sculpture, and placed it in the city's main square. Florence had fought wars with other cities in Italy, and Rome was one of its main rivals. This dramatic sculpture announced to the Florentines and their enemies that, like Rome, Florence had risen to become a powerful city to be feared.

Bas-Relief and High Relief

In bas-relief (the French word bas means low), the sculptor's marks are shallow. An example of this kind of sculpted surface was found in the North Palace of the Assyrian king Ashurbanipal in the ancient city of Nineveh in Mesopotamia (modern-day Iraq). Assyrian kings ruled over a large territory and had powerful armies. They decorated the interior walls of their palaces with images depicting their strength and power. The artist who carved away the stone to create Dying Lioness intended to reflect the great strength and bravery of King Ashurbanipal as he hunted and killed the most fearsome beast known to the Assyrians (2.144).

The Memorial to King Leopold of the Belgians was created to commemorate the death of Belgium's first king (it declared independence from the Netherlands in 1830) in 1865 (2.145). The British sculptor Susan Durant (1827–73) chose to incise the surface more deeply for the figures closer to the viewer; this means that they are in high relief. Thus these figures—the lion and the reclining image of Leopold—protrude from the surface more than the angels in the background, which have been carved in low relief. The illusion of depth emphasizes Leopold's bravery in accepting the Belgian National

Congress's invitation to become king. Durant was unusual in being a successful sculptor in nineteenth-century England at a time when it was not easy for women to break into such a profession. Durant was in demand for her portraits, which included a bust of Harriet Beecher Stowe, the author of the anti-slavery novel *Uncle Tom's Cabin*. Durant became a favorite sculptor to the British royal family. Her memorial to King Leopold I was originally installed in his niece Queen Victoria's chapel at Windsor Castle in 1867 but was moved to Christ Church, Esher, in 1879.

2.144 Dying Lioness. limestone relief from the North Palace of Ashurbanipal, Nineveh, Assyrian period, c. 650 BCE. British Museum. London, England

2.145 Susan Durant, Memorial to King Leopold of the Belgians, 1867, in Christ Church, Esher, England

Background: the part of a work depicted furthest from the viewer's space, often behind the main subject matter Bust: a statue of a person depicting only his or her head and shoulders

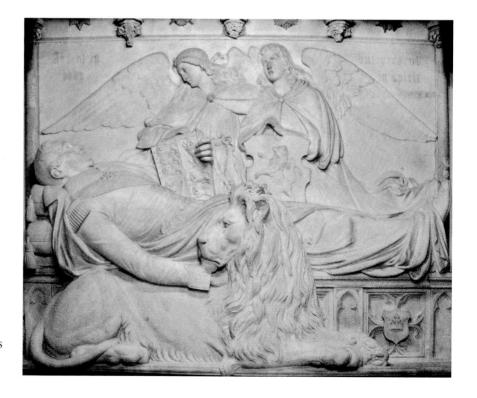

Methods of Sculpture

Sculptural methods are either subtractive or additive. In the subtractive processes, a sculptor uses a tool to carve, drill, chisel, chip, whittle, or saw away unwanted material. In the additive processes of modeling, **casting**, or constructing, sculptors add material to make the final artwork.

Carving

The most ancient works of art that still exist were made using subtractive methods of sculpture. Most of these were made of stone or ivory (because wood eventually decays, we have few ancient wooden sculptures) and were worked by chipping, carving, sanding, and polishing.

Casting: a sculpture or artwork made by pouring a liquid (for example molten metal or plaster) into a mold Form: an object that can be

Form: an object that can be defined in three dimensions (height, width, and depth)

Gateway to Art: Colossal Olmec Heads **How Olmec Sculptors Made the Colossal Heads**

The Olmec artist who sculpted this Colossal Head (2.146a, 2.146b) probably worked the way most subtractive sculptors do even today. After choosing a stone that best resembles the final shape, the artist works around it, knocking off large chunks of material until the final form has been established. Then the artist begins to bore into the surface, refining and establishing the main details of the work. In the case of the Colossal Head, that would probably have involved cutting deep into the stone to make the eyes, while making sure to leave enough material to make the nose and mouth. Then the artist would carefully hone the details and

2.146a, 2.146b Colossal Head #10, Olmec. Basalt. San Lorenzo, Veracruz, Mexico

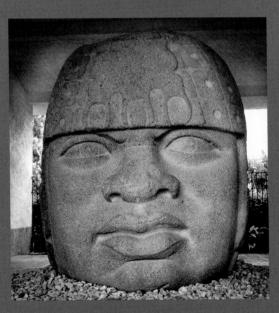

finish by polishing the surface to eliminate the marks made by the cutting tools. The achievement of the Olmec sculptors was especially impressive since the Olmec had no metal tools; archaeologists believe this head was made using stone hammers and wooden drills. Whatever method was used, the artist produced a memorable work that has lasted more than 2,000 years.

Michelangelo

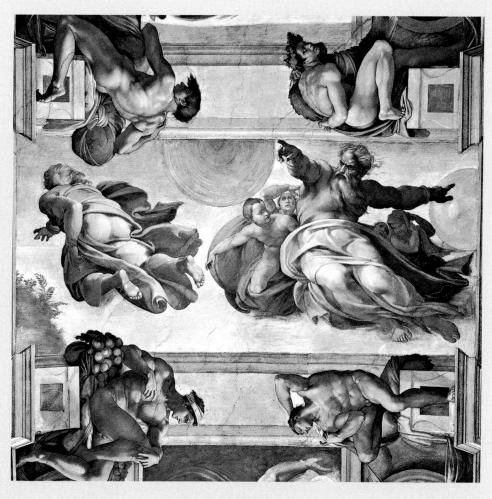

One artist in history stands out because of his unique mastery of the materials and methods of sculpture. Michelangelo (b. Michelangelo Buonarroti, 1475-1564) used an unconventional technique to "release" the figure, as he saw it, from the stone. Rather than remove stone progressively from all sides, as most sculptors do, Michelangelo began on one side of the stone and sculpted through to the other side. He felt that he was freeing the figure from the stone in which it had been trapped. His unfinished sculpture, Awakening Slave, gives an insight into the artist's technique (2.147).

Michelangelo excelled in architecture and painting as well as sculpture. Yet he saw these arts through the eyes of a sculptor; he believed sculpture itself was the finest, the most challenging, and the most beautiful of all the visual arts. While painting the Sistine Chapel

ceiling (2.148—Creation of the Sun and the Moon), which many see as his grandest work, Michelangelo dreamed of finishing the ceiling quickly so that he could get back to work on several large sculptures intended for the tomb of Pope Julius II. He wrote poems describing his agony to finish, for example:

And I am bending like a Syrian bow... John, come to the rescue. Of my dead painting now, and of my honor I am not in a good place. And I am no painter...

While working on the painting of the ceiling, Michelangelo continually made many sketches of the figures intended for the nude male sculptures (which Michelangelo called ignudi, from the Italian word meaning nude) that he planned would cover the tomb. Unfortunately,

2.147 (above left) Michelangelo, Prisoner, known as the Awakening Slave, 1519-20. Marble, 8'91/8" high. Accademia, Florence, Italy

2.148 (above) Michelangelo, Creation of the Sun and the Moon, 1508-10, detail from the Sistine Chapel ceiling, Vatican City

the tomb was never completed in the way that Michelangelo intended, but some sculptures carved for the project survive (2.149-Mosesis one example).

The muscular figures painted on the Sistine Chapel ceiling have led many viewers to believe they are looking at sculptures. The figures have the appearance of mass, particularly the nudes, which really seem to be men perched on architectural platforms. The ceiling is smooth, however; the illusion of these three-dimensional forms was created through the use of shading. Michelangelo painted darker shades in the areas that would have been carved more deeply if the figures had been sculptures. Thus, even when he painted, he thought like a sculptor.

2.149 Michelangelo, Tomb of Julius II, detail of Moses, 1513-16. Marble, 7'81/2" high. San Pietro in Vincoli, Rome, Italy

Sketch: a rough preliminary version of a work or part of

Mass: a volume that has, or gives the illusion of having, weight, density, and bulk

The nearly nine-foot-tall figure of the Hawaiian war god Ku-ka'ili-moku was carved (the subtractive method) from larger pieces of wood (2.150). The sculpture represents a god whose name translates from Hawaiian as "Ku, the land-grabber." Originally created for the powerful King Kamehameha I, the image of the god exhibits an open mouth (a disrespectful gesture) and was probably intended to gain divine favor. Another god, Lono (god of prosperity), is also symbolized by pigs' heads in Ku's hair. The combination of the two gods may have represented Kamehameha's invasions and conquests of adjacent kingdoms.

Modeling

Modeling in clay and wax (for example) is an additive process; the artist builds up the work by adding material. Clay and wax are pliable enough for sculptors to model them with their hands; sculptors also use specialized tools to manipulate them. Because such materials as clay often cannot support their own weight, sometimes an artist will employ a skeletal structure, called an

armature, to which the clay will be added; the armature will then later be removed (or burned away) when the work is dry. Permanent sculptures created from clay will most often be dried, then fired in a kiln until the chemical structure of the clay changes. Because this process produces a very dry and hard material, many works from antiquity made from clay still exist.

Large sculptures, such as the Etruscan sarcophagus (a kind of coffin) in 2.151, are built from multiple pieces fired individually. Four separate terracotta (baked clay) pieces make up this sarcophagus, which contains the ashes of the deceased. The sculptor paid particular attention to the gestures and expressions of the couple, shown relaxed and enjoying themselves at an Etruscan banquet, although the expressions are **stylized** and not a likeness of the deceased. The **plastic** character of clay allowed the artist to make images that are expressive and capture the mood of the event.

The way the sculptor interpreted the figures tells us two interesting things about their culture. Women actively participated in social situations; this woman is shown gesturing, and even reclines in front of her husband. And, since this sculpture is part of a tomb, it suggests that celebrations took place upon the death of loved ones, although the figures' joyful expressions may simply indicate the deceased in an eternal state of happiness.

Casting

Casting, another additive process, involves adding a liquid or pliable material to a mold. It is done in order to set a form in a more durable material, for example, bronze rather than wax, or to make it possible to create multiple copies of a work. The first step in casting is to make a model of the final sculpture. This is used to make a mold. A casting liquid (often molten metal, but other materials such as clay, plaster, acrylic polymers, or glass are also used) is poured into the mold. When it hardens, the result is a detailed replica of the original model.

The ancient Greeks cast bronze to produce many of their sculptures. Bronze is an alloy, or mixture, of copper and tin. It melts at a relatively low temperature (1,600°F) and is comparatively easy to cast. Once formed and cooled it is light

(compared to stone) and durable. The so-called *Riace Warrior A* is a fine example of the casting skills of ancient Greek artists (2.152). It is one of two sculptures discovered in 1972 by scuba divers off the coast of Riace, Italy. This sculpture reflects great attention to detail and was made at a time when the Greeks emphasized the perfection of the human body. It may have been cast to celebrate the victory of the Athenians over the invading Persians.

Riace Warrior A was created using the lostwax method of casting. (Each numbered stage refers to 2.153.) The artist begins by building an armature (1) and then adds clay to it to create the form (2). A thick layer of wax is added to the armature, and any detail the sculptor wishes to see in the final work is carved into the wax (3). Clay, sand, and ground-up pieces of old molds are used to cover the surface of the wax form, preserving all the detail. This hard coating, which needs to be strong enough to bear the heat and weight of the metal until it cools, will be the mold (4). Small holes are drilled in the bottom of the mold, which is then placed in a kiln. In the oven, the wax melts out through the holes in the bottom of the mold, leaving a hollow space inside the mold (5). After the mold has cooled, very hot molten metal—in this case, bronze—is poured into it (6). When the metal has cooled, the mold is removed (usually by breaking it with a hammer) to reveal the work—which is still not

2.151 Sarcophagus from Cerveteri, c. 520 BCE. Painted terracotta, $3'9^{1/2}" \times 6'7"$. Museo Nazionale di Villa Giulia, Rome, Italy

2.152 Riace Warrior A, c. 450 BCE. Bronze, 6'6" high. National Museum, Reggio Calabria, Italy

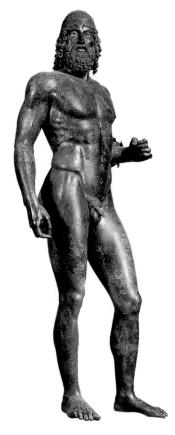

2.153 Seven steps in the lost-wax casting process

finished (7). The artist cuts off any extra metal, then sands and polishes. Over time, exposure to the elements can add surface color, called a patina, to bronze sculpture. Such a patina can enhance the beauty of the work. Nowadays it is commonly applied more artificially, by using chemical preparations.

Lost-wax casting is called a substitution process because the molten metal takes the place of the wax. Other materials, such as foam or wood, are occasionally used as substitution materials instead of wax because they can be burnt out of the mold.

Earthworks

Prehistoric artists of the Americas made monumental sculptures that used the surface of the Earth itself as material: this was additive sculpture on a very large scale. The most prominent of these is the Great Serpent Mound near Locust Grove, Ohio. As can be readily seen from the air, it resembles a snake with its mouth open, ingesting an egg (2.154). The identity of the people who created it is still debated. The head of the serpent and the egg are aligned to the position of the setting sun on the summer solstice

2.154 Great Serpent Mound, c. 800 BCE - 100 CE, 1330×3 , Locust Grove, Adams County, Ohio

Armature: a framework or skeleton used to support a sculpture

Stylized: art that represents objects in an exaggerated way to emphasize certain aspects of the object

Plastic: referring to materials that are soft and can be manipulated

Expressive: capable of stirring the emotions of the viewer Patina: surface color or texture on a metal caused by aging Monumental: having massive or impressive scale

2.155 Robert Smithson, Spiral Jetty, 1969-70. Black rock, salt crystals, and earth, 160' diameter, coil length 1500 × 15'. Great Salt Lake, Utah

(the longest day of the year), suggesting that the Great Serpent Mound was used in making solar observations. The original artists heaped piles of earth to "sculpt" this work onto the Ohio landscape.

In the 1960s artists again became interested in earthworks. The best-known modern earthwork is Robert Smithson's (1938–73) Spiral Jetty in the Great Salt Lake in Utah (2.155). Smithson chose a spiral, a shape naturally found in shells, crystals, and even galaxies. The coiled artwork was made by dumping 6,550 tons of rock and dirt, off dump trucks, gradually paving a spiralling roadbed out into the salt lake. The artwork is not static in the way it interacts with nature. Over the years the lake has repeatedly submerged and then revealed the sculpture. The artwork is constantly evolving as it drowns and then rises with a new encrustation of salt crystals.

Because of their enormous size, earthwork projects need the collaboration of many artists and workers. Such works as the Great Serpent Mound required a community effort. Today, earthwork projects are obliged to have permits and community approval, and to involve large groups of workers and heavy equipment. Artists do not earn money from their artworks but create them as a service to the community. Many contemporary artists believe that earthworks should represent a harmony between nature and humanity.

Construction

When engineers make a piece of machinery, they use a variety of methods to create and put together its components. Some of the parts will be made by sawing, grinding, milling, and using other ways of removing material; others will be modeled, molded, and cast. All the components will then be assembled. Some artists construct sculptures in a similar way.

The idea of constructing sculptures is relatively new. Methods for doing so have proliferated with the growth of standardized, engineered materials, such as sheet metals and plastics. In the late nineteenth century sculptors began to look beyond traditional carved or cast forms to the process of constructing. The artists of the **Constructivist** movement in the Soviet Union created an entire art movement based on sculptural construction techniques associated

Constructivism: an art movement in the Soviet Union in the 1920s, primarily concerned to make art of use to the working class

Space: the distance between identifiable points or planes

2.156 Naum Gabo. Constructed Head No. 2, 1916. Cor-ten steel, 69 × $52^{3}/_{4} \times 48^{1}/_{4}$ ". Tate, London, England

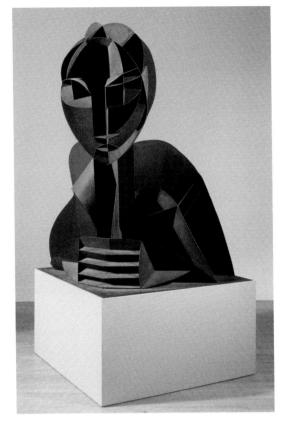

2.157 Damien Hirst, The Physical Impossibility of Death in the Mind of Someone Living, 1991. Glass, painted steel, silicone, monofilament, shark, and formaldehyde solution, $7'1^{1/2}$ " × $17'9^{3/8}$ " × $5'10^{7/8}$ "

more with a factory than with an art studio. Constructivists considered art to be a scientific investigation of the social needs of the time. One of the group's members, Naum Gabo (b. Naum Neemia Pevsner, 1890-1977), had

studied physics, mathematics, and engineering in college. His Constructed Head No. 2 (2.156) investigates the sense of **space** and form implied by flat planes, in contrast to the solid mass of conventional sculpture. Here Gabo is more interested in showing its interior construction than the exterior surface. He has welded the intersecting planes of metal together more as if he were a mechanic or engineer.

Contemporary artists have adopted modern-day industrial techniques and unconventional materials to create their sculptures. They have challenged traditional notions of what sculptures can be. Today's sculptors can use anything to communicate their message. British artist Damien Hirst (b. 1965) made his work The Physical Impossibility of Death in the Mind of Someone Living out of quite unconventional materials (2.157). This constructed work is made with a large tank full of formaldehyde in which the artist has suspended a dead shark. Of course, not every part of this work was constructed; Hirst did not construct the shark, he had it caught by fishermen. The entire work resembles a dissection specimen from a biology class. Hirst is known for creating his sculptures from unusual objects that contrast life and death.

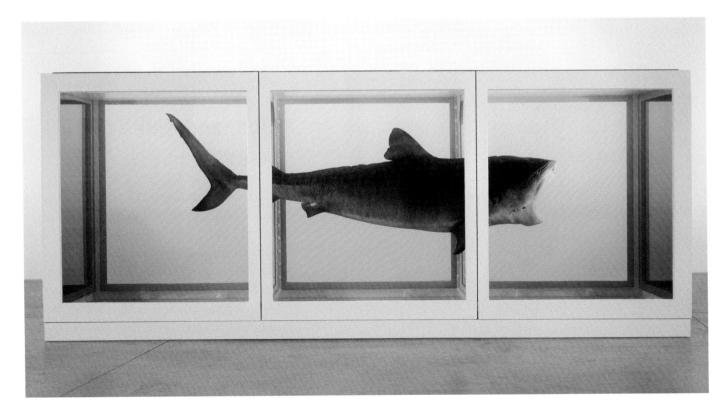

Artifact: an object made by a person

Found object: an object found by an artist and presented, with little or no alteration, as part of a work or as a finished work of art in itself

Appropriation: the deliberate incorporation in an artwork of material originally created by other artists

Readymade: an everyday object presented as a work of art

Kinetic sculpture: threedimensional art that moves, impelled by air currents, motors,

Depth the degree of recession in

Two-dimensional: having height and width

2.158 Pablo Picasso, Bull's Head, 1942. Assemblage of bicycle seat and handlebars, $13\frac{1}{4} \times 17\frac{1}{8} \times 7\frac{1}{2}$ ". Musée Picasso, Paris, France

Readymades

In the early twentieth century a few artists began to create works using as raw materials artifacts that already existed. Sometimes, they simply decided that **found objects** were works of art. Pablo Picasso (1881–1973) once took the handlebars and the seat of a bicycle and combined them to make his Bull's Head (2.158). Although Picasso did not make the individual parts, he arranged them in such a way that they resemble a bull's head, yet they are also readily recognizable as parts of a bicycle. The artist's intent was both a serious and a humorous attempt to redefine art.

Historically, artworks have been appreciated for the effort and skill that went into making them. Artworks have been valued for their originality or because they were made by the hands of a famous artist. In the twentieth century, artists rebelled against such notions about the purpose and meaning of art, while seeking new ways of creating their works.

Appropriation involves an artist taking over a pre-existing image or object and altering its appearance in a way that changes its original meaning or purpose. Some consider Fountain, by French artist Marcel Duchamp (1887–1976), to be revolutionary (2.159). By appropriating a readymade object—a urinal—and turning it on its side while proclaiming it art, Duchamp has enabled us to see it (and art) in a new way.

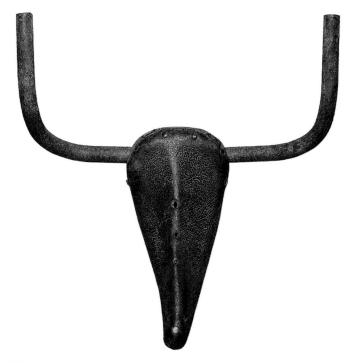

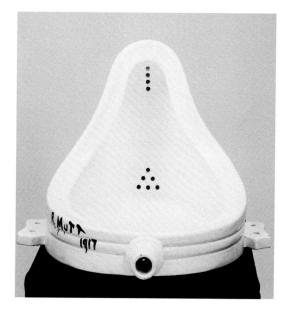

2.159 Marcel Duchamp, Fountain, 1917. Replica (original lost). Porcelain urinal, 12 x 15 x 18". Philadelphia Museum of Art, Louise and Walter Arensberg Collection

Duchamp subverts our expectations by changing the context and reorienting our perception of the object, leading to an experience that is entirely new. For Duchamp, any object, by virtue of being chosen and presented by an artist, can become a work of art. The act of discovery (of conceiving the artwork) is the most important part of the artist's process; it is his original interpretation of the appropriated object that makes it art. I chose it!" Duchamp exclaimed, creating endless possibilities for artists to redefine art as ideas. and help us see things differently.

Light and Kinetic Sculpture

Technological advances in our society have created more opportunities for creativity. Sculptors who work with movement and light express their ideas in ways that would not have been possible just a century or two before. These moving and lighted sculptural works, like those of the Constructivists, rely on mechanical engineering as well as the creative input of the artist.

Sculpture that moves is called **kinetic sculpture**. One of the first artists to merge movement, lighting, and performance into a single

work was the Hungarian László Moholy-Nagy (1895-1946). Moholy-Nagy was interested in the work of the Constructivists and wanted to incorporate technology into his art. The sculpture Light Prop for an Electric Stage, initially created as a stage lighting device, eventually became the main character in a film, also by Moholy-Nagy. The work has a motor that moves a series of perforated discs so that they cross in front of the lighting unit (2.160). This creates a constantly changing sculptural object, and the changes in lighting influence the surrounding environment.

Moholy-Nagy's investigations into the use of light influenced artists who were interested in effects produced by controlling the lighting of an interior space. Through the use of light an artist can change how a viewer perceives a threedimensional space. Carefully organized light projection can create the illusion that a surface exists in three dimensions even if it only has two. In Remagine, by Danish-Icelandic artist Olafur

2.160 (above left) László Moholy-Nagy, Light Prop for an Electric Stage, 1929-30. Exhibition replica, constructed 2006, through the courtesy of Hattula Moholy-Nagy. Metal, plastics, glass, paint, and wood, with electric motor, $59^{1}/_{2} \times 27^{5}/_{8} \times 27^{5}/_{8}$ ". Harvard Art Museums, Busch-Reisinger Museum, Cambridge, Massachusetts

2.161 (left) Olafur Eliasson, Remagine, 2002. Spotlights, tripods, or wall mounts, control unit, dimensions variable. Installation at Kunstmuseum Wolfsburg, Germany, 2004

2.162 (right) George Rickey, Breaking Column, 1986 (completed by the artist's estate, 2009). Stainless steel, $9'11^3/8'' \times 5^1/2''$. Contemporary Museum, Honolulu, Hawaii

Eliasson (b. 1967), the illusion of **depth** is created by the projection of light onto the walls of the gallery (2.161). The work challenges our perceptions of two-dimensional and threedimensional art by using the space of the gallery and the illusion created on its flat walls.

The American artist George Rickey (1907– 2002) designed works that were carefully balanced so that they could pivot in a variety of directions and provide an infinite number of constantly changing views. His Breaking Column is moved by the slightest current of air; it also has a motor, and moves even when there is no wind (2.162).

Perspectives on Art: Antony Gormley Asian Field

2.163a Antony Gormley

Antony Gormley (2.163a, b. 1950) is a British sculptor whose work is concerned with the human form. He developed the vast installation, Asian Field (1991-2003), as an art project beginning in 1983 (2.163b). Traveling to communities around the world, Gormley handed out fist-sized balls of clay and instructed participants to form them into an image of their own bodies, working as quickly as possible. Then participants were told to place the figure in front of them, at arm's length, and give it eyes. Gormley explains his approach to the human form and to Asian Field in particular.

The figures in my work are not portraits, they are corpographs: a three-dimensional equivalent of a photograph but which is left as a negative, as a void. They don't do anything, they don't represent anything, they are simply still objects in a moving world. And their meaning, if they have one, only comes when they act as a response to the lived time that surrounds them.

To make a work I have to stand very still and concentrate. One of the most direct ways to re-establish direct first-hand experience is to close your eyes and be in whatever that space is that you find yourself in. I've called this experience lots of things: the space of the body, the space behind appearance, the darkness of the body, the space of embodied consciousness.

My work is at its best when inserted into the stream of everyday life—whether that's in rooms, standing on walls or ceilings, or on the street. They may look at first hand like statues, but in fact they are simply lived moments made into matter. They identify a space that was occupied at a particular time by a particular body, and by implication can be occupied by anyone.

I am working in the most direct way I can to build a bridge between art and life. What the effect of my works is on their environment and on the internal condition of others I have no control over. I think of my works as objects that act on the

> space in which they are placed, allowing it to become a space for imagination and reflection.

The Field works were made differently from much of my work, in collaboration with large numbers of people. In each rendition of the installation there are thousands of clay figures, each modeled by an individual hand. The figures have empty voids for eyes. This is because sight is itself a form of blindness. It wraps us in a world of names and forms that are immediately translated into symbols, signs, emblems.

2.163b Antony Gormley, Asian Field, 2003. 210,000 hand-sized clay elements, installation view, warehouse of former Shanghai No. 10 Steelworks, China

2.164 Ilya and Emilia Kabakov, The Man Who Flew into Space from His Apartment, 1985-8. Wood, board construction, furniture, found printed ephemera, and household objects. dimensions variable

Medium (plural media): the material on or from which an artist chooses to make a work of art, for example canvas and oil paint, marble, engraving, video, or architecture

Installation: an artwork created by the assembling and arrangement of objects in a specific location

Installations

Modern artists have explored many ways of expanding the range of sculpture as a **medium**. **Installation** sculpture involves the construction of a space or the assembly of objects to create an environment; we are encouraged to experience the work physically using all our senses, perhaps entering the work itself.

The Man Who Flew into Space from His Apartment (2.164) was constructed by the Russian emigré Ilya Kabakov (b. 1933). Kabakov has re-created a room—which can be viewed but not entered—in a small apartment in the former Soviet Union. The room is plastered with Communist propaganda posters. The room's inhabitant is no longer there because he has launched himself through the ceiling, bits of which lie scattered on the floor. Kabakov's work juxtaposes the private life of the comrade with the presence of the

Communist state. The Soviet Union was the first nation to launch a human in space, a proud moment for Soviet society. The artist parodies the aspirations of an individual in such a society:

The person who lived here flew into space from his room, first having blown up the ceiling and the attic above it. He always, as far as he remembered, felt that he was not quite an inhabitant of this earth, and constantly felt the desire to leave it...

Conclusion

Sculpture is art that occupies and defines threedimensional space. Sculpture can be either freestanding or carved in relief (either bas-relief or high relief). Although sculptors have many choices of materials and processes to create their work, all sculptural processes and methods can be classified as either additive or subtractive.

We know about sculptural works created 30,000 years ago because they were made of materials durable enough to have survived for us to study and admire today. Often sculptors have chosen to carve subtractively in stone because they wished to make their gods, saints, and kings seem immortal. Bronze was a more adaptable material, and the additive casting technique made it possible for artists to model soft wax. The comparative ease of making the sculptures helped the ancient Greeks celebrate ideas of perfection of the human form. Earthworks are additive works on an enormous scale, involving whole communities, and explore humanity's relationship with nature.

In the last hundred years, sculpture has changed to reflect our new and complex modern world. Artists can make sculpture from perishable products, such as food, from industrial materials, such as iron, concrete, or steel, or—if it is created with light—from no material at all. Some sculptures—readymades—have simply been chosen, while some installations immerse us in a new sensory environment. In the creative hands of the artist, sculpture is a living, changing medium that has always expressed the richness of the world and the people in it. The tangible physical presence of a sculpture affects us by its very existence.

MEDIA AND PROCESSES

2.10

Architecture

Architecture communicates important ideas; it has a special place in our lives. Architecture—design that surrounds and influences us—represents the safety of home, the strength of government, the energy of commercial enterprise, and the power of human innovation. It connects us to our history in a very real way: a historic building shows us how people lived in the past, while a new building adapts design ideas from previous eras to a modern context. Architecture suggests feelings of permanence and place. It is no wonder we all have an opinion about a new building, because a building inevitably affects all who see or enter it, whether or not they are aware of this.

Architectural space is the result of thoughtful design by an artist, or by a team of artists working to a common idea. The architect is the master planner who creates a building's overall design. Thoughtful design reflects a building's function and its intended role in the community. For example, an architect designing a college building will consider its users—the instructors and students—and will design classroom spaces that are well lit and flexible. Sometimes an interior designer is responsible for making the space inside appropriate for the building's intended use. In the case of a college classroom, an interior designer will choose colors and furnishings and plan the organization of the space in a way that reflects the needs of students and teachers. A landscape architect may be employed to organize the outdoor spaces around the building. This designer will plan the landscaping, parking, and entry and exit routes to be consistent with the rest of the structure. The architect, interior designer,

and landscape architect actively communicate with the building contractors to ensure that the final construction will accord with the design team's intentions.

The Context of **Architecture**

Although buildings can be some of the largest and most complicated man-made objects, they usually begin from the simplicity of a drawing. Fumihiko Maki created a simple drawing as he began working on a design for the New World Trade Center in New York City (2.165). The

2.165 Fumihiko Maki, Sketch of Four World Trade Center, 2006

2.166 Taos Pueblo, New Mexico, pre-1500

drawing shows how his building will fit in with other buildings by continuing a spiral design.

Before drawing a picture, an architect collects information about the planned location of the building and its place in the community, selects the appropriate building techniques, and decides which materials are needed to construct it.

The location, or site, influences the design. Is the building going to sit on a plain or a mountainside, in a city or a rural community, on a waterfront or in a desert? Each of these sites presents different challenges the design must try to answer. For example, a building facing the sea might need to be strong and resilient to resist the effects

of storms, while one in a desert must be made of materials that can help keep the building cool.

Artists must consider the availability and cost of building materials when they plan their projects. The unique character of these materials—for example their flexibility, strength, texture, and appearance—also affects the architect's choices.

The engineering of the building, or its structural integrity, dictates some of the design decisions. Wood-frame buildings may require waterproof external cladding to protect the timber from damp and rot. Tall office buildings may need to have a strong steel frame (or an alternative) to bear the combined weight of all of the structure.

The final appearance of the structure will reflect—in some way—the community. In Taos Pueblo, New Mexico, for instance, many buildings are made of adobe brick (2.166). Their character derives from the available materials, such as the abundance of sand and clay; perhaps the community has traditional standards, such as the building methods and styles of the native Pueblos and Spanish settlers. The architecture of New York City looks very different, but is based on similar principles. Generations of people have admired the coherent **composition** of the **forms** of the skyscrapers, like a **Cubist** painting, as if the community had somehow combined together as a single artist to make something beautiful (2.167).

2.167 SoHo lofts. New York City

The Engineering and Science of Architecture

The engineering and science of architecture tries to understand and control the forces pushing or pulling the structure of the building. These forces, called stresses, are constantly at work. When stresses pull they create tension, which lengthens and stretches the materials of the building. When stresses push they create compression, which can squash and shorten the same materials. Architectural engineers work to create balances between tension and compression so that the amount of push equals pull. Each kind of building material resists the stress of compression or tension differently. Architects measure the strength of the material so that they can anticipate and control the balance of forces at work. If balanced correctly, a building can stand for many thousands of years; if not, it may collapse.

Traditional Construction in Natural Materials

Ancient cultures derived their building materials from the earth. Stone, wood, and clay are plentiful and easily available, but they must be modified for use in architecture. When shaped and used with great care and skill, these raw materials can result in architecture that transcends time.

Basic Load-Bearing Construction

Probably the most direct way to build something is simply to make a pile, for example the pyramids in Giza, Egypt (see Gateway Box: The Great Pyramid of Khufu). The ancient Egyptians' ability to move and place such large stones, with the few tools available at the time, has always been a cause of wonder.

But such massive load-bearing works have occurred throughout history. Protruding out of the Guatemalan rain forest at Tikal are hundreds of Maya pyramids that rise sharply toward the

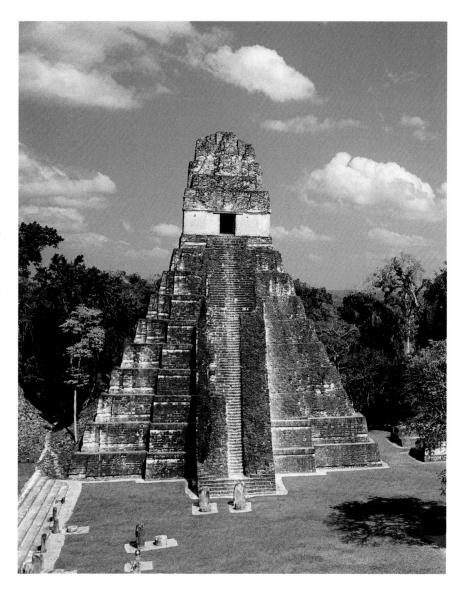

sky, emphasizing their role as gateways to the gods (2.168). Maya pyramids primarily served as platforms for temples. Temple I has a threeroom structure at its peak where Maya priests conducted religious rites.

Post-and-Lintel Construction

The **monumental** quality of ancient pyramids stands as a testament to the ingenuity and will of humankind. But these impressive structures did not provide the spacious interiors we have come to expect in everyday architecture. In order to create an interior space, an architect must create a span, or a distance between two supports in a structure. One of the oldest and most effective ways of doing this is a system called post-andlintel construction.

2.168 Temple I in the Great Plaza, Maya, c. 300-900 cE, Tikal, Guatemala

Monumental: having massive or impressive scale **Span:** the distance bridged between two supports such as columns or walls

Gateway to Art: The Great Pyramid of Khufu Math and Engineering

Some of the world's most imposing and dramatic architecture was made by the apparently simple process of piling one stone or brick on top of another. The pyramids at Giza, Egypt, with the exception of some tunnels and tomb chambers, are basically a carefully organized stack of stones. The weight of the capstone (2.169a) bears down on the stone beneath it. which, in turn, bears down on the stone beneath it, and so on, holding all the stones securely in place. Construction on this scale required sophisticated engineering and mathematical skills to ensure that such an enormous structure formed a perfectly symmetrical shape that would stand for thousands of years.

The pyramid of Khufu contains about 2.300,000 blocks of stone that have been calculated to weigh on average 2.5 tons. although some weigh as much as 50 to 80 tons. Its construction was a massive achievement. The ancient Greek historian Herodotus claimed that it took 100,000 people to build a pyramid.

2.169a Basic load-bearing architecture: pyramid

Even though current estimates are considerably lower (from 10,000 to 36,000 workers), a substantial crew was toiling for as many as 23 years to build Khufu's pyramid, the oldest of the three Great Pyramids (2.169b). Ancient graffiti found in the village where the workers lived indicates that at least some of these workers took pride in their work and the Pharaoh they worked for, calling their teams "Friends of Khufu" or "Drunkards of Menkaure." These teams of workers created one of the world's most impressive examples of load-bearing construction.

2.169b Great Pyramids at Giza, left to right: Menkaure, Khafre, and Khufu. с. 2560 все, Giza, Egypt

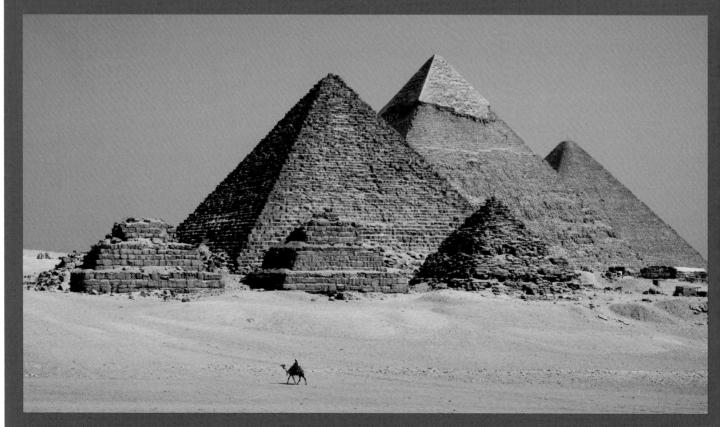

2.170 Post-and-lintel construction

2.171 Temple of Amun-Re, Middle Kingdom, 1417-1379 BCE, Karnak, Egypt

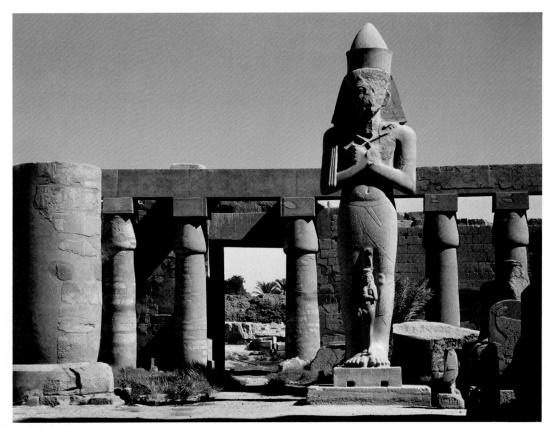

2.172 Kallikrates, Temple of Athena Nike, 427-424 BCE, Acropolis, Athens, Greece

In basic **post-and-lintel construction** (2.170) the lintel rests on top of two posts. Ancient Egyptian architects built the Temple of Amun-Re at Karnak by placing a series of post-and-lintel

spans side by side to create a spacious interior (2.171). This particular architectural space is known as a **hypostyle hall**, a room created by using a series of columns, or a colonnade, to support a flat ceiling. The hall was used by Egyptian priests for rituals to worship the god Amun-Re, while ordinary people stood outside in an open courtyard. Amun-Re's temple, still one of the largest religious structures in the world, is just one of many at Karnak.

The architects of ancient Greece must have been aware of the majestic architecture of the Nile valley. They adapted the systems invented by the Egyptians and became some of the world's greatest practitioners of post-and-lintel construction. The Temple of Athena Nike (2.172) is attributed to the Greek architect Kallikrates (working c. 450 BCE). It employs an elegant, thin variant of the Ionic column (so-called from its origin in Ionia, east of the Greek mainland). By using columns thinner than those of the Egyptians, the architect made the huge statue of the goddess Athena inside the temple seem much larger. The building was dedicated to the worship of Athena, the patron of the city of Athens where this temple was located.

Arches, Vaults, and Domes

The great limitation of early post-and-lintel architecture in stone is that the lintels could not span large spaces. Stone, while enormously strong in compression, is fairly weak in tension. Since stone cannot stretch, it risks making a weak point in the middle of a span that easily snaps under too much pressure. Architects who want to create large interior spaces in stone have to be aware of the weight of the building constantly pressing down. The ancient Babylonians in Mesopotamia (modern-day Iraq) and the Mycenaeans of early Greece both devised the corbeled arch as a solution to this problem. The stepping inwards of successive layers of stonework over the doorway allows for the compression created by the weight of the building to be directed outward rather than downward, reducing the pressure on the structure and allowing the architect to design and span larger spaces.

The Romans perfected the rounded arch (2.173), which was a more efficient way of distributing compressive stress over the whole of the structure. Its efficiency helped them span wider spaces. The upper level of the Pont du Gard, in southern France, is a Roman aqueduct,

2.173 Arch construction

built to move fresh water from mountain springs thirty miles away to the populated territories recently conquered by Rome (2.174). The lower level is a bridge across the river. The goal of the aqueduct was to create a consistent downhill path for the water: one inch down for every thirty-three inches along. The Romans made this impressive structure without any mortar holding the stones together, so perfectly were they cut to fit. After conquering an area the Romans often built aqueducts and roads. These structures benefited the local community, projected Roman imperial power, and enabled the army to move quickly across its new territory.

Post-and-lintel construction:

a horizontal beam (the lintel) supported by a post at either end Hypostyle hall: a large room with a roof supported by a forest of columns

Corbeled: with a series of corbels—architectural feature made of stone, brick, wood, etc.—each projecting beyond the one below

Aqueduct: a structure designed to carry water, often over long distances

2.174 Pont du Gard, first century CE, Nîmes, France

2.175 Barrel vault

Roman architects used three important architectural structures: the arch, vault, and dome. A **vault** is a ceiling based on the structural principles of the arch. The most common type of vault, the barrel vault, consists of a long semicircular arch (2.175). It is much like a long hallway with a rounded ceiling.

The Church of Sainte-Foy at Conques in France was a stop along the Christian pilgrimage route to Santiago de Compostela in Spain (2.176). The builders of the **Romanesque** church at

2.176 (right) Sainte-Foy, nave, c. 1050-1120, Conques, France

Vault: an archlike structure supporting a ceiling or roof Romanesque: an early medieval European style of architecture based on Roman-style rounded arches and heavy construction Aisles: in a basilica or other church, the spaces between the columns of the nave and the side walls

Nave: the central space of a cathedral or basilica

Flying buttress: an arch built on the exterior of a building that transfers some of the weight of the vault

Stained glass: colored glass used for windows or decorative applications

Pointed arches: arches with two curved sides that meet to form a point at the apex

Emphasis: the principle of drawing attention to particular content in a work

Rib vault: an archlike structure supporting a ceiling or roof, with a web of protruding stonework

Conques needed to create a space that could accommodate large numbers of visitors. Their solution was to use the barrel vault, but they had to deal with an important limitation of vault construction. Because the weight of the vault thrusts outward, the walls supporting it must be massive so as not to collapse. Vaulted aisles counteract this outward pressure on the walls and support both sides of the central nave. Even though Romanesque churches are large enough for plenty of pilgrims and worshipers, the thick walls have only small windows, creating dark and gloomy interior spaces.

The somber interiors of Romanesque churches did not satisfy one particular visionary church leader. Abbot Suger (1081–1151) had the Abbey Church of Saint-Denis, near Paris, France, rebuilt to provide a much grander place for worship. The Abbey Church of Saint-Denis was the national church of France; it housed the remains of the county's patron saint, Saint Denis, and many French kings. Suger decided that the existing church was too small and lacked the grandeur it deserved. Two ideas were central to Suger's new church: the worshiper should be bathed in divine light, and should feel lifted up toward heaven.

Adding larger windows to the structure could provide more light, but that would weaken the walls and increase the chance of a collapse. The walls of Saint-Denis had to be supported by external structures. Suger's plan incorporated an architectural structure called a flying buttress (see 2.178a and 2.178b) designed to transfer the weight of the ceiling outward beyond the walls. This idea worked well. Because the walls no longer needed to bear the weight of the building, the windows could be much larger to allow light into the interior. Suger was still not satisfied, however, because the light was not yet "divine."

Suger had seen small colored glass windows in German churches and decided that the methods used to make these smaller windows could be applied on a larger scale. By dividing up the window spaces into components of a larger design, Suger's glaziers were able to make enormous stained-glass windows (2.177). The light would pass through images based on Biblical narratives and be projected onto the worshiper. This was Suger's divine light.

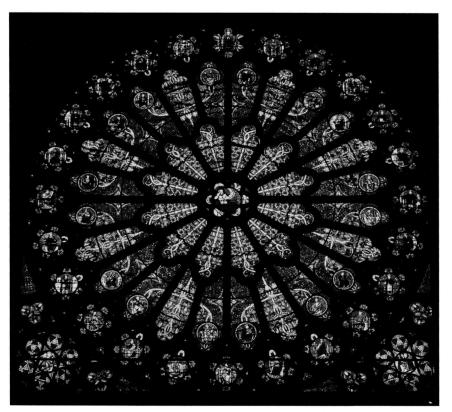

What about Suger's other requirement, that the worshiper feel lifted up toward heaven? The rounded arch of Romanesque churches tendedto appear squat, and Suger wanted an arch that would raise the worshiper's gaze upward. He achieved this by adding a point to the arch. **Pointed arches** are structural features that help conduct the downward thrust of the vault outwards, but they also have a strong upward visual **emphasis**. These pointed arches could be arranged so that two vaults would intersect to form **rib vaults**, which could be repeated in rows to open up long areas. Often associated with pointed arches, rib vaults appear in some earlier structures, but they were used throughout in Saint-Denis. Suger, because of his role in the creation of this remarkable building, was pivotal in establishing the architectural style that came to be known as Gothic.

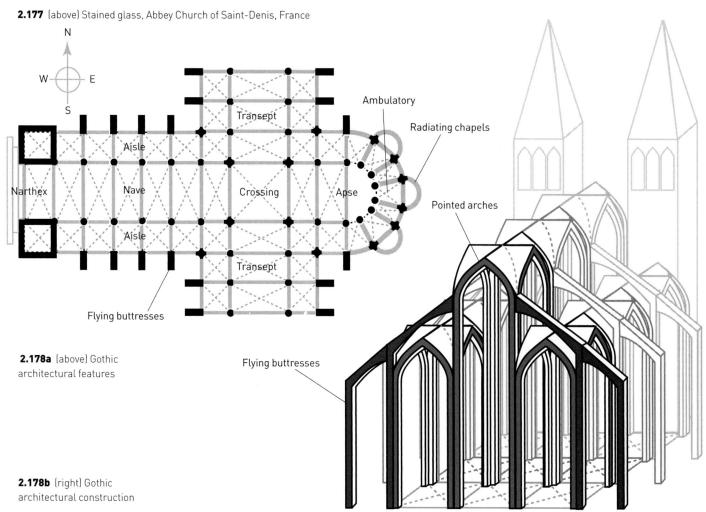

Dome: an evenly curved vault Axis: an imaginary line showing the center of a shape, volume, or composition

Clerestory windows: a row of windows high up in a church to admit light into the nave Pendentive: a curving triangular surface that links a dome to a square space below

2.179 Hagia Sophia, 532–5 cE, Istanbul, Turkey

Suger had said he wanted his church to be more impressive than the Church of Hagia Sophia (Holy Wisdom) in Constantinople (modern Istanbul, Turkey). The Hagia Sophia is a magnificent structure that had already been standing for more than 500 years by Suger's time. Its most impressive feature is its enormous **dome** roof (2.179). Structurally, a dome is like an arch rotated 360 degrees on its vertical axis. Shaped like an umbrella or a ball cut in half, it is a very strong structure. Domes can span large areas, because as in other arch structures, the weight of the dome is dispersed outward toward the walls. Most dome constructions require the support of

2.180 (above) Pendentives

thick walls or some other system for distributing the weight. The dome of Hagia Sophia is so large and high that, for nearly 1,000 years, it was the largest interior space of any cathedral in the world.

The inside of the Hagia Sophia is illuminated by a series of **clerestory windows** in the lower portion of the dome and in the walls just below it. The dome rests on four arches. Pendentives (2.180) elegantly transfer the load of the circular dome to the four massive pillars of the square building beneath it. It is no wonder that Suger admired and revered the architecture of this building.

Wooden Architecture

Architecture made from wood, a natural building material, combines strength and beauty.

The wooden post-and-beam construction technique (2.181) has been used to build some of the world's finest architecture. Two of the oldest wooden buildings in the world are in the grounds of the Buddhist Horyu-ji (Horyu Temple) in Nara, Japan (2.182). The construction of the Horyu-ji complex was the idea of the Japanese emperor Yomei, who hoped to gain spiritual favor so he could recover from illness, but he died before work started. In 607 Empress Suiko and Crown Prince Shotoku fulfilled the emperor's dying wish and built the first temple in the complex. Since then it has withstood the ravages of time and is an example of the durability of well-constructed wooden buildings.

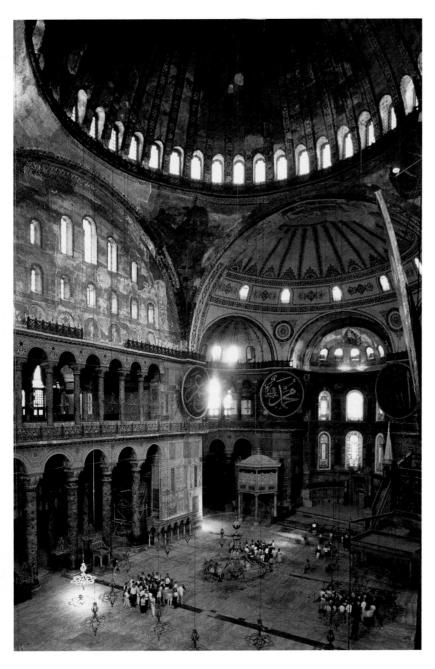

2.181 (left) Post-and-beam architecture

2.182 (right) Horyu-ji (Horyu Temple), Kondo and pagoda, c. 7th century, Nara, Japan

These buildings use a complex post-andbeam design that is both beautiful and structurally sound. Cross-beams and counterbeams create a series of layers supporting the elaborate curved roof. The main building of the

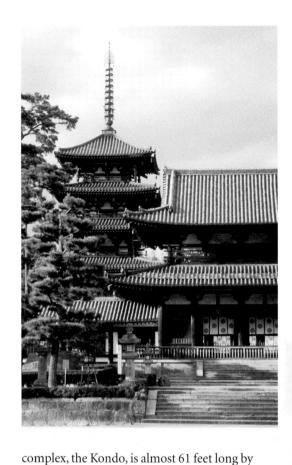

It was introduced when the advent of

50 feet wide. This same structural design also

2.183 Stick-style house using balloon framing, Brockville, Ontario, Canada

power sawing could efficiently and economically produce smaller cross-section lumber from saw logs. Originally balloon framing was a derisive term used by builders who stayed with traditional building methods and felt the new method was too fragile to support a building. Today, however, most houses in America are built using this method.

The Emergence of Modern Materials and **Modern Architecture**

In the nineteenth century, iron, steel, and concrete became both less costly and more widely available, and so came into common architectural use. New possibilities emerged as architects began to examine new ways to control tension and

compression. Buildings could be built taller and in different configurations. Architects could find exciting new ways to distribute the stress forces in their buildings. New types of building emerged, and new materials made buildings look radically different.

Cast-Iron Architecture

Cast iron has been available to humankind since ancient times. Iron is a more flexible material than stone. Molten iron can be cast in a mold to almost any shape, but it was not until the eighteenth century that it could be smelted in large enough quantities to play a significant role in building. An important example of the use of cast iron during the Industrial Revolution was the Crystal Palace, designed by Sir Joseph Paxton (1803-65) for the Great Exhibition of 1851 in

2.184 Joseph Paxton, Crystal Palace, 1851, London. 19th-century engraving

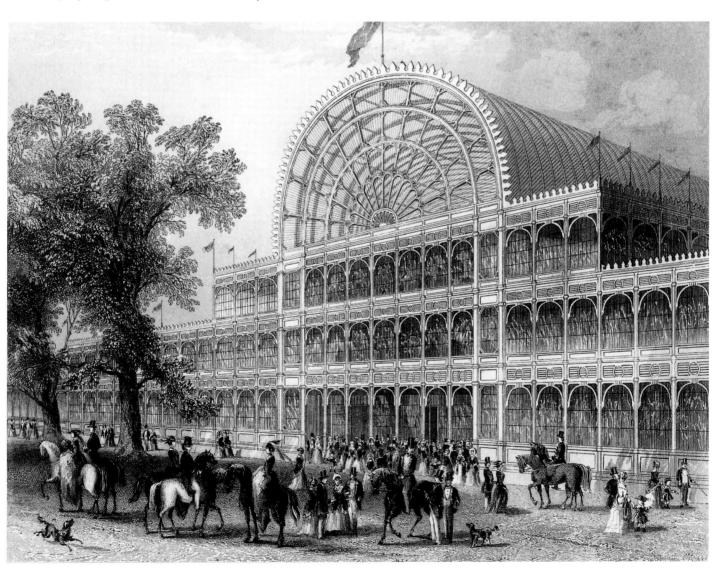

London (2.184). This event was intended to promote trade, and to showcase Great Britain's goods, services, and technical innovation—for which the building was a very good advertisement. The walls and roof were of glass supported by the skeletal cast-iron structure. The building was more than a third of a mile long; it was completed in only eight months by 2,000 men; and it used 4,500 tons of cast iron and 990,000 square feet of glass.

The Crystal Palace inspired other architects to work with iron, including French engineer Gustave Eiffel. It was eventually dismantled and reassembled in south London, where it became an exhibition center and concert hall. It was destroyed by fire in 1936.

Steel-Frame Construction

The use of cast iron for construction opened up new possibilities for architects. Cast iron was stronger than wood and more flexible than stone. It could be shaped into any form and was cheap, since iron ore was plentiful. Steel, a material made from iron and a small quantity of carbon, was stronger than pure iron and had even greater potential.

One architect who noted the advantages of steel was Louis Sullivan (1856-1924), called the "father of Modernism," who became a pioneer in the creation of the modern skyscraper. Sullivan, who attended Massachusetts Institute of Technology at the age of sixteen and took his first architect job at seventeen, participated in the rebuilding of Chicago after the Great Fire of 1871. Chicago provided fertile ground for creative young architects, and Sullivan pushed the use of steel frame to new heights.

Although he was based in Chicago, one of his masterpieces is in St. Louis, Missouri. The Wainwright Building, a ten-story office building, is one of the world's oldest skyscrapers (2.185). In this building Sullivan obeys his famous phrase "form follows function" by providing versatile interior space. Because the steel frame supports the building, and because it is mostly located at its outer edges, the space of the interior can easily be reconfigured to meet the specific needs of the user.

The skyscraper was a completely new idea, and architects like Sullivan had no precedents on

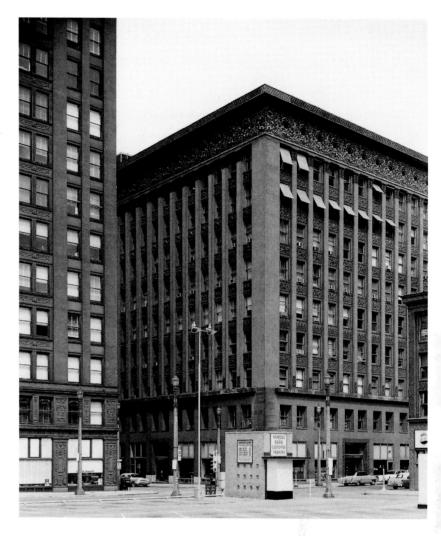

2.185 Louis Sullivan. Wainwright Building, 1890-91, St. Louis, Missouri

which to base their design. The Wainwright Building reflects the elements of a **column** (base, **shaft**, **capital**) in the organization of the exterior. Representing the capital, at the top of the building, is a cornice, or protruding ledge, that is highly ornamented with designs derived from Gothic cathedrals. The middle and tallest area shows strong vertical emphasis, with its projecting rectangular-section shafts and high, narrow windows. The lower section (base) shows little ornamentation and reflects ideas of the time about the frivolous nature of ornament. Later architects would avoid ornament altogether and rely on the aesthetic characteristics of the structure to provide excitement and interest in their design.

Because steel frames carry the load of the building, many Modernist architects realized there was no need to use a facing material, such as stone or brick; the entire side of the building could be sheathed in glass. The simplicity of this Modernist: a radically new twentieth-century architectural movement that embraced modern industrial materials and a machine aesthetic

Column: freestanding pillar, usually circular in section Base: the projecting series of

blocks between the shaft of a column and its plinth

Shaft: the main vertical part of a column

Capital: the architectural feature that crowns a column Cornice: molding round the top of a building

Aesthetic: related to beauty, art, and taste

Contrasting Ideas in Modern Architecture: Le Corbusier's Villa Savoye and Frank Lloyd Wright's Fallingwater

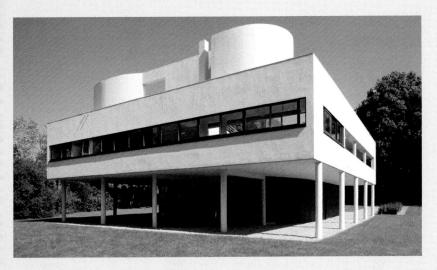

2.188 Le Corbusier, Villa Savoye, 1931, Poissy, France

Architecture is one of the most visible expressions of the Modernist movement. A building's appearance can be a visual expression of an idea the architect wants to communicate. Two buildings constructed about the same time, the Villa Savoye and

Fallingwater, are based on radically different ideas about architecture.

The Villa Savoye in Poissy, France, was built in 1930 as a weekend residence for a family that lived in Paris during the week. It is one of Le Corbusier's finest expressions of his architectural philosophy (2.188). Le Corbusier was a Swiss-French architect (also a designer and painter) who saw architecture as a "machine for living": the architecture of a building should be designed around the lifestyle of the occupants. Le Corbusier's architectural designs were part of the International Style that was promoted as a universal aesthetic form that could be built in any geographical or cultural environment relatively inexpensively. This style emphasized industrial and (in theory)

2.189 Frank Lloyd Wright, Fallingwater, 1939, Bear Run, Pennsylvania

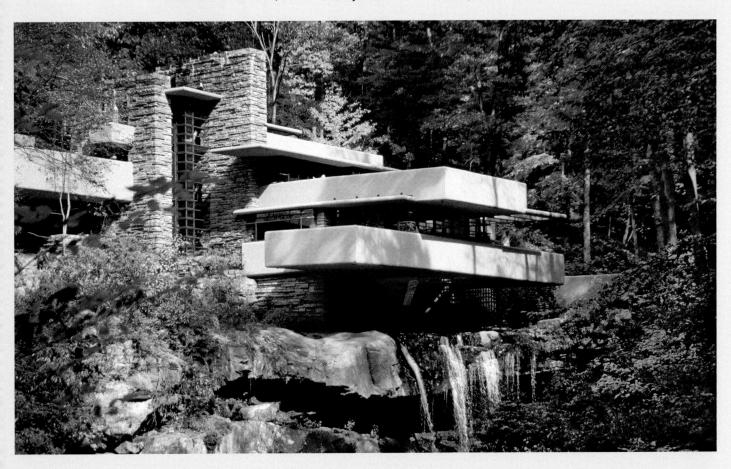

cheap materials, such as steel, glass, and concrete. It also favored a strongly geometric visual organization of spaces and elements of the building, including the shapes of the windows, roofline, and walls. With its preferences for unadorned, open interiors. the International Style claimed its rational approach to design could (and should) be used universally, for rich and poor alike.

Five years later, the American architect Frank Lloyd Wright (1867-1959) was commissioned to build Fallingwater in Bear Run, Pennsylvania, as a weekend getaway for the Kaufmann family (2.189). The profile of the house features vertical and horizontal elements much like those of the Villa Savoye, but Wright did not think that a house should be a machine. He believed the design of a house should respond organically to its location.

Rather than position the house so that the Kaufmanns could view the waterfall from inside, Wright placed the house right on top of it. He made the house so integral to the environment that the bottom step of one of the stairways hovered just above the creek. Wright believed so strongly in the organic relationship between site and building that he had many of the materials collected from the surrounding countryside. The stone was quarried nearby and the wood for the supports between the windows came from the surrounding forest. The design mimicked the layers in the rocks around the site, and the reinforced concrete was colored to fit in as well. Sometimes underlying rock juts into the living space of the house so that the occupants may take pleasure in stepping over or around the stone.

Le Corbusier's design was inexpensive compared with Wright's, particularly since Wright's building materials needed to be specially collected from the surrounding countryside. Each design creates a beautiful modern space. In Wright's work, architecture becomes part of the natural surroundings, whereas Le Corbusier wants nature to be viewed from a comfortable vantage point.

Wright's Fallingwater and Le Corbusier's Villa Savoye share similarities, but the two architects strove to express very different ideas.

idea captured the imagination of such architects as Germany's Mies van der Rohe (1886–1969) (2.186), who proclaimed "less is more," and the Swiss Le Corbusier (1887–1965), who called a building a "machine for living." (See Box: Contrasting Ideas in Modern Architecture.) A building could now reflect its surroundings while also giving people inside it a spectacular view of the landscape.

The Chinese-born architect I. M. Pei (b. 1917) combines beautiful design with a clear expression of structural integrity in the Bank of China Tower in Hong Kong (2.187). With its sharp triangular and diamond-shaped elements, which define or

2.186 Mies van der Rohe, Neue Nationalgalerie, 1968, Berlin, Germany

Organic: having forms and shapes derived from living organisms

2.187 I. M. Pei, Bank of China (center), 1990, Hong Kong

Articulate: to make smaller shapes or spaces within a larger composition

Expressive: capable of stirring the emotions of the viewer

articulate its vertical form, the building is a striking addition to the crowded Hong Kong skyline. There is a traditional Chinese belief system known as feng shui that studies the design and positioning of buildings in order to maximize their inhabitants' health and good fortune. According to these beliefs, the pointed shapes and mirrors of Pei's building deflect negative energy, thus bringing prosperity to those inside—a highly appropriate design solution for the Bank of China.

Reinforced Concrete

The character of architecture comes from its use of building materials, the sourcing or manufacture of which determines much of modern buildings' visual form. Steel and glass are produced in rectangular shapes that are a vital part of the visual aesthetic prizing the integration of form and function. But what aesthetic form would a material have if its raw manufactured state was liquid?

Architects began to use reinforced concrete as a way of avoiding the hard right-angled edges of

buildings made from blocks or bricks. Like steel and cast iron, reinforced concrete did not come into widespread use in architecture until the nineteenth century. Concrete is a mixture of cement and ground stone. It is reinforced through the use of either a fibrous material (such as fiberglass) or steel rods called rebars. The inclusion of fibrous or metal reinforcing helps the concrete resist cracking. In architecture, steel rebar is shaped to the architect's design specifications; builders make a large wooden mold, and then pour the concrete into the "form."

When the Danish architect Jørn Utzon (1918–2008) designed the Sydney Opera House, overlooking the harbor of Sydney, Australia, he broke away from Modernist rectangular designs (2.190). The structure is a testament to the **expressive** character of reinforced concrete. The rooflines resemble billowing sails, a reference to the building's harbor location. The "sails" were created over precast ribs and then set into place, allowing the architect more freedom in the creation of the design and (in theory) reducing

2.190 Jørn Utzon, Sydney Opera House, 1973, Sydney, Australia

the cost. In fact, owing to a succession of technical problems with this innovative building, the project cost fourteen times its intended budget. As controversy surrounding the project escalated, Utzon resigned nine years before its completion.

Contrasting Ideas in **Modern Architecture**

Beginning in the 1980s, a new approach to architecture, known as Postmodernism, combined the hard rectangles of Modernism with unusual materials and features of styles from the past. Postmodernism took hold as architects sought new ways to reflect a complex and changing world.

The Humana Building in downtown Louisville, Kentucky, designed by American Michael Graves (b. 1934), is an intriguing mix of historical styles and references (2.191). For example, the facade onto the street has a **stylized** Greek **portico**. The **negative space** of large windows and openings

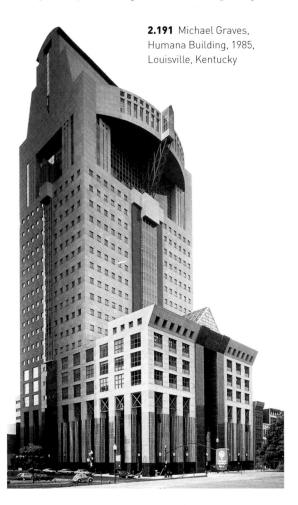

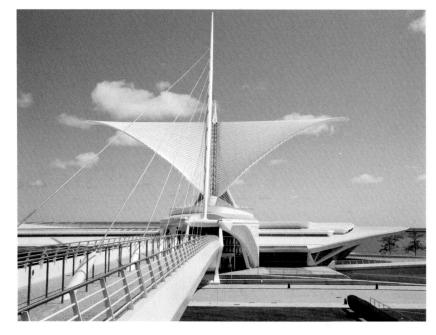

implies columns that rise up to support a cornice and triangular glass structure similar to the triangular **pediment** of a Greek temple. The upper portion of the building (set back from the street) suddenly changes from simple right angles to a series of curved surfaces that undulate like the architecture of the **Baroque** period. Graves also artfully varies the facing material, changing its color and texture at different intervals, seeking to avoid the austere simplicity and purity of Modernism.

In Postmodernist architecture, form no longer follows function with the same dedication as it did during the Modernist period. In fact, sometimes the building seems like a huge toy, a playful exploration of what we expect a building to be. The Quadracci Pavilion at the Milwaukee Art Museum was designed by Spanish architect Santiago Calatrava (b. 1951) to express the character of the site (2.192). Built on the shores of Lake Michigan, the pavilion reminds us of ships passing by; a cable-suspended bridge over a beautiful expanse of water also connects the museum to downtown Milwaukee. The building becomes a kinetic sculpture when a large moveable sunscreen atop the structure slowly rises and lowers throughout the day, like the flapping wings of the many species of birds that flock near the lake. The inside is reminiscent of the curved interior of a sailing ship. The Quadracci Pavilion provides an exciting exhibition space for the display of contemporary art.

2.192 Santiago Calatrava, Quadracci Pavilion, Milwaukee Art Museum, Wisconsin, 2001

Postmodernism: a latetwentieth-century style of architecture playfully adopting features of earlier styles Facade: any side of a building, usually the front or entrance

Stylized: art that represents objects in an exaggerated way to emphasize certain aspects of the object

Portico: a roof supported by columns at the entrance to a building

Negative space: an empty space given shape by its surround, for example the right-pointing arrow between the E and x in FedEx

Pediment: the triangular space, situated above the row of columns, at the end of a building in the Classical style

Baroque: European artistic and architectural style of the late sixteenth to early eighteenth centuries, characterized by extravagance and emotional intensity

Kinetic sculpture: threedimensional art that moves, impelled by air currents, motors, or people

Perspectives on Art: Zaha Hadid

A Building for Exciting Events

Zaha Hadid (b. 1950) was born in Iraq and trained as an architect in London. She has designed notable buildings in Europe and the United States. Here she describes how an architect thinks about a new building for art exhibitions, performances, and installations in downtown Cincinnati, Ohio.

The new home for the Contemporary Arts
Center is located on a small space in downtown
Cincinnati (2.193a and 2.193b). Our challenge was
to design for a prominent location an exciting
new building that would provide spaces for
many different activities: temporary exhibitions,
site-specific installations and performances,
an education facility, offices, art-preparation
areas, a museum store, a café, and public areas.

We designed the gallery spaces as a threedimensional "jigsaw puzzle" of interlocking solids and voids suspended above the lobby. The unique geometry, scale, and varying heights of the gallery spaces offer organizational flexibility to accommodate and respond to the size and media of the contemporary art that will be displayed.

We wanted to draw visitors into the building from the surrounding areas by creating a dynamic public space. Pedestrians enter the building and move around it through an "urban carpet" of polished undulating surfaces that curves slowly upward. As it rises and turns, the urban carpet leads visitors up a suspended mezzanine ramp through the full length of the lobby, which functions during the day as an open, daylit

artificial park. The urban carpet also connects to zigzag ramps that take visitors to the galleries.

Seen from the street, the building appears to be made up of stacked horizontal blocks of glass, metal, and concrete, suspended above the glass at ground level. We wanted to give the building a weightless quality, as if it were a sculpture, not just a building. The public and administrative spaces are glass, so that those outside are invited to look into the building, and those inside to look out at the cityscape. In this way the center's building is connected to the city it serves.

2.193a (left) Zaha Hadid, Contemporary Arts Center, Cincinnati, Ohio. Study model by the architects, experimenting with different structural ideas

2.193b Zaha Hadid, Contemporary Arts Center, 2003, Cincinnati, Ohio

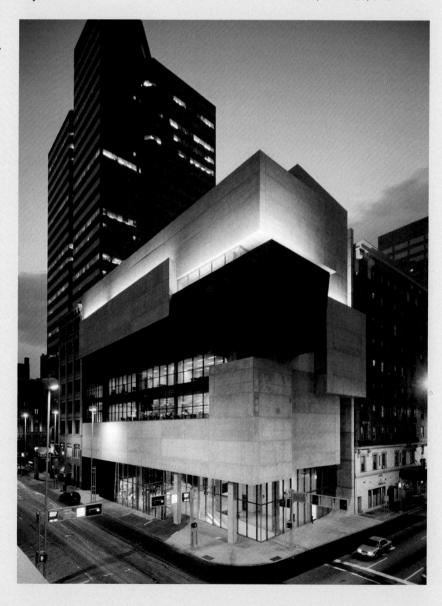

2.194 Architectural illustration of an urban block for a Szechuan Chinese village (Longju), Center for Maximum Potential Building Systems, 2005

The Future of **Architecture**

Architecture faces both challenges and opportunities as the twenty-first century unfolds. Concerns over limited resources, energy conservation, and sustainability have become important issues. American husband-and-wife team Gail Vittori (b. 1954) and Pliny Fisk III (b. 1944) have been considering the problems of sustainability and use of architecture for decades.

Since 1991 Vittori and Fisk have been codirectors of the non-profit Center for Maximum Potential Building Systems (founded by Fisk in 1975), which works to make new buildings more environmentally friendly. The center's design of a model village in Longju, China, is part of a larger vision that includes helping farmers to develop sustainable methods of farming (2.194). The design involves not just the buildings but also the working methods and entire lifestyle of the community. Fisk has created greener ways to raise crops and livestock so that each village can be more efficient and environmentally friendly. Vittori is on the board of directors of the U.S. Green Building Council, which promotes the LEED (Leadership in Energy and Environmental Design), a program and rating system that encourages building with renewable materials and appropriate technology. Because each building's location and unique needs can dictate energy use, the LEED provides guidance on the methods and materials that would best fit the structure.

Conclusion

From the earliest use of raw materials to contemporary methods of sustainable design, architecture both reflects and influences the way we live. It surrounds us as no other art form does. Across millennia, architecture has expressed how we make and think about our human world.

Communities and their architects have always adapted available materials to create buildings for shelter, worship, and all our other human needs. In the use of the natural strength, lightness, and beauty of wood to support a roof over our heads, we can see an evolution in structures from the plain (such as post and lintel) to the sophisticated (such as post and beam). Some of the earliest surviving stone buildings are also the simplest load-bearing structures. (The pyramids of Egypt also happen to be, even by today's standards, enormous and astonishingly well engineered.) Architects throughout history have valued the dignity and high compressive strength of stone. They have found ways to overcome its weight and weakness in tension so that they can use it to span ever-more exhilarating spaces. From corbelled to Roman arches, from barrel vaults to domes to Gothic flying buttresses, changes in the structural use of stone are a testament to human creativity.

In more recent times, changing technology and refined building materials have radically changed architects' repertory of design solutions. Industrial production of cast iron, steel, glass, and reinforced concrete have made possible buildings, such as skyscrapers, that were never dreamed of by the ancient Greeks. Architects have responded to the challenges with a new architectural language, Modernism, and its increasing numbers of associated styles.

The future of architecture is closely tied to the availability and thoughtful use of natural resources. Architects today consider how to recycle and reuse materials in making structures that fit the unique requirements both of their location and of the people who use them. Whatever happens during the twenty-first century, architectural design will become an increasingly important part of our lives.

HISTC

Art is not just the skillful application of design concepts and materials to produce an impressive work. Inevitably, an artwork is influenced by the time and place in which it was created. This influence is known as the context in which the art was made. The history of art is another important aspect of the many ways in which we can understand a work. In this part, as well as learning about context, you will discover how history has influenced art and how art, in its turn, reflects history.

PART 3

YAND CONTEXT

In this part you will study:

The Prehistoric and Ancient Mediterranean

Art of the Middle Ages

Art of India, China, and Japan

Art of the Americas

Art of Africa and the Pacific Islands

Art of Renaissance and Baroque Europe (1400–1750)

Art of Europe and America (1700–1900)

Twentieth and Twenty-First Centuries: The Age of Global Art

HISTORY AND CONTEXT

3.1

The Prehistoric and Ancient Mediterranean

Human prehistory is the long period during which humans and their ancestors developed societies for which no written record has been found. We know about the achievements of these early people from the material traces they left behind. In Europe, this takes us back thousands of years—even 2.5 million years, if we include tools. These ancient peoples survived by

gathering wild plants and hunting, and some found time to produce what we admire today as prehistoric art. Prehistoric art has been discovered in this region from as early as *c*. 30,000 BCE.

As humans formed larger communities, the Mediterranean region—the ancient Near East, northern Africa, and southern Europe flourished as an area of trade. Here, a succession

3.1 Map of prehistoric Europe and the ancient Mediterranean

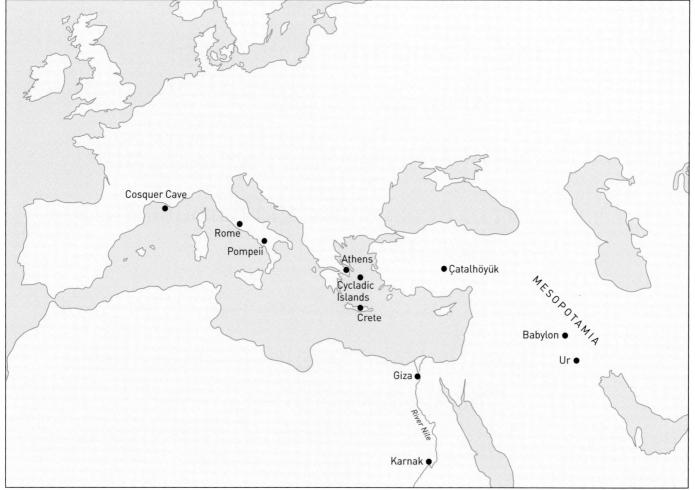

of civilizations arose that continue to shape the ways we live, even in the twenty-first century. It was here that humans first invented agriculture, started to live in urban settlements, and eventually planned cities; it was here that people invented writing, and produced works of art we still regard as great wonders of the world. The achievements of these people remain evident in our own lives. We write with an alphabet refined by the ancient Romans of Italy. Farmers who raise wheat crops today can do so because other farmers domesticated wheat and barley nearly 10,000 years ago.

These achievements, which we generally describe as the beginning of civilization, were matched independently elsewhere, for example in Asia and the Americas. The developments in the Mediterranean, however, are also part of the history of the Americas because of the arrival of Europeans more than 500 years ago. This chapter first tells the story of the sculptures, cave paintings, and monoliths made by prehistoric Europeans. Then we will look at the emergence of early civilizations in the ancient Near East and the rise of a great civilization in Egypt. Lastly we will study the powerful societies of ancient Greece and Rome and the beautiful sculptures, paintings, and buildings they produced.

Prehistoric Art in Europe and the Mediterranean

As long as 30,000 years ago, prehistoric people painted the interiors of caves; and sculptures still survive from 5,000 years before that. Not surprisingly, such art is preoccupied with the basics of life: procreation and sources of food. Prehistoric artworks are particularly important records of the lives of our early ancestors, because written records of these cultures do not exist. Often what we know about their lives is based upon archaeological finds, and our modern interpretations of these discoveries.

The earliest paintings in the world are found on cave walls. The entrance to the Cosquer Cave

3.2 Black horse, 27,000-19,000 BCE. Painting on top of finger tracings. Cosquer Cave, France

was discovered in 1985 by a diver, Henri Cosquer, 120 feet underwater off the coast of Marseilles in southern France. To reach it, one must swim underwater through a long narrow passage arriving at a large chamber where paintings have survived above the water. In prehistoric time, however, the entrance was about 250 feet above sea level and about seven miles from the coast. The enormous cave complex is more than 300 feet long. Its images were made in two phases. The first, from about 28,000 years ago, includes many scratched tracings of fingers, some children's handprints, and at least 65 images in which the outline of a hand was painted. The second phase, about 10,000 years later, features more than 170 images of animals (charcoal paintings and engravings), including horses, ibex, bison, deer, and seals.

Prehistoric humans often painted over earlier images already on the wall. In 3.2, a horse was painted over tracings (visible in the lower right) of several human fingers that were made 10,000 years before. The area around the horse also shows significant scraping. Such scrapings, found throughout the cave, suggest that large amounts of calcium carbonate powder were taken from the walls. Scientists believe this powder was probably used for medicinal purposes, for even today we might use calcium carbonate to treat osteoporosis.

Monolith: a monument or sculpture made from a single piece of stone

3.3 Landscape with volcano eruption, detail of watercolor copy of a wall painting from Level VII. Catalhövük, Turkey. c. 6150 BCE. Wall painting. Ankara Museum of Anatolian Civilizations, Turkey. Watercolor copy: Private collection

Some of the earliest works of art from the Mediterranean region come from Catalhöyük, Turkey. Here, fragments of wall paintings remain from a large building complex that stood between c. 7000 and 5700 BCE. Inhabitants of the Catalhöyük settlements lived in mud-brick homes, which they entered from the rooftops; there was no organized street system. The deceased were buried beneath the floors, and sometimes homes were demolished to create a higher base from which to build new ones. More than twelve layers of building have been discovered at the site.

While many paintings from Çatalhöyük depict humans and animals (often in hunting scenes), one intriguing wall painting re-creates the design of the town, with rectangular houses closely aligned side by side (3.3). In the background is the double-peaked volcano, Hasan Da, which in reality is eight miles away. The volcano appears to be erupting; lava falls in droplets down the mountain, and smoke fills the sky.

The most common type of prehistoric artworks found throughout the world are female figures that suggest the celebration of fertility. On the Cycladic Islands, now part of modern-day Greece, a number of human figures, carved out of white marble, have been found, many of them at grave sites (3.4). Cycladic sculptures of females far outnumber those of males. Curiously, however, the female Cycladic figures look similar to their male counterparts, with barely noticeable breasts

and – apart from their broad hips – only minimal anatomical detail. The figures usually have a long head and protruding nose; they are generic renderings of females rather than individual portraits. Originally, these figures were painted in black, red, and blue to show some facial details, body ornamentation, and probably jewelry. Because of the sculptor's emphasis on parts of the body related to reproduction, such as the breasts and a slight swelling in the belly, many scholars believe these objects are fertility figures. It is thought that, since they are smaller than one's hand, they may have been carried around as a kind of talisman, or charm against bad luck. Little is known about the Cycladic culture because it did not have a written language, but these expressive, almost geometric figures are some of the most intriguing in the history of art.

Just over 100 miles south of the Cyclades and dating from a little later in time, there is ample archaeological evidence of a sophisticated and complex civilization, the Minoan, on the island of Crete from about 2700 to 1400 BCE. Minoan cities, with their powerful fleet and location at the hub of the eastern Mediterranean, grew wealthy as centers of trade. Some of our written evidence of Minoan culture comes from the Greeks. According to their legend, King Minos was the stepfather of the Minotaur, a half-man, half-bull, man-eating creature trapped in a labyrinth. The powerful Minos required the Athenians to send seven young men and seven young women each year to satisfy the Minotaur's appetite.

The Minoans built large palaces in the center of their cities, the largest being King Minos's Palace of Knossos (3.5). This complex—up to five

3.4 Reclining female figure of the Late Spedos variety, Cyclades, 2500-2400 BCE. Island marble, 233/8" high

Fresco: a technique where the artist paints onto freshly applied plaster. From the Italian fresco,

Subject: the person, object, or space depicted in a work of art

stories high—was a maze of some 1,300 rooms, corridors, and courtyards. These spaces were used for governmental and ceremonial functions, as accommodation for the king's family and their servants, large storerooms, and even as a theater. The palace complex was so full of twists and turns that it is easy to see how the Greeks developed a myth about the labyrinth.

The importance of bulls in Minoan culture can be seen from their inclusion in the Minotaur myth and in much of Minoan art. Several sculptures and **frescoes** with scenes of bulls were found throughout the Palace of Knossos, including the lively *Bull-leapers* (3.6). In this scene, three young acrobats are jumping a spirited bull. The boy flips over the beast as a young woman on the left—lighter skinned to identify her gender—prepares to take the next leap. The girl on the right has apparently just landed. The creature is depicted with great energy, yet the Cretans seem able to match it. Bull-leaping, boxing, and acrobatic scenes were all common **subjects** in Minoan art, evidence of an athletic people; these activities may have been for enjoyment, or for more ritualistic ceremonies.

Minoan civilization suffered a variety of upheavals, both natural and man-made, from around 1500 BCE, when, as some believe, a volcanic eruption on the nearby island of Thera created a huge tidal wave that destroyed the Minoans' cities and fleets. Some decades later, Mycenaean invaders from mainland Greece overran Crete, taking over such palace sites as Knossos.

3.5 Ruins of Palace of Knossos, Crete, Greece, c. 1700-1400 BCE. From 1900, parts of the palace were reconstructed, as seen here.

3.6 Bull-leapers, from Palace of Knossos, Crete, Greece, c. 1450-1375 BCE. Archaeological Museum, Heraklion, Crete, Greece

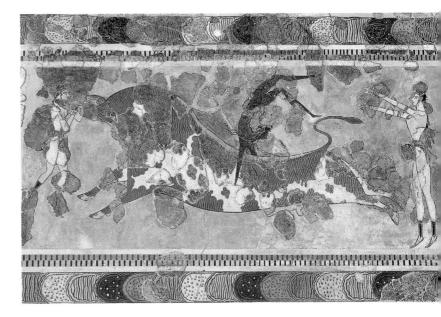

Mesopotamia: The Cradle of Civilization

Mesopotamia, from the Greek for "the land between the rivers" (a reference to the Tigris and Euphrates rivers), includes the regions of modern Iraq and portions of Syria, Turkey, and Iran. Ancient Mesopotamia is often called the "Cradle of Civilization," for it was here that urban centers first developed as early as 4000 BCE. Here too, in the rich land of the Fertile Crescent, complex irrigation systems enabled people to produce plentiful crops. Mesopotamia was frequently conquered by rulers desiring the wealth of its farmland. Among the many cultures that battled for control of the region were the Sumerians, Akkadians, Assyrians, and Babylonians.

Sumerians

The Sumerian civilization was the first great power in Mesopotamia. The Sumerians developed the earliest known form of writing, called cuneiform, which later evolved into a system of wedge-shaped symbols drawn with a reed "pen" in soft clay. They seem to have invented the wheel, which was probably first used to help potters make circular pots. The people of Mesopotamia worshiped many gods and goddesses (a practice known as polytheism) in temples or shrines located on huge ziggurats stepped pyramid structures made of baked clay which they constructed in the center of their communities.

The artists of Sumer excelled in the art of inlaying ivory and shell in wood, as seen in the Standard of Ur found in the Royal Cemetery of Ur (3.7). When it was first discovered, scholars thought it must have been carried on the end of a pole, like a standard, but there is no real evidence for this. The wooden box is only eight inches high and decorated with inlaid pieces of shell, lapis lazuli (a blue semi-precious stone), and red limestone. One side of the box shows war scenes, while the other shows life during times of peace. Each side is divided into three sections, known as registers. The bottom register of the war side shows chariots running over the bodies of the

enemy. In the middle register, the box shows soldiers (from left to right) marching, shaming their enemies by stripping them of their clothing, and forcing them to continue walking. In the center of the top register is the ruler. His larger size indicates his importance, a convention known as hierarchical scale. His status is reinforced by the fact that all the surrounding people are facing him. He has stepped out of his chariot while prisoners are brought before him. On the peace side, animals, fish, and other foods are brought to a banquet where seated figures drink while a musician playing a lyre entertains them. The standard is a fine example of narrative art and a source of evidence about what food the Sumerians ate, their clothing and weapons, their musical instruments, and their success in war.

The treasures found at the Royal Cemetery at Ur reveal the great wealth of the Sumerian elite. Buried with the bodies were gold jewelry and daggers inlaid with lapis lazuli. Whether the buried were royalty or religious leaders is unknown, but the chariots, weapons, and musical instruments buried with them are evidence of

3.7 Standard of Ur, Early Dynastic III, c. 2600-2400 BCE; War (below) and Peace (bottom). Wood inlaid with shell, lapis lazuli, and red limestone, 7\% x 18\1/2". British Museum, London, England

3.8 Head of an Akkadian Ruler, c. 2300-2200 BCE. Bronze, 15" high. National Museum of Iraq, Baghdad

Ziggurat: Mesopotamian stepped tower, roughly pyramidshaped, that diminishes in size toward a platform summit Hierarchical scale: the use of size to denote the relative importance of subjects in

Relief: a sculpture that projects from a flat surface

an artwork

their importance. Servants and soldiers were also buried with their leaders, possibly to protect and serve them in the afterlife.

Akkadians

The next Mesopotamian empire was founded by the Akkadian king Sargon, who ruled between c. 2334 and 2279 BCE. He conquered the Sumerian city states. Before King Sargon, most rulers of Mesopotamia were believed to be merely representatives of the gods on earth. However, the Akkadian rulers who followed Sargon elevated themselves to divine status. The bronze, life-sized Akkadian Head (3.8) is the portrait of a great king, probably Sargon's grandson Naram-Sin (c. 2254–2218 BCE). The figure's expression is one of proud majesty. The artist paid particular attention to the texture and patterning of the hair on the ruler's beard, eyebrows, and head. The eye sockets have been damaged from violent gouging, either to remove the materials (probably shells or lapis lazuli) used to make the eyes, or to make the figure's presence less powerful. The head was originally discovered in Nineveh in northern Iraq, and was one of the many objects missing after the looting of the National Museum of Iraq in Baghdad in 2003 during the U.S. invasion of Iraq. More than 15,000 artifacts were stolen, of which fewer than half have been recovered—this Akkadian head being one of them.

Assyrians

The Assyrians, who had intermittently enjoyed considerable power in the second millennium BCE, ruled much of Mesopotamia during the Neo-Assyrian period (883-612 BCE). The first great Assyrian king, Ashurnasirpal II (who ruled between 883 and 859 BCE), used slave labor to build the large city of Nimrud (near modern Mosul, Iraq), which became the capital of Assyria.

Ashurnasirpal II's grand palace was covered with relief sculptures of battles, hunting scenes, and religious rituals. An accompanying inscription refers to guardian figures (called lamassi) at gateways and entrances throughout the palace: "Beasts of the mountains and the seas, which I had fashioned out of white limestone and alabaster, I had set up in its gates. I made it [the palace] fittingly imposing."

These figures were meant to show the fearsome power of the Assyrian ruler and the authority given to him by the gods (3.9). Almost twice as tall as a human, this lamassu combines the head of a man with the body and strength of a lion and the wings and all-seeing eyes of an eagle. The horned cap signifies divinity, representing the gods' support and protection of the rulers of Assyria. Lamassi often have five legs, so they appear to be standing still when viewed from the front and striding forward when seen from the side. The lion is an animal that is often associated with kingship, and at this time in this civilization, only Assyrian kings were considered powerful enough to protect the people from the lions that

3.9 Human-headed winged lion (lamassu), from gateway in Ashurnasirpal II's palace in Nimrud, Mesopotamia, Neo-Assyrian, 883-859 BCE. Alabaster (gypsum), 10'31/2" high. Metropolitan Museum of Art, New York

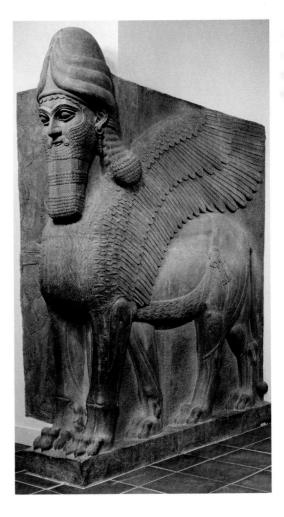

roamed the areas outside the cities, and only kings were allowed to hunt the creatures. Many of the reliefs decorating Ashurnasirpal II's palace show the king hunting lions.

Babylonians

In the late seventh century BCE the Babylonians defeated the Assyrians and re-emerged as a powerful force in Mesopotamia. The ruler Nebuchadnezzar II (605–562 BCE) built a grand palace famous for its Hanging Gardens. Around the city, he built fortified walls with eight gateways. The dramatic Ishtar Gate was the main entrance to the streets and temples of Babylon (3.10). This enormous ceremonial entrance was actually two arched gates, the shorter of which (shown here) stood 47 feet high. Golden reliefs of animals that symbolize specific Babylonian gods project out from a flat blue background made of glazed bricks.

A Processional Way ran through the Ishtar Gate, leading to the ziggurat on the south side of the city, which some believe to be the inspiration for the Old Testament story of the

Tower of Babel. Walls on either side of the Processional Way were covered with 120 glazed reliefs of lions (60 on each side), symbols of the goddess Ishtar.

The Ishtar Gate was taken in pieces in the early twentieth century to Germany and is now reconstructed at the Pergamon Museum in Berlin. In the same museum, next to the Gate, is a wall from the entrance to Nebuchadnezzar's throne room, which shows **stylized** palm trees above lions that are similar to those that covered the walls of the Processional Way.

Ancient Egypt

At the time of the pharaohs, the African land of Egypt traded with peoples throughout the Mediterranean, and thus many of the ideas and techniques invented by Egyptian artists were taken up by Mediterranean civilizations. Indeed, some thousands of years after they were made, the ancient Egyptians' extraordinary artistic and architectural achievements continue to be a source of wonder and astonishment worldwide.

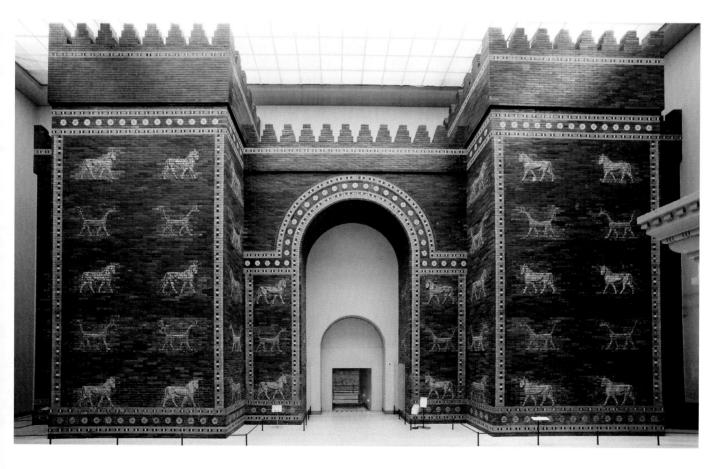

3.10 Ishtar Gate from Babylon (Iraq), reign of Nebuchadnezzar II (605–562 BCE), Vorderasiatisches Museum, Staatliche Museen, Berlin, Germany

It is perhaps appropriate that our fascination with Egyptian art should be so longlasting when so much of early Egyptian culture focuses on eternity and the afterlife. The Egyptians believed that their pharaohs ruled with the authority of gods, and as a result, the Egyptian people took great care to ensure that, when a pharaoh died, his needs in the afterlife—where it was believed a person would require everything he had needed when living—would be met. So in the pharaohs' tombs were buried furniture, weapons, jewelry, and food. Family and servants were even killed to accompany the dead pharaohs, although as time went on the Egyptians came to believe that art portraying these objects and people would be enough. (See Gateway Box: The Great Pyramid of Khufu.)

Stylized: art that represents objects in an exaggerated way to emphasize certain aspects of the object

Sarcophagus (plural sarcophagi): a coffin (usually made of stone or baked clay)

Gateway to Art: The Great Pyramid of Khufu Belief in the Afterlife

We can fully understand the function of the pyramids at Giza (3.11) only if we study Egyptian beliefs about the afterlife. The pyramids housed the tombs of pharaohs, who were believed to live forever after death. In front of Khafre's pyramid sits a colossal stone sculpture of a Sphinx, a mythical creature with the body of a lion and the head of a human king. The lion was in part an expression of royal power, but also a symbol of the Sun god who was believed to carry away in his boat the dead to their afterlife.

When a pharaoh died, in order to preserve his body for its afterlife, it was mummified, a process that took several months. The heart was left inside the body; Egyptians believed it to be the organ of thought and therefore

> necessary for the body to exist in the afterlife. The

brain was deemed to be of no value and was removed through the nostrils. The liver, lungs, intestines, and stomach were also removed, and preserved in containers called canopic jars (see 3.13 on p. 302). The body was then soaked in a salt preservative called natron for forty days and was finally wrapped in linen. An elaborate funerary mask was placed upon the face of the pharaoh, and he was buried under layers of sarcophagi. These complex burials were meant to protect the treasure and life force, or ka, of the buried. The great investment of time,

> in creating the pyramids demonstrates the importance the Egyptians placed on the afterlife.

labor, and wealth that was involved

3.11 Great Pyramids and Sphinx, c. 2558-2532 BCE, Giza, Egypt

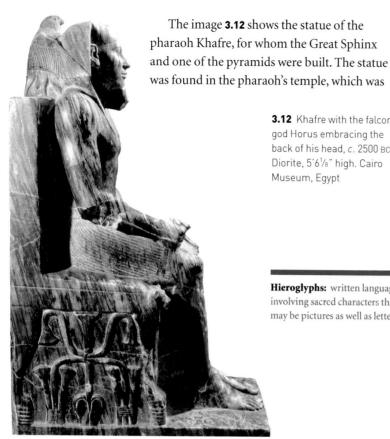

3.12 Khafre with the falcon god Horus embracing the back of his head, c. 2500 BCE. Diorite, 5'61/8" high. Cairo Museum, Egypt

Hieroglyphs: written language involving sacred characters that may be pictures as well as letters

connected by a walkway to his pyramid. When Khafre died, his body was taken to his temple and mummified, to preserve it for the afterlife, before being taken to his pyramid. In this statue, Khafre and the chair in which he sits have been carved from a single block of hard stone called diorite. He seems to sit stiffly, as if attached to his throne. Egyptian sculptures portrayed people with gracefully proportioned bodies, but they only subtly suggested movement, in this case by showing one hand clenched in a fist. To signify the pharaoh's importance, the powerful sky god Horus, symbolized as a falcon, perches upon his shoulder. In Egyptian belief, Khafre's statue provides a place for his soul to rest during the afterlife. In fact, in Egyptian writing, "sculptor" translates as "he who keeps alive."

The Egyptians invented a system of writing using hieroglyphs and often carved or painted them on their artworks (see Box: Hieroglyphs). Egyptian hieroglyphs were gradually deciphered after the finding of the Rosetta Stone in 1799.

Hieroglyphs

We can understand Egyptian art largely because we can translate hieroglyphs, the written language of the ancient Egyptians. This was made possible in 1799 through the discovery of the Rosetta Stone, which was found by the French army led by Napoleon during the course of its invasion of Egypt. The lettering on the stone is dated to 196 BCE and repeats the decrees of Ptolemy V, the Greek ruler of Egypt, in three separate forms of writing. Hieroglyphic and Demotic were different written forms of the Egyptian spoken language; Greek was familiar to many scholars and was the key to deciphering the other two. Hieroglyphs are often images of recognizable objects, but the image can represent the object itself, an idea, or even just a sound associated with that object. In 1822 Frenchman Jean-François Champollion was finally able to claim that, thanks to studying the Rosetta Stone, he understood the meaning

of the complex hieroglyphics of the ancient Egyptians.

We know quite a bit about the burial practices of the Egyptians from the hieroglyphs written on the objects buried with the boy king Tutankhamun, who ruled from 1333 to 1323 BCE. Four miniature coffins, each only fifteen inches high, were placed within an alabaster chest buried in Tutankhamun's tomb. These so-called canopic jars each hold an organ of the dead king and are protected by one of the sons of the god Horus. Hieroglyphs on the chest and jars tell us what these jars contain and their religious importance. The hieroglyphic inscription is inlaid in glass and lapis lazuli down the vertical gold band of the canopic jar that held the liver. It is a magical spell to guard the contents.

3.13 Detail of receptacle for internal organs, reign of Tutankhamun (1333-1323 BCE). Gold, cornelian, and vitreous paste, $15^{3}/_{8} \times 4^{1}/_{4} \times 4^{3}/_{4}$ ". Cairo Museum, Egypt

Perspectives on Art: Zahi Hawass

The Golden Mask of King Tutankhamun

Zahi Hawass is an Egyptian archaeologist and Secretary General of the Supreme Council of Antiquities. Among his responsibilities is the care of the fabulous treasures of King Tutankhamun, discovered by the English archaeologist Howard Carter in 1922. Dr. Hawass is one of the few people who can study the famous mask of the king up close. Here he describes how the mask was made.

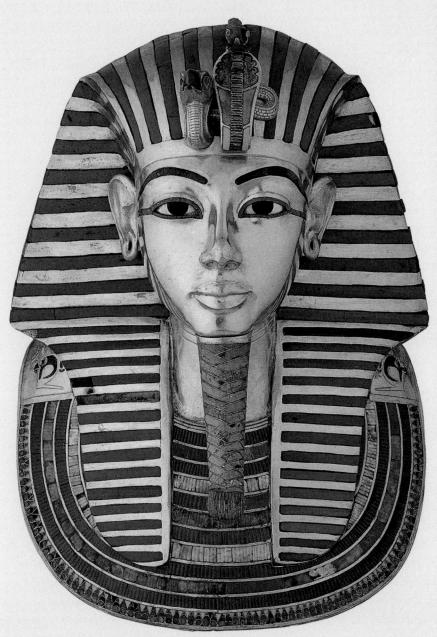

Whenever a television program wants to interview me about the golden king, I go directly to the mask (3.14). While the film crew is setting up the cameras, I have a chance to look again at the mask and I always discover something new. Each time, its beauty makes my heart tremble.

This spectacular mask represents an idealized portrait of the king. Intrinsically beautiful owing to the precious materials and masterful workmanship that went into its creation, it was also an essential item of the royal burial equipment, serving as an image that the soul could enter and occupy during the afterlife if something happened to the body.

The artisans who crafted this masterpiece began by hammering together two thick sheets of gold, thought by the ancient Egyptians to echo the flesh of the gods. They then shaped this metal into the likeness of the king wearing the striped nemes headcloth, using inlays of semiprecious stones and colored glass to add color and detail. The whites of the eyes were inlaid with quartz, and obsidian was used for the pupils. Red paint was lightly brushed into the corners of the eyes, subtly increasing their realism.

The vulture and cobra adorning the king's brow, images of the protective goddesses of Upper and Lower Egypt respectively, were made of solid gold with inlays of lapis lazuli, carnelian, faience, and glass. The long curled beard on the king's chin, emblematic of divinity, is made of blue glass laid into a golden framework.

On the shoulders and the back of the mask is a magical text that refers to the different parts of the body and mask, and their connection to particular gods or goddesses. This served to protect the king's body and render it functional for the afterlife.

3.14 Funerary mask of Tutankhamun, reign of Tutankhamun (1333–1323 BCE). Solid gold, semi-precious stones, quartz, and vitreous paste, 211/4" high. Cairo Museum, Egypt

3.15 Fowling scene, from the tomb of Nebamun, Thebes, Egypt, 18th Dynasty, c. 1350 BCE. Painted plaster, $38^{5}/8 \times 8^{3}/4$ ". British Museum. London, England

This single discovery made possible a much greater understanding and appreciation of the art and culture of Egypt. The revelation in 1922 of the extraordinary riches hidden within the tomb of Tutankhamun fueled renewed interest in the ancient dynastic culture (see p. 303, Perspectives on Art Box: The Golden Mask of King Tutankhamun).

Paintings made during the time of the ancient Egyptians are rich in details that tell us about the way people lived. Wealthy people filled their tombs with paintings showing what they wished to take with them into the afterlife. The image in 3.15 is from the tomb-chapel of Nebamun, a "scribe and grain accountant in the granary of divine offerings" in the Temple of Amun at Karnak. The hieroglyphic writing on the right identifies him and tells us that he enjoyed hunting. Nebamun is depicted hunting several species of birds; a cat holding birds in its mouth is shown underneath his right elbow. The artist included an Egyptian boat and the rich lush growth of the reed-like papyrus plant. This scene highlights the importance of the River Nile to the Egyptians, and how the flooding of the Nile symbolized a cycle of regeneration and new life

each year, just as Egyptians believed that after death they would be reborn. The artist depicted the figures in hierarchical scale, that is, in proportion to their importance: Nebamun is shown the largest, his wife is smaller, and their daughter is the smallest of all. Nebamun's legs are shown in profile while his torso is shown frontally, and although his face is in profile his eye looks straight at the viewer. This method of depicting figures is known as twisted perspective, also called composite view.

Art of Ancient Greece

"Man is the measure of all things."

(Protagoras, Greek philosopher)

The Greeks, like the civilizations that came before them, worshiped gods. But, as the quote from Protagoras indicates, they also valued humanity. Although their gods were portrayed as idealized and beautiful beings, they looked like humans and had some human weaknesses. The emphasis on the individual led the Greeks to practice democracy (the word means rule by the demos, or people), although their society did not give equal rights to women or slaves. Their great advances in philosophy, mathematics, and the sciences continue to influence our thinking up to the present day.

Athleticism was important in Greek culture and the Greeks held sporting contests, the origins of the modern Olympic Games, at which individuals competed for glory and money. Sculptures of men were predominantly of the nude body, shown with ideal **proportions**. For the Greeks, the idealized human form represented high intellectual and moral goals. Indeed, Greek architecture was based on mathematical systems of proportion similar to those applied to the human form. Greek pride in their own physical and intellectual achievements is evident in the art they produced.

Every large city in Greece had its own government and was protected by its own god. Each had an **acropolis**, a complex of buildings on the highest point in the city that was both a fortress and a religious center, dedicated to the city's patron deity. The best-known acropolis is in

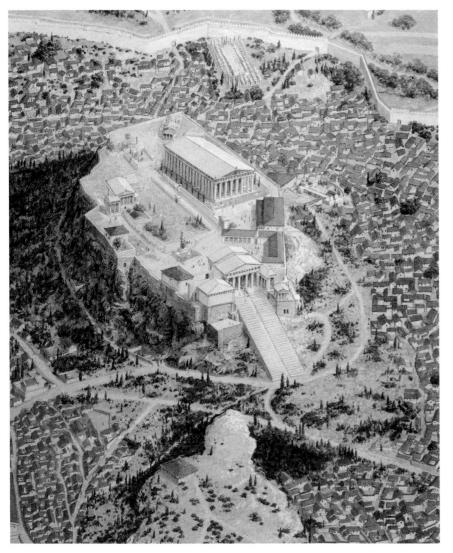

3.16 Reconstruction view of the Acropolis, Athens. Greece, at the beginning of the 4th century BCE

Twisted perspective, also known as composite view: a representation of a figure, part in profile and part frontally **Proportions:** the relationship in

size between a work's individual parts and the whole **Acropolis:** a high place in a

Greek city on which a temple is located

Classical: Greek art of the period c. 480-323 BCE

Athens, and is dedicated to Athena, the goddess of war, wisdom, and the arts (3.16). According to Greek mythology, the city was won by the goddess in a competition with Poseidon, god of the sea. Legend says that the goddess grew an olive tree, giving Athenians a source of wealth and defeating Poseidon, who had created a spring by striking the earth with his trident.

The original temple complex to Athena on the acropolis was burned by the Persian army in 480/479 BCE, less than a decade after it was begun. A new temple was built on the site because, according to legend, a new olive tree grew from the ashes of the old temple. This new temple, the Parthenon, was both the main temple to Athena and a war treasury. After the Persian attack the Athenians formed an alliance with other Greek cities to protect one another from further attacks by the so-called "barbarians." The cities

contributed funds to prepare for future wars; these were housed in the Parthenon.

The new Parthenon was so important it was made of glistening white marble transported several miles to Athens, and then carried up the steep slope to the acropolis. Its design was thought to epitomize ideal proportions, symbolizing for the Athenians their achievements as an enlightened society. Modern visitors to the Parthenon can see the basic architectural structure of the building but can gain only a slight impression of its original appearance (3.17). Originally it had a timber roof covered with marble tiles, but this was destroyed in 1687 when Turkish army munitions stored there exploded. When it was first made, the structure was covered with sculptures. Both building and sculptures were painted in red, yellow, and blue. The bright paint has fallen off or faded over time, giving modern viewers the incorrect impression that Greek architecture and sculpture were intentionally made the natural color of marble. In several places there were statues of Athena to receive offerings and prayer. One enormous statue of the goddess, 38 feet tall and made of gold and ivory, dominated the interior space. For many people, the Parthenon is the iconic example of **Classical** architecture (see Box: Classical Architectural Orders, p. 306).

3.17 Iktinos and Kallikrates, Parthenon, 447–432 BCE, Acropolis, Athens, Greece

Classical Architectural Orders

The Greeks developed three types of designs, called architectural orders, for their temples. Elements of Greek temple design have been used in government buildings throughout the United States, particularly in state capitols and in Washington, D.C. See if you can recognize aspects of Greek architecture on the buildings near where you live. The Doric and Ionic orders were first used as early as the sixth century BCE.

The Parthenon is unusual in that it combines the two: its exterior columns and frieze are Doric, while the inner frieze (as viewed from the outside) is lonic. The reason for this is debated, but it is likely that the blending of two styles popular in different parts of Greece marked a unity between different Greek cities. The Corinthian order was invented toward the end of the fifth century BCE. It was used for very few Greek buildings, but was widely applied by the Romans. The easiest way to recognize which

order was used in a building is to look at the columns, and more specifically the capitals. Ionic and Corinthian columns both have a more decorative and slender quality than the bolder, more masculine Doric order. The Doric column has the least amount of ornamental detail. The Ionic column has the most noticeable fluting (vertical grooves) on the shaft and a volute (inverted scroll) on the capital. The Corinthian column is the most ornate, with layers of acanthus leaves decorating the capital. The entablatures of the three architectural orders are also quite distinct. The Doric frieze is divided by triglyphs (a kind of architectural decoration so named because it always has three grooves) that alternate with metopes (panels often containing relief sculpture). The Ionic and Corinthian friezes have relief sculpture along the entire frieze, and do not contain metopes or triglyphs.

3.18 Diagram of the Classical architectural orders, differentiating between the Doric, Ionic, and Corinthian. Key parts of Greek temple design, such as the pediment, entablature, frieze, capital, column, shaft, and base are also identified.

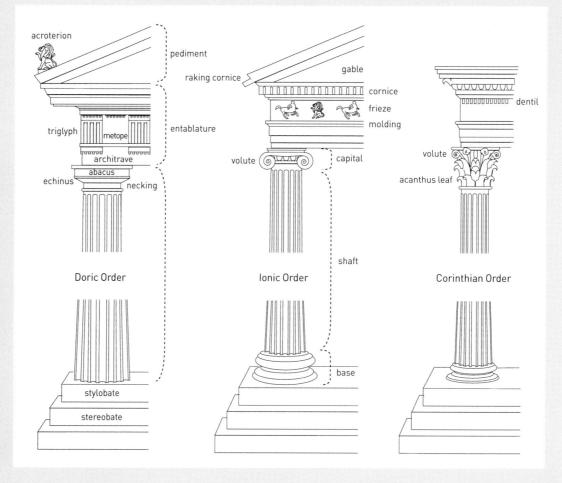

3.19 Metope of a Lapith and centaur in combat from the south side of the Parthenon, designed by Pheidias, c. 445 BCE. Marble, 525/8" high. British Museum, London, England

Architectural order: a style of designing columns and related parts of a Greek or Roman building

Frieze: the strip that goes around the top of a building, often filled with sculptural ornamentation Capitals: the architectural features that crown a column **Shaft:** the main vertical part of a column

Entablature: the part of a Greek or Roman building that rests on top of a column

Pediment: the triangular space, situated above the row of columns, at the end of a building in the Classical style

3.20 and **3.21** Andokides Painter, Achilles and Ajax Playing Dice, c. 525-520 BCE. Black figure and red figure (bilingual) two-handled jar (amphora), 21" high. Museum of Fine Arts, Boston, Massachusetts

The sculpture that covered the Parthenon was in a high Classical style (see Box: Sculpture throughout Ancient Greece, p. 308).

Placed in the metopes of the frieze in the Parthenon were sculptural reliefs of the battle in which the Lapiths, a legendary people in Greek mythology, tried to prevent the centaurs (creatures that are half-man and half-horse) from kidnapping the Lapith women (3.19). The scenes

are intensely energetic, yet neither side seems to win the battle. This subject was chosen as a metaphor for the Athenians (represented by the civilized Lapiths) who were always at war with the Persians (represented by barbaric centaurs). The sculptural scenes of gods that filled the **pediments**, and the reliefs in the metopes, were taken away between c. 1801 and 1805 by the British Ambassador Lord Elgin, who was given permission to do so by the Turks then in control of Athens. The Parthenon or Elgin Marbles reside today in the British Museum in London, although the Greeks have asked for their return.

Ancient accounts tell us that Greek paintings were remarkably convincing scenes with threedimensional figures that seemed to come to life. Unfortunately, only incomplete fragments survive. Several Roman mosaics were made as copies of Greek paintings, however. We can also surmise the skill of Greek painters by looking at the scenes painted on pottery.

The vase in 3.20 and 3.21 shows the Greek warriors Achilles and Ajax playing a game while waiting to battle with the Trojans. Through the layering of clothing, body parts, and even facial hair, the Archaic Greek artist was able to represent figures that seem to fill a real space. The shields perched behind the figures also help to create a sense of depth. The long body of the pot and its two handles identify this as an

Sculpture throughout Ancient Greece

Greek sculptures are categorized generally in three types, referring both to the date of their making and to their style. Archaic works were produced from the late seventh to early fifth centuries BCE. Art from c. 480-323 BCE is labeled Classical. Later works are known as Hellenistic. A comparison of sculptures from these three periods demonstrates the main differences between them.

The name for one of the earliest Archaic types of Greek statues is kouros, or "male youth" (3.22). Compare this work with the Egyptian sculpture of Khafre (3.12). The Greek sculptor subtly suggests movement by placing one foot in front of the other, whereas the seated statue of Khafre seems bound to the block of marble from which it was carved. Unlike the distant stare of Khafre, which suggests he is in the spiritual world of the dead, the kouros has lively energy and seems to be part of the world of the living. He wears nothing more than an Archaic smile, which conveys innocence and serenity. Statues like this were grave markers and offerings at sanctuaries. Statues of young maidens were called korai; interestingly, these were all clothed, as were most Greek statues of females at

Sculptors of the Classical period tried to give their work the idealized proportions of a perfect human form. The subjects of most Greek sculptors are heroes or gods. The Doryphoros (Spear Bearer) is a famous example of the work of Polykleitos; unfortunately, only a Roman copy of the original survives (3.23). Polykleitos developed a canon, or set of rules, for creating a harmoniously proportioned human body using a set of mathematical ratios. Polykleitos also gave his statue a new stance, called contrapposto,

3.22 Statue of a kouros (youth), Naxian, c. 590-580 BCE. Marble, 6'45/8" high. Metropolitan Museum of Art, New York

the time (see Chapter 4.9, Body).

which imitates the way humans balance their own weight. The Spear Bearer portrays a man who stands naturally with his left knee bent and whose weight is shifted to his right hip. His raised left arm balances this shift in weight. Such poses made figures appear less stiff than the typical kouros versions.

3.23 Roman version of the Doryphoros of Polykleitos. 120-50 BCE, after a bronze original of c. 460 BCE. Marble, 6'6" × 19" × 19". Minneapolis Institute of Arts

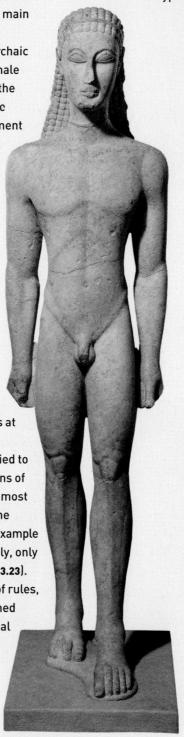

3.24 Laocoön and his Sons, copy of bronze original probably made at Pergamum c. 150 BCE. Marble, 6'1/2" high. Vatican Museums, Vatican City

One of the most compelling Hellenistic sculptures is the Laocoon, in which the priest Laocoon and his sons are shown struggling in agony as they are attacked by twisting sea serpents, sent by the god Poseidon (3.24). Hellenistic sculpture shows the same idealized muscular bodies as earlier Greek sculptures. Hellenistic artists, however, chose subjects that involved creating figures in dramatic poses, challenging the artist to convey an even greater sense of movement and heightened emotion. Renaissance artists were often impressed by the balanced forms from the Classical period, but this dynamic Hellenistic sculpture, discovered in Rome in 1506, inspired such artists as Michelangelo to imbue their art with similar drama and movement.

Archaic: Greek art of the period c. 620-480 BCE

Hellenistic: Greek art of the period c. 323-100 BCE

Kouros: sculpture of a nude Greek youth

Contrapposto: a pose in sculpture in which the upper part of the body twists in one direction and the lower part in another

Renaissance: a period of cultural and artistic change in Europe from the fourteenth to the seventeenth century

Slip: clay mixed with water used to decorate pottery

Incised: cut

Outline: the outermost line of an object or figure by which it is defined or bounded

amphora, a type of pot that was used to carry and store such goods as wine or olive oil.

Greek pots were made in large workshops headed by both a master potter, who formed the vase, and a master painter. The two worked together closely as the painting technique was intricately connected with the process of firing the pot. There were two main types of Greek vase painting: black figure and red figure. To make a black figure vase the painter used slip (watereddown clay) to paint the design on the pot; he then **incised** the details into the slip. A threephase firing method then turned the slip-covered areas black, while the rest of the pot remained the original red color. The red figure technique used the reverse process: the slip was used to **outline** the figures and paint in the details. This method had the advantage of making the figures appear slightly more three-dimensional. This amphora was made by the so-called Andokides Painter, the first artist known to have used the red figure technique. The artist made this pot to exemplify the differences between the two techniques; thus it is called "bilingual," with the same scene on each side, one created in each of the two processes.

Roman Art

The first evidence of a settlement at Rome dates back to about 900 BCE. This small village grew to become the center of an enormous empire that, by the year 117 CE, covered much of Europe, northern Africa, and large parts of the Middle East. In the process of conquering such large territories, the Romans absorbed many cultures, frequently adopting the gods of other people but giving them Latin names. The Roman emperors often associated themselves with qualities of the gods, and successful leaders were often deified after they died.

Another example of Roman absorption of other cultures was their adoption of the Corinthian architectural order developed by the Greeks (see p. 306). The Romans also used Greek methods to create ideal proportions in their architecture. At the center of each Roman city was a forum, or marketplace, which was

3.25 Reconstruction illustration of ancient Rome. In this image, the River Tiber can be seen flowing by the city. The two enormous stadiums (Circus Maximus and the Colosseum) stand out as an oblong and circular shape respectively.

surrounded by temples, basilicas, and civic buildings (3.25). Emperors made a public show of their power by commissioning architects to create grand arches and tall columns, which usually celebrated the rulers' triumphs in battle. Statues of the current emperor were also distributed throughout the empire.

The Romans greatly admired Greek bronze sculptures and often remade them in marble. While the Greeks celebrated the idealized human body and mostly portrayed nude gods and mythological heroes, Roman art focused instead on emperors and civic leaders, who were usually portrayed clothed in togas or wearing armor. Roman sculpture often portrayed the individual character of its subject with recognizable, rather than ideal, facial features. Aged members of Roman society were portrayed—and viewed—as wise and experienced, particularly in political settings.

Roman artists recognized individuals' accomplishments with naturalistic, lifelike portraits often made from death masks. Family members treasured such portraits as recording their loved one's likeness and character. In 3.26 a Roman citizen proudly displays the **busts** of his ancestors in order to reinforce his own social status. His face shows individuality, and he wears clothing appropriate to his social status.

The catastrophic eruption of Mount Vesuvius in 79 CE buried the buildings of the Roman cities of Pompeii and Herculaneum in a matter of hours under some sixty feet of volcanic ash. This unique act of accidental preservation has given us, centuries later, an incomparable opportunity to witness how Romans lived in their homes. Frescoes covered the walls of many rooms in the houses in Pompeii. Some of the paintings offer convincing illusions of landscape scenes. Some of the interiors are covered with what appear to be marble panels, but which in reality are only painted. One such room, shown in 3.27, is covered with scenes believed to describe rituals relating to the worship of Dionysus, the god of wine, ecstasy, agriculture, and the theatre. Excavation of Pompeii began in the eighteenth

3.26 Patrician carrying death-masks of his ancestors, c. 80 BCE. Marble, life-size. Barberini Museum, Rome, Italy

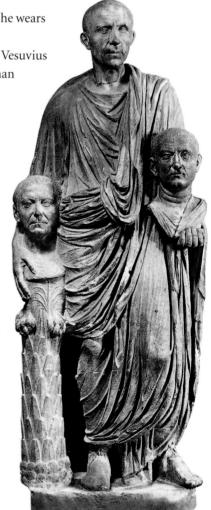

Bust: a statue of a person depicting only his or her head and shoulders

Frescoes: paintings made on freshly applied plaster

Facade: any side of a building, usually the front or entrance

3.27 Detail from Dionysiac mystery frieze in Room 5 of the Villa of the Mysteries, Pompeii, Italy, c. 60 BCE. Wall painting, 5'4" high

3.28 Pantheon, entrance porch, c. 118-25 CE, Rome, Italy

century, and the remarkable discoveries there stimulated interest in ancient art throughout Europe.

One of the Romans' most impressive works of architecture is the Pantheon ("Temple of all

the Gods"). It was originally constructed in the first century BCE. Emperor Hadrian had it rebuilt from c. 118 to 125 CE in order to enhance his own status. The entrance **facade** is a pediment atop Corinthian columns (3.28). Once inside, one is

Coffered: decorated with recessed paneling

Oculus: a round opening at the center of a dome

3.29 (left) Pantheon, interior view, c. 118-25 cE, Rome, Italy

3.30 (below) Arch of Constantine, south side, 312-15 cE, Rome, Italy

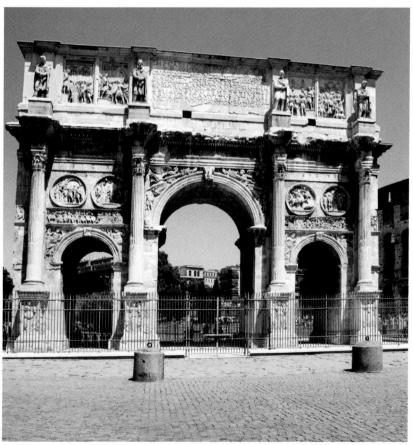

standing under a spectacular coffered dome 143 feet in diameter and 143 feet from the ground (3.29). The dome was made possible by the Romans' revolutionary use of concrete and their engineering genius. In the center of this dome is an oculus, or eye, open to the skies. One can tell the season and time of day by where the sunlight hits the interior. Any rain coming in runs quickly away into a central drain because the entire floor slopes gradually.

The enormous Arch of Constantine (3.30) was built between 312 and 315 CE by the emperor Constantine to commemorate the military victory (the Battle of the Milvian Bridge) that would ensure his future position as sole ruler of the empire. Constantine proclaimed his place in history, and therewith his greatness, by placing the arch close to the famed Colosseum, built by an earlier family of powerful emperors. Constantine also had sculpture removed from other imperial monuments, often erasing the faces of previous emperors from such statues and replacing them with his own likeness; he then had the sculptures placed upon the triumphal arch. By doing so, he proclaimed both his linage to previous great emperors and his belief in his superiority over them. Constantine associated himself with Apollo and other pagan gods, as well as with Christianity. He became known as Constantine the Great and would eventually make it legal to practice all religions, opening the doors for Christianity to grow into the primary religion of the Empire. He was baptized as a Christian on his deathbed.

Discussion Questions

- The ancient civilizations of the Mediterranean region were noted for their great battles and powerful rulers. Select two artworks from two different cultures and compare how the idea of power is reflected in your two examples.
- Discuss the architecture of the Ancient Greeks and Romans. What advancements did each culture make in building, and why are these works still considered such marvels today?
- How did the natural environment of the people of the ancient Mediterranean affect the style, materials, and subject matter of their art?

Images related to 3.1: The Prehistoric and Ancient Mediterranean

4.129 Woman from Willendorf, c. 24,000-22,000 BCE, p. 554

4.96a, 4.96b Palette of Narmer, c. 2950-2775 BCE, p. 526

4.3 Stonehenge, c. 3200-1500 BCE, p. 456

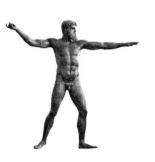

1.136 Poseidon [or Zeus], c. 460-450 BCE, p. 134

2.152 Riace Warrior A. c. 450 BCE, p. 266

4.14 Sumerian bull lyre, c. 2550-2450 BCE, p. 464

4.131b Menkaure and his Wife, Queen Khamerernebty, c. 2520 BCE, p. 556

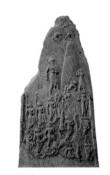

4.27 Stela of Naram-Sin, c. 2254-2218 BCE, p. 474

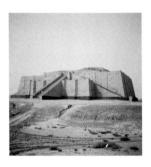

4.7 Ziggurat at Ur, c. 2100 BCE, p. 459

4.99 Stela of Hammurabi, c. 1792-1750 BCE, p. 528

4.157 Sphinx of Hatshepsut, 1479-1458 BCE, p. 575

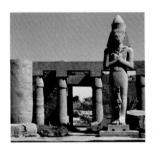

2.171 Temple of Amun-Re, 1417-1379 BCE, p. 278

4.95 Akhenaten, Nefertiti, and three daughters, c. 1353-1335 BCE, p. 525

2.151 Sarcophagus from Cerveteri, c. 520 BCE, p. 266

4.132 Myron, Discus Thrower (Discobolos), c. 450 BCE, p. 557

1.34 Imperial Procession from the Ara Pacis Augustae, 13 BCE, p. 67

4.97 Augustus of Primaporta, early 1st century CE (after original from 20 BCE), p. 527

4.5 Colosseum, 72-80 CE, p. 458

1.161 Equestrian statue of Marcus Aurelius, c. 175 ce, p. 152

4.100 Remnants of colossal statue of Constantine, 325-6 CE, p. 528

HISTORY AND CONTEXT

3.2

Art of the Middle Ages

3.31 Map of Europe and the Middle East in the Middle Ages

The Roman empire dominated the Mediterranean region from the second century BCE, later extending its control of western Europe and the Middle East, but by the fourth century CE the empire was crumbling in the west. In 330 the Roman emperor Constantine I (272–337 CE) moved the center of the Roman empire from Rome to Byzantium, which he renamed Constantinople

(today's Istanbul, Turkey). The eastern part of the empire became known as the Byzantine empire and lasted a millennium, until Constantinople fell to the Turks in 1453. In the west, however, a series of invasions had ended the Roman empire by 476. The period that followed is known as the Middle Ages, or the medieval period, because it comes between the time of the ancient

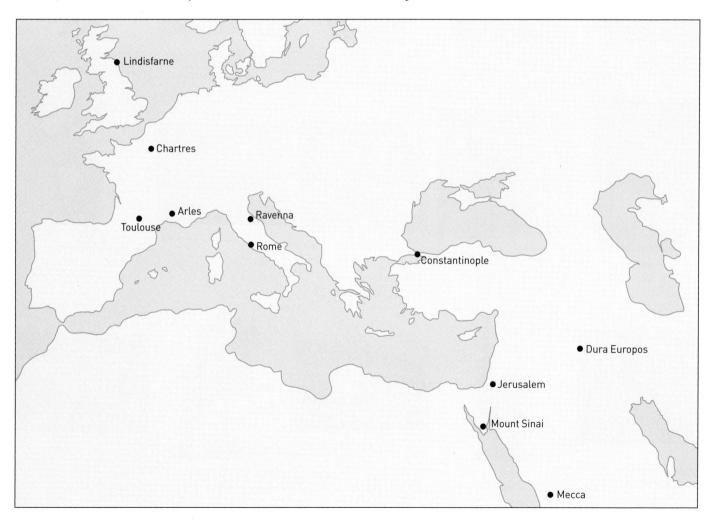

civilizations of the Mediterranean region and the rebirth, or Renaissance, of Greek and Roman ideals in the fifteenth century.

In the study of the history of art, the Middle Ages is often broken down further because of the stylistic variations of its art, particularly its architecture. Beginning in the eleventh century, large stone churches, heavily ornamented with sculpture inside and out, were built throughout the Christian world. These churches were later given the name Romanesque for their similarity to the heavy round-arched style of the Romans. This comparison is not obvious at first, but the term Romanesque was meant as a direct contrast to the architectural style that followed it, beginning around 1150, in which great **Gothic** cathedrals, the spires of which reached toward the heavens, were constructed. Religious belief was integral to the lives of the people—whether Christian, Jew, or Muslim who lived in Europe and the Middle East during the Middle Ages. Much of the art and architecture from the period reflects their beliefs.

Art of Late Antiquity

Jewish culture thrived periodically during the Middle Ages, although this was also a time of persecution. Partially as a result of the constant displacement of many Jews (see Box: Three Religions of the Middle Ages, p. 316), few examples of Jewish art from the Middle Ages survive. The oldest surviving Jewish artwork (other than coins) can be found in a synagogue in the ancient Roman city of Dura Europos, on the River Euphrates in modern Syria. Here, more than fifty stories are displayed in fresco paintings on the wall. The synagogue paintings were used to teach the stories upon which Jewish history and belief are based. The **didactic** nature of these images explains why figures are shown, a feature that is uncommon in later Jewish art. On the center of the west wall facing Jerusalem is a shrine containing the Torah, the most important part of the Jewish Bible that contains the commandments given to Moses by God (3.32).

3.32 Interior west wall of synagogue at Dura Europos, Syria, 244-5 ce. Reconstruction in National Museum, Damascus, Syria

Renaissance: a period of cultural and artistic change in Europe from the fourteenth to the seventeenth century Romanesque: an early medieval European style of architecture based on Roman-style rounded arches and heavy construction Gothic: western European architectural style of the twelfth to sixteenth centuries, characterized by the use of pointed arches and ornate decoration

Fresco: a technique where the artist paints onto freshly applied plaster. From the Italian fresco, fresh

Didactic: with the aim of teaching or educating

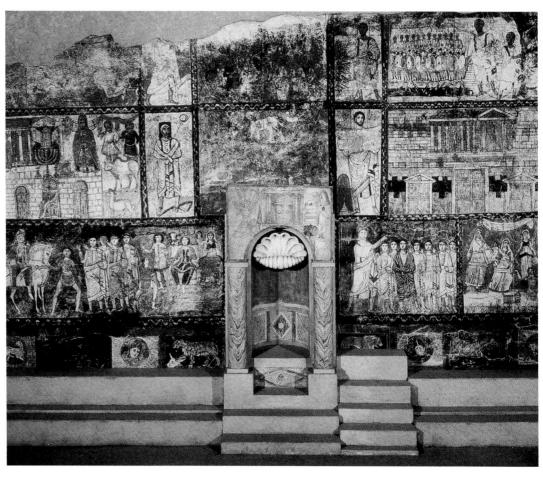

Three Religions of the Middle Ages

You shall not make for yourself an idol, whether in the form of anything that is in heaven above, or that is on the earth beneath, or that is in the water under the earth. You shall not bow down to them or worship them.

(Second Commandment, Exodus 20:4-5)

Judaism, Islam, and Christianity all have their origins in the Middle East. They have some similar beliefs—each religion considers Abraham to be a prophet, for example, and each considers their god to be the one true god. Importantly for the study of art, each also warns against the worship of false idols. Understanding some basic beliefs of followers of these faiths can help us to understand better some of the art produced during the Middle Ages.

- Judaism began with a contract between Abraham and God (Yahweh) in c. 2000 BCE. Abraham promised to exalt Yahweh as the one true God, and in exchange Yahweh promised Abraham many descendants, who are the Jewish people of today. The Torah (or "Teaching") was written by Moses under divine inspiration and is the core of Jewish belief and law. Jewish art does not show any more than the hands of Yahweh, and rarely shows human figures. Instead, it usually depicts objects used in acts of worshipscroll holders, candelabra, and the like.
- Christians worship Jesus Christ (a Jew who lived from c. 7-2 BCE to c. 30-36 CE), who they believe was the son of God. The Bible contains both the writings of the Jewish Bible ("The Old Testament") and what Christians see as their fulfillment in the life of Jesus ("The New Testament"). For Christians, Jesus was a great teacher who demonstrated how to lead a good and pious life, but who also suffered, was sacrificed and then rose again to show that the sins of man could be forgiven and that for those who were true believers. eternal life could be achieved after death. Christians have interpreted the Second Commandment in different ways, at times causing great conflict and even the destruction of images.
- Muslims (followers of Islam) call their one true god Allah. They believe that Jesus was a prophet but that Muhammad (c. 570-632) was the primary messenger of Allah. The Koran is the word of Allah given to Muhammad and is Islam's primary sacred text. Islamic art never depicts the figure of God. Also, human figures are not shown within the holy space of a mosque. The majority of Islamic art is decorative and often makes beautiful use of calligraphy to show the word of Allah.

The fresco painting of the scene in **3.33** does show God, but not his face; only his hands are seen, reaching down from the sky. In the passage from the Book of Exodus in the Torah, God tells Moses to guide the Israelites out of Egypt toward Mount Sinai, where Moses will receive the Ten Commandments. When they arrive at the Red Sea, God tells Moses to place his rod in the water. This action parts the sea, creating a safe crossing for Moses and his people. When they are safely on the other side, Moses again places his rod in the water. The Red Sea floods, drowning the Egyptian soldiers

who have been chasing the Israelites. The Exodus painting is a **continuous narrative**, in which different points in time in the story are shown within the same scene. Moses is shown in the center while the soldiers on the left are lined up to follow him. A second Moses is shown slightly in front and to the side of the first Moses. Behind the second Moses on the right side of the scene, the soldiers have been washed away as the sea has flooded.

The Christian Church, which had been unified under Roman rule, split in 1054. The result was a Greek Orthodox Church in the east

Calligraphy: the art of emotive or carefully descriptive hand lettering or handwriting Continuous narrative: when different parts of a story are shown within the same visual space

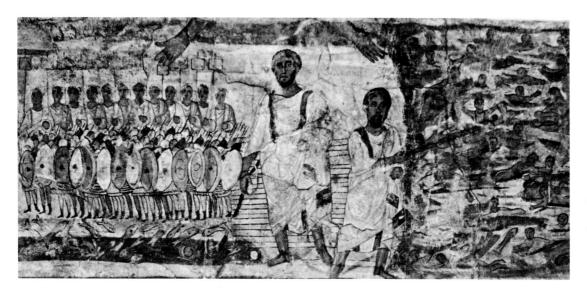

3.33 Exodus and Crossing of the Red Sea, panel from west wall of synagogue at Dura Europos, Syria, 244-5 ce. Reconstruction in National Museum, Damascus, Syria

and a Roman Catholic Church in the west, each ruled by separate leaders and following different doctrines and practices. The earliest examples of Christian art date from the early third century. From 200 CE to the sixth century, it was common practice among Christians, Jews, and others in Italy to bury the dead in underground cemeteries known as catacombs. The catacombs may also have served as sites for Christian worship. Scenes were often painted on burial-room walls and ceilings. One such scene in a catacomb in Rome

shows Jesus as the Good Shepherd in the center and tells the Old Testament story of Jonah in the semicircular areas around the central image (3.34). Christians believe that the story of Jonah, who was swallowed by a whale and then spat out alive three days later, foreshadows the death and resurrection of Jesus. It is intriguing to notice that, in their depiction of Christian themes, early Christian artists often used motifs and figures adapted from pagan cultures. For example, the Good Shepherd in 3.34 was adapted from images

3.34 Painted ceiling, late 3rd-early 4th century cE. Catacombs of Saints Peter and Marcellinus, Rome, Italy

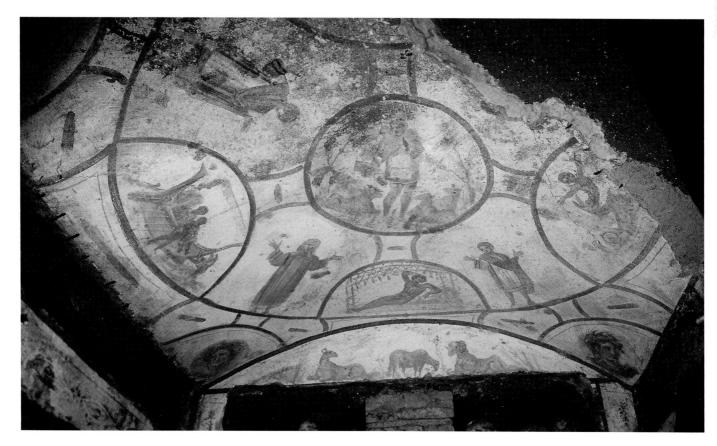

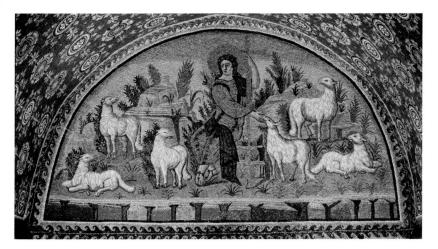

3.35 Good Shepherd, 425-6. Mosaic in lunette. Mausoleum of Galla Placidia, Ravenna, Italy

of several pagan figures, including the Greek hero Orpheus (who could charm animals with his songs) and the Greek god Apollo (god of music, the sun, and healing, who was always shown as a beardless youth).

A century later, the depiction of Christ changed. Christian artists developed a range of symbols that were more varied and elaborate. The mosaic in 3.35 was made for the building known as the Mausoleum of Galla Placidia, which was the family tomb of the Roman emperor Flavius Honorius. We can see that Christ is still portrayed as a Good Shepherd, here flanked by three lambs on each side, but he is seated and more mature. Compared to the image on the catacomb ceiling, Christ's appearance is regal. He wears a fine gold robe with a purple (the traditional color for royalty) cloth draped over his shoulder; he holds a golden cross. His hair is long, and a prominent gold halo shines behind him; the tesserae, small pieces of glass that make up the mosaic, create a beautiful glow that glitters and reflects light. Unlike figures in Roman art, Christ's body is sharply delineated and flat-looking rather than fully three-dimensional. These stylistic qualities foreshadow the art of Byzantium, the Christian empire that continued in the east after the fall of the western Roman empire.

created by fixing together small pieces of stone, glass, tile, etc. **Tesserae:** small pieces of stone or glass or other materials used to make a mosaic

Mosaic: a picture or pattern

Patron: an organization or individual who sponsors the creation of works of art

Icon: a small, often portable, religious image venerated by Christian believers; first used by the Eastern Orthodox Church

Central-plan: Eastern Orthodox church design, often in the shape of a cross with all four arms of equal length Nave: the central space of a cathedral or basilica

Apse: semicircular vaulted space in a church

Altar: an area where sacrifices or offerings are made

Byzantine Art

The Byzantine Emperor Justinian I (483–565) was a devoted **patron** of the arts. He funded hundreds of churches, mosaics, and paintings throughout his empire, including the Hagia Sophia in the

center of Constantinople. One of Justinian's greatest achievements was his protection of more than 2,000 icons at the monastery of St. Catherine, Mount Sinai, in Egypt. Icons, paintings of religious figures on wooden panels, are still used in the Eastern Orthodox Church for meditation and prayer. Many early Christians believed icons had special healing powers; therefore, icons that survive are often faded from being kissed and touched by numerous worshipers.

The sixth-century icon of Christ (3.36) from the St. Catherine Monastery at Mount Sinai is intended to show the dual nature of Christ as both human and God. As in the Good Shepherd mosaic (3.35), here Christ is shown as a regal figure, wearing a rich purple robe. Christ is now represented with a beard and long hair, which became the convention in subsequent Christian art. Christ's duality is brilliantly portrayed here by the differences made to each side of his face; his

3.36 Christ icon, 6th century. Encaustic, 33 × 18". St. Catherine Monastery, Mount Sinai, Egypt

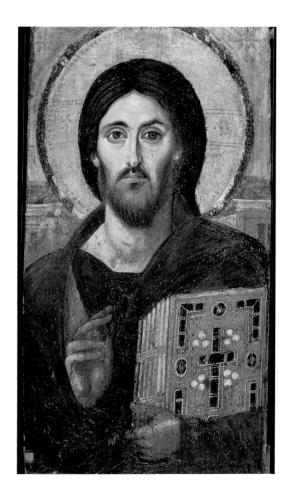

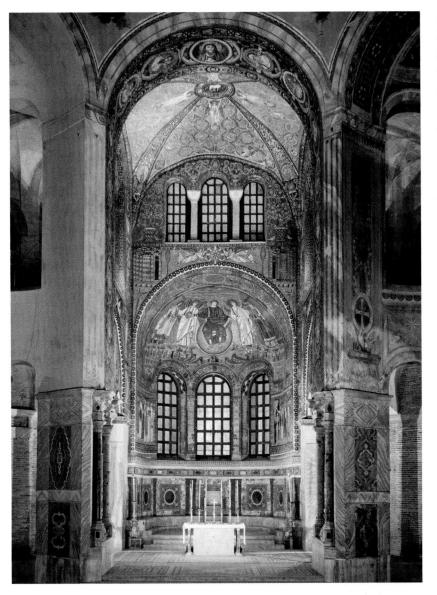

3.37 San Vitale, apse, c. 547, Ravenna, Italy

right side (the viewer's left) represents his heavenly half, and his left side his human half. The right side of Christ's face is ideally proportioned, with a healthy glow, and his hair is in place. By comparison, his left side seems to sag slightly, his eyes and mouth have wrinkles, and his hair is somewhat dishevelled. His right hand forms into a gesture of holy blessing, while his left hand holds scripture, sacred writings read by those on earth.

One of the most beautiful Byzantine churches was built in Ravenna, Italy, in the sixth century (3.37). "Central-plan" churches were a common style in the Eastern Orthodox tradition, as opposed to the Latin cross design of the west (see 3.51 on page 326). The floor plan of the Church of San Vitale is based on two octagons, one inside the other. The smaller octagon, the nave, is a space nearly 100 feet high, filled with windows, and covered by a dome. Natural light glistens off the glass mosaics that cover the walls. Eight semicircular bays emanate from the center, with the apse that contains the altar on the southeast side; above the altar is a mosaic of Christ enthroned on Earth. Flanking either side of the apse are glorious mosaics of the Emperor Justinian and the Empress Theodora. The mosaic of Theodora and her attendants is filled with rich details, such as the Three Magi on the hem of the empress's stunning purple robe (3.38). It is characteristic of Byzantine art that figures and their clothing are often boldly outlined. Such

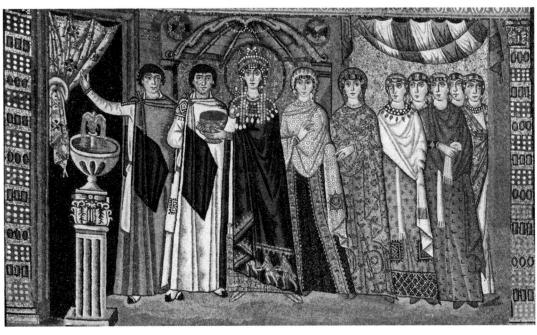

3.38 Theodora and Attendants, c. 547. Mosaic on south wall of apse, $8'8" \times 12"$. San Vitale, Ravenna, Italy

delineation creates a flatness to the figures and decreases their three-dimensionality. This lack of volume or mass, along with the way the figures seem to float, gives a timeless, spiritual quality to the image, as if it belongs somewhere between the heavenly and earthly realms. It is important to remember that this mosaic is placed in a very sacred part of the church. The empress carries a jeweled chalice of wine that she raises up in the direction of the actual altar, which is located directly to the left of the mosaic. The figures in the image are even layered so that their repetition creates a sense of movement toward the altar. On the opposite wall is a mosaic of the Emperor Justinian holding bread; the bread and wine are symbols of the important religious ceremony of the **Eucharist**, which took place in this church.

It is also significant that Theodora is depicted outdoors, shown clearly by the green grass, canopies, and fountain. The artist was clarifying that Theodora and her ladies were not in as sacred a realm as the emperor and his men in the opposite mosaic, who are surrounded by a solid gold background. Creating such different backgrounds was a way for the artist to show that women were only allowed in the courtyard of the church or on the second-story balcony surrounding the nave. In reality, the Empress Theodora would not have been allowed near the altar (where this mosaic was placed), not just because she was a woman, but also because she was from the lower classes, having been an actress and a prostitute when she met Justinian.

Manuscripts and the Middle Ages

Manuscripts (books written and decorated by hand) are some of the richest and most detailed artworks made by Muslims and Christians in the Middle Ages. The production of manuscripts was intensely laborious, from making the pages out of animal hides to copying painstakingly in careful handwriting. Manuscripts were the work of many artists (usually monks), some specializing in decorative lettering (scribes), and others in painting images (illuminators). Jewelers and workers

3.39 Page from the Koran. probably late 12th century. Maghribi on vellum, $7^{1/2} \times$ 71/2". British Library, London

in fine metals often contributed to decorating the covers. The great effort required to create a manuscript was considered a tribute to God.

Islamic manuscripts rarely show human figures, and never the image of Allah (God). Rather, attention is paid to the word of Allah, recorded in the Koran, and revealed in elegant script. Islamic artworks often have an arabesque quality, and this is particularly apparent in manuscripts.

Surah (chapters) from the Koran are written in Arabic, from right to left, but the script varies from region to region. In a beautiful page of the Koran from thirteenth-century Spain (3.39), the oldest Arabic script, *kufic*, is used for the headings, while the script *maghribi* is used for the rest of the text. This regional script derived its name from its popularity in the region of Maghreb, which in the Middle Ages included northern Africa and Islamic areas of Spain. The areas in the manuscript where the text is thicker and in gold signify the heading for a new chapter. The ornamental circular designs in gold break the reading into appropriate sections.

The Lindisfarne Gospels are an illuminated manuscript book of the gospels of Matthew, Mark, Luke, and John. They were made during the late seventh century. Each gospel is decorated with a "Cross and Carpet" page (named for its similarity to a carpet design). The design in the Cross and Carpet page at the beginning of St. Matthew's gospel appears to be made up of numerous intertwining lines (3.40). Upon closer

Three-dimensional: having height, width, and depth Eucharist: Christian ceremony that commemorates the death of Jesus Christ

Background: the part of a work depicted furthest from the viewer's space, often behind the main subject matter

Arabesque: an abstract pattern derived from geometric and vegetal lines and forms

Illuminations: illustrations and decorations in a manuscript

inspection, however, tiny animal heads can be seen twisting throughout (3.41). While the specific meaning of these animals is unclear, this decorative element was common in the Middle Ages, particularly in northeast England where the Lindisfarne Gospels were made.

The Lindisfarne Gospels were scribed fully or in part by a bishop named Eadfrith, who signed his name to the manuscript. The pages, written in Latin, would have taken him at least five years to complete. Such beautiful pages as these are often called **illuminations** because their rich colors recall light shining through stained glass in a cathedral. (Similarly, because of their didactic nature, stained-glass windows have been called "books in glass," and the sculpture around cathedrals "books in stone.") Both the Lindisfarne Gospels and the Spanish Koran were made to be studied and enjoyed over long periods of contemplation.

Manuscripts often illustrated religious stories or the visions of spiritual leaders. Hildegard of Bingen was a Christian mystic and visionary; she advised kings and popes, who often travelled long distances to meet with her. Born into an aristocratic family and educated as a nun, she eventually

3.40 (far left) Cross-carpet page introducing the Gospel according to St. Matthew. Lindisfarne Gospels, fol. 26b. British Library, London, England

3.41 Detail of 3.40

became abbess of a convent in Germany. Her visions included insights into medicine, astronomy, and politics, which she shared in a book called Scivias (Know the Ways), which was read throughout Europe. The original manuscript was destroyed during World War II; however, from copies of Scivias we know that Hildegard was repeatedly portrayed in the act of receiving a vision. Her assistant is also usually shown transcribing her vision (3.42). This misleadingly suggests that the scribe wrote the actual manuscript. In reality,

3.42 The Fifth Vision of Hildegard of Bingen, frontispiece for Liber Scivias, c. 1230, original manuscript lost. Biblioteca Governativa, Lucca, Italy

3.43 The Ascent of the Prophet Muhammad on his Steed, Buraq, Guided by Jibra'il and Escorted by Angels, 1539-43. Miniature painting from a manuscript of Nizami's Khamsa (Five Poems), originally produced in Tabriz, Iran

the manuscript took months to make and was carefully graphed out on large pieces of paper before being put together in book form. Hildegard described the experience of receiving visions as "a fiery light, flashing intensely, which came from the open vault of heaven and poured through my whole brain," an apt description for what is taking placing in the manuscript shown here.

Islamic manuscripts often depict events from the life of Muhammad, the main prophet of Allah. The manuscript painting in 3.43 shows the ascension of Muhammad, which Muslims believe took place at the site of the Dome of the Rock in Jerusalem (see 3.45). Muhammad's face is not shown, but is covered with a veil. He is

surrounded by blinding flames, which signify his holiness, as he rides his half-human horse Buraq toward the heavens. On the left, guiding Muhammad, is the angel Gabriel, whose head is also surrounded by smaller flames. Manuscripts in the Middle Ages are richly detailed objects that reflect the piety of the people of the time.

Pilgrimage in the Middle Ages

Pilgrimages were integral to the practice of Christianity, Islam, and Judaism. In medieval Europe, devout pilgrims journeyed to holy sites where significant religious events had occurred or where relics were kept. Relics were holy objects (such as a piece of the wooden cross on which Christ was crucified), or body parts of saints or holy figures. Elaborately decorated containers called reliquaries were made to house individual

3.44 Reliquary of the Head of St. Alexander, 1145. Silver repoussé, gilt bronze, gems, pearls, and enamel, 71/2" high. Musées Royaux d'Art et d'Histoire, Brussels, Belgium

relics, and they were designed to look like the relic they contained. Thus, such a reliquary as that of the Head of St. Alexander (3.44) houses a skull. This reliquary was made in 1145 for the Abbot Wibald of Stavelot in Belgium. The face is made of beaten silver (repoussé), with the hair made from gilded bronze. The emphasis on the portrait itself recalls the Roman heads of antiquity. The head is placed upon a base covered with gems and pearls. Small plaques painted in enamel show a portrait of the sainted Pope Alexander in the center, flanked by two other saints.

Jerusalem

Throughout the Middle Ages, devout people made pilgrimages to the city of Jerusalem; a shining gold dome still marks a site in the city that is sacred to Jews, Christians, and Muslims alike (3.45). The Dome of the Rock surrounds the sacred Foundation Stone, which Jews believe is the site of the beginning of the world and

Muslims believe is the rock from which Muhammad ascended to heaven. To Jews and Christians, this site is also thought to be the place where Adam was created and where Abraham was asked to sacrifice his son.

The Dome of the Rock was built as a site for pilgrims (not as a mosque) between 688 and 691 under the order of Adb al-Malik, who wanted it to surpass all Christian churches in the Middle East. Although al-Malik was a caliph (an Islamic ruler), the Dome of the Rock was probably built by Christian laborers; its proportions, octagonal shape, dome, and mosaic designs show a clear Byzantine aesthetic.

The glorious dome that crowns the shrine was originally solid gold, but was rebuilt in the twentieth century with aluminum. In 1993, King Hussein of Jordan spent more than \$8 million of his own money to gild the aluminum with gold. The height and diameter of the dome are approximately 67 feet each, as is the length of each of the eight walls. The walls of the octagon

Repoussé: a technique of hammering metal from the back

3.45 Dome of the Rock, 688-91, Jerusalem, Israel

are covered with verses in Arabic calligraphy from the Koran. Since 2006, although all religions are permitted on the Temple Mount, only Muslims have been allowed within the domed shrine.

Mecca

Mecca, Saudia Arabia, is the most important pilgrimage site for Muslims. The prophet Muhammad was born in Mecca around 570. Mecca is also the site of the Kaaba, a large cubeshaped building (today draped in black-and-gold cloth), built by Abraham for God (3.46), which is surrounded by a large mosque. Like Christian churches, mosques are designed to reflect religious belief and practice. In the center of each mosque complex is usually a large courtyard with a pool where the faithful can cleanse themselves before entering the mosque itself to pray. Muslims must pray five times a day in the direction of Mecca. They are called to prayer from the mosque's large towers (minarets) that rise above the city: nine distinctive minarets surround the mosque in Mecca.

All mosques include a special prayer niche, a mihrab, oriented toward Mecca (3.47). This mihrab from a mosque in Isfahan, Iran, shows the decorative attention given to a space of such importance. Geometric design, abstract floral

3.47 Mihrab from the Madrasa Imami, Isfahan, Iran, c. 1354. Mosaic of polychrome-glazed cut tiles on stonepaste body, set into plaster, $11'3" \times 9'5^{3}/4"$. Metropolitan Museum of Art, New York

designs, and calligraphy are created with small glazed tiles. The pointed arch and movement of the organic lines throughout the mihrab are both qualities of the arabesque style. The words

3.46 Kaaba, Al-Masjid al-Harām, Mecca, Saudi Arabia

Minaret: a tall slender tower, particularly on a mosque, from which the faithful are called to prayer

Mihrab: a niche in a mosque that is in a wall oriented toward Mecca

Portal: an entrance. A royal portal (main entrance) is usually on the west front of a church

Tympanum: an arched recess above a doorway, often decorated with carvings

Hierarchical scale: the use of size to denote the relative importance of subjects in an artwork

Lintel: the horizontal beam over the doorway of a portal

of God are emphasized in the decoration of this mihrab. Inside the central rectangle, proclaimed in elegant cursive, are the words, "The mosque is the house of every pious person." Script bordering the edges of the rectangular frame of the mihrab quotes from the Koran (IX:14–22), telling of the importance of a mosque and the duties of a believer. The kufic script that borders the pointed arch refers to the five central elements, or pillars, of the Islamic faith: devotion to Allah, prayer, charity, fasting, and pilgrimage to Mecca.

Symbolism in Medieval Churches

Symbolic Imagery

Most people in the Middle Ages were illiterate, so pictures taught religious stories to pilgrims and parishioners alike, and thus reinforced their faith. Entrances to Christian churches displayed relief sculptures of scenes from the Bible. The church of St. Trophîme in Arles, France, displays a scene symbolic of the Last Judgment (3.48). The sharp twisting of the elongated figures (a characteristic of Romanesque style) on the sculpture throughout the **portal** (see also **3.49**) creates a visually dynamic tension. In the **tympanum** above the entryway to the church, **hierarchical scale** is used to show the importance of Christ in the center; he is shown much larger than the angels, prophets, and ancestors that surround him. His raised hand holding two fingers upright is a gesture of blessing to those entering the church. Immediately to the left and right of Christ are symbols of the four evangelists who wrote the gospels (the first four books of the New Testament): Matthew is represented by an angel, Mark by a lion, Luke by an ox, and John by an eagle. Sculpted on the stone of the lintel below Christ are the twelve apostles. On the lintel to Christ's right (viewer's left) are the saved, shown in procession; on the lintel to Christ's left are the damned, shown naked, struggling, and chained to one another (3.48).

3.48 St. Trophîme, west portal with tympanum, 12th century, Arles, France

3.49 (below) Diagram of the west portal tympanum in 3.48

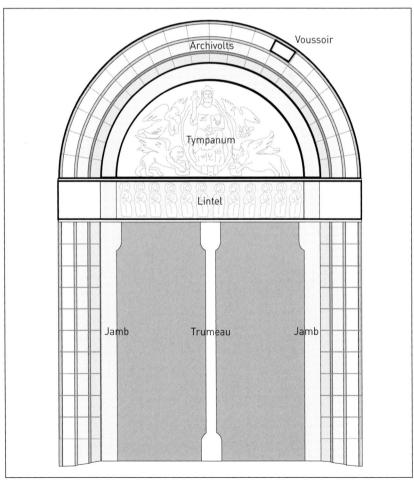

Medieval Church Plans

The church of St. Sernin in Toulouse, France, is located along a well-traveled pilgrimage road (3.50). It is substantially larger than earlier churches; it was built some 900 years ago specifically to accommodate crowds of pilgrims. The arches, vaults, and columns of this Romanesque structure recall architectural elements from ancient Rome. For example, the arches for the openings of the three lowest tiers of the bell tower are rounded. A new architectural feature during the Romanesque period was the pointed arch, examples of which can be seen on the two upper tiers of the tower; the spire at the top was added in the fifteenth century.

Churches in the Middle Ages in the Western tradition were often designed, as St. Sernin was, in the shape of a Latin cross (3.51). In this kind of plan the main and longer **axis** (nave) usually runs from west to east, with a shorter axis (transept) at right angles across it nearer the east end. Cathedral floor plans were designed

to guide the flow of visiting pilgrims and the congregation during services. Worshipers entered at the west end and walked eastward down the nave toward the altar. The **choir** continued the nave on the other side of the crossing. As it was closest to the apse, which contained the altar, it was reserved for the clergy and, as its name suggests, the choir of singers. Pilgrims could also circle around behind the apse through the ambulatory and visit individual chapels, most of which held sacred relics.

The west-east orientation of churches also has symbolic meaning. The crucifixion is often depicted in a painting or sculpture at the east end, while an artwork of the Last Judgment is displayed at the western portal, where parishioners and pilgrims would enter and exit. The orientation of the church also mimics the natural course of the sun: thus to the east, Christ, as "light of the world," rises like the sun in the morning, while to the west, the setting sun reminds worshipers of their own mortality and the impending Judgment Day.

Axis: an imaginary line showing the center of a shape, volume, or composition

Transept: structure crossing the main body of a cruciform church

Choir: part of a church traditionally reserved for singers and clergy, situated between the nave and the apse

Ambulatory: a covered walkway, particularly around the apse of a church

3.51 (above) Latin cross plan

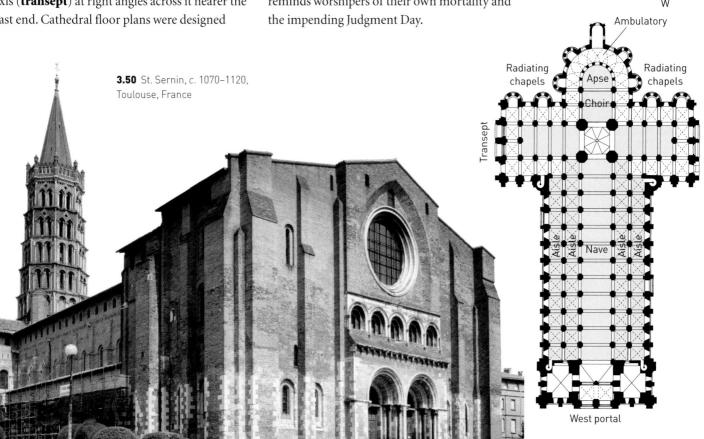

Rib vault: an archlike structure supporting a ceiling or roof, with a web of protruding stonework Flying buttress: an arch built on the exterior of a building that transfers some of the weight of the vault

3.52 (below) Chartres Cathedral, completed 1260, France

The Rise of the Gothic

New construction methods heralded a new style: Gothic cathedrals, which were first built in the twelfth century, are distinguished by their great height and glorious stained-glass windows. Rib vaults make the great height possible: the weight of the structure is spread through the ribs of the ceiling vaults, before further dividing the burden between the walls and flying buttresses. Flying buttresses (see 3.52) function like many long, outstretched fingers to prevent the walls from falling outward. Because these engineering achievements distributed the weight previously carried by very thick walls, it was possible to build at this time with walls that became

> progressively thinner. In addition, large stained-glass windows now filled cathedrals because the walls no longer needed solely to bear all the weight of the structure.

The Gothic cathedral of Chartres in France (3.52) is famous for the beautiful blue cast from its stainedglass windows (3.53). Upon entering Chartres, pilgrims walked the labyrinth on the floor, symbolic

3.53 Chartres Cathedral, interior view showing labyrinth

that guided the pilgrims to the numerous chapels containing relics.

The grand interior of Chartres combines all of the characteristic elements of Gothic architecture. The vaulted ceiling is 118 feet above the floor and the nave is more than 50 feet wide, surrounding receptive visitors with height and light to transport them beyond the cares and

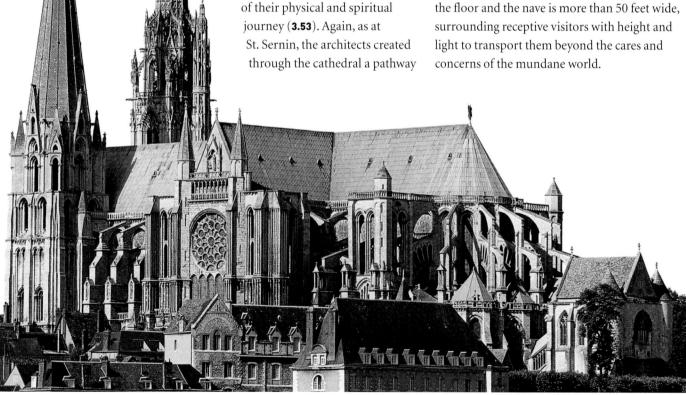

From the Gothic to Early Renaissance in Italy

How did artists represent in two dimensions the equivalent of the soaring spirituality of the Gothic style of architecture? And how did this evolve into a new style of painting that would come to be known as the Renaissance? Two paintings of the Virgin Mary and Christ Child, one by Cimabue (c. 1240–1302) and the other made thirty years later by his student Giotto di Bondone (c. 1266–1337), illustrate some of the characteristics that mark the transition from the Gothic to the early Renaissance style.

Cimabue's Gothic painting is reminiscent of Byzantine icons, with the rich gold throughout, the stylized quality of Mary's robe, the organization of the angels' faces and halos in orderly rows, the elegant elongation of the bodies, and the flatness of the figures appearing somewhat like paper cutouts (3.54). Cimabue's figures seem to float in space and rise up toward the top of the **composition** in much the same way that Gothic cathedrals emphasized height to inspire worshippers to look up toward the heavens.

While Giotto's Virgin and Child Enthroned (3.55) clearly shows architectural elements that recall Gothic churches (such as the pointed arch on Mary's throne), his painting makes many innovations, such as the three-dimensionality of his **forms** and the emphasis on creating a believable sense of the space in which Mary sits. We can also see through the throne: the figures nearer us overlap those that are behind them, and light seems to shine in a natural way and cast consistent shadows, helping to create the illusion that this is a three-dimensional space. Mary, Jesus, and the angels all also look more threedimensional than the more delineated figures in Cimabue's painting. Cimabue's Virgin and Child Enthroned seems to focus only on the spirituality of the scene; Giotto seems to wish to create a realistic space more like the world in which we live. This shift in approach was revolutionary, and Giotto's artistic inventions were at the forefront of the stylistic changes that would take place in the fifteenth and sixteenth centuries.

3.54 (left) Cimabue, Virgin and Child Enthroned, c. 1280. Tempera and gold on wood, $12^{\circ}7^{1/2}$ " × $7^{\circ}4$ ". Uffizi Gallery, Florence, Italy

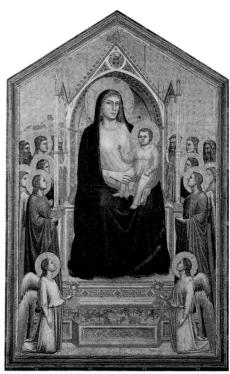

3.55 (right) Giotto, Virgin and Child Enthroned, c. 1310. Tempera on wood, 10'7" × 6'9". Uffizi Gallery, Florence, Italy

Discussion Questions

- 1 The Middle Ages was a time of strong religious belief. Select two artworks, each made for believers of a different religion, and contrast how the artist has emphasized the religious elements of the artwork.
- 2 Compare the architecture of a Gothic cathedral with that of an Islamic mosque. How does the architecture of each reflect the beliefs and rituals of its worshipers?
- Select one two-dimensional artwork (paintings, mosaics, manuscripts) from the West and one from the Byzantine tradition. Contrast the form and content of the two artworks.

Stylized: art that represents objects in an exaggerated way to emphasize certain aspects of the object

Composition: the overall design or organization of a work Form: an object that can be defined in three dimensions (height, width, and depth)

Images related to 3.2: Art of the Middle Ages

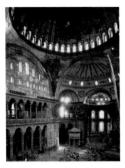

2.179 Hagia Sophia, 532-5 CE, p. 282

1.10 Pentateuch with Prophetical Readings and the Five Scrolls, 13th-14th century, p. 52

4.22a Doors depicting scenes from Genesis and the Life of Christ, 1015, p. 471

1.27 Banner of Las Navas de Tolosa, 1212-50, p. 61

1.32 Vesperbild (Pietà), c. 1330, p. 65

1.156 Great Mosque of Córdoba, 784-6, p. 148

4.89 Justinian mosaic, c. 547 ce, p. 521

4.110 Detail of Battle of Hastings, Bayeux Tapestry, c. 1066-82, p. 536

2.176 Interior, nave, Sainte-Foy, c. 1050-1120, p. 280

4.28 Virgin of Vladimir, 12th century (before 1132), p. 475

4.57 Gislebertus, Last Judgment, c. 1120-35, p. 494

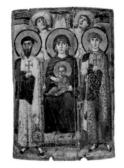

4.125 Icon of Virgin and Child with Saints, 6th century, p. 550

4.2 Notre Dame Cathedral, 1163-1250, p. 455

2.133 Rose window and lancets, Chartres Cathedral, 13th century, p. 254

4.34 Main entrance portal, Masjid-i-Shah, 17th century, p.480

HISTORY AND CONTEXT

3.3

Art of India, China, and Japan

3.56 Map of Asia: India. China, and Japan

The Asian countries that we know today as India, China, and Japan are home to artistic traditions that date back many thousands of years. India and China are large landmasses, both bordered by land and by great expanses of ocean. Japan, on the other hand, is a country of more than 3,000 islands off the eastern coast of mainland Asia. Trade by

sea and along the famed Silk Road—a network of trade routes between Asia and the Mediterranean world—led to the spread of cultural ideas and a sharing of religious and philosophical beliefs.

Religion and philosophy have been integral to the art of the entire region (see Box: Philosophical and Religious Traditions in Asia), yet certain

stylistic characteristics make the art of each of these cultures distinctive. In Indian art there is a noticeable tendency toward elaborate decoration and an emphasis on the human body, frequently showing sensual movement and suggesting fertility. Chinese art combines an interest in religious subject matter with a great respect for Chinese heritage and

ancestors. In general, Chinese artworks are also very precise and symmetrically balanced; Chinese artists desire to create uniformity and convey control of their material. In contrast, Japanese artworks tend to be more asymmetrical, organic, individual, and convey spontaneity. Japanese art is also distinctively contemplative and reveals a great reverence for

Philosophical and Religious Traditions in Asia

The arts of India, China, and Japan can be fully understood only in relation to each country's religions and philosophies. All three have a long tradition of religious pluralism, in other words the acceptance of beliefs from different religions and philosophies. They could also be described as syncretic; their religions blend two or more belief systems. As one example, it is common in Japan to be a Shinto, and a Buddhist, and to practice Confucianism all at the same time. This is possible partly because of the similar values of the various religions and philosophies. For instance, many of these religions strive for harmony with nature, and have a component of ancestral worship.

Buddhist beliefs are founded on the teachings of Buddha (563-483 BCE). Buddhism emphasizes an acceptance of the difficulties of life and of samsara (the cycle of birth, death, and reincarnation). Once one attains Enlightenment, the ultimate wisdom, one arrives at nirvana, the end of suffering for eternity. Zen Buddhism promotes meditation and introspection.

Confucianism is based on the philosophy of Chinese Master Kong (Confucius) (551-479 BCE), who promoted the use of ethics to attain social order. His teachings emphasize self-discipline, moral duty, and paying respect both to one's ancestors and (by extension) to the elders of society. Confucianism is common in China and Japan.

Daoism (The Way) comes from the teachings of Lao Zi (born 604 BCE), who explained in Dao de

jing (The Book of the Way) how to live in harmony with nature and the universe. Yin and yang is the concept that seemingly opposing forces are interconnected and need one another for balance. Such opposing forces might be male and female or light and dark. Daoism is found throughout Asia, but most prominently in China.

Hinduism encompasses a number of beliefs, including reincarnation, rebirth of the soul or of the body, and karma, the idea that one's actions will cause a reaction or consequence in the universe. Hindus believe in the existence of several gods (including Brahma, Shiva, and Vishnu), although individual practice and worship vary greatly among Hindus. Hinduism originated in India and has been adopted throughout Asia, although India still holds the largest Hindu population.

Islam: Muslims base their beliefs on a sacred text called the Koran that records the will of Allah (God) as revealed to the prophet Muhammad (570-632 ce). Islam originated at the birthplace of Muhammad (Mecca, Saudi Arabia) but today is practiced worldwide, with many followers in Asia, including India and China.

Shinto is a native religion of Japan. Its name means The Way of the Gods. Shinto worships several gods and emphasizes respect for nature and ancestors. Kami are spirits; they are believed to be forces in nature (such as wind or trees) or of ancestors.

nature. This chapter highlights both the individuality of these countries and the themes and ideas that unite their artistic traditions.

India

The landmass of India occupies a peninsula in southern Asia that is bordered on the north by the Himalayan mountains. It is about one-third the size of the United States. Buddhist and Hindu beliefs have been important influences on India's rich visual history. The shrines and temples built

for both of these religions are designed to be small replicas, or microcosms, of the universe, places to meditate and worship the gods. In the early twelfth century Muslim invaders from what is now Afghanistan began centuries of rule in India. These Islamic rulers were responsible for magnificent works of art, including India's bestknown landmark, the Taj Mahal.

Buddhism in Indian Art

Siddhartha Gautama (563-485 BCE), who would become the Buddha or "The Enlightened One," was born a prince in what is now Nepal. Traditions tell how Siddhartha was raised in comfort in the royal palace, but at the age of twenty-nine, he witnessed the lives of the poor and sick and became an ascetic, rejecting his wealth and worldly pleasures. Buddhists believe that he achieved Enlightenment through meditation and self-

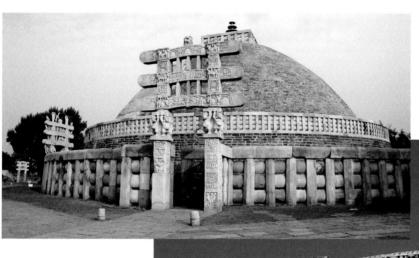

3.57 Great Stupa, third century BCE, enlarged under the Sunga and Andhra Dynasties, c. 150-50 BCE. Sanchi, India

3.58 East gate of Great Stupa, Sanchi, India

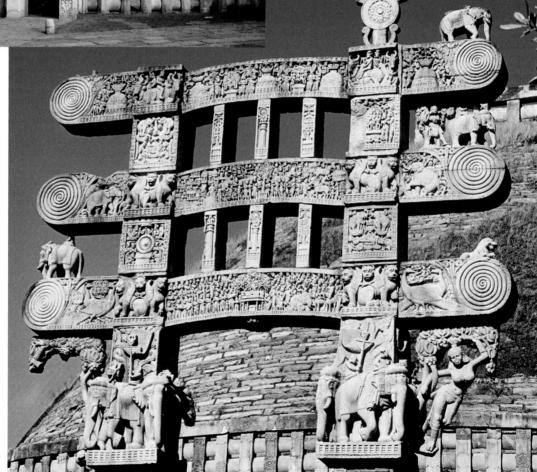

discipline; he spent the second half of his life teaching others to try and do the same. After his death, his life and teachings were spread by word of mouth throughout India. The Buddha's remains were cremated and buried in eight stupas, or burial mounds, the locations of which were relevant to important periods in the Buddha's life.

The Great Stupa in Sanchi, India, was built by King Ashoka as part of a large Buddhist monastery (3.57). Ashoka (304–232 BCE) was emperor of India in the mid-third century BCE. He was born a Hindu, but it is said that he became a Buddhist after feeling ashamed of the murderous destruction caused by a war in which his army killed more than 100,000 people. He became known as "the pious Ashoka" and gained a reputation as a charitable and peace-loving ruler who built hospitals and schools throughout India. When Ashoka converted to Buddhism, he disinterred the Buddha's remains and distributed them to thousands of stupas he built throughout India.

Surrounding the Great Stupa at Sanchi are four gateways, or toranas, placed at the four cardinal points surrounding the large mound. Sensual female figures of tree spirits hang from the brackets on some of the toranas (3.58). These figures symbolize procreation, abundance, and the source of all life. At a height of 35 feet, the columns and horizontal cross-beams of these toranas are covered with scenes of the Buddha's multiple lives (jatakas). The Buddha himself is not shown, but there are signs of his presence, such as an empty throne and his footprints. In this way, Buddhists are invited to follow in the footsteps of the Buddha. Pilgrims enter through the east gate and circle the stupa in a clockwise direction, following the path of the sun. Stone railings added after Ashoka's time allow pilgrims to climb higher safely as they encircle the Buddha's remains, a ritual that emulates Buddha's path toward Enlightenment. The stupa and its four gateways represent a three-dimensional mandala, or a re-creation of the universe.

During the fifth century CE, in Ajanta in western India, twenty-nine caves were carved into the side of a horseshoe-shaped cliff and were filled with Buddhist sculptures and paintings. Although only fragments of the mural paintings survive, the beauty of individual figures and the complexity of the scenes are apparent. Most scenes depict

portions of the jatakas, scenes of contemporary rulers, or Buddhist teachings. Several paintings are of bodhisattvas, beings who could have achieved nirvana but who chose instead to sacrifice themselves and help others work toward Enlightenment (3.59). In one cave painting, Padmapani, a bodhisattva who embodies compassion, is dressed as a prince with a glorious crown and a pearl necklace, and poses gracefully with a serene gaze that suggests contentment and enlightenment. He is shown holding a lotus flower, a common symbol in Buddhist art for its ability to grow from the mud and become beautiful.

3.59 Bodhisattva Padmapani, Cave 1, Ajanta, India. Cave painting, second half of 5th century

Stupa: a burial mound containing Buddha's remains Jatakas: stories from the previous lives of Buddha Mandala: a sacred diagram of the universe, often involving a square and a circle

Hinduism in Indian Art

Hinduism has been practiced at least as far back as 1000 BCE. Today, it is the world's third largest religion, with the majority of its followers living in India. The kinds of personal practices and gods that are worshiped vary greatly among Hindus, but Hindus all share the belief that one's spirit is eternal. Just as Buddhism grew because powerful people promoted it, the increase in popularity of Hinduism was largely due to the efforts of rulers to encourage Hindu worship, particularly by building religious temples. Around 1020, King Vidyadhara built a large

complex containing Hindu temples in Khajuraho,

in northern India. The largest of these, the Kandariya Mahadeva, is dedicated to Shiva, the Hindu god of creation and destruction (3.60). Hindus see their temples as "cosmic mountains," links between heaven and earth. The large towers on Hindu temples are called shikharas and represent mountain peaks. The vertical towers pull the eye upward to the heavens, suggesting to Hindus a desire for nirvana, or the final end of suffering. Every temple has a central room underneath the shikhara that contains an image of the god to whom the temple is dedicated. A Hindu priest's job is to maintain the sculpture (which embodies the god itself) through prayer, mediation, incense burning, feeding and clothing the sculpture, and pouring milk or honey on it.

The temple is aligned with the rising and setting of the sun, with stairs for entrance on the east. Horizontal decoration encourages the viewer to walk around the temple and view the intricate carving and relief sculpture. The exterior is covered with more than 600 sculptures in poses that suggest dancing, which creates a rhythmic pulsing effect over the entire structure (3.61). Many of the scenes are sensual and erotic, depicting the physical union of males and females. The sexual joining of these male and

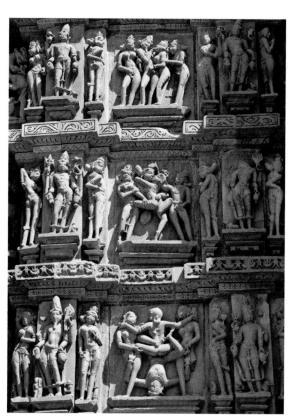

3.60 Kandariya Mahadeva temple, c. 1000, Khajuraho, Madhya Pradesh, India

3.61 Detail of exterior sculpture, Kandariya Mahadeva temple

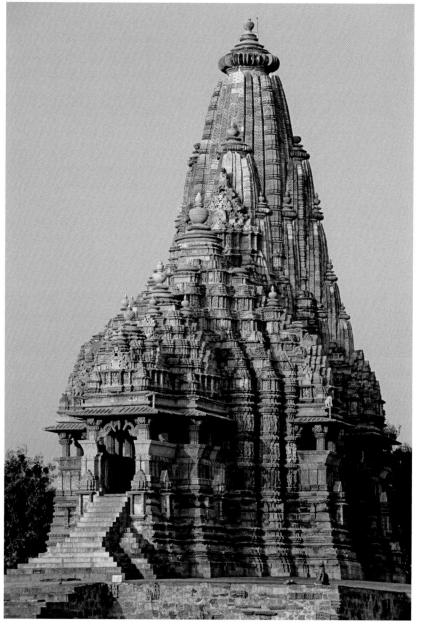

female forces represents the balance of opposing elements in the universe, or the unity of the cosmos.

Islam in Indian Art

By the mid-sixteenth century the Mughals (descendants of the historic Mongolian conqueror Genghis Khan, who had converted to Islam) had conquered part of northern India and were based in Delhi. The Mughals brought with them Persian artists who worked with their Indian fellow artists to develop a new painting school in India.

Jahangir (1569–1627), whose name means "World Conqueror," ruled the Mughal empire for a little more than twenty years in the early 1600s. In a beautiful miniature painting from this period (3.62), Jahangir is seated upon an hourglass throne, in which the falling sand symbolizes the passing of time. Cupids, an influence from European art, fly above the ruler and turn away to protect their eyes from the blinding nimbus (a combination of the sun and moon) that surrounds his head. Two clothed

3.62 Bichitr, Jahangir Preferring a Sufi Shaykh to Kings, from the St. Petersburg album, Mughal Dynasty, c. 1615-18. Opaque watercolor, gold, and ink on paper, 18\% × 13". Freer Gallery of Art, Smithsonian Institution, Washington, D.C.

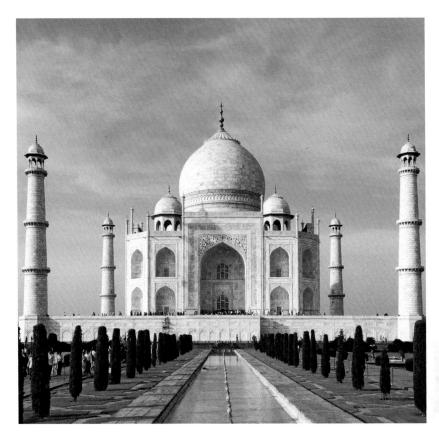

3.63 Taj Mahal, 1631-48, Agra, India

cupids below inscribe the hourglass with a wish that Jahangir live for a thousand years. In fact, the ruler died just a few years after the completion of this painting, possibly from his addiction to opium and wine, and left his kingdom to his son Shah Jahan.

Portraits of four men that relate to the life of Jahangir are shown on the left side of the page. The ruler hands an exquisite book to a whitebearded Muslim Sufi shaykh (mystic scholar) named Sheikh Husain, to whom Jahangir's father had prayed when asking for male heirs. The book is a gift and may symbolize the story of Jahangir's life. The black-bearded man below him is believed to be ruler of the Turkish empire, although scholars do not agree on the specific identification. Below him is King James I of England, facing forward; his likeness is taken from a painting given by the English king to the Mughal ruler. The figure in the bottom left corner is the artist himself, Bichitr. The painter also signed his name in the painting upon the step Jahangir would have used to ascend to his throne.

The Taj Mahal (3.63) is a great tomb built by Shah Jahan (1592-1666) for his wife, Mumtaz Mahal (1593-1631). Shah Jahan created this monument to her after she died giving birth to

their fourteenth child. Taj means "crown," but scholars do not know if this was the original name of the building. The Taj Mahal is part of a larger complex including a mosque, smaller tombs, enormous gardens, and a reflecting pool.

Inscriptions carved on the magnificent white marble, and poems written by the Shah, explain that the building represents the throne of God, and that the gardens that surround it are the gardens of Paradise:

Like a garden of heaven a brilliant spot, Full of fragrance like paradise fraught with ambergris.

In the breadth of its court perfumes from the nose-gay of sweet-hearts rise.

Shah Jahan would later be buried there in a central crypt, next to his wife.

The Taj Mahal is covered in white marble inlaid with semiprecious stones; it glistens beautifully in the sun. The central dome is 58 feet in diameter and 213 feet tall. The structure is completely symmetrical both when viewed from above and from any of its four sides. Four domed chambers emanate from this central dome, balanced on an octagon-shaped platform. Four towers called **minarets**, each 162 feet high, frame the corners of the large structure. The minarets and pointed domes are characteristic of Islamic art. The white marble is inlaid with jasper to make geometric patterns and arabesques of flowers and plants. It also shows passages from the Koran that relate to the theme of judgment.

China

The earliest traces of civilization in China have been found along the Yellow and Yangtze rivers. The first Chinese emperor, Qin Shi Huangdi, established the first unified Chinese dynasty in 221 BCE. China's boundaries have changed throughout its subsequent history according to its military success or failure, but today it is approximately the same size as the United States.

Buddhism and Daoism are the largest religions in China. Each faith integrates the

beliefs of the other and of Confucianism (see Box: Philosophical and Religious Traditions in Asia, p. 331) as well: the Chinese believe a person may practice more than one belief system.

This affects the whole of Chinese culture. In Chinese art, for example, scroll paintings are intended to enhance meditation, and respect for nature and one's elders—virtues that are valued by all three faiths. Many great Chinese artworks have been discovered in tombs, providing evidence both of a widespread reverence for ancestors, and of the importance of the idea of the afterlife.

Chinese Scroll Painting

The earliest known painting in China dates back some 10,000 years. Archaeologists have found painted pots, and paint on the walls and floors of caves and huts. From 200 BCE until today, however, many Chinese paintings have been made with ink on silk or paper, the same materials used in the arts of calligraphy (fine hand-lettering) and poetry. These three arts are inextricably linked for the Chinese (see The Three Perfections: Calligraphy, Painting, Poetry). Most Chinese paintings are made as hanging or hand scrolls; their subject matter includes battles, scenes of daily life, landscapes, birds, and animals. Chinese scroll paintings are meant to be experienced as though we were on a slow, contemplative journey. Artists who paint scrolls do not intend their work to be viewed from one position, as is usual in artworks created in the European tradition. Instead, the complexity and (in the case of a hand scroll) length of a painting invite us to view one portion of it at a time.

The calligraphy in the upper right of the hanging scroll shown in **3.64** tells us that *Ge Zhichuan Moving His Dwelling* is a historical scene from the life of a well-known Chinese writer. Ge Zhichuan was one of the first alchemists (someone who seeks to make gold or silver from lead or iron). He is also considered one of the great teachers of Daoism. In the painting, Ge Zhichuan is travelling to Guangzhou to find the red mercury-based mineral cinnabar. He is shown in the lower left

Minaret: a tall slender tower, particularly on a mosque, from which the faithful are called to prayer

Pattern: an arrangement of predictably repeated elements Arabesque: an abstract pattern derived from geometric and vegetal lines and forms

Calligraphy: the art of emotive or carefully descriptive hand lettering or handwriting

Colophon: comment written on a Chinese scroll by the creator, owner, or a viewer

The Three Perfections: Calligraphy, Painting, Poetry

In Chinese society, talented calligraphers are accorded the highest respect. The Chinese script used today goes back to at least the Qin dynasty (221-207 BCE). Chinese calligraphers can convey a mood through the handling of a brush, the thickness of a line, the quickness of a stroke. Skilled calligraphers can communicate through their script elegance, formality, sadness, or joyful exuberance. Historically, many poets became calligraphers so that they could express most eloquently the moods of their poems. Many painters, too, were calligraphers, because both art forms require great skill in the handling of the brush.

During the Song dynasty (960-1279), painters called literati wrote poems-either their own or the work of other poets-next to their paintings. The tradition continues to this day. Room for calligraphic inscriptions is often left on paintings, not only for the artist's signature but also to describe a scene, dedicate the painting, or add poetry.

The Chinese believe that any inscriptions on a painting become part of the work, whether or not they are written by the painter. Frequently, red seals or stamps are pressed on to part of a work to claim authorship, or to show admiration for that part. Colophons are inscriptions usually written in black ink, often poems or historical information about the artwork, made by the artist or admirers of the work. Therefore, a scroll painting with many inscriptions and colophons is one that has been much enjoyed, and this becomes part of the story of the painting.

on a bridge that crosses over a river. His family follows in the lower center. The scene shows the power of nature compared to the small scale of man.

The fantastic landscape full of twisting trees, steep cliffs, and high waterfalls shows the mystical nature of his journey; it also symbolizes the wondrous path we all take through life. We cannot view the entire scroll at one time, just as we cannot see everything going on around us. This is a metaphor for the Zen-like philosophy that one can only comprehend the universe in its entirety through the mind, thus achieving Enlightenment. As Ge Zhichuan follows his meandering path, he will eventually arrive at a new village, seen in the upper left. His destination is higher in the scroll than his present location; this is a device used in Daoist painting to symbolize the growth that the subject will experience on his spiritual path. Just like the people in the painting, the viewer may wander in any direction, exploring new territory and facing challenges; all of this is a metaphor for the journey of life. The mountain ridges high in the distance speak to the journeys yet to come.

Along the River during the Qingming Festival is one of China's most famous hand scrolls; only a

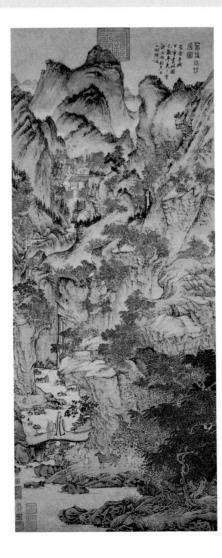

3.64 Wang Meng, Ge Zhichuan Moving His Dwelling, c. 1360. Hanging scroll, ink and color on paper, $54^{3}/_{4} \times 22^{7}/_{8}$ ". Palace Museum, Beijing, China

3.65 Zhang Zeduan, Along the River during the Qingming Festival, Northern Song Dynasty, 11th century. Handscroll, ink and color on silk, 10" x 17' 3". Palace Museum, Beijing, China

3.66 Detail of Zhang Zeduan, Along the River during the Qingming Festival

Piece mold casting: A process for casting metal objects in which a mold is broken into several pieces that are then reassembled into a final sculpture

Abstract: an artwork the form of which is simplified, distorted, or exaggerated in appearance. It may represent a recognizable form that has been slightly altered, or it may be a completely non-representational depiction

small portion of the 17-foot-long scroll is shown here (3.65). This national treasure is so valuable, and in such a delicate state, that it is rarely seen. It has been dubbed "China's Mona Lisa" because of its great fame and intriguing history (it has been frequently stolen and copied). When the scroll was displayed at the National Museum in Beijing

in 2002, the crowds were so big that viewers were allowed just five minutes to look at the very large and complex scene.

The painting illustrates life during the Song dynasty about a thousand years ago. The Qingming Festival is the annual holiday when people enjoy the springtime and remember their ancestors. There is no evidence that the artist intended to depict that specific occasion, but, through time, the scroll has become associated with it. Reading from right to left, the scroll begins with a serene landscape. This then transforms into a bustling scene; we can see 800 people going about their everyday activities. The painting is beloved for its extraordinarily detailed depiction of street merchants, animals, shops, bridges, and boats. This is the only known work by the artist, Zhang Zeduan; we know little about his life. We have learned his name only from one of the colophons on the far left of the painting, written in 1186 by a man named Zhang Zhu in appreciation of the scroll.

Death and the Afterlife

For thousands of years, Chinese people have worshiped their ancestors, who they believe are transformed after death into supernatural entities with the power to communicate with the gods and protect the living. The Chinese used to show respect for their ancestors by burying valuable items in their tombs. As early as the Shang dynasty (c. 1700–1050 BCE), Chinese people placed everyday objects in tombs, so that the deceased would have what they needed in the afterlife. Humans and animals were also sacrificed, in the belief that they would serve

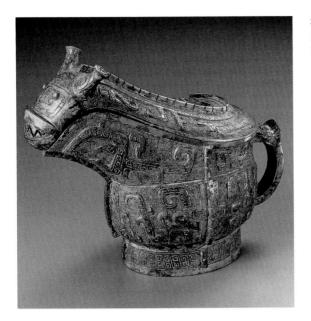

3.67 Ritual wine vessel (quang), late Shang dynasty, c. 1700–1050 BCE. Bronze, $6\frac{1}{2} \times 3\frac{1}{4} \times 8\frac{1}{2}$ ". Brooklyn Museum, New York

the dead in the next realm. Today, similar customs persist: the Chinese often burn money, food, and other objects in the hope that these will reach their ancestors in the spirit world.

The tombs of the Shang dynasty's rulers have preserved many lavishly made objects in jade, gold, ivory, and, in particular, bronze. The bronze sculptures of this period were made using a process known as piece mold casting, which involves cutting the mold into sections and then reassembling it before pouring in the molten bronze.

The bronze guang (lidded vessel; 3.67) was found buried in a tomb. It was used to pour wine during a ritual. The container depicts a hornheaded dragon with sharp teeth at its spout. The dragon was one of the most commonly used motifs in Chinese art, symbolizing good fortune, power, and immortality. The mazelike abstract design on the side of the vessel is called a t'ao t'ieh (monster mask). It warded off evil spirits and protected the ancestral soul.

The tomb of Lady Dai (died 168 BCE), a noblewoman of the Han dynasty (206 BCE-220 CE), was excavated in 1972, revealing a wealth of objects intended to accompany her into the afterlife. A stunning richly painted silk textile (3.68) had been placed over Lady Dai's coffin, protected by several additional layers of wooden

3.68 Detail from painted banner from tomb of Lady Dai Hou Fu-ren, Han Dynasty, c. 168 BCE. Silk. Hunan Museum, Changsha, China

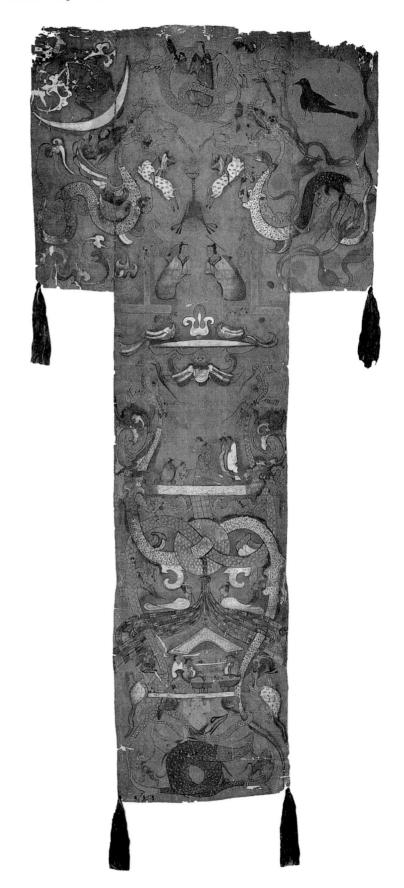

coffins. The silk banner is in the shape of a T; the wide horizontal section represents heaven with twisting dragons, a toad on a gold moon, and a crow on a red sun. At the top in the center, surrounded by a red serpent, is probably an imperial ancestor. Lady Dai stands upon a central white platform about halfway down the banner, awaiting her ascent to the heavenly realm. Above her is a bird and, at the cross of the T, two kneeling figures who are thought to be guardians or guides of some kind. A jade circle, crossed by two writhing dragons and known as a bi—frequently used as a symbol for heaven—sits below Lady Dai on her platform. Scholars have hypothesized that this banner either shows Lady Dai's funeral and her journey to heaven, or views of the three spiritual realms of heaven, earth, and the underworld.

In an effort to protect the skills needed to preserve Japan's traditional art forms, the Japanese government designates outstanding traditional artists "Important Intangible Cultural Property Holder" (popularly known as National Living Treasures). Sonoko Sasaki was named a National Living Treasure for her skills in weaving a traditional textile known as tsumuqi-ori. Here she explains her work.

3.69 Sonoko Sasaki, Sea in the Sky, 2007. Tsumugi-ito silk thread and vegetable dyes. $70\% \times 51\%$ ". Collection of the artist

Japan

Japan is a country of many islands off the eastern coast of Asia. In size, it covers about the same area as California. Combining its own cultural and religious traditions with influences from mainland Asia, Japanese art reflects stories of Buddha and of emperors, and (in modern times) the lives of ordinary people as well. Vulnerable to frequent tsunamis, earthquakes, and volcanic eruptions, the Japanese have a great respect for nature. According to the Shinto religion, spirits called kami are present everywhere, including within nature. Many Japanese combine aspects of Shinto with a belief in Buddhism. The Japanese reverence for nature, their desire for meditation, quiet reflection, and mental discipline, are all seen in the art they create.

The Japanese Tea Ceremony

Chanoyu (Way of the Tea) is the Japanese word for the traditional tea ceremony. Rooted in Zen Buddhism, chanoyu is a set of rituals that helps one find peace and solace from the ordinary world. It is a tenet of Buddhism that disciplined observation of the mundane things in life leads one toward Enlightenment, and chanoyu is designed to facilitate such observation. It also

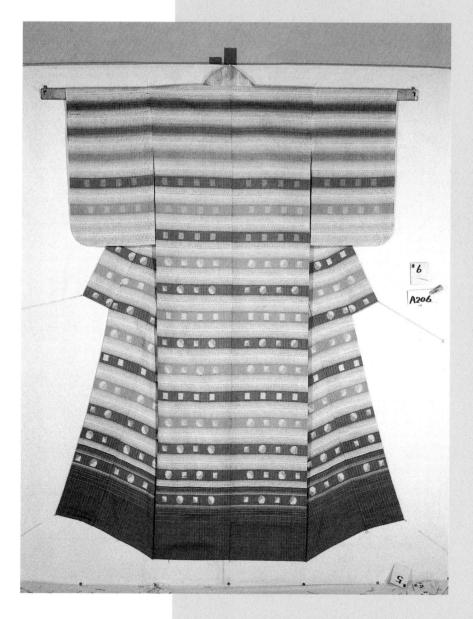

Perspectives on Art: Sonoko Sasaki

Art and Tradition in Japan

I work with tsumugi-ori textiles because the touch and look of the material are very attractive to me. Tsumugi thread is different from cotton thread because it consists of extremely long fibers that are tough, waterproof, and glossy.

Actually, tsumugi-ori was originally quite a rustic textile made by women involved in silk cultivation after their farming work. As a result, tsumugi-ori has always had a strong connection with the earth and nature, and with the cycle of the four seasons that in Japan shows us the beautiful scenes of the natural world. I always try to sharpen my sense of color with all five of my senses, which helps me give a variety of colors to my work. The colors I use also come from nature. The dyes I use to color my textiles come from roots, flowers, and fruits of plants of every season.

Water, light, and wind are also essential for tsumugi-ori textiles. Water is important for me, and fills me with awe, since the threads must be boiled in a dye and then washed. Sunlight and wind are needed to dry the dyed thread.

I weave my textiles using a hand-loom and then tailor the material to make kimonos, a traditional Japanese dress. In other words, my works have meaning and value only if someone wears them. Here the key is again the four seasons. I delicately change the color of the textiles according to the seasons. At the same time, people who wear my kimonos place a high value on their sense of the seasons. In this way the artist and the wearer share their consciousness of the seasons, a tradition, inherited by generations of women, which I think is special to Japan.

I do not have any idea why I have been designated as a National Living Treasure, but I understand that I have accepted a responsibility to work on and protect the art

3.70 Sonoko Sasaki at work at her loom

and culture of tsumugi-ori for the rest of my life. I am truly happy to pursue my "road of coloration" and "road of weaving" now and forever. Even if I were born again, I would still like to choose tsumugi-ori, as, for me, nothing is more glamorous than dyeing and weaving.

3.71 Sen no Rikyu, Taian teahouse, interior, c. 1582. Myoki-an Temple, Kyoto, Japan

helps create an environment for intense concentration. Tea masters train for many years in the practice of creating a meditative environment through the serving of tea and the preparation of the teahouse. In the sixteenth century, the tea master Sen no Rikyu developed an influential tea ritual; the Taian tearoom in

Kyoto is the only remaining teahouse by this master (3.71). The modest room is made with natural materials, such as mud for the walls, and bamboo and other wood for the trim and ceilings. The windows are made of paper, and the tatami (floor mats) are made of straw. The simple room has no decoration except for a simple scroll or small floral arrangement placed in a niche called a tokonoma.

Chanoyu can take hours. It involves preparing and drinking the tea, and quiet conversation. The ceremony begins as one removes one's shoes and enters the house on hands and knees, showing humility. The contemplative environment invites participants to enjoy conversation, and also to appreciate each object involved in the ceremony. A teabowl called Mount Fuji is so named for its abstract suggestion of snow above and a landmass below, bringing to mind the famous mountain (3.72). The teabowl shows the integration of forms drawn from nature with a man-made object. This type of Japanese ceramics, known as raku, is an example of wares used in the tea ceremony. Each piece has its own irregular **texture** and pattern, yet is simple, to encourage participants in the ceremony to notice small details. Users of the teabowl consider how it was made from earthly elements, admire the abstract design, and enjoy the way the object feels in their hands. By doing so, they train themselves to slow down and take note of every moment in their lives.

3.72 Hon'ami Koetsu, Teabowl (called Mount Fuji), Edo period, early 17th century. Raku ware, 3\%" high. Sakai Collection, Tokyo, Japan

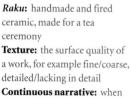

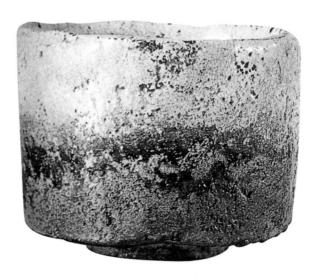

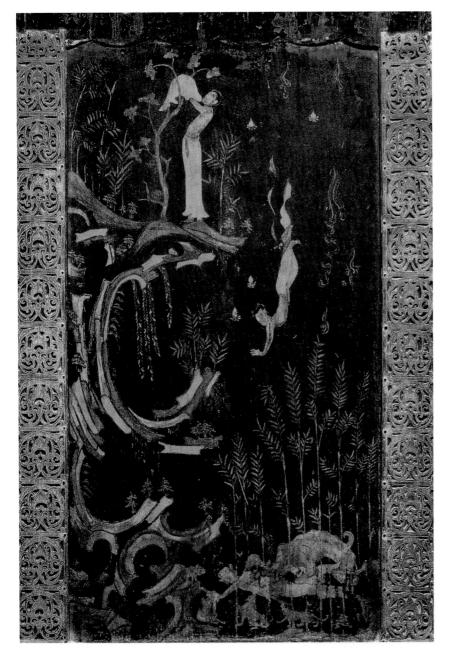

Storytelling

One of the oldest examples of storytelling in Japanese art appears on a wooden shrine in the Buddhist Horyu-ji temple in Nara (3.73). One side of the shrine is painted with a jataka (a story from the life of Buddha) known as *The Hungry* Tigress. The painting is a **continuous narrative**, meaning that it shows multiple scenes of a story in one pictorial space. In this story, Buddha sacrificed his own body to save a starving tigress and her cubs. Buddha is shown first at the top of a cliff carefully hanging his clothes from a tree, his slender body reflecting the curves of the natural elements that surround him. He then jumps off the cliff, and is finally devoured by the tigers in the valley below.

The *Tale of Genji* is one of the great works of Japanese literature. Written in the eleventh century by Murasaki Shikibu, a noblewoman at the court of the emperor at Heian-kyo (modernday Kyoto), it tells of the love affairs of Prince Genji. The chapters are filled with undercurrents of sadness, reflecting the Buddhist view that earthly happiness is fleeting, and that there will always be consequences for our actions. Some of the earliest surviving Japanese painting illustrates the Tale of Genji, including the scroll section shown in **3.74**.

The scroll is designed so that different portions of the tale are revealed as the scroll is unrolled from right to left. In this scene we see the prince from a so-called "blown-off roof" perspective, in which we as viewers peer, almost voyeuristically,

3.73 Hungry Tigress, panel from the Tamamushi Shrine, Horyu-ji Temple, Nara, Asuka period, c. 650. Lacquer on wood, shrine 7'73/4" high. Horyu-Ji Treasure House, Japan

3.74 Scene from the Tale of Genji . Heian period, first half of 12th century. Hand scroll, ink and color on paper, $8^{5}/8 \times 18^{7}/8$ ". Tokugawa Art Museum, Nagoya, Japan

into the private space of the palace. The flat figures and use of strong **diagonal** lines to guide the viewer through the scene are both qualities frequently used in Japanese painting. The strict diagonal and vertical lines not only powerfully divide the space within the scene, but also create a sense of drama and tension.

This scene specifically shows Genji at the naming cermony for his first son. Unbeknownst to anyone but Genji and his wife, however, the baby he holds is actually his father's son, and Genji is being forced to raise the child as his own. The claustrophobic positioning of Genji, trapped between two rows of curtains and crushed against the top edge of the page, reflects the trapped feeling of the character in the story. In the tale, he is being punished for his past deeds because he had an affair with one of his father's wives.

Ukiyo-e

Ukiyo, a Japanese word that means "floating world," is an idea that grows out of the Buddhist thought that life is fleeting and that each moment should be enjoyed. Ukiyo-e, or "pictures of the floating world," were **woodblock** prints that when first produced in the seventeenth century showed characters and scenes from the entertainment districts of Edo, modern Tokyo. The subject matter therefore included brothels, geishas, and theatre actors; later ukiyo-e included landscapes and images of different classes of women. The Japanese printmaker Kitagawa Utamaro (1753–1806) specialized in bijinga, or images of beautiful women (3.75). Ukiyo-e artists chose woodblock printing because it made possible the mass production of inexpensive images for a popular market. From the 1860s onward, ukiyo-e prints also became extremely popular imports in Europe and America (see Japonisme: The Influence of Ukiyo-e on French Artists). Katsushika Hokusai's series Thirty-Six Views of Mount Fuji remains a popular ukiyo-e series (see Gateway Box, Hokusai, 3.77, p. 346).

3.75 Kitagawa Utamaro, *Two Courtesans*, second half of 18th century. Woodblock print, 12^{5} /8 × 7^{1} /2". Victoria and Albert Museum, London, England

Diagonal: a line that runs obliquely, rather than horizontally or vertically Woodblock: a relief print process where the image is carved into a block of wood Impressionist: late nineteenth-century painter using a style that conveyed the impression of the effects of light

Composition: the overall design or organization of a work Outline: the outermost line of an object or figure by which it is defined or bounded

Japonisme: The Influence of Ukiyo-e on French Artists

Japonisme is a term used to describe the way in which the work of Japanese artists influenced many artists in Europe. Japanese prints often depicted space, cropped scenes, and flattened objects through the use of line rather than shadows. After studying Japanese prints, such Impressionist painters as Claude Monet, Camille Pissarro, and Edgar Degas began to incorporate slanted viewpoints, bright colors, and busy patterns into their work. Likewise, Henri de Toulouse-Lautrec made prints that were influenced by Japanese techniques, while Édouard Manet and Vincent van Gogh included copies of Japanese prints in their paintings.

The American painter Mary Cassatt (1844-1926) lived most of her life in France and exhibited with the Impressionists. After seeing more than a hundred of the Japanese printmaker Kitagawa Utamaro's prints exhibited in Paris in 1890, Cassatt wrote to friends raving about him; later she began creating prints very much in the style of Utamaro. Cassatt herself had always focused on the daily lives of women in her paintings. A comparison between one of Utamaro's prints (see 3.75; see opposite) and a painting by Cassatt (3.76), made three years after she had seen the Japanese artist's work in Paris, highlights the techniques Cassatt emulated.

The composition of the two scenes is very similar. Each has a form that creates a strong diagonal line from the upper right to the lower left. The musical instrument is gently being played by Utamaro's beautiful lady, while the foot of the child in Cassatt's painting is gently stroked by her mother's hand. The mother's right arm and that of the musician are both, in contrast to the objects they hold, strictly vertical.

The dress of Utamaro's lady is completely in outline, with no effort to create a sense of volume in the figure, or shadows in the dress. Similarly, Cassatt dresses the mother in bold stripes that create a linear effect that resembles the outlines of Utamaro's lady. The background of Utamaro's print is mostly empty, creating an absence of space behind the lady

3.76 Mary Cassatt, The Child's Bath, 1893. Oil on canvas, 391/2 × 26". Art Institute of Chicago

apart from some twisting flowers and crowded calligraphy in a music book. Cassatt fills her background space, but her busy floral patterns echo the flowers in the Japanese work.

Lastly, Japanese prints often look at their subject from multiple vantage points. Utamaro's lady is being viewed from directly in front of her, but the bottom of her dress, the music, and parts of the instrument are seen from above. Similarly, in Cassatt's painting, the scene is depicted from various vantage points. For example, the viewer looks at the child's torso, the dresser in the background, and at the pitcher in the lower right corner from directly in front at the same height. Yet, simultaneously, the bowl of water and the rug are viewed from above.

Gateway to Art: Hokusai, "The Great Wave off Shore at Kanagawa" Mount Fuji: The Sacred Mountain of Japan

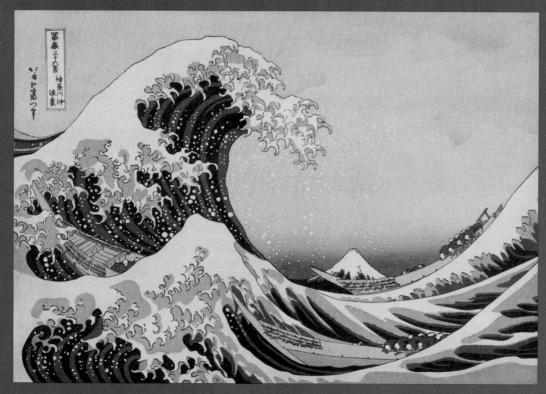

3.77 Katsushika Hokusai, "The Great Wave off Shore at Kanagawa", from Thirty-Six Views of Mount Fuji, 1826-33 (printed later). Print, color woodcut. Library of Congress, Washington, D.C.

is the only part of the scene that is not in motion; it is therefore a powerful stabilizing force. Indeed, the fierce movement of the wave thrashing the boats around contrasts markedly with the eternal and still form of the mountain. As one looks at the print, an abstract yin and yang (3.78) appears in the intertwining of the large wave with the sky. Two smaller focal points then become Mount

Fuji and the boat on the left.

All of the views in this series contrast the stable form of Mount Fuji with the daily actions (fleeting life) of people. In "The Great Wave," Hokusai shows the hard lifestyle of the fishermen who worked in the area of Edo, and their courage in the face of the power of nature. Just as their lives were at risk, Hokusai was also likely thinking of his own mortality: he was in his 70s when he made this print. Here, he demonstrates the balance and harmony of man and nature.

3.78 Yin and yang symbol

Katsushika Hokusai's series Thirty-Six Views of Mount Fuji was so popular in his time that he made forty-six scenes. Mount Fuji is the largest mountain in Japan (12,388 ft. high), and has become a recognizable symbol of the country. The mountain is sacred to believers of both Buddhism and Shinto. Because it is an active volcano, it is believed to have a particularly powerful kami, or spirit, although it has not erupted since 1708. In one print from Hokusai's series, "The Great Wave off Shore at Kanagawa" (3.77), the mountain

Discussion Questions

- 1 In what ways are religion and philosophy reflected in artworks from Asia? Cite examples from India, China, and Japan.
- 2 Humankind's relationship with nature is a strong element in many artworks from Asia. Consider the artist's interpretation of nature in three artworks introduced in this chapter.
- 3 Chinese scroll paintings are a unique kind of
- artwork. Discuss the format of a scroll, how it is viewed, and the skills needed by the artist. How do these characteristics of scroll paintings differ from other kinds of painting you have studied?
- Religious and political leaders often influence the kinds and quantities of artworks made in a certain time or culture. Cite two examples in which a ruler or leader impacted the art of Asia. What role did he or she play?

Images related to 3.3: Art of India, China, and Japan

1.122 Ritual container from Gui, China, 1600-1100 BCE, p. 125

4.11 Soldiers from mausoleum of Qin Shi Huangdi, c. 210 BCE, p. 462

4.35 Ise Jingu, 4th century CE, rebuilt 1993, p. 481

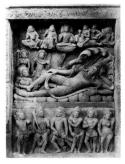

1.118 Vishnu Dreaming the Universe, c. 450-500 CE, p. 122

4.23 Life of Buddha, c. 475 CE, p. 472

4.124a and **b** Colossal Buddha from Bamiyan (before and after destruction), 6th or 7th century CE, destroyed 2001, p. 549

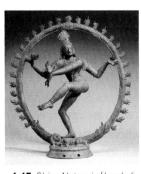

4.45 Shiva Nataraja (Lord of the Dance), 11th century,

1.123 Muqi, Six Persimmons, c. 1250, p. 126

4.111 Night Attack on the Sanjo Palace, late 13th century, p. 537

2.129 Porcelain flask with decoration in blue underglaze, 1425-35, p. 252

1.125 Amitayas mandala created at Drepung Loseling Monastery, Tibet, p. 127

1.146 The Emperor Babur Overseeing his Gardeners, c. 1590, p. 140

1.152 Pashmina carpet with millefleur pattern, second half of 17th century, p. 144

4.90 Portrait of the Yongzheng Emperor in court dress, 1723-35, p. 521

2.43 Kitagawa Utamaro, Lovers in an Upstairs Room, 1788, p. 194

1.148 Ando Hiroshige, Riverside Bamboo Market, Kyōbashi, 1857, p. 141

4.101 Mao Zedong's portrait over Tiananmen Square, p. 529

2.32 Hung Liu, Interregnum, 2002, p. 186

additional face above it with thin eyes, a scroll nose, and fanged smile. What was formerly the headdress repeats the crocodile face menacingly. Such designs, with lines that describe more than one object at the same time, possess what is known as **contour rivalry**. They allow a figure to serve a dual purpose and to project multiple readings.

The Chavín culture's principal deity, known as the Staff God, has a close connection to nature, agriculture, and fertility, as does the crocodile. In Chavín culture generally and in this artwork in particular, animals feature prominently and are strongly associated with all three realms of the cosmos: snakes with the earth, crocodiles or caymans with the watery

3.81 Paracas textile, embroidered with mythological figure, 3rd century. Wool embroidery. Museo Arqueología, Lima, Peru

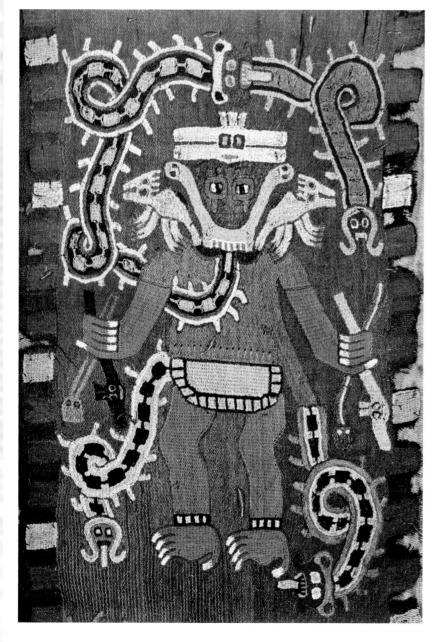

underworld, and birds with the celestial realm of the sky.

Andean textile design is closely related to carved stone **relief** sculpture, such as the Raimondi Stela. They both use contour rivalry to create complex patterns that encourage multiple interpretations. Some of the most spectacular textiles were made by the Paracas people, who lived on the coast of Peru from about 600 to 200 BCE. The dry conditions of their **necropolis** have preserved a great number of these textiles. They show a continuation of the style (single lines describing more than one thing and readable in more than one direction) and content (natural life and mythical beings) developed by the Chavín culture. A Paracas textile (3.81) shows a mantle, a cape-like garment often made by the Paracas people for burial purposes. Intricately **embroidered** stitches form each figure; their repetition creates a pattern. Outlines merge into body parts, and costumes resemble animals (in 3.81, a kind of mythical being with deer on its shoulders—a shaman with its animal self as a disguise). Plant forms and animals appear frequently in Paracas imagery, and deer shown here represent revered creatures associated with the hunt.

The Moche

Visually and conceptually intricate designs were also common for the Moche culture of northern Peru. Moche art, made from about 200 BCE to 600 CE, tells us much about their society. The earspool (a large-gauge ornament worn through the earlobe) in 3.82 was found in a royal tomb at Sipán. It shows a figure dressed almost exactly like the man found buried in the tomb, who is believed to be a warrior-priest. Pictured standing next to him on the earspool (and also lying next to him in the tomb) are two attendants dressed for battle. The detailed depiction includes replica turquoise-and-gold earspools, a war-club and shield, a necklace of owl's heads, and a crescent-shaped helmet. Although gold was not considered as valuable as textiles in the ancient Andes, its symbolic associations with the sun's energy and power made it nonetheless very important.

3.82 Earspool, c. 300 cE. Gold, turquoise, quartz, and shell, 5" diameter. Royal Tombs of Sipán Museum, Sipán, Peru

The Inca

Like the Moche metalworkers who integrated the world they saw around them into their designs, the Inca, too, were inspired by nature. The Inca culture may have existed as early as 800 CE. It became an empire when the powerful Inca ruler Pachacuti centralized the government. By the early 1500s a series of rulers had increased the area of land under their control until it covered more than 3,000 miles along the western coast of South America, thus becoming the largest empire in pre-Columbian America. Pachacuti selected a ridge high on a mountaintop in Peru for Machu Picchu, his private estate and religious retreat (3.83). The location offered privacy and protection as well as breathtaking views. The condor, a majestic bird of prey, is depicted throughout the site, which includes a building known as the Condor Temple, and a stone carved in the shape of a curved beak. The walls, terraces, platforms, and buildings are

3.83 Machu Picchu, 1450-1530, Peru

Contour rivalry: a design in which the lines can be read in more than one way at the same time, depending on the angle from which it is viewed

Relief: a sculpture that projects from a flat surface

Necropolis: cemetery or burial place

Mantle: sleeveless item of clothing—a cloak or cape Embroidery: decorative stitching generally made with colored thread applied to the surface of a fabric

The Importance of Wool

stand for the conquest of all possible ethnicities. The tunic refers to an important Inca creation myth, when the great god Viracocha sent out all the different peoples with their ethnic patterns painted on their bodies.

In the Andes, textiles were made exclusively by women. Weaving was such a sacred art that it had its own god, Spider Woman, who featured prominently in the Inca creation story. Textiles were not only considered sacred, but were also more valuable than gold or silver. This scale of values was not shared by the Spaniards who conquered Peru in the sixteenth century: they demanded gold and silver from the Inca and melted down fine works of art to ship the precious metals home to Spain.

3.85 Tunic, c. 1500. Interlocked tapestry of cotton and wool, $35\% \times 30\%$. Dumbarton Oaks Research Library and Collections, Washington, D.C.

Andean artists often honored animals in their artworks. Here, a small silver llama figurine (3.84) seems to wear on its back a red blanket-made of inlaid cinnabar edged with gold. This sculpture was probably a burial offering and was wrapped, along with the body, in actual textiles. It indicates the crucial role the llama played in supplying wool for weaving. Cloth not only served the practical function of warmth and protection, but also identified the wearer's social status as part of a particular group. For instance, the clothing worn by an unmarried woman would easily distinguish her from a married woman in her own group, as well as from members of another social group.

The checkerboard tunic in 3.85 was worn by an Inca ruler. Its square designs contain a number of patterns that together indicate the high status and importance of the person who wore it. The little checkerboard designs would have decorated tunics worn by warriors serving the ruler; similarly, the diagonal lines and dots indicate the clothing of administrators. The other patterns do not directly represent specific roles or people as such, but through the complexity and variety of designs, they

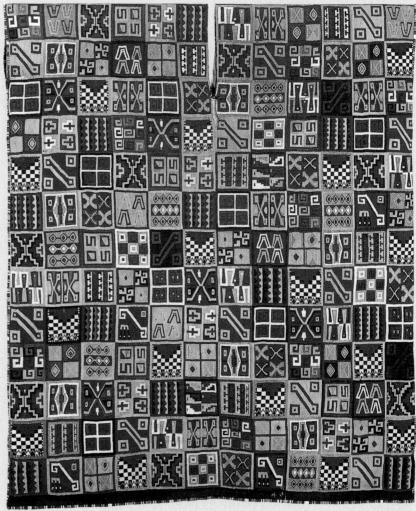

constructed of huge stones precisely stacked and fitted close together without mortar. Machu Picchu was abandoned around 1527, probably after the devastating effects of a smallpox epidemic resulting from contact with Europeans. Because of its elevated location, the site was not excavated until 1911, when Yale archaeologist Hiram Bingham led an expedition to the Inca trail. After more than 100 years, in early 2011 Yale University was scheduled to give the Peruvian government artifacts secured during the excavation.

Mesoamerica

"Mesoamerica" is the name given by archaeologists to the area occupied by modernday Mexico and Central America. The many different people and cultures that inhabited the region founded powerful city-states and produced diverse artworks. Skilled astronomers and mathematicians, Mesoamericans developed an accurate calendar that they used to calculate the dates of important ceremonies and rituals and to predict astronomical events. They shared similar religious beliefs and many cultural traditions, including a ball game played with a hard rubber ball (see **3.91**, p. 356).

The art and architecture of the Olmecs, who lived on the fertile lowlands of Mexico's Gulf Coast from c. 1200 to 400 BCE, influenced later Mesoamerican people, for example the inhabitants of the city of Teotihuacan, the Maya, and the Aztecs. The Olmecs used images to record information, a tradition also common among other people of Mesoamerica. Eventually the Olmecs, and later the Teotihuacanos, used images as a form of writing, although scholars have not yet been able to interpret their scripts. The Maya also developed a system of writing, called **hieroglyphs**, much of which can now be read. Some Aztec **pictographs**, too, can be deciphered.

3.86 Map of Mesoamerica

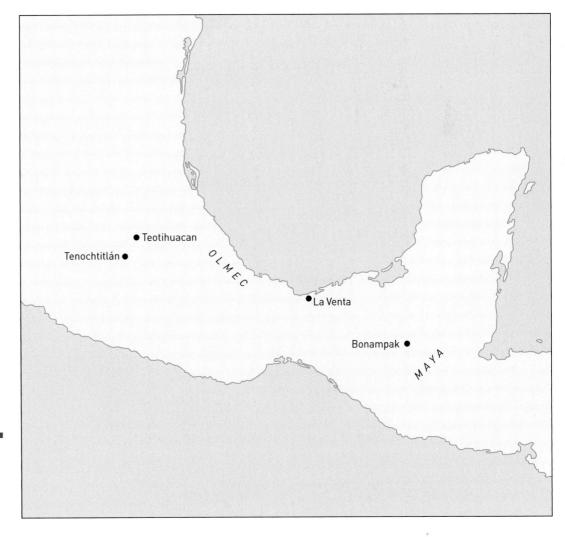

Hieroglyph: written language involving sacred characters that may be pictures as well as letters Pictograph: picture used as a symbol in writing

Gateway to Art: Colossal Olmec Heads

The Discovery of Monumental Portraits at La Venta

Today we often see Olmec art in modern museums, but centuries ago these massive monuments were displayed in the ceremonial centers of Olmec cities. They were then forgotten for hundreds of years as they lay buried in remote locations. David Grove, an archaeologist and an expert on the Olmec, recounts the discovery in 1940 of four Olmec heads and other Olmec wonders at La Venta by the archaeologists Matthew and Marion Stirling:

It had taken the Stirlings five days to reach La Venta, and they would spend a total of ten days exploring the site. Led by a local guide, they followed trails through dense tropical forest and then "wallowed afoot in the muck" of waist-deep swamps until eventually emerging onto the high ground upon which La Venta is situated. However, even after reaching the site's ruins the stone monuments were not immediately visible to them.

The primary purpose of their visit was to locate, study, and photograph the eight stone monuments that had been reported by the scholars Frans Blom and Oliver La Farge in 1925. The narrow four-mile-long island was heavily forested except for some scattered clearings used as agricultural plots by the few residents of that remote area. To assist them they recruited seven local men. Some of those workers remembered seeing carved stones in the forest and the fields, but had paid little attention to them. They were happy to show Matt and Marion the stones they knew of—if they could find them again . . .

Eventually, one of the workers recalled seeing some stones in another area of the forest to the south of the site's large pyramid mound. As Stirling relates the tale, the worker "cut his way through the dense growth for no more than fifty yards when we came to a large

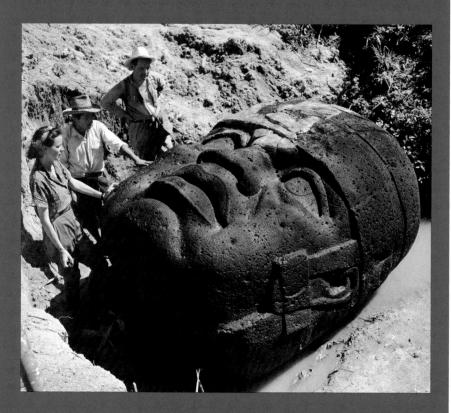

hemispherical stone almost completely concealed by vines and growth. I looked at it closely. Lo and behold, here was Blom's colossal head that we had almost given up hope of locating! . . . Less than twenty yards away a large stela lay on its back. This I immediately recognized as Blom's Stela 2.

"While this work was going on, a small boy who happened to be standing by remarked that he had seen some stones near the new milpa (maize field) his father was working. I went with him to a point in the forest about a half mile away, and one after another he showed me three round projecting stones in a line about thirty yards apart." When excavated, those stones turned out to be three more colossal stone heads! They were positioned about 100 yards north of the pyramid, and occurred in an east-west row (3.88). The new discoveries received the labels Heads 2, 3, and 4.

3.87 With the help of local villagers, the archaeologists Matthew Stirling and his wife, Marion, discovered this 8-foot-tall colossal head (Monument 1) in San Lorenzo in the state of Veracruz, Mexico, in 1945, a few years after their discoveries in La Venta.

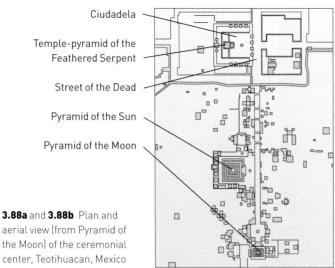

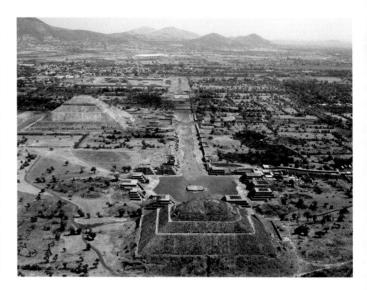

aerial view (from Pyramid of the Moon) of the ceremonial center, Teotihuacan, Mexico

Teotihuacan

The main components of the Olmec site at La Venta are a pyramid and a plaza, a layout that also features, on a much larger scale, at Teotihuacan, in the Central Highlands of Mexico about thirty miles from modern-day Mexico City. Teotihuacan was one of the largest cities in the world at the time. Around 500 CE, at the peak of its power, it had 600 pyramids and 2,000 apartment compounds (3.88a and 3.88b). A wide street, the Avenue of the Dead, runs north-south and is

about three miles long. At its northern end lies the Pyramid of the Moon. The Pyramid of the Sun lies on its east and the Temple of the Feathered Serpent is located to the south (3.88a and 3.88b).

The Pyramid of the Sun, Teotihuacan's largest structure, is a **stepped pyramid** (3.89). Covering 13 acres, its base is about 700 feet across on each side; it is 210 feet tall. The location of the Pyramid of the Sun was of utmost importance. It faced west—toward the setting sun and the Avenue of the Dead—and was built on top of a cave and a spring. Caves had religious significance

3.89 Pyramid of the Sun, c. 225 cE, Teotihuacan, Mexico

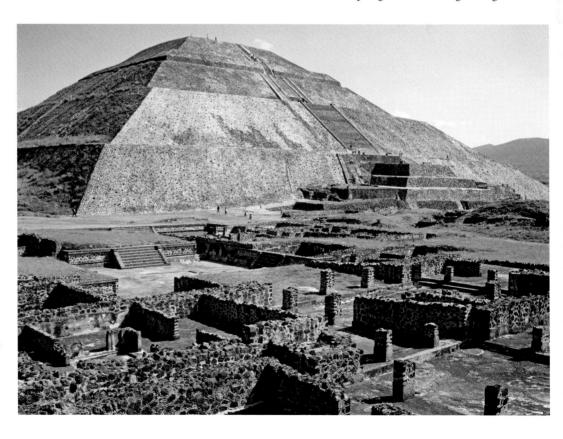

Stepped pyramid: a pyramid consisting of several rectangular structures placed on top of one another

3.90 Architectural sculpture with serpent heads and masks on the Temple of Quetzalcoatl at Teotihuacan, Mexico (also known as Temple of the Feathered Serpent)

throughout Mesoamerica because they were thought to connect the world of humans with the world of the gods. The Aztecs, who established a powerful empire in central Mexico about 800 years after Teotihuacan was abandoned, admired the cultural achievement of the Teotihuacanos. In fact, the name Teotihuacan is Aztec for "The Place of the Gods," and the Pyramid of the Sun was a place of pilgrimage for the Aztecs.

The Temple of the Feathered Serpent at Teotihuacan is located in an enclosed compound. The plaza next to it is below ground level to symbolize the underworld. Sculpted heads on the temple depict serpents with feathers and jaguar features alongside square heads with goggle eyes and fang-like teeth (3.90). To the Aztecs these sculptures looked like images of their gods Quetzalcoatl, the feathered serpent, and Tlaloc, the goggle-eyed rain god. These figures symbolized warfare and fertility, or perhaps cycles of wet and dry seasons.

The Maya

The dates for Maya civilization are from about 2000 BCE to 1500 CE. At the peak of the Maya empire, from about 300 to 900 CE, there were Maya centers in Mexico, Guatemala, Belize, Honduras, and El Salvador. By 900 most of them had faded

away, but the civilization continued to exist in isolated locations. Surviving Spanish colonization, the Maya continue to speak their own language and now number an estimated 7 million.

Mythology and cosmology and their associated rituals were important to Maya society. The ballgame was a common ritual event in Mesoamerica and could also be played for sport, gambling, or as a gladiatorial contest to the death (3.91). The rubber ball, magnified on the cylindrical vessel shown here, was about eight inches in diameter. The game was played on a court; the objective was to get the ball through a ring or into a goal area without using one's hands. The rings were very high off the ground and virtually impossible to get the ball through. Players wore protective gear, including yokes, fitted round the waist to strike the ball and protect the body. They used hachas or palmas (thin flat stones) to guide and deflect the ball. The elaborate quality of the yokes and helmetlike headdresses of the players on the vessel in 3.91 indicate that this was a ceremonial game played for the purposes of ritual.

Mesoamerican ballgames often served as the arena for the final stages of warfare in which captured enemies met their fate. The murals at the Maya city of Bonampak in southern Mexico show the victory of the Lord of Bonampak, Chaan Muan, in 790 CE, and the treatment of his

3.91 Cylindrical vessel with ritual ballgame scene. c. 700–850. Ceramic, $6^{1/4} \times 4^{\circ}$. Dallas Museum of Art. Texas

3.92 Bonampak mural, Room 2, copy of fresco from Room 2. original 8th century. Peabody Museum, Harvard University, Cambridge, Massachusetts

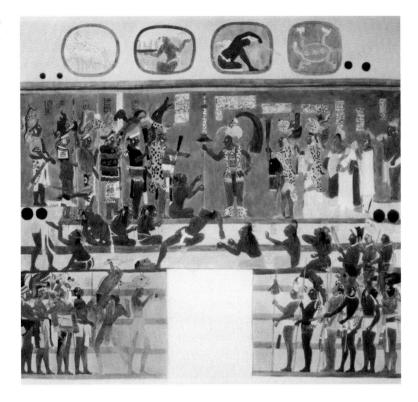

defeated opponents. The wall illustrated in 3.92 shows the ritual presentation of captives on the steps of a temple. Chaan Muan is shown at the center of the composition wearing a headdress with long green feathers; his ministers and aides stand beside him, well armed and in full regalia. The prisoners have been stripped of their own clothing and weapons, and are naked and vulnerable. They have been tortured, perhaps starved, and likely made to play a fixed and fatal ballgame in which the losers are eventually to be executed. The man sprawled out on the step at the ruler's feet has an incision in his side, indicating that he is already dead. To the left of this figure are several prisoners with blood dripping from their fingers, their fingernails recently ripped out. The Maya considered blood on the steps a sign of their triumph and a sacrifice to please the gods, and they wanted as much of it on the building as could be spilled.

The Aztecs

The Aztecs formed a powerful empire in Mesoamerica, which they dominated at approximately the same time the Inca were in power in South America (from 1400 until Spanish occupation in the 1520s and 1530s). At its peak,

the empire covered Central Mexico, Guatemala, El Salvador, and Honduras; the Aztecs were conquered by Cortés in 1524.

In a manner similar to the Olmec, Teotihuacan, and Maya societies before them, the Aztecs placed pyramid structures in the center of their cities, emphasizing their importance as the site of rituals. Among the most notorious of these rituals was the practice of sacrificing a person by extracting from the body his or her still-beating heart (3.93). Sacrifices to the gods

3.93 A human sacrifice, fol. 70r of the Codex Magliabechiano, 16th century. European paper, $6^{1/2} \times 8^{7/8}$ ". Biblioteca Nazionale Centrale, Florence, Italy

Pueblos: word meaning "town" that refers to Anasazi settlements throughout the Four Corners area of Utah, Colorado, New Mexico, and Arizona; also the name of groups descending from the Anasazi

were performed at specific times of the year, such as planting season, and at certain points in the ceremonial calendar, for example the end of a 52-year cycle. Important events, such as the dedication of a new temple, might also be the occasion for sacrifices. Capturing victims for this purpose was one of the major goals of warfare, another being to expand the empire. People sometimes sacrificed members of their own community. In some cases it was considered an honor to die by the sacrificial blade; other individuals were selected because they had been born on an "unlucky" day.

The Aztecs based some of their sacrifice rituals on the story of their origins, which they traced to a mythical place called "Aztlan." The Aztecs believed that their ancestors had journeyed from Aztlan to their future capital at Tenochtitlan (modern Mexico City). During their journey they met Coatlicue, or "Serpent Skirt," the guardian at Serpent Mountain. Coatlicue had been impregnated by a ball of feathers that fell from the sky; her son Huitzilopochtli, the god of war, was miraculously born fully armed.

When Coatlicue's other children attempted to murder their dishonored mother, Huitzilopochtli

defended her by attacking his sister Coyolxauhqui, or "She of the Golden Bells." Coyolxauhqui's dismembered body was rolled in pieces down Serpent Mountain.

The events of Huitzilopochtli's birth are the source for many Aztec artworks, including a colossal sculpture of Coatlicue (3.94). A ferocious face, created by the profiles of two facing serpent heads, enhances her imposing presence. She also has a necklace

3.95 The Dismemberment of Coyolxauhqui, Goddess of the Moon, late postclassic. Stone, 9'101/8" diameter. Museo del Templo Mayor, Mexico City

made of human hearts and hands, with a skull pendant. Coatlicue was the Mother Goddess, associated with the earth, fertility, and transformation, who was seen as both creator and destroyer.

Coyolxauhqui's dismemberment was commemorated on a stone disk (3.95) placed at the base of an early temple built on the site of the Great Temple of the Aztecs in Tenochtitlan. The goddess is shown in a simplified but realistic way, with parts of her body scattered across the circular surface. Each limb, like her waist, is tied with a rope that has snake heads on the ends. The incorporation of skulls throughout the sceneat her waist, elbows, and knees-evokes her violent murder. The placement of the disk also symbolized the treatment of sacrificial victims: their bodies were thrown down the steps of the Great Temple to land where the disk of Coyolxauhqui lay as a sign of their defeat.

This story poetically explains astronomical phenomena observed by the Aztecs. Coatlicue (the earth) gives birth to Huitzilopochtli (the sun), who then slices up his sister (the moon), as their siblings (the stars) stand by. It is a metaphor for the phases of the moon, when the sun—with the help of the earth's shadow—appears to slice up the moon during an eclipse.

3.94 The Mother Goddess. Coatlicue, c. 1487-1520. Andesite, 11'6". National Museum of Anthropology, Mexico

North America

During the thousands of years before Europeans arrived, the people who lived in the North American continent occupied arctic regions, ocean coasts, dry desert lands, semi-arid plains, and lush forests. The resources available to these original Americans were therefore very diverse. In modern Arizona, New Mexico, and Colorado, some groups lived in permanent dwellings made of adobe. Other people from the midwest to modern-day Mississippi and Louisiana constructed settlements of wood and earth and made large ceremonial mounds. On the northwest coast, fishing communities built villages using abundant local wood. Still others lived nomadic lives, moving to find their food and other essential materials. Not surprisingly, the people of North America spoke many different languages and developed diverse cultural traditions. Their structures and domestic objects met their practical needs, but many were so beautifully decorated that today we call them "art." Although European invaders killed many native people and displaced others, some survived, maintained their cultural traditions, and continued to make fine artworks.

The Anasazi

The people of North America used local materials to build practical structures that provided shelter. Late in the twelfth century (c. 1150 CE), a drought forced the Anasazi people to abandon their homes, called **pueblos**, on the canyon floors of New Mexico, and move north to what is now southwestern Colorado. When they arrived at Mesa Verde they constructed communal dwellings of stone, timber, and adobe (sun-dried bricks made of clay and straw) in ridges high on cliff faces often hundreds of feet above the canyon floor (3.97). These locations took advantage of the sun's orientation to heat the

3.96 (above right) Map of North America

3.97 (right) Cliff Palace, 1100-1300, Mesa Verde, Colorado

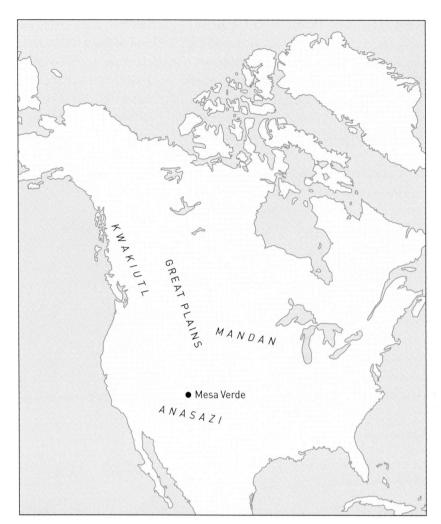

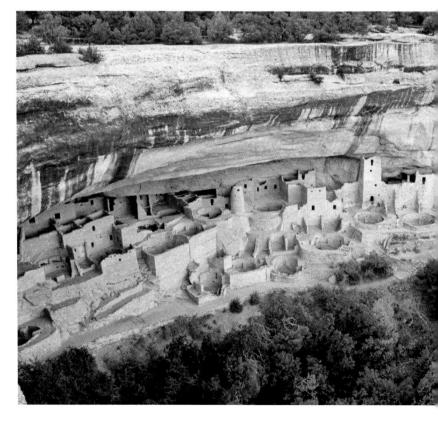

pueblo in the winter and shade it during the hot summer months. Exactly why or even how the cliff dwellings were constructed we do not know. Similarly, we do not know what happened to the Anasazi after the four-corners area (the place where today Utah, Colorado, New Mexico, and Arizona meet) was abandoned between about 1300 and 1540. Although modern descendants of the Anasazi—the Hopi, Zuni, Tewa, and Taos Indians—have many cultural and symbolic connections with their ancestors, even they do not know the full story.

Plains Indians

Pushed westward by European expansion, many native Americans were forced into the Great Plains region. Groups belonging to the Sioux clan, such as the Lakota and Crow, became nomadic, living in portable homes called tipis (also spelled teepees), made of

wooden poles covered with bark or deer and buffalo hides. The Mandan had been living on the Plains in what is now North and South Dakota for more than a thousand years. They had established permanent villages, but they used tipis when hunting or traveling. The Battle Scene Hide Painting in 3.98 shows a detailed,

3.98a and (detail) 3.98b Robe with battle scene, 1797-1800. Tanned buffalo hide, dyed porcupine quills, and pigments, $37 \times 40^{1/4}$ ". Peabody Museum of Archaeology, Harvard University, Cambridge, Massachusetts

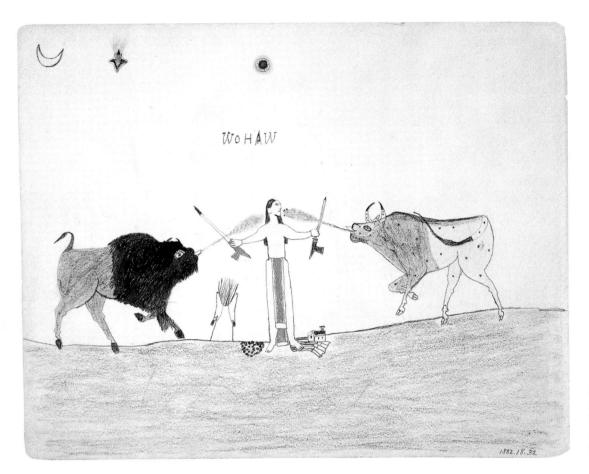

3.99 Wo-Haw, Wo-Haw between Two Worlds, 1875-7. Graphite and colored pencil on paper, 8 ½ × 11". Missouri Historical Society, St. Louis

naturalistic representation of a battle in 1797 between the Mandan of North Dakota and the encroaching Sioux. Sixty-four combatants, twenty of them on horseback, are engaged in battle with spears, bows and arrows, tomahawks, and guns. This hide was meant to be draped over the shoulders of its wearer, likely someone who played a key role in the battle it depicted. Hides used for tipis and as garments were decorated with different **motifs**. This narrative scene would have served a commemorative purpose for both the individual wearer and the Mandan people.

While the Mandan robe tells us something of a battle between two native North American tribes, Wo-Haw between Two Worlds offers a window into the changing existence of one individual as a result of westward European expansion (3.99). It is a drawing from a sketchbook kept during the artist's imprisonment in Fort Marion, Florida, between 1875 and 1878. Wo-Haw was one of about seventy Kiowa, Cheyenne, and other Plains individuals arrested in Oklahoma for allegedly committing crimes

against white settlers. Twenty-six of the men made art while they were in captivity. No traditional materials, such as the buffalo hide and mineral pigments used in the Mandan robe, were available, so they used the pencils and paper provided for them.

Wo-Haw's self-portrait shows him caught between the two worlds referenced in the drawing's title: that of his ancestry on his right side (our left) and the new presence of European settlers on his left. His Kiowa heritage is represented by a buffalo and a tipi underneath a crescent moon and a shooting star. The world of whites is represented by a domesticated bull, cultivated fields, and a European-style frame house. Wo-Haw holds peace pipes toward both the Native American and European worlds, expressing the hope that they can learn to live in peace.

The Kwakiutl

The Kwakiutl, native Americans in southern British Columbia, Canada, continue to practice ceremonies passed down through the generations. Tipi or teepee: portable dwelling used by Plains groups Naturalistic: a very realistic or lifelike style of making images Motif: a distinctive visual element, the recurrence of which is often characteristic of an artist's work

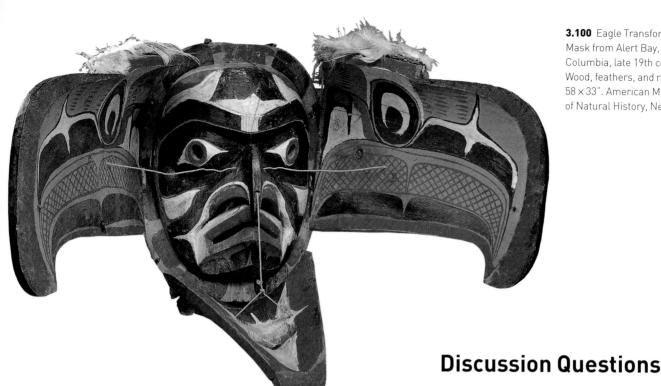

3.100 Eagle Transformation Mask from Alert Bay, British Columbia, late 19th century. Wood, feathers, and rope. 58 x 33". American Museum of Natural History, New York

They are known for their masks, which they use ceremonially in different ways, depending on the time of year. The late-nineteenth-century Eagle Transformation Mask (3.100) was probably used in a public summer performance for a coming-of-age ceremony. The eagle was likely the spirit guardian revealed during a vision quest undertaken at the onset of puberty. As such, the Eagle Transformation Mask showed the deep, inner reality of the wearer, who used the strings to open and close the mask, giving the impression he was transforming into an animal. In flickering firelight the mask's movement created an impressive spectacle as its human aspects, such as the large nose, combined with animal features, in this case a curved beak. The dancer thus transformed himself from human to eagle and back again as he danced. This performance served a ritual function, highlighting the powerful nature of the eagle, transferring that bravery and strength to the human wearer and his community. It also represents the ancestral connections between humans and eagles. The transformation that was enacted during the performance also symbolized the changes the wearer experienced during initiation.

- 1 Select three artworks from the Americas that deal with supernatural beings or gods. What do you think they tell us about the importance of the supernatural to ancient Americans? You might choose one work from another chapter in this book, for example: 1.35, 2.139, 4.51.
- Select three examples of artworks that incorporate aspects of nature or the environment in their imagery and discuss why artists of the ancient Americas were so interested in these themes. You might choose one work from another chapter in this book, for example: 1.1, 4.50.
- Choose three artworks that represent the power of rulers and discuss how that power is represented visually. You might choose one work from another chapter in this book, for example: 4.49, 4.92.
- The arrival of European settlers on the American continent had a profound impact on indigenous beliefs and cultural practices. Select three works of art from the Americas that in different ways would have clashed with European viewpoints or that expressed the views of indigenous Americans about the European settlers. You might choose one work from another chapter in this book, for example: 4.46.

Images related to 3.4: Art of the Americas

2.154 Great Serpent Mound, **4.12** Cahokia, Illinois, c. 1150 c. 800 BCE-100 CE, p. 267

(reconstruction drawing), p. 463

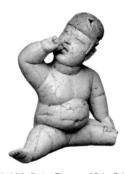

century BCE, p. 251

2.128 Baby Figure, 12th–9th **1.1** Spider, c. 500 BCE–500 CE, p. 47

4.49 Sarcophagus lid, tomb of Lord Pacal, c. 680 cE, p. 490

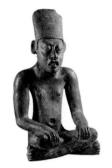

2.127 Seated Figure, 300 BCE-700 CE, p. 250

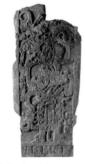

1.35 Stela with supernatural scene, 761 CE, p. 67

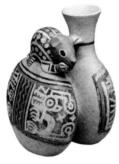

1.141 Double-chambered vessel with mouse, 4th-8th century, p. 136

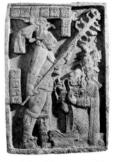

4.92 Shield Jaguar and Lady Xoc, c. 725 CE, p. 523

4.59 Eccentric flint depicting a crocodile canoe with passengers, 600-900 cE, p. 497

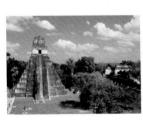

2.168 Temple I in the Great Plaza, Tikal, c. 300-900 CE, p. 276

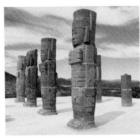

4.108 Tula warrior columns, 900-1000 CE, p. 534

4.60 Calendar stone, late postclassic, p. 497

4.51 Vessel with mask of Tlaloc, c.1440-69, p. 491

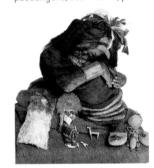

4.46 Mummy of a boy, c. 1500, p. 488

2.139 Tlingit Chilkat dancing blanket, 19th century, p. 258

4.50 Hopi kachina doll, c. 1925, p. 491

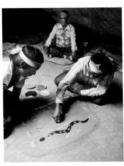

4.16 Navajo medicine man in healing ceremony, c. 1908, p. 465

3.5

Art of Africa and the Pacific Islands

As diverse as they may at first seem, the artworks produced on the expansive continent of Africa and in the remote islands of the Pacific Ocean have some intriguing similarities. In both areas art integrates and responds to the environment, incorporates important mythological beliefs, and follows traditional methods of construction and decoration.

Both of these regions' artistic traditions rely on such natural materials as wood, reeds, shells, and earth. For example, cowrie shells feature prominently in the nkisi nkonde (see p. 366) from the Democratic Republic of Congo and the decoration of the Abelam cult house in Papua New Guinea (see 3.116, p. 374). In both parts of the world, the shells are symbols of fertility. Natural materials often have symbolic significance, but because they—wood in particular—are usually perishable, few examples of ancient artworks made from such substances remain.

As we find elsewhere in the world, artists in Africa and the Pacific Islands tend to serve as communicators for and within their communities. They record events and relate important cultural beliefs, such as rules for acceptable behavior, or fables that seek to explain the mysteries of the world. In both areas, ritual is an integral part of their creations. Special objects are produced for ceremonies to celebrate birth, to mark a child's passage into adulthood, and to remember those who have died.

Perhaps the most striking similarity between art made in Africa and that of the Pacific Islands is the continuity of traditional techniques. Artists usually have to undergo an apprenticeship

lasting several years. In these cultures, learning traditional ways to make objects is more important than building an individual reputation. Although some artists have become legendary, the names of most have been forgotten over time.

Art of Africa

Modern Africa has 54 different countries, more than 955 million inhabitants, and at least 1,000 different languages. Archaeological evidence from about 200,000 years ago suggests that the first modern humans lived on the African continent, before moving to other parts of the world. As regards more recent records of human activity, oral history has been more important for African communities than written documentation: records of specific events do not exist in many areas, especially south of the Sahara. Art has therefore been a particularly important form of communication and cultural expression. Among the earliest examples of African art are portable objects, such as beads made from shells that date back to 75,000 years ago. Wooden sculpture and architecture also have long traditions, although ancient examples have perished.

Portraits and Power Figures

For thousands of years, people have used art to tell stories about and create images of their daily lives. African rulers, like elites everywhere, have used art to assert and reinforce their power, and

3.102 Head from Rafin Kura, c. 500 BCE-200 CE. Terracotta, 141/4" high. National Museum, Lagos, Nigeria

3.101 Map of Africa

Figurative: art that portrays items perceived in the visible world, especially human or animal forms

Terracotta: iron-rich clay, fired at a low temperature, which is traditionally brownish-orange in color

Coiling: the use of long coils of clay-rather than a wheel-to build the walls of a pottery vessel Firing: heating ceramic, glass, or enamel objects in a kiln, to harden them, fuse the components, or fuse a glaze to the surface

some of the art they have commissioned has also emphasized their connection with the supernatural realm, thereby encouraging a sense that their authority to rule has been bestowed upon them by gods or ancestor spirits. It is also believed that artworks can act as conduits to the spirit world, and permit supernatural forces entry into the human world, to bestow good or ill fortune.

The objects themselves are invested with power, and a certain amount of power is also associated with the owner. Often objects or artworks communicate the rules and customs that members of society are expected to follow. These objects can be symbolic, related to a particular position or role; or they can tell a tale, illustrating a proverb or a story with a specific message.

Although we do not know the exact meanings and uses of some of the oldest known figurative sculptures in Africa, they have a strong physical presence. The Nok of Nigeria made hollow, lifesized terracotta figures with a coiling technique

commonly used to make pottery vessels. The features and details of the sculptures were carved in a manner similar to woodcarving. Because clay is a durable but breakable material, very few of the sculptures have been found undamaged. In many cases only the heads remain intact (3.102).

Like many Nok heads, the piece in **3.102** has a distinctive hairstyle or headdress, with three conical buns on top. Also characteristic of Nok sculpture, the head has triangular-shaped eyes and holes in the pupils, nostrils, mouth, and ears, which probably facilitated air flow during **firing**. In the life-sized sculptures that have survived, Nok figures are shown standing, kneeling, and sitting, wearing detailed jewelry and costumes. The heads are proportionally much larger than the bodies, a feature that is also common in later traditions in African art: the head, because it is associated with knowledge and identity, is emphasized in many figurative sculptures.

3.103 (above left) Twin figure, probably from Ado Odo in Yorubaland, pre-1877 (probably 19th century). Wood, 10" high. Linden Museum, Stuttgart, Germany

3.104 (above right) Standing male figure (nkisi Mangaaka), late 19th century. Wood, iron, raffia, ceramic, kaolin pigment, red camwood powder (tukula), resin, dirt, leaves, animal skin, and cowrie shell, $43^3/4 \times 15^1/2 \times$ 11". Dallas Museum of Art. Texas

The Yoruba of western Nigeria contributed much to the rich tradition of figurative sculpture in Africa. Sculptors working in the Yoruba city of Ife produced impressive terracotta and metal sculpture; and the twin figure in 3.103 displays Yoruba skill at woodcarving. This sculpture is essentially a doll; it was used to teach young children how to raise a baby, and was carried around, dressed, and fed. This doll looks like a miniature woman, with elongated breasts, an elaborate hairdo, and scarification associated with childbirth, but it also has some features that are characteristic of a girl: its small size, large eyes, and the lock of hair worn in front. Such dolls were commonly commissioned when twins were born. If one of the twins died, the doll was cared for alongside the child who lived. The doll was a lifetime possession. When a woman married she kept her doll with her to aid her fertility. This twin figure shows how Yoruba hand-made objects are invested with spiritual powers of their own.

Also known for a strong sculptural tradition, the Yombe use power figures as reminders of

social obligations and enforcers of proper behavior. Objects called minkisi nkondi (the singular nkisi means "sacred medicine"; nkondi comes from konda, "to hunt") could take the form of shells, bags, pots, or wooden statues. Substances, or actual medicines, might be placed inside the minkisi to give them certain properties. In carved figures, these medicines were placed in the head or stomach area. A particular type of nkisi, called nkisi Mangaaka, is a standing figure with a beard that served as an additional reservoir for magical properties (3.104). White kaolin clay, shells, and other reflective objects on figures like this one symbolized contact with the supernatural. All minkisi were activated by ritual specialists believed to have the power to release the spiritual presence within the object.

Each figure served a specific function, but generally an nkisi Mangaaka was responsible for making sure that oaths sworn in its presence were honored. Each time the figure was needed, the ritual specialists would drive nails, blades, and other metal objects into its wooden surface to make it "angry" and "rouse it into action." As a mediator between the ancestral spirit world and the living world of human beings, the nkisi Mangaaka was able to bring protection and healing to the community. The nkisi Mangaaka shown here has been activated many times by iron blades. The giant cowrie shell on its abdomen is a powerful symbol for the Yombe people as well as other cultures. Widely used as currency, the cowrie likely refers to the power of the king, or, more generally, to fertility. This nkisi Mangaaka has wide, staring eyes and an imposing stance to help ensure that no other forces will interfere with the fulfillment of its ritual function.

Personal Stories and Symbolism

Because many kinds of information have traditionally been communicated visually rather than verbally in Africa, objects are often made with a specific purpose or even a specific person in mind. Artworks that contain abstract designs and patterns can convey information that is just as important, recognizable, and specific as

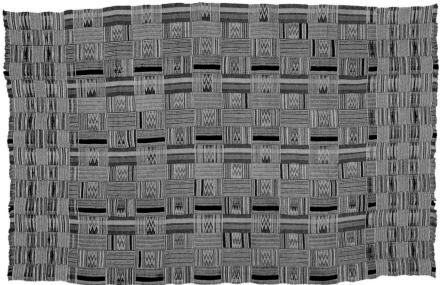

3.105 Textile wrapper (kente), 20th century. Silk, 6'105/8" long. National Museum of African Art, Smithsonian Institution, Washington, D.C.

representational images. They can also communicate a great deal about the maker or the user of an object. The symbols that decorate utilitarian objects, from clothing and pipes to bowls and chairs, and the care that went into making them, give them significance.

The colors, materials, and designs of textiles can indicate a person's age, station in life, and cultural connections. In the West African kingdoms of Akan and Asante in Ghana, woven fabrics called kente were traditionally worn only by royalty and state officials: the weaving techniques were too complex and the materials too valuable for ordinary people to wear the cloth. More recently kente have become accessible to the general public, though they are typically reserved for special occasions.

Making kente requires a loom that allows the weaver to integrate vertical and horizontal designs in a strip ranging from two to four inches wide. The strips are sewn together to make a complete cloth of geometric shapes and bright colors. Women wear the cloth in two parts, as a floor-length skirt and a shawl over the shoulder, while men drape it around themselves like a toga. The kente in 3.105 contains yellow, representing things that are holy and precious; gold, a symbol of royalty, wealth, and spiritual purity; green, for growth and good health; and red, for strong political and spiritual feelings.

In museums, masks are often presented as lifeless objects on display, isolated from the

vibrant sights, sounds, smells, and movements of the masquerade. For African groups, though, the mask is most meaningful when being performed. In fact, sometimes masks are created for a particular event and discarded afterward because they are no longer "alive." In other cases, masks are maintained from year to year and generation to generation by the performers and their apprentices.

The Dogon of Mali in West Africa traditionally used the Kanaga mask in ceremonies designed to assist the deceased in their journey into the spiritual realm (3.106). The two cross bars on the mask represent the lower earthly realm and the upper cosmic realm of the sky. In performance, dancers swoop down and touch the mask to the ground; loud noises, like the crack of gunfire, scare away any souls that might be lingering in the village. Today such rituals, also called masks, are danced only for tourists.

3.106 Kanaga mask from Mali, Dogon culture, early 20th century. Polychrome wood, leather cords, and hide, 451/4" high. Musée Barbier-Mueller, Geneva, Switzerland

Abstract: an artwork the form of which is simplified, distorted, or exaggerated in appearance. It may represent a recognizable form that has been slightly altered, or it may be a completely non-representational depiction Representational: art that depicts figures and objects so

that we recognize what is

represented

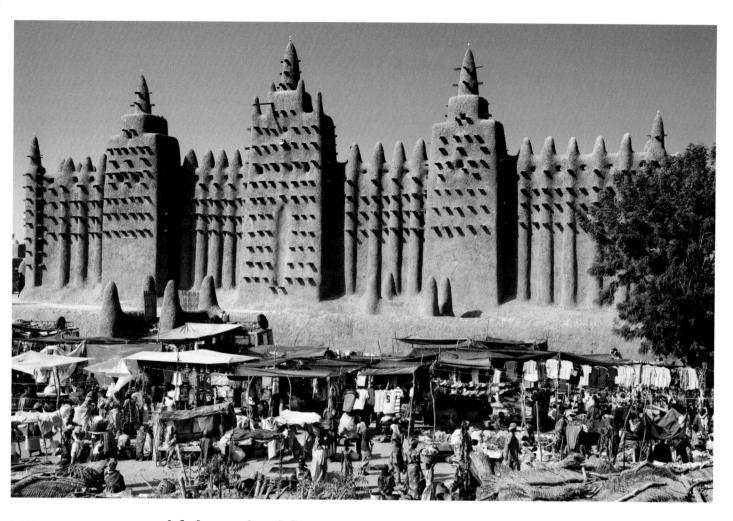

3.107 Monday market, Great Mosque, Djenné, Mali

African Architecture

The history of architecture in Africa is difficult to track because so many buildings were made of perishable materials, such as mud-brick and wood. Some ceremonial structures, places of worship, and royal residences have been maintained over time, but others have fallen into ruin, creating only a mysterious sense of the past. The symbolism of the structures and ornamentation of the buildings communicate to us the importance of spiritual concerns, ties to ancestors, and connections with nature.

The town of Djenné in Mali has long been a trade center and site of Islamic learning and pilgrimage. The town's Great Mosque is located next to Djenné's bustling marketplace. An earlier building on this site was a mosque adapted from the palace of Koi Konboro when he converted to Islam in 1240. Several centuries later, in 1834, Sheikh Amadou Labbo ordered that the mosque be demolished. He considered the original too

lavish, and built a more modest one on the site. The current building, more in keeping with the thirteenth-century version, was finished around 1907 while Mali was under French occupation. It is considered the largest mud-brick structure in the world.

The Great Mosque combines characteristics of Islamic mosques with West African architectural practices. The *qibla*, or prayer wall, faces east toward Mecca. Three **minarets**, or towers, call the faithful to prayer. Spiral staircases inside the minarets lead to the roofs with coneshaped spires topped by ostrich eggs. These ostrich eggs are important symbols of fertility and purity for the people of Djenné.

The clay-mud and palm-wood exterior of the building is similar to the houses of Mali. Numerous wooden beams line the mosque's surface not only to give it a distinctive look but also to serve functional purposes. Some beams structurally support the ceiling, but most are used to access the walls for annual maintenance. The

3.108 Conical Tower, c. 1350-1450, Great Zimbabwe, Zimbabwe

area's hot climate has also affected the building's design, with roof ventilation to cool the building and mud-brick walls to regulate the temperature. The walls' thickness ranges from 16 to 24 in.; they are thickest where they are tallest. They absorb heat to keep the interior cool during the day, and release it at night to keep it warm.

Among the largest and most impressive examples of architecture south of the Sahara Desert are the massive stone walls of the Great Zimbabwe, built and expanded from the eleventh to the fifteenth centuries in southern Africa (3.108). The name Zimbabwe comes from the Shona phrase for "venerated house," indicating a connection that the modern-day Shona make between themselves and the former inhabitants of this site. The remnants of altars, stone monoliths, and soapstone sculptures found at Great Zimbabwe suggest that it may have been an important

religious shrine. During its prime, from about 1350 to 1450, this site functioned as an important cattle farm and trade center. Exports of gold, copper, and ivory went to the Indian Ocean region and East Africa; cloth, glass beads, and ceramics were imported from India, China, and Islamic countries. It is estimated that between 10,000 and 20,000 people lived in the city's surrounding area, with several hundred elite residing inside the walls of the Great Enclosure. But by the end of the fifteenth century, when centers of trade moved to the north, the site had been abandoned.

Many of the original mud-and-thatch buildings and platforms have long since disintegrated, but the sturdily built stone walls and structures remain. The walls likely served as a symbolic display of authority, a way to distinguish the areas used by royalty from the rest of the village. The curving walls were built without mortar from slab-like pieces of granite quarried from the nearby hills. They range in thickness from 4 to 17 ft. and are about twice as high as they are wide. The stability of the walls is increased by their design, which slopes slightly inward at the top. The purpose of the Conical Tower, an imposing structure that is completely solid and rises above the high wall of the Great Enclosure, remains a mystery.

Sculptures are often integrated into buildings as decoration and to invest the space with symbolic meaning. Eight carved pieces of soapstone, each about 16 in. tall, were found on top of columns at the Great Zimbabwe. The image of the creature in 3.109 combines the features of a human-like bird and crocodile (the crocodile's eyes and zig-zag mouth are visible just below the bird's leg and tail feathers). The bird's beak has been replaced with human lips, and its claws look more like feet, suggesting that these figures have supernatural significance. In fact, the Shona believe that ancestral spirits visit the living world through birds, especially eagles. Birds are considered messengers from the spirits because they traverse freely between the realms of the sky and the earth. These sculptures reflect some of the core beliefs in many African cultures: the symbolic use of emblems of royal authority, reminders of familial relationships, and expectations of spiritual reward in the afterlife.

3.109 Bird on top of stone monolith, 15th century. Soapstone, 141/2" high (bird image). Great Zimbabwe Site Museum, Zimbabwe

Qibla: the direction to Mecca, toward which Muslims face when praying

Minaret: a tall slender tower, particularly on a mosque, from which the faithful are called to prayer

Monoliths: monuments or sculptures made from a single piece of stone

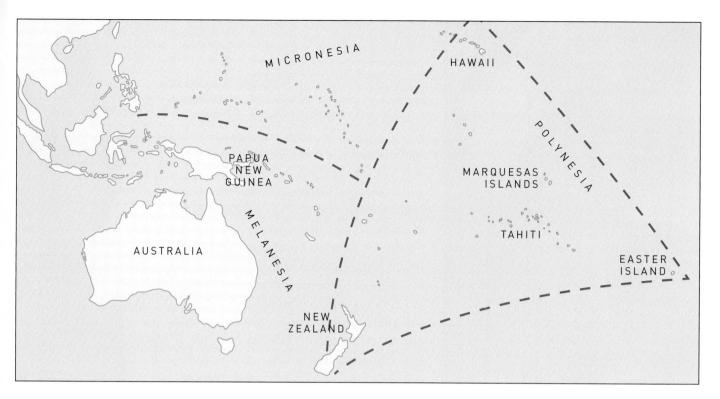

Art of the Pacific Islands

The geographic area of the Pacific Islands includes Polynesia, Melanesia, Micronesia, and Australia (see Perspectives on Art: Australian Rock Art). The islands are separated by enormous expanses of ocean, but since ancient times the people living there have been connected by shared beliefs, languages, and similarities in their cultures, which strongly value customary ways of life and behavior, such as farming, ancestor worship, and the preservation of social and artistic traditions.

The art of the Pacific Islands includes such portable objects as jewelry, furniture, and weapons; body ornamentation; wooden sculpture; paintings on rock; monumental sculptures; masks; and ceremonial architecture. The works often combine practical usefulness with sacred significance, thus linking the everyday world and living people with their ancestors and gods.

New Zealand

The Maori of New Zealand have one of the most elaborate traditions of tattooing in the world. Their words for it are ta moko. **Tattoos** (or moko) are made by injecting a pigment or dye under the skin so that a permanent mark is left on the body. It is not known when the first tattoos were made. The earliest preserved tattooed bodies date back to c. 3300 BCE and feature abstract tattoos composed of designs with dots and line patterns; Maori designs are part of this tradition (3.111).

The designs mark specific events in the wearer's life, such as reaching puberty, becoming a warrior, making a kill, getting married, having a

3.110 Map of the Pacific Islands

3.111 Sydney Parkinson, Drawing of traditional Maori tattoo, from A Journal of a Voyage to the South Seas (1784), Pl. 16

Tattoos: designs marked on the body by injecting dye under

Contour lines: the outlines that define a form

Perspectives on Art: Paul Tacon **Australian Rock Art**

3.112 X-ray kangaroo rock painting, c. 1900. Ocher and kaolin paint, 6'91/2" high. Kakadu National Park, Northern Territory, Australia

Paul Tacon is an Australian anthropologist and archaeologist who specializes in the art of the Aboriginal people of Australia. Here he describes how Aboriginal rock paintings thousands of years old served communal purposes. He also connects them to the practice of contemporary Aboriginal artists.

Rock art subject matter in Australia is often derived from the life experience of the Aboriginal people and from nature, but it also has much mythological content. In many cases it is intimately linked to oral history and storytelling, singing, and performance. Hunting kangaroos would have been a familiar activity, but the slender figure, a "Mimi," is one of the spirits who taught humans to hunt and paint during one of the early eras of the "Dreaming," or the creation period. Paintings of this type from Arnhem Land in Australia's north are less than 4,000 years old. They often show figures with aspects of internal or "x-ray" detail, such as an indication of the spine and some internal organs, in addition to the exterior contour lines. Although these

paintings could be used to teach young people about hunting and food-sharing practices, it seems most paintings were not used as a magical aid to hunting. Rather, both x-ray and solid infill animals were more often painted after they were caught and as part of storytelling.

Aboriginal Australian designs are tremendously variable across the country and over time. Some form of art has been practiced for at least 40,000 years, although most surviving prehistoric art is less than 15,000 years old. It is estimated there are well over 100,000 surviving rock art sites—places with paintings, drawings, stencils, carvings, and figures made out of beeswax; these artworks have been made on the walls and ceilings of rock shelters, in caves, on boulders, and on rock platforms. Today, Aboriginal artists paint on such surfaces as sheets of bark, paper, canvas, bodies, houses, cars. They use cameras, make films, and produce multimedia and computer-manipulated works. A concern for the land, people, and other creatures has always been important for all Aboriginal groups.

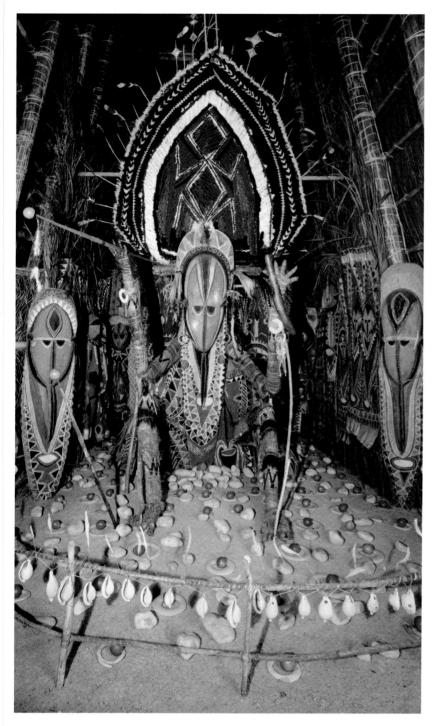

3.116 Interior of Abelam cult house, Bongiora, Maprik, Papua New Guinea, Melanesia. Museum der Kulturen, Basel, Switzerland

Another important ceremony for the Abelam has traditionally been the initiation cycle for male members of the community. Eight separate rituals take place over the course of twenty or thirty years before a man is fully initiated. The elaborate ceremonial houses where some rites of passage take place are meant to impress the initiate with the power and intrigue of Abelam deities and traditions (3.116). The interior space is filled with detailed wooden figures

representing supernatural beings, and with meaningful objects.

Colors and shapes have symbolic meaning in Abelam art; for example, white is believed to make long yams grow, and the pointed oval shape represents the belly of a woman. The use of yellow, red, and white is common. Certain objects, such as large cowrie shells, represent fertility and prosperity. Abelam see individual carvings, as well as the entire ceremonial houses, as temporary. They are important during use but to be discarded afterwards. Because of the powerful nature of the objects and imagery, they must be taken far away from the village, and are sometimes abandoned in the jungle or sold to collectors or museums.

Discussion Questions

- Discuss three artworks that have been used in a ritual context. Consider how they were made and why they might have been made that way. You might choose one work from another chapter in this book, for example: 1.158, 4.16, 4.39.
- Consider the ways that inanimate objects have been imbued with power. What has to be done to them for their power to be activated? What happens to that power over time? You might choose one work from another chapter in this book, for example: 4.26, 4.43, 4.134.
- Choose three artworks connected with family or ancestors. Consider how the artworks express ideas about family and ancestors and why these concepts might be important. You might choose one work from another chapter in this book, for example: 4.16, 4.24, 4.44.
- 4 Mythology and legend have been very informative to the makers of art in these areas. Consider the stories that are being told according to the evidence we have about the artworks in this chapter. What kinds of information are we missing? How might we fill in the blanks?

Images related to 3.5: Art of Africa and the Pacific Islands

0.18 Benin hip pendant, mid-16th century, p. 43

1.116 Romare Bearden, The Dove, 1964, p. 120

1.133 Figure of Oni, early 14th-15th century, p. 132

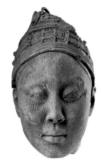

4.134 Head, possibly a king, 12th-14th century, p. 559

4.39 Ritual vessel, 13th-14th century, p. 484

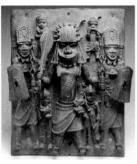

4.98 Plaque with warrior and 1.158 Bai-ra-Irrai, originally attendants, 16th-17th century, p. 527

built c. 1700, p. 149

2.150 Figure of the war god Ku-ka'ili-moku, 18th or 19th century, p. 265

4.24 Mother and child figure, late 19th-mid-20th century, p. 472

4.148 Chibinda Ilunga, mid-19th century, p. 569

4.44 Kneeling female figure with bowl and child, 19th-20th century, p. 487

4.43 Bis ancestor poles, late 1950s, p. 487

4.16 Pair of Gèlèdé masqueraders, 1970, p. 465

4.26 Chair, early 20th century, p. 473

3.6

Art of Renaissance and Baroque Europe (1400-1750)

The thousand years of European history known as the Middle Ages were followed by the period known as the **Renaissance** (1400–1600). The term means "rebirth," a reference to a renewed interest in the Classical world of Greece and Rome. The influence of Classical subject matter is evident in the numbers of nudes and mythological figures in Renaissance art. Yet artworks from the Renaissance, even those

with Classical subjects, often have a Christian message.

The Renaissance was also marked by an increased interest in education and the natural world. Improved literacy, travel, and books (made possible by the invention of moveable type in the 1400s) expanded the transmission of ideas and artistic developments throughout Europe. Humanism became influential as a philosophical

3.117 Map of Renaissance and Baroque Europe

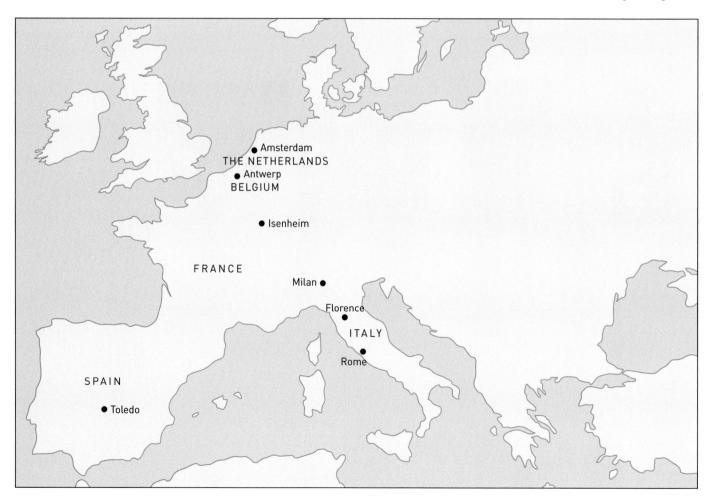

approach to life that stressed the intellectual and physical potential of human beings to achieve personal success and to contribute to the betterment of society.

Religion continued to be a large component of people's lives. The Reformation (beginning in 1517) resulted in Protestants breaking away from the Catholic Church. The Catholic Church's Counter-Reformation (1545–1648) was an attempt to define further the beliefs of Catholics in opposition to the Protestants. Both the Reformation and the Counter-Reformation had a great impact on the way art was made. Generally, Catholic artwork highlighted the power of intermediaries such as saints and the Church—between Christians and God. Since the Catholic leadership was based in Rome, much of the artwork of the Italian Renaissance reflects Catholic doctrine. By contrast, in northern Europe, artworks inspired by Protestant beliefs were common. Protestantism is based on a more individual and direct relationship with God rather than one strictly guided by and through the Church. As a result, northern Renaissance imagery often includes intimate scenes and intricate details.

Italian artist and historian Giorgio Vasari (1511–74) used the term Renaissance (rinascità) in the first art history book, The Lives of the Most Excellent Painters, Sculptors, and Architects, which was published in 1550 (3.118). Vasari's text emphasized the intellectual ability required to make paintings, sculptures, and architecture. Around this time artists began to be seen as creative geniuses, even divinely inspired, rather than manual producers of craft products. The art of the Renaissance can be divided into chronological and stylistic periods: early, high, late, and Mannerist, all of which are discussed in this chapter.

The period that followed the Renaissance is known as the **Baroque** (1600–1750). Like Renaissance, Baroque refers to both a historical period and a style of art. The seventeenth century is noted for an increase in trade, advancements in science, and the permanent division between the Roman Catholic Church and Protestants. Baroque art draws on much of the same subject matter as the Renaissance, but Baroque images tend to include more motion and emotion. The

3.118 Portrait of Michelangelo from Giorgio Vasari's Lives of the Great Artists, second edition, 1568. Engraving

Renaissance and Baroque periods were both marked by constant warfare throughout Europe, and art was often used to memorialize battles or to inspire people to support their rulers. Throughout these centuries, artworks were commissioned by wealthy patrons, often a church or ruling family, who determined such things as the size, subject matter, and even how much of an expensive pigment, such as ultramarine blue, the artist could use.

The Early Renaissance in Italy

Following the renewed interest in the Classical past and the influence of humanist thought, Italian artists during the early Renaissance were preoccupied with making pictures that their viewers would find entirely believable. The real, however, was balanced by the ideal, especially when the subjects were mythological or religious. Whereas during the Middle Ages, depictions of the nude body had been avoided except to show the weakness and mortality of such sinners as Adam and Eve, during the Renaissance, artists portrayed the idealized nude figure as the embodiment of spiritual and intellectual perfection.

Renaissance: a period of cultural and artistic change in Europe from the fourteenth to the seventeenth century Baroque: European artistic and architectural style of the late sixteenth to early eighteenth centuries, characterized by extravagance and emotional

individual who sponsors the creation of works of art Pigment: the colored material used in paints. Often made from finely ground minerals Ideal: more beautiful, harmonious, or perfect than reality

Patron: an organization or

Toward the end of the Middle Ages, the works of Giotto created a more believable, human space. They were part of a transition from spiritual Gothic art to the **three-dimensional** space that became characteristic of the Italian Renaissance. In art, although religious **subjects** remained popular, the emphasis switched from a belief in faith as the only factor in attaining immortality after death, to a concentration on how human actions could enhance the quality of life on Earth. Mathematics and science, derived from a renewed study of classical Greek and Roman works, encouraged the systematic understanding of the world. Renaissance artists used and refined new systems of **perspective** (discussed below) to translate their careful observations more consistently into realistic artistic representations. These influences inspired Renaissance artists to combine existing subject matter and techniques with innovative approaches.

The Italian sculptor and architect Filippo Brunelleschi (1377–1446) is famous for solving an architectural problem in Florence. More than a century after construction started, the cathedral was still unfinished because no one had figured out how to build its enormous 140-foot-diameter dome. In 1419 a competition was held and Brunelleschi's radical proposals won (3.119). He not only designed the dome but also devised the machinery used to build it, and oversaw the construction itself, thus earning him the right to be called the first Renaissance architect.

The dome was a great technological challenge. Existing construction techniques required temporary wooden scaffolding to form the shape of the dome (170 feet above the ground at its top) until the stonework was finished—which in this case would have been too costly and heavy. The enormous weight of the bricks and stone could not be held up by external stone supports either, because of the existing buildings around the cathedral. Brunelleschi invented equipment to hoist the building materials and came up with an ingenious system that used each stage of the structure to support the next as the dome was built, layer by layer (3.120). The dome's construction began in 1420 and took sixteen years to complete.

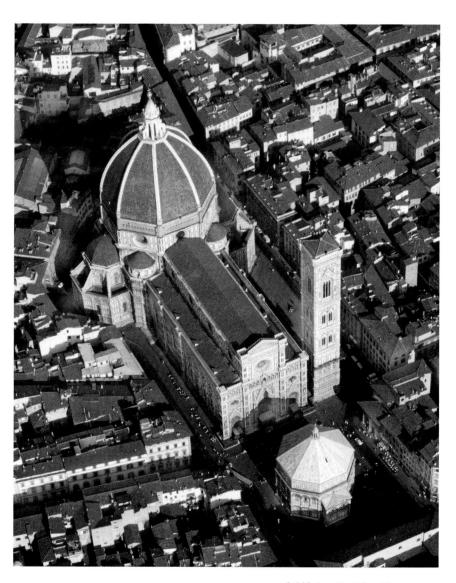

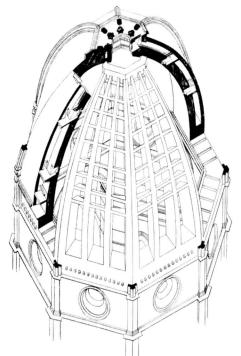

3.119 Arnolfo di Cambio and others, Florence Cathedral, view from south, begun 1296

3.120 Filippo Brunelleschi, Dome of Florence Cathedral. 1417-36

Three-dimensionality: the condition of having height, width, and depth

Subject: the person, object, or space depicted in a work of art **Perspective:** the creation of the illusion of depth in a twodimensional image by using mathematical principles

Linear perspective: a system using converging imaginary sight lines to create the illusion of depth

Fresco: paintings made on freshly applied plaster

3.121 Masaccio, Tribute Money, c. 1427. Fresco, 8'1" × 19'7". Brancacci Chapel, Santa Maria del Carmine, Florence, Italy

Scale: the size of an object or artwork relative to another object or artwork, or to a system of measurement

Naturalism: a very realistic or lifelike style of making images Vanishing point: the point in a work of art at which imaginary sight lines appear to converge, suggesting depth

Focal point: The area in a composition to which the eye returns most naturally

Atmospheric perspective: use of shades of color to create the illusion of depth. Closer objects have warmer tones and clear outlines, while objects set further away are smaller and become hazy Chiaroscuro: the use of light and dark in a painting to create the impression of volume

Narrative: an artwork that tells a story

Continuous narrative: when different parts of a story are shown within the same visual

Volume: the space filled or enclosed by a three-dimensional figure or object

Brunelleschi is also credited with inventing a new method for drawing, known as linear perspective, a technique for creating the illusion of three-dimensional space. He shared the process with other Florentine artists, including his close friend, a painter nicknamed Masaccio, or "Big Clumsy Tom" (1401–28). Leon Battista Alberti (1404–72) wrote in his treatise On Painting (1435) about the theories of perspective that were already being put into practice by Brunelleschi and Masaccio, and the technique spread.

Masaccio applied the rules of linear perspective in several large-scale fresco paintings, including Tribute Money (3.121). Here, figures, architecture, and landscape are integrated into a believable scene. The buildings in the foreground appear on the same **scale** as the group of figures standing next to them. As the buildings and people get further away from us, they get smaller, and lead, in a naturalistic way, toward a vanishing point on the horizon. The focal **point** converges on Jesus, and the vanishing point lies behind his head, making him the visual and symbolic center of the scene. Masaccio uses atmospheric perspective to show the distant landscape, where the mountains fade from greenish to gray.

Innovations in this painting include consistent lighting throughout, a wide range of colors, and the use of chiaroscuro (extremes of light and dark) to enhance the illusion of threedimensional form. Tribute Money is one of Masaccio's most original paintings: it also shows three scenes in a sequence within one setting. While the fresco maintains the medieval tradition of **narrative** painting, the composition deviates from the earlier practice in an important way. Rather than showing each scene on a separate panel, events that take place at different times are shown together in a unified space, or a **continuous narrative**. In the center, the tax collector, with his back to us, demands the Jewish temple tax as the disciples look on. Jesus tells Peter to retrieve the money from the mouth of the first fish he catches. We see Peter doing so in the middle ground on our left. On our right, Peter pays the collector double the amount owed, using the money miraculously obtained from the fish's mouth. This story from the gospel of Matthew would have been particularly relevant for contemporary Florentines, who were required to pay a tax for military defense in 1427, the same year the painting was made.

Like other Renaissance artists, Masaccio used linear perspective to convince viewers they were looking at reality rather than a symbolic representation. He incorporated an understanding of the movement of the bodies beneath the drapery to increase the sense of volume. This series of frescoes, which were

displayed in the Brancacci family chapel, was a major influence on later artists, including Michelangelo (see below), who specifically went to the chapel to study Masaccio's paintings.

The High Renaissance in Italy

The Italian artists Leonardo da Vinci (1452–1519), Michelangelo (1475-1564), and Raphael (1483-1520) dominated the art world at the beginning of the sixteenth century. All three of them utilized the rules of perspective and illusionism, but willingly departed from exact mechanical precision in order to create desired visual effects.

Leonardo was the oldest among them. He was known not only as a great painter but also as a scientist and engineer. Leonardo invented a painting technique he called sfumato, which consisted of applying a hazy or misty glaze over the painting. In Leonardo's Last Supper, the bestknown depiction of Christ sharing a last meal

with his disciples before his crucifixion, the artist used an experimental mixture of **media** (3.122).

Leonardo was commissioned by Dominican friars to paint The Last Supper for their dining hall in the monastery of Santa Maria delle Grazie in Milan, Italy. Leonardo emphasizes Christ as the most important figure in four ways. First, Christ is depicted in the center of the painting. Second, he is shown as a stable and calm triangular form, in contrast with the agitated activity of the other figures. Third, his head is framed by the natural light of the middle of the three windows behind him. Finally, Leonardo arranged the linear perspective of his painting so that the vanishing point is directly behind Christ's head.

This work is not simply a representation of a meal, however, for Leonardo highlights two important aspects of religious doctrine related to this event: the Eucharist, or communion ceremony, and the betrayal of Judas. Here Leonardo portrays the tradition accepted by Catholics, who believe that the communion bread and wine are the body and blood of Christ. The artist also invites the viewer to locate Judas: by depicting the moment when Christ has just announced, "One of you is

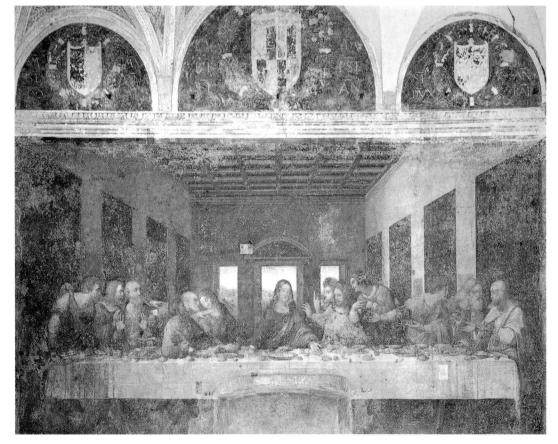

3.122 Leonardo da Vinci. The Last Supper, c. 1497. Refectory of Santa Maria delle Grazie, Milan, Italy

Sfumato: in painting, the application of layers of translucent paint to create a hazy or smoky appearance and unify the composition

Media: plural of medium; the materials on or from which an artist chooses to make a work of art

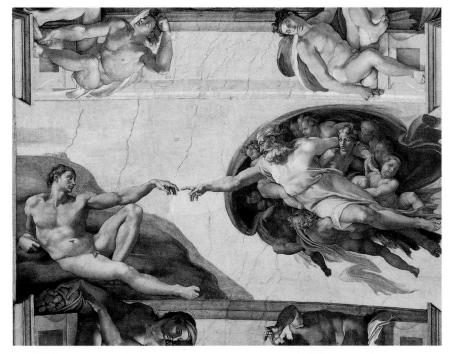

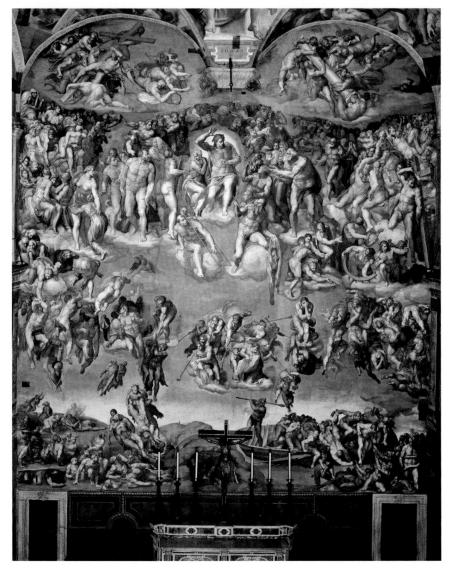

about to betray me" (Matthew 26:21), Leonardo shows, through gesture and facial expression, the individual reaction of each of the disciples. Judas has his elbow on the table and is in the group of three to Christ's right (our left). The deceiver clutches a money bag in his right hand and has just knocked down a salt dish, which is a bad omen.

The Catholic Church was an important patron of the arts. Like the Dominican friars who hired Leonardo in Milan, Pope Julius II also commissioned important artworks. As part of Julius's campaign to restore Rome and the Vatican to its ancient grandeur, he had Raphael working on the School of Athens fresco in the Vatican apartments between 1510 and 1511 (see Gateway Box: Raphael, 3.125, p. 382), while Michelangelo was nearby painting the ceiling of the Vatican's Sistine Chapel. The painting, which took Michelangelo four years to complete, is so believable we could be fooled into thinking the beams, pedestals, and structural elements are real (3.123). Michelangelo preferred stone carving to painting, which perhaps explains why he painted the ceiling with such apparently three-dimensional figures and surrounded them with architectural elements and sculpture. The nine panels at the ceiling's center detail the Old Testament stories of Genesis, from the creation of the heavens and earth, to the creation and fall of Adam and Eve, and ending with scenes from the Great Flood. The ceiling is covered with detailed figure studies, Michelangelo's specialty. In the Creation of Adam panel, for example, human nudity could be associated with the perfection of man.

Michelangelo also worked on another famous commission in the Sistine Chapel more than twenty years later. When the artist was in his sixties, Pope Clement VII requested that Michelangelo paint the Last Judgment on the wall behind the altar (3.124). As during the earlier commission, Michelangelo was forced to delay

3.123 (above, left) Michelangelo, Detail of Creation of Adam, Sistine Chapel ceiling, 1508–12. Vatican City

3.124 (left) Michelangelo, Sistine Chapel, Vatican City, with view of Last Judgment (1534-41)

Gateway to Art: Raphael, *The School of Athens* **Past and Present in the Painting**

Apollo: god of music Plato (great Classical The sky (and Plato Architecture and and lyric poetry; philosopher) modeled pointing to it) as coffered ceiling use made to look like after Leonardo rules of perspective as a reference to the Michelangelo's da Vinci a reference to man's heavens as realm of Dying Slave design ability and the ideal perhaps dominance Socrates, in green, over nature Aristotle holding engaging youths Nicomachean Ethics in debate, talking to Alexander and pointing to the Athena: goddess the Great ground—the material of Wisdom world Poetic Diogenes Self-portrait of Ancient thinkers Raphael, second from scientists the right, listening to Euclid bending Heraclitus, modeled after Ptolemy. In a group Michelangelo, leaning on a block of with compass and because he was Pythagoras with marble. Shown by himself because slate, modeled Ptolemy holding the gregarious. Perhaps he was a solitary person Celestial Globe after Bramante a book representing Apelles

In The School of Athens, Raphael depicts the Classical world within the Renaissance as a rebirth of the physical and mental advancements of the ancients. Raphael links a gathering of great philosophers and scientists from the Classical past—Plato, Aristotle, Socrates, Pythagoras, and Ptolemy, for example—to sixteenth-century Italy by using people he knew as models for the figures from ancient Greece and Rome. By using the Renaissance painter Leonardo da Vinci as the model for the honorable figure of the Greek philosopher Plato, Raphael expresses admiration and reverence for Leonardo's accomplishments. Using the face of Leonardo allows us to see Plato in the flesh as a fully formed, believable individual. Raphael also pays homage to his contemporary Michelangelo, who is shown sitting by himself on the steps, in the guise of the pessimistic philosopher Heraclitus. This is a reflection of Michelangelo's solitary, even melancholic personality, which was likely familiar to all who knew him. Raphael also subtly includes a self-portrait of himself as the Greek painter Apelles in the group on the right listening to the mathematician and astronomer Ptolemy (holding a globe), showing himself to be a gregarious, intellectual person. The thinkers on the left represent the Liberal Arts of grammar, arithmetic, and music, while those on the right of center are involved with the scientific pursuits of geometry and astronomy. The setting for this symposium is a grand Roman building with majestic arches and vaults that open up to the heavens. The Classical past is further invoked through the sculptures of Apollo (on our left) and Athena (on our right) in the niches behind the crowd. Despite its sixteenth-century references, the scene is utterly convincing, with calm, orderly groups of scholars and thinkers from throughout history gathered according to Raphael's carefully organized plan.

3.125 Raphael, The School of Athens, 1510-11. Fresco, 16'8" × 25'. Stanza della Segnatura, Vatican City

sculptural projects that captivated him more fully. His muscular, dynamic figures on both the ceiling and the altar wall highlight Michelangelo's first love of sculpting the nude male body. After years of wishing he could be sculpting rather than painting, and of enduring frequent unsolicited advice regarding his compositions and choice of nude figures, Michelangelo painted the mask on St. Bartholomew's flayed skin within The Last Judgment as a self-portrait of the tortured artist who would have preferred his chisel and hammer (3.126). Some scholars speculate that the location of Bartholomew (and Michelangelo's self-portrait) on the side of the damned are a cloaked reference to the artist's homosexuality.

The energetic, whirlpool effect of the judgment scene is much more chaotic and psychologically dark than many other Last Judgment scenes made by previous artists. The nude figures within it, which took the artist eight years to complete, represent blessed and damned souls as they face their last moments on earth. The Last Judgment reflects the uncertainty of the late Renaissance and points to the preoccupations of the Baroque era to come.

3.126 Michelangelo, Detail of Last Judgment showing selfportrait in St. Bartholomew's skin, 1536-41. Sistine Chapel, Vatican City

The Renaissance in Northern Europe

3.127a Jan van Eyck, The Arnolfini Portrait, 1434. Oil on panel, $32\% \times 23\%$ ". National Gallery, London

Over time, developments in Italian art were widely admired by artists in the northern European countries we now know as the Netherlands, Germany, France, and Belgium. Throughout the fifteenth century, though, the artists of the Netherlands continued using the traditional methods established in medieval manuscript illumination painting. At that time they had a reputation for producing much of the best art in Europe, and their work influenced the visual arts elsewhere on the Continent. Artists in the northern countries were known for their careful attention to **texture** and to fine details in their artwork, achieved in part through the

Chandelier is very ornamental and expensive, a clear sign of wealth

Single candle burning in the chandelier: possibly a symbolic reference to Christ; or a unity candle used in a marriage ceremony; or a sign of a legal event

Man stands near the window to show that he is part of the world outside

Woman stands near the elaborate bed to indicate her domestic role and the hope that she will bear children

Fruit on the window: sign of fertility. Indicates wealth (oranges and lemons were expensive because they had to be imported from Spain); also a reference to innocence and purity before humans sinned in the Garden of Eden

Figure carved on the chair: St. Margaret, protector of women in childbirth

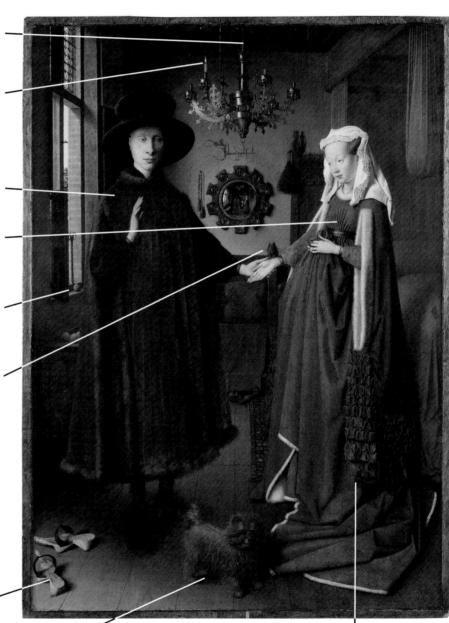

Shoes/clogs: given to a woman as a wedding gift; symbol of stability; removed to show that the event taking place here is sacred and makes the ground so, too

Dog: sign of fidelity and wealth

Full-skirted dress: fashion of the day because the current queen was pregnant (the woman in the painting is not pregnant herself, because she never had children)

Texture: the surface quality of a work, for example fine/coarse, detailed/lacking in detail Oil paint: paint made of pigment floating in oil Glazing: in oil painting, adding a transparent layer of paint to achieve a richness in texture, volume, and form

3.127b Detail of Jan van Eyck, The Arnolfini Portrait widespread use of oil paint (see Box: Pieter Bruegel: A Sampling of Proverbs, p. 386). Many of the everyday objects depicted so convincingly in these paintings also have significant religious symbolism.

The development of oil paint has been attributed to Dutch artist Jan van Eyck (c. 1395-1441), who was born into a family of artists and eventually served as court painter to the Duke of Burgundy. Vasari credits van Eyck with the invention of oil painting, but it was actually used in the Middle Ages to decorate stone, metal, and, occasionally, plaster walls. The technique of glazing, which van Eyck developed with such virtuosity, was widely adopted throughout Europe after 1450.

One of the most important northern Renaissance paintings, The Arnolfini Portrait by Jan van Eyck, has been a source of mystery for scholars (3.127a). Art historians have been trying to identify the people in this painting since at least the 1930s. Scholars have claimed that the portrait depicts Giovanni Arnolfini and his wife. Some have also suggested it could have been some kind of legal document, perhaps certifying their wedding ceremony. An inscription on the wall above the mirror says "Johannes de eyck fuit hic 1434," or "Jan van Eyck was here 1434,"

announcing the painter's presence at this event and possibly suggesting he was one of two witnesses visible in the convex mirror behind the principal figures (3.127b).

Van Eyck's painting relies on illusion in several ways. The young couple and the room in which they stand are painted in such detail that viewers feel as if they are looking into a real room with real people. Fifteenth-century viewers would probably have paid careful attention to the mirror, with its circular minipictures, or roundels, depicting scenes from the crucifixion of Christ, since such an object would have been very expensive, a truly luxurious possession. The mirror helps extend the illusion of reality by showing in its reflective surface the room in front of them, which is otherwise not in the picture. Numerous other symbols help to reveal the sacramental nature of marriage: the shoes that have been taken off because the ground is considered sacred for the event; the dog, which is a sign of fidelity; the single candle lit in the chandelier, which suggests unity; and the exotic, ripe fruit near the window, which indicates the hope of fertility.

Many northern Renaissance artists also explored explicitly religious subject matter.

"Johannes de eyck fuit hic 1434": innovative signature of the artist (seen by some as evidence that this is a marriage contract)

Crystal prayer beads beside the mirror: indicate the couple's piety

Reflection in the mirror includes the entire room and likely the artist

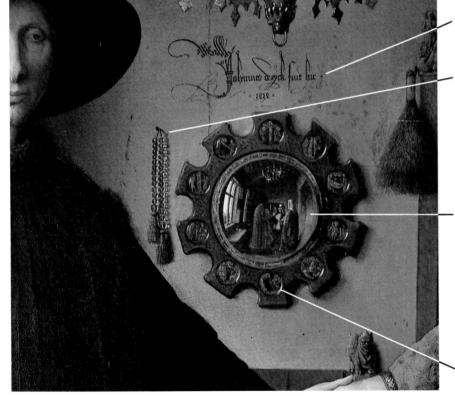

Roundels around the mirror show scenes from the Passion of Christ

Pieter Bruegel: A Sampling of Proverbs

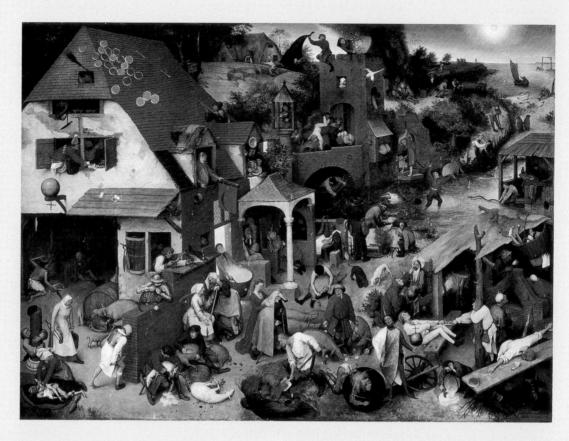

3.128 Pieter Bruegel the Elder, Netherlandish Proverbs. 1559. Oil on oak, 3'10" × 5'2". Gemäldegalerie, Staatliche Museen, Berlin, Germany

> Pieter Bruegel the Elder (c. 1525/30-69) was an artist from the Netherlands who became famous for his landscapes and humorous scenes of peasant life. His work comments on the beliefs and customs of his day. The painting Netherlandish Proverbs depicts recognizable types, such as farmers and townspeople (3.128 and 3.129 a-c). The people are general and universal figures, rather than specific or

idealized portraits. The examples shown here identify a selection of the more than one hundred proverbs that Bruegel illustrated in this painting. A few of the proverbs that are still familiar to us include the "world turned upside down"; the man who is "beating his head against a wall"; and the two women gossiping -"one winds the distaff, the other spins it."

3.129 a, b, c Details from Pieter Bruegel the Elder, Netherlandish Proverbs

3.130 Matthias Grünewald. Isenheim Altarpiece (closed). c. 1510-15. Oil on panel, center panel: Crucifixion, $8'9^{5}/8'' \times 10'$; predella: Lamentation, $29^{7/8}$ " × $11'1^{7/8}$ "; side panels: Saints Sebastian and Anthony $7.6\frac{5}{8}" \times 29\frac{1}{2}"$ each. Musée d'Unterlinden, Colmar, France

Sometime around 1515 the German artist Matthias Grünewald (c. 1475/80–1528) painted a scene of the crucifixion of Christ on an altarpiece made for the chapel in a hospital that cared for patients with skin diseases, the Abbey of St. Anthony in Isenheim (in what is now northeastern France). The Crucifixion scene of the Isenheim Altarpiece, one of the most graphic images of Christ's crucifixion in the history of art, is visible when the altarpiece is closed (3.130). It is designed to make the viewer empathize with Christ's suffering and to be thankful for his sacrifice. When patients prayed before this altarpiece they saw the green pallor of Christ's skin, the thorns that drew blood from his body, and the deformations of his bones caused by hanging on the cross for so long. The altarpiece could be opened to reveal additional scenes inside.

The vivid details offered patients suffering from a variety of serious diseases a way to identify with Christ in his human form, as well as comfort that they were not alone in their own suffering. St. Anthony, shown on the right wing of the altarpiece, was the patron saint of sufferers from skin disease. Indeed, a common disease that

caused a swollen stomach, convulsions, gangrene, and boils on the skin was named "St. Anthony's Fire."

Christ's suffering was further emphasized when the altarpiece was opened on certain occasions, such as Easter Sunday. When the left door was swung open, Christ's arm would look separated from the rest of his body, making him appear to lose his arm. Similarly, opening the left side of the Lamentation scene at the bottom of the altarpiece would make Christ's legs appear to be cut off. As limbs were often amputated to prevent further spreading of disease, many patients could directly identify with Christ's experience.

A quarter of a century after Leonardo's famous painting of the Last Supper, the woodblock print of the same subject made by the German artist Albrecht Dürer (1471–1528) offers a different interpretation. Dürer was a talented draftsman and one of the first painters to work seriously on woodcuts, etchings, engravings, and printed books. Two study trips that he made to see the paintings of Renaissance Italy were deeply influential. They encouraged him to paint Classical subject matter and to

Altarpiece: an artwork that is placed behind an altar in a church

3.131 Albrecht Dürer. The Last Supper, 1523. Woodcut, $8\% \times 11\%$ ". British Museum, London, England

calculate carefully his depictions of the human form and its environment. Like Leonardo, Dürer draws attention to Christ in his **composition** by placing him centrally and surrounding his head with white light (3.131). Only eleven disciples are there; the absence of Judas tells us that he has already gone out to betray Jesus to the authorities. Dürer's print reflects the ideas of the Protestant Reformation and, in particular, the doctrine of the Lutheran Church. While Lutherans accepted the Communion ceremony, they insisted it was only a re-enactment of the Last Supper, not a literal receiving of Christ's body and blood. To emphasize this important doctrinal point, Dürer displays an empty plate in the foreground, signifying that the meal has already taken place.

Composition: the overall design or organization of a work

Dissonance: a lack of harmony Mannerism: from Italian di maniera, meaning charm, grace, playfulness; mid- to late sixteenth-century style of painting, usually with elongated human figures elevating grace as an ideal

Rhythm: the regular or ordered repetition of elements in the work

Late Renaissance and **Mannerism**

The Sack of Rome by the troops of Charles V of Spain in 1527 brought the high Renaissance to a close. Pope Julius II's building campaign and patronage of the arts had helped make Rome the center of artistic and intellectual activity in Italy.

When Pope Clement VII humiliatingly had to crown Charles as Holy Roman Emperor in 1530, it was further evidence of the end of those days of supremacy and assuredness. The disorder of the period was reflected in its art.

Compared to the art that came before it, the late phase of the Renaissance (c. 1530–1600) tends to feature compositions that are more chaotic and possess greater emotional intensity. The successes of the high Renaissance could not be rivaled: Leonardo, Raphael, and Michelangelo were thought to have achieved perfection in the arts. Artists were faced with the predicament of where to go from there. In reaction, instead of harmony, many artworks stressed dissonance. Imagination often took the place of believable reality. Distortion and disproportion, rather than mathematically precise depictions, were intentionally used to emphasize certain anatomical features and themes. During the late Renaissance period, a style called **Mannerism** developed, characterized by sophisticated and elegant compositions in which the accepted conventions of poses, proportions, and gestures became exaggerated for emotional effect.

The Italian Mannerist artist Sofonisba Anguissola (c. 1532–1625) achieved a level of success rarely enjoyed by women during the Renaissance. Known primarily for her portraits, she gained an international reputation that led to an official appointment at the court of the queen of Spain. Anguissola emphasized emotion and heightened the realism in her artworks. Portrait of the Artist's Sisters Playing Chess (3.132) shows an everyday scene in the outdoors, as indicated by the tree behind the girls, and the landscape in the distance. Anguissola concentrates on the rich details of the textures of the girls' clothing, jewelry, and hair. Rather than focusing on creating a unified and mechanically precise scene, Anguissola has emphasized the individuality of each one of her sitters, from the expressions on their faces to the elegant placement of their fingers. As the older sisters play their game, the clear sense of joy in the youngest sister's face is balanced by the expression of the maid, who looks on with care and concern.

The Last Supper is a traditional biblical subject; Leonardo's famous version was painted eighty years before the one shown in 3.133. But Paolo Caliari of Verona, known as Veronese (1528–88), took a new and unconventional approach. His painting combines the strict **rhythm** of the prominent, Classical architectural

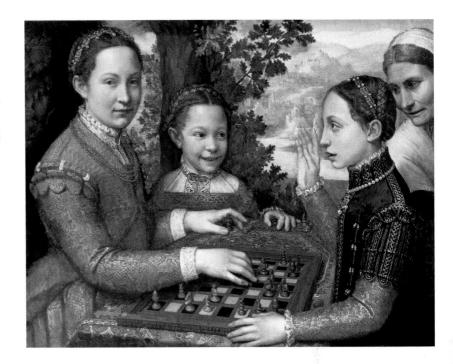

features, especially the three Roman arches that frame and balance the scene, with the chaos and activity common in later Renaissance art. Overall, the composition is formally balanced and detailed in an elegant architectural setting, but the artist has introduced lively and unconventional characters. Along with Christ and the disciples, Veronese includes members of the Venetian elite, and entertainers.

3.132 Sofonisba Anguissola, Portrait of the Artist's Sisters Playing Chess, 1555. Oil on canvas, 283/4". National Museum, Poznań, Poland

3.133 Paolo Veronese, Christ in the House of Levi, 1573. Oil on canvas. $7'3\%" \times 16'8\%"$. Galleria dell'Accademia, Venice, Italy

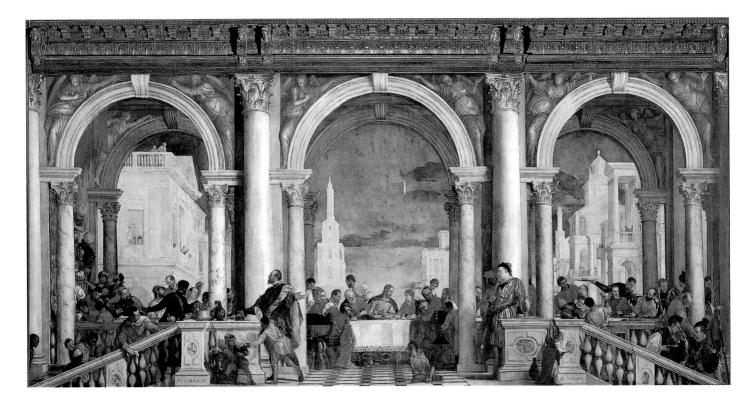

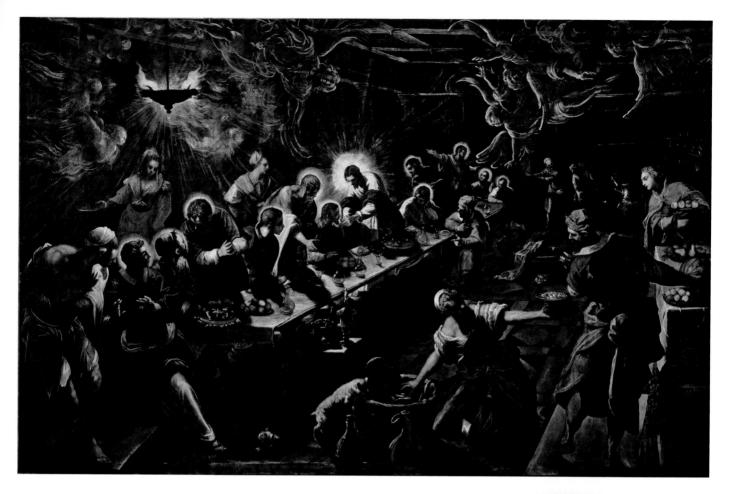

This approach proved controversial with Church officials. They objected that Christ, in this key moment in the gospels, is shown so near such unsavory characters as clowns, dwarves, and dogs. The Inquisition, a religious court that could punish heresy with death, charged Veronese with irreverence. To avoid making painstaking changes to his painting, he re-titled it to portray the Feast in the House of Levi, based on a story in the Bible in which Jesus scandalized the Jewish priests by eating with sinners.

The surge of Protestantism at this time led in its turn to the Counter-Reformation, in which the Catholic Church powerfully reasserted core Catholic values and enforced them through the Inquisition. Catholicism had long believed that images should be used as powerful teaching tools, and this belief now became more apparent in the art of the time. For example, the intensely dramatic quality of The Last Supper by the Italian artist Tintoretto (1519–94) highlights the urgency of the Catholic mission to encourage believers to remain in the Church rather than converting to

3.134 (above) Tintoretto, The Last Supper, 1592-4. Oil on canvas, 11.1134" $\times 18.75$ %". San Giorgio Maggiore, Venice,

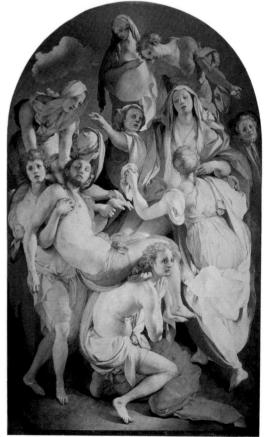

3.135 (right) Jacopo da Pontormo, Deposition, 1525-8. Oil on wood, $10'3^{1/4}" \times 6'3^{5/8}"$. Capponi Chapel, Santa Felicita, Florence, Italy

Protestantism (3.134). Tintoretto depicts the Last Supper as a glorious and spiritual event. There are many ordinary people busy in service and conversation—we can almost hear the buzz of conversation and clatter of dishes. At the same time, the heavens seem to be opening up to send down angels to witness the event. This scene is a marked change from the symmetry and emotional balance of both Leonardo's (3.122; see p. 380) and Dürer's (3.131; see p. 388) versions. But Tintoretto still makes Christ the focal point by placing him in the center with the largest and brightest halo, reaching out with a glass to one of the disciples; Judas is easy to find, too, alone without a halo on the opposite side of the table from Jesus. But Tintoretto's picture conveys a dynamic-even disturbed-sense of motion and drama, with the table placed at an angle pointing off-center deep into space, dramatic contrasts of lighting, and the theatrical gestures of the characters.

In Jacopo da Pontormo's (1494–1556) Mannerist painting of the Deposition, the arrangement of the group of figures appears to be very unstable (3.135). Pontormo has stacked the figures vertically and placed them in an oddly swirling pattern, almost as if they are supported by the figure at the bottom of the composition, who is crouching unsteadily on tiptoe. Far from being a realistic depiction of observable reality, the figures are overly muscular and the colors are striking. We would expect to see grief and sorrow in a deposition scene, but here the faces show expressions of feeling lost and bewildered. Everything contributes to a sense of anxiety and disorder.

Another Mannerist, Domenikos Theotokopoulos (c.1541–1614), called El Greco ("The Greek"), worked in Venice and Rome before moving to Spain. Laocoön is a subject from Greek mythology (3.136). The Trojan priest Laocoön attempted to warn the inhabitants of Troy that Greek soldiers were trying to infiltrate their fortifications by hiding inside the Trojan Horse, seen in the middle ground at the center of this painting. El Greco shows the priest and his sons being attacked by snakes sent by the god Poseidon (who supported the Greeks) to stop

3.136 El Greco, Laocoön, c. 1610/14. Oil on canvas, $54\frac{1}{8} \times 68$ ". National Gallery of Art, Washington, D.C.

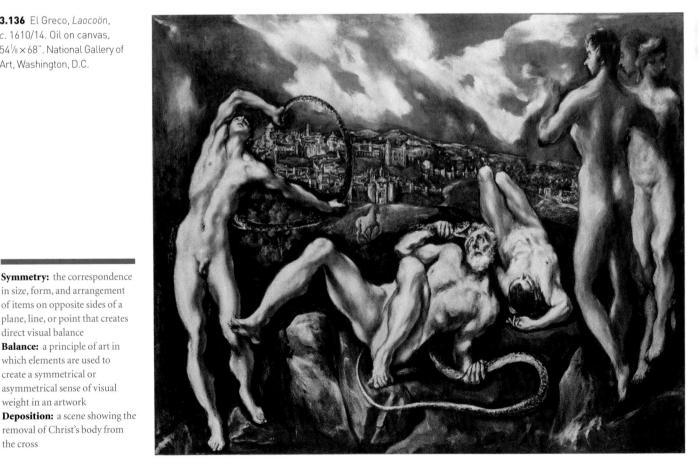

in size, form, and arrangement of items on opposite sides of a plane, line, or point that creates direct visual balance Balance: a principle of art in which elements are used to create a symmetrical or asymmetrical sense of visual weight in an artwork

Deposition: a scene showing the removal of Christ's body from the cross

Depictions of David

The biblical story of David and Goliath inspired three renowned Renaissance and Baroque sculptors in three centuries. Donatello, Michelangelo, and Bernini each took a different approach to the appearance of the hero, David. Each work displays the characteristic cultural and artistic concerns of their respective eras. In the Bible, David is a young Israelite who battles the giant Goliath. Goliath challenges the Israelites to send a champion to fight in single combat. Only David is brave enough to face him. Armed with just his shepherd's hook, slingshot, and a handful of stones, he fells Goliath with a single slingshot to the forehead and then uses the giant's own sword to cut off his head. David's triumph against a powerful opponent became an emblem for the city of Florence after its forces defeated a much stronger army from Milan in 1428. Our comparison of statues of David considers two sculptures made for Florence and one made in Rome.

Donatello (c. 1386/87-1466) was a skilled sculptor of both bronze and marble. At the time he made David, he was reinvigorating the ancient technique of bronze casting. His David, the first nearly full-scale male nude since antiquity, also reflects the sculptor's familiarity with and admiration for the Classical ideal depictions of the human body (3.137). Rather than emphasizing the mortal and corruptible nature of the body, as was common during the Middle Ages, Donatello follows the idealized nude model used by Greek and Roman sculptors. Donatello's statue reveals the artist's careful observation of physical posture. David stands with his weight on his right leg, leaving the left leg relaxed. His right shoulder is higher and his left lower as a result. Donatello's understanding of human anatomy makes his David look mobile and lifelike.

Michelangelo's David was carved from a single block of marble (3.138). It was originally intended to be placed in a high niche of Florence Cathedral as a symbol of the city's power and (temporary) freedom from the tyranny of the Medici. The sculpture was so popular that on its completion in 1504 it was

instead placed near the entrance to the main piazza, or plaza, where it could be viewed by masses of people. Its Classical attributes include athletic musculature and essentially ideal proportions. By presenting David as nude, with a scarcely noticeable slingshot draped over his shoulder—the only reference to his identity—Michelangelo creates a sculpture of a man as well as a hero. David's facial expression is idealized and calm, but his gaze, which is purposefully directed off to the side, reveals a mood of concentration and intensity.

Gianlorenzo Bernini (1598-1680) created his David in the Baroque period. It is a dynamic, three-dimensional sculpture that emphasizes movement and action (3.139). Whereas Donatello's sculpture shows David as triumphant and Michelangelo's sculpture shows him as contemplative, Bernini's sculpture shows David at a moment of dramatic, heightened tension, when he is about to launch the stone. The energy of David's entire body is focused on the physical movement he is about to make. Even the muscles in his face tighten. Bernini is said to have studied his own reflection to create the perfect facial expression for such an energetic feat. Unlike Michelangelo's and Donatello's sculptures, which are meant to be viewed from the front, Bernini's is intended to be seen and understood in the round.

These three sculptures are clearly different in several ways. Michelangelo's sculpture is more than twice the size of the other two, in order to allow viewers to see all of the detail had the sculpture been installed in its originally planned location, high above the ground. Donatello's sculpture is the only one to include weaponry other than a slingshot: his David holds the sword with which he has just beheaded his opponent, whose head lies at his feet. Bernini's sculpture, like Michelangelo's, features the slingshot, but it is in action, and a pile of cast-off armor lies beneath. Such a prop was necessary to allow for the wide stance and gesture of the figure, as marble sculptures are prone to snap if their weight is unsupported.

3.137 Donatello, David, c. 1430. Bronze, 5'21/4" high. Museo Nazionale del Bargello, Florence, Italy

The moment each artist chose to depict has a strong influence on the resulting appearance and effect of their sculptures. Donatello shows a triumphant, boyish David standing in calm repose after the fight. Michelangelo presents David as an adult: the sheer size and mass of his form are much more manlike than Donatello's slim, youthful figure. Michelangelo's David stands poised at a moment of anticipation and determined contemplation before the battle; a concentrated expression is visible on his face. Bernini's David, more mature, is dynamically focused on casting a lethal strike at the giant Goliath—the time of calculation and reflection has passed; now it is time for action.

Religious stories were common subjects for artworks during the Renaissance and Baroque. Instead of having to invent something completely new, these three artists' David sculptures show their originality in their treatment of the subject.

3.138 (below left) Michelangelo, David, 1501–4. Marble, 14'2%" high. Galleria dell'Accademia, Florence, Italy

3.139 (below right) Gianlorenzo Bernini, David, 1623. Marble, 5'7" high. Galleria Borghese, Rome, Italy

In the round: a freestanding sculpted work that can be viewed from all sides

Expressionistic: devoted to representing subjective emotions and experiences instead of objective or external reality Color: the optical effect caused when reflected white light of the spectrum is divided into a

Outlines: the outermost lines of an object or figure, by which it is defined or bounded

separate wavelength

Modeling: the representation of three-dimensional objects in two dimensions so that they appear solid

Laocoön's warning. The landscape in the background is a view of Toledo, Spain, where El Greco lived and made his best-known works late in his life. El Greco combined Mannerist exaggeration, seen in the elongated forms and distorted figures, with his own expressionistic use of color, outlines, and modeling. Like other Mannerist artworks, this intricate composition combines carefully observed factual information with mythological stories according to the dictates of the artist's imagination.

The Baroque

The Baroque period was a time of exploration, increased trade, and discovery in the sciences. The Western world now accepted the theory of astronomer Nicolaus Copernicus that the Sun, rather than the Earth, was the center of the universe—a theory the Catholic Church had previously rejected. Light, both heavenly and otherwise, became a prominent feature in many Baroque artworks. The seventeenth century was also a time of frequent battles throughout Europe, largely the result of the divisions in the Catholic Church after the Reformation. Baroque artworks give us a sense of this turmoil: their theatrical, dynamic compositions are marked by dramatic movement and light. Some Baroque artists, such as Nicolas Poussin, continued the high Renaissance interest in carefully ordered calmness. Others, such as Gianlorenzo Bernini (see left: Depictions of David), displayed heightened emotion and created figures that seem to be in action, often breaking into the viewer's personal space.

French artist Nicolas Poussin (1594–1665) specialized in paintings of subjects from Classical antiquity. Everything in his paintings was carefully constructed and positioned. He would even arrange miniature figures on a small stage when choreographing the scenes for his landscapes. Yet, though these and his buildings look detailed and realistic, their appearance and placement were always invented from his imagination. The Funeral of Phocion depicts two men carrying the deceased Phocion, an Athenian general, over a winding road that leads away from

Gateway to Art: Gentileschi, Judith Decapitating Holofernes The Influence of Caravaggio

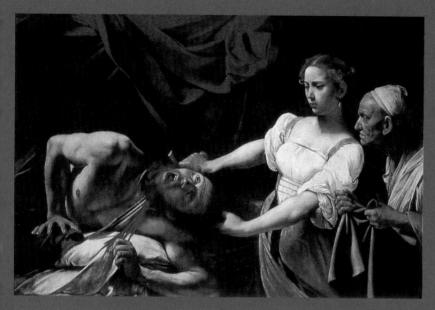

3.142 Caravaggio, Judith Decapitating Holofernes, 1599. Oil on canvas, $4'9'' \times 6'4^3/4''$ Galleria Nazionale d'Arte Antica, Palazzo Barberini,

Along with many other artists in Europe in the seventeenth century, Artemisia Gentileschi (1593-1652/53) imitated the artistic style of Italian artist Caravaggio (1571-1610). In addition to being an accomplished painter, Caravaggio led a tumultuous existence. By the time he was in his late twenties, Caravaggio's innovative approach to painting had earned him an impressive reputation and he was receiving Church commissions. At the same time, he was involved in numerous brawls; he eventually killed a man in a fight over a tennis match. While on the run from these charges, he died of unknown causes on a beach at the age of 39.

3.143 Artemisia Gentileschi. canvas, $6'6\frac{3}{8}" \times 5'3\frac{3}{4}"$. Uffizi Gallery, Florence, Italy

Caravaggio's paintings, although often of religious stories. look like everyday genre scenes, filled with people from the lower classes, shown unidealized and wearing unkempt clothes. This naturalistic, down-to-earth approach offended some viewers who believed religious figures in artworks should be presented as idealized individuals to signify their holiness. Caravaggio's talent, however, was also greatly appreciated by many art lovers

and patrons, particularly those in the pope's circle. His development of tenebrism, the dramatic use of intense darkness and light, was adopted by other painters during his lifetime and by later artists as well.

In Caravaggio's Judith Decapitating Holofernes (3.142), a strong beam of light seems to stop time as Judith's knife slices through the general's neck. The light emphasizes the drama of this particular moment and shows the main characteristics of Caravaggio's style. The scene seems to emerge into the light from a darkened background in a way similar to the effect of a modern spotlight. Because the background is so dark, the action takes place in a shallow, stagelike space, again reinforcing dramatic effect. The details Caravaggio has focused on, such as the seventeenth-century clothing, emphasize the ordinary aspects of this biblical event.

Artemisia Gentileschi's style was greatly influenced by Caravaggio's detailed realism and dramatic use of tenebrism. In their paintings on the same subject, Judith decapitating Holofernes (see 3.142 and 3.143). both artists use extreme darks and lights for dramatic effect, emphasize the violence of the scene through spurting blood and bloodstained sheets, and show the female characters performing the murder with a marked strength and resolve that are untypical of conventional ideas about feminine behavior at the time.

Gentileschi also infused her Judith image with active physical strength on the part of the women in a way that allows the viewer to sense the sheer effort required to sever the brute's head. By contrast, Caravaggio's Judith, apart from having powerful forearms, appears quite delicate, and shocked at her deadly deed. Judith's maidservant in Caravaggio's painting is shown as an old woman who appears to take no active part in the murder. The maidservant in Gentileschi's scene, by contrast, physically restrains the Assyrian general as Judith severs his head.

finished works for important clients himself. His Raising of the Cross was one of several paintings commissioned by wealthy merchants to be installed in churches (3.141).

Genre: categories of artistic subject matter, often with strongly influential histories and traditions

Tenebrism: dramatic use of intense darkness and light to heighten the impact of a painting

Foreground: the part of a work depicted as nearest to the viewer Implied line: a line not actually drawn but suggested by elements in the work

3.140 Nicolas Poussin, The Funeral of Phocion, 1648. Oil on canvas, $44^{7/8}$ " × $68^{7/8}$ ". National Museum of Wales, Cardiff

3.141 Peter Paul Rubens, center panel from The Raising of the Cross, 1610-11. Oil on canvas, $5'1^{1}/8'' \times 11'1^{7}/8''$. Cathedral of Our Lady, Antwerp, Belgium

the city (3.140). Phocion had been executed after being falsely accused of treason; because he was considered a traitor, he was buried outside the city.

The composition highlights the tragedy of Phocion's burial as a traitor, when he was in fact a hero who should have been honored. The two figures carrying Phocion's body, covered with a white sheet, are prominently placed in the foreground. The large tree to the right arches over and creates an **implied line** from pallbearers through the figures, trees, and buildings that gradually become smaller as they recede into space. The winding road both emphasizes the distance of Phocion's burial from the city and creates a sense of deep space, skillfully guiding our gaze into the landscape. The carefully structured sense of the landscape continues the Renaissance emphasis on balance and order. Similarly, the classically designed buildings and figures dressed in antique clothing call our attention to the past.

Peter Paul Rubens (1577-1640) produced about 2,000 paintings in his lifetime, an impressive output made possible because he operated a large workshop in Antwerp (in modern-day Belgium). His assistants were responsible for producing some of his paintings, but Rubens generally

In *The Raising of the Cross*, we can sense the physical exertions of these muscular men to raise Christ on the cross. A dynamic tension is created along the diagonal line of the cross that visually connects the men at its base as they strain to pull Christ up toward the right side of the painting. Although, in fact, Christ would have been tortured and close to death at this point, the artist has painted his flesh as almost immaculate, and lighter than that of those around him. In this way, and by bathing him in light, Rubens makes Christ the focal point and emphasizes his holiness.

Rembrandt van Rijn (1606-69) was an extremely popular painter who also had a large workshop at one point in his life. Yet, despite his impressive reputation, he filed for bankruptcy in old age. In The Night Watch, the gathering of officers and guardsmen likely commemorates a visit by Queen Maria de'Medici to Amsterdam in 1638 (3.144). The painting was commissioned by the civic militia, and scholars believe that all of those portrayed in this scene contributed financially to the artist's fee. The Night Watch is a fine example of Rembrandt's innovative approach to a group portrait. His painting is not only convincing but also full of the vitality and energy typical of a group getting ready for an important occasion. The various members

3.144 Rembrandt van Rijn, The Company of Frans Banning Cocq and Willem van Ruytenburch (The Night Watchl, 1642, Oil on canvas, 11'11" x 14'4". Rijksmuseum, Amsterdam, Netherlands

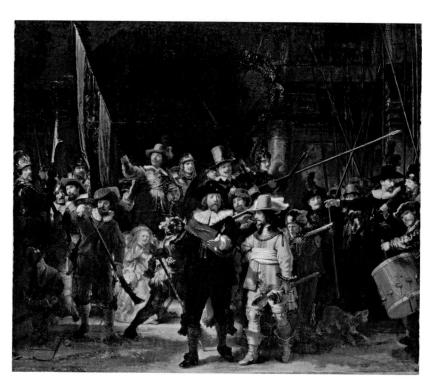

of the company are shown busily organizing themselves. This painting came to be known as The Night Watch because its dark atmosphere made it look like a night scene. Rembrandt made skillful use of chiaroscuro, tenebrism, and dramatic lighting to enliven his composition, but the impression of night-time was actually created by years of accumulated dirt and layers of varnish. The painting was revealed to be a daytime scene when it was cleaned after World War II.

Discussion Questions

- 1 Find two examples of artworks in this chapter in which linear perspective plays an important part. Point out the parts of the composition that use linear perspective to create the desired illusion. Discuss what the artist wants to communicate by using linear perspective.
- From this chapter choose a northern Renaissance artwork and an Italian Renaissance work. List the prominent characteristics of each. Include information about both the form and the content of the artworks in your lists.
- Select three artworks that deal with subject matter from the Bible. Consider how they portray their biblical themes: examine style, medium and technique, content, and any other aspects that the artist emphasizes (1.70, 2.148, 4.163).
- Select a Renaissance work and a Baroque work from this chapter. List their similarities and differences. Consider their subject matter, style, content, and emotional impact.
- Select three Renaissance artworks that draw on the artistic and intellectual heritage of Classical Greece and Rome. Make a list of the ways in which they use the Classical past. Make another list of any Renaissance innovations, either in terms of form or of content. You might choose one work from another chapter in this book, for example: 4.133, 4.136.

Images related to 3.6: Art of Renaissance and Baroque Europe (1400–1750)

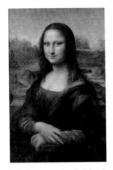

0.8 Leonardo da Vinci, Mona Lisa, 1503-6, p. 33

1.65 Masaccio, Trinity, c. 1425-26, p. 88

1.115 Piero della Francesca, The Flagellation, c. 1649, p. 119

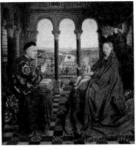

2.28 Jan van Eyck, The Madonna of Chancellor Rolin, 1430-34, p. 185

4.133 Sandro Botticelli, The Birth of Venus, c. 1482-6, p. 558

1.70 Andrea Mantegna, The Lamentation over the Dead Christ, c. 1480, p. 91

2.42 Albrecht Dürer, Four Horsemen of the Apocalypse, c. 1497-8, p. 193

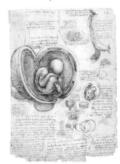

2.2 Leonardo da Vinci, Studies of the foetus in the womb, c. 1510-13, p. 167

2.148 Michelangelo, Creation of the Sun and the Moon, 1508-10, p. 264

4.77 Parmigianino, Selfportrait in a Convex Mirror, c. 1524, p. 511

4.136 Titian, Venus of Urbino, 1538, p. 560

1.144 Peter Bruegel the Elder, Landscape with the Fall of Icarus, c. 1555-8, p. 138

1.124 Andrea Palladio, Plan and part elevation/section of the Villa Rotonda, begun 1565/6, p. 127

1.52 Caravaggio, The Calling of St. Matthew, c. 1599–1600, p. 79

4.163 Rembrandt van Rijn. Self-portrait with Saskia in the Scene of the Prodigal Son at the Tavern, c. 1635, p. 580

2.34 Artemisia Gentileschi, Self-portrait as the Allegory of Painting (La Pittura), 1638-9, p. 187

2.16 Claude Lorrain. The Tiber from Monte Mario Looking South, 1640, p. 176

4.29 Gianlorenzo Bernini, The Ecstasy of St. Teresa, 1645-52, p. 475

1.169 Diego de Silva y Velázquez, Las Meninas, c. 1656, p. 160

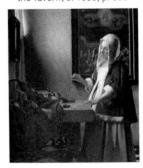

4.58 Johannes Vermeer, Woman Holding a Balance, c. 1664, p. 495

3.7

Art of Europe and America (1700-1900)

The period from 1700 to 1900 was an era of upheaval in European and American societies. There were revolutions in France and the Americas, and the great increase in industrialization brought correspondingly rapid social and economic changes in Europe and the United States. This was an age also known as the Enlightenment, sometimes called the Age of Reason. Enlightenment thinkers called for reason over faith, liberty over tyranny, and equal rights for all men.

At the beginning of the eighteenth century, most European countries were governed by absolute monarchs—rulers who, it was believed, derived their power and authority from God. Some artworks of the time are evidence of the extreme wealth and frivolous attitude of these rulers. By the end of the eighteenth century, however, absolute monarchies had been overturned in the United States and France, and had been challenged elsewhere in Europe. New ideologies of government by and for the people replaced the concept of absolute monarchy. Artists reflected this new way of thinking in their work, addressing issues of inequality and the need to educate the masses.

Organic: having forms and shapes derived from living organisms

Baroque: European artistic and architectural style of the late sixteenth to early eighteenth centuries, characterized by extravagance and emotional intensity

Patron: an organization or individual who sponsors the creation of works of art

Rococo

The undisputed power of the European ruling classes during the seventeenth and much of the eighteenth centuries inspired a period of extravagance among the very wealthy. Desiring the finest in everything, the ruling

classes financed endless commissions of artworks in a style known as the Rococo. Rococo artworks tend to be fanciful and lighthearted, featuring elaborately curved lines and organic forms of ornament. Stylistically, the Rococo is an outgrowth of the **Baroque**, but while the Baroque's subject matter was religious and moralistic, the Rococo's was whimsical.

The extravagance of the Rococo era began with France's King Louis XIV (1638–1715), whose self-centered and grandiose view of the world epitomized the power of the absolute monarch. Louis called himself the Sun King to associate himself with the Greek sun god Apollo, and to imply that the activities of France began when Louis arose in the morning and stopped when he retired at night. He commissioned the finest artists in Europe to construct and decorate Versailles as the largest palace in the world. The palace includes a Hall of Mirrors, which the king used as a ballroom and to welcome (and impress) foreign visitors (3.145). Mirrors were extremely expensive at this time, and the Hall of Mirrors has seventeen large arches filled with mirror panels that reflect the view overlooking the palace gardens. The 239-foot-long hallway is lavishly covered with gilding, chandeliers, sculpture, and paintings.

Louis was a great **patron** of the arts. When he decided to build Versailles, he turned the old royal palace in Paris, the Louvre, into a residence for the artists who worked for him. During his reign the Royal Academy of Painting and Sculpture, founded in 1648, was tremendously

3.145 Jules Hardouin-Mansart, Château de Versailles, Hall of Mirrors (Galerie des Glaces), 1678-84, Versailles, France

influential. Academies offered artists their best opportunities to display and sell their work (see Box: European and American Art Academies, **3.147**, p. 400).

Ornate decoration was used in Rococo palaces and churches throughout Europe. The German architect Johann Balthasar Neumann (1687-1753) built churches the interiors of which are predominantly bright white, as if to reflect Germany's glistening winter snow. The basilica of Vierzehnheiligen ("Fourteen Holy Ones") near Bamberg, in Bavaria, southern Germany, has fourteen statues around the altar, depicting Catholic saints; believers pray to the saints for protection against illness and disease. These saints are venerated in this region because of the help they are thought to have given during the severe suffering caused by the Black Plague centuries before. There is constant interest and vivacity in the ornate decoration of the church's interior. From the subtle pink and yellow in the columns, to the paintings on the oval recesses in the ceilings, to the gilded touches throughout, rich detail prevails (3.146).

Rococo paintings were often commissioned by the aristocracy and are playful in mood,

sometimes with erotic undertones. The delicate brushstrokes and pastel colors create a sense of lightness and ease, and the frequently frivolous subject matter suggests that those who commissioned such artworks had ample time to amuse themselves.

3.146 Balthasar Neumann, Basilica of Vierzehnheiligen, 1743-72, near Bamberg, Germany

European and American Art Academies: Making a Living as an Artist

3.147 Pietro Antonio Martini, The Salon, 1785. Musée du Château de Versailles, France

During the eighteenth century and for much of the nineteenth, in Europe, governmentsponsored art academies provided the main outlet for European artists to exhibit their work. Since patrons often chose artists who were members of an academy, such academies exercised considerable control over an artist's ability to earn a living. France was the artistic center of Europe at this time, and the French Academy of Painting and Sculpture (renamed the Academy of Fine Arts in 1816) was vastly influential in determining artistic success. Its system of training artists and exhibiting their work was imitated throughout Europe and in America. Its strict curriculum required artists to copy ancient works of art before they were allowed to study a living model. Students also studied history, mythology, literature, and anatomy, which were important subjects of academic art. The Academy thrived on the notion of competition. The winner of the most important competition, the Prix de Rome (Rome Prize), was sent to Rome to study Classical works and the masters of the Renaissance.

The Academy also developed a hierarchy that determined the relative importance of

the subject matter of a painting. History paintings, which depicted historical or mythological scenes, were considered to be the finest of the genres, perhaps because these were most favored by the Sun King. Portraits were the next most valued paintings, then scenes of the lower class, landscapes, and finally still life paintings. While artists who excelled in any of these subjects could belong to the Academy, only those who

were considered history painters were allowed to teach there.

Academy painters showed their work at the Salon in Paris, and the public flocked to this social event. In Pietro Martini's print of the Salon of 1785 (3.147), paintings fill the walls from floor to ceiling. The history paintings (always much larger in scale) were given prominent places, and the lowest of the genres, the still lifes, were usually hung lower. Critics around the world reviewed the exhibition, making or breaking artists' reputations. Martini's print highlights the prominent placement (at the center of the middle wall) of David's Oath of the Horatii (see 3.151, p. 403) in the 1785 Salon.

After the French Revolution (1789), the French Academy continued, but its rules and organization no longer fulfilled the needs of artists in the modern world. Previously, enormous and expensive history paintings had been popular with the aristocracy. Now, the emerging middle classes began to see the value of the lesser genres; they could afford to buy them, and had room to hang them in their homes. The increasing numbers of such people enabled artists to exhibit in venues the Academy did not control.

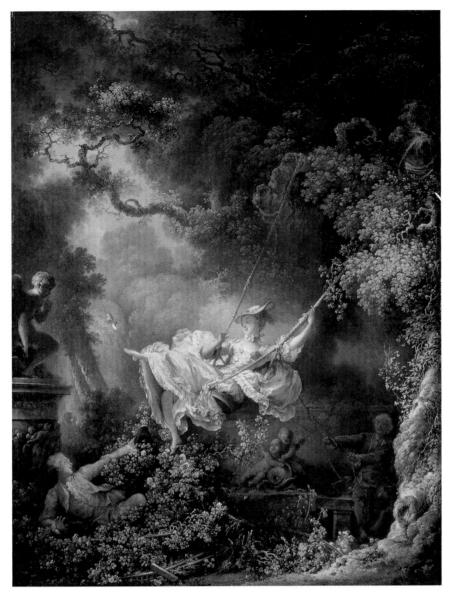

3.148 Jean-Honoré Fragonard, The Swing, 1766. Oil on canvas, $31\frac{7}{8} \times 25\frac{1}{4}$ ". Wallace Collection, London, England

At first sight, The Swing, by Jean-Honoré Fragonard (1732–1806), appears to be an innocent scene of a refined young lady enjoying her swinging (3.148). Upon closer inspection, however, we see that the woman has flirtatiously kicked her shoe into the air, which allows the "gentleman" (the patron of this painting) in the bushes below a view up her skirt. In a statue on the left side of the canvas, Cupid puts his finger to his lips, suggesting a secret love tryst between the young couple. A bishop, standing in the shadows in the lower right-hand part of the canvas, holds a rope that controls the swing. The artist's inclusion of this bishop, who otherwise seems an unlikely character to feature in such a work, has been interpreted by some as a comment on the Church's ignorance of immoral behavior, and by

others as a chiding of the Catholic Church for not condemning such conduct.

The works of British painter and **engraver** William Hogarth (1697–1764) were a reaction to the aristocratic classes of the Rococo era. Hogarth's narratives criticized the morals of his time. Many of his paintings were reproduced as prints, which were released one at a time to spur interest and curiosity; these were the soap operas of the eighteenth century. Hogarth's prints (often engraved by others) made his work affordable for the lower and middle classes, who were a receptive audience for his satirical series. If they could afford only one artwork, it was often a Hogarth print. Those who could not afford to own one themselves could still see them hung in public establishments around London.

Classical: artworks from ancient Greece and Rome Renaissance: a period of cultural and artistic change in Europe from the fourteenth to the seventeenth century Genre: categories of artistic subject matter, often with strongly influential histories and traditions Still life: a scene of inanimate objects, such as fruits, flowers,

or motionless animals Salon: official annual exhibition of French painting, first held in 1667

Engraving (engraver): a printmaking technique where the artist gouges or scratches the image into the surface of the printing plate

Narrative: an artwork that tells a story

Print: a picture reproduced on paper, often in multiple copies

3.149 William Hogarth, The Marriage Settlement, c. 1743. Oil on canvas, $27^{1/2} \times 35^{3/4}$ ". National Gallery, London, England

The series Marriage à-la-Mode (A Fashionable Marriage) includes six paintings on which the highly successful engravings were based. The *Marriage Settlement* is the first in the series (3.149). The betrothed couple sit together on the left, completely uninterested in one another. The miserable bride toys with her handkerchief while her father's lawyer, Silvertongue, flirts with her.

The bridegroom admires himself in a mirror, too much of a snob even to look at his bride. The two dogs shackled together in the foreground echo the attitudes of the bride and groom. The marriage contract is being arranged by their fathers. The groom's father, on the far right, proudly displays in his family tree his aristocratic lineage as Earl Squander. The bride's father, a successful merchant, offers a fine dowry in the form of a pile of coins placed in front of the earl. Out the window above the earl can be seen his building project, which will be financed by the dowry.

In the rest of the series, both husband and wife have affairs and gradually fritter away their fortune. The Lady's Death is the final image of the series; 3.150 shows it as an engraving, as the public would have seen it. The wife has poisoned herself; in the previous scene in the series, her lover Silvertongue killed her husband; he was executed for the murder. Only one of the dogs from the first scene (which symbolized the couple) returns here, as an emaciated animal eating the carcass of the other dog. The fathers, instigators of this disastrous marriage, are also represented here. The bride's father has removed the ring from his daughter's finger just minutes after she has died. The old earl's use of the dowry can be

3.150 William Hogarth, The Lady's Death. Engraving published London, 1833

seen in the completed building project outside the window.

Much of Hogarth's artwork addresses the need for social change. He was especially concerned with the needs of children, and in response to the rising number of homeless children, he founded a hospital for orphans and was a foster parent to many.

The Marriage à-la-Mode series condemns the devastating effect of immorality on society, particularly children. In this final scene, the future seems bleak for the child as she kisses her mother goodbye; the sore on her face indicates that her parents have passed on to her their syphilis. In eighteenth-century London, almost two-thirds of children died before they reached the age of five.

Neoclassicism

Those marks of heroism and civic virtue presented to the eyes of the people will electrify the soul, and sow the seeds of glory and loyalty to the fatherland.

(Jacques-Louis David)

This statement by the French painter David summarizes the moral objectives of neoclassical (literally, "new Classical") art. This was a movement that developed during the late eighteenth century. Neoclassical artworks recall, in their imagery and subject matter, the ancient Classical cultures of Greece and Rome. This interest in the ancient world was fueled by such archaeological discoveries at about this time as the remains of the Roman city of Pompeii. Ancient Greece and Rome were thought to embody such virtues as civic responsibility and an emphasis on rational thought. At a time of public unrest, neoclassical artworks used historical or mythological stories to convey a moral message.

Jacques-Louis David (1748–1825) lived through one of the most tumultuous periods in French history. He made paintings purchased by the monarchy, then supported revolutionary leaders who opposed the king, and later painted numerous portraits of the French emperor Napoleon. Although David's image is often linked with the ideas that fueled the French Revolution, because of its promotion of civic

3.151 Jacques-Louis David, The Oath of the Horatii, 1784. Oil on canvas, 10'10" x 13'11³/₈". Musée du Louvre, Paris, France

duty, or accepting personal sacrifice in the service of one's nation, The Oath of the Horatii (3.151) was made for King Louis XVI, five years before the Revolution against him.

The painting shows a scene from early Roman history in which three brothers make a vow to their father to fight for Rome. The scene is neoclassical in its serious subject matter, its muscular Classical figures, and its stable, balanced composition. The three Roman archways divide the scene with the brothers on the left, the father in the center, and the women of the family on the right. While the soldiers stand heroically, the women mourn the losses they know will come. The painting's message of sacrifice was particularly potent a few years later when the French Revolution began.

The Swiss-Austrian Angelica Kauffmann (1741–1807) was one of only two women among the thirty-four original members of the British Royal Academy of the Arts. Founded in 1768, it was the British version of the French Academy of Painting and Sculpture (see p. 400). Kauffmann's neoclassical scenes are best known for their female characters. In Cornelia Pointing to Her Children as Her Treasures, a Roman woman is represented as a model of motherhood and morality (3.152). While the woman on the right displays her fine jewelry, Cornelia gestures to her sons as her source of pride, her own jewels; they will grow up to be the political leaders Tiberius

3.152 Angelica Kauffmann, Cornelia Pointing to Her Children as Her Treasures. c. 1785. Oil on canvas, $40 \times$ 50". Virginia Museum of Fine Arts, Richmond

and Gaius Gracchus. Cornelia's daughter, curious, strokes the woman's jewels, but Cornelia holds her hand firmly and models strength of character rather than pride in material wealth. Even without knowing the story, it is clear that the scene is neoclassical from the figures' Roman attire and the Classical architecture behind them.

Neoclassicism represented the ideals of Americans in the late eighteenth century: equality, patriotism, and civic responsibility. The new American cities chose neoclassicism as their preferred architectural style. Thomas Jefferson (1743–1826), author of the Declaration of Independence and America's third president, designed a neoclassical home for himself in Charlottesville, Virginia; he named it Monticello (3.153). The house has a dome with an oculus,

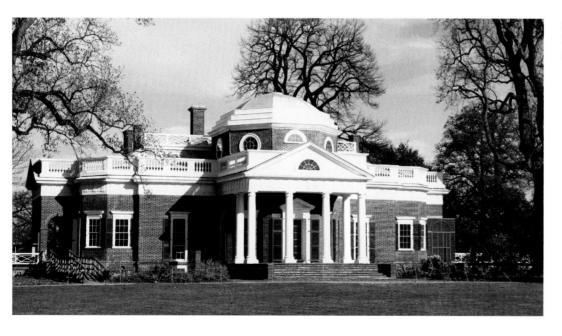

3.153 Thomas Jefferson. Monticello, 1769-1806, Charlottesville, Virginia

similar to a Roman dome. At the front and back there are porticos (porched entryways) with columns and **pediments** reminiscent of ancient architecture. The house also has eight fireplaces and thirteen skylights. It was begun in 1769, but Jefferson continued to make changes and additions to it until his death, more than fifty years later.

Romanticism

While the style and subject matter of neoclassical art were inspired by ancient Greece and Rome, Romantic artworks, by contrast, surge with movement, drama, and heightened emotion. Romanticism in art, which emerged in the first half of the nineteenth century, reflects the turmoil of the European and American revolutions, when the people rose up against the ruling classes and demanded their freedom. Romantic art challenged the traditional norms and structures of society, and often showed citizens' sacrifices for ideals of liberty, equality,

and humanity. One of the most shocking and moving Romantic images is Francisco Goya's Third of May, 1808 (see Gateway Box: Goya, 3.156, p. 406), commemorating the Spanish resistance to Napoleon's occupation of Madrid.

Liberty Leading the People, by Eugène Delacroix (1798–1863), is one of the most prized possessions of the Louvre Museum in Paris, France (see Box: The Museums of Paris, 3.177, p. 419), partly because it depicts the French people bravely rising up against their government in the three-day July Revolution of 1830 (3.154). In the painting, the bare-breasted symbol of freedom, Liberty, carries the flag of the revolution in one hand and a musket in the other. The painting shows the sacrifice of people of all ages and social classes. A little boy fearlessly marches forward carrying two pistols, while an upper-class gentleman in a top hat holds a rifle. Crowds of people with muskets and swords follow Liberty as she climbs over those who have died.

The British artist and poet William Blake (1757–1827) conveys in both his visual and

3.154 Eugène Delacroix, Liberty Leading the People, 1830. Oil on canvas, $8'6^{3/8}$ " × 10'8". Musée du Louvre, Paris, France

Oculus: a round opening at the center of a dome

Pediment: the triangular space, situated above the row of columns, at the end of a building in the Classical style

Romanticism: movement in nineteenth-century European culture, concerned with the power of the imagination and greatly valuing intense feeling

Gateway to Art: Goya, The Third of May, 1808

The Artist and the Royal Family

3.155 Francisco Goya, Family of Charles IV, c. 1800. Oil on canvas, $9'2^{1}/4'' \times 11'^{3}/8''$. Museo Nacional del Prado, Madrid,

The Spanish royal family commissioned paintings from Goya before and after the French occupation of Spain (1808-14). An examination of The Third of May, 1808 and Goya's portrait The Family of Charles IV poses interesting questions about Goya's personal views and the turbulent history of the time.

In his portrait of 1800, Goya shows the royal family ornately dressed. The king wears black military attire and many gold medals. Yet critics commented on how Goya represented the less flattering aspects of the royal family, one describing them as "a shopkeeper and his family after they have won the lottery." The king and queen are both shown as aging and overweight, the king's bulging paunch the antithesis of what one expects from a nation's military leader. The queen is prominent in the center, somewhat obtrusively stealing the stage from her husband and children. Her prominent position perhaps reflects the fact that she was the most powerful person in the family; that she arranged the individual sittings for the painter; and that she approved the final

work. The royal couple's two younger children stand on either side of her while the eldest. Prince Ferdinand VII, is shown on the far left in a rich regal blue. He holds hands with a young lady; her face is not visible because she represents the prince's bride, who has not yet been chosen. Behind them is the grandmother with a large mole, which the painter made no effort to hide, on her face.

There is no evidence, however, that Goya intended to insult or make fun of the royal family. The painting may reflect his respect for truth and nature; and the sitters seemed quite pleased with the portrait, even allowing the artist to include his self-portrait in the shadows on the far left of the canvas. Goya's inclusion of himself in the painting is a reference to Las Meninas, a famous royal portrait of the family of an earlier Spanish monarch, Philip IV, by Diego Velázquez (see 1.169, p.160).

Eight years after he appeared in Goya's portrait of his family, Ferdinand VII helped the French to overthrow his father. The Spanish people had mixed responses to the French occupation; some hoped it would bring an end to the tyranny of the Inquisition, which enforced religious orthodoxy. Goya's painting The Third of May, 1808 documents and memorializes the ill-treatment of the Spanish people who initially rose up against the French. Interestingly, the painting was commissioned in 1814 by Ferdinand VII, who had replaced his father as King of Spain.

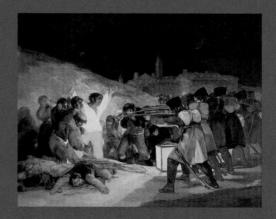

3.156 Francisco Goya, The Third of May, 1808, 1814. Museo Nacional del Prado. Madrid

3.157 William Blake, Elohim Creating Adam, 1795. Color print finished in ink and watercolor on paper, $17 \times$ 211/8". Tate, London, England

literary works emotionally charged messages of his beliefs in personal and creative freedom. Blake resisted any controls on either his creativity or behavior, rejecting many of the accepted Christian values of the time and rebelling as well against the philosophies of the British Royal Academy. In *Elohim Creating Adam* (**3.157**), Blake transforms Michelangelo's famous Creation of Adam from

the Sistine ceiling in Rome into an emotionally charged Romantic image. In Blake's vision, God ("Elohim" in Hebrew) has enormous wings that seem to grow from the tendons in his shoulders. Blake's figures struggle; the process of creation is shown to be painful for both creator and created. The sadness evident in Elohim's face may convey his knowledge that the creation of man will inevitably bring about the fall of man, symbolized in the image by the snake. Blake believed that man's spiritual freedom was suppressed on the day of his creation, and his painting shows it: Adam's body is restrained by a snake and his mind is restrained by the hand of God.

The Hudson River School was a group of Romantic American painters who painted the American landscape as an expression of national pride in the expansion of the developing nation and also in its great natural beauty. This group's paintings embody the idea of the sublime, where the awe-inspiring power of nature overwhelms the smallness of man. Thomas Cole (1801–48) was the founder of the Hudson River School. In his painting The Oxbow, Cole has chosen a dramatic vantage point from which to view the twisting Connecticut River (3.158). A large tree in the foreground has been battered by weather, while the river is far in the valley below. Above the

3.158 Thomas Cole. View from Mount Holyoke, Massachusetts, after a Thunderstorm—The Oxbow, 1836. Oil on canvas, 4'31/2" × 6'4". Metropolitan Museum of Art, New York

Sublime: feeling of awe or terror, provoked by the experience of limitless nature and the awareness of the smallness of an individual

tree are fierce thunderclouds, while the distance shows the sky after the storm has passed. The only trace of man in this scene is the artist wearing a hat in the lower center of the canvas.

Frederic Edwin Church (1826-1900) was a close student of Thomas Cole. Together, they sketched Niagara Falls, a popular subject for artists in this period both because of its grandeur and because it symbolized America's territorial expansion: it marks the northern border of the United States. Niagara represented the presence of God in nature. When Church's Niagara was exhibited in 1857, viewers praised its grand scale (3.159). The vantage point was miraculous; viewers felt as if they were almost standing in water at the top of the falls. One critic remarked, "This is Niagara, with the roar left out!"

Realism

Show me an angel, and I'll paint one! (Gustave Courbet, French painter, defending realism)

Beginning around the mid-nineteenth century, a significant shift took place in the objectives of visual arts and in the way art looked. To varying degrees, a number of artists broke away from the traditions of earlier eighteenth- and nineteenthcentury art to create objective representations of the real world. Realists observed contemporary life, and in particular, the circumstances of social classes previously rarely depicted by artists. Realist artists chose modern-day subjects and portrayed them in untraditional ways. Artists also began to allow the process of creating art to show through in their final works, and were less concerned with illusionistic surfaces. Gustave Courbet (1819–77) is credited with first using the term "realist" to describe his own work. As a reaction to the extremely emotional paintings of the Romantics, Courbet argued that it was more meaningful to paint people and things in everyday life.

The painting Stonebreakers was shocking for its depiction of working-class people on a largesized canvas, a scale normally reserved for heroic subject matter (3.160). Courbet's painting highlights the monotonous, backbreaking work of the poor. The breaking of stones was a job taught by older generations to young men, and it was a job a man would have for a lifetime. The painting shows an older worker and his young assistant as powerful and unrelenting, qualities that alarmed the upper classes: a year before Courbet painted this work, workers throughout Europe had rebelled and demanded an end to bad working conditions and to low pay.

The desire to portray realistic subject matter that reflected everyday life was taken up by painters in the United States as well. Henry

3.159 Frederic Edwin Church, Niagara, 1857. Oil on canvas, $3'6^{1/4}" \times 7'6^{1/2}"$. Corcoran Gallery of Art, Washington, D.C.

Realism: nineteenth-century artistic style that aimed to depict nature and everyday subjects in an unidealized manner Illusionistic: something made to look real by artistic skill or trickery

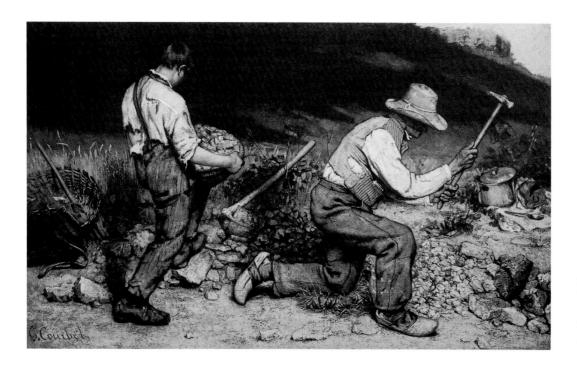

3.161 (below) Henry Ossawa Tanner, The Banjo Lesson, 1893. Oil on canvas, $48 \times$ 35½". Hampton University Museum, Hampton, Virginia

3.160 Gustave Courbet, Stonebreakers, 1849. Oil on canvas, $5.3" \times 8.6"$. Formerly in the Gemäldegalerie, Dresden, Germany; believed to have been destroyed in 1945

Ossawa Tanner (1859–1937) was born into a middle-class African-American family. He was educated at the Pennsylvania Academy of the Fine Arts, where his professor, the painter Thomas Eakins, encouraged him to study anatomy and observe nature closely. Later Tanner moved to Paris, where he was influenced by French painters, including Courbet.

Just as Courbet's Stonebreakers showed an older man training a younger worker, Tanner's Banjo Lesson shows the passing of knowledge between generations (3.161). In a humble home, a young African-American boy is patiently being taught by his grandfather to play the banjo. Tanner's painting challenges the stereotype then common in America, of smiling black men as simple-minded entertainers. Tanner creates a dignified image of a poor black family by showing a thoughtful black man as teacher, and an intelligent black child engaged in learning. Tanner sets a calm scene with natural objects and earthy colors, but he symbolizes the boy's spiritual and mental growth with the light coming in through the window, creating a soft rhythm, which can be likened to the act of playing the banjo.

The French painter Édouard Manet's (1832– 83) Déjeuner sur l'Herbe (Luncheon on the Grass) revolutionized painting in the way it portrayed characters from the modern world and transformed the painted surface (3.162). Viewers were shocked to see two men casually placed in a local park next to a nude woman whose body is not idealized like that of a goddess in an academic painting, but is harshly lit; she stares boldly out at us. Painters who worked in the more traditional methods that were taught at the Academy tried to create an illusion that a painting was a window into another reality. Manet was one of the earliest painters to reject this approach, using his art to acknowledge that the canvas is a painted surface. In Luncheon on the Grass, each of the figures has a bold **outline**, rather than gradual **shading**. Flat-looking figures that lack volume appear almost as overlapping cutouts superimposed on the landscape.

As a result of his integration of traditional painting with new techniques and subjects from contemporary life, Manet came to epitomize the notion of a modern painter.

Auguste Rodin (1840–1917) did the same thing in the realm of sculpture (see Box: Modern Sculpture: Auguste Rodin and Camille Claudel, 3.167 and 3.168, p. 414). Although Manet and Rodin often made visual references to artists respected by the Academy, their work differed dramatically from the Academy's preferred historical and mythological artworks.

Manet's painting was not accepted for the 1863 Salon. In that year, however, so many artworks were rejected that the French government created a new exhibition, the Salon des Refusés (Salon of the Rejected), which was installed near the official Salon. This second exhibition was designed to appease artists who felt unfairly excluded from the Salon, but the Academy also saw it as a chance to allow the public to ridicule the works its jury had rejected. Such paintings as Manet's Luncheon on the Grass were indeed mocked by some critics. But with the public now exposed to art that had not been approved by the Academy, artists were emboldened to exhibit independently in venues throughout Paris.

3.162 Edouard Manet, Le Déieuner sur l'Herbe (Luncheon on the Grass), 1863. Oil on canvas, $6'9^{7}/8" \times 8'8^{1}/8"$. Musée d'Orsay, Paris, France

Outline: the outermost line of an object or figure, by which it is defined or bounded **Shading:** the use of graduated light and dark tones to represent

a three-dimensional object in two dimensions Volume: the space filled or

enclosed by a three-dimensional figure or object

Pre-Raphaelite Brotherhood: English art movement formed in 1848 by painters who rejected the academic rules of art, and

often painted medieval subjects

in a naïve style Impressionism: a late nineteenth-century painting style conveying the impression of the effects of light

3.163 John Everett Millais, Ophelia, 1851-2. Oil on canvas, 30 × 44". Tate, London, England

While Realist painters in France were rejecting the traditions of the Academy, a group of English painters and writers who called themselves the **Pre-Raphaelite Brotherhood**, formed in 1848, were opposed to the values of the Royal Academy of Arts in Britain, which promoted artwork inspired by artists of ancient Greece and Rome and of the Renaissance. The Pre-Raphaelite artists were instead inspired by elements of art from the Middle Ages. They were realist in their true-to-life depictions of nature and people.

Ophelia (3.163) by John Everett Millais (1829-96) is a scene from Shakespeare's tragedy Hamlet, in which Ophelia drowns herself because her lover Prince Hamlet has rejected her and accidentally killed her father. Millais' depiction of nature is painstakingly detailed. To make this painting, he selected a single spot on a nearby river and painted the plants growing there so carefully that botanists can identify every one. He worked at the site almost every day over a five-month period. Millais also included flowers that were not growing by the river but that are mentioned in Hamlet. He then took realism to the extreme by having his model pose for the painting in a filled bathtub so that he could study

the way her hair and dress floated. Although she often had oil lamps around her to keep her warm, the model caught a severe cold from spending so many hours in the water in the middle of winter.

Impressionism

The artists who came to be called **Impressionists** worked in individual, sometimes very different, styles, but they were united in rejecting the formal approach of the art taught in the Academy. Their art attempted not so much to portray exactly and realistically such scenes as a landscape or life in a city (although they did depict those subjects), as to capture the sensations produced by the scene. The Impressionists formed a group to show their work together outside the official Salon in eight exhibitions held between 1874 and 1886. Their subject matter was scenes of everyday life: rural landscapes, and life in the modern and growing cities of France—especially scenes of the middle classes engaged in leisure pursuits. The Impressionists were often intent on capturing the essence of moments in time, and

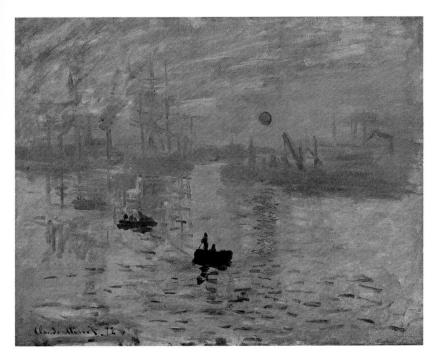

3.164 Claude Monet, Impression Sunrise, 1872. Oil on canvas, $19^{1/2} \times 25^{1/2}$ ". Musée Marmottan, Paris, France

many of them painted en plein air (outdoors). Many reinterpreted the bright natural light of day in their paintings by applying a layer of white paint as a base coat.

Before the Impressionists, artists who followed traditional methods of painting gave their work a

smooth surface, often finishing paintings with a topcoat of varnish, so that the way in which they had applied the paint was not evident. Impressionists, on the other hand, chose to reveal their brushstrokes. The almost sketchy, unfinished appearance of many Impressionist works breaks away from the academic tradition of simply creating an illusion of threedimensional space on the canvas. Instead, Impressionists played with space and welcomed visible **texture**. It is perhaps this desire to experiment with new ways of painting that most unites this diverse group of painters.

At the first of the Impressionist exhibitions, in 1874, hung a painting by Claude Monet (1840–1926) called *Impression Sunrise* (3.164). Monet's title was meant to convey that he had somehow captured the essence of light glittering on water in the harbor of Le Havre. A critic described Monet's painting—which indicated with only a few brushstrokes the sea, the reflection of the sun, and the boats in the background—as merely "an Impression indeed!," thus giving the group of painters their famous name. This same critic claimed that a man had

3.165 Pierre-Auguste Renoir, Moulin de la Galette, 1876. Oil on canvas, $51^{5}/_{8} \times 68^{7}/_{8}$ ". Musée d'Orsay, Paris, France

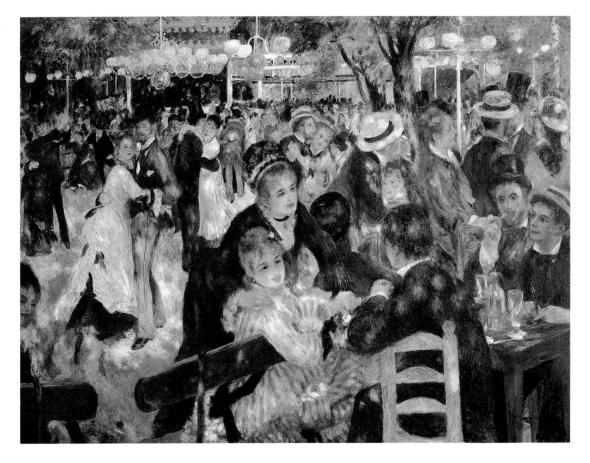

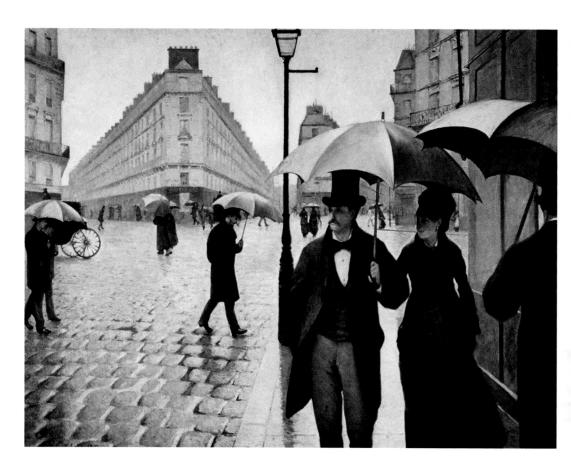

3.166 Gustave Caillebotte. Paris Street: Rainy Day, 1877. Oil on canvas, $6.11^{1/2} \times 9.3^{4}$. Art Institute of Chicago

run into the street, raving mad from looking at

In the background of his picture, Monet suggests the masts and smokestacks of an industrial port. The second half of the nineteenth century was a time when French cities were undergoing a major change as they became industrial centers.

Whereas many painters in the past had taken the upper classes as their subject, the Impressionists instead chose to capture the urban middle classes of the bustling cafés. In a period when people had more leisure time than ever before, the Impressionists depicted Parisians, for example, dancing, drinking, swimming, and attending the opera or the ballet. Such paintings as Moulin de la Galette by Pierre-Auguste Renoir (1841–1919) were intended to transport viewers into a world of beauty and pleasure (3.165). Renoir shows people at a popular outdoor café in the Montmartre district of Paris. At the end of the nineteenth century this venue was also a dance hall and gathering-place for artists and intellectuals. The absence of strong outline, almost as if the artist painted with a cotton ball,

and his use of dark blues and purples instead of black, are characteristic of Renoir's style. The spontaneous brushstrokes he used and the cheerful gathering he chose to depict reflect his belief that life was, or should be, a perpetual holiday.

Another perspective on the life of the urban middle class can be seen in a painting by Gustave Caillebotte (1848–94). He was a wealthy lawyer as well as a painter, and he supported other Impressionists financially. His works often make use of extreme perspective into the distance, as in Paris Street: Rainy Day, where boulevards extend in every direction—as they do in Paris—like spokes on a wheel (3.166). A green lamppost and its shadow extend beyond the height of the canvas, creating a strong vertical line that divides the composition. To the left of the post is a newly built housing project. To the right is a welldressed couple who, although surrounded by the different classes of people in the city, seem to be alone and in their own world. Caillebotte's use of perspective makes us feel as if we are part of the busy city and will soon collide with the strolling couple.

Three-dimensional: having height, width, and depth **Texture:** the surface quality of a work, for example fine/coarse, detailed/lacking in detail

Modern Sculpture: Auguste Rodin and Camille Claudel

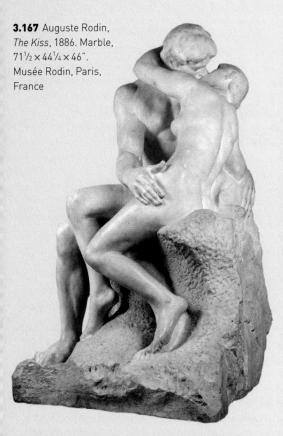

The Frenchman Auguste Rodin (1840–1917) epitomizes the modern sculptor. Rather than copying from Classical busts and using traditional poses, as had been done for centuries, Rodin used live models and depicted energetic and passionate figures. By the beginning of the twentieth century, Rodin was one of the most famous living artists. He had a large workshop of sculptors who produced his works in both bronze and marble. Rodin was careful to maintain his individual style, however, and frequently completed the final work on his sculptures himself.

The Kiss is a sculpture of two nude lovers embracing, engaged in a passionate kiss (3.167). The couple was originally conceived to be part of Rodin's Gates of Hell, two large bronze doors depicting scenes from a masterpiece of medieval Italian literature, Dante's Divine Comedy. The Kiss is based upon the story of Paolo and Francesca, lovers from Dante's time who were killed by Francesca's husband (Paolo's brother).

Rodin did not include them in the final door composition, and instead made several copies of *The Kiss*, one of which was a marble commissioned by the French government.

Camille Claudel (1864-1943) worked in Rodin's workshop, and quickly became his lover as well. A talented sculptor in her own right, Claudel was able, through Rodin's connections, to meet important people, and to receive commissions she might not otherwise have had. The Waltz shows two dancers intertwined as they move as one (3.168). The woman's dress has fallen off her body and blows to the side, expressing the energetic movement of the couple. One writer proclaimed, "In this group of a waltzing couple, they seem to want to finish the dance so they can go to bed and make love." A government representative who had purchased many of Rodin's erotic nudes remarked that The Waltz was too erotic, and suggested that Claudel should put clothes on the figures.

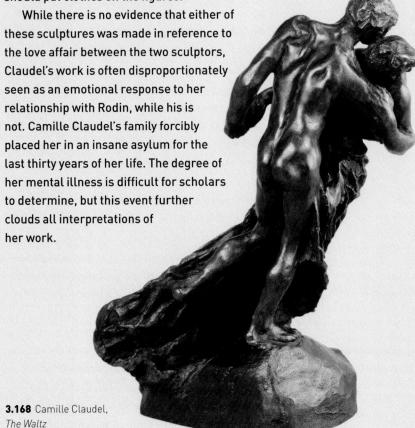

3.169 Edgar Degas, Blue Dancers, c. 1890. Oil on canvas, $33^{1/2} \times 29^{3/4}$ ". Musée d'Orsay, Paris, France

Cropping: trimming the edges of an image, or composing it so that part of the subject matter is cut off

Abstract: art imagery that departs from recognizable images from the natural world Post-Impressionists: artists either from or living in France, c. 1885-1905, who moved away from the Impressionist stylenotably Cézanne, Gauguin, Seurat, and Van Gogh **Symbolism:** movement in European art and literature,

c. 1885-1910, that conveyed

yet ambiguous symbols

meaning by the use of powerful

Edgar Degas (1834–1917) is well known for his paintings and pastels of female subjects, including laundresses, prostitutes, singers, and bathers. One of his favorite subjects was ballet dancers, whom he studied not only during performances, but also during practice, stretching, and backstage. Degas' scenes of dancers, in both public and private settings, evoke the everyday quality of the life of a dancer. His *Blue Dancers* shows the performers fixing their tutus and hair, preparing to walk on stage (3.169). Degas' composition gives the impression of immediacy, as if the viewer has caught the dancers in a fleeting moment. The Impressionists experimented with techniques they learned from two sources: popular imported Japanese prints, and the new medium of photography. In Degas' pastel, for example, the sharp **cropping** of the image, particularly the cutting off of the girl's tutu on

the right, and the view of the scene from slightly above (known as bird's-eye view), are techniques acquired from these two sources. The experimentation with such influences and a desire to capture the spontaneity of modern daily life were shared by all the Impressionists.

Post-Impressionism and Symbolism

By the 1880s, Impressionism had gained great public popularity, but by the middle of that decade some artists had already rejected the movement's interest in capturing the essence of modern life and of nature. Instead, they chose to emphasize **abstract** qualities or symbolic content in their artworks. They explored new scientific theories, and used abstraction and the distortion of form and color to express emotion. This group of artists came to be known as the Post-Impressionists. Some Post-Impressionist painters also developed an interest in a literary and artistic movement known as Symbolism. Symbolist painters were inspired by the use of the emotionally potent and often dreamlike images of the Romantics; yet, while using universal symbols and devices in their artworks (such as colors to suggest mood), they also encouraged individual interpretation.

The French painter Paul Cézanne (1839– 1906) developed a new type of landscape painting through intense study of Mont Sainte-Victoire, a mountain he could see from his studio (and childhood home) in Aix-en-Provence, where he worked for much of his adult life. Cézanne made several paintings of this mountain, working on some of them for years. By gradually adding brushstrokes to reflect the mountain's changing atmosphere and weather conditions, Cézanne sought to capture the essence of the mountain as it appeared over time, rather than at a single moment.

Cézanne created the structure and depth of his landscape in a very different way from earlier painters. He conceived a view of nature in which forms became abstracted, and depth began to disappear. For example, Cézanne utilized his

3.170 Paul Cézanne, Mont Sainte-Victoire, c. 1886-8. Oil on canvas, $26 \times 36^{1/4}$ ". Courtauld Gallery, London

Atmospheric perspective: use of shades of color and clarity to create the illusion of depth. Closer objects have warmer tones and clear outlines, while objects set further away are cooler and become hazy

understanding of atmospheric perspective to blend warm and cool colors within the same structure, as in the mountain (3.170). This creates a push-pull effect for viewers, as the warm hues of the mountain come toward us, and cool colors recede. The tree in the foreground creates a similar experience as we look at it, a feeling of being pulled into the depth of the painting and then being pushed forward, as if the image has been flattened. The upper branch seems to echo the outline of the distant mountain, bringing it closer to us.

The French painter Paul Gauguin (1848– 1903) was a successful stockbroker, but at the age of thirty-five he gave up his career to become a painter. Modern civilization was, in Gauguin's view, materialistic and lacking in spirituality. This led him to become interested in Symbolism, and, seeking people who were pure and untouched by materialistic values, Gauguin went to Pont-Aven in Brittany. The Vision after the Sermon shows the pious people of Pont-Aven dressed in their Sunday clothes (3.171). The scene in the upper right depicts the sermon the townspeople have just heard, that of the biblical story of Jacob wrestling with the angel. The spaces are abruptly flattened, the figures lack volume and are closely cropped. Yet rather than just showing a scene from everyday life, Gauguin expresses what is in these people's minds: a vision. Some scholars believe that Gauguin depicted himself as the figure with closed eyes in the lower right of the canvas, as if he too is experiencing a vision. Gauguin once said, "I shut my eyes in order to see." The bright red ground makes this a clearly invented, and intensely emotional, scene.

The paintings of Dutch artist Vincent van Gogh (1853–90) also express strong emotions, yet Van Gogh claimed he could not invent images, but instead painted emotion into what he saw. He once stated:

I cannot work without a model. I won't say that I don't turn my back on nature to transform a study into a picture, arranging the colors, exaggerating, simplifying, but when it comes to form I'm too fearful of departing from the possible and the true... I exaggerate, sometimes I make changes... but I do not invent the whole picture.

Van Gogh, who struggled with mental illness all his life, painted Starry Night during a stay in an asylum; it is a view from his window (3.172). He infused the scene with his own emotions:

3.171 Paul Gauguin, The Vision after the Sermon (Jacob Wrestling with the Angel), 1888. Oil on canvas, $28^{1/2} \times 35^{7/8}$ ". National Gallery of Scotland, Edinburgh

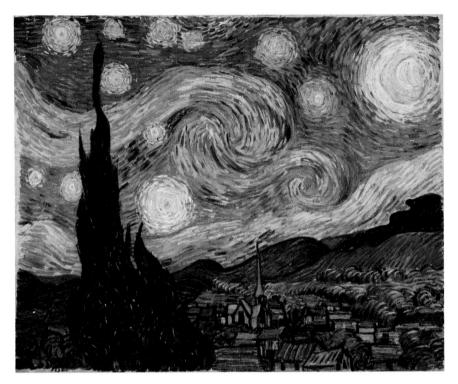

Ground: the surface or background onto which an artist paints or draws Impasto: paint applied in thick layers

3.172 Van Gogh, Starry Night, 1889. Oil on canvas, $29 \times 36^{1/4}$ ". MOMA, New York

one can sense the very physical act of applying the thick paint (**impasto**), and the energy of the artist, in swirls that show movement in the sky and the light emanating from the stars. A cypress tree, resembling flames reaching up to the sky,

3.173 Odilon Redon, Ophelia, 1900–5. Pastel on paper, $19^{1/2} \times 26^{1/4}$ ". Private collection

fills much of the left side of the canvas. The church in the distance may hint at Van Gogh's personal trials with religion; some believe it relates to his childhood church in the Netherlands. Van Gogh's use of color and form expresses his emotional suffering; in 1890, the year following this painting, Van Gogh shot himself in the chest with a revolver and died two days later.

The French Symbolist Odilon Redon (1840-1916) painted images of well-known scenes, but he depicted them in an imaginary, evocative way. Redon's portrayal of Ophelia (3.173) contrasts markedly with Millais' realist version of the same subject (see 3.163, p. 411). The Symbolist scene is otherworldly, as if Ophelia is caught somewhere between this world and the next. Is she floating on the water or trapped underneath? Are the flowers floating above, or are some of them part of the pattern in her dress? Is this an image of Ophelia, or is it a reflection of one who looks into the water? Redon, intentionally mysterious, invites us to infuse his artworks with personal meaning.

Fin de siècle and Art Nouveau

Fin de siècle (from the French, "end of the century") refers to the period from the end of the nineteenth century to the start of World War I in 1914. This was a time of great social change in Europe. A growing middle class had sufficient income to enjoy the pleasures that life had to offer. As they faced the new century, some were anxious, however (and rightly, in view of the war that ensued a decade later), about the changes it would bring. Others devoted themselves to self-indulgence, pushing the traditional boundaries of etiquette and challenging the standards laid down by society.

Fin de siècle artists favoured new, modern materials, such as cast iron. This was the material chosen for the construction of the Eiffel Tower. While it was being built, many Parisians considered it a monstrosity that was ruining the skyline of their city (3.174). For its

critics, the tower symbolized the decadence of the modern generation, who were destroying French history and long-held traditions:

We, writers, painters, sculptors, architects, passionate lovers of the beauty, until now intact, of Paris, hereby protest with all our might, with all our indignation, in the name of French taste...in the name of French art and history under threat, against the construction, in the very heart of our capital, of the useless and monstrous Eiffel Tower.

The engineer Gustave Eiffel (1832–1923) pushed on regardless, and the criticism decreased after the tower was completed. Today, of course, the Eiffel Tower is a beloved and iconic symbol of Paris.

The Eiffel Tower had been made to welcome to Paris the 1889 World's Fair, with the intention that it would later be torn down. Critics had been concerned that the unique modern design and its iron structure would overpower the city. Yet the delicate curvature of the four corner bases, the balance between modern materials and graceful organic lines, create an elegant addition to the Parisian skyline.

During the fin de siècle era, Parisian nightclubs were legendary for their beautiful dancers, and many artists created posters promoting the local nightlife. The French artist Jules Chéret (1836-1932) was one of the first. The poster in **3.175**

advertises a show by the dancer Loie Fuller, who performed in costumes made of yard upon yard of silk fabric. As she danced, theatrical lighting captured the movements of the fabric and created such beautiful designs that Fuller herself seemed to disappear. The swirling colors and sensuous body of the red-haired beauty in this poster capture the essence of fin de siècle nightlife.

3.174 (above left) Gustave Eiffel, Eiffel Tower, 1889, Paris

3.175 (above) Jules Chéret, Poster advertising a dance performance by Loie Fuller at the Folies Bergère, 1893

3.176 Gustav Klimt, The Kiss, 1908. Oil paint, silver, and gold leaf on canvas, $70\% \times 70\%$

The Austrian artist Gustav Klimt (1862–1918) was well known for his sumptuous and erotic works. In The Kiss, a woman is engulfed by the arms and kiss of a powerful man (3.176). The anxiety of the *fin de siècle* is conveyed by the couple's position upon a precipice filled with flowers, signifying both the danger and the beauty of passion. This decorative patterning flattens the figures, making the ornamental design the most noticeable aspect of the artwork. The work is from the artist's so-called golden phase, named for the large amounts of gold leaf he used in his paintings. The patterns from

nature found on the couple's clothes and in the background reflect Klimt's interest in Art Nouveau (French for "new art"). This was the visual style most closely associated with this era. Art Nouveau is characterized by organic flowing lines, simulating forms in nature.

Art Nouveau also emphasized decorative pattern and applied it to the traditional "fine arts" (such as painting and sculpture), the decorative arts (such as furniture, glass, and ceramics), and architecture and interior design. Entire rooms and even buildings were designed in Art Nouveau style.

Salon: a French term for an exhibition of work by multiple artists

The Museums of Paris

Art museums as we know them today—as places where artworks are displayed outside of their original settings and for all classes of people to see—are a modern phenomenon. Many of the artworks made by French artists from the eighteenth to the early twentieth centuries are housed in the Louvre Museum and the Musée d'Orsay, in Paris.

The Louvre is the most visited art museum in the world. First built as a fortress in the twelfth century, it was gradually expanded by French rulers over the next several centuries. It was used as a palace by most of the French monarchs until Louis XIV decided to make his home at Versailles, a few miles west of Paris. The Louvre then became a residence for the artists who worked for Louis, mostly in decorating Versailles. After the period of the French Revolution (1789-99), the art collection of the king became public property. The Louvre was used to display the royal collection and to hold exhibitions, called salons, of artwork by contemporary artists. Today, the enormous collection includes artworks from around the globe. The glass-and-metal pyramid, which marks the entrance into the lower levels of the museum, was designed by Chinese-American architect I. M. Pei (b. 1917) and added in 1989 (3.177).

The Musée d'Orsay (3.178), across the River Seine from the Louvre, houses art dating from 1848 to 1914, made by realists, Impressionists,

and Symbolists and belonging to the French national collections. The structure itself was originally a train station. Built with iron and glass for the 1900 World's Fair, the Orsay station was the first terminal to use electric energy to

power trains. It is thus a symbol of the modern era and of the growing city of Paris at the beginning of the twentieth century. The arched ceiling and windows and a large working clock remain from the original train station. As trains became longer, the station became unusable. In 1986, it was transformed into a museum.

3.177 Louvre with Pyramid, Paris, France

3.178 Musée d'Orsay (interior), Paris, France

3.179 Lucien Lévy-Dhurmer. The Wisteria Dining Room, 1910-14. Carved walnut and amaranth. Metropolitan Museum of Art, New York

The Wisteria Dining Room (3.179) was originally in a private home near the Eiffel Tower. It is completely decorated in Art Nouveau style: all of the objects, furniture, decoration, and architecture in the room were chosen to harmonize in what was called a "total work of art." The French designer, Lucien Lévy-Dhurmer (1865–1953), chose the wisteria vine, a symbol for welcome, as a central integrating theme. Lévy-Dhurmer himself painted canvases for the walls that include peacocks, herons, and wisteria. The wood paneling is carved to look like wisteria. Organic designs that simulate wisteria are stamped into the leather chairs, used as the bases for lamps, gilded onto the fire screen, and even used as door handles.

Discussion Questions

- 1 Find in this chapter three artworks that reflect new political ideas or revolutionary turmoil. List the ways in which the composition and content of each artwork express political ideas.
- 2 Enlightenment thinkers in the eighteenth and nineteenth centuries emphasized liberty and

- equal rights, and the importance of reason, rather than faith. Find an artwork in this chapter that reflects such ideas, and discuss how it expresses Enlightenment thinking.
- Choose one Rococo, one neoclassical, and one Romantic artwork. Discuss and compare the visual characteristics of the three works. You might choose one work from another chapter in this book, for example: 4.116, 4.118.
- Select one realist, one Impressionist, and one Post-Impressionist work of art. Discuss how the Impressionist work built on and deviated from the style of the realist work. Next, discuss how the Post-Impressionist work built on and deviated from the style of the Impressionist work. You might choose one work from another chapter in this book, for example: 4.66, 4.86.
- In the eighteenth and nineteenth centuries many artists were trained in Academies. Find a work in this chapter made by an artist who had an academic training, then find an artwork made by an artist who rejected the methods of the Academy. Compare and contrast the two works and suggest how the artists sold their work.

Images related to 3.7: Art of Europe and America (1700–1900)

4.93 Hyacinthe Rigaud, Louis XIV, 1701, p. 524

4.62 Joseph Wright of Derby, An Experiment on a Bird in the Air Pump, 1768, p. 499

4.169 Henry Fuseli, The Nightmare, 1781, p. 584

4.94 Élisabeth-Louise Vigée-Lebrun, Marie Antoinette and Her Children, 1787, p. 524

1.166 Jean-Auguste-Dominique Ingres, Grande Odalisque, 1814, p. 157

4.116 Théodore Géricault. Raft of the Medusa, 1819, p. 542

2.54 Honoré Daumier, Rue Transnonain, April 15, 1834, p. 200

2.79 Louis-Jacques-Mandé Daguerre, The Artist's Studio, 1837, p. 218

4.137 Édouard Manet, Olympia, 1863, p. 561

4.170 James Abbott McNeill Whistler, Nocturne in Black and Gold: The Falling Rocket, 1875, p. 584

4.63 Thomas Eakins, Portrait of Dr. Samuel D. Gross (The Gross Clinic), 1875, p. 499

2.96 Eadweard Muybridge, The Horse in Motion, June 18, 1878, p. 229

4.66 Georges Seurat, Sunday **1.160** Rosa Bonheur, Plowing on La Grande Jatte, 1884-6, p. 501

in the Nivernais: The Dressing of the Vines, 1849, p. 151

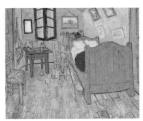

1.18 Vincent van Gogh, The Bedroom, 1889, p. 56

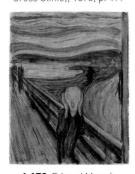

4.172 Edvard Munch, The Scream, 1893, p. 586

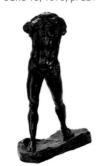

4.143 Auguste Rodin, Walking Man, c. 1890-95, p. 565

2.65 William Morris and Edward Burne-Jones, Page from Works of Geoffrey Chaucer, 1896, p. 208

2.184 Joseph Paxton, Crystal Palace, 1851, p. 284

3.76 Mary Cassatt, The Child's Bath, 1893, p. 345

3.8

Twentieth and Twenty-First Centuries: The Age of Global Art

The beginning of the twentieth century was a period of great experimentation in art. Influenced by the Impressionists and Post-Impressionists (see pp. 398–420), artists continued to explore representational art (depicting something easily recognizable) but also ventured into the realm of abstraction.

Artists responded to this time of great change in technology and society. The invention of aircraft and the automobile; new methods of communication, such as movies, radio, and the telephone; progress in such scientific disciplines as psychology and physics; the emergence of large cities; cataclysmic world wars; and the development of new social ideologies all affected the ways artists saw the world. As the century progressed, artists responded to the speed of change by inventing new forms of representation and by challenging established notions of what constituted art. Art during the twentieth century was very much about the artist and the way he or she defined art.

Partly as a result of this experimentation, the twentieth century was an era of many styles and approaches. For many artists, the formal qualities—the **elements** that make up the appearance—of their artwork were a key concern. Some avoided specific references to their personal experience and instead favored a universal form of expression in their work, a preference that often led to a focus on abstraction rather than representational art. Some artists, though, concentrated more on the ideas behind their works of art than on the way they looked. Later in the century,

artists re-introduced into their artworks recognizable imagery and references to past styles of art.

Another key aspect that affected art during this time was the rapid spread of many new ideas about society and politics through radio and television. During the Modern (c. 1860– 1960) and Contemporary (c. 1960–present) periods, art became a global phenomenon in terms of exposure, influence, and production. Beginning in the 1970s, and continuing into the twenty-first century, as a result of such significant ideologies as feminism and other movements concerned with equality, art became noticeably socially conscious and multiculturally aware. During the 1990s, global technologies and communication increasingly provided access to beliefs, practices, and the artistic production of people all over the world. While museums and galleries have continued to play important roles in the art world, artists living outside such urban centers as New York, Los Angeles, Paris, and Tokyo have been able to show their work to international audiences via the Internet. In recent years art has taken on a distinctly international character.

which an image is altered from an easily recognizable subject **Elements:** the basic vocabulary of art-line, form, shape, volume, mass, color, texture, space, time and motion, and value (lightness/darkness)

Representation: the depiction

of recognizable figures and

Abstraction: the degree to

Color: the optical effect caused when reflected white light of the spectrum is divided into a separate wavelength Form: an object that can be

defined in three dimensions (height, width, and depth) Naturalistic: a very realistic or

lifelike style of making images

The Revolution of Color and Form

Henri Matisse (1869–1954) and Pablo Picasso (1881–1973) are towering figures in the development of modern art. Matisse, a

Frenchman, had already earned some professional notoriety by the time the young Picasso moved from Spain to Paris in 1904. Picasso left behind his academic training in representational art to embrace the brave new world of experimental approaches he found there. Meanwhile, Matisse was already in Paris, exploring the expressive potential of color and its relation to **form**—as he was to do throughout his career. Over their long creative lifetimes, Matisse and Picasso developed a mutual respect for each other, but they were also rivals: each one wanted to be considered the leader of the progressive art world. As it turns out, both artists enjoyed extremely productive careers and have been extraordinarily influential: Matisse for his expressive forms, decorative style, and bold use of color; Picasso for his radical handling of form and shape.

Henri Matisse

The colors in Matisse's Joy of Life—orange and green bodies, pink trees, a multicolored sky—are not strictly **naturalistic** (3.180). These departures from everyday appearances are intentional. An artist's inspired choice of colors varies according to what he or she sees or imagines. For Matisse, color was principally a way to express emotions. He often emphasized colors and made them bold and intense rather than rendering them as subdued or covering them up to make a scene more realistic. Matisse was interested in making an artwork, not in imitating nature or copying external appearances. He was not trying, as artists from earlier times had principally done, to persuade us into believing that we are looking through a window onto a "real" world. In response to a viewer who complained that one of his portraits did not resemble the dimensions of an

3.180 Henri Matisse, Joy of Life. 1905-6. Oil on canvas. $5'9\%" \times 7'10\%"$. Barnes Foundation, Merion, Pennsylvania

3.181 Henri Matisse, The Red Studio, 1911. Oil on canvas, $5.11\frac{1}{4}$ " × $7.2\frac{1}{4}$ ". MOMA. New York

used paper cutouts as preparatory sketches; later in his life he presented them as finished artworks in themselves (see Gateway Box: Cutouts as Finished Art).

In The Red Studio he has included a lot of information about his working environment, but he has also left a lot out (3.181). He accurately shows a number of the paintings, sculptures, and ceramics he had been working on. The space is filled with an intense red; this makes the artworks stand out against the walls and floor, which have been collapsed into a single flat **plane**. The furniture is also red, with subtle gold outlines indicating the edges and details. Matisse is keenly concerned with the use of color to convey his experience of place.

Picasso, Braque, and Cubism

In the early twentieth century, shortly after Matisse was experimenting with new ways of using color in the 1890s, Picasso and the French artist Georges

actual woman, Matisse said, "I did not create a woman. I made a picture."

When Matisse worked on a painting he generally started with complex **sketches** and, over time, simplified the image by eliminating details and paring down the composition. He also

3.183 Henri Matisse in his studio, 1953

Gateway to Art: Matisse, Icarus Cutouts as Finished Art

un moment di libres ne devraite has faire ac. complie un mand voyage en avion aux jeunes gens ayanttermine Ceurs études.

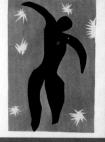

3.182 Henri Matisse, Icarus, from Jazz, 1943-7. Page size $16\frac{7}{8} \times 12\frac{7}{8}$ ". MOMA, New York In early 1941 Henri Matisse was diagnosed with cancer of the intestines. After his treatment, he was permanently confined to a wheelchair (3.183). Matisse had previously used cutout pieces of paper as preparatory sketches, pinning them on a canvas to help him place the

figures in a composition. After his operation, however, he began to present the cutouts as the completed works themselves.

The stencil print Icarus was originally designed using cutouts that Matisse shaped with scissors, making an image filled with movement and life (3.182). His assistants

Braque (1882–1963) revolutionized the way artworks were made, by concentrating on their underlying geometric form and the construction of pictorial space. The two artists together eventually developed the **style** known as **Cubism**. Instead of showing conventionally realistic objects in the illusion of **three-dimensional** space in the way that had fascinated Western artists since the **Renaissance**, they enabled us to see what an object might look like if we could see more than one side of it at the same time. They broke up objects and figures into geometric shapes and changed them according to their own conception of deeper truth.

Picasso explored new ways of depicting the human figure in his painting Les Demoiselles d'Avignon (3.184). Rather than re-creating the way we actually see a room with people standing in it, Picasso has treated the space in the picture, and the figures within it, in a truly revolutionary way. He has simplified the forms into abstract planes, made the figures more angular, and broken down the individual faces and bodies into geometric pieces. The blue and white planes of what would usually be called the background clash violently with the angular pink figures of the women in a complex struggle for dominance.

3.184 Pablo Picasso, Les Demoiselles d'Avignon, 1907. Oil on canvas, 8' x 7'8". MOMA, New York

would paint paper in bright colors, then he would use scissors as if to "draw" the elegant lines of the shapes he wanted.

There seems to be no limit to the ideas Matisse could fashion in this way. He used cutouts to design tapestries, the interior decoration of buildings, and stained-glass windows. His final cutout compositions were on a large scale, some covering an area of more than 87 square feet. Toward the end of a long career Matisse found that simple scissors and paper offered a way to help him continue, once again, finding new ways to experiment with line and color.

The two women near the center of the painting are simplified, with almond-shaped eyes, triangular noses, and outlines for bodies, but they are still recognizable as female figures. The heads of the standing figures on the far left and far right have been dramatically replaced by African masks. Picasso, along with Matisse and other European artists in the early twentieth century, studied and collected art from outside the Western tradition, especially Africa and the Pacific Islands, and this interest is reflected in the masked faces.

The crouching figure at the bottom right has the most abstract features. Her body is splayed out, and the geometric shapes that make up the woman's face do not correspond to the usual orientation. The eye on our left is shown from the front, while the eye on our right is in profile. The nose is also in profile with the mouth off to the side and a crescent shape in place of the

Sketch: a rough preliminary version of a work or part of a work

Plane: a flat surface

Outlines: the outermost lines of an object or figure, by which it is defined or bounded

Composition: the overall design or organization of a work

Stencil: a perforated template allowing ink or paint to pass through to print a design

Style: a characteristic way in which an artist or group of artists uses visual language to give a work an identifiable form of visual expression

Cubism: a twentieth-century art movement that favored a new perspective emphasizing geometric forms

Three-dimensional: having height, width, and depth Renaissance: a period of cultural and artistic change in Europe from the fourteenth to the seventeenth century

Composite view: representation of a subject from multiple viewpoints at one time Collage: a work of art assembled by gluing materials, often paper, onto a surface. From the French coller, to glue

3.185 (below) Georges Braque, Houses at L'Estaque. 1908. Oil on canvas, $28^{3}/4 \times$ 23½". Kunstmuseum Bern, Switzerland

jawline. The **composite view** of this figure shows us more parts of her body than we could see from one vantage point. In this painting, the figures are still fairly recognizable. Picasso's later Cubist pieces become far more abstract, yet always intentionally retain a connection to the visible world.

An early Cubist painting, Georges Braque's *Houses at L'Estaque*, emphasized the geometry of the setting (3.185). In this painting, inspired by the style of the Post-Impressionist artist Paul Cézanne (see pp. 415–16), the houses become stacked golden cubes and pyramids surrounded by the slightest suggestion of trees and shrubs. By eliminating the details and making all of the houses the same color, Braque focuses attention on the underlying shapes and overall pattern of the picture. The shading is applied in a decorative way to give the shapes more definition. The bold treatment of this painting's forms might seem to come solely from the artist's imagination.

3.186 (above) Pablo Picasso, Glass and Bottle of Suze. 1912. Pasted paper, gouache, and charcoal, $25\% \times 19\%$. Mildred Lane Kemper Art Museum, St. Louis, Missouri

Photographs taken at this site, however, indicate that, in fact, Braque was surprisingly true to the configuration and placement of the trees and houses. The changes he made to the colors and shapes make the painting an abstraction based on nature.

In a further innovative artistic development, Braque and Picasso used newspaper and wallpaper as well as fine art papers to make paper collage. The papers were cut into shapes and glued to a support. This kind of construction is very familiar to us today, but in the early twentieth century it was a completely new technique for making art. Picasso's Glass and Bottle of Suze includes some shapes that relate to a table (the blue circle around the objects near the center), a glass (the handshaded section to the left), and a bottle (the layered triangular shapes on top of the table). By using an actual bottle label, the artist is able to identify the shapes as a bottle and to bring everyday materials into the picture (3.186).

Gertrude Stein as an Art Patron

The American writer Gertrude Stein (1874-1946) and her brother Leo (1872-1947), who lived together in Paris from 1904 to 1913, began to collect art by avant-garde artists, and eventually had an outstanding collection of modern art. They were among the first art patrons to support progressive artists, a major boost for these artists at a time when their work was not well received by the general public. The weekly salons Gertrude held in her studio apartment provided a meeting place for both artists and writers. In fact, the Steins introduced Picasso and Matisse to one another, sparking their friendship and artistic rivalry.

In 1905, two years before Les Demoiselles d'Avignon, Gertrude Stein commissioned her now famous portrait from Picasso (3.187). She wrote that she sat for him ninety times. Picasso worked on the painting for months but was never satisfied. Eventually he abandoned the naturalistic approach and painted out the details of her facial features. He replaced them with mask-like ones, inspired by ancient Iberian sculptures he had seen in Spain and at the Louvre museum in

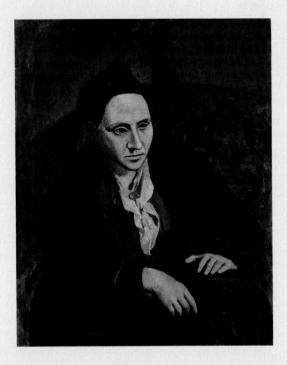

Paris. The resulting painting inspired a new phase of his work that relied on his own personal vision rather than on what he observed, starting him on the path toward Cubism. When someone remarked that Gertrude Stein did not look like her portrait, Picasso responded, "She will."

3.187 Pablo Picasso, Portrait of Gertrude Stein, 1906. Oil on canvas, $39\% \times 32$ ". Metropolitan Museum of Art, New York

Expressionism

The raw emotionality of Les Demoiselles d'Avignon was not emphasized in the Cubists' coolly analytical studies concentrating on form and space. In the meantime, from around 1905 to around 1920, other artists evolved a style that came to be known as **Expressionism**, in which they chose to explore ways of portraying emotions to their fullest intensity by exaggerating and emphasizing the colors and shapes of the objects depicted.

Expressionists, like the Impressionists and Cubists, were concerned with the representation of objects and the world. But as Expressionists

depicted their subjects, they emphasized inner states of feeling. Expressionist artists tried to depict what they felt rather than what they saw, with sometimes unconventional results.

The making of self-portraits was central to Expressionism because artists could explore, in repeated studies, a great variety and intensity of emotions. Self-portraits also allow artists to express both the inner and outer worlds that they know most fully. For instance, when making a portrait of someone else, an artist could only guess at the other person's mood, thoughts, or motivations. While making a self-portrait, however, he or she could decide which moods or motivations to show and how best to do so.

Avant-garde: early twentiethcentury emphasis on artistic innovation, which challenged accepted values, traditions, and techniques

Patron: an organization or individual who sponsors the creation of works of art

Salon: the routine gathering of a circle of notable people—often figures from the worlds of art, literature, and politics-at the home of one member of the group

Expressionism: an artistic style, at its height in 1920s Europe, which aimed to portray the world in terms of vivid extremes of personal experience and feeling

The German Expressionist artist Paula Modersohn-Becker (1876–1907) made several self-portraits (3.188). She also has the distinction of being one of the first women to make nude self-portraits. Her style reflects the flattened forms, reduced details, heavy outlines, and solid geometry she saw in earlier avant-garde styles of such artists as Paul Cézanne and Paul Gauguin in Paris (see p. 416). At the same time, her work balances delicate details in gesture and mood with a portrayal of the physical substance of her body.

Russian Vasily Kandinsky (1866–1944) was one of the first artists to make **non-objective**, or completely abstract, paintings. Non-objective art makes no reference to recognizable subjects; there are only abstract shapes, designs, and colors. Kandinsky said his Improvisation #30 was inspired by talk of war in 1913, a year before

3.188 Paula Modersohn-Becker, Self-portrait with Camellia, 1906-7. Oil on canvas, 241/4 x 12". Museum Folkwang, Essen, Germany

World War I began (3.189). The chaotic and energetic forms reflect the turmoil of the time, though they do not illustrate any particular event. While he made the painting spontaneously, with no specific scene in mind, as we look at it we can make out some leaning buildings, a crowd of people, and a cannon firing. But many of his later pieces avoid such recognizable objects because Kandinsky came to believe that, instead of expressing any outward and visible content, art should express an inner spiritual necessity.

German artist Ernst Ludwig Kirchner (1880-1938) used a deliberately raw painting style in his search for meaning beyond surface appearance. Kirchner used flat planes of intense color, simplified forms, and rough, even aggressive, brushwork. Kirchner's painting Street Berlin reflects his belief that art should come from direct experience (3.190). The figures he saw in this street scene are very civilized and dressed for a night on the town. Their similar clothing and mask-like faces turn these people into clones. In this painting Kirchner seems to ask why these elegant people lack purpose and why

3.189 Vasily Kandinsky, Improvisation #30 (Cannons), 1913. Oil on canvas. $43^{3}/4 \times 43^{1}/4$ ". Art Institute of Chicago

Non-objective: art that does not depict a recognizable subject Dada: anarchic anti-art and anti-war movement, dating back to World War I, that reveled in absurdity and irrationality

3.190 Ernst Ludwig Kirchner, Street Berlin, 1913. Oil on canvas, $47\frac{1}{2} \times 35\frac{7}{8}$ ". MOMA. New York

they all appear to be the same. He was part of a group of artists, called Die Brücke ("The Bridge"), who intended their new mode of expression to form a bridge between the past, present, and future. According to these artists, the decadence and dehumanization of society could only be counteracted by the younger generation—artists like themselves.

Dada

The devastating effects of World War I had a profound impact on how people thought about the world, "progress," and civilization. Improvements in science and industrial manufacturing may have led to some positive developments in life, but to many people they seemed primarily to have resulted, disastrously, in arms production on an unprecedented scale, and in mass slaughter in the trenches of northern Europe. The war inevitably also affected artists and the way they made art. **Dada** protested the kinds of "rational" thought processes that had led to war. It also took the Impressionists' and Cubists' questioning of representation still further and radically rejected the notion of art altogether.

The name Dada was notoriously chosen at random from the dictionary. It is both a nonsense word and one that has contradictory meanings in several languages. Dada was anti-art and refused to call itself a movement. It was founded by a group of artists and writers who avoided the draft by taking refuge in the neutral country of

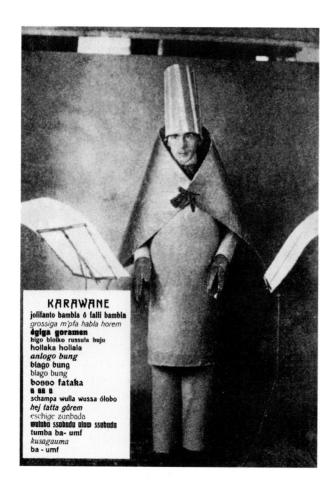

3.191 Hugo Ball, Performance of "Karawane" at Cabaret Voltaire, Zürich, Switzerland, 1916

Switzerland. Dada soon spread to the United States and later to Berlin, Cologne, Paris, Russia, eastern Europe, and Japan. Dada works, performances, and publications were critical and playful. They emphasized individuality, irrationality, chance, and imagination.

In keeping with its activist nature, Dada was inspired by revolutionary thinking and initially took the form of events, posters, and pamphlets. In February 1916 German actor and anarchist Hugo Ball (1886–1927) opened the Cabaret Voltaire in Zürich, Switzerland, with his future wife, Emmy Hennings (1885–1948). The Cabaret was a **bohemian**, avant-garde nightclub that provided artists and writers with a place to meet, perform, and be entertained. Ball organized and promoted many of the events. The performances were lively and highly theatrical. At a particularly flamboyant recital of one of his sound poems, "Karawane," Ball wore a costume that made him look like a figure from a Cubist painting (3.191). His poems were made of nonsense words and sounds, intended to be chanted, screamed, and howled. Sometimes

several poets would recite at the same time while others yapped like dogs.

The French artist Marcel Duchamp (1887– 1968) was a key figure in the New York branch of Dada (he became an American citizen in 1955). One of his earliest and most enduring anti-art statements was his Bicycle Wheel (3.192). Its date of production, 1913, shows that the spirit of Dada pre-dates the war. This **assemblage** of

3.192 Marcel Duchamp, Bicycle Wheel, 1913. Metal wheel mounted on painted wood stool, $50^{1}/2 \times 25^{1}/2 \times 16^{5}/8$ ". MOMA, New York

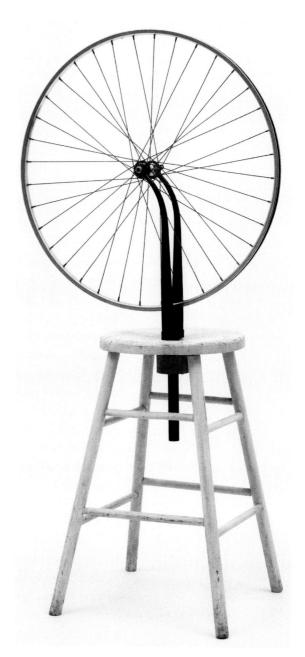

Bohemian: derived from the gypsies of the former Czech Kingdom of Bohemia who moved around; a wanderer; an artist or writer who functions outside the bounds of conventional rules and practices Assemblage: artwork made of three-dimensional materials including found objects Found object: an object found by an artist and presented, with little or no alteration, as part of a work or as a work of art in itself

Readymade: an everyday object presented as a work of art Kinetic sculpture: three-

dimensional art that moves, impelled by air currents, motors,

Conceptual art: a work in which the ideas are often as important as how it is made

Photomontage: a single photographic image that combines (digitally or using multiple film exposures) several separate images

Surrealism: an artistic movement in the 1920s and later, the art of which was inspired by dreams and the subconscious

3.193 John Heartfield, Have No Fear, He's a Vegetarian, published in Regards, no. 121 (153), Paris, May 7, 1936. Stiftung Archiv der Akademie der Künste, Berlin, Germany

found objects resembles a sculpture, with a stool serving as the base, and the wheel itself as the main subject. Duchamp first made the piece for his own pleasure, because he "enjoyed looking at it, just as I enjoy looking at the flames dancing in the fireplace."

The original Bicycle Wheel was lost when Duchamp moved to the United States in 1915. Usually, an artwork's value partly depends on the existence of "an original" creation that is unique, but Duchamp unflinchingly re-created the piece for an exhibition in 1916. This version, too, was lost. According to the Museum of Modern Art in New York, the Bicycle Wheel in its collection is the third re-make. Duchamp, in true Dada style, subverts the institution and originality of art.

Duchamp was responsible for three major innovations in art in the twentieth century: readymades (ordinary objects turned into artworks simply by the decision of the artist), kinetic sculptures (sculptures with moving parts), and what came to be known as conceptual art (see pp. 442–3 below). For Duchamp, the making of the work and its appearance were secondary. What mattered were the choices of the artist and art's effects in our mind.

A member of Berlin Dada, German John Heartfield (born Helmut Herzfeld, 1891–1968)

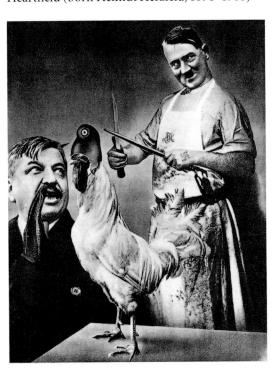

made political statements using the medium of **photomontage**. He boldly published works criticizing the then leader of Nazi Germany, Adolf Hitler. As a result, Heartfield eventually had to flee to Prague (in what is now the Czech Republic) and later to England to escape arrest and persecution. He distributed his work on posters and in magazines. His piece Have No Fear, He's a Vegetarian powerfully warns about Hitler's plans for conquest (3.193). It foreshadows many of the disasters, from widespread starvation to genocide (the deliberate mass killing of a specific race or group of people), that were to take place throughout Europe. Hitler was a vegetarian, but he is shown here wearing a blood-spattered apron. He also grins maniacally while he sharpens a large carving knife to kill a cock as French Prime Minister Pierre Laval looks on. The cock symbolizes France, a country Hitler would invade four years later.

Surrealism

Like Dada, **Surrealism** was also opposed to rationality and convention. Surrealists believed that art was a model for human freedom, meaning, and creativity in an absurd world. The movement began in 1917 amongst a group of writers and poets in Paris, and continued to develop after World War I; the group's ideas were then taken up by visual artists. Surrealism was the first artistic style based directly on the ideas of Austrian psychoanalyst Sigmund Freud. Surrealists used techniques that Freud had originally pioneered to access his patients' unconscious minds in order to make artwork that was not fully under their conscious control: dreams and dreamlike images were therefore very important to their work. Sometimes the Surrealists used extremely realistic images (see the work of Dalí and Magritte on pp. 504 and 76) in surprising ways to jolt our expectations. Surrealists challenged the very idea of objective reality, which they considered nonsense.

One artist whose work influenced the Surrealists was the Greek-born Italian Giorgio De Chirico (1888–1978). He was not a member of the Surrealist movement, but, as the Surrealists

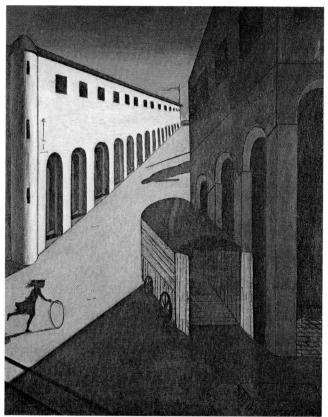

3.194 Giorgio De Chirico, The Melancholy and Mystery of the Street, 1914. Oil on canvas, $34\frac{1}{4} \times 28\frac{1}{8}$ ".

Private collection

later would be, he was interested in intuitive and irrational approaches to art. In his work Melancholy and Mystery of the Street, De Chirico creates a dreamlike environment in which more questions are posed than resolved (3.194). The little girl with the hoop, herself a shadow, seems unaware of the figure with a pole looming around the corner. Although the narrative remains unclear, a vague sense of threat fills the still air. The crisp clarity of the forms, the Classical architecture, and the gradation of colors in the otherwise empty sky are all characteristic of De Chirico's work and enhance the enigma.

Max Ernst (1891–1976) was a German-born artist who was first involved with Dada and then Surrealism. For him, the process of making art was of utmost importance. Ernst used different techniques—such as collage, rubbing, and scraping—to encourage chance events that would reduce his conscious control over his work. These processes, as he stated, would liberate the human

3.195 Max Ernst, Le Surréalisme et la Peinture (Surrealism and Painting), 1942. Oil on canvas, 6'5" x 7'8". The Menil Collection, Houston, Texas

imagination. He deliberately embraced the bizarre, strange, and irrational to express truths that he believed were buried by logic in the conscious mind. In Ernst's Surrealism and Painting the figure shown painting is not a human being but an amorphous blob (3.195). This shapeless being can be interpreted in different ways. It may refer to the difficulty of

3.196 Joan Miró, Object, 1936. Assemblage: stuffed parrot on wood perch, stuffed silk stocking with velvet garter and doll's paper shoe suspended in hollow wood frame, derby hat, hanging cork ball, celluloid fish, and engraved map. $31\% \times 11\% \times$ 101/4". MOMA, New York

Narrative: an artwork that tells a story

Classical: ancient Greek and Roman; more generally, art that conforms to Greek and Roman models, or is based on rational construction and emotional equilibrium

understanding or explaining creativity generally. Perhaps it depicts the chance processes Ernst used in making art. The painting on the easel is a representation of the equally uncertain results, here seen as abstractions that seem vaguely cosmic, like planets and intergalactic matter in the uncharted territory of outer space. Overall, Ernst made a strong statement about how liberating it can be to allow the imagination to wander in the mysterious realm of creativity.

Using the technique of assemblage, Surrealists created the three-dimensional equivalent of collage. These assemblages were generally intended to be playful and nonsensical and to reflect new ways of thinking. Spanish artist Joan Miró (1893-1983) compiled an unexpected assortment of objects in his sculpture called Object (3.196). A derby hat, which serves as the sculpture's base, has a map placed on one side of its brim and a red plastic fish on the other. A block of wood sits on the hat with a perch on top of it that supports a stuffed parrot. Miró fashioned a miniature woman's leg by stuffing a silk stocking in a shapely manner, placing a doll's shoe on one end, and wrapping a band for a garter on the other. This leg is hanging in an oval-shaped opening of the wooden block. A cork ball hangs from the parrot's perch beside the leg. The objects have the whimsical quality of toys. When viewed together, as the artist has arranged them, they also have an air of mystery, as if they are clues to an unsolved crime or random items that make sense only to their owner.

The Influence of Cubism

Cubism's (see pp. 425–6 above) ground-breaking approach to art had a huge impact throughout Europe. Many artists adopted the Cubist style, while others explored ways of making art and representing objects that had not been conceived of before Cubism.

Futurism

In Italy, during the period from 1909 to the late 1920s, some artists were influenced by Cubism's clashing planes and geometry to develop a style

3.197 Umberto Boccioni, Unique Forms of Continuity in Space, 1913 (cast 1931). Bronze, $49^{3}/4 \times 35 \times 16^{\circ}$. Private collection

known as Futurism. Unlike Cubist artworks, though, Futurist works celebrated dynamic movement, progress, modern technology, and political beliefs that were later to be known as Fascist. They also expressed contempt for the past. Italian Umberto Boccioni (1882–1916) explored some of these concepts in his Futurist sculpture Unique Forms of Continuity in Space (3.197). Looking like a flame, the figure forcefully strides through space. Boccioni made the sculpture in plaster; it was not cast in bronze during his lifetime. The shiny, golden appearance of the metal version embodies the words of the founder of Futurism, Filippo Marinetti: "War is beautiful because it inaugurates the long dreamt-of metallization of the human body." Nonetheless, the figure has heroic monumentality as it leaves behind the artistic traditions of the past.

Marcel Duchamp showed his Nude Descending the Staircase at the Armory Show in New York in 1913 (3.198). The scandal it caused earned Duchamp an international reputation. For this short period in his career he combined Cubism's figures—broken into geometric planes —with Futurism's emphasis on movement. Like many other works at the Armory Show, this painting shocked an audience familiar only with representational imagery, or pictures "of" something. Although Nude Descending a Staircase no longer seems dangerous, threatening, or criminal, many people saw it that way in 1913.

3.198 Marcel Duchamp, Nude Descending a Staircase, No. 2, 1912. Oil on canvas, 57% × 35%". Philadelphia Museum of Art

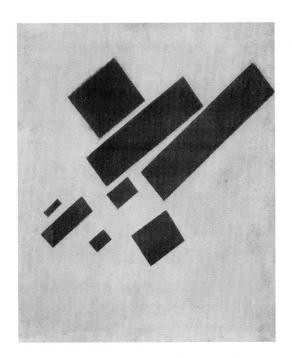

3.199 Kazimir Malevich, Suprematist Painting (Eight Red Rectangles), 1915. Oil on canvas, $22^{1/2} \times 18^{7/8}$ ". Stedelijk Museum, Amsterdam, Netherlands

Abstraction

Russian Kazimir Malevich (1878–1935) was, like Kandinsky, one of the first artists to make completely non-objective paintings. Unlike Kandinsky, Malevich concentrated solely on direct geometric forms. He called his approach Suprematism because he considered it morally, spiritually, and aesthetically superior to what

had been done in the past. Malevich believed that recognizable objects were a burden for the viewer and that geometric abstraction helped to free the mind from the thoughts of politics, religion, and tradition that were so much on people's minds in the early twentieth century, partly as a result of the cataclysmic conflict of World War I. Most of Malevich's Suprematist works consist of rectangular shapes floating on a white **ground**. While they look like Cubist collages, the shapes are actually painted. In Suprematist Painting (Eight Red Rectangles) the **palette** has been reduced to two colors, and the rectangular forms are tilted to suggest movement (3.199).

The Dutch painter Theo van Doesburg (1883–1931) was a founder of the movement called **De Stijl** ("The Style") in the Netherlands. He began painting naturalistic subjects in 1899. In 1915, after he discovered the work of another Dutch artist, Piet Mondrian, van Doesburg began to concentrate on non-representational works consisting of intersecting lines, diagonals, right-angled shapes, and colored planes. In such works as Counter-Composition V (3.200), he translated natural appearances to geometric forms. His art was based on mathematical

3.200 Theo van Doesburg, Counter-Composition V, 1924. Oil on canvas, $39^{3}/8 \times 39^{3}/8$ ". Stedelijk Museum, Amsterdam, Netherlands

Ground: the surface or background onto which an artist paints or draws

Palette: the range of colors used by an artist

De Stijl: a group of artists originating in the Netherlands in the early twentieth century, associated with a utopian style of design that emphasized primary colors and straight lines

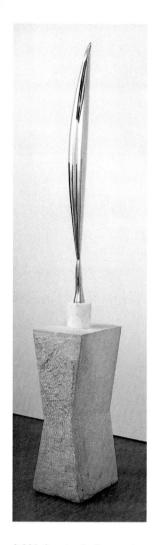

3.201 Constantin Brancusi, Bird in Space (L'Oiseau dans l'espace), c. 1941, Polished brass, 6'33/8" high. Musée National d'Art Moderne. Centre Georges Pompidou, Paris, France

principles and used ideas that van Doesburg saw in the work of the Cubists. Van Doesburg's focus on color and geometric abstractions was also expressed in his designs for stained glass and tiled floors, and in his interest in architecture. His work, like that of other Stijl artists, aspires to a rational beauty that is objective and appeals to the mind rather than to the subjective beauty of the senses.

The Romanian-born French sculptor Constantin Brancusi (1876–1957) devoted his working life to finding the very simplest and most elegant way to express the essence of his chosen subject. His Bird in Space distills the vital qualities of a bird to what, at first sight, looks like a totally abstract form (3.201). The shape exquisitely reminds us of a bird's body, a feather, or even the soaring quality of flight.

This sculpture, with the polished brass form stacked on top of a small stone cylinder with a darker-colored stone square underneath, shows Brancusi's careful consideration of even the base of the sculpture. He chose the materials

of the base—usually wood, metal, stone, or marble—to contrast in texture with a different material used for the rest of the sculpture. In this case, the comparative roughness and bulk of the stone suggest heaviness and earth, while the contrasting thinness of the smooth and shiny brass makes it look as if it would slip easily through the air.

The American Romare Bearden (1911–88) trained as an artist in both the U.S. and Europe. His work incorporates many artistic influences, including Cubism and African masks. Bearden was also inspired by his childhood spent growing up in Harlem in New York City. This was the time of the Harlem Renaissance (1918-35), an artistic, literary, and musical flowering of the African-American community that fostered cultural pride and racial consciousness. Prominent musicians and writers, such as Duke Ellington, Langston Hughes, and Ralph Ellison were close family friends who instilled in the young Bearden a lifelong connection to literature and jazz. In such pieces as Three Folk Musicians (3.202), Bearden brings

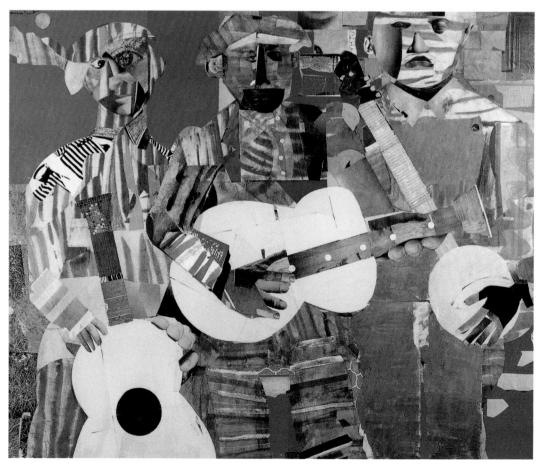

3.202 Romare Bearden. Three Folk Musicians, 1967. Collage of various papers with paint and graphite on canvas, 501/8 × 60". Private collection

all his diverse interests together in the form of collage, the **medium** for which he is best known. In this work we see a rhythmic interpretation of a common, everyday scene using disjointed fragments of paper. Here collage has been used by Bearden to express African-American experience.

Abstract Expressionism

Whereas the other avant-garde artistic developments described so far began in Europe, Abstract Expressionism was the first Modernist art movement to originate in the U.S. This movement, which evolved in the 1940s and 1950s, was perhaps a sign of increasing national selfconfidence after the end of World War II. Abstract Expressionist artists wanted to create, with energy and emotion, a universal visual experience that anyone could respond to, regardless of their prior life experience, political beliefs, or religious preferences.

To make his enormous paintings, American artist Jackson Pollock (1912-56) started by unrolling the canvas onto the floor. Then he could move about freely, almost dancing around and over the piece (3.203). Pollock also used sticks as well as brushes to drip and pour the paint onto the surface. The absence of any recognizable subject fixes our attention on the actions and gestures of the artist. The process becomes the subject, making the

3.203 Jackson Pollock painting in his Long Island studio, 1950, photo by Hans Namuth

painting about the act of creation itself. The results of Pollock's process, known as action **painting**, are complex abstract paintings so large that when we stand before them they completely dominate our field of vision. Pollock's artworks evolved organically and spontaneously rather than from precise preplanning. The improvisational process and the tension between the rhythms and cross-rhythms of Pollock's paintings also have some similarities to jazz music, which he liked to listen to as he worked (3.204).

Medium: the material on or from which an artist chooses to make a work of art Abstract Expressionism: a mid-twentieth-century artistic style characterized by its capacity to convey intense emotions using non-representational images Action painting: application of paint to canvas by dripping, splashing, or smearing that emphasizes the artist's gestures

3.204 Jackson Pollock, Mural. 1943. Oil on canvas. $8'1\frac{1}{4}" \times 19'10"$. University of Iowa Museum of Art

3.205 Mark Rothko, *Untitled*, 1949. Oil on canvas, 6.9% × 5.63%. National Gallery of Art, Washington, D.C.

Pop art: mid-twentieth-century artistic movement inspired by commercial art forms and popular culture

Silkscreen: method of printmaking using a stencil and paint pushed through a screen

Value: the lightness or darkness of a plane or area

Pointillism: a late nineteenth-century painting style using short strokes or points of differing colors that optically combine to form new

American artist Mark Rothko (1903–70) emigrated to the U.S. from Russia with his family. He was originally interested in Surrealism as a way to move beyond depicting familiar subjects. Eventually he entirely eliminated representation from his compositions and concentrated on form and color. For about twenty years, from c. 1950 to 1970, his works consisted of luminous rectangles floating in fields of color, like the *Untitled* piece from 1949 (3.205). This piece includes four different-sized rectangles in red, eggplant, black, and forest green, stacked on a goldenyellow background. Rothko chose not to give his works narrative titles and allowed us to respond deeply and individually. Rothko famously said, "people who weep before my pictures are having the same religious experience I had when I painted them. And if you, as you say, are moved only by their color relationships, then you miss the point!"

Pop Art

Unlike the Abstract Expressionists, the artists who began producing **Pop art** in the late 1950s embraced recognizable subject matter in their work. But they did so in a way that had never been done before in the realm of fine art. Because they wanted their subjects to be immediately familiar to their audiences, Pop artists borrowed their imagery from popular culture, including famous artworks, comic books, commercial advertising, car design, television, movies, and everyday experience. At the time there was a division between fine art (a supposedly sophisticated part of "high" culture) and its opposite, popular culture (considered unrefined and ordinary). Pop artists bridged this gap by combining fine art materials with commercial elements, such as pictures from newspapers and magazines, sometimes printing by silkscreen (which is used for printing packaging), and then selling their pieces in fine art galleries.

American Andy Warhol (1928–87) began his professional career as an illustrator and graphic designer in advertising. Around 1960, using the expressive brushwork and drips of paint that were characteristic of Abstract Expressionism, Warhol made acrylic paintings of the comic-book heroes Superman, Batman, and Dick Tracy. He then quickly turned to the imagery of advertising, using as his subjects such familiar products as Campbell's soup and Coca-Cola. He also began using the silkscreen technique. This process allowed him not only to make art more quickly, but also to give it a depersonalized and massproduced quality very different from some art's emphasis on personal expression or technique. Warhol even borrowed, or appropriated, the famous image of the Italian Renaissance artist Leonardo da Vinci's *Mona Lisa* (see p. 33). The title of this piece, Thirty Are Better than One, clearly echoes the language of advertising and consumerism—"more is better" (3.206). It refers to the multiple reproductions of the painting in Warhol's work while also undermining the "high art" tendency to value an artwork financially and aesthetically only if it is "original" and unique.

perceived colors

3.206 (left) Andy Warhol, Thirty Are Better than One, 1963. Silkscreen ink on synthetic polymer paint on canvas, $9'2" \times 7'10"$. Private collection

3.207 (below) Rov Lichtenstein, Girl with Mirror, 1964. Enamel on steel, 42 × 42". Private collection

The American artist Roy Lichtenstein (1923–97) also made works based on comics. Lichtenstein challenged traditional notions of the subject matter and appearance of fine art painting by embracing everyday subjects. In his painting Girl with Mirror he uses strong black outlines filled with bold primary colors (3.207). In order to create gradations of a color, Lichtenstein borrowed a technique from older kinds of newspaper printing and comics. The regular pattern of dots emulates the screen visible on printed pictures, where areas of light value have small dots, and those of dark value have large ones nearly joined together. Lichtenstein's use of dots recalls the Post-Impressionist technique of **pointillism**, while his use of black, white, and primary colors references the color palette of such geometric abstract artists as Theo van Doesburg (see 3.200, p. 435).

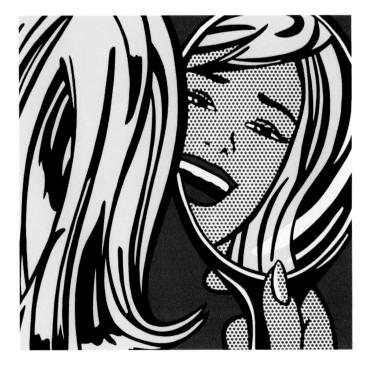

Religion and Symbolism in The Throne

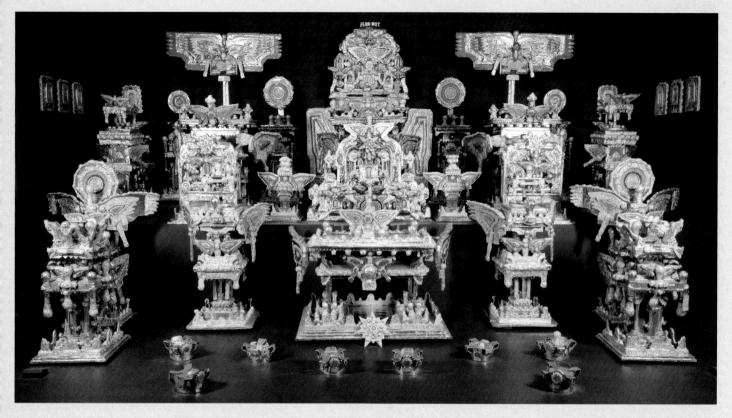

3.208 James Hampton, The Throne of the Third Heaven of the Nations' Millennium General Assembly, 1950-64. Gold and silver aluminum foil, colored kraft paper, and plastic

sheets over wood, paperboard, and glass, 180 pieces, $10\frac{1}{2} \times 27 \times 14\frac{1}{2}$. Smithsonian American Art Museum, Washington, D.C.

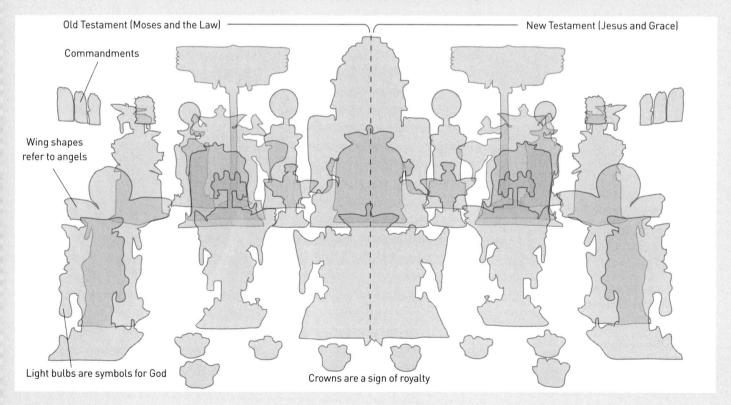

James Hampton (1909-64) was a janitor in Washington, D.C. He would go to a rented garage space after his night shift to work on what he called his "life's work," The Throne of the Third Heaven of the Nations' Millennium General Assembly (3.208). Hampton's work is visionary art, art made by artists who are self-taught and who explore their own creative vision through their work. Though Hampton hoped to open his own church one day, very few people saw this piece during his lifetime.

Hampton constructed about 180 pieces for The Throne with found materials, including discarded items he collected while he was at work, objects he found on the street, and some pieces he bought at second-hand shops. The furniture, jelly jars, cardboard, construction paper (originally deep purple, now faded to tan), electrical wire, and so on are transformed by coverings of gold and silver foil. Hampton has arranged them into a large tableau suggesting the Kingdom of Heaven at the second coming of Christ on Judgment Day, as described in the Book of Revelation in the Bible. Hampton believed God visited him often and, through religious visions, helped to guide him in the making of The Throne.

The actual throne is at the center. To the left of the throne (as we look at it) is the Old Testament side related to Moses and the Law, while to the right is the New Testament side, which references Jesus and the Christian idea of Grace. Many of the chairs and furniture are labelled—Adam, Eve, the Virgin, Pope Pius XII. The wall plaques at the back along the sides also contain the Ten Commandments in Hampton's indecipherable script, along with the names of prophets on the Old Testament side and apostles on the New Testament side. There are also crowns (a sign of spiritual kingship), wing shapes (like angels), and light bulbs (a symbol for God as the light of the world), all of which have symbolic significance. Hampton's dedication in creating such an ornate, spiritually inspired piece while working in complete seclusion makes him one of the most fascinating and enigmatic American visionary artists.

Visionary art: art made by selftaught artists following a personal vision

Tableau: a stationary scene arranged for artistic impact

3.209 Donald Judd, Untitled, 1967. Stainless steel and Plexiglass, $190\frac{1}{8} \times 40 \times 31$ ". Modern Art Museum of Fort

Minimalism

Minimalist artists in the 1960s reacted against what they saw as the excessive emphasis on the artist's personality in the work of Abstract Expressionists. Minimalism is an approach to making art that is non-representational by its very nature. Minimalists sought instead to use neutral textures, geometric shapes, flat colors, and even mechanical construction in order to strip away any traces of emotion or underlying meaning in their work.

American Minimalist sculptor Donald Judd (1928–94) produced pieces that were totally

> abstract, usually rectangles and cubes. Although during the early stages of his career Judd was a painter and he did go on to paint some of his sculptures, he generally preferred the medium of sculpture to painting. According to Judd, any painting, no matter how abstract, shows something, whereas a sculpture is something, in real space. His sculptures had an industrial appearance and were commercially manufactured.

For his Untitled piece (3.209), Judd ordered from a factory ten boxes made with stainless steel around the edges and Plexiglass on the top and bottom, each measuring $9\frac{1}{8} \times 40 \times 31$ inches. Then, when the piece was installed, it was spaced according to his specifications. Judd preferred to have his pieces made in this way because it made them stand on their own, limited the role of the artist as creator, and downplayed any underlying message.

American artist Dan Flavin's (1933-96) work, like that of other Minimalists, is made from industrial materials and has a clean geometric quality. Flavin created individual artworks and

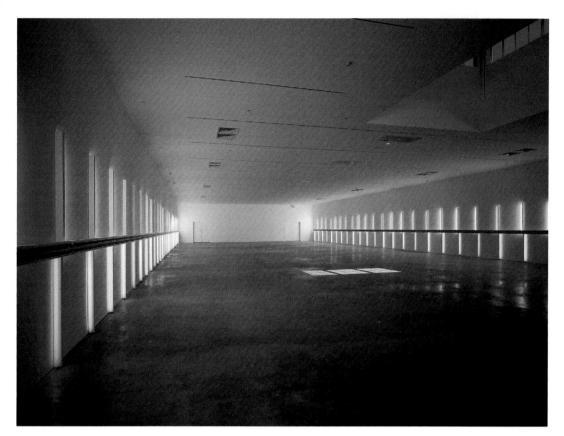

3.210 Dan Flavin, Untitled, 1996. Installation of 4' fixtures in two opposing banks for the east and west interior walls of Richmond Hall. Pink, yellow, green, blue, and ultraviolet fluorescent tubes and metal fixtures, two sections, each 8' high, approx. 128' wide. Menil Collection, Houston, Texas

installations with fluorescent light tubes. The sculptures have a physical aspect (the fixtures and tubes), but they also focus our attention on the use of light itself as a means to impact the space. The light from the bulbs, which are commonly used in offices, stores, and even homes, takes on a new significance in the form of a sculpture on the walls of an art gallery. When the fluorescent tubes

are placed together in an installation (see **3.210**), the noticeable glow transforms the space. Flavin's work promotes the idea that a simple object that has been commercially purchased can become a work of art and cause us to look at such familiar objects in new ways.

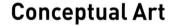

Conceptual art takes the non-representational tendencies that are apparent in Minimalism even further, often eliminating the art object altogether. Instead of painting a canvas, for example, an artist might arrange certain objects together in a way that makes people reconsider each one in a new light. Some conceptual artists focused their efforts on planning, rather than producing, artwork. The results of conceptual art include documentation, sketches, artist's books,

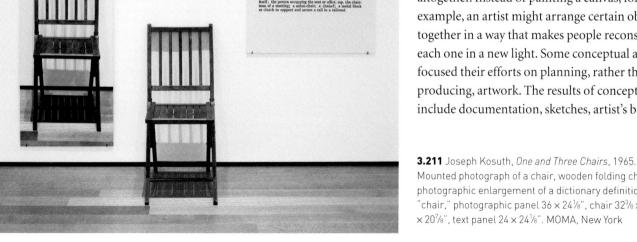

Mounted photograph of a chair, wooden folding chair, and photographic enlargement of a dictionary definition of "chair," photographic panel $36 \times 24\%$ ", chair $32\% \times 14\%$ $\times 20^{7}$ %", text panel 24 $\times 24^{1}$ %". MOMA, New York

photographs, performances, and mail art (any artwork, often in the form of postcards or small packages, distributed through the mail).

The work of American Conceptual artist Joseph Kosuth (b. 1945) provokes questions in the minds of viewers. His processes, approach, and materials were inspired by Marcel Duchamp's readymades (see 2.159, p. 270 and 3.192, p. 430), as well as by his interest in art that appeals to the mind rather than the senses. On one level, Kosuth's One and Three Chairs simply presents three things that a chair could be: on our left, a photographic representation of a chair; in the center, an actual wooden chair; and on our right, an enlarged dictionary definition of the word "chair" (3.211). On another level, this piece represents a sophisticated investigation about how we know and understand the world around us. Which of these chairs is more familiar? Which is more "real"? Which one provides us the most information? Ultimately, our experience of a "chair," its meaning, our awareness of how we communicate ideas, and the way all these things impact art is changed after seeing this piece.

The Cuban-born artist Ana Mendieta (1948–85) is known for using her own body as an integral part of her art making. Her performances and art actions explore personal themes (such as the social displacement she experienced by moving away from her home country to the United States). She also incorporates references to natural elements (water, earth, fire, blood) and biological cycles (life, death, spiritual rebirth). For her Silueta series (see 3.212), Mendieta situated her body in various outdoor environments: on the ground, in front of a tree, on a sandy beach. In the example shown here, the artist's body is camouflaged by the flowers and mud that cover it. Whether her body or its silhouette is shown in the photograph, the images of this series reinforce the powerful connection between a woman's body and nature as sites of strength, endurance, and nourishment.

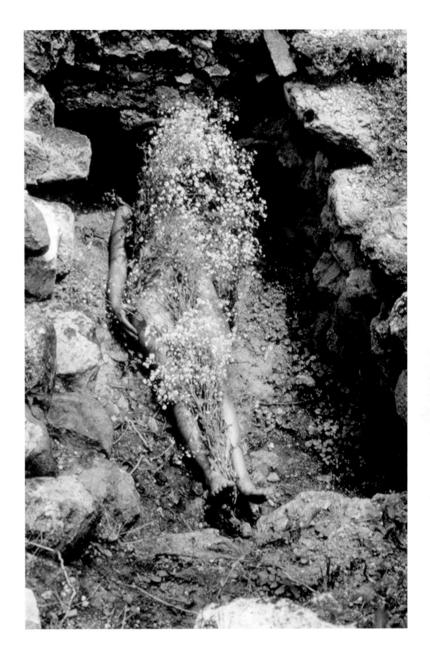

Postmodernism, Identity, and Multiculturalism

Postmodern artworks and architecture are often complex and even ambiguous, incorporating visual references to earlier artworks or buildings, philosophical ideas, or political issues (see Box: Modern and Postmodern Architecture, pp. 444–5). The Postmodern movement, part of the Contemporary period (c. 1960 to the present), constituted both a reaction to and a continuation of ideas developed during the Modern period (c. 1860–1960). Alongside the interest in artistic

Silueta: series of images by Ana Mendieta in which the artist's body is situated in outdoor environments

Modern and Postmodern Architecture

3.214 Gerrit Rietveld, Schröder House, 1924-5. Utrecht, Netherlands

In architecture, the predominant style from the late nineteenth century until the 1960s was Modernism. Modernist architecture was characterized by straight lines and geometric shapes. Its designs were intended to be direct, clean, uncluttered, and progressive. As early as the 1960s, Postmodernist architects reacted against the use of lines, severe geometry, and subdued colors of Modernism, considering the aims of Modernists to be too idealistic and inaccessible. As a result, Postmodern designs often combine dynamic forms (for example, Frank Gehry's Guggenheim Museum, Bilbao, see pp. 74-5) and incorporate familiar elements from different historical periods, such as columns reminiscent of buildings in ancient Greece.

Like his fellow Dutch De Stijl artists (see 3.200), Modernist designer Gerrit Rietveld (1888-1965) emphasized geometric shapes, horizontals and verticals, and a limited color palette of black, white, and primary colors.

3.215 Michael Graves, Portland Public Services Building, 1980, Portland, Oregon

His Schröder House, created in 1924, integrates Modernist design into a building that served the specific needs of Rietveld's client. The lower floor consists of traditional kitchen, dining, and living areas, while upstairs Rietveld took an innovative approach to the bedrooms. Modular partition walls separate the areas of the upper floor, providing private quarters for sleeping but allowing a more open space to be used during the day. The balconies, windows, concrete planes, and linear elements on the building's exterior, which resembles a three-dimensional version of an abstract painting, show how architects achieve balance through asymmetry. Rietveld's emphasis on geometry and function influenced the International Style of architecture, which stressed logical planning, followed an industrial or machine aesthetic, and eliminated all arbitrary decoration.

By the 1960s architects began to react to the severity of International Style Modernism by incorporating references to earlier buildings and including ornamentation that was not required by the structural design. This new approach marked the beginning of the Postmodern style. The Portland Public Services Building, designed by American Michael Graves (b. 1934) in 1980, was the first public building to employ the Postmodern approach. Its distinctive design includes a brightly colored exterior, small square windows, and Classical architectural forms. Columns have been extended up to ten stories tall on either side of the entrance and on the sides of the building. On the facade, the shape of the exaggerated capitals has been repeated on the upper floors. While this building has generated some controversy, it stands as a significant example of Postmodern ingenuity and of Postmodernism's potential to integrate diverse ideas. More recently, Graves has become well known for a line of kitchenware and domestic merchandise available at Target stores. The line of household products that Graves has designed for Target has sleek shapes and stylish colors that incorporate many Postmodern design principles and integrate distinctive design into functional items.

Primary colors: three basic colors from which all others are derived **Asymmetry:** a type of design in which balance is achieved by elements that contrast and complement one another without being the same on either side of an axis

Installation: an artwork created by the assembling and arrangement of objects in a specific location

3.213 Xenobia Bailey, (Re)Possessed (installation view, John Michael Kohler Arts Center), 1999-2009; mixed media environment; dimensions variable. Photo courtesy of John Michael Kohler Arts Center © the artist and Stefan Stux Gallery, New York. Components include the following: Xenobia Bailey, Mandalas, 1999-2009 and Sistah Paradise's Great Walls of Fire Revival Tent, 1993; Doughba H. Caranda-Martin, Teas, 2008; Barbara Garnes, Tea Service, 2006.

form and content that was prominent in the midto late twentieth century, many Postmodern artists embraced their own personal and cultural history in their work, drawing directly on their own experiences. By the 1980s artists and art institutions recognized the need to be more inclusive in their consideration of artists from all cultural backgrounds.

Intrigued by the impact of African art on contemporary culture, American Xenobia Bailey (b. c. 1955) established her reputation initially by making crocheted hats. After her designs were featured in *Elle* magazine, they appeared as props in Spike Lee's film Do the Right Thing and on television's Cosby Show. Over time, her work has expanded to include costumes, wall hangings, and full-blown museum **installations**. The forms, shapes, and colors she uses are inspired by African hairdos, architecture, and headdresses; Hindu religious figures; and Chinese opera head pieces. Her work *Mothership* I: Sistah Paradise's Great Walls of Fire Revival *Tent* (**3.213**) is a teepee-like structure that, in

addition to looking like an enlarged version of one of her hats, references the absence of historical information about enslaved Africans in America. Bailey created Sistah Paradise, a mythological individual, as a reminder of colonization and as a figure to inspire the continued pursuit of justice and equality for African Americans.

The American artist Carrie Mae Weems (b. 1953) also investigates the collective African-American experience that is rooted in slavery. Her work embodies an interest in personal and cultural identity. Her series "From Here I Saw What Happened and I Cried" reinterprets a series of early photographs of African slaves taken by white Americans in the nineteenth century. In the original photographs the sitters were stripped and exposed to the scrutiny of racist theorists who sought to examine and investigate them in a coldly analytical, supposedly "scientific" way. Weems rephotographed the images, colored them red, and framed them with circular mats to highlight the fact that they were being seen through the camera lens. The text she inscribes on the glass

challenges ideas of race, gender, and class that were once taken for granted. Pointing out that these individuals had become part of "An Anthropological Debate" and were turned into "A Photographic Subject" (3.216) restores some of the dignity that had been denied and motivates viewers to understand and respect the sitters' humanity.

Throughout her artistic career, Native-American artist Jolene Rickard (b. 1956) has also told complex stories as she examines her heritage through myths, stories, cultural practices, and experiences, both past and present. Her work often combines spiritual experiences and events from daily life, which are familiar to the Tuscarora nation, but less so to outside audiences. Rickard's installation Corn Blue Room (3.217), part of an exhibition called "Reservation X: The Power of Place," explores the importance of home in the formation of identity, and also the changing nature of the reservation as a community and home. Ears of corn hang from above, saturated with blue light. The photographs and CD-ROM in the space relate to nature on one side (corn, the seasons,

3.216 Carrie Mae Weems, You Became a Scientific Profile & A Photographic Subject, from the series From Here I Saw What Happened and I Cried, 1995. Chromogenic color prints with sand-blasted text on glass, $25^{5}/8 \times 22^{3}/4$ ". MOMA, New York

community) and technology on the other (the towers of a hydroelectric plant owned by the New York Power Authority), both of which have significantly impacted on the Tuscarora community's land in upper New York State. The installation invites viewers to walk into the space and interact with it. By looking at the photographs and the CD-ROM, they can experience the importance of songs and dances as ways of expressing kinship and of passing knowledge from one generation to the next.

Iranian-born artist Shirin Neshat (b. 1957) has lived in the United States since 1974, when she was seventeen years old. Her photographs and films explore the experience of a woman caught

between the tradition and heritage of her native Iran and her perspective as a woman living outside that culture. When she was allowed to return to Iran in 1990, following the Islamic Revolution, the country had become a conservative, theocratic republic. One of the most striking changes was the requirement for women to wear the chador, a loose robe that covers them from head to toe, leaving only their faces and hands exposed. Neshat made art as a way to process her feelings of displacement, exile, and loss. Over time her work has taken a more critical stance against the erosion of individual freedom in the extremist environment she knows the people of her country are enduring.

3.217 Jolene Rickard, Corn Blue Room, 1998. Mixed-media installation, Denver Art Museum, Colorado

3.218a Shirin Neshat, Rapture, 1999. Production still 3.218b Shirin Neshat, Rapture series, 1999. Gelatin silver print, $42^{1/2} \times 67^{1/2}$ "

In such artworks as the film *Rapture* (3.218a and 3.218b) Neshat projects two images into the space at the same time. One screen shows men wearing white shirts and black pants in a stone fortress. The motivation behind their collective actions is never explained, but they seem to revolve around the cannons located on the building's rooftop. On the other screen, women wearing black chadors are shown making their way to a beach where they push a small group of women out to sea in a rowboat. Whether the women are being persecuted or liberated, whether they chose to leave or were forced to go is unclear. Because she deals with social, political, and cultural issues in a very poetic way, Neshat's work has a broad appeal to audiences all over the world.

Contemporary and Postmodern art often contains references to complex matters by integrating fact and fiction (see Box: The Complexity of Today's (Art) World). A captivating video installation called Ever Is Over All, (3.219) by Swiss artist Pipilotti Rist (b. 1962) creates a multi-sensory experience that subtly comments on decorum and the breaking of the rules that normally govern society. A two-part projection into the corner of the room, it also has an ambient sound component that pulses throughout the gallery or museum space. On one screen we see a woman whose brilliant aquamarine dress and ruby-red slippers contrast

3.219 Pipilotti Rist, Ever Is Over All, 1997. Video installation with two monitors, dimensions variable. MOMA, New York

The Complexity of Today's (Art) World

As computers, televisions, and i-Phones bombard us with an overwhelming number of images and ideas 24 hours a day, 7 days a week, many contemporary artists acknowledge and embrace the complexity and chaos of the world in which we live. The Internet and increasingly easy international travel make the world seem smaller, and have hugely expanded our awareness of and interest in other cultures. Some artists have brought order to their own experiences of this global culture by creating personal symbols and sign systems. Others incorporate widely ranging styles, techniques, and messages into single artworks. Like the experience of living in the twenty-first century, contemporary artists assimilate approaches from all kinds of sources, past and present, real and imagined. Artworks made in response to the complexity of today's world, not surprisingly, contain many elements that operate on more than one level. The more you learn, the more each individual element makes sense and comes alive.

From 1994 to 2002 American artist Matthew Barney (b. 1967) produced, created, and starred in five full-length films called the Cremaster cycle. The complexity of these films lies in the large number of characters used, the concepts behind all aspects of the films, and the underlying biological metaphor that is woven into the series. "Cremaster" literally refers to the set of muscles that control the height of male testicles. Barney adopted the cremaster as a metaphor because it expresses the sense that identity changes over time: from prenatal sexual differentiation (in Cremaster 1) to a fully formed, or "descended," being (in Cremaster 5). The films do not use narrative or dialogue in the conventional sense, but visually and conceptually incorporate the history of the place where the films are set, episodes of invented mythology, Barney's personal interests, and a symbol system that he has developed.

In the still from Cremaster 5 (3.220), Barney plays a fictional character known as the Queen's Giant, who is undergoing the final stages of his transformation to a fully formed man. At the same time, Barney also plays a character called The Magician, who jumps off a bridge as part of a complicated web of symbols and associations that runs throughout the Cremaster films. In a 2004 interview. Barney explained that he was not searching for coherence in the Cremaster cycle, but that the films' ambiguity mimics his own wandering interests and the way he absorbs things on a day-to-day basis. The intricate symbolism that Barney invests in the people, places, and things in the films recalls all the simultaneous meanings that these elements can have (whether we are aware of them or not), and suggests that we can access them at the touch of a button or the whim of an artist.

3.220 Matthew Barney, Cremaster 5, 1997. Production still

Artworks reveal the concerns of humanity. Throughout the world, similar issues, or themes, are explored by artists. By comparing artworks in terms of their meaning, we come closer to understanding the uniqueness of different cultures and artists. Exploring topics commonly addressed by artists throughout space and time, and through a variety of methods and materials, also makes us more aware of shared concerns Artworks deal with belief systems, survival, the natural world, and technology; and with issues related to status, power, identity, and creative expression. By studying art in this way we can better understand various cultures and ourselves.

PART 4

THERMES

In this part you will study:

Art and Community

Spirituality and Art

Art and the Cycle of Life

Art and Science

Art and Illusion

Art and Rulers

Art and War

Art of Social Conscience

The Body in Art

Art and Gender

Expression

4.1

Art and Community

The community mural process makes art more accessible; it brings art into the lives of people who didn't have it.

(Susan Cervantes, San Francisco muralist)

This is a way of getting your art on the street. Lots of people stop to look at it. It's not like being famous, but it's a way of getting your art looked at. You have an audience.

(Aliseo Purpura-Pontoniere, urban youth arts student)

We tend to think of art as the work of a single individual. However, art often involves large numbers of people, even whole communities. As the statements above by professional artist Susan Cervantes and a student who worked with her demonstrate, artists can create art for the enjoyment and benefit not just of a single **patron**, or for a larger audience in an art gallery, but also for an entire community. Community art may require numerous people to become involved in its construction. Other times, artworks play important roles for performers in ceremonies and group events. Still other community art, situated in public places, is contemplated by countless viewers. A community—whether a small rural town, an apartment complex, a neighborhood, a college campus, an Internet discussion group—shares a common interest, if not a physical space. Studying the art made by and for communities throughout history tells us a great deal about the interaction between artists and their environments.

In this chapter we will examine the many ways in which art has been used to pursue

community objectives. Because buildings have such a direct impact on shaping a community, often becoming symbols of a particular place, we will look at several examples of architecture as well as at paintings and ritual performances.

Civic and Ceremonial Places

Structures have been designed to house ceremonies, civic events, and entertainments in times and places as varied as ancient Greece, medieval France, and present-day New York City (see Box: Art in Public Spaces, p. 456). Whether they serve as gathering sites, indicate concerns that are important to a group, or come to symbolize a particular place, buildings (and their appearance) reflect the concerns and practices of the communities that use them.

The Parthenon in Athens, Greece, was the grandest building on the Acropolis, the fortified district located at the highest point of the city. It was an important religious center dedicated to the maiden goddess Athena, the protector of Athens. The masses did not enter the sacred interior space of the Parthenon, but congregated outside the temple to worship at the altar to Athena in front of the building's western end. Relief sculptures on the Parthenon indicate the significance of the celebrations that occurred on this site (4.1). Ordinary Athenians are shown participating in the Panathenaic Festival, an annual ritual procession to honor Athena.

Patron: an organization or individual who sponsors the creation of works of art
Gothic: western European architectural style of the twelfth to sixteenth centuries, characterized by the use of pointed arches and ornate decoration

Passion: the arrest, trial, and execution of Jesus Christ, and his sufferings during them
Arches: structures, usually curved, that span an opening
Stained glass: colored glass used for windows and decorative applications
Vaulted: covered with an archshaped ceiling or roof
Nave: the central space of a cathedral or basilica

4.1 Detail of The Procession, from the lonic frieze on the east side of the Parthenon. c. 445-438 BCE. Marble, 43" high. Musée du Louvre, Paris, France

All of Athens's inhabitants were allowed to take part in the festival, although only citizens could enter the Acropolis.

While the Parthenon was designed for worship at an outside altar, **Gothic** cathedrals were intended, with their magnificent interior spaces, to inspire worshipers to religious devotion. These spectacular churches, built using the resources of the entire community, were a source of great civic pride. Pilgrims traveled to Notre Dame Cathedral (4.2) in Paris, France, to worship, both because the building was so impressive and because it held relics Christians considered sacred, such as a piece of the True Cross on which Jesus Christ was crucified, a fragment of the Holy Lance used to pierce his side, and the Crown of Thorns that the Romans made to mock Christ as King of the Jews. Pilgrims curious to see these items from Christ's Passion also hoped to benefit from their mystical power. Notre Dame's grand interior combines all of the characteristic elements of Gothic architecture, including pointed **arches** and stained-glass windows. The vaulted ceiling is 102 feet above the floor and the **nave** is more than 39 feet wide, surrounding receptive visitors with soaring height and spiritual light to transport them beyond the cares and concerns of the ordinary world.

4.2 Notre Dame Cathedral, interior, 1163-1250, Île de la Cité, Paris, France

Art in Public Spaces

Two famous works of art, made more than 4,000 years apart, occupied public spaces used by large numbers of people. Both structures were created by the efforts of masses of laborers. Considering these enormous works together can help us understand how a work of art can change a public place and how people interact with such works.

Very little is known about the makers of Stonehenge (4.3), but the creators of *The Gates* (4.4), Christo (b. 1935) and Jeanne-Claude (1935–2009), explained themselves in countless statements and interviews. We know about the construction methods of Christo and Jeanne-Claude from descriptions and from video documentation, but the techniques used to erect Stonehenge, and the intentions of its builders, remain shrouded in mystery. Stonehenge is still standing after thousands of years, while *The Gates* was designed to last a little more than two weeks. Despite their

differences, both works share a common aim: to focus the attention and movements of crowds of people in directions calculated by the artists who designed them.

The oldest parts of Stonehenge, on Salisbury Plain in England, are the circular embankment and ditch that surround the monument. This site was used for hundreds of years before the stones were imported from as far as 23 miles away. The massive stones in the sarsen circle weigh up to 50 tons apiece, each one equaling the weight of 500 people or five buses. We will probably never know how the builders moved those stones. Most scholars believe Stonehenge, 106 feet in diameter and up to 20 feet tall in places, served as a giant observatory or calendar. People who gathered at Stonehenge on the longest day of the year (known as the summer solstice) would have seen the sun rise precisely over the great stone known as the Heelstone, which stands outside

4.3 Stonehenge, c. 3200–1500 BCE, Salisbury Plain, Wiltshire, England

4.4 Christo and Jeanne-Claude, The Gates, Central Park, New York City, 1979-2005. Steel, vinyl tubing, and nylon fabric, c. 16' high

the circle. For a farming community, such as the one that built Stonehenge, the precise date of the summer solstice was important: it signaled the time to prepare for the fall harvest.

The Gates, installed in 2005, meandered through the 23 miles of walkways in New York's Central Park for just sixteen days. The installation was intended for public enjoyment, and an estimated four million people visited Central Park during the exhibition. The piece required community support garnered through petitions and meetings between the artists and New York City officials. Discussions about The Gates began in 1979 and the project was finally approved in 2003. The negotiation process was integral to the production of Christo's and Jeanne-Claude's installations, emphasizing the important role that the community plays in the conception and creation of their artworks.

Facts and figures provided on the artists' website indicate the mind-boggling amounts of material and labor involved in the making of The Gates. A total of 60 miles of saffron-colored nylon fabric hung from 7,503 gates. Each gate was 16 feet tall with fabric coming down to approximately 7 feet above the ground. The gates ranged from about 5 feet to 18 feet

across, depending on the width of the walkway. The artists employed engineers; project directors: fabricators for the materials in the U.S. and Germany; 600 paid workers to install, monitor, and remove the pieces; and security guards to protect the work at night. After The Gates was taken down the materials were recycled, reflecting the artists' environmentally sustainable practices.

Although these two works were made at different times on different continents, they have in common the fact that their construction required the efforts of significant numbers of people and that they were used or viewed by an entire community. While it is uncertain how or why Stonehenge was built, it is clear that a highly organized social structure must have been in place to see such a venture through. The Gates similarly required teams of experts and construction crews to carry out the artists' vision. Keen on involving the community and having their work enliven public spaces, but interested in maintaining creative freedom, Christo and Jeanne-Claude did not accept any government or public funding and themselves paid for the creation, installation, and maintenance of the work.

Sarsen: a type of hard, gray sandstone

4.5 Colosseum, 72-80 CE, Rome, Italy

While worship is a common function of many community buildings, others have been built for public entertainment. Amongst the most famous arenas of the ancient world was the Colosseum, one of Imperial Rome's largest public buildings and an extraordinary feat of architecture and engineering (4.5). Measuring 615 feet long by 510 feet across and standing 159 feet tall, the Colosseum could hold between 45,000 and 55,000 people. The Romans were the first to exploit fully the structural possibilities of concrete, which they used to construct the Colosseum's massive foundations and parts of its vaulted ceilings. The exterior was covered with travertine limestone and marble and decorated with columns and with pilasters made of another type of local limestone. There were 76 entrance doors, called vomitoria, a word that offers a vivid mental image of the crowds spilling from the doors after an event. Roman citizens flocked to the Colosseum to see mock sea battles

The Colosseum was designed almost 2,000 years ago for the entertainment of enormous crowds. Today, in addition to stadiums and amphitheaters, we have museums to attract the public for entertainment, cultural instruction, and reflection. Museums also serve as sources of local distinction, much as cathedrals did centuries ago. The design of the Guggenheim Museum in New York City employs strong

and gladiatorial fights with both man and beast.

geometric shapes, which is characteristic of many modern buildings. This white circular building, though, is distinctive among the city's rectangular blocks and glass skyscrapers. For large numbers of visitors its design is as much of an attraction as the art collected inside. Architect Frank Lloyd Wright (1867–1959) sought to provide what the

4.6 Frank Lloyd Wright, Solomon R. Guggenheim Museum, 1956-9, New York

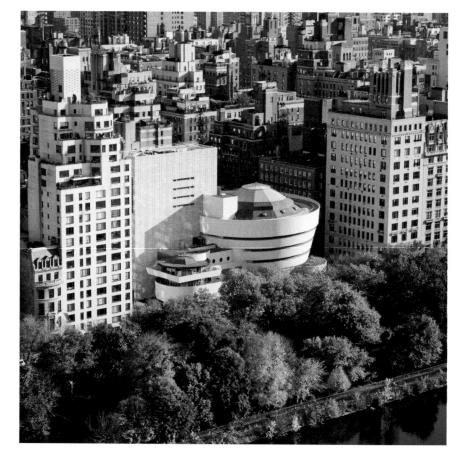

Concrete: a hard, strong, and versatile construction material made up of powdered lime, sand, and rubble

Pilaster: a vertical element, square in shape, that provides architectural support for crossing horizontal elements in post-and-lintel construction; also used for decoration

Atrium: a central, normally public, interior space, first used in Roman houses

Pyramid: ancient structure, usually massive in scale, consisting of a square base with four sides that meet at a point or apex with each side forming a triangular shape

Ziggurat: Mesopotamian stepped tower, roughly pyramidshaped, that diminishes in size toward a platform summit

4.7 Ziggurat, Ur (near Nasiriyah, Iraq), originally built c. 2100 BCE and heavily restored

director of the museum had asked for, "a temple of spirit, a monument." The interior is open, with a continuous spiral ramp around the central **atrium** connecting each successive floor. The space is filled with light from the domed skylight above.

Manmade Mountains

Buildings and other constructions intended to shape and dominate the environment—as Wright surely intended with his design for the Guggenheim—have been made since ancient times. Earthen mounds and pyramids are amongst the most intriguing kinds of architecture. Mysteries surround their creation, function, and symbolic significance. Why were such substantial human and material resources devoted to these manmade mountains? Whether they were built as memorials for the dead, for administrative purposes, or for religious worship and rituals, these structures had a dramatic and lasting impact on the geography of their locations (see Gateway Box: The Great Pyramid of Khufu, 4.8, p. 460).

While they resemble the Egyptian pyramids in their form, the ziggurats of the ancient Near East, such as the one in the city-state of Ur in Sumer (now part of Iraq), were built to be used by the living rather than to bury the dead (4.7). The ziggurat was part of a temple complex with civic and ceremonial purposes. The mud-brick structures are made up of at least three stepped levels, accessed by stairways or ramps. The lowest level is about 50 feet high and about 210 by 150 feet in area, with the others decreasing in size as they get closer to the heavens. The topmost platform served as an elevated stage for the priest. The priest, one of the few people allowed access to the ziggurat, served both as the principal human intermediary to the god who protected the city and the chief administrator of the ziggurat. The ziggurat at Ur was dedicated to the moon god Nanna, one of the three important sky deities in Sumerian religion, whose sacred city it was. Festivals were organized around the phases of the moon, especially when it appeared as a crescent, and offerings were left on the high platform to please Nanna and ensure the abundance of such sacred liquids as water, milk, and blood.

Gateway to Art: The Great Pyramid of Khufu Community Art: The Building of the Pyramids

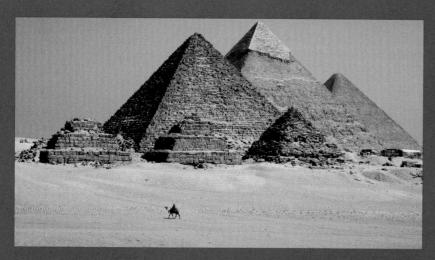

4.8 Great Pyramids at Giza, left to right: Menkaure, Khafre, and Khufu, c. 2560 BCE, Giza, Egypt

There are many theories as to how the ancient Egyptians managed to build pyramids of such enormous size and precision. Renowned archaeologist Mark Lehner wrote about assembling a team to test methods that may have been used to construct the Great Pyramids (4.8). This experiment showed that an enormous communal effort over many years was required to make these great structures. The exact method employed to build the pyramids remains a mystery, however.

I teamed up with Roger Hopkins, a stonemason from Sudbury, Massachusetts, and a team of Egyptian masons, quarrymen, and laborers to build a small pyramid near the Giza plateau. Working in the shadow of the Great Pyramids. pressures of a film schedule allowed us only three weeks for quarrying and three for building, so we were forced to use tools and technology not available to the ancient Egyptians. Our masons used iron hammers, chisels, and levers—their ancestors had only wood, stone, and copper. And Roger brought in a front-end loader for shifting and setting the stones of lower courses so that we would have time to test different methods at the top, where restricted space created special difficulties.

We knew that to fully replicate pyramid building would require nothing less than replicating ancient Egyptian society. Although we failed to match the best efforts of the ancient builders, it was abundantly clear that their expertise was the result not of some mysterious technology or secret sophistication, but of generations of practice and experience.

We found that stones weighing as much as 2.5 tons could be moved simply by **tumbling**. Just four or five men were able to lever up and flip over blocks of less than 1 ton. To shift heavier blocks, a rope was looped around the top and it was then pulled by up to twenty men, with a couple more on levers behind. But it is most unlikely that sufficient stones could have been tumbled up a ramp to build a whole pyramid within a king's lifetime. Faster methods were needed.

Wooden sledges on rollers offered a much quicker way of moving stones, even though, as we soon discovered, simply loading a block on to a wooden sledge is an operation requiring considerable skill. Next, on soft sand we built an artificial trackway of planed lumber, though ancient tracks were wider, with a surface of hardened gypsum or packed clay. Then we used rollers consisting of small, cylindrical pieces of wood. The lynchpin of the entire operation was the man who received the rollers from the back of the sledge and put them down in front, creating a continually rolling roadway. With twelve to twenty men pulling the load at a swift pace, his was a very skilled task. A huge number of rollers would have been needed to move the stones up on to the pyramid. With neither abundant supplies of wood, nor the mechanical lathe, this method must have had only restricted application.

Artificial slideways proved a much more efficient method. In our experiment we built two parallel retaining walls which were then filled with debris to create an inclined ramp. On top we built a roadbed with wooden crosspieces, following the approximate specifications of those at Lisht [another site]. We found that a 2-ton stone on a sledge could be pulled by twenty men or fewer. This success, in conjunction with

4.9a (right) First course of pyramid is leveled 4.9b (right below) Raising heavy blocks by levering 4.9c (far right) Raising topmost blocks by levering 4.9d (far right below) Masons trim casing from the top downward

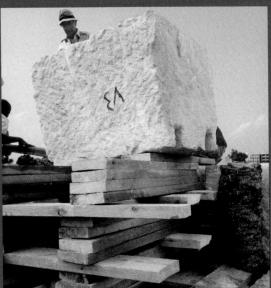

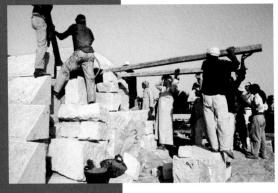

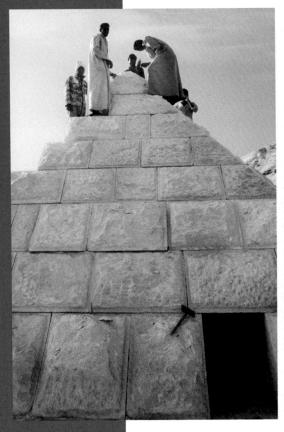

evidence of tomb representations and remains of ancient embankments and trackways at Lisht, convinced us that this was the most likely means the Egyptians used to bring in the bulk of the core stones.

While it is widely agreed that ramps were used to raise blocks, several theorists have proposed that it was achieved by levering. When we put levering to the test, unforeseen difficulties emerged. A set of levers is needed on two sides to lift a block: one side is raised and supported, then the other side is levered up to bring it level. As the stone is rocked upward it is supported on a stack of wood. This required two deep notches in each side of a block, which are not found on

pyramid core stones. More critically, the wooden supports were precarious and unwieldy, in spite of our using planed lumber. Similar difficulties arose with the fulcrum, which had to rise with the load. It seemed to us, therefore, that some system involving a ramp or ramps was the most likely method used.

Many pyramid theorists resort to levering to explain how the capstone and the topmost courses were set, since by that level there was simply no longer room for ramps. However, to climb the pyramids of Khufu and Khafre and look down their steep slopes and narrow steps is to realize that the great bulk of the pyramid could not have been raised in this way.

Course: a single row of stones or bricks forming a horizontal layer of a structure **Tumbling:** the use of levers to roll heavy objects over short distances Gypsum: fine-grained, powdery mineral often used to make a smooth plaster Levering: to move or raise an object using a leverlike action Capstone: a final stone forming the top of a structure; on a pyramid, it is pyramid-shaped

4.10 Tomb mound and complex of Emperor Qin Shi Huangdi, c. 210 BCE. Lintong, Shaanxi Province, China [CGI reconstruction]

Rather like the Egyptian pharaohs, the emperors of ancient China also tried to take their riches with them to the afterlife. Ancient historians described how the first Emperor of China, Qin Shi Huangdi, prepared for his death by constructing a burial mound with a vast underground city palace that matched the one he occupied in life. These accounts were believed to be sheer legend until 1974 when excavations of a tomb mound revealed evidence that the ancient stories were true (4.10). Soon after he came to the throne at the age of thirteen, Qin Shi Huangdi began overseeing the elaborate preparations for his own resting place, which continued for thirty-six years until his death in 210 BCE. Artisans filled the complex surrounding Qin Shi Huangdi's tomb with all the treasures he would need in the afterlife, including an army of terracotta soldiers and horses (4.11). The 8,000 figures were intended to guard the body of the Emperor. They have similar rigid and upright poses, indicating that a mold might have been used for the general shape, but each one has unique clothing, weaponry, and facial features.

More than one thousand years after the death of Qin Shi Huangdi, builders made the largest earthen mound ever discovered in North America (4.12). Cahokia, located in what is now southern Illinois near St. Louis, covered 6 square miles and had an estimated population of

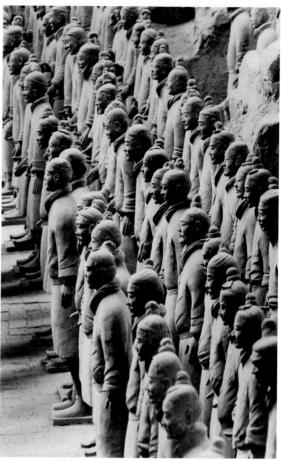

4.11 Soldiers from mausoleum of Emperor Qin Shi Huangdi, c. 210 BCE. Terracotta and pigment, figures approximately lifesize. Lintong, Shaanxi Province, China

10,000-20,000. As with other communities that built such impressive structures, there is evidence of a highly organized society, advanced engineering knowledge, and a productive work force at this site.

The focal point of the settlement at Cahokia was Monks Mound, which was originally surrounded by about 120 smaller mounds. The base of Monks Mound measures 1,080 by 710 feet and is topped by two smaller platforms. Though its exact purpose is uncertain, Monks Mound likely served as an elite residence, a temple, a burial structure, or perhaps all three. Monks Mound is aligned with the sun at the equinoxes, the two times of the year (in spring and fall) when day and night are exactly the same length. These alignments suggest that it may have functioned as a calendar and also served a ceremonial purpose. The site was abandoned around 600 years ago due

4.12 Cahokia, Illinois, c. 1150 (reconstruction drawing)

4.13 Aerial photo of the ruins of the Aztecs' Templo Mayor, downtown Mexico City, Mexico, with overlaid CGI reconstruction drawing

to climate changes and the depletion of natural resources. Because Monks Mound has suffered from slumping and erosion, the huge earthen mound's appearance is much less dramatic and impressive than it must have been at the height of Cahokia's occupation.

Unlike Monks Mound, we know that the Aztec stepped pyramid called the Templo Mayor, or Great Temple, was designed for a specific purpose: as a platform for performing ritual sacrifices (4.13). Our information about the Great Temple comes from Aztec manuscripts, Spanish accounts, and archaeological excavations of the temple's remains underneath present-day Mexico City. On top of the Great Temple were two shrines. The North Temple, dedicated to Tlaloc, the rain god, was painted white and blue and adorned with symbols of rain and water, including water plants. To the south was the temple of Huitzilopochtli, the god of war, painted white and red and decorated with symbols of war and sacrifice. The construction of the 200-foot-tall Great Temple must have required the labor of hundreds of people and vast quantities of construction materials, but clearly the Aztecs considered it a price worth paying. The hearts of war captives were cut out on a sacrificial stone on top of the pyramid, a sacrifice presented to the rain god in the hope that the crops would be renewed and life would continue to flourish.

Ritual: Performance. Balance, and Healing

The production of art is often deeply connected to philosophical, religious, and ideological beliefs. Artworks made to be used in a ritual context often have symbolic meanings in addition to their appearance and visual impact. With such objects as musical instruments, temporary constructions, and masks, it is important to keep in mind that the way they were experienced in their original context would have been very different from the way we now see them in the pages of a book or inside glass cases in museums. The objects themselves are suggestive of the sights, sounds, and even smells to which we no longer have access.

Three lyres, stringed instruments similar to a harp, were found amongst the magnificent objects in the Royal Cemetery of Ur. Lyres were popular musical instruments in ancient Sumer, but the example in 4.14 is more elaborate than most. As it was found in a grave, it seems to have been intended as a suitable burial offering for a powerful person. Although the body of the instrument disintegrated long ago, the wooden section of the lyre has been reconstructed to give an idea of its appearance. The original panels on the sound box of another of the lyres, made of lapis lazuli and shell, have survived (4.15). They reveal that the lyre, which played music we can no

4.15 Inlaid panel from a Sumerian lyre's sound box, showing mythological figures, c. 2550-2400 BCE. Gold, silver, lapis lazuli, shell, bitumen, and wood, 13" high. From the King's Grave, Royal Cemetery, Ur, Iraq

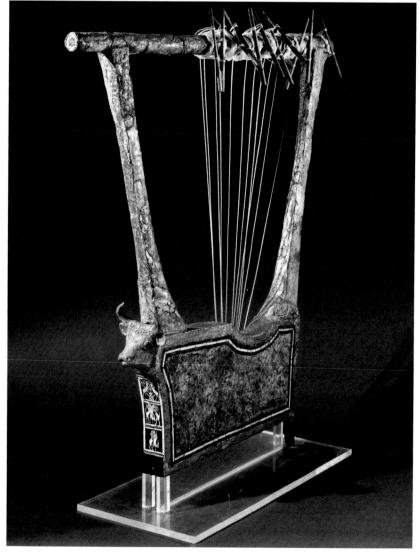

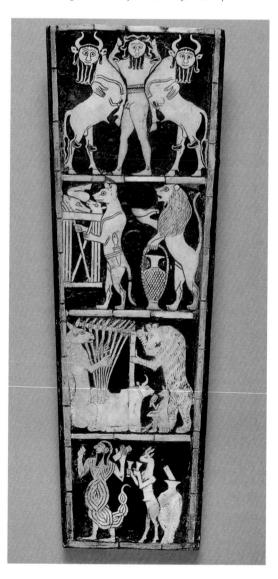

4.14 Sumerian bull lyre,

lazuli, gold, silver, shell,

bitumen, in modern wood

Ur, Iraq. University of

of Archaeology and

Pennsylvania Museum

support, 46×55 ". From the King's Grave, Royal Cemetery,

c. 2550-2450 BCE. Wood, lapis

longer hear, was also covered in symbols that we now do not entirely understand. The panels show animals engaged in such human activities as dancing, walking on two legs, and bringing instruments and refreshments to a ceremony, probably much like the ones in which this lyre was used. The fusion of humans and beasts, such as the scorpion man below and the humanheaded bulls above, suggests a sacred event, perhaps a marriage or a funeral procession. Some scholars, however, suggest that the scenes decorating the lyre show activities in the supernatural realm of the dead.

Although the details of some cultures' ritual performances, like the music of the Sumerians, can no longer be recovered, other groups recorded their rites in rock art that has survived for thousands of years. Still other ancient people, such as the Navajo of New Mexico, intentionally chose an impermanent **medium** for their important ceremonies. Navajo sand paintings are temporary works of art, constructed as part of a prayer or ceremony (4.16). The paintings are closely connected to nature, both in materials used (such as corn, pollen, charcoal, sand, and powdered stones) and imagery. The subject matter comes from Navajo creation mythology

4.16 Navajo medicine man in healing ceremony

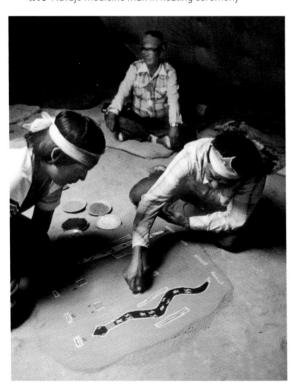

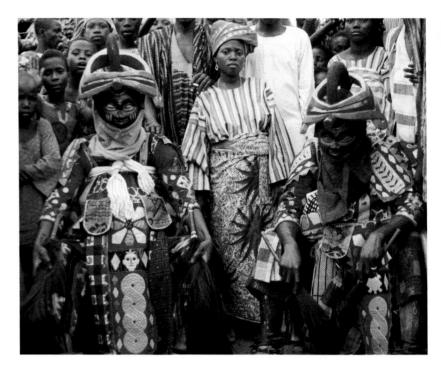

and includes logs, holy plants, animals, and deities. After an image has been meticulously created over the course of days or weeks, a healing ceremony takes place, overseen by a **shaman** or medicine man (rarely a woman). The person to be healed sits in the painting's center in order to absorb power from Navajo ancestors and from the gods, whose images are depicted in the painting. The shaman acts as an intermediary between the natural, physical world and the supernatural, spiritual realm.

Masks and **masquerades** serve a similar function of mediating between the human and spiritual realms. Masquerades enable humans to communicate with the spirit world, allowing the masker's personality to be replaced temporarily with that of the spirit being evoked. At the same time, the ritual performance of masquerades is often designed to reinforce the cultural beliefs of a community. While the mask is generally the focal point of the performance, it must be combined with costumes, music, and dance in order to invoke a particular spirit. **Gèlèdé rituals** performed by the Yoruba in Nigeria celebrate female power, honor women as mothers, and commemorate the woman's role in producing children in order to help sustain the community (4.17). These ceremonies acknowledge the important part played by female ancestors in Yoruba society and also promote spiritual well-being and social harmony.

4.17 Pair of Gèlèdé masqueraders wearing appliquéd cloth panels, Ketu area, town of Idahin, Benin. Photo by Henry John Drewal, 1971

Lyre: a stringed instrument that is played by being plucked; the strings hang from a crossbar that is supported by two arms connected to a hollow box, which amplifies the sound Lapis lazuli: bright blue semiprecious stone containing sodium aluminum silicate and sulphur

Medium (plural media): the material on or from which an artist chooses to make a work of art

Sand painting: also known as dry painting, a labor-intensive method of painting using grains of sand as the medium

Shaman: a priest or priestess regarded as having the ability to communicate directly with the spiritual world

Masquerade: performance in which participants wear masks and costumes for a ritual or cultural purpose

Gèlèdé ritual: ritual performed in Nigeria's Yoruba society to celebrate and honor women

Art in the Public Sphere

Not all art exists in galleries and museums. Public art generally appears in plazas and parks, or on the exterior walls of buildings. Public artworks are therefore accessible to a wide audience, and they are often much beloved by the community. But they can also cause problems. Sometimes

public art can be taken out of context or misunderstood. Sometimes people can have different views about what should be seen in public or is appropriate in a particular environment. Public artworks can excite strong emotions, both positive and negative, and can sometimes spark fierce controversies.

Tilted Arc, by the American Minimalist sculptor Richard Serra (b. 1939), was

Perspectives on Art: Richard Serra A Sculptor Defends His Work

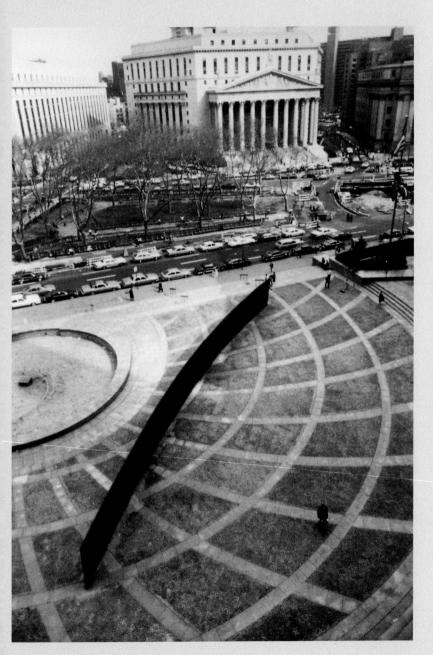

In 1979 the General Services Administration (GSA) contracted the American sculptor Richard Serra to install a work on Federal Plaza in New York City. The sculpture, Tilted Arc, was erected in 1981. The work proved controversial and in 1985 Serra had to defend his sculpture at a public hearing.

My name is Richard Serra and I am an American sculptor.

I don't make portable objects. I don't make works that can be relocated or site adjusted. I make works that deal with the environmental components of given places. The scale, size, and location of my site-specific works are determined by the topography of the site, whether it be urban, landscape, or an architectural enclosure. My works become part of and are built into the structure of the site, and they often restructure, both conceptually and perceptually, the organization of the site.

My sculptures are not objects for the viewer to stop and stare at. The historical purpose of placing sculpture on a pedestal was to establish a separation between the sculpture and the viewer. I am interested in creating a behavioral space in which the viewer interacts with the sculpture in its context.

4.18 Richard Serra, Tilted Arc, 1981 (destroyed March 15, 1989). Weatherproof steel, $12' \times 120' \times 2^{1/2}$ ". Collection General Services Administration, Washington, D.C. Installed at Federal Plaza, New York

commissioned by the federal General Services Administration (GSA) and installed on Federal Plaza in downtown New York City in 1981 (4.18). It became the subject of controversy shortly after it was installed. The 12 foot by 120 foot sculpture, a curving wall of Cor-ten steel, cut across the plaza. Some of the people who worked in the GSA building complained that it interfered with their use of the plaza and caused a safety hazard as well,

One's identity as a person is closely connected with one's experience of space and place. When a known space is changed through the inclusion of a site-specific sculpture, one is called upon to relate to the space differently. This is a condition that can be engendered only by sculpture. This experience of space may startle some people.

When the government invited me to propose a sculpture for the plaza it asked for a permanent, site-specific sculpture. As the phrase implies, a site-specific sculpture is one that is conceived and created in relation to the particular conditions of a specific site, and only to those conditions.

To remove Tilted Arc, therefore, would be to destroy it...

It has been suggested that the public did not choose to install the work in the first place. In fact, the choice of the artist and the decision to install the sculpture permanently in the plaza were made by a public entity: the GSA. Its determination was made on the basis of national standards and carefully formulated procedures, and a jury system ensured impartiality and the selection of art of lasting value.

The selection of this sculpture was, therefore, made by, and on behalf of, the public.

The agency made its commitments and signed a contract. If its decision is reversed in response to pressure from outside sources, the integrity of governmental programs related to the arts will be compromised, and artists of integrity will not participate. If the government can destroy works of art when confronted with such pressure, its capacity to foster artistic diversity and its power to safeguard freedom of creative expression will be in jeopardy.

attracting graffiti artists, rats, criminals, and potentially even terrorists. Although the majority of testimonies at a public hearing to decide whether or not to leave the sculpture in place were in favor of keeping the work, it was ordered to be removed. The artist's lawsuit against the GSA failed to reverse the decision and the sculpture was dismantled in 1989. Serra had argued that Tilted Arc was designed specifically for Federal Plaza and that relocating it was the equivalent of destroying it, so the metal was sent to a scrap yard (see Perspectives on Art Box: Richard Serra: A Sculptor Defends His Work). Even though the sculpture was demolished, the artist's hope of making people aware of their environment, pay attention to the path they follow on the way to work, and think about their surroundings was in some ways achieved by the attention generated by the controversy.

The dispute over Serra's *Tilted Arc* raises many questions that have a bearing on the form and functions of all public art. What is the desired impact of public art? Does it need to please its audience, or can it be used as a tool to challenge their beliefs and experiences? How much weight should be given to the artist's freedom of expression? Should consideration be given to whether the artwork is in keeping with the kind of work an artist is known to produce? How much power should public voices be given, whether they belong to specialists in the art world or members of the general community? What bearing does the issue of funding—which may come from the government through special programs aimed at promoting public art or from individual patrons—have on how one answers such questions?

The subject matter of public art, especially when it has political implications, has also been a source of debate. One of the most infamous scandals surrounding a public art project occurred in 1932 when the Mexican artist Diego Rivera (1886–1957) was commissioned by American businessman and millionaire Nelson Rockefeller to paint a mural in the Radio Corporation Arts (RCA) Building at Rockefeller Center in Manhattan. Rivera was inspired by Mexico's tradition of adorning walls with paintings and sculptures, which originated long

Minimalist: a mid-twentiethcentury artistic style characterized by its simple, unified, and impersonal look, and often employing geometrical or massive forms

Cor-ten steel: a type of steel that forms a coating of rust that protects it from the weather and further corrosion

Mural: a painting executed directly on to a wall

4.19 Diego Rivera, Man, Controller of the Universe, or Man in the Time Machine, 1934. Fresco, 15'11" × 37'6'/8". Full composite view of the fresco. Palacio de Bellas Artes, Mexico City, Mexico

before European contact. Such murals create an environment rich with stories related to all aspects of life. Rivera's written plan for *Man at the Crossroads Looking with Hope and High Vision to the Choosing of a New and Better Future*, which Rockefeller approved, included depictions of forces of nature as well as technology, and looked forward to "the liquidation of Tyranny" and a more perfect society. In the course of painting, however, Rivera made some changes inspired by his communist inclinations. The most notable was on the right side of the mural, where he included a portrait of the Russian revolutionary Vladimir Lenin leading a demonstration of workers in a May Day parade.

When he was asked to remove Lenin's portrait, Rivera refused, and offered instead to balance it with a depiction of Abraham Lincoln. Rockefeller rejected this proposal, paid Rivera his full fee, and banned him from the building. Rockefeller then made plans to remove the mural. An outpouring of public support for the project followed: picket lines were formed, newspaper editorials were published, and Rivera made a speech at a rally outside City Hall. Despite suggestions that the mural be moved a few blocks away to the Museum of Modern Art, it was ultimately demolished with pickaxes in February 1934. That same year Rivera re-created the mural, with the new title Man, Controller of the Universe, in Mexico City (4.19). Rivera rather bluntly described the conflict that can arise between the vision of artists with strong opinions and their audiences: "[The artist] must try to raise the level of taste of the masses, not

debase himself to the level of unformed and impoverished taste."

Rivera's public art projects have influenced artists since the 1930s, though by no means do all public murals generate such controversy. The hundreds of murals that now adorn the walls of buildings in San Francisco are part of a rich tradition that began with the three murals Rivera painted at the Pacific Stock Exchange, the San Francisco Art Institute, and the 1939 World's Fair (now at San Francisco City College). Contemporary muralist Susan Cervantes (b. 1944) founded the Precita Eyes Mural Arts Center in San Francisco to focus on issues of Hispanic heritage, to promote community-based art projects, and to make art accessible to inner-city residents. The community aspects of all these initiatives are crucial. Local residents help decide the subjects of the murals and they also collaborate on their creation. Cervantes served as lead artist for an award-winning mural called Precita Valley Vision on the facade of the Precita Valley Community Center (4.20). In addition to showing activities promoted by the center, the mural commemorates a tragic event in nearby Precita Park, where two teenagers had been murdered while on a picnic. Their faces are included among the depictions of cultural performances, athletic displays, and welcoming scenes of community. As this mural project reveals, art displayed in public places often reflects issues that resonate for the community, by commemorating people who were once part of it and by raising issues—such as violent crime that need to be addressed.

4.20 Precita Valley Vision, 1996. Lead muralist Susan Cervantes. Mural, 30 x 28'. Precita Valley Community Center, San Francisco, California

Discussion Questions

- 1 In this chapter you have studied artworks that in different ways reflect the importance of community. What does community mean to you? Think of an artwork in your community (a building, painting, or sculpture for example). Discuss the ways in which it conveys (or perhaps contradicts) your own ideas of the importance of community.
- Research a public artwork that interests you. Consider art in public buildings, parks, schools and colleges, churches, etc. Do you
- consider the work controversial? Explain your reasons. Was the artwork publicly funded? Are you in favor of such works receiving public funding? Compare the artwork to a controversial artwork discussed in this chapter.
- Choose a work in this chapter that was the result of the combined efforts of a number of people. Then find three other collaborative works elsewhere in this book (1.1, 1.125, 2.120) or by searching the Internet. Compare the ways in which collaboration affected the works and how the results were innovative or inspiring.

4.2

Spirituality and Art

For as long as art has been made, there have been artworks inspired by beliefs in ancient deities, spirit beings, and the sacred figures of the world's religions. Through these works artists have sought to express things that cannot be seen and are little understood. In this chapter we use the term spirituality to examine the ways in which beliefs have generally inspired artists for thousands of years. Spirituality encompasses our sense of being connected to others, our awareness of both mind and body, and our wish to understand life's meaning and the world in which we find ourselves. Spirituality serves as a source of inspiration and a way for us to share our beliefs. This chapter investigates four broad categories of artworks with a spiritual context: artworks that incorporate specific gods or deities; artworks that refer to the

spirits of the natural world or ancestors; artworks that reflect communication with the spirit world; and places that have a sacred resonance.

Deities

Artists communicate the stories of specific religious figures or deities to help explain their importance. Depictions of individuals considered divine in Greek mythology, the Christian Bible, and Buddhist scripture can make those individuals more accessible and memorable.

The ancient Greeks often made artworks to honor their gods and deities. The sculptures in **4.21** are from the **pediment** of the temple dedicated to the god Zeus at Olympia, Greece,

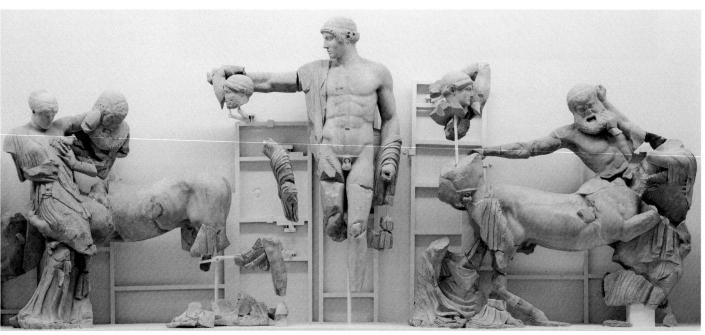

Pediment: the triangular space, situated above the row of columns, at the end of a building in the Classical style **Idealized:** represented as perfect in form or character, corresponding to an ideal

where the Olympic Games were born. The scene depicts the legendary battle between the Lapiths of Thessaly and the Centaurs—half-human and half-horse creatures, which, according to Greek mythology, lived in the nearby mountains. During the wedding feast of the Lapith king, the Centaurs, who were amongst the guests, drank too much wine and tried to abduct the bride and the other women. The civilized Lapiths are depicted as idealized, rigid, and without emotion. The barbarian Centaurs, on the other hand, are shown with more dramatic gestures and ferocious expressions. Apollo, the god of the sun, who was also associated with the poetic arts and medicine, stands at the center of the event

> and brings order to the violent struggle. He is the appropriate deity for this scene because he represents reason, order, and male beauty. The Centaurs, who are associated, by their drinking, with Dionysus the god of wine, represent the opposite attributes of change, chaos, and even madness.

In Christian Europe in the eleventh century, visual artists often illustrated themes and events from the Bible. Bishop Bernward, who directed the building of the Church of St. Michael's at Hildesheim, Germany, commissioned a set of doors that depict scenes from the book of Genesis on the left side and scenes from the life of Christ on the right. In chronological order the doors are read counterclockwise, beginning at the top of the left door. But the panels are also arranged so that events from the Old Testament are paired with related episodes from the New Testament (4.22 a-c).

For example, the third panel from the top matches the Tree of Knowledge on the left with the Tree of Life on the right. In the left scene the original sin is committed. Because Eve accepted the forbidden fruit from the Tree of Knowledge, she and Adam were expelled from the Garden of Eden into the world of suffering and death. On the right, the cross on which Jesus was crucified, understood as the Tree of Life, offers eternal life to believers who ask for forgiveness of their sins and accept Christ as their savior. The elongated

Paradise Lost

Salutations

Tree of Knowledge (sin)

Judgment

Separation from God Firstborn Son

of Eve (Cain)

and Poverty Abel's Sacrificial

Lamb

Despair, Sin, Murder

Formation Noli Me of Eve Tangere Eve The Three Presented to Marys at the Adam Tomb Temptation The and Fall Crucifixion Accusation and Judament of Judgment of Jesus by Adam and Eve Pilate Expulsion from Presentation of Paradise Jesus in Temple Adam and Eve Adoration of Working the Magi Offerings by Cain (grain) and The Nativity Abel (lamb) Cain Slaying The Abel Annunciation

Old Testament New Testament

Paradise Gained

Salutations

Tree of Life, The Cross. Salvation

Judament

Reunion with God

Firstborn Son of Mary (Jesus) and Wealth

Jesus, Lamb of God

Hope and Everlasting Life

4.22a (above) Detail of Hildesheim Doors: Expulsion from the Garden of Eden

4.22b (right) Doors depicting scenes from Genesis and the Life of Christ, commissioned by Bishop Bernward for the Abbey Church of St. Michael's, Hildesheim, 1015. Bronze, 16'6" high. Dom-Museum, Hildesheim, Germany

4.22c (far right) Diagram with identification of panels on Hildesheim Doors

4.23 *Life of Buddha*, stela, Gupta period, *c*. 475 cE. Sandstone, 41" high. India Museum, Calcutta, India

and frail appearance of the figures and the unnaturalistic settings reflect the Christian emphasis on internal, spiritual matters and themes instead of the exterior, physical world.

The subject matter of Buddhist art is the life of Buddha and his teachings and beliefs, which are considered pathways to achieving spiritual perfection. Buddha, or the Awakened One, was a Hindu prince named Siddhartha Gautama who lived in Nepal and northern India from about 563 to 483 BCE. The larger panels of the **stela** in 4.23 show the cycle of Buddha's life. In the bottom section we see his miraculous birth as he emerges from his mother's right side. The second section, above the birth scene, is the moment of his enlightenment as he touches the earth with a symbolic gesture of strength and renewal. In the third section he is shown giving his first sermon, seated with his legs crossed and his hands posed in prayer, with the wheel of law

behind him. At the top of the sculpture he is shown reclining as he achieves tranquillity, called nirvana. The smaller carvings along the sides of the stela show noteworthy moments after he decided to leave his princely life at the age of thirty to become a holy man.

Spiritual Beings and Ancestors

In African cultures, artworks often reflect beliefs in the spirits of gods and ancestors. According to these cultures' traditional beliefs, objects are infused with a spiritual presence. They help to continue and preserve cultural practices, beliefs, and family ties. Contemporary artists who examine black history often refer to traditional African art, customs, and rituals in their artwork.

4.24 Mother-and-child figure, late 19th-mid-20th century. Wood, 25" high. Cleveland Museum of Art, Ohio

The religion of the Senufo people of West Africa is centered on a creator deity, nature spirits, and ancestors, including a female ancestral spirit called "ancient mother" or "ancient woman." These spirits can be beneficial or harmful. They are often depicted as beings with an anatomy very different from that of humans. The head, legs, and detailed features of the Senufo sculpture in 4.24 are relatively small while the arms and breasts are exaggerated. The inclusion of a nursing baby suggests that this is one of the female ancestral spirits. Such an "ancient woman" would serve as a guiding spirit for adult males in the community, who were responsible for maintaining Senufo religious

In traditional African cultures, functional objects were often esteemed as status symbols. These objects, which could include staffs, masks, and even wooden stools, acquired their power through use, and only people of a certain rank could own them. This chair from the Democratic Republic of

and historical traditions.

4.25 Chair, early 20th century. Wood, brass, and iron tacks, $23\frac{5}{8} \times 13\frac{1}{4} \times 23\frac{3}{4}$ ". National Museum of African Art, Smithsonian Institution, Washington, D.C.

Congo is believed to have belonged to a chief of the Ngombe people (4.25). It was carved from a single block of wood (with the exception of the crossbeams) and decorated with brass and iron tacks imported from Europe. This stool, by itself a symbol of dignity and authority, contains a triangular **chevron** motif at the top and bottom of the seat, which suggests masculinity and royalty. Such a stool, used throughout a person's life, acquired additional significance after the user died by serving as the resting place for the soul. Family ties and the continuation of practices established by ancestors were especially important in the case of the chief, who was considered divine or semidivine. This stool was a tangible reminder of its owner's status and values even after he died. As it was passed down or prepared to accompany the ruler in the afterlife, such an object served as a tangible reminder of the owner's life and carried his legacy for later generations.

The contemporary African American artist Betye Saar (b. 1926) has adopted some of the influences that were important to traditional African groups as she explores themes of personal and communal identity. Saar examines the survival of African traditions in black culture and often challenges **stereotypes**, such as those

represented by figures like "Aunt Jemima." Saar has an ongoing interest in religious beliefs and revered objects, finding imagery and ideas in the traditions of voodoo and spirit worship. The title of her sculpture Ancestral Spirit Chair conveys the power an object can have for later generations (4.26). Like the Ngombe chair in 4.25, which incorporates European tacks and construction techniques, Saar's chair combines contrasting materials and methods. The European-style legs, seat, and back are made of unrefined twigs that have been embellished with paint, bone, glass, and metal. Saar has stated:

I am not about imitating African art or primitive art, but I am interested in the power it has and that kind of power being transferred to the work I do. And by power, I mean some kind of communication between me and my materials on one level and then the final product, communicating with the viewer.

Stela: upright stone slab decorated with inscriptions or pictorial relief carvings Chevron: a V-shaped stripe, often reproduced upside down or on its side in decorative patterns Stereotypes: oversimplified notions, especially about marginalized groups, that can lead to prejudiced judgments **Voodoo:** a religion based on Roman Catholic and traditional African rituals, practiced in the West Indies and southern U.S.

4.26 Betye Saar, Ancestral Spirit Chair, 1992. Painted wood, glass, plastic, metal, and vine, $60 \times 46 \times 32$ ". Smith College Museum of Art, Northampton, Massachusetts

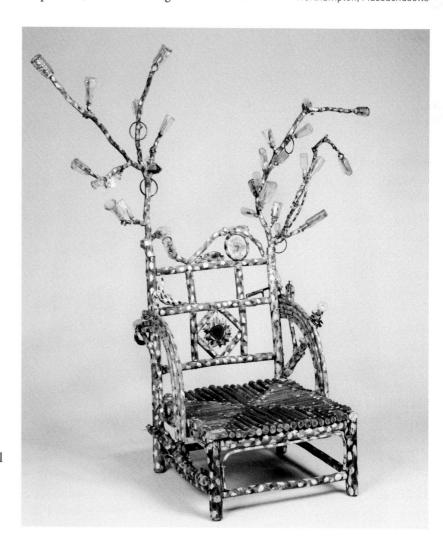

Connecting with the Gods

Communication with the gods has been an important subject matter for art in many cultures. Sometimes special individuals serve as intermediaries between people and a deity. Christian saints and mythological figures interact with gods to provide role models or to help educate viewers about religious practices.

4.27 Stela of Naram-Sin, c. 2254-2218 BCE. Pink sandstone, 6'7" × 3'5". Musée du I nuvre, Paris, France

In other cases, rulers have been depicted interacting directly with divine beings or travelling into supernatural realms. Artworks that show these kinds of interaction reinforce the power of rulers by convincing their people that they are blessed, even aided by the gods, and worthy of their exalted position.

Human interaction with a deity is the focal point of the Stela of Naram-Sin (4.27). Naram-Sin, an Akkadian king who ruled central Mesopotamia (part of modern Iraq) around 2254-2218 BCE, was both a religious figure and a military leader. His stela commemorates the Akkadian victory over the Lullubi people. The lower portions of the scene show signs of the battle that has taken place on a mountain. Above, Naram-Sin stands victorious near the summit, his horned helmet and larger size emphasizing his importance. The sun god is not depicted in human form but appears symbolically as a sunburst. Naram-Sin's location as close as possible to the sun god illustrates his own supreme, divine status in society and, especially considering the recent victory, suggests that he was looked upon with approval by the gods. In the ancient Near East there was a close relationship between people and the gods. Because humans were imperfect and in need of assistance from a higher being, prayers were offered, and rituals and sacrifices performed, to keep the gods happy. As the deified representative of his community, a ruler like Naram-Sin needed to maintain a favorable connection with the supernatural realm in order to ensure continued prosperity for his kingdom.

During the Middle Ages, Christians in the Eastern Orthodox Church used icons depicting holy figures as a focus of devotion and a source of inspiration. Icons were believed to be able to communicate with God and were even sometimes considered to have other miraculous powers. Many were painted on wood panels, which meant they could be carried around, although some were attached to chapel screens in churches. The portable icons, however, were more accessible for ordinary people. They could also be transported from Byzantium to distant places, such as Russia, in order to help spread Christian beliefs. Although icons themselves were not

4.28 Virgin of Vladimir, 12th century (before 1132). Tempera on panel, $30\frac{3}{4} \times 21\frac{1}{2}$ ". Tretyakov Gallery, Moscow, Russia

worshiped as divine, they became the subjects of intense veneration because they depicted individuals whose saintliness meant they were close to God, and therefore able to spread goodness.

The Orthodox Church required the form and content of icons to follow traditional rules. As a result, although each painting is unique, it has a family resemblance to other icons: gold backgrounds, linear outlines, and stylized but believable poses. It was important that the figures in the icons could be recognized by anyone who saw them. Thus the Madonna and Child were always shown with haloes to represent their holiness. The Virgin of Vladimir portrays Mary as the "Virgin of Loving Kindness," with her face touching Jesus to emphasize her virtue (4.28). This icon, probably made in Constantinople, was intended to bless and protect the city in which it was housed (it has

been in Moscow almost continuously since 1395). Only the faces are original; the rest of the panel, probably damaged by people touching it, has been repainted.

The Ecstasy of St. Teresa by Gianlorenzo Bernini (1598-1680) is another Christian artwork that is meant to inspire devotion and reverence (4.29). It was made between 1647 and 1652 to decorate a funerary chapel for the

Icon: a small, often portable, religious image venerated by Christian believers; first used by the Eastern Orthodox Church Linear outline: a line that clearly separates a figure from its surroundings **Stylized:** art that represents objects in an exaggerated way to emphasize certain aspects of the object

4.29 Gianlorenzo Bernini, The Ecstasy of St. Teresa, 1647-52. Polychromed marble, gilt, bronze, yellow glass, fresco, and stucco, 4'11" high (figures only). Cornaro Chapel, Santa Maria della Vittoria, Rome, Italy

Cornaro family in the Church of Santa Maria della Vittoria in Rome, Italy. This massive marble sculpture (more than 11 feet tall) depicts one of St. Teresa of Ávila's mystical visions: she is about to be pierced by an angel's arrow that will infuse her with divine love. The theatrical staging and the emphasis on dramatic light—created by the use of gilt bronze rays behind the figures and by the light falling from a hidden window above the sculpture—are typical of the **Baroque** style. Bernini's sculpture is executed with great attention to detail. The whole scene seems to take place in the clouds and the angel almost hovers above St. Teresa. Marble is made to suggest several different textures including smooth skin, gauzy fabric, clinging draperies, and the heavy wool of the nun's habit worn by the saint. The combination of accurate and believable details with an exaggerated picture of devotion reflects the Catholic Church's new emphasis at that time on believers establishing a strongly personal relationship with Christ. In Bernini's sculpture Christ's **Passion** is relived in the intensity of

St. Teresa's piety, which serves as an example to be followed by the devout.

In Bernini's Christian artwork, it is the angel who has had to descend from heaven to visit St. Teresa on earth. But in Mesoamerica it was the human rulers who possessed the ability to cross the threshold from one world to another. Olmec leaders sat on "altars," or thrones, during public ceremonies. The altar from the Olmec site of La Venta, Mexico, in 4.30 shows a ruler emerging from a cave opening. He holds a rope that stretches around the back of the monument and wraps around the carved necks of several seated prisoners. All of the elements in the altar reflect important motifs in the creation mythology and belief systems of the Olmec. The cave is a point of access to the here and now from a previous world or an underworld. The carvings over the man's head indicate that the cave is a living being with eyes, nose, and teeth. This opening is like the jaws of the earth monster. The cave was considered the place of creation, like a womb, so when it is combined with the

4.30 Altar 4, La Venta, c. 800 BCE. Basalt, 59¹/4" high. Parque Museo La Venta, Villahermosa, Tabasco, Mexico

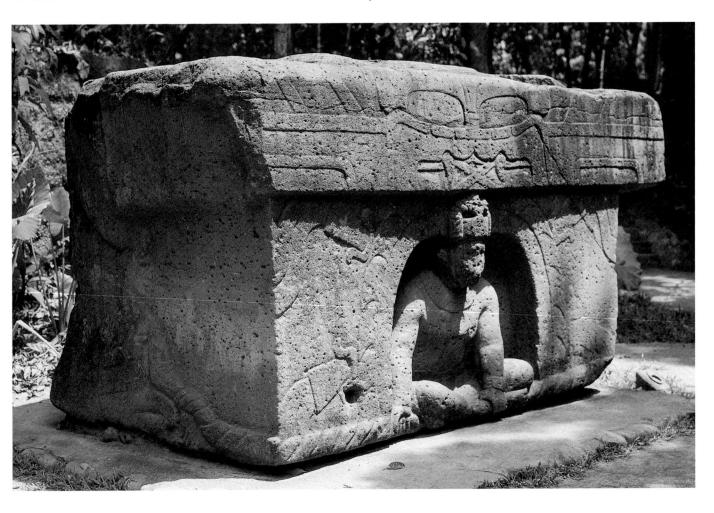

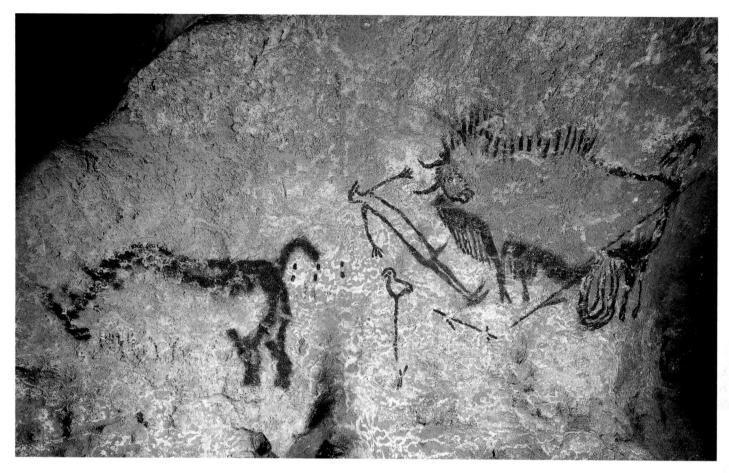

4.31 Rhinoceros. bird-headed man, and disemboweled bison. c. 15000-13000 BCE. Paint on limestone. Lascaux Caves, Dordogne, France

emerging figure it signifies the birth of man, as if all life originates from the ruler. The rope in his hand reveals that he also possesses the power to capture and control the prisoners who will be sacrificed in order to appease the gods and ensure continued prosperity for the entire community.

The spirit world and its impact on people have been conceived of in numerous ways even before written history began. The bird-headed man painted on a cave wall at Lascaux in southern France is a rare example of a human depicted during Paleolithic times (4.31). In this case, it may have been important to show a person in order to tell a specific story about the interaction between a man, a rhinoceros, and a bison. The figure seems to be lying down, suggesting that he has been killed by one of the beasts. Because the human has the head of a bird, he may represent a **shaman**, who acts as an intermediary between the invisible spirit world and the physical realm of humans. A shaman uses magic for healing or to control events. Wearing an animal or bird mask can

indicate that a shaman is in a trance-like state, when he or she becomes another being and brings divine properties to the community. In this painting, therefore, the human figure may be depicted with a bird's head to show that he is becoming a bird or a bird deity. Thus, this painting probably served a ritual or ceremonial function.

Sacred Places

We all have places that restore our souls. Whether it is the mountains, the beach, or the family dinner table, there are places that allow us to feel connected and at peace. Certain artworks represent places of personal retreat or communal worship as sites of reverence, renewal, and contemplation. By marking these sites and communicating these experiences, artists and architects give us a sense of their connectedness to nature, religion, or community (see Box: What Makes a Place Sacred?, pp. 478–9; and Gateway Box: Matisse, 4.37, pp. 482-3).

Baroque: European artistic and architectural style of the late sixteenth to early eighteenth centuries, characterized by extravagance and emotional intensity

Passion: the arrest, trial, and execution of Jesus Christ, and his sufferings during them

Paleolithic: prehistoric period, extending from 2.5 million to 12,000 years ago

Shaman: a priest or priestess regarded as having the ability to communicate directly with the spiritual world

What Makes a Place Sacred?

Places that people returned to again and again, like the prehistoric caves of Lascaux and the catacombs of Rome, were clearly important for their users. When such places, which had been created for memorial or religious purposes, were adorned with artworks, their sacred nature took on a new dimension.

The walls of the Lascaux Caves in southern France (4.32a) were painted sometime between 15000 and 13000 BCE. One section is densely packed with paintings of animals (4.32b). The effort required to adorn the walls of the caves with so many images suggests that these depictions of animals that were encountered on a daily basis were incredibly important. Some of the most magnificent paintings are contained in the Hall of the Bulls (4.32b) in the main cave, which is 66 feet wide and 16 feet high. The hall is located near the entrance to the system of caves, unlike the painting in 4.31 (see p. 477), which is in a remote part of the complex. The hall, as its name suggests, is decorated with outlines and realistic details of numerous bulls—one of them more than 15 feet long. The paintings in this area overlap, indicating that the site was visited repeatedly, that it was decorated over a period of time, and that making these paintings in this particular place was significant. They mark it as a location that was sacred in some way to the people who used it.

Because the makers of the paintings at Lascaux had no system of writing, we must deduce the stories of these images from the pictures themselves. In addition to telling a story, which was one likely purpose of the images, prehistoric cave paintings may also have been used to teach hunting and to represent shamanic or ritual practices (as suggested by the birdheaded man). Paintings similar to those at Lascaux have been found in other places in France and also in Spain, indicating that these paintings were part of a widespread cultural practice by people who either moved from place to place or shared ideas with others.

The human desire to paint important or sacred places is equally evident in the catacombs constructed outside the city of Rome, Italy, between the second and fourth centuries CE. An underground system of tunnels measuring between 60 and 90 miles in length and containing the ancient remains of 4 million people, the catacombs were sacred spaces for Romans, who held different religious beliefs and went there to visit their ancestors' burial places. While pagan Romans practiced both cremation and burial of the dead, burial was especially important for Jews and Christians. The catacombs were also used as temples for religious observances, a space where Christians could gather, and hiding places for fugitives.

4.32a Hall of the Bulls. Plan of Lascaux Caves, Dordogne, France

4.32b Hall of the Bulls. Pigment on limestone rock. Lascaux Caves

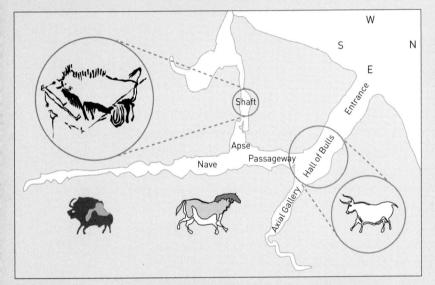

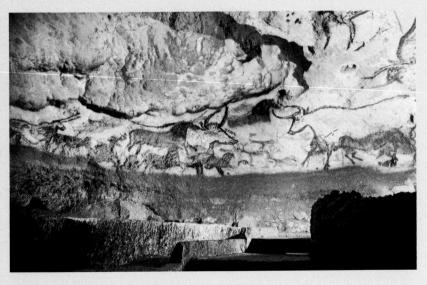

4.33a Plan and section (through main gallery of oldest region) of catacomb of Callixtus, 2nd century CE, Rome, Italy

4.33b Catacombs of Priscilla. 2nd and 3rd centuries CE, Via Salaria, Rome, Italy

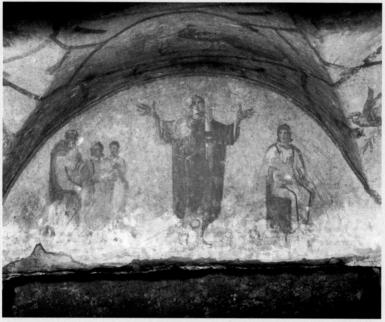

Like Lascaux, the catacombs contain paintings in different types of areas. In the catacombs, frescoes ornament both the places used for burial and the rooms in which people could congregate. The paintings consist of pagan, Jewish, and Christian scenes. Although the same imagery was seen by Romans of all three faiths, particular subjects, such as banquet scenes or shepherds, would be interpreted differently, according to the viewer's religion. For example,

the central figure in the Christian fresco from the catacombs of Priscilla is shown standing in a praying position (4.33b). Such a pose appears in pagan art, but it has a distinct meaning for Christians, who understand the figure to be praying to their god. Using imagery, such as this prayerful person, that was familiar to practitioners of other religions probably helped win potential converts to Christianity while also conveying a clear message to existing believers.

Prehistoric: dating from the period of human existence before the invention of writing Catacombs: an underground system of tunnels used for burying and commemorating the dead

Realistic: artistic style that aims to represent appearances as accurately as possible

Fresco: a technique where the artist paints onto freshly applied plaster. From the Italian fresco, fresh

A mosque is a building where Muslims gather to pray to Allah. Because mosques are often the largest structures in a city, they have also played a significant role in community activities when used as schools or hospitals. The Mosque of the Imam in Isfahan (present-day Iran) has four iwans, or vaulted entrances between the courtyard and the mosque's interior. Large towers (minarets) rise above the city to call citizens to prayer. Pointed arches, a characteristic feature of Islamic architecture, crown the mihrab, iwans, and decorative walkways throughout the mosque. In its central courtyard there is a large pool for cleansing before prayer. Muslims must pray five

4.34 Main entrance portal (iwan), Masjid-i-Shah, early 17th century, Isfahan, Iran

times a day facing the direction of the city of Mecca. A special prayer niche (mihrab), placed on the wall oriented toward Mecca (qibla wall) indicates the correct direction for worshipers' prayers.

The walls of the Mosque are decorated with the intricate blue tilework, calligraphic texts, and foliage designs commonly found in Islamic architecture. A fine example of complex Islamic geometric patterning can be seen in the honeycomb design of the muqarnas in one iwan entrance to the Mosque (4.34). The muqarnas (or stalactite vaults) are decorative elements originally used to cover the tombs of holy men. The shape of the muqarnas in the pointed vault resembles a series of small domes lined up in rows and stacked on top of one another. One description suggests that the muquarnas sanctify the space by symbolizing "the rotating dome of heaven."

Marking a site as sacred is a common practice in the long-standing Japanese religion called Shinto, which emphasizes the ways such natural elements as the sun, mountains, water, and trees are connected to well-being. Unlike Christianity and Islam, Shinto focuses on the here and now and reveres nature itself as a deity. For example, Shinto recognizes a mountain as a sacred object because it is the source of water for rice cultivation. Such a mountain was once worshiped directly, but over time shrines were built as places to worship a god, known as a Kami, that was important to a particular area or community. These sites, like the Grand Shrine of Ise, or Ise Jingu, started with small piles of stones in an area surrounded by stone enclosures, which have gradually evolved to include buildings, fences, and gates.

Ise Jingu is one of thousands of shrines throughout Japan dedicated to the sun goddess Amataerasu Omikami. Local residents visit the shrine to revere the goddess and seek her assistance. The site is now marked by a stately **A-framed** wooden building that is simple in design and made with natural materials (**4.35**). Because nature is cyclical, the shrine must also be renewed and refreshed. Since 690 CE, Ise Jingu has been rebuilt every twenty years with a special ceremony in which meals are shared with the *Kami*, infusing the everyday act of eating with ritual significance.

A-frame: an ancient form of structural support, made out of beams arranged so that the shape of the building resembles a capital letter A

Octagonal: eight-sided Abstract Expressionism: a mid-twentieth-century artistic style characterized by its capacity to convey intense emotions using non-representational images

4.35 Ise Jingu, site dates from 4th century CE, rebuilt 1993, Mie Prefecture, Japan

The Rothko Chapel in Houston, Texas, is a place of worship open to people of all beliefs (4.36). The chapel's octagonal interior walls hold fourteen paintings by the Russian-born American Abstract Expressionist painter Mark Rothko (1903-70). Rothko worked closely with the architects on the designs for the chapel. He

wanted his paintings to be hung a certain distance from the floor, presented in low lighting, and shown together in a group in order to create an environment that enveloped and transported viewers beyond their everyday experience. The canvases at the Rothko Chapel employ a restricted, dark palette of colors ranging from

4.36 Rothko Chapel, 1966-71, Menil Collection, Houston, Texas

Gateway to Art: Matisse, *Icarus* **Designs with Cutouts**

The French artist Henri Matisse (1869–1954) employed paper cutouts to create finished works of art, but he also used cutouts to plan works in other **media**. *Icarus* was designed as a cutout and produced as a **stencil** print in a book (4.38). Late in his career Matisse used cutouts to design the entire interior of a building.

In 1941, while recovering from surgery for intestinal cancer, Matisse was cared for by a

nurse named Monique Bourgeois. Bourgeois later became a nun and she asked Matisse to build a chapel for her convent in Vence, near the Mediterranean coast of France. Matisse agreed and worked on the Chapel of the Rosary from 1948 to 1951.

Matisse considered the Chapel of the Rosary to be his masterpiece (4.37). It combined the interests in form and color that had been developing throughout his entire career, and it

4.37 Chapel of the Rosary, Vence, Côte d'Azur, France. Plan devised by Henri Matisse, 1948–51

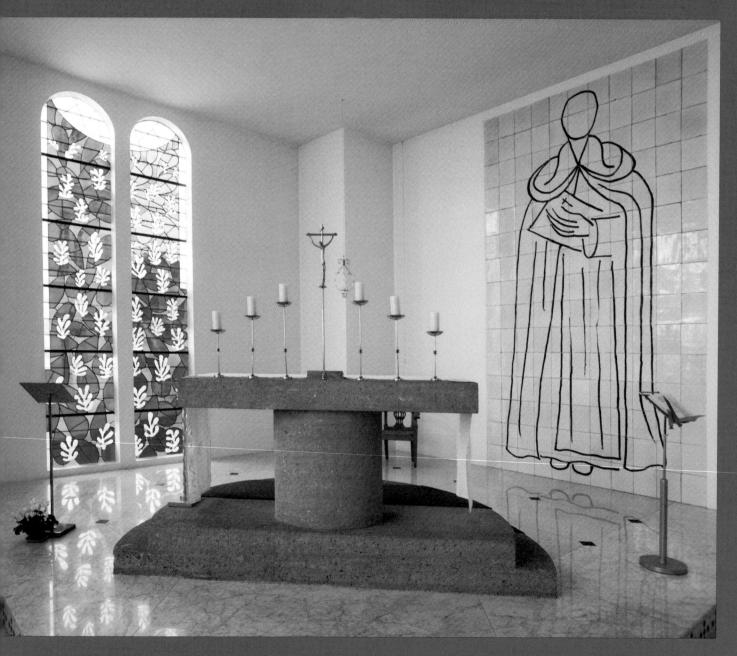

un moment di libres. ne devraited pas faire ac. complir un grand voyage en avion aux Jennes gens ayanttermine Ceurs études.

4.38 Henri Matisse, Icarus, from Jazz, 1943-7. Page size $16\% \times 12\%$ ". MOMA, New York

incorporated elements derived from his method of working with cutouts in order to emphasize graphic shapes and bold patterns. He designed all aspects of the project: the architecture of the building; its stained-glass windows; its interior decoration, including painted wall tiles; and its furniture. The interior of the space is bright, white, and serene. The Mediterranean light enters the chapel through three sets of stained-glass windows, which transform it into washes of bright color. Matisse designed these stunning windows to look like fluid drawings. Their appearance was inspired by his many years of emphasizing an economical use of color, as seen in his cutouts. Like Icarus, the chapel windows employ a limited color palette. While Icarus uses bold blue, yellow, red, and black, the stained glass has bright yellow and an intense blue (representing the sun and the sea) with a slightly more subdued green for tree and leaf forms.

Black contour drawings are printed on the otherwise pure white ceramic tiles that cover the walls. Designs include such natural forms as clouds, life studies of figures representing scenes from the Bible, and symbols related to the Christian faith. The furniture, designed to have clean lines and geometric shapes, includes an altar with a crucifix and candlesticks. The chapel brings together many of the essential aspects of Matisse's art: his selective use of light and color, his emphasis on bold shapes from the cutouts, and his love of drawing and sculpture.

maroon and plum to black. The fields of color are intense and powerful, creating a tranquil and contemplative atmosphere. The chapel marks a culmination in the artist's search for the simplest means to express universal truths that are spiritual in nature but unconnected to any particular religious experience or doctrine. The Rothko Chapel has become a sacred place for worship and religious services, a site for performances and scholarly lectures, and a space for visitors to contemplate while immersed in an experience that integrates Rothko's paintings with architecture.

Discussion Questions

- Find three works of art that deal with spirituality (in other chapters in this book, in your community, or any other examples that you know about). Into which category of works in this chapter do they fit? If they do not seem to fit any of these sections, how would you categorize them?
- 2 Review the sacred places covered in this chapter and then think of a building, public space, or sculpture that is important to you. Choose a place or artwork that you are comfortable discussing with others and that is personally significant and connected in deep ways to your sense of self. Describe it as fully as possible (the function of the space, what you do there, what it looks like, how you feel when you are there, whether other people have similar experiences there, and so on). Be sure to consider how your experience could best be shared with someone unfamiliar with your personal sacred space.
- In this chapter you have encountered some spaces that have been sacred to a large community and even to a global body of followers. Alone or in groups describe a sacred space with universal appeal, or invent and design one. Sacred spaces often harmonize with nature or feature geometric forms, and include sacred symbols. Will your space include any of these elements? Try to make your chosen space reflect feelings and/or physical attributes that are important to you.

Medium (plural media): the material on or from which an artist chooses to make a work of art

Stencil: a perforated template allowing ink or paint to pass through to print a design

Palette: the range of colors used by an artist

4.3

Art and the Cycle of Life

How strange is the lot of us mortals! Each of us is here for a brief sojourn; for what purpose he knows not, though he senses it. But without deeper reflection one knows from daily life that one exists for other people.

(Albert Einstein, physicist and Nobel Prize winner)

Human cultures from the earliest times to the twenty-first century have been deeply concerned with fundamental questions of existence: where do we come from? What happens when we die? What lies beyond death? These persistent concerns, not surprisingly, have also been a frequent subject of works of art.

In this chapter, we look at the ways in which artists have examined the cycle of life. Visual artists have dealt with topics as unfathomable as the beginning of human existence, as miraculous as the birth of a child, as enduring as natural forces or the passage of time, and as overwhelming as the finality of death. The artworks in this chapter suggest the enormous variety of ways in which artists have addressed these themes. The examination of life's mysteries takes the form of mythical visions, narrative accounts, and direct portrayals of life's beginnings, its endings, and what happens in between.

Life's Beginnings and **Family Ties**

Stories about the beginning of civilization and the creation of humankind are found

4.39 Ritual vessel, 13th-14th century. Terracotta, 97/8" high. University Art Museum, Obafemi Awolowo University, Ife, Nigeria

throughout history in cultures across the globe. Creation myths can help us come to grips with concepts that we may not understand intellectually, such as the fact of life itself. Equally important are stories that tell about the process of childbirth and emphasize how we are connected to our family members. Artworks with such subjects often reflect the beliefs of an entire community.

Many creation myths tell of separate realms inhabited by gods and people. A ritual vessel made by the Yoruba of West Africa displays many literal and metaphorical references to their culture's ideas

4.40 Tlazolteotl giving birth to the maize god, c. 1500. Aztec granite carving, $8 \times 4^{3}/_{4} \times 5^{7}/_{8}$ ". Dumbarton Oaks Museum, Washington, D.C.

about creation and the origins and authority of their kings (4.39). The vessel was made in Ife (now in Nigeria), a city sacred in Yoruba mythology. Ife was the "navel of the world," because it was believed to be the place where humans were created and kingship began. Yoruba kings still trace their ancestry to the first ruler of Ife. The top of the vessel in 4.39 refers to the navel as the central point of the body as well as an opening that connects the exterior to the interior. The vessel's round shape, which resembles a piece of fruit, a pregnant female, or perhaps the earth itself, further reinforces the biological connection with human birth. The snake-like form on the side of the vessel resembles an umbilical cord. The snake, which is associated with the earth, regeneration, and rebirth, is joined to the human figure shown in a rectangular house. Vessels like this one were ceremonially broken, allowing the offerings contained within them to flow into the earth and play a key role in the cycle of birth and rebirth.

For some cultures, such as the Aztecs of central Mexico, it was important to mark the physical, if still mystical, beginnings of human life. For the Aztecs, a woman giving birth was seen as a female warrior going to battle on behalf of the state. Women who died in childbirth were afforded the same respect as men who died on the battlefield; they resided in the same final resting place as heroes, accompanying the sun on its daily

journey through the sky. The goddess Tlazolteotl, an earth mother and patron of childbirth, was known as the "filth eater" because she visited people at the end of their lives and absolved, or ate, their sins. She was responsible for bringing disease as well as curing it. A stone sculpture of Tlazolteotl shows her in the act of giving birth (4.40). The grimace on her face resembles a skull, and a tiny figure, a miniature adult, emerges from her body. Female deities worshiped by the Aztecs, like Tlazlteotl, often had dual personalities. Not only were they acknowledged as life-givers, but they were also feared as powerful and terrifying.

While the Tlazolteotl sculpture shows a symbolic representation of childbirth, the Dutch artist Rineke Dijkstra (b. 1959) highlights some of the stark realities of birth in her Mothers series. *Julie* (4.41) captures a mother and her newborn baby just one hour after delivery, at a time and in a

4.41 Rineke Dijkstra, Julie, Den Haag, The Netherlands, February 29, 1994. C-print, $60^{1/4} \times 50^{3/4}$ "

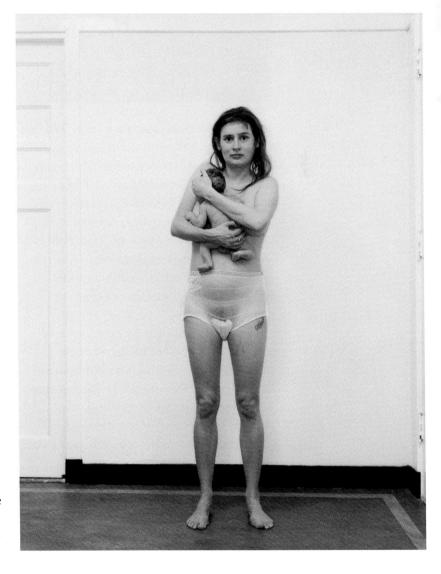

4.42 Tierney Gearon, *Untitled*, 2004. From the series *The Mother Project*. C-print

way that defies most expectations of mother-and-child imagery. They are standing against a cold, anonymous wall. Their position starkly exposes the vulnerability, even shock, that both mother and baby probably feel. Dijkstra makes public a time in a woman's life that is now generally considered private and personal. Inspired by watching the birth of a friend's baby, Dijkstra's photographs capture the awkwardness and enduring strength of the early moments of a new life.

Photographs taken by the American artist Tierney Gearon (b. 1963) of her own close relations also show unexpected views of family interactions. For this reason they have sometimes been controversial. Indeed, Gearon gained notoriety for a series of images showing her children nude and wearing masks. In the *Mother Project* series she shows her aging mother—sometimes nude and sometimes dressed in what look like costumes—either alone, or with Gearon and her children (4.42). According to the artist, this project was important because:

My mom is mentally ill, and a big part of it is how I celebrated my mom instead of being embarrassed or trying to hide from her. Instead, I celebrate the beauty in her and a lot of people—especially older people—are moved because it is something they can relate to.

Through these pictures Gearon portrays both her own experiences with her mother and the reality of her mother's life altered by age and illness.

The Asmat people live on the island of New Guinea in the southern Pacific Ocean. They trace their origins to the mythical figure called Fumeripits, who carved the first humans from wood and brought them to life by playing a drum. Woodcarving is thus an esteemed tradition amongst the Asmat, and sculptures are often made to represent and honor people who have recently died and the ancestors they are joining in the afterlife.

Ancestor poles known as bis (4.43) represent both stories about the cyclical nature of human

Inlay: substance embedded in another, contrasting material

4.43 Bis poles, late 1950s. Wood, paint, and fiber, $18' \times 3'6'' \times 5'3''$. Metropolitan Museum of Art, New York

life and the social and family ties that connect the community. The bis is carved with imagery associated with power, virility, and fertility, including strong bodies, horns used in headhunting, and trees where the spirits dwelled. At the top, a root from the tree has been retained, creating a wing-like projection. In the main section of the sculpture, there are representations both of the dead individual for whom the bis was made and also of other ancestors. The lower part of the sculpture, called the "canoe," is believed to carry the deceased into the afterlife.

Ancestor poles like this one were once made in connection with headhunting and warfare but now serve a ritual function for male initiation and memorial feasts. A profound bond exists between the figures the Asmat carve and the trees they come from, which are as important as the relationships between generations of

Sacrifice, Death, and Rebirth

ancestors. Once a sculpture has served its ritual

palms to decay and strengthen future harvests

function it is returned to the groves of sago

of the trees.

Art and ritual often mark different stages of life. Artists have recorded images of birth and death as ways to consider the fleeting existence of the life force that ultimately defies comprehension. While some artifacts refer to the ceremonies undertaken to ask ancestors or supernatural beings to ensure continued prosperity, others present the lifeless body itself. There are many questions, often unanswerable, that artists confront. What happens after we die? Do we leave the world of the living? Is it important for the body to stay intact? Is there a place to which the soul is believed to go? These concerns about life, death, and the afterlife have inspired artists for millennia.

For the Kongo people of the Democratic Republic of Congo (in Central Africa) an important connection between past and present exists in the reverence they show for their ancestors and the nature spirits that influence their lives. The rituals they perform are as crucial to their livelihood as the chores and tasks of daily life. A painted wooden sculpture made by the Kongo people shows a woman kneeling as she holds a bowl in one hand and supports a child with the other (4.44). This sculpture could be a simple representation of a routine daily event—a woman goes to collect water and takes her child with her—but the artist has given us clues that it has further significance. Her hairstyle and pose, as well as the objects she possesses, suggest the woman is performing a ceremonial function. She is kneeling to show respect to a person of higher social status, an ancestor or deity. The shiny **inlay** used for her eyes indicates

that she is in some sort of trance, perhaps

early 20th century. Wood, pigment, and glass, $21\frac{1}{2}$ × $10 \times 9^{1/2}$ ". Dallas Museum of Art, Texas

4.44 Kneeling female figure with bowl and child, late 19th/

4.45 Shiva Nataraja (Lord of the Dance), Chola Period, 11th century. Bronze, 43⁷/s" high. Cleveland Museum of Art, Ohio

in contact with a god. The bowl and the child may be gifts bestowed by the god, or they may represent sacrifices the woman is prepared to make. For the Kongo people, white paint (as has been used on this sculpture) identifies nature spirits, who are associated with the ancestors. This woman thus provides a role model for the living members of the community: they are to honor their ancestors with gifts of sustenance and with children who will continue the traditions they have worked so hard to establish.

In India, connections between the present life and those before and after it are central to the Hindu belief system. One of the principal Hindu deities, Shiva, embodies a balancing of contradictory qualities: half-male and half-female, benevolent and fearsome, giver and taker of life. As Nataraja, or "Lord of the Dance" (4.45), Shiva is responsible for dancing the world into existence and bringing to life the endless cycle of death and rebirth, known as *samsara*, in which Hindus believe. The flames surrounding Shiva's agile form represent the periodic chaos and

destruction that happen when the dance ceases. During these periods of inactivity, the fire cleanses the physical world by providing a release from *samsara*. Shiva dances while poised on top of a dwarf who represents the evil and ignorance that are stamped out during the dances. Shiva's dance creates a balance between creation and destruction that, over the course of time, manifests itself in the cycle of life.

For the Inca of South America, the deceased were believed to continue to exist in a separate reality that was parallel with the living human world. As a result, spirits could inform the life of the living and ancestors could be consulted after death. The Inca sacrificed human beings to ensure prosperity for the community, to appease the gods, and to achieve balance among natural forces. For them, sacrifice was a sacred act in which something precious was given up in order to gain something else. A number of mummified children have been found on high mountain peaks throughout the Inca territory. These children, who usually came from wealthy or noble families, were adorned with fine tapestries, jewelry, and feather work, and were accompanied

4.46 Mummy of a boy, c. 1500. Museo Nacional de Historia Natural, Santiago, Chile

Renaissance: a period of cultural and artistic change in Europe from the fourteenth to the seventeenth century

the seventeenth century

Foreshortening: a perspective
technique that depicts a form at
a very oblique (often dramatic)
angle to the viewer in order to
show depth in space

by several specific objects. One mummy, a boy of about nine years old found at Cerro el Plomo in Chile, appears still to be sleeping (4.46).

Children were selected for these sacrifices because they were innocent and considered near perfection. It was a great honor to be one of these sacrificial victims. The Cerro el Plomo mummy was preserved along with a feather bag containing coca leaves, a silver figurine with an elaborate featherwork headdress wrapped in textiles, and several llama figurines. After a prolonged series of rituals, the child would have been given a strong drink called *chicha* (corn beer), fallen into an intoxicated slumber, and passed on into the afterlife. As a result of the mummifying effects of the freezing temperatures and dry climate, this child's body has been preserved, achieving a kind of immortality that matches the Inca conception of the spirit living on.

Another way in which artists have pondered what happens after a person dies is by creating images of the deceased. Christian artists during the **Renaissance** often made pictures of the body of Christ after his crucifixion. Such images were important because Christ was thought to live on after the demise of his physical body, and the concept of eternal life after death is at the core of Christianity. The artist Andrea Mantegna (c. 1431–1506), who was born near Padua in northern Italy, created a direct and intimate view of the body in Dead Christ (4.47). Because Mantegna has **foreshortened** the scene, we are first confronted by the stigmata (the wounds from the nails with which Christ was hung on the cross) in his feet and, further into the picture, in his hands. His body, covered in carefully depicted drapery, extends away from us on a marble slab. Beyond the muscular torso, we see his lifeless face. By Christ's side are the Virgin Mother and Mary Magdalene, who are mostly cropped out of the picture. While their grief adds to the atmosphere of the scene, the artist focuses our attention on the immediacy of Christ's body and the fact that he is no longer alive.

Perhaps because we are somewhat detached from death, or perhaps out of a sense of propriety, contemporary images of the deceased are not as common as they were during the Renaissance. Photographs of the dead can be especially shocking because today we no longer have such a

direct relationship with the dead as people did in the past. Then, loved ones died at home, not in hospitals; bodies were laid out for burial by family members, not by funeral homes. The American artist Andres Serrano (b. 1950) made a series of photographs in a morgue in which the subjects are identified only by the manner of their deaths. The composition of *The Morgue (Gun Murder)* (4.48), with the feet pointing away from the

4.47 Andrea Mantegna, Dead Christ, c. 1500. Tempera on canvas, $26^{3}/_{4} \times 31^{7}/_{8}$ ". Pinoteca di Brera, Milan, Italy

viewer, is the opposite of Mantegna's Dead Christ. The dark background, the white bandages and body bag, and the strong lighting create a sense of drama and contrast. The formal beauty of the image itself contradicts the shocking reality that this person, whose identity we will never know, was murdered. As Serrano's photograph demonstrates, art can often challenge us intellectually. Even if we do not find the imagery pleasant, it can convey a powerful message and provide us with a deeper understanding of difficult subjects.

4.49 Sarcophagus lid, tomb of Lord Pacal (Shield 2), Temple of the Inscriptions, Palengue, Mexico, c. 680

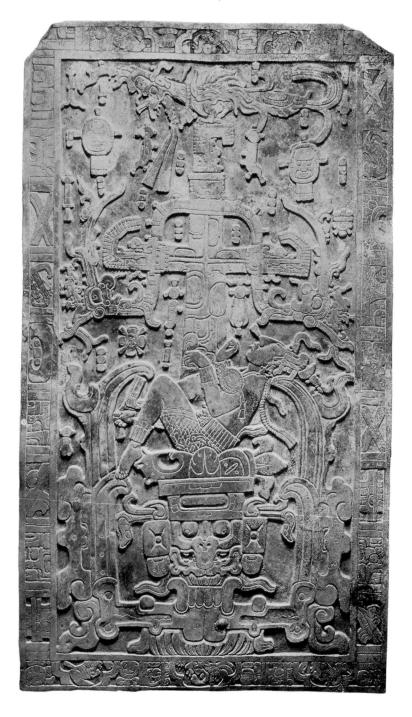

Life, death, and the afterlife are inseparably connected in many religions and belief systems. A tomb lid made for Pacal, the seventh-century ruler of the Maya city-state of Palenque in southern Mexico, illustrates the king's integral role in the cycle of life (4.49). The elaborate scene, carved in low relief, shows Pacal reclining on a slab that marks the intersection of the earthly realm and the underworld. Just beneath Pacal is the face of the setting sun, representing death. From Pacal's navel sprouts the world tree, which connects the three cosmic realms: its roots are in the underworld, its trunk is in the earthly world, and its branches are in the sky. The ruler himself serves a similar purpose. By carrying on the lineage of his ancestors, he ensures sustenance and productivity for his people and provides a connection with the gods.

The Power of Nature

Artists have long been fascinated by the power of nature to benefit or harm humankind. Many cultures believe that natural events are caused by gods. The authority that the gods possess can explain everything from the movements of the sun and moon to the absence or presence of life-giving rain. Personifying natural forces, as artists often do in stories and images, makes them more accessible and memorable.

For the Hopi of the southwestern United States, kachinas are supernatural spirits that personify events and natural elements. The phenomena represented by kachinas include the solstices (the longest and the shortest days of the year, which marked the beginning of a new stage in the seasonal ritual cycle), patterns of stars (constellations), plants, and animals. During the planting season, masked dancers embody the kachinas in annual festivals dedicated to rain, fertility, and good hunting. Dolls associated with these spirits are also made. Originally they were intended to teach the Hopi about the nature deities; over time, they were also sold to tourists. The kachina doll shown in **4.50** represents the Jemez kachina, which appears near the end of the season when the kachinas are about to leave the steep-sided, elevated plateaus known as

4.50 Hopi kachina doll, c. 1925. Wood, feathers, and pigment, 251/4" high. Gustav Heye Center, New York (National Museum of the American Indian)

mesas, where the Hopi lived, for six months. The elaborate headdress on the Jemez kachina contains cloud symbols, denoting its effectiveness in bringing rain, and it carries a rattle in one hand and a sprig of Douglas fir (here represented by a feather) in the other. As the first kachina to bring

mature corn to the Hopi, this figure helps ensure a successful corn crop.

Because rain is essential to sustain life, rain gods were important to the ancient Mexicans. For many groups in central Mexico, such as the Aztecs, their rain god is known as Tlaloc. Also associated with the earth's fertility, Tlaloc is represented by the colors blue and white and by the symbols for raindrops and water plants. A large ceramic vessel representing Tlaloc, which was found at the Templo Mayor in the Aztec city of Tenochtitlan (under present-day Mexico City), exhibits the god's most prominent characteristics: goggle-like circles around his eyes as well as snake-like fangs (4.51). In Mexico's dry climate, the crops depend on seasonal rains. If there

4.51 Vessel with mask of Tlaloc, c. 1440-69. Fired clay and paint, $13^{3}/_{4} \times 14 \times 12^{3}/_{8}$ ". Museo del Templo Mayor, Mexico City, Mexico

Low relief: carving in which the design stands out only slightly from the background surface

4.52 Gustave Courbet, Fox in the Snow, 1860. Oil on canvas, 33½ × 50". Dallas Museum of Art. Texas

was no rain, people went hungry, so the Aztecs were careful to keep Tlaloc happy. It is likely that offerings were made during ceremonies in which this vessel was used in order to prevent droughts and ensure that rain would nourish the Aztec crops.

The French artist Gustave Courbet (1819–77) painted a very different representation of the violent forces of nature (4.52). Courbet shows an ordinary moment in the wilderness when one life is given for the sake of another. A red fox is devouring a rat that it caught on a snowy day. Courbet was renowned for his ability to render realistic details: he depicts the fluff of the fox's coat, the coarseness of the rocks, the delicacy of the snow on the grasses, and the intensity of the rat's blood. By choosing this subject, Courbet has captured a moment that emphasizes the fleeting quality of life, in which tomorrow the fox could very well be the hunted instead of the hunter.

Judgment

As we live our lives, our choices determine the impact we will have and how we will be perceived. In many belief systems, the moral implications of our decisions have lasting consequences. As a result, the act of judging a life before the deceased is allowed to pass into the afterlife has been the theme of numerous artworks.

In ancient Egypt, the deceased were buried with a set of belongings that reflected their position in life (see Gateway Box: The Great Pyramid of Khufu). One of the most important of these possessions was a book of the dead, a scroll with spells and incantations designed to help the deceased navigate the passage into the afterlife. As we can see in the book of the dead that belonged to a scribe named Hunefer, who lived over 3,000 years ago, a successful journey required proof that one had lived an honorable life and that proper respect had been paid to the gods (4.53).

At the top of the scroll, Hunefer pleads his case to the forty-two judges of the dead, represented here by just fourteen mummified deities because the artist did not have room to show them all. In the bottom panel, Hunefer is escorted by Anubis (the jackal-headed god associated with mummification and the afterlife) to the scales where his soul will be weighed.

4.53 Book of the Dead: Last Judgment before Osiris, c. 1275 BCE. Painted papyrus, 153%" high. British Museum, London, England

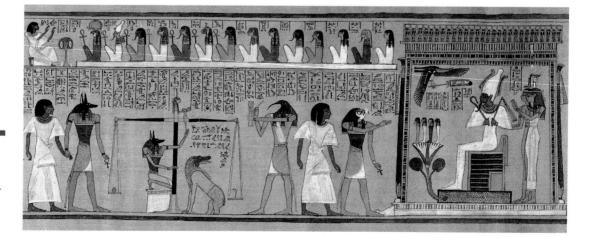

Pyramid: ancient structure, usually massive in scale, consisting of a square base with four sides that meet at a point or apex with each side forming a triangular shape

Gateway to Art: The Great Pyramid of Khufu Mathematical and Astronomical Alignments of the Pyramids

The ancient Egyptians' beliefs about the cycles of life and death grew out of their daily experiences. For example, their work habits were controlled by the cycles of the Nile. Its annual flooding followed the harvesting of the crops, which were able to grow because of the previous year's inundation by the river. The Egyptians, believing that people lived forever after death, spent much of their time on earth preparing for the afterlife. They saw the building of the Great Pyramids, which were tombs for pharaohs, as integral to the cycle of life.

The pyramids built by the ancient Egyptians on the Giza plateau around 2500 BCE are among the most impressive structures in the world (4.54). Although the geometric shape of the pyramid appears simple, complicated mathematical calculations and astronomical knowledge went into the making of the complex at Giza. The base of each pyramid is oriented so that the four triangular sides align with the four cardinal directions. Alignments with such celestial bodies as planets and stars have also been noted. Perhaps the most interesting proposition is that the location and size of the three pyramids exactly mimicked the arrangement of the stars in the "belt" of the constellation Orion (4.55). After their deaths, the Pharaohs Khafre, Khufu, and Menkaure, who were buried in the pyramids, were believed to take their places as immortal beings in the star that corresponded with each tomb. It seems that the ancient Egyptians believed in a profound connection between life on earth, a resting place for the deceased, and an afterlife in the night sky.

4.54 (top right) Great Pyramid of Khufu, c. 2560 BCE, Giza, Egypt

4.55 (right) Diagram illustrating the proposition that the location and size of the three pyramids exactly mimicked the arrangement of the stars in the "belt" of the constellation Orion

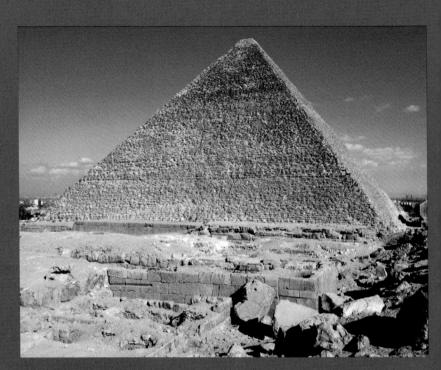

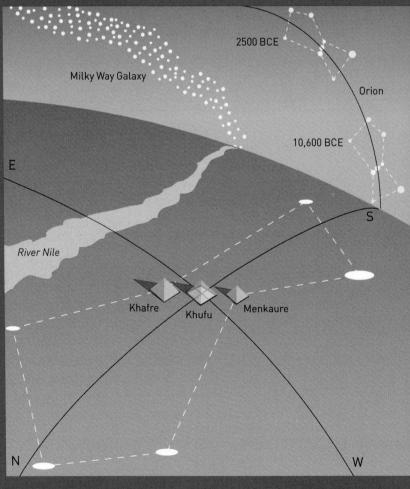

As Ammit ("Eater of the Dead," with the head of a crocodile, mane and forequarters of a lion, and hindquarters of a hippopotamus) anxiously looks on, Anubis determines that Hunefer's soul, in the form of his heart in a **canopic jar**, is lighter than the ostrich feather it is weighed against. Having been proven worthy, Hunefer is presented by Horus (falcon-headed god of the sun, sky, and war) to Osiris (god of goodness, vegetation, and death), who is seated on his throne. This book of the dead was placed in Hunefer's coffin with the hope that its script would be followed and he would successfully gain immortality in the afterlife.

In twelfth-century Europe, depictions of the Last Judgment took on an ominous tone in scenes showing the fate of the blessed and the damned side by side. In **4.57**, the **lintel**

4.56 (right) Detail from Gislebertus, Last Judgment

4.57 (below) Gislebertus, *Last Judgment*, *c.* 1120–35. Tympanum from West Portal, Cathedral of Saint-Lazare, Autun, France

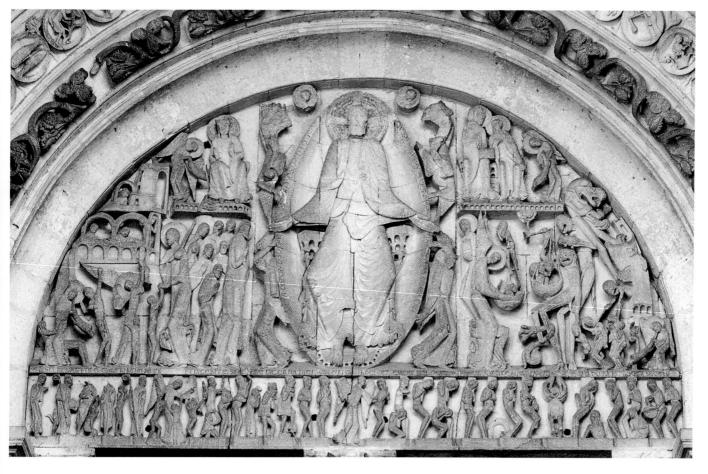

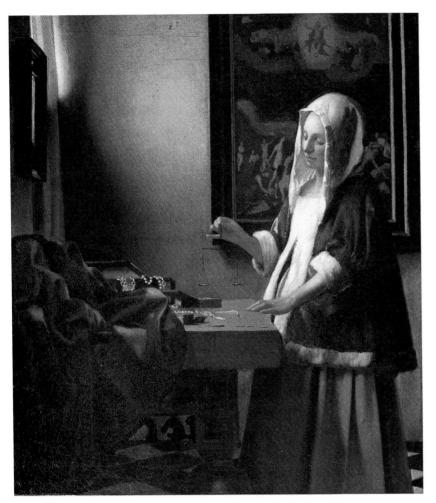

4.58 Johannes Vermeer, Woman Holding a Balance, c. 1664. Oil on canvas, $16^{3}/_{4} \times$ 16". National Gallery of Art, Washington, D.C.

Canopic jar: a jar used by ancient Egyptians to hold the embalmed internal organs removed from the body during mummification

Lintel: the horizontal beam over the doorway of a portal

Tympanum: an arched recess above a doorway, often decorated with carvings

Baroque: European artistic and architectural style of the late sixteenth to early eighteenth centuries, characterized by extravagance and emotional intensity

underneath the main panel contains a row of figures awaiting judgment. A pair of hands comes down from above to gather the sixth figure from the right for his weighing. In the center of the carved **tympanum** Christ is shown as larger than all the rest of the figures, indicating his key role in the judgment of humankind. On his right (our left) are the angels and the souls of the blessed who will go on to live out eternity in heaven. Their bodies are smooth, elegant, and peaceful. On Christ's left are the scales in which souls are weighed, and the ravaged bodies of the damned. Their horrid, grotesque appearance was meant to send a strong message to churchgoers about the consequences of living a sinful life and give them a glimpse of the misery that an afterlife in hell would hold.

The Dutch **Baroque**-era painter Johannes Vermeer (1632-75) subtly includes religion in a scene from everyday life in his Woman Holding a Balance (4.58). As was common at the time,

Vermeer focuses on an ordinary moment, in which the woman is standing at a table by a window near her open jewelry boxes. The painting on the wall behind her provides a symbolic backdrop for her actions. It shows the Last Judgment, with Christ in the sky above and the souls to be judged below, and serves as a reminder that life is short and that it is important to be honest and decent. The scales the woman holds are empty, but perfectly balanced, suggesting that one's actions rather than one's possessions are the true indication of a person's worth.

Discussion Questions

- Choose two artworks from this chapter that fit one of the following criteria: (1) one that depicts a human and one that depicts a mythical being; (2) one personal and one communal; (3) one about birth and one about death. Compare and contrast what the artworks look like and what they are communicating and note at least three points of comparison and contrast. What does this comparison reveal to you about the artworks that you had not considered before?
- Find several artworks in this chapter or elsewhere in this book (for example, 2.2, 2.218, 3.76, 3.93, 4.47, 4.49, 4.52) from the same cultural tradition that deal with the theme of the cycle of life. What do your chosen artworks have in common? In what ways are they similar? What do they tell you about your chosen culture's attitudes to life and death?
- 3 Many artworks that deal with the cycle of life are full of symbolic meanings, chosen to make the work memorable. Find two works in this chapter that use symbols in this way and discuss what they hope to communicate to their audience. Then think of an event in your life that could be represented by symbols. What things (colors, scents, feelings) stand out most in your mind? Finally, translate your own personal myth into a picture that can visually communicate the event's importance to others.

4.4

Art and Science

Customarily, we consider science and art to be separate disciplines, even complete opposites. We tend to think of art as intuitive and emotional, and science as rational and objective. But this has not always been the case. In fact, numerous artists in history actively engaged in the scientific questions of their day. The great **Renaissance** artist Leonardo da Vinci (1452–1519), for example, was not only a painter, but an engineer, anatomist, botanist, and mapmaker. Art and science interact more often than we might suppose.

Like scientists, artists are keen observers of phenomena and events. Often, artworks contain scientific knowledge and ideas. Sometimes, artworks openly celebrate scientific advancements, and some artists have even used scientific methods to make art. The appreciation of art relies, of course, on the human senses, and artists have always been particularly keen on manipulating the perception of the viewer of artworks. This has involved some artists in the science of **psychology** and the **physiology** of perception as well.

Astronomical Knowledge in Art

For millennia, the regular yet ever-changing night sky was a source of endless fascination and study. We know, for example, that in the Middle East, navigation guides called astrolabes, which tracked the skies and the planets, were in use by 500 CE. In another part of the world, in ancient Mexico, amongst the Maya and Aztecs, the planets were

regarded as gods, and their movements were closely monitored. Some of the most fascinating artworks of the Maya and Aztecs reflect this interest in astronomy. Careful astronomical observation enabled these people to create remarkably precise calendars.

The **flint** in **4.59** incorporates elements of the cosmology (beliefs about the origin of the world) and astronomical knowledge of the Maya. The delicate carving of this very hard stone reveals a high level of craftsmanship. Light enough to be held in one hand, the flint depicts the story of creation, said by the Maya to have occurred precisely on August 13, 3114 BCE, when the First Father was sacrificed after losing a ball game against the Lords of Death. The First Father's soul is seen riding a crocodile to the Maya underworld (called the Place of Creation, ruled by a watermonster god) accompanied by other Maya lords. The **profiles** of the First Father and two of the lords appear on top of the crocodile, leaning back to suggest the speed of the journey. Two additional figures are shown facing downward toward the underside of the crocodile. The serrated edge on the bottom of the flint represents the forceful waves encountered on the journey. The moment shown here is the transformation of the crocodile into a sacred canoe just before it dives into the rough waters, signifying the death of the First Father. Soon thereafter, the First Father will rise from the waters, transform into the maize god, and become the creator of humans.

The flint, however, is more than a depiction of a Maya story; it is also an instrument for

Renaissance: a period of cultural and artistic change in Europe from the fourteenth to the seventeenth century

Psychology: a science that studies the nature, development, and operation of the human

Physiology: a science that studies the workings of the body and its organs

Flint: an object or tool made from the very hard, sharp-edged stone of the same name **Profile:** the outline of an object,

especially a face or head, represented from the side

4.59 Flint depicting a crocodile canoe with passengers, 600-900 cE. $9^{3}/_{4} \times 16^{1}/_{4} \times ^{3}/_{4}$ ". Dallas Museum of Art, Texas

astronomical observations. When held up to the sky on August 13 each year, the five heads on this flint align with the brightest stars of the Milky Way galaxy. For the Maya, the stars reenact the story of man's creation when, at midnight, the stars of the Milky Way align horizontally east to west. In the next several hours, the galaxy appears

to pivot and fall out of the sky, resembling a canoe diving into water. Then, immediately before the sunrise, the three stars of Orion's belt appear, symbolizing for the Maya the three hearthstones at the site of the First Father's rebirth.

Like the Maya, the Aztecs were skillful observers of the skies. The Aztec Sun Stone in 4.60 is a store of astronomical and mathematical knowledge. Originally painted in shades of brown, red, white, blue, and green, the heavy Sun Stone (weighing 24 tons) stood atop the main temple at Tenochtitlan, the capital of the Aztec empire. Later it was buried, to be uncovered again only in 1790 in what is now downtown Mexico City.

The Sun Stone, also known as a calendar stone, reveals how the Aztecs counted time, and illustrates their belief that the earth endures recurring cycles of destruction and creation. The center of the stone shows the face of Tonatiuh, the sun god to whom Aztecs offered frequent human and animal sacrifices. Each of the four squares emanating from Tonatiuh's face frames a symbol representing the ways in which the earth previously came to an end: by wind, by fire, by floods, and by wild beasts. The Aztecs

4.60 Calendar stone (Sun Stone), late postclassic. Basalt, 12' diameter. National Museum of Anthropology. Mexico City, Mexico

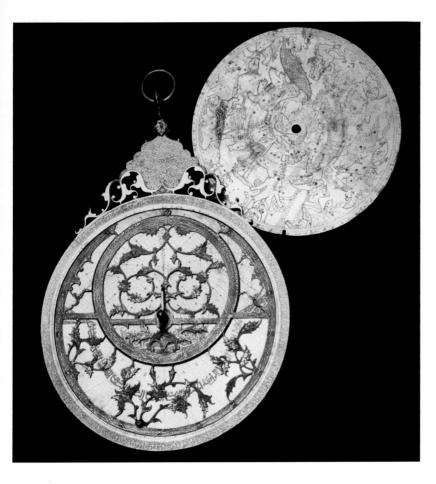

4.61 Muhammad Mahdi al-Yazdi, Astrolabe, 1659-60. Gilt brass, silvered brass, brass, and glass, 73/8" diameter. National Maritime Museum, London, England

Latitude: a point on the earth's circumference measured to the east or west

Tracery: a complex but delicate pattern of interwoven lines Enlightenment: an intellectual movement in eighteenthcentury Europe that argued for science, reason, and individualism, and against tradition

Tenebrism: dramatic use of intense darkness and light to heighten the impact of a painting

Realism: nineteenth-century artistic style that aimed to depict nature and everyday subjects in an unidealized manner

believed that the earth would be destroyed again by an earthquake. In the ring surrounding these symbols are twenty animals, each framed by a rectangle. These represent the days of the Aztec month. Priests used the calendar stone to determine sacrificial periods.

Used as guides for navigation, astrolabes were made as early as the fifth century CE in the Middle East, and by 800 they had become extremely common in the Islamic world. During the early twelfth century, the technology spread to Europe via Muslims living in Spain. The astrolabe was especially useful to Muslims, who were required to pray while facing toward the city of Mecca five times a day; the astrolabe could find the direction of Mecca as well as calculate the time of day.

An astrolabe is made up of layers of disks or plates that fit into a larger brass dial called a mater. Each of the five plates in the example in **4.61** is aligned to a different **latitude**. On the very top is a smaller disk called a rete, which has been cut out almost completely and on which the positions of heavenly bodies are indicated.

The brass astrolabe shown here is an example of fine metalwork. It was made during the seventeenth century in the Safavid Empire, in what is now Iran. Floral decorations serve as the pointers on the rete. The astrolabe is covered with Persian and Arabic inscriptions. For example, on the outside edge, there are verses about fourteen important Islamic figures. On the rete, there is a series of verses that describe the parts of the astrolabe metaphorically. The **tracery** around the mater contains a dedication inscribed to a Safavid leader. And on the back of the instrument, there is an inscription by the astrolabe's maker dedicating himself to God.

Art Celebrating Science

While art can be used to decorate scientific instruments, many artists have also observed science in action and recorded their studies in works of art.

The English painter Joseph Wright of Derby (1734–97) was friendly with members of the Lunar Society, an informal club of scientists, intellectuals, and manufacturers who met monthly to discuss developments in science and technology. Wright lived during the period known as the

Enlightenment, a time of intense interest in science and reason. He often painted scientific and industrial subjects, employing a notably dramatic use of light and dark, called **tenebrism**.

His painting An Experiment on a Bird in the Air Pump shows a traveling scientist demonstrating the creation of a vacuum before an audience (4.62). If the scientist removes all the air from the glass container in which a bird is imprisoned, the bird will suffocate and die a dreadful death. The artist has chosen to depict the climactic moment of truth. He has increased the drama by his use of shadows and light, which highlights reactions of concern and indifference, contempt and resignation, pity and fear. Strong light from behind the glass (which contains a skull) in the center of the table shines on the faces of the observers. While light is a symbol of knowledge, the scientist's outward gaze involves us, the viewers of the painting, in the moment's moral dilemma as well. We feel a strong desire to stop the experiment and prevent the bird from suffocating.

4.62 Joseph Wright of Derby, An Experiment on a Bird in the Air Pump, 1768. Oil on canvas, 6 × 8'. National Gallery, London, England

4.63 Thomas Eakins,
Portrait of Dr. Samuel D.
Gross (The Gross Clinic),
1875. Oil on canvas, 8' × 6'6".
Philadelphia Museum of Art
and Pennsylvania Academy
of Fine Arts

Artists study anatomy to learn how to depict figures, and many artists have become interested in dissection and medical procedures. The American painter Thomas Eakins (1844–1916) depicted a demonstration he witnessed by a famous surgeon, Dr. Samuel Gross, in Philadelphia (4.63). Assistants surround the body while the white-haired doctor lectures to medical students, dimly lit in the seating in the background. Eakins's detailed observation of the procedure created such a brutally **realist** depiction that a critic for the *New York Daily Tribune* commented,

It is a picture that even strong men find it difficult to look at long, if they can look at it at all.

Eakins's meticulous detail makes his painting a useful historical document of early surgical procedure. For instance, he shows us the use of anesthesia (the anesthetist holds a white cloth over the patient's face), a recent invention that had made such surgery as this possible. The artist was not however satisfied with mere accuracy; he also wanted to give his painting emotional impact. The lighting is not typical of an operating room, but

instead is highly theatrical. Eakins also includes the patient's distraught mother, seen on the left, who in reality was probably not present at the surgery.

Using Science to Create Art

Advancements in science enable artists to create new kinds of art. The advent of the microscope, for example, has enabled one artist to create minuscule artworks, while medical studies have enabled a scientist to preserve bodies and exhibit them as art.

The British artist Willard Wigan (b. 1957) has created the smallest sculptures in the world. His artwork is only possible because he uses a microscope: his creations can barely be seen by the naked eye. He carves individual pieces of sand or grains of rice and places them on equally tiny bases, such as the head of a pin or a strand of human hair. The Statue of Liberty in **4.64** was re-created inside the eye of a needle. Wigan then paints his artworks using an eyelash for a brush. To create one of these microscopic works, Wigan

puts himself into a very calm state of mind, which slows his heartbeat and decreases hand tremors: "I need to work between heartbeats, or else the pulse in my finger will cause a mistake," he says. He works through the night so that daylight activity, such as cars frequently driving by, will not disturb his steady hand. Wigan found that the intense concentration required for this sculpting helped him come to terms with his difficulties as a dyslexic child. As he recalled:

I became obsessed with making more and more tiny things. I think I was trying to find a way of compensating for my embarrassment at having learning difficulties: people had made me feel small so I wanted to show them how significant small could be.

A German medical scientist, Gunther von Hagens (b. 1945), used his knowledge of anatomy and science to develop a technique, called plastination, that preserves bodies after death and allows them to be arranged in poses. His popular traveling exhibition, Body Worlds, has been seen 4.65 Basketball Player, 2002. by millions of people, many of whom consider it Gunther von Hagens's Body Worlds exhibition. to be art. The exhibition, however, has been www.bodyworlds.com controversial. Although all the bodies featured in it are those of willing donors, many people consider the display irreverent, and complain about the overly theatrical poses of the bodies as well as the fact

4.64 (left) Willard Wigan, Statue of Liberty

that the shows are often promoted as art, rather than science.

One specimen, Basketball Player, is posed as if dribbling a ball down the court (4.65). The skull has been split so that we can see the brain. This dramatic presentation allows us to see the tension of the inner body and to understand better how we ourselves move. The Body Worlds exhibition also includes a body with the damaged lungs of a smoker, and a pregnant woman with her deceased fetus still in her body.

The Science of Perception and the Senses

Since art is a visual medium, artists expect viewers to respond to the artwork through their sense of sight. It is not surprising, therefore, that artists have often been keenly aware of scientific studies of visual perception. Some artists,

however, have also experimented with ways to use their images to trigger responses from the other senses, such as hearing or smell.

Sunday on La Grande Jatte (4.66) is a picture of people engaged in the activities of everyday life. But its artist, the Frenchman Georges Seurat (1859–91), also applied to this artwork recent scientific studies on the way that the human eye perceives color. Seurat developed a process called pointillism, a meticulous way of applying color **theory** in his paintings. He relied on two optical effects (**optical mixture** and **afterimage effect**) to create scenes in which the figures are very distinct, almost like cutouts, because of the precise way in which he applied tiny dots of color to the canvas. The colors we see when we view Sunday on La Grande Jatte from several feet away are quite different from the colors we see up close. For example, the green grass is made up of dots not only of various shades of green but also of oranges and purples. Seurat took three years to paint this work, meticulously applying dots while

Pointillism: a late nineteenthcentury painting style using short strokes or points of differing colors that optically combine to form new perceived colors

Color theory: the understanding of how colors relate to each other, especially when mixed or placed near one another

Optical mixture: when the eye blends two colors that are placed near each other, creating a new color

Afterimage effect: when the eve sees the complementary color of something that the viewer has spent an extended time viewing (also known as successive contrasts)

4.66 Georges Seurat, Sunday on La Grande Jatte, 1884-6. Oil on canvas, $6'9^{3}/4" \times 10'^{1}/4"$. Art Institute of Chicago

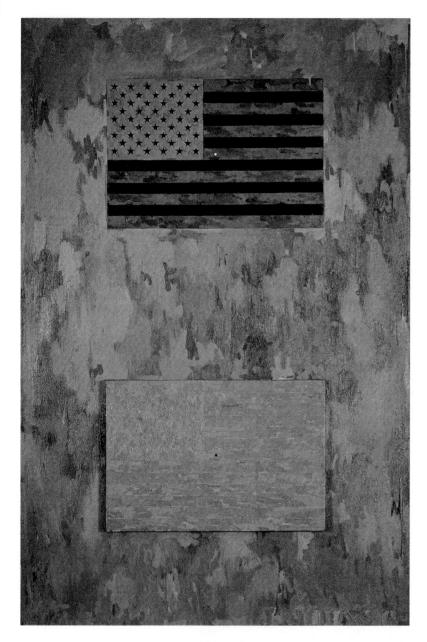

4.67 Jasper Johns, *Flag*, 1965. Private collection

considering the effects of color theory on his **palette** choices. To ensure that the optical arrangement would not be disrupted when the painting was framed, Seurat also painted a border using the same pointillist technique.

The American artist Jasper Johns (b. 1930) makes us take a second look at familiar subjects, objects the artist says are "seen but not looked at." He uses iconic images such as numbers, letters, targets, and, perhaps most famously, the American flag, of which he painted several versions. In the version of Flag reproduced here, Johns uses his knowledge of color theory to create an optical illusion that forces a viewer to stare intently at an image of the flag (4.67). The top flag is made up of black and green stripes, while black stars are placed on a background of orange; these colors are **complementary** to the white, red, and blue colors of the American flag. Johns's optical effect depends on the use of these complementary colors. The rectangle on the bottom half of the painting is just a faded ghost of a flag. For the optical illusion to work, stare at the top flag for a full minute. Focus your attention on the white dot in the center. After a minute has passed, blink and look at the black dot in the center of the lower flag. The red, white, and blue of the American flag will appear. Johns is utilizing the science behind afterimage effect. While looking at the top flag, your eyes became fatigued from the colors. Therefore, when you blinked your eyes and looked at the lower flag, your eyes produced the complementary colors of each aspect of the upper flag.

4.68 Marcia Smilack, *Cello Music*, 1992. Photograph, 12³/₄ × 24". Collection of the artist

At times, artists often try to trigger other senses in addition to sight. The process whereby stimulation in one sense causes experiences in a different sense—such as visualizing color when we hear music—is called **synesthesia**. The artist Marcia Smilack (b. 1949) experiences life as a synesthete, and creates artworks that reflect this correspondence between the senses. She describes her experience:

The way I taught myself photography is to shoot when I hear a chord of color... I hear with my eyes and see with my ears.

Of the photograph Cello Music (4.68), Smilack says:

I walked by the water and heard cello... I couldn't resist the sound so I gave in and aimed my camera at what had elicited it. As soon as I let go of my thoughts, the texture of the water washed over me in synch with the sound and turned to satin on my skin. When I felt myself climb into the shadows between the folds, I snapped the shutter. I hear cello every time I look at it today, though I discovered that if I turn it upside down, it becomes violin.

Science of the Mind

While some artists have introduced the science of perception and color theory into their works, others have explored different aspects of the science of the mind. Some artists have tried to understand and mimic the workings of the minds of children or the mentally ill. Others have studied psychology and dream theories and tried to represent the subconscious world in their work.

Many artists speak of trying to recapture the creativity we all have as children. The French artist Jean Dubuffet (1901–85) was influenced by the art of children as well as by art made by the mentally ill. He coined the term **Art Brut** to mean art that is raw, inspired by very basic instincts, or, as Dubuffet said, "works produced by persons unscathed by artistic culture." Dubuffet's artwork often has heavy **impasto** and a childlike quality. In *Cow with the* Subtle Nose a bold outline separates the cow from its green background (4.69). The brushstrokes are not smooth, but spontaneous. The cow's eyes are simply round circles; the horns, udder, and tail are simple scratches, like those of a child.

In the 1940s, Dubuffet began to collect art made by the insane. Dubuffet's collection marked Palette: the range of colors used by an artist

Complementary colors: colors opposite one another on the color wheel

Synesthesia: when one of the five senses perceives something that was stimulated by a trigger from one of the other senses Art Brut: "raw art," artworks made by untrained artists, and having a primitive or childlike quality

Impasto: paint applied in thick layers

4.69 Jean Dubuffet, Cow with the Subtle Nose, 1954. Oil and enamel on canvas, $35 \times 45^{3}/4^{\circ}$. MOMA, New York

4.70 Salvador Dalí, Persistence of Memory, 1931. Oil on canvas, $9\frac{1}{2} \times 13^{\circ}$. MOMA, New York

the beginning of increased public interest in artworks by the mentally ill (see Perspectives on Art Box: Art Inspired by Insanity). His collection is now housed at the Musée de l'Art Brut in Lausanne, Switzerland.

Salvador Dalí (1904–89) was one of a group of artists known as the **Surrealists**, who were inspired by psychology and dream studies, and most particularly by the theories of the father of **psychoanalysis**, Sigmund Freud. Themes of sexual desire and fear are common in Dalí's paintings, which he associated with Freud's studies on sexual desire and behavior.

In *Persistence of Memory* (**4.70**), the stretched form in the center (a nose with long eyelashes and a tongue hanging out) is a self-portrait, and the cliffs in the background resemble the Catalan coast in Spain, where Dalí lived. After a late night with some friends, Dalí was inspired to paint *Persistence of Memory* while playing with some melted cheese left over from dinner. He said the painting was "nothing more than the soft,

extravagant, solitary, paranoiac-critical Camembert cheese of space and time." Dalí invented the term paranoiac-critical, which he defined as the

spontaneous method of irrational knowledge based on the critical and systematic objectivity of the associations and interpretations of delirious phenomena.

The consistency of the cheese inspired the three warped, dangling watch faces. The limp watches may be interpreted as symbols of both impotence and recent sexual satisfaction.

Scholars have remarked on a link between this work and the physicist Albert Einstein's theory of relativity, which addresses the complexities of time. In Dalí's painting, the clocks each read a different time, conveying a distorted sense of time and space. Dalí also painted a fly on the drooping watch on the ledge, a visual metaphor for the phrase "time flies."

Surrealist: an artist belonging to the Surrealist movement in the 1920s and later, whose art was inspired by dreams and the subconscious

Psychoanalysis: a method of treating mental illness by making conscious the patient's subconscious fears or fantasies Motif: a distinctive visual element, the recurrence of which is often characteristic of an artist's work

Perspectives on Art: Martín Ramírez **Art Inspired by Insanity**

Painful experiences and disabling illness can be sources of extraordinary art, as works produced by psychiatric patients demonstrate. Here, the art historian Professor Colin Rhodes, an expert on this subject, discusses the work of the Mexican schizophrenic artist Martín Ramírez (1895-1963), who spent thirty-three years in Californian mental hospitals where he produced hundreds of artworks, many now in major museums.

For a long time, the images created by Mexican artist Martín Ramírez were thought to be the more or less unconscious outpourings of a mind liberated from daily reality by mental illness. His practice was markedly obsessive, characterized by repetition of a few motifs, which nonetheless were combined in powerful and subtle variations. There is a visionary feel

4.71 Martín Ramírez, Untitled (La Inmaculada), 1950s. Crayon, pencil, watercolor, and collaged papers, 7'8" × 3'9". High Museum of Art, Atlanta, Georgia

to his work, born of his use of stylized, large forms loosely anchored on an indistinct background. His store of motifs is closely connected to his cultural background. Ramírez was a native of Jalisco, Mexico, who left for California in 1925 to support his wife and children. The Great Depression left him unemployed and homeless. He became a patient in Californian asylums from 1931 until his death. Ramírez's diagnosis was first manic depression and subsequently schizophrenia.

Many of Ramírez's works include iconic images of the Madonna, particularly in the form of Our Lady of the Immaculate Conception, standing on a globe, with a serpent at her feet, symbols he would have seen in his home parish. Though it is always dangerous to attribute specific pictorial qualities to illness, there can be little doubt that Ramírez's condition and experience of incarceration were a source of artistic creativity. Artistic production can fix memory in the face of separation from loved ones and of boredom. And since his illness made it impossible to communicate in the usual sense. Ramírez created an alternative world in his imagination. In this work Ramírez replays his life in Mexico before incarceration (4.71). The two Mexican Madonnas float above a shallow landscape of shell-like mountains. Their gaze is contemplative and their faces expressive. Their dress, though, is as much landscape as clothing. In the background another, more worldly, woman half imitates their pose. Like most of Ramírez's works, the large drawing is made from a number of smaller sheets pasted together—the only materials available to him, but also indicative of his compulsive need to expand the universe of his drawing to accommodate the developing image, as opposed to fitting the image into a single sheet. The result, in the case of Ramírez. whose illness caused a withdrawal from physical and verbal interaction with the world. was an outpouring of some of the most powerful visual art of its time.

The Scientific Restoration of Artworks

Scientific advancements in chemistry have helped improve the techniques used in the restoration of artworks. The most momentous restorations in recent times have been the cleaning of the **frescoes** at the Vatican in Rome, Italy. The restoration of Michelangelo's Sistine Chapel ceiling, which

began in 1980, took nine years to complete, twice as long as it took Michelangelo to paint the ceiling originally (4.72).

In order to decide on the best way to clean the frescoes, restorers first had to determine what was original and what was due to the effects of time, such as candle smoke, the interventions of previous restorers, rain damage, the settling of building foundations, and even bacteria introduced by the visits of millions of tourists.

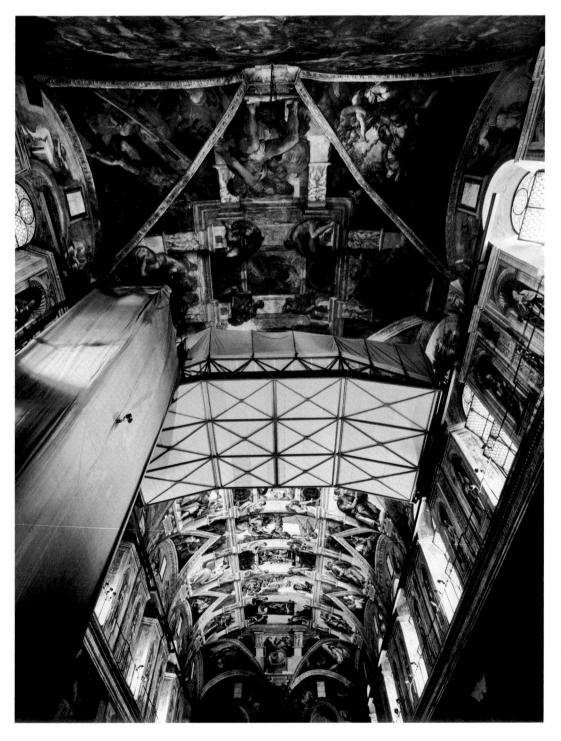

4.72 Cleaning of Sistine Chapel ceiling, Vatican City, 1980–9

Fresco: a technique where the artist paints onto freshly applied plaster. From the Italian *fresco*, fresh

4.73 Detail of Christ from Michelangelo, The Last Judgment. Photo taken during restoration of Sistine Chapel, Vatican City, 1990-4

They analyzed the chemical composition of numerous minuscule samples of the paint, glue, wax, and varnish taken from the many layers they found on the ceiling. This analysis, plus their ability to examine the entire ceiling at close range, caused them to believe that Michelangelo had painted the ceiling almost entirely in buon fresco (when the plaster was still wet) with only slight corrections executed a secco (after the plaster had dried), and that all other layers were later additions.

The most shocking discovery, revealed after centuries of dirt were removed, was the bright colors that Michelangelo had used. Critics denounced the cleaning as a disaster, accusing the restorers of removing Michelangelo's original varnish. However, an international committee of the world's leading art conservators was convened to review the approach taken by the restoration team, and after a lengthy inspection

of the restorers' research, methods, and handiwork, the panel unanimously declared that the team had been thorough and painstaking, and that their approach was accurate and correct: the original paintings had indeed been this bright.

The cleaning of the Sistine Chapel ceiling paved the way for further restorations at the Vatican, including Michelangelo's Last Judgment (4.73) on the altar wall of the Sistine Chapel (restored 1990-4) and, down the hall, four rooms of paintings by Raphael, including The School of Athens (restored 1995-6).

Discussion Questions

- Many artists study synesthesia, are synesthetic themselves, or try to trigger synesthetic responses in the viewer. Study the work of an artist who is known for trying to evoke music in his or her artworks, for example Georgia O'Keeffe (1.24), James McNeill Whistler (4.170), Vasily Kandinsky (3.189), or Paul Klee. Choose a single painting and, through formal analysis, determine how the artist is trying to inspire sensations that are similar to those stimulated by the playing of music.
- Elsewhere in this book we have looked at examples of the artwork of the great Italian Renaissance artist Leonardo da Vinci (see for example 08 and 3.121). Find three scientific studies by Leonardo (2.1 and 2.2, for example) and discuss how they might have contributed to his paintings and other artworks. Would you categorize Leonardo's drawings as art or science, or both? Why? How do you think his scientific studies may have contributed to the making of his paintings?
- 3 In this chapter we discussed the art of Willard Wigan and Gunther von Hagens. Many contemporary artists create computergenerated artwork or reflect subjects (such as outer space or DNA) influenced by discoveries in science. Can you find any examples of contemporary art that were influenced by such recent technological advancements?

4.5

Art and Illusion

Trompe l'oeil: an extreme kind of illusion meant to deceive the viewer

Two-dimensional: having height and width

Three-dimensional: having height, width, and depth Fresco: a technique where the artist paints onto freshly applied plaster. From the Italian fresco, fresh

Renaissance: a period of cultural and artistic change in Europe from the fourteenth to the seventeenth century

Zeuxis painted a boy carrying grapes, and when the birds flew down to settle on them, he was vexed with his own work, and came forward saying...I have painted the grapes better than the boy, for had I been perfectly successful with the latter the bird must have been afraid.

(Pliny the Elder, Natural History)

The ancient Roman author Pliny the Elder tells a story that reveals the centuries-old efforts by artists to create convincing illusions. Pliny describes a contest between two great Greek painters, Zeuxis

and Parrhasius, to see who could paint the most realistic picture. As Pliny tells it, Zeuxis's painting of grapes was so realistic that birds flew down to peck at them. Parrhasius in turn painted such a convincing curtain that Zeuxis reached for the drapery, hoping to see the painting on which his rival was working. After being fooled, Zeuxis conceded that Parrhasius had won the competition.

Many artists since have striven to continue and even surpass these achievements, developing techniques that fool us into thinking we are looking at real spaces and objects rather than artworks. Trompe l'oeil ("fool the eye") is the French term for **two-dimensional** artworks that convincingly appear to be three-dimensional objects. Even in three-dimensional art, such as architecture, artists have employed visual tricks to "fool the eye."

Although the paintings of Zeuxis and Parrhasius do not survive, other examples of illusionism exist from the ancient world in paintings found in cities that were covered by the eruption of Mount Vesuvius in southern Italy in 79 CE. Frescoes from a villa owned by a wealthy Roman family create the illusion of architectural features that are in fact

4.74 Cubiculum from the Villa of Publius Fannius Synistor, Boscoreale, Italy, c. 50-40 BCE. Fresco, room size $8.8\frac{1}{2} \times 10.11 \times 19.7\frac{1}{8}$. Metropolitan Museum of Art, New York

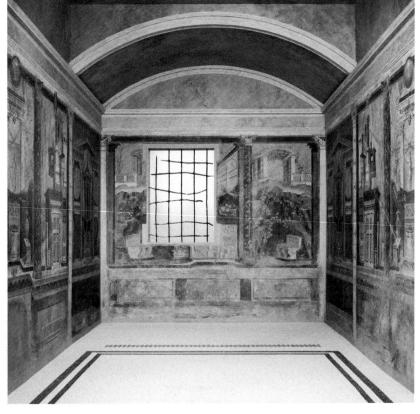

only painted, not part of the structure, and of a distant landscape beyond (4.74). Similarly illusionistic scenes in other Roman wall paintings show fruit, birds, greenery, and stage-like settings, all recalling the story of Zeuxis and Parrhasius.

Artists of the Italian **Renaissance** revived the ideals of the ancient Greeks and Romans, including the desire to impress others with artworks that imitate the real world. The architect and thinker Leon Battista Alberti (1404–72) wrote in his treatise On Painting that artists should design their paintings as illusionary windows through which viewers would be able to perceive a new reality (see Gateway Box: Raphael).

Humanism: the study of such subjects as history, philosophy, languages, and literature, particularly in relation to those of ancient Greece and Rome

Gateway to Art: Raphael, The School of Athens **Architectural Illusion**

4.75 Raphael, Stanza della Segnatura, Vatican City, 1509-11

The Italian artist Raphael (1483-1520) painted The School of Athens on one of the walls of the library of Pope Julius II in the Vatican, in Rome, to create the illusion of an architectural space that was separate from the actual room and

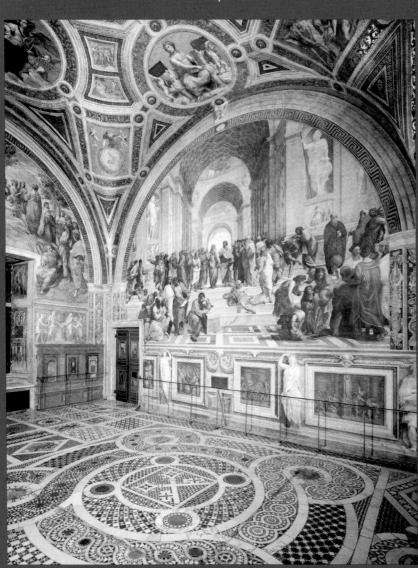

filled with life-sized figures linking the Classical world with the humanist Renaissance (4.75). This painting was designed as part of a larger program including three other paintings, an intricately tiled floor, and a painted ceiling, all choreographed thematically as a backdrop for Pope Julius II's library. The pope's hundreds of books were laid on shelves built directly under the paintings on each of the four walls (these shelves have since been removed).

The School of Athens highlights the development of learning in the ancient world, focusing particularly on the great philosophers Plato and Aristotle, who are the two central figures in the painting. The other large paintings, turning counterclockwise around the room, are: Parnassus, a mythological story of Apollo, representing poetry (seen on the left wall in 4.75); Disputa, a work that unites Classical ideas with Renaissance Christian theology; and Jurisprudence, which emphasizes law and justice. The thematic decorative scheme reflects the purpose of the room: the subjects of Julius's books were arranged to correspond with the Classical topic addressed in the wall painting above them. Beneath The School of Athens were books on philosophy and mathematics; beneath Parnassus, poetry; and so on. The ceiling further unites the themes of the walls through the depiction on it of four female figures, who personify Philosophy, Poetry, Theology, and Justice. To one standing in the room, the illusion of depth created in The School of Athens is even more successful because the paintings on all four walls appear to be separate rooms.

4.76 Andrea Mantegna, Detail of central oculus, ceiling of the Camera degli Sposi. Fresco, 8'9" diameter. Ducal Palace, Mantua, Italy

During the Renaissance, the Italian artist Andrea Mantegna (c. 1431–1506) created a *trompe l'oeil* for an entire room of the palace of Ludovico Gonzaga, the Duke of Mantua. The chamber, known as the Camera degli Sposi (Room of the Newlyweds), was used both to greet government officials and as a bedroom for the duke and his wife (4.76). Mantegna painted the walls with scenes of the royal family and of historical victories of the Gonzagas.

In the vaulted ceiling the artist painted the illusion of what seems to be an **oculus** opening onto a blue sky, and surrounded it with figures looking down at the people below. There are **putti** with their chubby baby bodies, some hanging on to the painted **balustrade**, others looking down through the painted oculus.

Several young girls peer over the balustrade, as does an enigmatic turbaned figure. One light-skinned girl wears a white veil, referring to the title of the room and to the duke's recent marriage to his wife. Similarly, the prominent peacock symbolizes Juno, the Roman goddess of marriage. All of this activity surprises the viewer below, who may feel particularly nervous about the potted plant precariously held in place with a pole by two smirking young girls.

The Italian artist Francesco Mazzola (1503–40), known as Parmigianino ("the little one from Parma"), gave a self-portrait to Pope Clement VII in order to attract commissions (4.77). The painting is on a **convex** piece of wood; holding it, one seems to be looking into a convex mirror—except that one does not see one's own

Oculus: a round opening at the center of a dome

Putto (plural putti): a representation of a nude or scantily clad infant angel or boy, common in Renaissance and Baroque art

Balustrade: a railing supported by short pillars

Convex: curved inward, like the exterior of a sphere

4.77 Parmigianino, Self-portrait in a Convex Mirror, c. 1524. Oil on wood, 91/2" diameter. Kunsthistorisches Museum, Vienna, Austria

reflection in the artwork, but the portrait of Parmigianino, who studied himself in an actual convex mirror to create this painting. Parmigianino, however, made one change from what he saw when he studied his reflection. The artist accurately depicted himself as right-handed, but in order to do so he would presumably have had to study his left hand when he actually painted. Parmigianino also featured a portion of the frame of the painting he was creating (visible on the right side of the artwork) in order to heighten the illusion of it being a handheld mirror.

In the nineteenth century, the American painter William M. Harnett (1848-92) was so skillful at tricking his audiences with trompe l'oeil that, when he created a truly convincing dollar bill in one of his paintings, he was investigated for counterfeiting by the U.S. Treasury Department. In The Old Violin, Harnett painted a violin and sheet music so that they appear to be hanging from a real wooden door (4.78). The only part of the painting that is in fact real is a blue envelope signed by the artist, which he attached to the lower left corner of the painting. The artist teases viewers, leading us to question what is reality and what is illusion. If we were to read the small piece of torn newspaper so

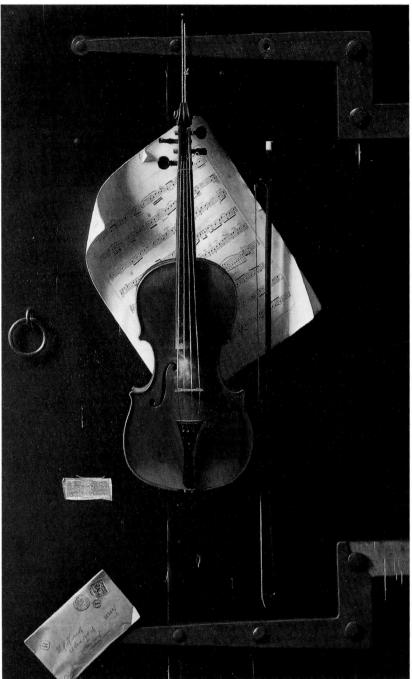

skillfully painted slightly to the left of the bottom of the violin, we would find that the text is gibberish: it is not a newspaper, but another superb illusion. When this painting was first exhibited, guards had to be posted around the painting constantly to prevent viewers from reaching out to test if the objects were real.

The contemporary Japanese artist Shigeo Fukuda (1932-2009) is known for his optical tricks. In fact, he filled his own home in Tokyo with deceptions. What appeared to be the front

4.78 William M. Harnett, The Old Violin. 1886. Oil on canvas. $38 \times 23\%$ ". National Gallery of Art, Washington, D.C.

4.79 Shigeo Fukuda, *Encore*, 1976. Wood, $19^{1/2} \times 19^{1/2} \times$ 113/4". Private collection

door opened onto a blank wall; his real front door blended into the exterior wall, which created a secret passageway. Utilizing **form**, light, and shadows, Fukuda created numerous artworks in two and three dimensions, many of musicians, in which the subject changes depending on the beholder's point of view. In Encore, a silhouette of a piano and pianist transforms into a violinist when the carved wooden sculpture is viewed from a different angle (4.79). The title of the work (audiences traditionally call out "encore!" at the end of musical performances, to encourage the musician to play "again!") expresses the way the work is experienced, as if more than one performance is being seen.

Illusionism as Trickery

With wonderful skill, he carved a figure, brilliantly, out of snow-white ivory...and fell in love with his own creation.

> (The ancient Roman poet Ovid on Pygmalion's carving of Galatea)

In Classical mythology, the sculptor Pygmalion created a statue of a woman so fine and beautiful that he fell in love with her. He dressed and pampered her, believing her more perfect than any human woman. He begged the gods to grant him a wife as perfect as his statue, and the goddess of love, Venus, granted his wish by bringing the statue to life. The myth suggests that an artist's love for his work, and his skill at re-creating the natural world, will reap great rewards.

Like Pygmalion, sculptors can use their skill to create works that appear to be convincingly real. With painstaking attention to every minute detail, the Australian artist Ron Mueck (b. 1958) infuses his sculptures with life. He patiently recreates each hair, wrinkle, and pore on his human figures through a lengthy process that would be tedious for most of us. The remarkable realism of his works—one is tempted to reach out to touch the figures—catches us by surprise. A sculpture of Mueck's own sleeping face, even though it is a disembodied head, is so believable that we

Form: objects that can be defined in three dimensions (height, width, and depth) Silhouette: a portrait or figure represented in outline and solidly colored in **Stylobate:** the uppermost platform on a Classical temple, on which the columns stand **Entasis:** the slight swelling or bulge at the midpoint of a column

4.80 Ron Mueck, Mask II, 2001-2. Mixed media, $30^{3}/8 \times 46^{1}/2 \times 33^{1}/2$ ". Private collection

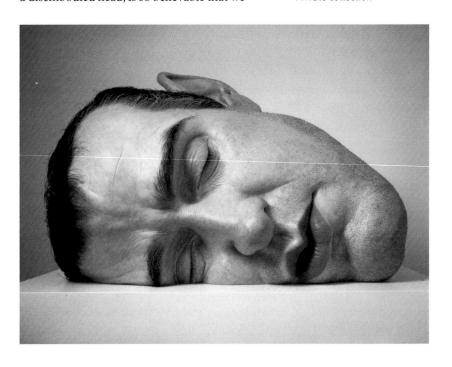

anxiously wait for the mask to open its eyes (4.80). Each feature, no matter how small, is precisely reconstructed. And the lips and cheeks droop slightly, as if subject to the effects of gravity, just as they would on a human face. At the same time, Mueck subverts his own illusion by making his figure extremely oversized.

In ancient Greece, the designers of the Parthenon understood that the human eye could play tricks on the beholder. They used their knowledge of mathematics to ensure that the building would appear just as they wished it to (4.81a). Because of the great size of the temple, the base and columns would appear warped unless the architects could adjust their design to counteract these naturally occurring optical illusions. For example, the stylobate, or platform on which the columns stand, would appear to sag if it were constructed as a precisely straight horizontal structure. To account for this, the architects created a slight upward swelling in the center of the stylobate, which makes the base of the temple seem perfectly horizontal when we look at it.

Several other visual manipulations were utilized in the design of the columns. For example, the columns of the Parthenon actually swell at about mid-height (4.81d). This optical trick prevents them from appearing, when looked at from a distance, to be hourglass-shaped, which would happen if the columns were flawlessly straight sided. This swelling at the midpoint of such columns is called entasis. In addition, the columns are not perfectly vertical but actually slightly tilted. If they were extended into the air, the implied lines created by the four corner columns would eventually intersect about a mile and a half into the sky. Finally, the columns are not all spaced equidistantly, as they appear to be; those closer to the corners have less space between them. This is another visual trick used to compensate for the optical illusion that makes columns near the end of a row appear further apart than ones near the middle.

4.81a (top right) Kallikrates and Iktinos, Parthenon, 447-432 BCE, Acropolis, Athens, Greece

4.81b-d (right) Diagram showing the optical illusions utilized in the Parthenon

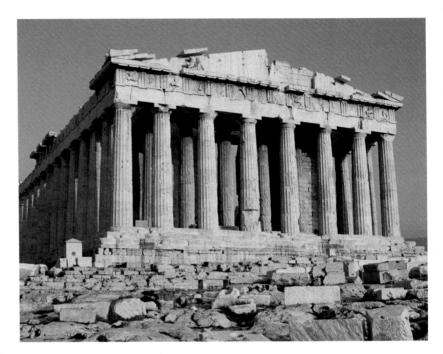

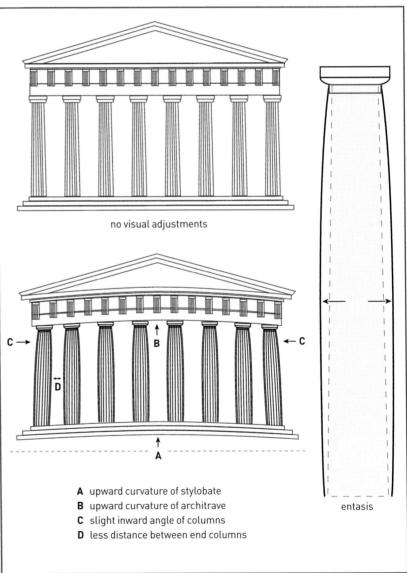

Architectural and two-dimensional illusory techniques were both utilized by the Italian artist and architect Giulio Romano (c. 1499–1546) designed a villa for the same Gonzaga family that had commissioned the decoration of the Camera degli Sposi from Mantegna (see 4.76). As both architect and interior painter for the Palazzo del Tè in Mantua (4.82), Giulio Romano designed a building that subtly broke many of the rules of Classical architecture, with the result that, when looked at closely, the villa appears to be unstable. Romano achieved this playful illusion by taking Classical architectural elements used in such buildings as the Parthenon, and arranging them to create the impression of instability rather than the solidity normally expected of architecture. The **architraves** that rest on the columns are narrower than would normally be the case; but, even stranger, they seem to break in the middle rather than reaching from one column to the next, as they should. As a result, some of the **triglyphs** in the **frieze** above the columns appear to be slipping down, as if they might even fall to the ground. The material of the structure itself is also an illusion; rather than marble or stone, which were normally used for luxurious buildings, the exterior is **stucco**-covered brick.

The explanation for the odd design of the Palazzo del Tè's exterior becomes apparent when one enters the building (4.83). A painted scene of the Fall of the Giants playfully suggests why the exterior appears to be falling apart. The painting depicts an episode from Greek mythology, when the gods defeated the giants in battle. Having been trained by Raphael, and having worked as his assistant on his paintings for the Vatican (see p. 509), Giulio Romano built on the techniques of his master for this powerful painted illusion. The building in Giulio's painting appears to be tumbling down, crushing the struggling giants below. The powerful wind, shown in the corner blowing a trumpet, is controlled by the gods in the clouds of Mount Olympus, and therefore protected from the turmoil below.

4.82 Giulio Romano, Palazzo del Tè, exterior, 1527-34, Mantua, Italy

4.83 Giulio Romano, Fall of the Giants, 1526-35. Fresco, Sale dei Giganti, Palazzo del Tè, Mantua, Italy

The British artist Julian Beever (b. 1960) applies a special form of trompe l'oeil known as anamorphosis to his sidewalk art. An anamorphic image is one that is stretched and distorted, but becomes clear and realistic when viewed from a single, oblique angle. Beever's chalk drawings confront passersby with what appear to be convincing scenes taking place in

three-dimensional space. When his Woman in Pool is viewed from the right vantage point, it appears that a woman is lying back in a swimming pool, drink in hand, kicking her leg in the air (4.84a). But when it is viewed from the opposite direction, the illusion is destroyed and one can see that Beever used extreme foreshortening to represent the woman's leg (4.84b). The only

4.84a (top right) Julian Beever, Woman in Pool, drawn in Brussels, Belgium, 1992. Colored chalks, 14'91/4" × 13'11/2" (correct viewing point)

4.84b (below right) Julian Beever, Woman in Pool, drawn in Glasgow, Scotland, 1994. Colored chalks, 14'91/4" x 13'11/2' (incorrect viewing point)

Architrave: a beam that rests on the top of a row of columns **Triglyph:** a projecting block carved with three raised bands, which alternates with figurative reliefs in a frieze

Frieze: the strip that goes around the top of a building, often filled with sculptural ornamentation

Stucco: a coarse plaster designed to give the appearance of stone Anamorphosis: the distorted representation of an object so that it appears correctly proportioned only when viewed from one particular position Foreshortening: a perspective technique that depicts a form at a very oblique (often dramatic) angle to the viewer

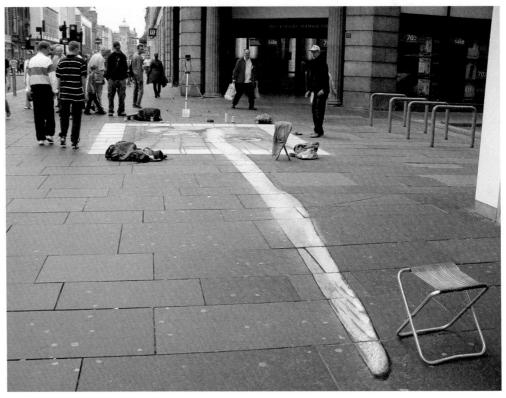

genuinely three-dimensional element in the photograph of the illusionistic drawing (**4.84a**) is the artist himself, who is holding a drink and has his foot placed flat on the pavement.

Illusion and the Transformation of Ideas

The American artist Chuck Close (b. 1940) creates artworks that inspire us to question what we see. As a child, one of Close's favorite pastimes was to entertain neighbors and schoolmates by

doing magic tricks. As an adult artist, he has become known for manipulating portraits of friends and family. He begins his creative process by taking photographs of them, which he then transforms into artworks in another **medium**. For example, although *Fanny/Fingerpainting* looks like a photograph, Close actually handpainted an image of his wife's grandmother using only his thumb- and fingerprints (4.85). As with most of his artworks, Close laid a grid over the original photograph of the subject, and then carefully enlarged and copied each block so that the entire image fills an 8 foot 6 in. by 7 foot canvas. Through this process, the

4.85 Chuck Close, Fanny/Fingerpainting, 1985. Oil on canvas, 8'6" x 7'. National Gallery of Art, Washington, D.C.

Medium (plural media): the material on or from which an artist chooses to make a work of art

Perspective: the creation of the illusion of depth in a twodimensional image by using mathematical principles

4.86 Édouard Manet, A Bar at the Folies-Bergère, 1882. Oil on canvas, $37^{7/8} \times 51^{1/4}$ ". Courtauld Gallery, London

original photograph is transformed into a much bigger image that appears to be a photographic enlargement produced by technology. Close's process, while still quite mechanical, remains personal because of the use of the artist's own hands in the act of creation.

The painting A Bar at the Folies-Bergère, by French artist Édouard Manet (1832–83), similarly asks the viewer to consider the relationship between truthfulness and illusionism in a work of art (4.86). The Folies-Bergère was one of the most popular bars and entertainment houses in Paris in the nineteenth century; the club offered entertainment by dancers, singers, and even trapeze artists (a pair of feet can be seen hanging in the upper left of Manet's painting), all dressed in revealing and provocative clothes. The blurry background behind the barmaid suggests she is standing

in front of a mirror, which reflects the Parisian club scene she is facing. Discrepancies in the reflection, however, make one question the accuracy of what one sees. For example, the bottles next to the barmaid on the left of the canvas appear to be placed in a different order and in a different place in the reflection behind her. In addition, some viewers question whether the posture of the barmaid on the far right is an accurate reflection of the barmaid looking out at us. Manet certainly had the skill to depict **perspective** precisely, so one must consider why he chose to create such an ambiguous reflection.

Several interpretations of A Bar at the Folies-Bergère have been suggested. If we assume that the figure on the right is indeed a reflection of the barmaid, then we viewers are standing in the place of the man in the top hat to whom she is

talking. He is presumably a client. It was common for the female entertainers and barmaids at the Folies-Bergère to be hired by the clientele for sexual favors. Perhaps that is the nature of the interchange taking place between them. The

ambiguities in the reflection may be a way for the artist to suggest different emotional states in the barmaid, contrasting her personal experience or feelings with her external appearance. Some have argued that she appears to be much more

Satirizing Illusionism: Hogarth's False Perspective

In this work, William Hogarth (1697–1764), an eighteenth-century British artist, satirizes the traditional training of painters who were taught to use the rules of perspective to create believable spaces (4.87). Here, Hogarth applies these rules in order to break them. He thus creates the illusion of a space that is, in fact, impossible. On the bottom of the print, he wrote:

Whoever makes a Design without the Knowledge of Perspective will be liable to such Absurdities as are shown in this Frontispiece.

See if you can find these spatial impossibilities:

- The woman in the window of her building is lighting the pipe of the man standing on top of the hill. Lower in the image, we can see a tree, and horses pulling a wagon, between the building and the base of the hill. How can the woman reach the man?
- The man in the right foreground must have quite an extraordinarily long fishing line in order to reach beyond the rod of the man in the distance.
- In the lower left, the sheep closest to us are smaller than those further away.
- Similarly, the trees at the bottom of the hill get larger as they recede into the distance, suggesting that the bird on the furthest tree is improbably big.
- The church in the distance appears to be both grounded on land and floating on water.
- The man in the boat in the center of the scene appears to aim his gun at a swan, but instead shoots the underside of the bridge.
- The sign on the building in the foreground

- seems to be hanging behind the trees on the hill in the background.
- The barrel behind the large man in the foreground shows both the top and bottom of the container.
- The vanishing point of the grid upon which the man in the foreground stands is projecting into the viewer's space, rather than receding into the pictorial space, making it seem as if the man should be falling forward out of the picture.

4.87 William Hogarth, False Perspective. Engraving from Dr. Brook Taylor's Method of Perspective Made Easy, Both in Theory and Practice, 1754

4.88 René Magritte, The Human Condition, 1933. Oil on canvas, $39\% \times 31\% \times 5\%$ ". National Gallery of Art, Washington, D.C.

engaged in the reflected image than she is as she stands before us in the center of the painting. Her gaze leaves us questioning her state of mind: is she sad, distracted, or bored? Another interpretation suggests that the artist is depicting a fantasy.

Some artists employ satire to question or play with the tradition of using perspective and other illusionary tools to create artworks that imitate reality (see Box: Satirizing Illusionism). The Belgian artist René Magritte (1898–1967) asks the viewer to question what appears to be a painting of a landscape on an easel, which has been placed before a window that looks out onto the same landscape (4.88). However, we realize that the scene outside the window is also an invention; the window and drapes and the painting on the easel are both part of the painted canvas that we behold. The artist explains,

[The tree] exists for the spectator, both inside the room in the painting, and outside in the real landscape, in thought. Which is how we see the world: we see it as being outside ourselves even though it is only a mental representation of it that we experience inside ourselves.

Magritte confronts us with issues of representation and truth and refers directly to the achievements in **linear perspective** made by the artists of the Renaissance. What at first seems an extension of the desire to create a convincing view through a window is shattered when Magritte forces us to consider what is real, and what is only of the mind. Magritte showed that the "illusionistic window" of the Renaissance is indeed only a canvas. By so doing, he opened the door for artists to make paintings with purposes other than the representation of perfect threedimensional illusions of subjects as if they were real life. As Magritte demonstrated, painting can be a powerful mode for expressing complex ideas, rather than solely re-creating what we see with our eyes.

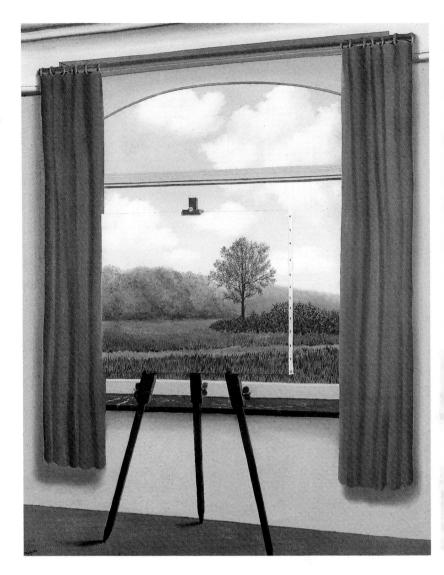

Discussion Questions

- Look at artworks by René Magritte (for example, The Human Condition in this chapter (4.88) and The Treachery of Images on p. 76 (1.47)). Write a short essay of two or three paragraphs explaining what Magritte was saying about the Renaissance idea of the "illusionistic window."
- 2 Select one of the artists in this chapter and study other works by them. Does the artist use illusionism frequently? What do you think is the artist's motivation for doing so?
- 3 Study Hogarth's False Perspective. Now draw a scene from your imagination and include in it at least three examples of altered visual reality like those included in Hogarth's print.

Vanishing point: the point in a work of art at which imaginary sight lines appear to converge, suggesting depth

Satire: work of art that exposes the weaknesses and mistakes of its subjects to ridicule

Linear perspective: a system using converging imaginary sight lines to create the illusion of depth

4.6

Art and Rulers

Rulers have always made use of works of art to help define and assert their political power and to influence their people. Seeking to demonstrate supreme control, leaders have used artworks to highlight their right to rule, sometimes even to claim that their authority has been granted by the gods. Regal portraits are often idealized, emphasizing rulers' importance by portraying them in elaborate clothing, or showing them seated on a throne, placed centrally in the composition, or depicted larger than other figures. Leaders have frequently commissioned artworks to reinforce their reputations as skillful commanders and to project an image of military strength. Thus artworks can be a potent propaganda tool for sustaining a ruler's power. This chapter explores how rulers have seen themselves and how they wished to be viewed by both friend and foe.

Regal Portraits

What image comes to mind when you think of a great leader? Artists have endeavored for centuries to develop ways to show rulers as figures of grace and authority, deserving the trust of the people whom they govern. **Byzantine** artists created glorious tile **mosaics**, and the Chinese used rich silks as the base for luxuriously colorful royal portraits. The ancient Olmec conveyed their leaders' power in the massiveness of the stone images they carved (see Gateway Box: Colossal Olmec Heads, **4.91a** and **4.91b**, p. 522). Portraits vary in the degree to which they accurately depict

the physical characteristics of the sitter. Rulers are sometimes identified by their attire and placement rather than their facial features.

The Byzantine emperor Justinian is remembered as a remarkable military and civil leader, as well as a great **patron** of the arts who funded the building of hundreds of churches. Portraits of Justinian, who ruled in the sixth century, were often placed in these churches to demonstrate his patronage as well as his power, which was believed to have been granted by God. In the Church of San Vitale, in Ravenna, Italy, there is a glorious coloured glass mosaic of the Emperor, which he probably never saw (4.89).

Justinian stands in the center of the mosaic, wearing the imperial color purple. On either side of him are clergy in white robes. To his far right are soldiers, who display a large shield that bears the Greek letters for Christ (chi-rho), emphasizing Justinian's role as a Christian military leader. There are other Christian symbols in the mosaic: the men to the left of the emperor hold a cross, a copy of the Gospels (the first four books of the New Testament). and a censer used to burn incense in church services. Justinian holds the bread used to represent the body of Christ in the communion service, and the mosaic itself is displayed near the altar where the service would take place. Interestingly, one other figure in this mosaic is given special recognition: the local bishop, Maximianus, who arranged the commission, organized the composition so that his figure was the only one identified in writing on the image

Byzantine: relating to the East Roman Empire, centered on Constantinople (modern-day Istanbul) from the fifth century CE to 1453

Mosaic: a picture or pattern created by fixing together small pieces of stone, glass, tile, etc. **Patron:** an organization or individual who sponsors the creation of works of art

4.89 Justinian mosaic, c. 547 cE. Glass, San Vitale, Ravenna, Italy

(his name is written above his portrait), and so that his feet should be placed slightly in front of the emperor. One wonders what Justinian would have thought, had he seen the mosaic. Justinian himself needed no such label: the imperial robe, in addition to his crown and halo, were enough to identify the ruler.

Unlike the depiction of Justinian, which shows the ruler surrounded by followers, the portrait of the Yongzheng Emperor (who reigned between 1722 and 1735) in 4.90 shows the Emperor of China by himself and enthroned. Many aspects of the portrait—the ruler's expression and pose, his yellow robe, and the rich colors on the silk scroll—follow the traditions of royal portraiture used for centuries in China. The accurate depiction of the facial features, however, makes each portrait unique. The gilded throne and richly colored textiles of his robe, seat cushion, and carpet emphasize the wealth and authority of the ruler. Dragons intricately stitched all over the robe, and the monstrous carving on the throne, symbolize the emperor's fearsome power. Imperial portraits like these were often made upon the death of

4.90 Portrait of the Yongzheng Emperor in court dress, Yongzheng period, 1723-35. Hanging scroll, colour on silk, $9'1" \times 4'8^{1/2}"$. Palace Museum, Beijing, China

Gateway to Art: Colossal Olmec Heads

Portraits of Powerful Rulers

4.91a Colossal Head, Olmec, 1200-600 BCE. Museo Nacional de Antropología, Mexico City, Mexico

The distinctive facial features and individual headdresses of the seventeen Colossal Olmec Heads suggest that each one represented a real person (4.91a). Scholars think they probably depict specific Olmec rulers. The effort it must have taken to create each sculpture is evidence of the power of the ruler. The material used to make the colossal heads is a hard volcanic stone known as basalt. In San Lorenzo, Mexico,

where ten colossal heads have been found. the stone would have been transported more than fifty miles over rivers and marshy terrain, suggesting that the ruler had a wealth of resources at his disposal. Many Olmec heads have been discovered underground, indicating that they were buried as part of a ritual. In addition, many of the heads have been mutilated or carved from the stone of Olmec "altar-throne" sculptures, leading some scholars to conclude that old sculptures were damaged, buried, or recycled as new sculptures when a new ruler took power. Scholars cannot say with certainty why this was done, but it seems likely that the burial and mutilation of Olmec monuments occurred when the ruler died. Although there is much we will never know about why these heads were made, it seems clear that they express the power of mighty rulers.

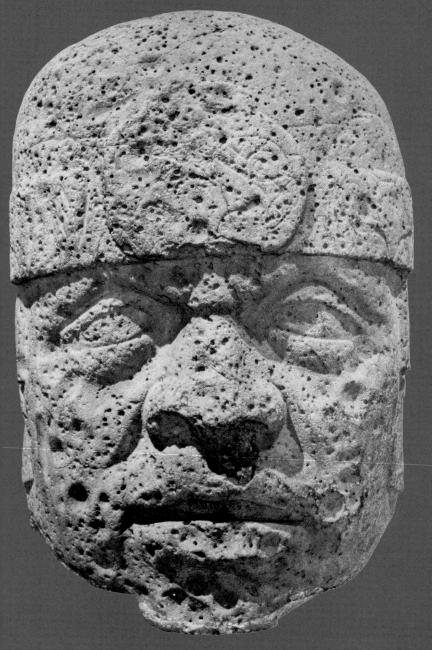

4.91b Colossal Head, Olmec, 1500-1300 BCE. Basalt. Museo de Antropología, Veracruz, Mexico

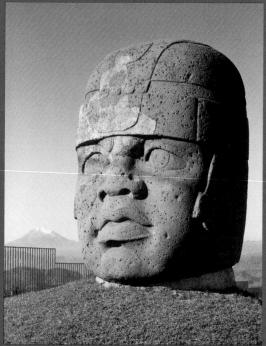

the ruler and hung in family shrines. The ruler's descendants would burn incense and bow before their ancestor's portrait, asking for protection and guidance. Such images were themselves safeguarded by an ancestral power. In fact, it was considered blasphemous and even dangerous to possess the portrait of someone who was not your own ancestor.

Art to Demonstrate **Absolute Power**

A ruler with absolute power is one who has the freedom to govern as he or she pleases. How is such unlimited power achieved? Often such leaders are believed to have been given their authority by divine powers. Even when rulers seem unjust or extreme, their subjects are less likely to rebel if their authority is believed to have derived from God. Absolute rulers control the wealth of their country, and may choose to spend it on personal luxuries, rather than for the benefit of all (see Box: The Extravagance of the French Monarchy, pp. 524–5). Leaders with such total power may determine the religion of their people and how that religion is practiced.

In ancient Maya culture, a ruler's power was reinforced through prayers and sacrifices to the gods. An intricately carved lintel from a temple in Yaxchilán in southern Mexico shows Lady Xoc, wife of the ruler Shield Jaguar, kneeling before her husband and pulling a rope covered with thorns through a hole in her tongue in a bloodletting ritual (4.92). The writing around the edges of the scene tells us the names of the figures and describes what is taking place. According to the symbols above the king's head, this ritual took place on October 28, 709 CE.

Bloodletting led to what is called a hallucinogenic state, in which the individual concerned imagines that he or she is seeing things. The Maya may have enhanced such states by fasting and taking drugs; they believed that such rituals caused spiritual visions. Shield Jaguar and Lady Xoc prayed to the sun god; they both wear his image on their pectorals. This ritual

may be related to a specific battle, as Shield Jaguar, dressed as a warrior, wears an elaborate headdress that includes the shrunken head of a victim sacrificed to the gods. He holds a large burning torch to light the evening ritual.

This lintel is one of three that depict specific bloodletting ceremonies undergone by Lady Xoc (each with different dates); they were placed together over a doorway in a temple dedicated to her. Although Lady Xoc is shown as clearly subordinate to Shield Jaguar, her

Lintel: the horizontal beam over the doorway of a portal Pectoral: a large ornament worn on the chest

4.92 Shield Jaguar and Lady Xoc, c. 725 cE. Limestone, 43 x 30". British Museum, London, England

The Extravagance of the French Monarchy

Louis XIV (1638-1715) ruled France as an absolute monarch and his power was thought to be based on the divine will of God. He proclaimed himself the Sun King, believing that he was the center of all things, and that the world revolved around his whims. The regal portrait by Hyacinthe Rigaud (1659-1743) is meant to demonstrate the king's absolute power (4.93). Louis is dressed in royal attire. the gold fleur-de-lis (or "lily-flower," the symbol of the French monarchy) embroidered on a rich blue velvet gown, lined in expensive white fur known as ermine. Insisting on the finest of everything, Louis XIV dressed himself in the most opulent textiles from around the world. He invented the high heels shown here, which he used to increase his height (5 ft. 4 in.) and to show off his healthy legs. This painting was done when the monarch was in his sixties.

The Sun King stands at the entrance to the famed Hall of Mirrors, an opulent chamber filled with mirrors (an expensive commodity at the time) in his grand new palace of Versailles, near Paris. This enormous edifice had hundreds of rooms, each ornately decorated by the finest artists in Europe. Vast gardens covering almost 2,000 acres were designed to surround the palace. They were filled with 200,000 trees and 210,000 flowers, which were replanted frequently, and with 2,100 sculptures, many of them placed on spectacular fountains. Versailles has more than fifty fountains. There was not enough water to run them all at once, though, and servants used a system of whistles to alert one another to turn on the fountains whenever the Sun King was within viewing range.

By the late eighteenth century, the wasteful spending of the monarchy had

4.93 (below left) Hyacinthe Rigaud, *Louis XIV*, 1701. Oil on canvas, 9'1" × 6'4³/₈". Musée du Louvre, Paris, France

4.94 (below right) Élisabeth-Louise Vigée-Lebrun, *Marie Antoinette and Her Children*, 1787. Oil on canvas, 9'½" × 7'5/8". Musée National du Château de Versailles, France

caused such popular opposition that the monarchy itself took notice. Marie Antoinette, the wife of King Louis XVI (1754-93), had become the symbol of the royal family's extravagance. While the French state suffered financial strain and the people went hungry, the queen decorated herself with expensive clothes and jewels and was given her own chateau, or palace, which she decorated extravagantly. The French directed much of their anger at the queen; many considered her promiscuous, even incestuous, although historians find that some of the accusations against her were greatly exaggerated.

The portrait of Marie Antoinette and Her Children (4.94) was painted to improve the queen's reputation. She is shown seated in Versailles with the Hall of Mirrors behind her right shoulder, just as Louis XIV had been portrayed. While her rich velvet dress shows her status as Queen of France, her wardrobe is neither overly revealing nor lacking in French style and taste, which had been a criticism of previous portraits. In dramatic opposition to her growing reputation as promiscuous and unavailable to the king, she is shown as a loving mother adored by her children, who cling to her. Her somber expression suggests sorrow over the recent loss of her youngest daughter, for whom the empty cradle was intended. In fact, Élisabeth-Louise Vigée-Lebrun (1755-1842), who painted this and many other portraits of Marie Antoinette, wrote in her diary of the kind nature of the queen, and of the queen's sympathy for the painter when she herself was pregnant and when she faced challenges as a female artist in the Royal Academy of Painting and Sculpture. The portrait did not, however, assuage the growing anger of the French people. It was removed from public display shortly after being exhibited in 1788, for fear that it would be attacked. The following year, the French Revolution began. Three years later, in 1792, the monarchy was overthrown, and in 1793 Louis XVI and Marie Antoinette were beheaded.

4.95 Akhenaten, Nefertiti, and three daughters, c. 1353-1335 BCE. Limestone, 121/4" high. Ägyptisches Museum, Staatliche Museen zu Berlin, Germany

elaborate costume, her role in the ritual, and the fact that this bloodletting scene was imitated in artworks of later generations highlights that she too was a person of importance.

The ancient Egyptians believed their kings, known as pharaohs, were descended from the gods. The pharaoh Akhenaten, like Shield Jaguar, ruled under the authority of a sun god. Although previous pharaohs had worshiped many gods, Akhenaten, who ruled in the fourteenth century BCE, used his supreme power to recognize only the sun god Aten. Akhenaten's beliefs are clearly stated in a sunken relief, originally painted, that depicts the pharaoh on the left, his wife and trusted adviser Nefertiti opposite him, and their three daughters cradled on their laps (4.95). The sun is carved deeper than anything else in the relief, which signifies visually its importance as a god, and its rays emanate toward the family, suggesting the sun god's support of the royal family. The flames at the end of the rays are small hands, some holding an ankh, the character that symbolizes life in ancient Egyptian writing. The depiction of Nefertiti as almost the same size as her husband indicates her importance. Some historians believe she ruled the kingdom with Akhenaten.

Sunken relief: a carved panel where the figures are cut deeper into the stone than the background

Palette: a smooth slab or board used for mixing paints or cosmetics

Pigment: the colored material used in paints or cosmetics. Often made from finely ground minerals

Register: one of two or more horizontal sections into which a space is divided in order to depict the episodes of a story **Hierarchical scale:** the use of size to denote the relative importance of subjects in

High relief: a carved panel where the figures project with a great deal of depth from the background

an artwork

4.96a (front) and **4.96b** (back) Palette of Narmer, Early Dynastic Period, c. 2950–2775 BCE. Green schist, $25\frac{1}{4} \times 16\frac{5}{8}$ ". Egyptian Museum, Cairo, Egypt

The Power to Command

The power to command a nation's army is one of a leader's most important duties. Rulers are expected to protect their people, to defeat their enemies in battle, and bring peace. Countless artworks have been made to record successful military campaigns. Many rulers themselves have commissioned artworks they hope will lead to eternal recognition of their military prowess, or that will persuade their people to consider them as gods. Such objects are meant to show the ruler as protector of and peacemaker for his people.

The Palette of Narmer, one of the earliest surviving ancient Egyptian artworks, records the unification of Egypt by the first pharaoh, Narmer (4.96a and 4.96b). Before the reign of Narmer, Egypt was divided into Lower Egypt (near the mouth of the Nile River, to the north) and Upper Egypt (higher terrain, to the south). Palettes were used to grind pigment that both men and women painted around their eyes to protect them from the sun. The round area on the front of the Palette of Narmer, in which the necks of two creatures intertwine, would have been used for the mixing of the paint. The detailing and expense of this object, however, suggest that it may not have been used; or if it was, that it was used only for a very important ceremony.

The front of the palette is divided into four **registers**. The top register shows a pair of horned

strength of the king. Between them is a symbol for the name of the king. In the next register the king is shown larger than the other figures to indicate his importance, a convention known as hierarchical scale. Narmer's unification of Egypt is recorded by a number of symbols. He wears the Red Crown of Lower Egypt, denoting his rule over that region. (The palette was painted, originally, so the red of the crown would have been clearly visible.) The figures lined up in a procession in front of him hold standards with markings that probably signify regions now under Narmer's control. On the far right of this register are ten bodies with severed heads between their legs, indicating the scores of enemies Narmer has killed. The intertwining of the fantastical long-necked creatures in the next register embodies the unification of Upper and Lower Egypt. In the bottom register, Narmer is again represented as a bull, who bows his head toward a fortified city and tramples on an enemy. The back of the palette features a large scene

bull heads, which represent the aggressive

The back of the palette features a large scene in which the pharaoh, wearing the White Crown that symbolizes Upper Egypt, prepares to club an enemy who kneels before him. The falcon represents the god Horus, suggesting that Narmer was supported by the gods. Horus stands on papyrus plants, symbols of Lower Egypt, where the plants grew. The smaller figure standing behind Narmer is a servant, who carries the pharaoh's

shoes. (Another servant appears behind the ruler on the other side of the palette.) At the very bottom of the reverse side of the palette is a scene of two fallen enemies, viewed as if from above. Much of the picture writing on the palette has not yet been interpreted, but it seems to record the names of places conquered by Narmer. Taken as a whole, the palette shows this pharaoh's military might as he unifies all of Egypt under his rule.

Just as the Palette of Narmer focused on the military successes of Egypt's first pharaoh, Augustus, the first Emperor of Rome, used art as propaganda to demonstrate his military prowess and to claim descent from the gods. Augustus wished to present himself as an exceptional military leader, and in fact he defeated the rival Roman general Mark Antony and Cleopatra, Queen of Egypt, in 31 BCE, and thus expanded the Roman Empire. The Augustus of Primaporta portrays him in military garb and with his arm upraised, ready both to lead his troops into battle and to deliver an inspiring speech (4.97). Cupid, son of Venus, the Roman goddess of love, is shown at Augustus's feet. He represents the divine lineage of Augustus, who claimed to be the descendant of Aeneas (also a son of Venus), the mythical founder of Rome. The pose and proportions were copied from Greek art, which the Romans admired, and were believed to represent an ideal youthful physical form, although Augustus was actually in his forties when the statue was made.

Originally much of the sculpture was painted with bright red and blue, making the scenes on Augustus's armor easier to read. In the center of his chest plate is a scene showing the return of one of the Roman military standards captured by the army of the Parthian Empire, a reference to Augustus's superb diplomatic skills. Both Mark Antony and the talented general and politician Julius Caesar had failed to retrieve the standards, so Augustus's success shows him as more powerful than his predecessors.

A plaque from the palace of an African king suggests, as did the statue of Augustus, that military strength is often needed to bring peace to a kingdom (4.98). The kings, or obas, of Benin, were both military and spiritual leaders of a West African state that was at its height between 1450 and 1700. The obas commissioned hundreds of brass

artworks to reflect their power, including plaques to cover the royal palace, many of which depict warriors who followed the orders of the oba. The central warrior in this plaque is larger than the two beside him, signifying his importance; he is in **higher relief** than the others, making him seem closer to us. The ceremonial sword he carries in his left hand and his elaborate helmet tell us that he is a high-ranking chief. His spear and the shields of those beside him are imposing, emphasizing their physical power and that of their ruler, the oba. The chief wears a leopard tooth necklace and has dotted markings on his stomach and arms resembling the spots of a leopard. Leopards, known for their power and speed, were a symbol of the oba.

4.97 Augustus of Primaporta, early 1st-century CE copy, after original bronze from 20 BCE. Marble, 6'8" high. Vatican Museums, Vatican City

4.98 Plaque with warrior and attendants, 16th-17th century. Brass, 183/4" high. Metropolitan Museum of Art, New York

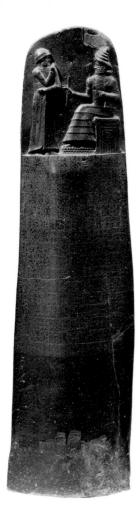

4.99 Stela of Hammurabi, c. 1792–1750 BCE. Diorite, 885/8 × 255/8". Musée du Louvre, Paris, France

Art and Societal Control

Leaders have the authority to try to influence the course of history, and they frequently use art to announce their intentions. Strong leaders also understand the power of art as a tool for propaganda, both to convey their messages and to influence the people to adhere to their laws. The ancient Babylonian king Hammurabi used an image to emphasize his divine connection to the gods in order to persuade his people to follow his decrees. Both the Roman emperor Constantine and the Chinese communist leader Mao Zedong utilized their own portraits on a grand scale to symbolize their political strength.

King Hammurabi of Babylon (now part of Iraq) is best known today for the code of law that he established around 1790 BCE. It was innovative for being a set of written statutes, as opposed to unwritten or arbitrary rules, which might vary by region or local authority. His code was carved into a **stela** for public viewing (**4.99**). King Hammurabi's code has often been summarized as "an eye for an eye," because it often called for a person to be punished for wrong-doing by suffering in the same way as the person who had been wronged. Yet Hammurabi's laws were often more complex and less even-handed when they pertained to people with low status, such as slaves, freedmen, and women. For example, the law did

not punish a husband for adultery, although it did consider the wife's financial well-being if her husband decided to leave her. In contrast, a woman caught in an adulterous affair was thrown into a river, with her hands tied, along with her lover. If her husband only suspected her of adultery, but had no proof, she was required to jump into the river. If she survived, she was deemed innocent.

The scene at the top of the stela shows that Hammurabi's power has been given to him by the gods. The sun god Shamash, seen with flames radiating from his shoulders, is seated upon a throne that is in the mountains, signified by the three steps below the god's feet. The sun god reaches toward Hammurabi as he dictates to the king the laws he will implement. Written below this scene is a long description of the gods' support for Hammurabi and the king's law code.

Constantine the Great ruled part of the Roman Empire from 306 CE and was sole emperor from 324 until his death in 337. Constantine was successful in numerous military campaigns, and he is notable for having been the first Christian Roman emperor. A colossal marble and bronze statue of the emperor seated on a throne was made in 325 to be placed in a **basilica** in the center of Rome. Only parts of the statue survive (4.100), but the head alone, which is more than 8 feet tall, gives an idea of the imposing force one must have felt standing in the presence of this

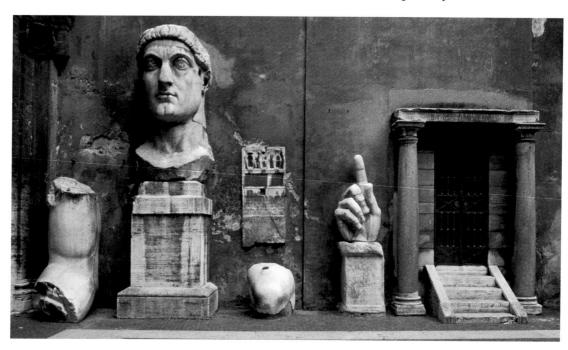

4.100 Remnants of colossal statue of Constantine the Great, 325–6 cE. Marble, head 8'6" high. Palazzo dei Conservatori, Rome, Italy

Stela: upright stone slab decorated with inscriptions or pictorial relief carvings Basilica: an early Christian church, either converted from or built to resemble a type of Roman civic building

statue, which was made to remind the people of Constantine's power even when he was away.

In its youthful features and ideal athletic body, the statue was modeled after portraits of earlier emperors. The emperor was enthroned in a manner similar to seated statues of the Roman god Jupiter, but he held in his hand an orb on which a Christian cross was placed. This statue is one of the earliest examples of how pagan art was often reinterpreted to incorporate Christian symbolism and meaning. Constantine's far-off gaze toward the heavens is also distinct from earlier portraits of Roman emperors and signifies his close connection to, and therefore power derived from, God.

Mao Zedong led the Communist Party to power in the Chinese civil war that ended in 1949. Mao, who ruled the most populous country in the world for twenty-seven years, understood the power of imagery and, like leaders for centuries before him, used artwork to promote his political and social agenda amongst his thousands of subjects. Mao installed a huge portrait of himself at Tiananmen (the Gate of Heavenly Peace), in Beijing, the capital of China, when he declared the country to be the People's Republic of China (4.101). Tiananmen, the site of many important political and cultural events in China's history, was built in the fifteenth century as a gateway to the Forbidden City, the home of the Chinese emperors for centuries. The portrait has been replaced over the years by replicas with only slight

white suit seen in the portrait today, but his head was slightly turned. In the mid-1960s the portrait was altered to show both of Mao's ears, symbolizing that he listened intently to the people. The total number of portraits of Mao made for this location is unknown; however, the Chinese appear to have copies in storage in case of damage to the one currently hanging.

variations. Originally Mao wore the collared

Mao's colossal image is considered a national symbol in China. Portraits of Mao, in the form of posters, paintings, sculptures, badges, and postage stamps, were disseminated more than any other image throughout China in the 1960s and 1970s. When Mao died in 1976, the large oil painting at Tiananmen was replaced temporarily with a black-and-white photograph to signify China's mourning. The portrait is a powerful symbol both for supporters of the Chinese government as well as for its opponents. It was splattered with red paint during the pro-democracy student protests of 1989, and in 2007 an unemployed man set fire to it. In both cases, the portrait was replaced immediately and the vandals arrested.

4.101 Mao Zedong's portrait. The Gate of Heavenly Peace, Tiananmen (south entrance to the old Forbidden City).

Beijing, China

Discussion Questions

- 1 In this chapter we have examined portrayals of rulers from many cultures and eras. Find another artwork in which a ruler is represented. Considering the elements and principles of art discussed in Part 1 of this book, perform a visual analysis of your selected artwork. How does the artist convey the power of the ruler?
- Rulers are often shown as powerful warriors. Select one such work from this chapter and then find another in another chapter in this book (for example, 1.133, 3.12, 4.27): make sure the two are from different cultures or eras. Compare the two representations. In what ways are they similar and in what ways different?
- Do royal portraits tell us what a ruler really looked like? Choose four examples from this chapter and for each make a list of aspects of the artwork that seem individual and realistic and those aspects that may exaggerate or idealize the ruler's appearance. Discuss your findings in a short essay.

Art and War

War has been a theme of artworks for centuries. Artists re-create the terror of battle, the tragedy of death, the joy of victory, and the sorrow of defeat. Artists choose war as a theme for a variety of reasons: to educate us about the realities of conflict, to inspire us through the depiction of heroism, or to shock us into opposing violence. Artworks about historical events can be rich sources of information, skillfully documenting the kinds of weapons used in a particular battle or the uniforms the soldiers wore; but artists may also manipulate scenes in order, for example, to inspire support for one side over another. Art about war should therefore be treated with caution, for just as we bring our own biases when we engage with an artwork, so artists may also be promoting their own point of view.

Documenting War: Unbiased Facts or **Biased Judgments?**

As a viewer, do you question certain visual documents of history more than others? Do you assume that visual images (such as photographs and video) that show current events are accurate, or do you sometimes think they might have been manipulated?

When artists document actual events, they may try to record exactly what they have seen. More frequently, however, artists tend to infuse their images with the emotions aroused by the sight of death, destruction, and tragedy. An image of battle,

therefore, can have a profound impact on the people who see the artwork, even as the artist's emotions sometimes distort the facts of history. Art that seems to be documentary evidence may not be entirely factual. It is important to assess the art of war with great care and attention as to the context in which the work was created. (For two contrasting views of the same battle, see Gateway Box: Goya, **4.104** and **4.105**, p. 532.)

American Timothy O'Sullivan (1840–82) took the famous Civil War photograph Harvest of Death after a day at Gettysburg, the battle that caused the most casualties of the entire conflict (4.102). His photograph shows a field covered with bodies, highlighting the tragic loss of life. The clothes of some of the soldiers have been partly removed, suggesting that thieves have been searching their bodies. O'Sullivan has focused the composition on the face of the soldier in the foreground, his arms flung out from his sides. By concentrating on this individual, whose features we can see, O'Sullivan reduces to a human level the great loss of life at Gettysburg.

One often assumes that a photograph can be trusted as an accurate documentation of an event. Yet photographers, like other artists, can manipulate their scenes through lighting and **composition**. O'Sullivan was known to rearrange bodies and otherwise alter the setting before taking his photos. We do not know if he arranged the corpses or their clothing in order to heighten the emotional impact of this powerful image. If we knew he had staged the scene in some way, would we doubt the truth of the tragedy he represents?

Composition: the overall design or organization of a work

4.102 Timothy O'Sullivan, Harvest of Death, Gettysburg, Pennsylvania, July 1863. Photograph. Library of Congress, Washington, D.C.

We tend to assume that photography is "real" in a way that painting is not. In contrast to a photographer, who makes an image of a subject that already exists, a painter begins with a blank canvas. The French painter Ernest Meissonier (1815-91), however, depicted a scene that eyewitnesses to the event described as remarkably accurate, as truthful and "real" as one would assume an eyewitness video to be today (4.103).

Meissonier was serving in the French National Guard during the insurrection of 1848, when Parisians fought their fellow Parisians, and rebels overthrew the monarchy and established the Second Republic. More than 1,500 people died in the short civil war, many of them innocent bystanders. Meissonier recorded the carnage:

I saw the defenders shot down, hurled out of windows, the ground strewn with corpses, the earth red with blood.

In his painting, bodies are piled one upon another amongst the rocks of a collapsed barricade in the middle of Paris. The painting, admired at the time as a true representation of what had happened, was removed by the French government from the important public art exhibition, the Salon of 1850, because it provided too powerful a reminder of the recent past.

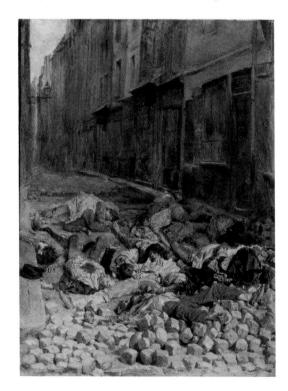

4.103 Ernest Meissonier, Remembrance of Civil War. 1848 (The Barricade, rue de la Mortellerie, June 1848), exhibited 1850. Oil on canvas, $11\frac{1}{2} \times 8\frac{3}{4}$ ". Musée du Louvre. Paris, France

Gateway to Art: Goya, *The Third of May, 1808* **Two Views of a Battle**

Sometimes, we can look at a painting on its own and reach one conclusion; but when we look at it next to another work, our opinion of both paintings changes. If we look at Francisco Goya's painting *The Third of May, 1808* on its own, for example, we might conclude that it is a powerful condemnation of the French Emperor Napoleon and his troops (4.104). But what happens if we view the work beside another that Goya painted in the same year, *The Second of May, 1808* (4.105)? Can both paintings be understood better as a condemnation, not of Napoleon in particular, but of war in general?

The Spanish War of Independence (1808–14), the beginnings of which are depicted in *The Second of May, 1808*, was known for its guerrilla fighting and for the heroism of the civilian population. Goya's *Third of May* shows the punishment of civilians who had brutally attacked the invading French soldiers on the

previous day (the subject of *The Second of May, 1808*).

Unlike The Third of May,
The Second of May does not
show sympathy for the Spanish
rebels. While the figures in The
Third of May seem to be still, as
if frozen by the horror of the
moment, The Second of May is
full of movement and chaotic
action. In fact, when the two

paintings are viewed together, we may view the executions on May 3 to be inevitable following the violent slaughter of French soldiers the day before. The French general Joachim Murat, angered by the riots, proclaimed, "French blood has flowed. It demands vengeance." At least 400 Spaniards were executed in Madrid, more than forty on the hill of Príncipe Pío, the location depicted in Goya's *Third of May*.

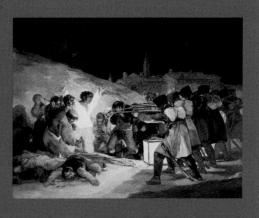

4.104 Francisco Goya, *The Third of May, 1808*, 1814.
Oil on canvas, 8'4%" × 11'3%".
Museo Nacional del Prado,
Madrid, Spain

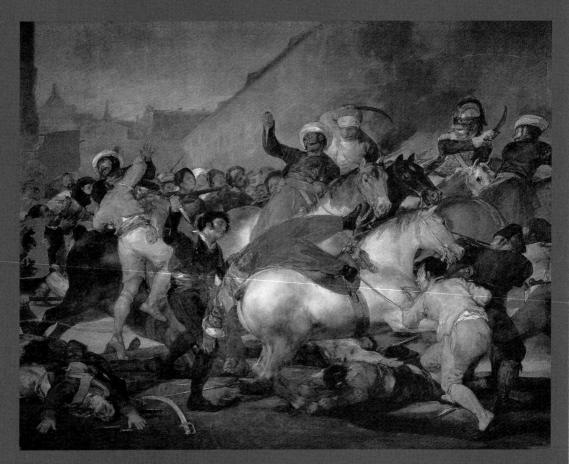

4.105 Francisco Goya, The Second of May, 1808, 1814. Oil on canvas, 8'9" × 11'4'/8". Museo Nacional del Prado, Madrid, Spain

Historians consider O'Sullivan's and Meissonier's artworks to be amongst the most truthful records of the aftermath of battle, yet the emotional impact created by each scene suggests that they may have been somewhat manipulated. The photograph by the Vietnamese Nick Ut (b. 1951) of children running from their village in Vietnam after a napalm attack was so shocking that some, including the U.S. president Richard Nixon, questioned its authenticity when it appeared in newspapers on June 12, 1972 (4.106). The image also moved many Americans to question their nation's involvement in the Vietnam War. The photographer defended its authenticity for years:

The picture for me and unquestionably for many others could not have been more real. The photo was as authentic as the Vietnam War itself. The horror of the Vietnam War recorded by me did not have to be fixed. That terrified little girl is still alive today and has become an eloquent testimony to the authenticity of that photo.

Although the photograph records an actual event, Ut's disapproval of the war and his concern for its victims influenced the way his shot was composed. He focused on the little girl, Kim Phuc, screaming in terror, running naked, her clothes having been burned off her body. Her two brothers are running on the left side of the image, while her two cousins hold hands behind her on the right. The soldiers in the background appear strangely calm, a dramatic contrast to the horrified expressions of the running children.

The story of the people in the photograph did not end with that moment. The nine-year-old girl kept screaming; the photographer gave her his water and rushed her to a hospital. Physicians predicted Phuc would die. But because of the fame of the photograph, money poured in to save her. She underwent seventeen surgical operations and later emigrated to Canada. Nick Ut became "Uncle Nick" to the little girl and the two have remained in close contact throughout their lives. Although this photograph shows the suffering of a small group of people, it symbolizes for many the tragedy of the entire Vietnam War.

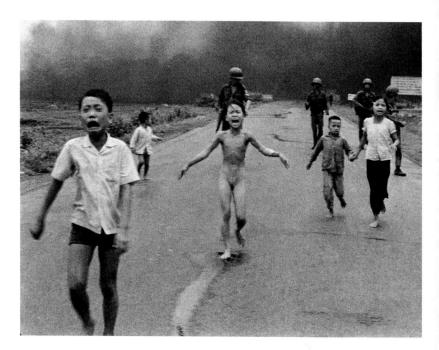

4.106 Nick Ut, Vietnamese Girl Kim Phuc Running after Napalm Attack, June 8, 1972. Photograph

In contrast to Nick Ut, who stated plainly that he opposed the Vietnam War and wanted to influence opinion with his images of the conflict, the American artist Chris Burden (b. 1946) has said that his 1987 work All the Submarines of the *United States of America* was meant to be unbiased: it simply documented the total number of submarines there had ever been in the United States Navy up until the year this artwork was made (4.107). His installation comprises 625 cardboard models of submarines hung at

4.107 Chris Burden, All the Submarines of the United States of America, 1987. 625 cardboard submarines. $80 \times 20 \times 12$ '. Installation at the 1989 Whitney Biennial

Installation: an artwork created by the assembling and arrangement of objects in a specific location

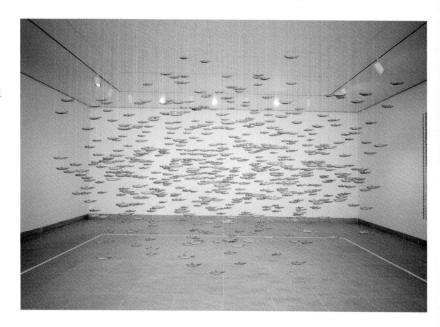

different heights from the ceiling of a large room. The name of each submarine is listed in black on a wall of the gallery.

It is left to the viewer to interpret the artwork, as the piece embodies opposing forces: individualism versus unity, war versus peace. Individualism is represented by each crafted submarine; at the same time, the submarines work as a whole unit, appearing in the room like a school of fish. One viewer might naturally see U.S. Navy submarines as weapons of war because submarines are stealthy by nature, traveling secretly under water. Another viewer, conversely, might interpret a submarine as a tool for keeping the peace.

Warriors and Scenes of Battle

Artists have often recorded and celebrated the bravery of warriors, both their successes and defeats, in great detail. Although at times, as we have seen, an artist's interpretation of historical events is skewed and presented through an emotional lens, artworks can be valuable records of critical historical moments. They can teach us the significance of certain battles, and provide accurate studies of the kinds of weapons used and the uniforms worn by those who took part in them.

4.108 Tula warrior columns, 900–1000 cE. Basalt, 15–20 high. Tula, Hidalgo, Mexico

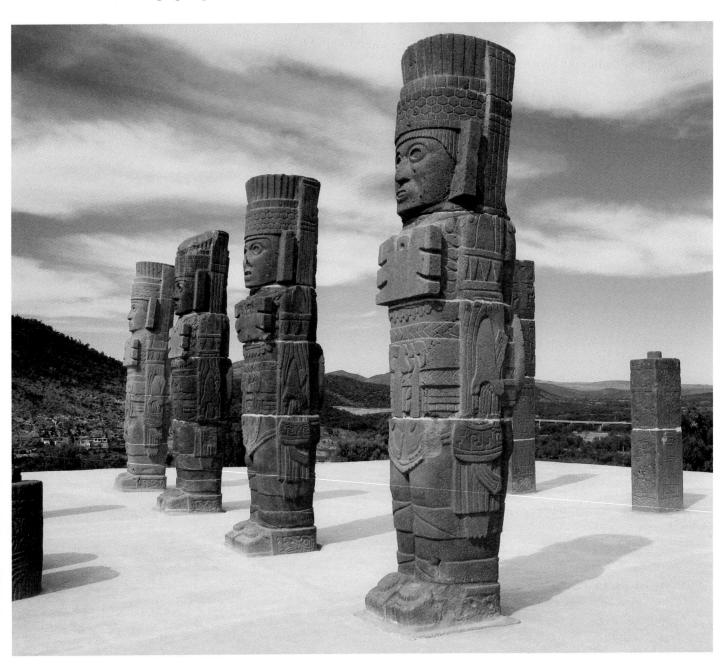

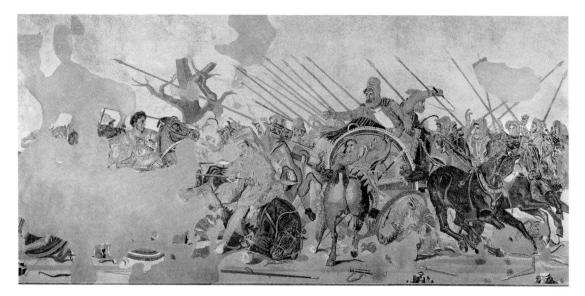

4.109 Alexander Mosaic (Battle of Issus), c. 200 BCE. Mosaic. 8'10" × 16'9". National Archaeological Museum, Naples, Italy

Four large warrior columns, standing between 15 and 20 feet tall, are some of the few remaining artworks of the ancient Toltec people of Mexico (4.108). Little is known about this militaristic society except what can be learnt from the legends of later cultures, such as the Aztecs, who often sought to demonstrate an ancestral link with the Toltec. These legends suggest that the Toltec ruled a substantial empire. It is believed that around 1000 CE the Toltec capital of Tula was the largest city in Mexico at that time, with a population of more than 50,000.

The warriors in 4.108 stood high above the city, painted in bright colors. The imposing figures once supported the roof of a temple that stood on a pyramid and was reached by a steep stairway. The carving of the columns gives us some sense of how a Toltec warrior would have looked. The figures are identical, each wearing a feathered headdress, a butterfly-shaped **pectoral**, sandals decorated with symbols of the gods, and a belt supporting a large mirror or shield on their lower back. Each warrior holds spears or arrows in his left hand and a spearthrowing device in his right. Similar warriors—ranging from the small scale to the large, and occurring both as freestanding figures and as columns in temples comprise the majority of the few Toltec sculptures that survive. This suggests that the Toltec probably lived in a time of frequent warfare, and that they revered their warrior rulers.

The Tula warriors are not shown fighting in the heat of battle but are standing still, acting as guards. By contrast, the so-called *Alexander* Mosaic in 4.109 glorifies the military prowess of Alexander the Great (shown on the far left) and his victory over King Darius III of Persia (to the right of center) in the Battle of Issus in 333 BCE.

This **mosaic**, a copy of a well-known Greek painting that does not survive, was made around 200 BCE for a private home in the city of Pompeii in southern Italy. Its dynamic composition gives us an idea of the beauty of Greek **fresco** painting, complete examples of which no longer exist. It also displays the skill of ancient mosaicists, who pieced together more than one million tesserae in numerous subtly different shades to create a battle scene with layers of depth and figures with three-dimensionality.

The composition of the Alexander Mosaic is designed to convey action and emotion. The men and horses are crowded together in the lower two-thirds of the scene, while the lengthy spears pointing in various directions evoke the chaos that takes place on the battlefield. Darius is shown rising above the rest, eyes wide open with fear. The horses communicate the urgency of the movement with their expressive faces and their bodies turning in every direction, including away from the viewer. Under Darius's left arm, and lying on the ground, one man witnesses in horror his own demise through the reflection in his shield. Alexander (on the left) is depicted as a fearless warrior, ready to face Darius's entire army as he stabs an enemy soldier with his long spear.

Pectoral: a large ornament worn on the chest Mosaic: a picture or pattern created by fixing together small pieces of stone, glass, tile, etc. Fresco: a technique where the

artist paints onto freshly applied plaster. From the Italian fresco,

Tesserae: small pieces of stone or glass or other materials used to make a mosaic

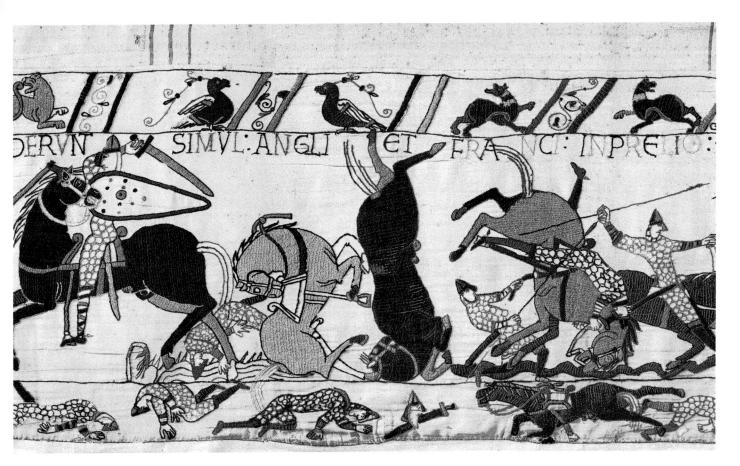

Other artists have conveyed the sounds and sensations of war using completely different **media**. Both the *Bayeux Tapestry* and the *Tale of the Heiji Rebellion (Heiji Monogatari)* portray rousing battle scenes (**4.110** and **4.111**). We can almost hear the clanking of weapons and smell the odor of burning flesh. And while a few figures illustrate the courage of the enemy, both artworks are skewed toward celebrating the overwhelming prowess of the victors. Both artworks, too, consist of multiple scenes and are meant to be viewed slowly, unravelling their historical stories one incident at a time. Their very long horizontal formats take the viewer on a visual journey through history.

The 275-foot-long *Bayeux Tapestry* records the events surrounding the Battle of Hastings (1066), in which the Normans, led by William the Conqueror, seized control of England from the Anglo-Saxons. It was probably commissioned by William's brother Odo, the Bishop of Bayeux in France, shortly after the Norman victory. The so-called **tapestry** was actually embroidered by women (legend says William's wife was one of the embroiderers), and took more than ten years

to complete. It shows the events that led to the battle, the preparations of the Norman fleet, the Battle of Hastings itself, and finally the coronation of William the Conqueror as King of England. More than six hundred men, but only three women, are shown in the fifty scenes on the tapestry. The embroiderers were highly skilled. To establish a sense of depth, each figure is given a border, which is filled in with stitches running in the opposite direction to the rest of the embroidery, and then outlined in boldly contrasting colors. The process creates clearly delineated figures, a flat sense of space (to guide the viewer in a horizontal direction), and, through repeated patterns, a sense of overall rhythm.

The Night Attack on the Sanjo Palace (4.111) is one scene from one of five long painted scrolls that depict battles from the Tale of the Heiji Rebellion, a Japanese war epic about the short-lived Heiji era (1159–60). In this period several clans fought for control of Kyoto, the historical capital of Japan. This scene shows the burning of the palace by samurai warriors of the Fujiwara and Minamoto clans during the raid in which

4.110 Detail of Battle of Hastings, *Bayeux Tapestry*, c. 1066–82. Linen with wool, 275' long. Bayeux Tapestry Museum, Bayeux, France

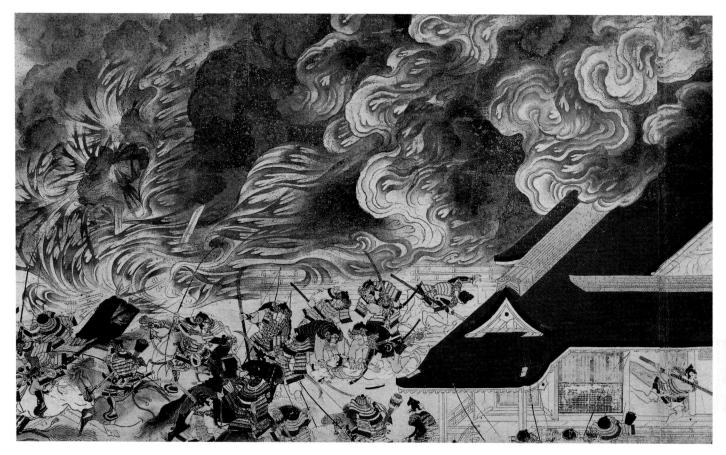

4.111 Night Attack on the Sanjo Palace, from Heiji Monogatari, Kamakura period, late 13th century. Hand scroll, ink and color on paper, $16\frac{1}{8}$ " \times 22'11 $\frac{1}{4}$ " (whole scroll). Museum of Fine Arts, Boston

they captured the Emperor Nijo. Soon afterward, another clan, the Taira, rescued the emperor and regained control of Kyoto.

Like the *Bayeux Tapestry*, the *Night Attack on* the Sanjo Palace is representative of the visual style of its period. The 23-foot-long Japanese scroll employs **isometric perspective** from a bird's-eye view: the diagonal lines of the buildings and the layering of the figures function as a kind of guide to direct the viewer (reading from right to left) from one scene to the next. The horses and warriors are carefully delineated and detailed. The precise lines and limited use of blurry brushwork (as in the horses' tails and the billowing smoke) demonstrate the artist's intense skill.

As with the sculptures of the Toltec warriors, the attention to detail in both the Japanese scroll and the Norman tapestry gives us a strong sense of the equipment and weapons used by the warriors of these peoples. The Japanese samurai

are shown covered in intricately detailed armor atop their fine and powerful horses. Lengthy bows and arching swords are their weapons of choice. The soldiers of the Bayeux tapestry wear patterned armor and conical helmets, and carry broadswords, kite-shaped shields, and spears.

The Artist's Response to War

Artists have often created artworks that attempt to convey their personal experience of war. This is sometimes a cathartic exercise, releasing emotion, and it is sometimes meant to inspire awareness of the realities of war. But by no means all powerful responses to war have been created by artists who actually witnessed the events they portray. Artists can produce powerful visual statements about the horrors of war from both their experiences and their own imagination. (See the Perspectives on Art Boxes: Michael Fay, Storm and Stone: An Artist at War, pp. 538-9, and Wafaa Bilal, Domestic Tension: An Artist's Protest against War, p. 540.)

Medium (plural media): the material on or from which an artist chooses to make a work of art

Tapestry: hand-woven fabricusually silk or wool-with a non-repeating, usually figurative, design woven into it Rhythm: the regular or ordered repetition of elements in the work

Isometric perspective: a system using diagonal parallel lines to communicate depth

Perspectives on Art: Michael Fay

Storm and Stone: An Artist at War

Michael Fay was a combat artist in the United States Marine Corps. He is now retired from the Marines. As he says, "I am a combat artist. My job is simple, go to war, do art." Here he explains how he created one of his works and why, even in war, fine art has value.

I am often asked why, in our era of instant digital satellite imagery, the traditional practice of fine art is still valid in capturing images of war. Perhaps the answer lies in the "slowed" vision of the images. With a painting or sculpture the artist can take many personal impressions, images, and memories and through the creative process distill them into a single composite creation. War is often seen as one of the most potentially dehumanizing and destructive experiences and perhaps it is also reassuring that artists are still willing to witness and create from it.

My painting, Storm and Stone, is a composite of personal experiences while deployed to Afghanistan during the spring

of 2005 (4.112). I participated in a long-range patrol into the foothills of the Tora Bora Mountains to a place called Wazir Pass. The ride there was a bone-jarring journey crisscrossing rivers swollen with the spring melt, and along rocky trails lined with mulberry trees, and whitewashed stone cairns warning of minefields.

4.112 Michael Fay, Storm and Stone

The German painter Otto Dix (1891–1969), who fought in World War I, recorded the horrors he witnessed in the painted **triptych** *The War* (4.113). The central panel shows death and destruction. A soldier wearing a gas mask, representing Dix himself, witnesses the devastation first hand. Bloody bodies are piled on top of one another, one with legs in the air. Chaos fills the scene. Arched pieces of metal stretch out across the sky and support a skeletal figure, whose outstretched finger points toward the bulletridden body on the right. The arching forms enclose the scene, leaving us feeling smothered by the horror that is shown. Our anxiety is increased with nothing to calm us or to rest our eyes upon.

The left wing of the triptych shows heavily equipped soldiers, united in their duty and prepared for battle. The scene precedes the horror that will take place in the central panel. The right-hand wing shows a man, a self-portrait of Dix, carrying a wounded soldier. The sky in the triptych symbolizes the increasing danger of the situation, beginning on the left with pale sunlight, moving toward foreboding clouds, and ending with a stormy and destructive sky on the right. Underneath the central panel, in a section called the **predella**, Dix has painted a sleeping or dead soldier, lying in a trench.

The triptych format is traditionally used for religious scenes, with Christ's crucifixion portrayed in the center and his entombment in the predella below. By using this format, Dix elevates the importance of his subject matter. And in associating an ordinary soldier with the soon-to-be-resurrected Christ, he endows him with the status of a martyr.

Everywhere you looked there was the intense beauty of earth and sky framed by snow-capped peaks. At the same time this beauty was juxtaposed with the imminent threat of a violent death.

Our first night out was marked by the most violent thunderstorm I've ever witnessed. In the lightning flashes through thick curtains of torrential rain I could see fellow Marines being rolled about in uprooted tents. Later, in the damp inky blackness, I could hear them stumbling about righting gear and nursing bruised bodies. With the next day's dawn the phrase storm and stone was deeply etched in my mind.

Storm and Stone is essentially figures in a landscape. I wanted to express several key elements: an expanse of space, groups of figures, and the approach of a storm. But I also wanted to get something of the feeling of being far off the beaten path in the most violent and dangerous place on Earth. From field sketches and photos I created two distinct groups of figures. To the far left are four Marines, the basic "fire team," and at the right is a lieutenant pointing into the distance while conferring with his sergeant. I deliberately left a void, a source of visual

tension, in the middle. I was not after a wellbalanced soothing pastoral effect, but rather something unsettling that went to the core of my own personal experience on that particular patrol.

My own artistic impulse is naturalistic. to render as closely as possible the reality of what is before me in the context of my own experience. It is also my hope that this personal experience, though grounded in realism, is more poetry than prose, and more art than journalism. I have been to war; in the heat, watchful and tense at the beginning of a dawn raid; surrounded by children at the edge of a soccer field littered with unexploded mortar rounds; confronted by the slack and ashen gray faces of friends killed in battle. I have been discomfited by the horrors and boredom of war, and at the same time filled with the mystery of people and places in times of conflict. It is from this internal chemistry, steeped in genuine experience and rooted more in art than science, that I've tried to create an exterior reality, a body of authentic artwork flowing from the most controversial and demanding of human experiences... war.

Triptych: an artwork comprising three painted or carved panels, normally joined together and sharing a common theme Predella: an artwork designed as a companion piece to a more important work

4.113 Otto Dix, The War. 1929-32. Oil and tempera on wood, $6'8\%'' \times 13'4\%''$. Staatliche Kunstsammlungen, Gemäldegalerie Neue Meister, Dresden, Germany

Perspectives on Art: Wafaa Bilal

Domestic Tension: An Artist's Protest against War

4.114 Wafaa Bilal, Domestic Tension

Iraqi-born Wafaa Bilal teaches photography and art and technology at the School of the Art Institute of Chicago. His art reflects his concerns with the injustices committed in Iraq under the dictatorial regime of Saddam Hussein and, since then, during American military operations in the country.

As an Iraqi artist living in the U.S. since 1992, I have created many provocative works to raise awareness and create dialog about U.S.-Iraq conflicts. But when my brother Haji was killed by an American bomb at a checkpoint in our hometown of Kufa, Iraq, in 2004, the war became deeply personal.

I had to find an unconventional new approach to translate this tragic event into a work of art that empowered its audience. Not something that lectured the audience, nor something dogmatic, but a dynamic encounter between me and my audience.

A TV news segment about a soldier in Colorado remotely dropping bombs on Iraq highlighted the anonymous and detached nature of this current war, and the complete disconnect between the comfort zone here in the U.S. and the conflict zone in my home country. I needed to create a platform for people to be nudged out of their comfort zone.

The result was an interactive performance entitled *Domestic Tension* (4.114). I stayed in a Chicago gallery for a month with a paintball gun aimed at me. People could control the paintball gun, and command it to shoot at me, over the Internet.

I wanted to create a virtual and physical platform, turning the virtual to physical and vice versa, and, by putting my body on

the line, create a physical impact in viewers by enabling them to identify with the physical effect on my body.

The project generated worldwide attention, with more than 60,000 shots taken and 80 million hits to the website from 137 countries.

I never anticipated how many people would be drawn to the project and how it would become a truly dynamic artwork in which the viewers had control over the **narrative**. It achieved an unexpected goal of democratizing the process of the viewing and the making of the artwork, by enabling the audience to participate.

As evidenced by dialog on the website's chat room, the experience had a profound impact on many people from all sides of the political spectrum. At the conclusion of the project, I felt fulfilled in my mantra that, "Today we silenced one gun; hopefully one day we will silence all guns."

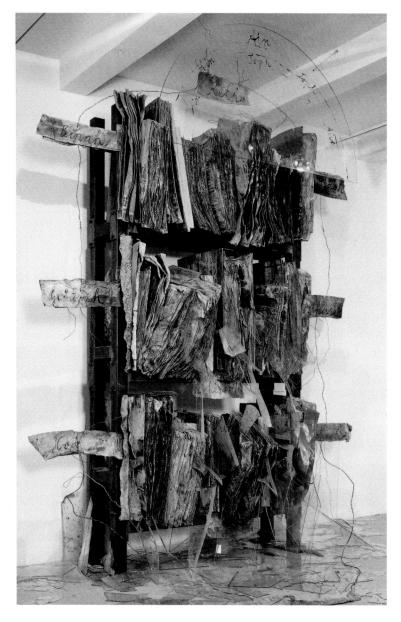

4.115 Anselm Kiefer, Breaking of the Vessels, 1990. Lead, iron, glass, copper wire, charcoal, and Aquatec, $12.5" \times 27.5 \frac{1}{2}" \times 17"$. St. Louis Art Museum, Missouri

During World War II, Otto Dix's work was censored by the Nazis for its negative presentation of war. The contemporary German artist Anselm Kiefer (b. 1945) addresses such censorship in his work. Kiefer was born in Germany just months before World War II ended. He grew up in a society ashamed of its past. His artworks force viewers to acknowledge the horrors of the Nazi regime that ruled Germany from 1933 until 1945. His attempts to confront this past have often shocked and angered Germans. For example, he photographed himself making the Nazi salute—a gesture that has been illegal in Germany since 1945.

Kiefer's *Breaking of the Vessels* conveys the loss of life and the destruction of knowledge caused by the extermination of millions of Jews during

the Holocaust (4.115). The imposing 27-foot-tall artwork is made of lead and glass. The heavy lead books appear to be scorched, just like the human beings (also holders of knowledge) who were incinerated in concentration camps. The shattered glass also recalls Kristallnacht (Night of the Broken Glass), when the Nazis destroyed hundreds of Jewish stores and synagogues in 1938. The splintered glass on the ground makes any access to these books of knowledge a dangerous and frightening proposition. Symbolically, Kiefer has conveyed the fear and pain one must face to confront the past.

In Breaking of the Vessels, Kiefer draws upon the Jewish religion and more specifically the Kabbalah, a collection of Jewish mystical writings. The words "Ain-Sof," which mean the infinite presence of God, are written on the arched piece of glass above the bookshelf. Ten lead labels are placed around and on the bookshelf; these represent the ten vessels containing the essence of God as described in the Kabbalah. In this way, the books represent the presence of God even in the midst of human destruction.

Discussion Questions

- 1 Find an artwork that depicts a battle. Perhaps choose one from the Revolutionary War, Civil War, or a famous battle from European history. Study the history of the battle and then ask yourself whether the artist recorded the event accurately. Did he or she try to persuade the viewer to support one side in the battle? How?
- 2 Find a photograph that documents a scene from the Civil War, World War II, or the Vietnam War. Considering the elements and principles of art discussed in Part 1 of this book, perform a visual analysis of the photograph. What does this tell you about the way the artist used the medium of photography to convey a message?
- Study images of the entirety of the *Bayeux* Tapestry and of the Heiji Monogatari scroll. Bearing in mind the format of these works, how do they use their format to convey a narrative? Stylistically, how does each artwork show scenes of battle?

Narrative: an artwork that tells a story

4.8

Art of Social Conscience

The visual language of art can be an extremely effective medium for communicating a point of view on social issues. While words can describe an event, art can demonstrate it visually with raw power. Art often reflects historical, social, and political concerns. It can even provoke change. Artists can spur people to become involved in a social issue, and can call for the punishment of those responsible for a wrong. Art is able to arouse such strong emotions that artworks themselves can become the focus of protest, sometimes suffering damage or destruction as a result. Art can commemorate with enormous power the sacrifices made by individuals or an entire nation. It can also inspire us toward a better and more just world. This chapter is concerned with the ways that artists have expressed their convictions through artworks that have, at times, caused powerful, even violent, reactions.

Art as Social Protest

By creating potent artworks that activate emotional responses, artists can instigate social change. Here we examine artworks that have sought to combat cruelty and slavery, and protested against the barbarities of war. And, closer to

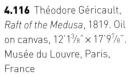

Perspectives on Art: Dan Tague

Art Made from Dollar Bills

4.117 Dan Tague, Unite NOLA, 2008. Archival inkjet print on rag paper, 42 × 34". Collection New Orleans Museum of Art

> The American artist Dan Tague (b. 1974) lives and works in New Orleans. He was displaced for a year after Hurricane Katrina, in 2005. When he returned to the city he created a series of works made from folded dollar bills to protest at the lack of resources to rebuild New Orleans (4.117). Here he explains why and how he made these artworks.

The appeal and power of money are the issues at the core of this series. In a capitalist society cash rules everything. Society teaches us that

you can buy love, happiness, and status through possessions. You can even right wrongs by taking away a bit of someone's happiness through fines and lawsuits. Politicians buy votes through claims of lowering taxes.

Lack of money was the reason that the rebuilding of New Orleans was slow and for most of the city non-existent for well over a year after Katrina devastated the city. Displaced, confused, and feeling neglected, I decided to use the design qualities of dollar bills, which contain detailed decorative engravings, masterful portraits and architectural renderings, and elegant type. I folded and twisted the bills to create abstract imagery. The precise and calculated folds of the bills combined to make political messages from the letters on the bills in such works as Unite NOLA (New Orleans, LA) as a battle cry for the community and the nation to take action; Home Is a Tent, inspired by people living in a tent city; and The End Is Near, referring to the failing economy and failure to rebuild the city.

I scanned the folded bills at very high resolution and made ink-jet prints on archival rag paper. I made fifteen prints and showed them at the Jonathan Ferrara Gallery, in New Orleans, and later at galleries in New York, North Carolina, and Florida.

home, we look at a project that focused attention on the plight of the people of New Orleans after Hurricane Katrina in 2005 (see Perspectives on Art Box: Dan Tague: Art Made from Dollar Bills). While considering this section's protest artworks from past and present, also think about your own response. Does the artist inspire you to agree with his or her point of view?

The painting *Raft of the Medusa* (**4.116**), by the French artist Théodore Géricault (1791–1824), memorializes on a grand scale a scandalous event in history. On July 2, 1816, the French naval vessel Medusa ran aground off the coast of West Africa. While the captain and approximately 250 crew

boarded the lifeboats, the rest of the passengers— 146 men and one woman, some of them slaves got onto a makeshift raft that had been built from the wreckage. Although the raft was pulled by the lifeboats initially, the captain soon abandoned it. Left to battle starvation, sunburn, disease, and dehydration, only fifteen men survived the horrors of the sea; some cannibalized their shipmates. Géricault's painting shows with emotional intensity the moment when the raft's survivors are about to be rescued.

Géricault interviewed the survivors, studied corpses, and even had a replica of the raft built in his studio in preparation for this project. The

Abstract: an artwork the form of which is simplified, distorted, or exaggerated in appearance. It may represent a recognizable form that has been slightly altered, or it may be a completely non-representational depiction

Composition: the overall design or organization of a work

survivors told him of their despair and madness when they saw a ship on the horizon on the thirteenth day. They had seen ships in the distance before but the ships' crews had not seen them, and many feared this ship, too, would disappear. But the survivors, all close to death, were rescued, and they told the world the story of their abandonment.

In Raft of the Medusa, Géricault depicts the emotions of the survivors. Several men, their arms reaching out toward the tiny ship in the distance, convey desperate hope. Another is shown still slouched in despair, and surrounded by corpses; he even holds one on his lap. The artist painted the skin of the men with a green pallor to indicate that they are near to death. Yet the musculature of their bodies gives them nobility. Standing at the painting's apex, atop a pyramid of bodies, a black man waves a piece of his clothing to get the attention of the ship in the distance. The dramatic intensity is heightened by the use of diagonal lines that compose the figures into a large X. From the bottom left corner of the **composition** the bodies of the men are arranged in a line that leads the viewer's eye to the black man in the upper right. An opposing diagonal is

made from the mast in the upper left to the nude male body on the lower right, which appears to be falling from the raft.

Géricault's picture criticizes not only the *Medusa* disaster but also colonization and slavery. Although only one African survived the wreck, Géricault includes three in this painting, including the powerful figure trying to attract the attention of the distant ship.

A couple of decades later, the British painter J. M.W. Turner (1775–1851) created a painting that also condemned the slave trade (4.118). Although slavery was illegal by this time throughout Britain, Turner was highlighting the injustice of the slave trade and protesting against any consideration of its renewal. His dramatic canvas portrays an infamous incident aboard the slave ship Zong in 1781. It was common practice for slave-ship captains to fill their vessels with more slaves than they would need, knowing that disease might spread amongst them. The captain of the Zong knew that he would be paid for any slaves lost at sea, but not for those who were sick when they arrived. He therefore had sick slaves thrown overboard while still far from land.

4.118 Joseph Mallord William Turner, *Slave Ship* (*Slavers Throwing Overboard the Dead and Dying, Typhoon Coming On*), 1840. Oil on canvas, $35\sqrt[3]{4} \times 48\sqrt[3]{4}$ ". Museum of Fine Arts, Boston

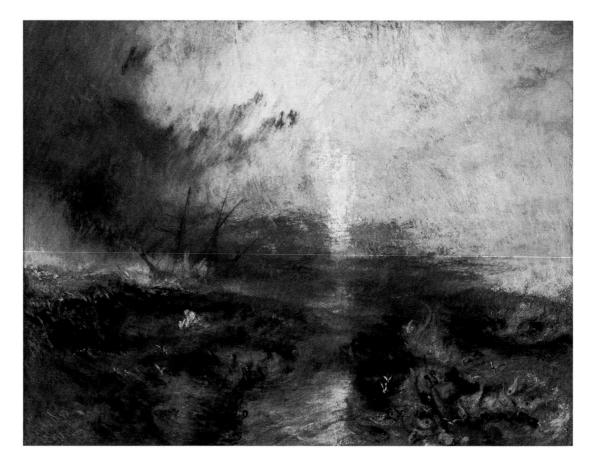

Turner's chaotic canvas shows a fierce storm. Body parts, still shackled and being attacked by sharp-teethed fish, can be seen in the central and right foreground. Turner uses intense colors and turbulent brushstrokes to convey the heightened emotion of the event. Man versus nature was a common theme in art during the nineteenth century, and here the immense power of nature overpowers the slaves. Turner's canvas has an abstract quality, making its subject matter difficult to understand. Turner placed beside his painting a quotation from the book that had inspired it, in order to help viewers understand his artwork's meaning.

The Spanish artist Pablo Picasso (1881–1973) painted Guernica as a passionate response to the aerial attack carried out on April 26, 1937, on a small town of that name in northern Spain (4.119). During the Spanish Civil War, the Nationalist general Francisco Franco, who would later become the country's ruler, allowed German and Italian planes to test their bombing tactics on Guernica and learn about the psychological effects of air warfare. More than 1,000 civilians were killed in three hours of bombing. News of the attack quickly spread to Paris, where Picasso read stories and saw photographs of the devastation.

While the general meaning of Guernica is clearly outrage against the violence directed at the citizens of the small Spanish town, Picasso never explained the specific symbolism of the figures in the painting, nor elaborated on his political motivations for the work. Picasso would have accepted all interpretations because he believed in viewers making their own reading of an artwork. He stated:

A picture is not thought out and settled beforehand. While it is being done it changes as one's thoughts change. And when it is finished, it still goes on changing, according to the state of mind of whoever is looking at it.

The painting is black, gray, and white, perhaps because Picasso associated the attack with blackand-white newspaper photographs. The small dashes on the body of the horse also seem to recall the print from a newspaper. Expressive faces with distorted necks scream and cry in despair. On the right, a figure reaches to the sky as it escapes from a burning building; flames appear like scales on the back of a dragon. The tortured figure on the left experiences the horror of her child's murder.

The bull, often associated with the violence of Spanish bullfighting, is seen by many as a symbol of Franco. The terrified horse, as it tramples upon a man lying on the ground, may represent the chaos inflicted upon the people by the attack.

4.119 Pablo Picasso, Guernica, 1937. Oil on canvas. $11'5\frac{1}{2}" \times 25'5\frac{3}{4}"$. Museo Nacional Centro de Arte Reina Sofia, Madrid, Spain

4.120 Poster for the film *Hotel Rwanda*, directed by Terry George, 2004

The lightbulb shining powerfully at the top of the canvas may symbolize awareness and knowledge, as if illuminating the situation.

Picasso exhibited this large protest statement at the Spanish Pavilion during the 1937 World's Fair in Paris, France, and declared that neither he nor the painting would go to Spain as long as Franco ruled. The artwork travelled the world before coming to rest in New York's Museum of Modern Art. Franco died in 1975, two years after Picasso. In 1981, *Guernica* was finally sent to Madrid, Spain, to be exhibited permanently.

Many artists use the plight of a single person to address larger social problems (see Gateway Box: Lange). The movie *Hotel Rwanda* (2004) increased the American public's awareness of the 1994 genocide of 800,000 Tutsi people by Hutu militias in the small Central African country of Rwanda (4.120). The killings resulted in the deaths of approximately one out of every seven Rwandans. The film, which tells the true story of one man's personal sacrifice during the atrocities, is also a protest against the world's failure to intervene. The Irish director Terry George (b. 1952) focuses the story on a single individual to reveal the impact one person can have, even on a monumental problem.

Paul Rusesabagina, manager of the Hôtel des Milles Collines, protected more than 1,000 hotel guests, mostly vulnerable Tutsi, when the violence broke out. The film depicts the atrocities he witnessed, and shows him risking his own life to get supplies for the people hiding in his hotel. The film also highlights the role played by the Americans and the Europeans in allowing the war to continue. The weapons possessed by the Hutu, we learn, were obtained from France and Belgium. The local presence of the United Nations is depicted as ineffective and helpless. Through the medium of film, Terry makes the unimaginable vividly real, and condemns the violence in Rwanda and the lack of intervention by the world community. The film's goal is to inspire more activism against contemporary genocides.

Art as the Object of Protest

Art can inspire a forceful response. Sometimes the power of a work of art is such that viewers wish to destroy it, along with the message or attitude they see represented in it. The following two artworks were not made in protest at a social issue. They were, in fact, not intended to be offensive to anyone. Each, however, came to represent something offensive or even dangerous to somebody.

Medium (plural **media**): the material on or from which an artist chooses to make a work of art

Gateway to Art: Lange, Migrant Mother

The Impact and Ethics of Documentary Photography

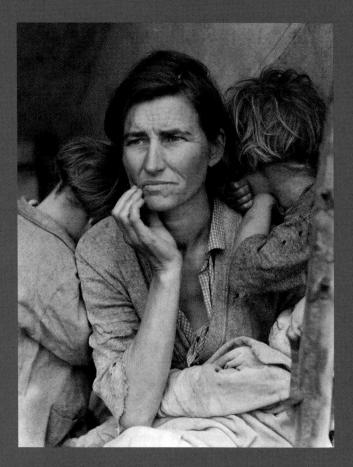

4.121 Dorothea Lange, Migrant Mother, 1936. Library of Congress, Washington, D.C.

Dorothea Lange's famous photograph of Florence Thompson, known as the Migrant Mother, was used to demonstrate the plight of the poor and remains a powerful symbol of the struggle against poverty (4.121). The picture was taken in 1936 when Florence and her children were living in the remains of a Californian pea-picker's camp. Lange's image had an immediate impact. The photograph was published in several newspapers and Time magazine. The federal government sent 20,000 pounds of food to the camp. Unfortunately, the Thompson family had migrated elsewhere before the supplies arrived.

While the photograph had an incalculable affect on people's understanding of the devastation of the Great Depression, Thompson herself was always ashamed and irritated by the portrait. To her mind, it never had a positive effect on her life. When the photograph was

taken she was recently widowed, had six children, and worked wherever she could to support her family. She eventually had eleven children, and lived in fear that if the government knew of her financial difficulties they might take her children away. The identity of Thompson was not discovered until 1978, and she was quoted as saying, "I wish she hadn't taken my picture," and complained about never being compensated.

After Thompson's death, her children spoke of the frustration the photograph caused them as well. When they first saw their mother's photograph in a newspaper in 1936, with an ink mark across her forehead, they assumed she had been shot and ran home, relieved to find her there alive and well. Additionally, Lange's notes seem to have mixed up the details of the Thompsons with another family. The newspapers never mentioned that Thompson was a native American who became a migrant when she was displaced from her tribal land at a young age. It was not until 1983, when Florence lay on her deathbed, and letters of sympathy poured in, that the children changed their outlook:

None of us really understood how deeply Mama's photo affected people...it gave us a sense of pride.

The experience of the Thompson family raises questions of the role of an artist when depicting an actual event. To what extent should the subject's privacy be protected, and to what extent should they be compensated, if at all, when their image has demonstrable effects on the social conscience? Because photography is a medium that can be reproduced and manipulated, an image like Migrant Mother also raises the ethical question of how such an image should be used later. Lange's photograph continues to be a symbol of people struggling against poverty and deprivation. Since 1936 it has been published many times in books and newspapers and has twice featured on U.S. postage stamps.

Iconoclasm: Destruction of Religious Images

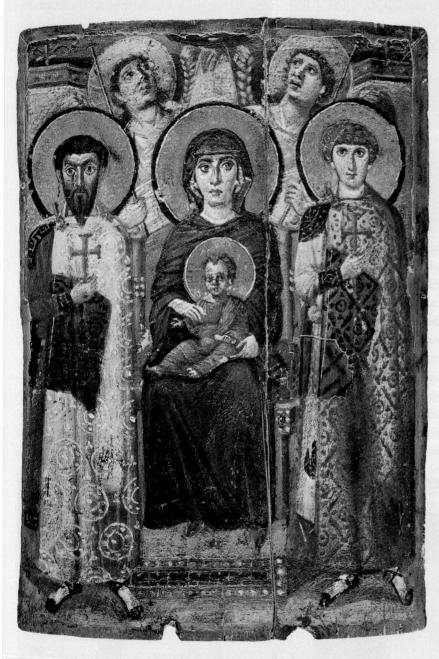

4.125 Virgin and Child Surrounded by Saints, 6th century. Encaustic, 27 × 19⁵/8". Monastery of St. Catherine, Sinai, Egypt

Icons, or religious images, are designed to create a state of meditation, in which the artworks are studied for long periods, inspiring worship. Iconoclasm, or the destruction of religious images, shows the power art can have, and the fear its power can generate. The Byzantine Empire's iconoclastic controversy in the eighth and ninth centuries was provoked by divisions among Christians over the interpretation of the Bible's Second

Commandment: "You shall not make for yourself an idol in the form of anything in heaven above or on the earth beneath or in the waters below. You shall not bow down to them or worship them." Some Christians took this commandment to mean that icons, which might inspire too much worship, should be prohibited.

A study of the icon Virgin and Child Surrounded by Saints (4.125) can help us understand why the iconoclasts were so concerned that Christians might confuse worship of an image with worship of the holy figures themselves. In the icon, Mary initially attracts our attention because she sits in the center, wearing a dark purple gown (the imperial color), and presents Christ, who sits on her lap. The bearded St. Theodore and the beardless St. George stand slightly in front of the Virgin's throne. The saints are closest to us because they are human and therefore most like us. A hierarchy is thus created as we "enter" the picture through them and become closer to Mary, who is herself an intercessor for Christ. The two figures behind the enthroned Mary are angels looking up at heaven. Their gaze reminds Christian believers that the figures in the icon will bring them closer to the heavens above.

Iconoclasts believed that the faithful were worshiping icons of religious figures rather than worshiping Mary and Jesus directly. This fundamental disagreement led to the destruction of thousands of Byzantine icons, including almost all portrayals of Christ and Mary. Most of the surviving icons from before the ninth century are in St. Catherine's Monastery at the foot of Mount Sinai, where they were protected by their location in the Egyptian desert. Iconoclasm has occurred many times in the history of humankind, whenever people passionately believe that certain art has gained too much influence and power.

when paintings could not be completely removed from the walls, they scraped out the eyes of the faces. That such destruction happened at Bamiyan is particularly disheartening: located on the Silk Road, a centuries-old trade route running from China to the Mediterranean, it was historically a place where cultures from East and West had met and exchanged ideas. The sculptures reflected this blending of cultures, fusing two very different styles. The body forms and facial features followed Asian traditions, while the figures wore drapery represented in a manner derived from the artistic style of the ancient Greeks.

The Taliban said that they destroyed the Buddhas because they considered them to be false idols (see Box: Iconoclasm: Destruction of Religious Images). They later argued, however, that they had destroyed the artworks to protest that so many countries wanted to give money to preserve the statues but did not think to make donations to help feed the people of Afghanistan. Many people believed that the Taliban would use any donations for weapons instead of helping the people. Today the Bamiyan area is still a refuge for the poor, and the enormous cliffs and niches that were made for the now destroyed sculptures can be seen from miles away, an ever-present reminder of their violent destruction.

Memorials and Remembrance

Art can serve as a way to acknowledge a historical tragedy, mistreatment, or suffering, often in the hope that similar events will not be repeated. Memorials may address the history of a single individual or of many people. While memorials are often designed to promote healing and comfort the grieving, they can also be statements of tragedy, and can fuel uprisings. They can also express hope for a better world in the future.

The French artist Jacques-Louis David (1748-1825) memorialized the French revolutionary leader Jean-Paul Marat in a painting completed a few months after his murder (4.126). Marat, who suffered from a skin disease that required him to spend much of his

time in a medicinal bath, worked and even received visitors while in his tub. A young woman named Charlotte Corday, who claimed to have the names of conspirators working against the French revolutionaries, in fact supported a political party opposed to Marat; she stabbed him in his bathtub on July 13, 1793. Corday was executed by guillotine for the murder.

David, a close friend of Marat, was a master of propaganda. In order to fuel the revolutionaries' anger, he organized a spectacle two days after Marat's death, which included a public viewing of Marat's corpse. The body was nude from the waist up to display the wound. The dead man's bathtub, the wooden crate on which he wrote, and his inkpot and pen were also carried in procession behind him. Later, David organized a ceremonial viewing of his

Icon: a small, often portable, religious image venerated by Christian believers; first used by the Eastern Orthodox Church Iconoclast: someone who destroys imagery, often out of religious belief

4.126 Jacques-Louis David, Death of Marat, 1793. Oil on canvas, 5'3" × 4'1". Musée Royale des Beaux-Arts, Brussels, Belgium

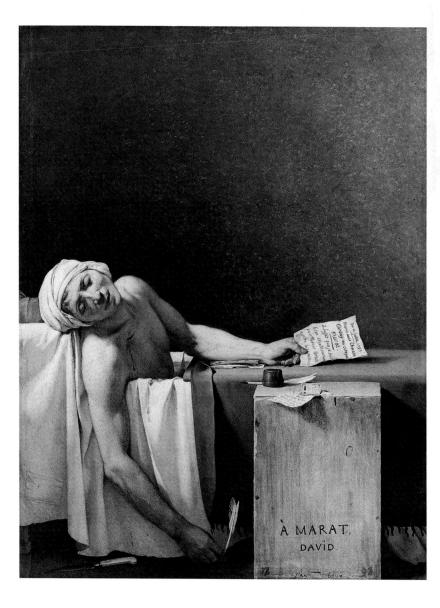

painting, on the same day that the queen, Marie Antoinette, the symbol of the selfish waste of the French monarchy, was guillotined.

In this painting, David portrays Marat as if in a tomb. The bathtub resembles a rectangular box, like a coffin, covered by green cloth. The box placed next to the bathtub represents a tombstone, with a dedication to the fallen leader: "To Marat, [from] David." It is dated from the beginning of the revolutionaries' new regime: "Year Two." In the painting, Marat's left hand holds the note from Charlotte Corday that allowed her to visit him. The letter on the crate is an offer of money to a widowed mother of five, suggesting that Marat was a generous man. The stab wound and knife on the ground highlight the violence of his death. Marat's pose is that of a martyr.

The Vietnam Veterans Memorial was built in Washington, D.C., to pay tribute to many fallen men and women and in the hope of laying to rest some of the lingering controversy over the war (4.127). The design itself was immediately controversial, however. The competition to design the monument—which drew more than 1,400 submissions—was won by a 21-year-old American of Chinese descent studying architecture at Yale University. Maya Lin (b. 1959) envisaged her monument as a place for mourning and healing. A black-granite, V-shaped wall descends into the earth, and then ascends, giving one a sense of coming into the light. The wall also becomes taller as one descends, creating a

4.127 Maya Lin, Vietnam Veterans Memorial, Washington, D.C., 1981-3. Granite, each wing 246' long, 10'1" high at highest point

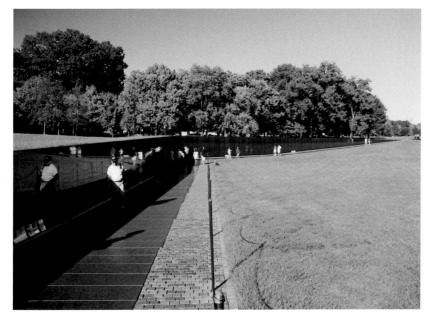

powerful visual expression for the enormous loss of life during the war. It symbolizes the eternal wound in America caused by the conflict, but also the healing that Lin hoped would take place as those who experienced the monument would physically rise again.

The names of the dead are carved into the wall and organized by the date of death. The surface is polished because, the artist explained, "the point is to see yourself reflected in the names." The walls are aligned toward two other monuments, the Washington Monument and the Lincoln Memorial. The integration of the Vietnam Veterans Memorial with these important structures acknowledges the significance of the Vietnam War to American history.

Lin intended the memorial as a tribute, and most visitors are moved upon experiencing it. Some veterans, however, saw it as part of a continued condemnation of the war. Rather than uplifting and instilling pride in the soldiers who fought, they said, the monument's descent into the ground symbolized a moral criticism both of the war and its soldiers. They also perceived the choice of black granite, as opposed to the more conventional pure white marble, as a criticism. In response to these protests, a bronze sculpture of three soldiers, more traditional in style, was later placed a short distance from the wall.

The Chinese artist Wenda Gu (b. 1956) says that he makes his so-called "hair monuments" in an effort to unite the people of the world through a chain of artworks. The monuments are made of walls or screens woven from human hair that has been donated by people from countries around the globe. Gu then paints what appear to be ideograms (symbols that convey the meaning of words) with a brush that is itself made from human strands of hair. The signs he paints are simply suggestive of particular cultures rather than literal transcriptions. China Monument: Temple of Heaven (4.128) is reminiscent of a Buddhist temple in which one partakes of a tea ceremony, and includes ancient-looking Chinese tables and chairs. Video monitors in each chair seat show clouds, so that the people experiencing this artwork are given the sense that they are sitting in the heavens. The artist's words are also seen in the video. When translated, they read:

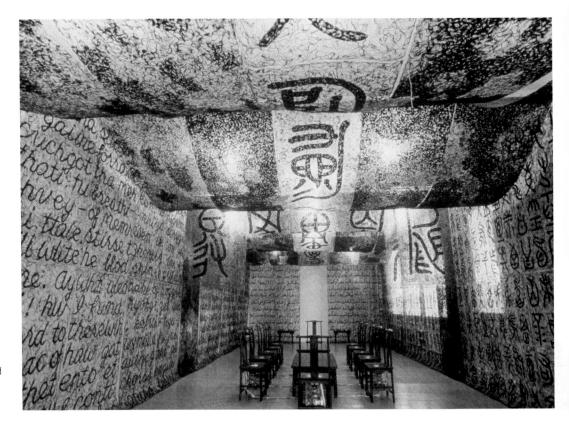

4.128 Wenda Gu, United Nations—China Monument: Temple of Heaven, 1998. Mixed media, $52 \times 20 \times 13'$. Hong Kong Museum of Art

Ancient wisdom says that life is as fleeting as clouds...

you shall sit... you shall listen... you shall be silent... you shall meditate... you shall be free from gender, nationalities, races, politics, cultures, religions... you shall fantasize while you ride on running clouds... you shall have moments of transcending...

The space also unites a variety of cultures by including symbols that imitate Arabic, Hindi, and Chinese, as well as the Latin alphabet used by western languages. Gu's United Nations series of hair monuments has been made in more than twenty countries on five continents. More than a million people have contributed their hair to this series. Humans around the world are thus physically connected, through their common biology, in Gu's work. The artist hopes someday to create monuments in every country in the world, linking all the different cultures of humanity.

Ideogram: a symbol that expresses an idea or a thing without representing the sounds in its name (for example, "8")

Discussion Questions

- 1 In this chapter we have studied many ways in which artists have made a powerful case about an issue that concerned them. Now ask yourself what issue you feel most passionately about, and create an artwork that communicates your ideas. Be persuasive and try to convey the reasons you believe as you do.
- Study artworks in this chapter that have been censored or in some other way withheld from public view. Are there any other works you have read about that the public has been prevented from seeing? Do you believe that artworks should never be censored, or do you think that there are some subjects that should be banned? Write half a page defending your belief in the limits or freedom of expression in art, using at least two specific artworks as examples to make your point.
- 3 Which of the artworks in this chapter do you find to be the most moving or persuasive? Considering the elements and principles of art discussed in Part 1 of this book, perform a visual analysis of the artwork and consider what the artist did (in your opinion) so successfully.

4.9

The Body in Art

The human form is one of the most common subjects in art. Some of the earliest sculptures made during **prehistoric** times depict human figures. Since then, artists have continued to portray the body, both clothed and unclothed, in motion and in repose. The body is not always portrayed as it "actually looks," and it may even be altered so much that it does not resemble a real human body at all. The reality of the body can be distorted to suggest great beauty, or to emphasize such qualities as power, status, wisdom, even godlike perfection. Personal and cultural preferences often determine the way an artist chooses to portray a body. Of course, the body itself can also participate in art: through performances, dances, rituals, and so on. The body as a subject offers endless expressive possibilities.

Archetypal Images of the Body

The Dutch-born American artist Willem de Kooning (1904–97) made a series of paintings of women that incorporate bold, apparently aggressive, even violent, marks and slashing strokes. De Kooning famously said that his *Woman* series referred to "the female painted through all the ages, all those idols." The types of ancient figures to which de Kooning alluded, for example the *Woman from Willendorf* (4.129), serve as iconic artistic models for the idea and image of woman.

The *Woman from Willendorf* is one of the earliest known artworks, dating to about 26,000

years ago. Female figurines have been discovered all over the world. In fact, such sculptures as this are commonly among the oldest created objects in a number of societies. The small size of this figurine, just over 4 inches tall, made it easily portable, a benefit for nomadic people. Because of the maker's emphasis on female anatomy (breasts, buttocks, and rotund belly), the *Woman*

4.129 Woman from Willendorf, c. 24,000–22,000 BCE.
Oolitic limestone, 4%" high. Naturhistorisches Museum, Vienna, Austria

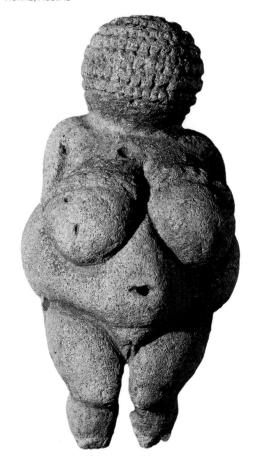

Prehistoric: dating from the period of human existence before the invention of writing **Iconic:** a sign, the form of which directly suggests its meaning

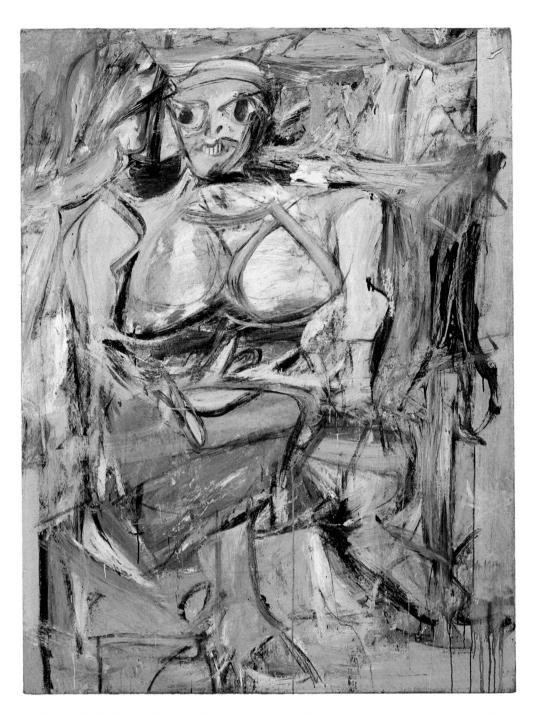

4.130 Willem de Kooning, Woman I, 1950-52. Oil on canvas, 6'3% × 4'10". MOMA, New York

from Willendorf is believed to be a fertility figure. Perhaps it was used as a charm to encourage pregnancy, or as a teaching tool. It almost certainly celebrates the woman as a mother and bringer of life.

The exaggerated form and emphasis on characteristically female elements of human anatomy visually connect the Woman from *Willendorf* with de Kooning's *Woman I* (**4.130**). This large painting, made thousands of years after the tiny sculpture was created, features the glaring eyes and grinning mouth of a woman's face at the

top of the composition. By contrast, the Woman from Willendorf does not include facial features at all. In Woman I the most prominent parts of the body are the breasts, while the arms and legs are minimized in a manner similar to the Woman from Willendorf. Although both artworks convey the inherent power of women as givers and protectors of life, they do so very differently. De Kooning's woman seems strong to the point of being ferocious. The painting is physically big, over lifesized, making literal the larger-than-life feeling conveyed by the small sculpture. Both

figures have an **abstracted** form, visible in the rough shapes of the *Woman from Willendorf* and the jagged brushstrokes of *Woman I*. Their appearance makes them less representations of individual people and more reflections of a universal idea of powerful women. As de Kooning's statement suggests, *Woman I* embodies "the female...through all the ages."

Ideal Proportion

Long before de Kooning's search to find something universal about the female figure, the ancient Egyptians applied formal mathematical systems in consistent ways to depict their ideal of the human form. They developed a standardized method for depicting men and women and used it for thousands of years. The Egyptian system of proportion was later adopted by the Greeks for their **figurative** sculpture and influenced

European artists during the **Renaissance**. These **idealized** proportions, clearly visible in figurative paintings, reliefs, and three-dimensional sculpture, were applied to architectural construction as well. The **canon of proportions** was developed to make the depicted body match ancient Egyptian notions of perfection.

The Egyptian canon of proportions is calculated in the form of a grid that provides consistent measurements of the parts of the body (4.131a). Each square of the grid represents a standard small measurement, or a unit, based on the width of the palm of the hand. Sometimes other ratios are used to make the grid, resulting in a slightly different but still standardized appearance.

Thus, in ancient Egyptian art, the portrayal of the body followed **conventions**, or prescribed methods, that produced consistent results. Egyptian depictions of the human body, as a result, look very similar even when they have been produced thousands of years apart. In sculpture,

4.131a (below left) Canon of proportions: *Menkaure and His Wife, Queen Khamerernebty*

4.131b (below right)

Menkaure and His Wife, Queen

Khamerernebty, 4th Dynasty,
c. 2520 BCE. Greywacke, 54³/₄ ×
22¹/₂ × 21¹/₄". Museum of Fine

Arts, Boston

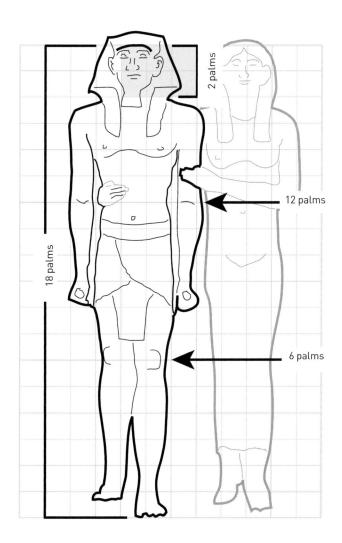

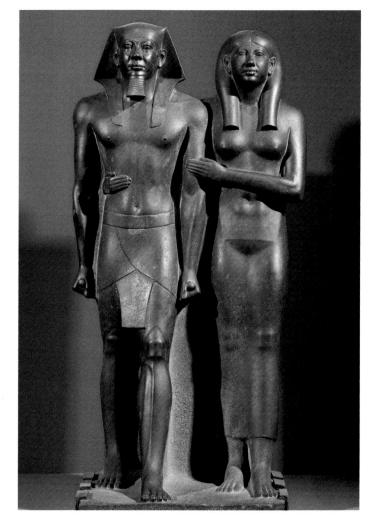

royal figures are shown either seated or standing, firmly connected to the stone from which they are carved, with their arms and hands close to their sides. In standing poses, the feet are firmly planted on the ground with the legs slightly apart and one foot in front of the other, as if the figure is about to take a step. Any suggestion of movement is potential, however, as if the figure is frozen; if it were in motion, its weight would shift to one side or the other. In the Egyptian figure, the feet are flat, the hips are even and immobile, and the shoulders are entirely square.

The use of the canon gives the sculpture of Menkaure and His Wife, Queen Khamerernebty an austere strength (4.131b). Their poses make the figures look rigid, calm, and enduring. They stand close together, as a single unit, his hands close to his sides and hers embracing his arm and torso. Their bodies do not twist and the features are bilaterally symmetrical (meaning that the left side matches the right). The strong, frontal pose suggests that the power of the pharaoh is changeless, unwavering, and eternal. This representation is idealized: the couple's appearance is based on abstract concepts rather than direct observation.

Notions of Beauty

Ideal proportions inform many cultural notions of preferred body type. Our notions of beauty are formed by our personal experiences and by the society in which we live. If we look at the ways in which artists have depicted the human form, we soon realize that in different times and places beauty can mean very different things (see Box: Reclining Nudes, pp. 560–61). In some cultures small feet or long necks are admired. Some groups may favor plump, even voluptuous, bodies, while others prefer slender, very thin and angular physiques. Our bodies can also express many things about our personalities: we can appear calm or agitated, elegant or unkempt, smart or stupid, sensuous or intellectual. The complex relationship between internal characteristics and outward appearance has led artists to explore these aspects of beauty through the human **form**.

The notions of beauty held by the ancient Greeks were based upon the combination of an underlying canon of mathematical proportions with the finely honed physiques possessed by male athletes. It was far more common to see a Greek male than a Greek female figure sculpted in the nude. Depicting the body without clothes allowed artists to study musculature and reflect observations and knowledge of the anatomy in a way that a clothed body does not show. Because the Greeks hoped to model themselves after gods, they aimed for perfect balance between mind and body in both their lives and their art. Such sculptures as the Discus Thrower demonstrate the ideal musculature of the athletic body (4.132). Greek athletes competed in the nude, and sculptures of male sportsmen celebrated the strength and virility inherent in the masculine form. The Discus Thrower also shows the competitor immersed in concentration, his mind in complete harmony with his physique.

departs from recognizable images from the natural world Figurative: art that portrays items perceived in the visible world, especially human or animal forms Renaissance: a period of cultural and artistic change in Europe from the fourteenth to the seventeenth century **Idealized:** represented as perfect in form or character, corresponding to an ideal Canon of proportions: a set of ideal mathematical ratios in art, used to measure the various parts of the human body in relation to one another Convention: a widely accepted way of doing something; using a particular style, following a certain method, or representing something in a specific way Form: an object that can be defined in three dimensions

Abstract: art imagery that

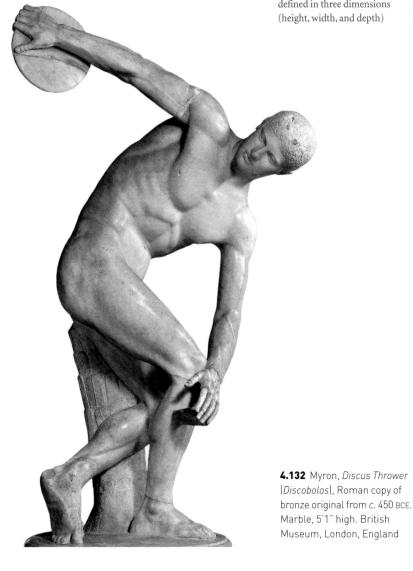

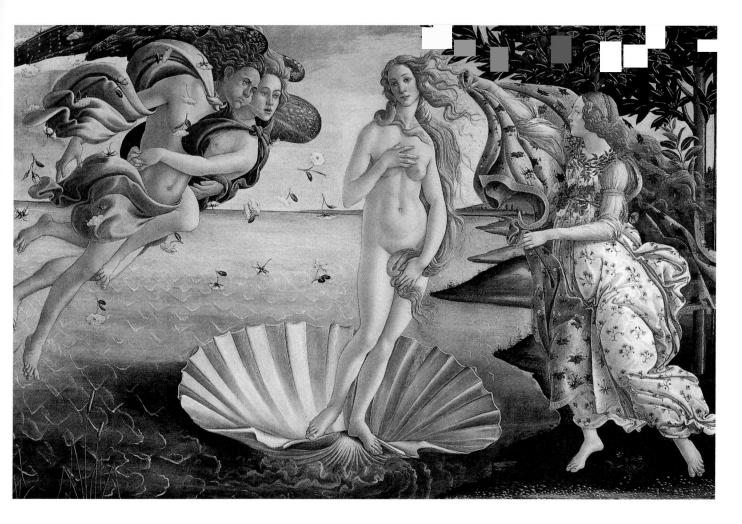

4.133 Sandro Botticelli, The Birth of Venus, c. 1482–6. Tempera on canvas, 5'8" × 9'15%". Uffizi Gallery, Florence, Italy

In ancient Greece, although the male **nude** was certainly more common, the female nude eventually began to gain respectability in the late fourth century BCE. Years later, during the Renaissance, such Italian artists as Sandro Botticelli (c. 1445–1510) revived the appearance of the female nude as it had been depicted in antiquity. In Botticelli's day the female nude became an acceptable subject as long as it appeared in a historical or mythological context. According to Classical mythology, Venus, the goddess of love and beauty, first emerged from the sea as a fully formed adult on a shell. In his painting The Birth of Venus (4.133), Botticelli focuses on the moment when Venus has been blown to shore. She is wafted toward the land by Zephyr, the god of the west wind, who is accompanied by the earth nymph Chloris. Awaiting her is a goddess or nymph who will wrap her in a blanket of flowers. Venus has smooth ivory-colored skin, long flowing hair, and an elegant pose. She discreetly covers her nudity,

indicating that chastity is part of her appeal. The graceful shape and the flawless quality of her body reflect the purity of the newborn goddess and create a harmonious and pleasing composition. Botticelli has modeled his figure on an ancient sculpture, thus basing his conception of beauty on Classical Greek standards.

In African societies, notions of beauty are often closely tied to the community's core values of composure, wisdom, and power. In other words, beauty is about more than external appearance. It is also about internal and societal principles. Being calm, wise, and composed were important attributes for the kings of Ife in West Africa. The elegant lines, delicate features, and elaborate headdress of the terracotta head in 4.134 indicate that it probably represents an Ife king, or *oni*. As the head was considered the seat of intelligence and the source of power, this sculpture's exquisite features draw our attention there. The lifelike details—the folds of the ears,

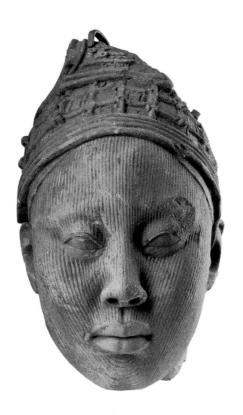

4.134 Head, possibly a king, 12th-14th century. Terracotta with residue of red pigment and traces of mica, $10\frac{1}{2} \times 5\frac{3}{4} \times 7\frac{3}{8}$ ". Kimbell Art Museum, Fort Worth, Texas

the contours of the nose, and the plumpness of the lips—are extremely naturalistic, but also graceful and refined. The fine lines on the face resemble scarification patterns, or scars created by cutting or branding the skin. Beauty in this case is a balance of invisible internal characteristics and an idealized visible outward appearance.

Many cultures determine beauty by a person's ability to conform to expectations, whether through clothes, cosmetics, or body shape. In Japan, traditional female performers called geisha are known for their social skills and artistic talents, such as singing, dancing, and serving tea. Geisha, not to be confused with courtesans or prostitutes, have a professional relationship with their clients and are strongly discouraged from becoming too intimate with them. A geisha's appearance changes over the course of her career. Early on she wears dramatic hairstyles, heavy makeup, dark eyeliner, and red lip pencil applied to make her lips look small. As an apprentice, the source of her beauty lies in her appearance, but later it is seen to derive from her maturity

and her gei, or art. After three years of apprenticeship, a geisha adopts less elaborate kimonos tied with simpler knots, lighter makeup, and a subdued hairstyle, like the one seen in Kaigetsudo Dohan's Beautiful Woman (4.135). Like other Japanese artists, Kaigetsudô Dohan (working 1710–16) celebrated beautiful women, here emphasizing the experienced geisha's impressive attire and relatively natural appearance. In addition to her musical skills and gift for intelligent conversation, this mature geisha would have been appreciated for her inner beauty.

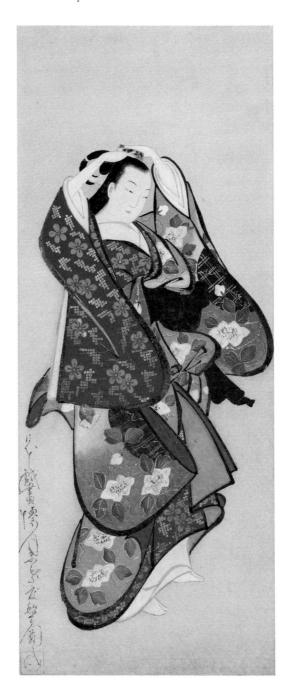

4.135 Kaigetsudo Dohan, Beautiful Woman, Edo Period, 18th century. Hanging scroll, ink and color on paper, $64^{3}/_{8} \times$ 201/8". Metropolitan Museum of Art, New York

Nude: an artistic representation of the naked human figure

Reclining Nudes

While nudes have long been a subject in the history of art, the tradition of depicting the nude female figure lying down or reclining was established during the Renaissance. These types of picture recall the ancient Greek emphasis on the beauty and honesty conveyed by the nude human form. In some cases they also suggest the sensuality of the nude.

The Venetian painter known as Titian (c. 1488-1576) was influenced by the Classical tradition when he painted a female nude for the duke of the Italian town of Urbino (4.136). The roses in the woman's right hand hint at her identity: they are a symbol of Venus, the Classical goddess of beauty (hence the name by which the painting is commonly known, the Venus of Urbino). She looks out from her couch with a cov expression and casually covers her pubic area, at once modest and inviting, as if she exists simply to be looked at. The presence of the maids in the background preparing her clothes, however, connects her to the concerns of a real woman. But by suggesting that his painting depicted a mythological figure,

Titian was able to explore in depth such secular themes as the nature of love and desire.

It is clear that the French artist Édouard Manet (1832-83) was familiar with the Venus of Urbino when he painted his Olympia (4.137). The composition of the paintings and the posture of the women within them are almost identical. Manet, however, has replaced the sleeping dog at the foot of the bed with a hissing black cat. And instead of the maids in the background, there is a black servant who brings Olympia flowers. In this painting, as in others, Manet took a Classical subject and updated it for his own time. In modernizing the reclining nude, Manet considered the reality of the situation. Why would a woman be naked and on display? One obvious answer: because she is a prostitute. Not only was Olympia a common name for a prostitute, but Manet depicted her as a real woman, thin (at least by the standards of the time) and probably poor. Olympia's pose would have seemed confrontational because she stares out at

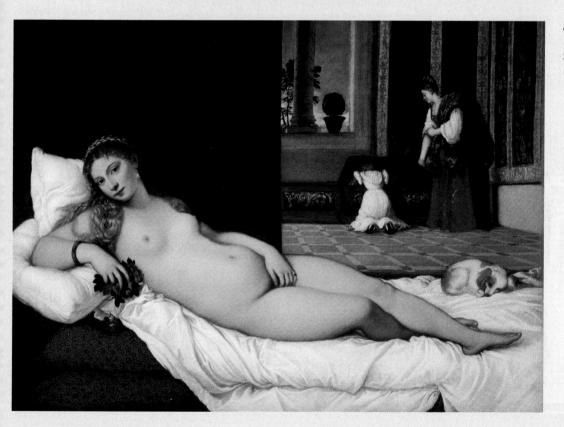

4.136 Titian, Venus of Urbino, 1538. Oil on canvas, $3'10^{7/8}" \times 5'5"$. Uffizi Gallery, Florence, Italy

4.137 Édouard Manet, *Olympia*, 1863. Oil on canvas, 3'3%" × 6'23/4". Musée d'Orsay, Paris, France

the viewer in an assertive way, while people at that time were used to seeing more passive women with voluptuous bodies and docile expressions similar to the Venus of Urbino's.

In the late twentieth century, the Japanese artist Yasumasa Morimura (b. 1951) revisited the theme of the reclining nude (4.138). The meaning of this piece, like that of Manet's Olympia, gains depth if one knows about the earlier artworks to which it alludes. Morimura employs digital processes, which allow him to play the roles of both Olympia and the servant. The resulting photograph is part of a series that the artist made in which he impersonates famous female icons from western culture. transcending race, gender, and ethnicity. Here, the act of covering the genitalia with the left hand takes on entirely new significance in disguising the truth of his masculinity. The robes of the earlier pieces are replaced with a kimono and the cat at the foot of the bed is a porcelain Lucky

4.138 Yasumasa Morimura, Portrait (Futago), 1988-90. Color photograph, printed in 2 editions at varying sizes

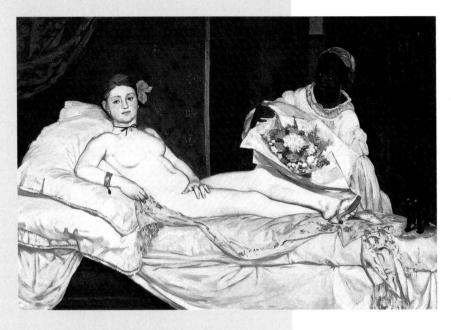

Cat, commonly found in Japanese restaurants and shops as a talisman of good fortune. Morimura's reclining nude updates the theme with current technology and raises pertinent questions about identity, suggesting that appearances can be deceptive, that race and gender are artificial constructions, that we should not make assumptions about identity, and that our understanding of who we are is influenced by the past.

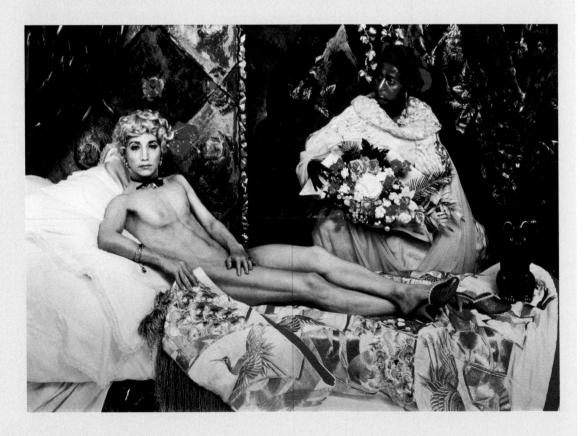

Performance Art: The Body Becomes the Artwork

Geisha are considered living works of art. Similarly, in **performance art**, and in some **installations**, the body and its actions become the artwork (see pp. 564–5, Perspectives on Art Box: Spencer Tunick: Human Bodies as Installations.) A performance by definition involves the human form in action, but by engaging all of a viewer's senses through movement, expression, sound, smell, and so on, it also activates the space itself. The performers share a space with the audience, and the art becomes part of the viewer's lived experience. Because performances are not permanent or static, once they are finished they can only be re-experienced indirectly, through documentation. Written accounts, photographs, and videos taken at the time later remind us of the performances themselves.

Perhaps inspired by his deep interest in the martial art of judo, the French artist Yves Klein (1928–62) began experimenting with "living brushes," or women using their bodies as the vehicle for applying paint to canvas. In the late 1950s he had been one of the first artists to make monochromatic, or one-color, paintings. He used

a bright, dense, ultramarine blue, a color that he eventually patented as "International Klein Blue" (IKB). Klein integrated performance in an innovative way to make the blue paintings for which he was known. The first paintings made by the "living brushes" were monochromes that looked like the ones Klein himself had produced. Later, the women left imprints of their bodies on the canvas or paper (4.139 b).

Klein devised the pieces, directed the women, and hired an orchestra for the first public performance of the "living brushes," called Anthropométries de l'époque bleue (or Anthropometries of the Blue Period) (4.139 a). In order to create a musical accompaniment that was suitable for monochromatic paintings, Klein had the musicians play a single chord for twenty minutes and then sit in silence for twenty minutes. In an art gallery, works of art are usually inert, still objects and it is the viewers who move around (often in silence). In the case of Klein's performances, the artwork itself moved and made sounds while the audience sat still, giving the work a very physical presence in the usually quiet and austere gallery. At the same time, attention was brought to the odd circumstance of living nude figures as "art," now active in the gallery space instead of represented in artworks, and surrounded by a fully clothed audience.

Performance art: a work involving the human body, usually including the artist, in front of an audience Installation: an artwork created by the assembling and arrangement of objects within a specific location Monochromatic: having one or more values of one color

4.139a Yves Klein, Anthropométries de l'époque bleue, March 9, 1960. Galerie Internationale d'Art Contemporain, Paris, France

4.139b Yves Klein, Anthropométrie sans titre, 1960. Pure pigment and synthetic resin on paper mounted on canvas, $50^{7/8} \times 14^{5/8}$ ". Private collection

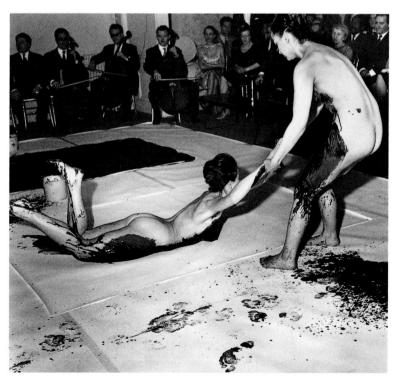

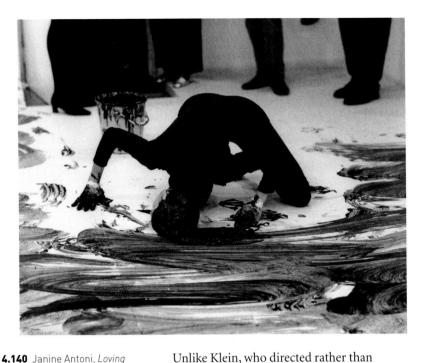

4.140 Janine Antoni, Loving Care, 1993. Performance with Loving Care hair dye Natural Black, dimensions variable. Photographed by Prudence Cuming Associates at Anthony D'Offay Gallery, London, 1993

performances. In Loving Care, named for a brand of hair-care products, Antoni dipped her head in a bucket of hair color and proceeded to mop the floor with it, using her hair as a paintbrush (4.140). As more and more of the floor became

participated in his artworks, artist Janine Antoni

(b. 1964 in the Bahamas) uses her own body and

her own actions as the basis for most of her

covered with gestural marks, viewers were pushed out of the gallery space. The artwork comments on several typically "feminine" actions, including the domesticity of mopping and the messiness of using cosmetics for beautification. Antoni takes the dynamic creative role here, bringing attention to the actions she is performing as well as to the status of women in the art world and in society.

The Italian artist Vanessa Beecroft (b. 1969) also brings the female figure out of the frame and into the gallery space. She takes the idea of the confrontation between the model and the viewer to a new extreme. Her performance pieces consist of groups of women standing in the gallery space with instructions not to speak or move. They create a sense of discomfort because the models are occupying the same space as the viewers, and actively returning their stares.

In pieces like VB35 ("VB" stands for Vanessa Beecroft and "35" is an identifying number, given sequentially to her performances), the women's appearance at once embodies and challenges the expectations of ideal beauty established by contemporary media (4.141). The women are all model thin and posed like mannequins, reinforcing the idea that women, in order to be beautiful, must all look the same. Closer

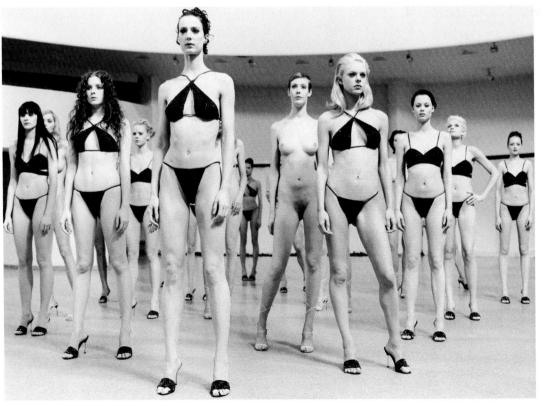

Perspectives on Art: Spencer Tunick

Human Bodies as Installations

The American photographer Spencer Tunick (b. 1967) is famous for his installations involving large numbers of nude people (4.142a). Here he explains how he came to make work that sometimes involves thousands of nudes, and how complicated it can be to organize them.

I didn't start out photographing hundreds or thousands of nude people. From 1992 to 1994 I

worked on individual portraits of nudes on the streets of New York. I gained confidence in my ability to work on a public street, to deal with traffic, traffic light intervals, and the police. I switched to multiples when I had so many people to work with. I would carry the photographs round in my wallet and show them to people. By 1994 I had phone numbers for twenty-eight people and I decided to photograph

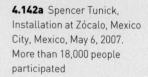

4.142b (opposite above) Spencer Tunick steps through 300 people whom he arranged as a living sculpture near City Hall, Fribourg, Switzerland, 2001

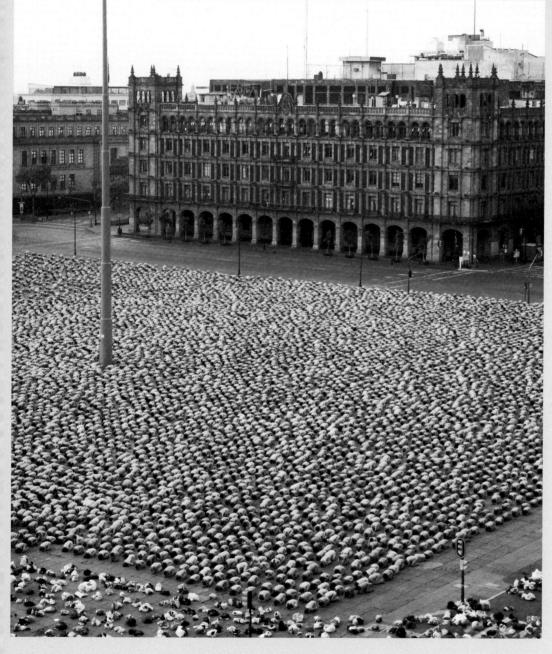

them all at once outside the UN building in New York. Then in 1997 I gathered 1,000 people on an air-force base in Maine at a music concert.

I travel with a team of eight. In each city a contemporary art museum commissions my work and I can work wherever in the city I like. The museum provides team leaders and volunteers. Mexico City took three years to organize and one day to make the art. There were 250 team leaders and volunteers and 250 police officers. In Caracas, Venezuela, there were almost 1,000 police and military.

I know 75 percent of what I am going to do before we start but I like to keep an element of mystery. I have control of thousands of people, but in a way I don't like that control. I like to keep the event loose, personal, and intimate. Participants are not involving themselves in a spectacle but in a work of art. After ten minutes, once they get used to being nude, they get excited and start raising their hands in the air and so on, and then they calm down and we get organized.

I consider my works to be installations, not performances or photographs. I document the installations with photos and videos. I have two videographers and could have people take the photographs also, but I like to frame the photos and tweak them on location.

I still do individual portraits in streets. I am interested in the body and its relationship to the background. Instead of the body creating a meaning for the background, the background creates a new meaning for the body.

inspection reveals the women's individuality. Some have darker skin, others lighter. They have different hair color and different hairstyles. Their black bathing suits—like their bodies, poses, and posture—are not identical, but individual to each woman. In fact, some women in the performance were nude and did not wear a bathing suit at all. Beecroft's performances broach the subject of body image for a world of women, young and old, trying to live up to impossible standards.

The Body in Pieces

Artists have used exaggeration, stylization, and

innovation to create abstract representations of the human body. Approaches from outside the western European tradition, such as African masks and Pre-Columbian sculptures from the Americas, influenced some modern European artists to make works that suggest forms that are altered but recognizable. Others have taken certain elements of the anatomy out of their usual context by distorting or fragmenting the body. We do not have to see a whole body to read it as a human figure (see Gateway Box: Matisse, 4.145, p. 566). Recognizing this fact, artists have focused attention away from identifying a particular individual or illustrating a coherent story in order to emphasize ways in which the body can be broken down and presented as a product of the human imagination.

The French artist Auguste Rodin (1840–1917) altered the appearance of the human body, which is one of the reasons he is now known as a pioneer in the field of modern sculpture. His innovations influenced many twentieth-century sculptors, including Henry Moore and Alberto Giacometti (see 4.146 and 4.147). Although he had been formally trained, Rodin chose not to make his sculptures in the traditional way. Instead of idealizing figures to look like perfected versions of actual people, Rodin intentionally left his surfaces rough, as seen in his sculpture Walking Man (4.143). The scrapes and gouges on the

figure's chest, torso, and hips stand as evidence of the material the artist touched and manipulated to make the sculpture. Rodin also considered fragmentary representations, such as this one, which has no

4.143 Auguste Rodin, Walking Man, c. 1890-95. Bronze, 33³/₄ \times 22 \times 11". MOMA, New York

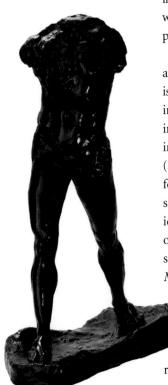

Gateway to Art: Matisse, Icarus

The Blue Nude: Cutouts and the Essence of Form

Experimental artists like the Frenchman Henri Matisse (1869-1954) have consistently used the female nude as a subject for creative innovation. Throughout his career, Matisse was moving toward a more economical use of artistic elements. Early on, he made very detailed recordings of the world he observed around him. After the 1940s, he chose to isolate forms and reduce the range of his palette, emphasizing the elements he thought to be the most important for a particular subject, because, as he wrote, "exactitude is not truth." Even his sketches for individual artworks went from complex recordings of very detailed observations to pictures with selected details and limited colors. This approach suited the technique of making cutouts. In his cutouts, as seen in both Icarus (4.144) and Blue Nude II (4.145), Matisse gives us enough information to know that we are looking at a human body. Their shapes are rough, but energetic. The palette in Blue Nude II is restricted to blue only. The color blue is not used to shade the female figure or to make her look as if she is bathed in blue light. Instead, her form is made entirely of flat planes of color.

An essay of 1947 by Matisse, describing a series of self-portraits made using a mirror, helps explain how he arrived at this technique and what he hoped to communicate by making art the way he did:

These drawings sum up, in my opinion, observations that I have made for many years about the character of drawing, a

un moment
di libres.

ne divraitem
pas faire ac.
complir un
gnand voyage
en avior aux
jeunes gens
ayanttermini
Ceurs études.

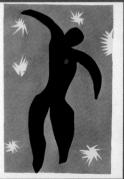

4.145 Henri Matisse, *Blue Nude II*, 1952. Gouache on paper, cut and pasted on white paper, $45\% \times 32\%$.". Musée National d'Art Moderne, Centre Georges Pompidou, Paris, France

character that does not depend on forms being copied exactly as they are in nature, or on the patient assembling of exact details, but on the profound feeling of the artist before the objects that he has chosen, on which his attention is focused, and whose spirit he has penetrated.

My conviction about these things crystallized when I realized for example that in the leaves of a fig tree—of a fig tree particularly—the great difference of forms that exists among them does not keep them from sharing a common quality. Fig leaves, whatever their fantastic variations of form, always remain unmistakably fig leaves. I have made the same observation about other growing things: fruits, vegetables, etc.

Thus there exists an essential truth that must be disengaged from the outward appearance of the objects to be represented. This is the only truth that matters...

Exactitude is not truth.

4.144 Henri Matisse, *Icarus*, from *Jazz*, 1943–7. Page size $16\% \times 12\%$ ". MOMA, New York

4.146 Henry Moore, Recumbent Figure, 1938. Green Hornton stone, $35 \times 52^{1/4} \times 29$ ". Tate, London

Contours: the outlines that define a form

Avant-garde: early twentiethcentury emphasis on artistic innovation, which challenged accepted values, traditions, and techniques

head or arms, to be completed sculptures rather than preparatory sketches. At the time, Rodin's pieces, which looked so different from the smooth, idealized figures people had come to expect, were harshly criticized. Since then, his approach has been praised for allowing the figures to be more expressive, emotional, and individual.

Like Rodin, the British sculptor Henry Moore (1898–1986) created figures that did not match

the way the human body

actually looks. Instead

Moore made connections

with natural forms in the shapes of bodies and their parts, which often resemble mountains, hills, cliffs, and valleys. The organic lines in his sculptures mimic the organic contours of the materials he used, usually wood and stone. In addition to nature, Moore was inspired by other works of art. He studied a range of artistic traditions outside the West, as well as Classical and avant-garde European approaches. As a result of these influences, he departed from visible reality for the sake of making a strong artistic statement. A consistent characteristic of his sculptures is his use of the void, an empty space that opens up the figure and creates visual interest. In Recumbent Figure the large hole in the center of the piece is surrounded by the masses that make up the body (4.146). The legs look like peaks while the abdomen is

in the place of a valley. The breasts help to identify the shape as a female figure.

The Swiss artist Alberto Giacometti (1901-66) also stretched the

boundaries of the recognizable form: first through Surrealist examinations of the human body, and then, after World War II, through the existential views represented in such sculptures as Man Pointing (4.147). Giacometti's obsessive nature at times caused him to reduce figures to the point where they were almost nonexistent. Eventually he began to accept his own artistic vision, in which the bodies look as if they are being seen from an extreme distance. The figures seem to have stepped out of the artist's dreams and into reality, carrying with them an air of mystery. Man Pointing is an imposing figure, despite its apparent fragility. At almost six feet tall, it is hard to believe that it can support its own weight. Giacometti struck a delicate balance between the figure and its surroundings in this sculpture, which he first made in clay and then cast in bronze. Nothing indicates why the man is pointing, but the space around him seems almost heavy. The sculpture looks like a trace of the shadow the man casts rather than the man himself, emphasizing the figure's loneliness and isolation.

Discussion Questions

- Thinking of artworks you have studied in this chapter, compare and contrast a work that contains static representations of the human form with a performance. How would making these two types of artwork have been different for their creators? What role does the person represented in the artwork play? How do the results compare visually?
- 2 What have the artists in this chapter discovered through their exploration of the human body? Find an example in the chapter that was especially interesting to you. What did learning about that artist's exploration reveal to you?
- In this chapter we have looked at several ways in which artists have explored the body as an artistic theme. Identify three of those approaches. Now think of other works you have seen in this book and select three examples from outside this chapter that take a different approach to the body. List the ways in which your chosen works differ from those discussed in this chapter.

4.147 Alberto Giacometti, Man Pointing, 1947. Bronze, $70^{1/2} \times 40^{3/4} \times 16^{3/8}$ ". MOMA, New York

4.10

Art and Gender

Gender affects all people, including artists, whether they are male, female, or someone who does not fit neatly into either of those categories. Unlike sex, which indicates whether a person is biologically male or female, gender refers to a person's inner identity. It is one of the most significant aspects of a person's sense of self. But it is not clear whether common assumptions about gender roles are natural or imposed by society: should pink and dolls always be associated with females and blue and airplanes with males?

While gender affects everyone on some level, it often becomes an issue for discussion in relation to groups that have been disenfranchised by the mainstream and male-dominated culture, perhaps because they are female, or homosexual, or transsexual. At several points in the twentieth century, feminism encouraged us to consider the role of women as both creators and subjects of important artworks. Contemporary feminist and lesbian, gay, bisexual, transgender (LGBT) movements have inspired a great deal of debate about and exploration of the ways gender affects personality, relationships, and preferences.

The artworks in this chapter illustrate some of the ways in which artists have explored, reinforced, and challenged traditional gender distinctions. By presenting their own personal experiences of daily life, their interpretations of historical events, and their commitment to social or political agendas, artists encourage us to question common assumptions about gender and the possibilities beyond the binaries of male and female.

Gendered Roles

Our assumptions about gendered roles are often based on cultural stereotypes. For example, the ancient Egyptians and Greeks developed formal methods for representing the ideal human figure in art, with males being presented as strong and athletic, while females appear demure. Similarly, in our modern society we construct our own ideas about what men and women should look like and how they should behave. Artworks depicting men have historically referred to their powerful bodies or leadership roles. In contrast, women have tended to be shown in artworks either as passive, eroticized subjects who exist solely for the viewer's pleasure, or, alternately, in the role of nurturers in domestic scenarios. There are, however, numerous examples of artworks that consciously counter these stereotypical representations and show images of men as vulnerable and women in positions of power.

In many cultures, heroes manifest the desirable attributes of the society in a largerthan-life way. The sculpture Chibinda Ilunga, made by the Chokwe people of Central Africa, depicts a legendary leader who was a masterful hunter, a successful king, and a descendant of a deity (4.148). The figure carries a staff, a symbol of prestige that stands for the passage of power from an ancestor to a chief or from one chief to another. His flaring nostrils and the antelope horn he carries identify him as a hunter. The horn was a trophy of his successes

4.148 Chibinda Ilunga, mid-19th century. Wood, hair, and hide, $16 \times 6 \times 6$ ". Kimbell Museum of Art, Fort Worth, Texas

in capturing game, and it also served as a container for potent substances or medicines, contributing an additional element to his arsenal of impressive traits. The sculpture conveys the valued attributes of authority, potency, and restraint that made this celebrated hunter a model leader.

Manual labor relies on strength and endurance, which have traditionally been considered distinctly masculine, allowing laborers to be seen as heroic through their hard work. Shortly after World War I, the American sociologist and photographer Lewis Wickes Hine (1874–1940) made a series of Work Portraits. Unlike some of his earlier projects, which condemned the exploitation of children in factories and mines, this series celebrated the positive connection between the worker and the machines he used. Power House Mechanic Working on Steam Pump salutes the man's muscular physique and its complementary relationship with the tools of his trade (4.149). Hine's visual commentary records the commanding role the worker played as the driving force behind the progressive industrial era. (As a counterpoint to Hine, see Gateway Box: Lange, **4.151**, p. 570.)

4.149 Lewis Wickes Hine, Power House Mechanic Working on Steam Pump, 1920. Silver gelatin print, sheet: 91/2 \times 6 $^{3}/_{4}$ ". National Archives and Records Administration, Records of the Work Projects Administration

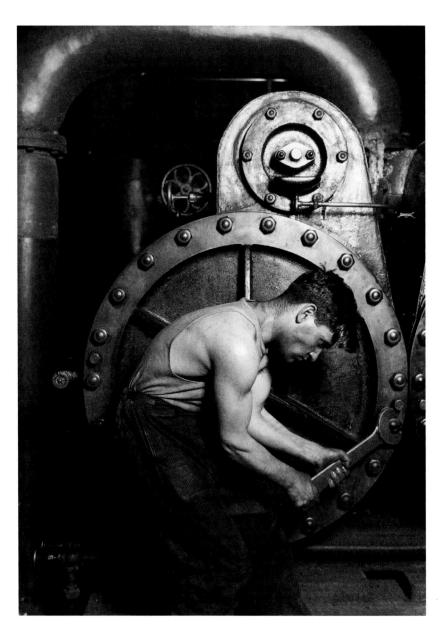

4.150 John Coplans, *Self-portrait Sideways No. 3*, 2001. Gelatin silver print, 4'2" × 6'8".

The British photographer John Coplans (1920–2003) directly challenges traditional views of the ideal male **nude**. He frankly shows wrinkles, sags, and rolls of skin. Self-portrait Sideways No. 3 is part of a series of self-portraits the artist began when he was in his sixties (4.150). These selfportraits highlight the realities of the aging body in direct and personal but also enigmatic ways. The photographs often transform actual body parts through extreme close-ups, making it hard to tell if we are looking at the crook of a finger, the crease of an elbow, or the bend of a leg. These images, which rarely include Coplans's face, give an edge of humility, and an unexpected voice, to the artist's self-examination, and expand the depictions of male figures and aging bodies in art.

The American photographer Cindy Sherman (b. 1954) plays the roles of all of the women

Gateway to Art: Lange, *Migrant Mother* **The Image of Motherhood**

Byzantine, medieval, and **Renaissance** depictions of mothers and children generally focus on the ideal mother. Later artists show

4.151 Dorothea Lange, *Migrant Mother*, 1936. Library of Congress, Washington, D.C.

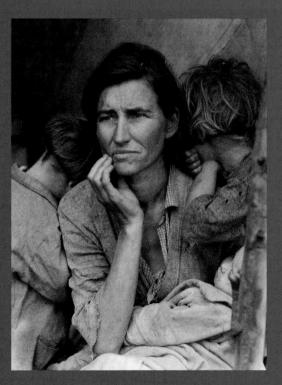

children as more precious than jewels (for example, see p. 404, 3.152, Angelica Kauffmann's Cornelia Pointing to Her Children as Her Treasures) and reveal the sweet interactions of ordinary moments (see, for example, p. 345, 3.76, Mary Cassatt's Child's Bath). Lange captured a slightly different view, showing the intimacy of a family that has very little but each other.

Migrant Mother offers poignant evidence of a mother's strength and determination in a time of extreme need (4.151). Because the early pea crop had failed, this migrant worker and her three young children were starving. Photographer Dorothea Lange found the family surviving on frozen vegetables from the surrounding fields and birds they were able to kill. Like other mother and child images, Migrant Mother draws attention to the nature and enduring quality of the bond. This photograph resonates because of the way the mother's face reflects the pressures placed on the family unit.

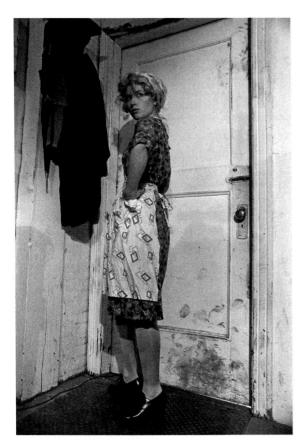

portrayed in her acclaimed Untitled Film Stills series, creating an intriguing visual puzzle as we try to uncover the "real" Cindy Sherman. The images she makes are not, however, intended to be self-portraits in the way that Coplans's photographs are. Sherman has explained that the images are not about her, but are about the representations of the women being shown and the ways that each viewer interprets them (see Perspectives on Art Box: Cindy Sherman: The Artist and her Identity).

For the Untitled Film Stills, Sherman fabricated backdrops and costumes for imagined characters from nonexistent 1950s B-movies. At that time, the film roles for women were limited to such stereotyped characters as housewife, starlet, country girl come to the city, and so on. In *Untitled Film Still #35* we see a woman—perhaps a housewife or a maid—with a distinctly bad attitude (4.152). The circumstances of the scene are far from clear, though. Is she sulking about

4.152 Cindy Sherman, Untitled Film Still #35, 1979. Black and white photograph, 10 × 8". MOMA, New York

Nude: an artistic representation of the naked human figure Renaissance: a period of cultural and artistic change in Europe from the fourteenth to the seventeenth century

Perspectives on Art: Cindy Sherman The Artist and Her Identity

The American photographer and film director Cindy Sherman is best known for her photographs in which she is dressed in costumes as if she were another person (see above, 4.152). Here she explains her general working process and one specific image, Untitled Film Still #35, inspired by the Italian film actress Sophia Loren.

There is a stereotype of a girl who dreams all her life of being a movie star. She tries to make it on the stage, in films, and either succeeds or fails. I was more interested in the types of characters that fail. Maybe I related to that. But why should I try to do it myself? I'd rather look at the reality of these kinds of fantasies, the fantasy of going away and becoming a star...

The black-and-white photographs were... fun to do. I think they were easy partly because throughout my childhood I had stored up so many images of role models. It was real easy to think of a different one in every scene. But they were so clichéd that after three years I couldn't do them anymore. I was really thinking about the movies, the characters are almost typecast from movies.

For the woman standing in front of my studio door, I was thinking of a film with Sophia Loren called Two Women. She plays this Italian peasant. Her husband is killed and she and her daughter are both raped. She is this tough strong woman, but all beaten-up and dirty. I liked that combination of Sophia Loren looking very dirty and very strong. So that's what I was thinking of....

I realized I had to become more specific in details, because that's what makes a person different from other people.

something, planning to leave, or about to pull a wallet from the jacket hanging on the hook? Why are there so many scuff marks on the door? More questions are raised than answered in the scenarios Sherman invents. Her Untitled Film Stills, which were created between 1977 and 1980, revisit these 1950s-inspired women in order to make it clear how narrow the representations of and expectations for women had been only a few short years before. At the time Sherman made Untitled Film Still #35, feminism was beginning to have a significant impact on artistic representations of women as well as on the possibilities for women in society. Sherman made sixty-nine photographs in the series and the women in them always seem as if they are being watched, the object of an unseen voyeur's gaze. These scenarios call attention to and question the way we look at these and all women.

Feminist Critique

In Western countries, for many centuries women had far fewer opportunities than men to become artists, and were rarely given the recognition granted to their male counterparts. For example, women were not allowed to draw from the nude in their art classes until the nineteenth century. It was also believed that "genius" was a trait exclusively available to men, and language with a gender bias—such as the word "masterpiece" to describe a great artwork—reinforced that belief. Before the 1970s few people even noticed that women had largely been excluded from the institutions and systems that produced serious artists.

In many cases, successful women had simply been written out of the history of art. The Italian artist Artemisia Gentileschi, for example, enjoyed an impressive reputation in the seventeenth century, but her efforts were eventually forgotten, only to be rediscovered in the early twentieth century (see Gateway Box: Gentileschi). The feminist movement of the 1960s and 1970s made a significant impact on the production and understanding of artworks made by women. It acknowledged that women artists had been left out of much of the history of art, and it introduced the possibility that this situation could be rectified. As a result, feminist artists expanded the

subject matter of art, making it more relevant to women's issues, and many more works made by women were included in museums and galleries.

The American artist Judy Chicago (b. 1939) appreciated the achievement of such women as Gentileschi. She realized that many women had been forgotten over time and, likewise, that women who seem prominent today might in the future also be omitted from history. From 1974 to 1979, Chicago worked on an epic sculpture called *The Dinner Party* (4.153), which honors women from the past and present. Her huge triangular dinner table has thirteen place settings on each side. Every setting features a placemat, on which is embroidered the name of a famous historical or mythical woman, and an elaborate plate designed intentionally to resemble the shape of a butterfly or a vagina. The appearance of all the elements on each setting was inspired by the woman whose place it is. Layers of lace designate the place of the nineteenth-century poet Emily Dickinson, while the plate for the artist Georgia O'Keeffe (4.153) resembles a sculpted version of one of her abstract flower paintings. Artemisia Gentileschi's place setting has a brightly colored plate surrounded by lush fabric similar to the kind shown in her paintings.

Abstract: an artwork the form of which is simplified, distorted, or exaggerated in appearance. It may represent a recognizable form that has been slightly altered, or it may be a completely non-representational depiction Baroque: European artistic and architectural style of the late sixteenth to early eighteenth centuries, characterized by extravagance and emotional intensity

Medium (plural **media**): the material on or from which an artist chooses to make a work of art

Ceramics: fire-hardened clay, often painted, and normally sealed with shiny protective coating

4.153 Judy Chicago, The Dinner Party, 1974–9. Installation view showing Georgia O' Keeffe placesetting. Embroidery on linen and china paint on porcelain, entire work 48 × 48°. Brooklyn Museum, New York

Gateway to Art: Gentileschi, Judith Decapitating Holofernes **Professional Artist and Painter of Women**

At a time when there were very few women professional artists, the Italian Artemisia Gentileschi (1593-c. 1656) earned a reputation as a talented and accomplished Baroque painter. While women were accepted as portrait artists in the seventeenth century, Gentileschi also worked in the more highly esteemed genres of historical, mythological, and religious paintings. Women were not allowed to follow the traditional avenues of apprenticeship to complete their training as painters and sculptors, but Gentileschi was the daughter of an artist, and her talent was recognized and fostered by her father. Unlike her male contemporaries, Gentileschi often depicted strong female figures with emotion, intensity, and power.

One of the subjects she painted was the story of Judith Decapitating Holofernes, from the Bible (4.154). Judith became a heroine of the Israelite people when she murdered Holofernes, an Assyrian general sent by King Nebuchadnezzar II to punish the western nations of his empire—including the Israelites—for not supporting his reign. After Holofernes became intoxicated, Judith used his sword to cut off his head. The Hebrews were then able to defeat the Assyrian army and avoid surrender. Scholars generally agree that such scenes of powerful women taking vengeance on immoral men are connected to events in Gentileschi's own life. At the age of eighteen

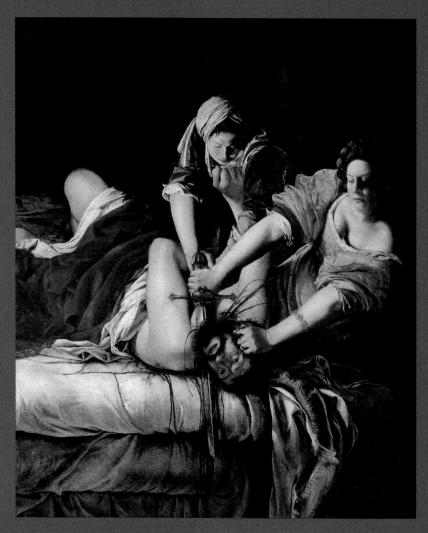

Gentileschi was sexually assaulted by her painting teacher and had to endure a humiliating public rape trial in her attempts to bring her attacker to justice.

4.154 Artemisia Gentileschi, Judith Decapitating Holofernes, c. 1620. Oil on canvas, $6'6\frac{3}{8}" \times 5'3\frac{3}{4}"$. Uffizi Gallery, Florence, Italy

Chicago made the table an equilateral triangle not only because the shape was an ancient sign for both woman and goddess, but also because it could be used here to symbolize the world of fairness and equality that feminists sought. She chose to have thirteen guests to a side both because there were thirteen witches in a coven and because it was an important number for those ancient religions that worshiped a mother goddess. The number is also a reference to the biblical Last

Supper, here reconfigured with women as the guests instead of Jesus and his twelve disciples. The idea of a dinner party—as well as the **media**, such as needlework and ceramics, which are included in her piece—evokes the role of woman as homemaker, which Chicago and other feminists believed should be admired and praised.

In 1985, a group of women artists in New York City formed a collective organization called the Guerrilla Girls to protest at the unequal treatment

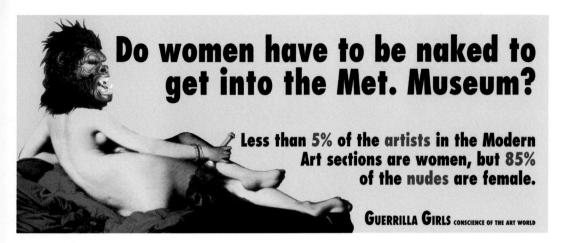

4.155 Guerrilla Girls, *Do Women Have to be Naked to get into the Met. Museum*?, 1989.

Poster, dimensions variable

of female artists in the art world. Their name indicates their willingness to engage in unconventional tactics in their fight for equality. The Guerrilla Girls, who are still active, are known for the gorilla masks the members wear to avoid being recognized by the art world establishment and institutions they might criticize. Their productions take the form of public protests and lectures as well as flyers and posters. One of their best-known posters, Do Women Have to be Naked to Get into the Met. Museum? (4.155), includes statistics to highlight the disproportionate representation of women artists (5 percent) compared to female nudes (85 percent) in the collection of the Metropolitan Museum of Art in New York. As this poster shows, one of their principal goals is to oppose the lack of representation of women artists in major museum collections.

The American artist Lorna Simpson (b. 1960) has confronted similar issues about the treatment

of women, as well as assumptions regarding race, in art and society. Her combinations of text and imagery raise questions about gendered and racial identity, both verbal and visual. You're Fine shows a woman lying on an examination table (4.156). She wears a nondescript white slip and has her back to us, so we are not able to identify her by the usual means of looking at her face. The text accompanying the image indicates multiple levels of meaning. This woman, whose pose recalls a reclining nude from Classical art, is lying down here for the purposes of a medical inspection. The plaques on the left list procedures and tests, probably ones she is undergoing. Those on the right, however, suggest that she is being subjected to this scrutiny in order to gain a secretarial position. Finally, the lettering above and below the picture reveals that her body has passed inspection: "You're Fine. You're Hired." Unlike all those images that the Guerrilla Girls noted, Simpson's model is not nude and her identity has not been exposed.

4.156 Lorna Simpson, *You're Fine*, 1988. Four color Polaroid prints, 15 engraved plastic plaques, 21 ceramic pieces, 3'4" × 8'7". Private collection

Blurring the Lines: **Ambiguous Genders**

We frequently assign roles to men and women according to our ideas of "normal" gender. Of course, traditional roles are frequently reversed: women have been primary breadwinners, worked in mines or gone to war, and men have been nurturers and raised children. But in recent years it has become more acceptable to address other ways of transcending the conventional gender boundaries. Public awareness of such issues as transvestism and transgender surgery has been raised by more open discussion. The investigation of the ways that bodies and identities can assume various levels of masculinity and femininity, however, is not entirely new to art. It is a question that artists from many cultures and eras of history have sought to address.

Almost 3,500 years ago, ancient Egypt was governed by a woman called Hatshepsut. She was arguably the most powerful of the handful of female rulers in Egyptian history. Hatshepsut controlled the kingdom for about twenty years in the fifteenth century BCE, first as regent for her stepson and nephew Thutmose III, and then as pharaoh in her own right. To legitimize her reign, Hatshepsut emphasized that she was her father's choice as successor, ahead of her two brothers and half-brother. She also claimed direct lineage from Amun, the sun god who was worshiped at that time.

Like all Egyptian rulers, Hatshepsut commissioned many sculptures and relief carvings to replicate and immortalize her image. A few show her as a woman, but she is most often depicted in the conventional poses and clothing of a male king. The image in 4.157 is one of a group of sphinxes that possess Hatshepsut's face. It was not uncommon for pharaohs to be represented in the form of a sphinx, a creature with the body of a lion and the head of a human. The artist has clearly followed the customary guidelines for depicting male pharaohs, including the traditional headcloth and royal beard. But, although the portrait is idealized, the sculptor has not attempted to disguise the delicate lines of Hatshepsut's features.

4.157 Sphinx of Hatshepsut, 18th Dynasty, 1479-1458 BCE. Granite and paint, $5'4^{5}/8'' \times 11'3''$. Metropolitan Museum of Art, New York

The American photographer Diane Arbus (1923-71) was fascinated by subjects that crossed established boundaries, including conventional gender distinctions. She made direct, even confrontational pictures of people outside the mainstream, such as the midgets, giants, twins, and sword swallowers that she met at sideshows, carnivals, and circuses. Her photograph Hermaphrodite with a Dog conveys a fascination with, and a kind of reverence for, extreme difference (4.158). Her subject's experience of being both male and female and, at the same time, not conforming to either gender, adds up to a shocking reality. The spectacle of the hermaphrodite's dual nature is highlighted in the visible juxtaposition between the feminine costume, make-up, and clean-shaven right side and the masculine tattoo, wrist watch, and hairy body on the left.

4.158 (below) Diane Arbus, Hermaphrodite with a Dog, 1968. Gelatin silver print, 20×16 ".

Unlike Arbus, the American artist Robert Mapplethorpe (1946-89) photographed a lifestyle of which he was himself a part. The issue of gender affects his photographic work because he chose subjects that were highly sexualized and often related to his own interests as a gay man. His photographs are carefully composed, elegantly lit, and technically perfect, making subjects that might previously have been seen as deviant appear normal, even beautiful. A national controversy was sparked by the exhibition of Mapplethorpe's work that traveled to several museums across the U.S. shortly after the artist died of AIDS-related illness. Some museum officials and politicians considered the graphic sexual nature of Mapplethorpe's X Portfolio to be problematic because the artist had been awarded a grant from public funds.

Mapplethorpe, however, did not see a significant difference between a flower, a Classical sculpture, or a nude male figure.

In Mapplethorpe's 1980 Self-portrait (#385), his hair is curled and he wears eye shadow, blush, and lipstick (4.159). If one looks solely at his face, he seems to be a woman. His bare chest, however, tells us that he is a man. Mapplethorpe's appearance raises many questions about the assumptions we make based on the way people look. It also reveals the degree to which gender is a construction and suggests that not all people fit the conventional distinctions between the sexes. Mapplethorpe photographed what he wanted to see, the things that he considered visually interesting but did not find elsewhere in the art world. Through his carefully crafted compositions and technically masterful prints

4.159 Robert Mapplethorpe, Self-portrait (#385), 1980. Gelatin silver print, 20×16 "

4.160 Catherine Opie, Melissa & Lake, Durham, North Carolina, 1998. Chromogenic print, 40 × 50"

he ensured his models (including himself) looked their absolute best.

The American artist Catherine Opie (b. 1961) uses photography to investigate the nuances of gender and identity. Her pictures include studio portraits of her lesbian friends dressed in leather or wearing false facial hair, staged depictions of radical performance artists, high school football games, and landscapes. Opie created her *Domestic* series while traveling across the U.S. in order to photograph lesbian couples, such as Melissa and Lake, in their everyday settings (4.160). This photograph accentuates some of the similarities in the couple's appearance, such as their short haircuts with bangs. The point of the picture, however, is their bond, not their gender or sexual identity. Opie's portraits, by highlighting the lesbian community, introduce some viewers to new ways of life. They remind others that the familiar people, places, and things we see each day can be thought of in new ways. Such pictures are not about difference, they are celebrations of individuality.

Discussion Questions

- 1 What kind of words can you think of that are specifically gendered? Come up with a list of five "male" and five "female" adjectives. Are they based on facts or opinions? Find an artwork to illustrate each of your terms. Find an artwork that contradicts each of your terms. Make sure that at least half the artworks you choose are not from this chapter.
- 2 What obstacles have women faced in being taken seriously as professional artists? What has been done to counteract that inequity? What artworks, either in this chapter or elsewhere, effectively express either these challenges or the changes in institutional practices toward women in the arts?
- Consider the artworks you have studied and then describe an artwork that expresses your personal experience as a man or woman. What roles have you played in your life that conform to or deviate from established norms? How can you communicate that experience to your audience in an artwork?

4.163 Rembrandt van Rijn, Self-portrait with Saskia in the Scene of the Prodigal Son in the Tavern, c. 1635. Oil on canvas, 5'3³/₈" × 4'3⁵/₈". Gemäldegalerie Alte Meister, Dresden, Germany

More than two centuries before van Gogh, another Dutch painter, Rembrandt van Rijn (1606–69), known as Rembrandt, was one of the first artists to dedicate a significant portion of his output to self-portraits. He made more than ninety of them over the course of forty years, reflecting the changes that occurred both in his appearance and in the style of his artworks across his lifetime. Rembrandt's self-portraits portrayed him in many guises, from a peasant to an aristocrat, and gave him the opportunity to examine different

facial expressions and character types. In *Self-portrait with Saskia in the Scene of the Prodigal Son in the Tavern*, Rembrandt appears as the prodigal son, from the biblical story of a young man who rebels against his father's wishes by squandering his inheritance on wasteful living (4.163). Rembrandt creates a lively mood in the tavern: he raises his glass toward the viewer, as the barmaid, modeled on his wife Saskia, looks on.

A slightly different (and much later) take on the story of the Prodigal Son is provided by the

4.164 Duane Michals, The Return of the Prodigal Son, 1982

American photographer Duane Michals (b. 1932). Like Rembrandt, Michals includes himself in the scene, although he plays the part of the forgiving father rather than the wayward son (4.164). The reconciliation between father and son is shown in five frames. In the first scene, the father is reading the newspaper by a window as his son enters the room, naked and with his head hanging in shame. In the second frame, the father stands up, while the son hides his face and body, not sure what kind of reaction to expect. By the final frame the father and son have switched places: the father is now naked and the son is wearing his clothes as they embrace. This reversal suggests that the father, in addition to welcoming his son back into his life, also accepts some of the blame for his son's failings.

The British painter Jenny Saville (b. 1970) is another artist who has chosen an unconventional approach to the self-portrait. In such larger-thanlifesize paintings as Branded, which is 7 feet tall, she appears as a monumental nude (4.165). From this vantage point Saville's breasts and stomach are far more prominent than her head, which is barely squeezed into the frame. She glances down with a look of disdain as she pinches a roll of flesh with her left hand, as if peering into a mirror. Not only does her nude figure appear fat, countering contemporary society's bias toward thin women (and noticeably exaggerating Saville's actual size), but her discolored skin is also far from ideal. To make her paintings, Saville refers to photographs and medical illustrations of flesh tones, bruises, dimples, and pockmarks. Such words as "delicate," "supportive," "irrational," "decorative," and "petite," inscribed on her body, comment on society's expectations of the kind of body a

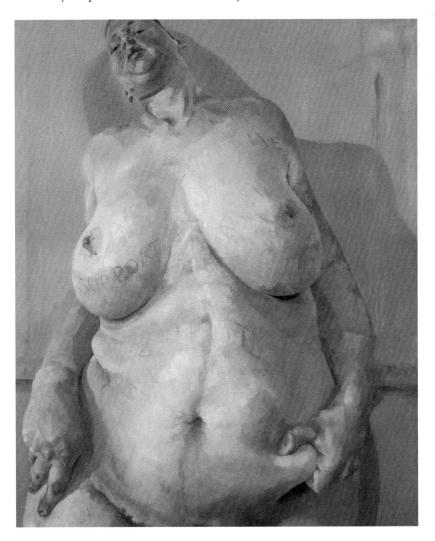

4.165 Jenny Saville, Branded, 1992. Oil on canvas, 7×6

4.166a ORLAN, Seventh surgery-performance, entitled *Omnipresence*, November 21, 1993. *Smile of Delight (Sourire de Plaisir)*. Cibachrome in diasec mount, $43^{1}/4 \times 65^{\circ\circ}$

4.166b ORLAN, Fourth surgery-performance, entitled *Successful Operation*, December 8, 1991, Paris

woman should have. Saville has said that she uses her body as a prop that she is willing to distort and manipulate. The results are direct, if harsh and critical. By confronting—even exaggerating—the imperfections of reality, Saville comments on the conflicted relationship women sometimes have with their own body image.

The French **performance artist** ORLAN (b. 1947) adopted an even more extreme approach to constructing the self. ORLAN's artistic medium is her own body: in order to create a completely new persona, she underwent a series of plastic surgeries that transformed her appearance, and documented the entire process (4.166a and 4.166b). An operating room became the stage for ORLAN's "performance." She was the star, the medical team the cast, with costumes created by famous fashion designers. Because she was given only a local anesthetic, ORLAN was able to remain conscious and read aloud from philosophical and poetic texts while the surgical procedures were carried out. Video cameras in the operating room transmitted a live feed of the surgery to CBS News, the Sandra Gering Gallery in New York, and the Centre Georges Pompidou in Paris. ORLAN also documented the stages of her transformation with photographs taken as she healed.

In her final incarnation, ORLAN had become a composite woman. Her features were modeled after several famously beautiful paintings of women: her chin was copied from Botticelli's Venus (in *The Birth of Venus*); her mouth from the Roman deity Diana in a renowned French

Renaissance canvas; her nose from Psyche, the mythical lover of Cupid, in a later French painting by François Gérard; and her brow from Leonardo da Vinci's Mona Lisa, ORLAN has said her work has several aims: to intervene in the historical representation of women in art by actively determining her own appearance; to comment on the ways technology empowers us to transcend our human limitations; to critique the cult of beauty that imposes unfair standards on women; and to make a statement about the impossibility of physical perfection even in an age when plastic surgery is performed routinely. Ultimately, ORLAN has used her own body to raise questions about cultural perceptions as well as about what constitutes art.

Finding an Artistic Voice

In addition to depicting themselves directly or indirectly in their artworks, artists often use their own experiences, dreams, fears, or confusions as inspiration. Sometimes the result is very different from the way other people might have experienced a similar emotion or event. Learning about the original context of a piece of art, such as the circumstances surrounding its making, can help us to understand the artist's intentions and the ways that their work might contain more than meets the eye. (See Gateway Box: Gentileschi; and Perspectives on Art Box: Mona Hatoum: Art, Personal Experience, and Identity, p. 585.)

Performance artist: an artist whose work involves the human body (often including their own)
Patron: an organization or individual who sponsors the creation of works of art

Gateway to Art: Gentileschi, Judith Decapitating Holofernes Self-Expression in the Judith Paintings

The powerful heroines in the paintings of Artemisia Gentileschi (1593-c. 1656), such as Judith, who beheads Holofernes with steadfast determination, have a strong correlation with events in the artist's own life. Gentileschi was the victim of a sexual assault by Agostino Tassi, who was her painting teacher and a colleague of her father. During the public rape trial that followed, Tassi claimed that Gentileschi was not only a willing lover, but also guite promiscuous. Gentileschi and her father felt that, in addition to the physical violence she had suffered in the assault, their family name and reputation had been attacked. They feared that her prospects of marrying had been damaged both by the rape and the trial. Tassi was eventually sentenced to exile, and Gentileschi married another man, with whom she had five children.

Gentileschi is known to have painted seven works showing different events from the biblical story of Judith's encounter with Holofernes. The first, depicting Judith and her maidservant cutting off his head, was painted about a year after the Tassi trial (4.167). The painting of this violent assault by a woman on an invader has been interpreted as both an expression of the artist's anger at her own attacker, and as a cathartic way of healing the effects of her ordeal. In fact, Gentileschi's heroines in the Judith paintings resemble her own features.

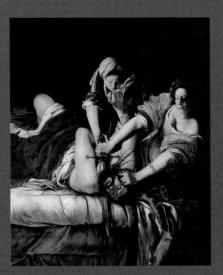

Another of the painter's depictions of the story, made about a decade later, shows Judith and her maidservant by candlelight while making their escape from the murder scene with the bloody head (4.168). While there may indeed be an element of autobiography at least in Gentileschi's earlier paintings, the various versions of the story that she made over a thirty-year period were probably created for a variety of other reasons. The beheading of Holofernes was a popular theme with other artists of the time, suggesting that the **patron** who commissioned Gentileschi's painting may have requested the subject, or that some of her later representations may have been intended for purchasers who had seen and admired her earlier work.

4.168 Artemisia Gentileschi, Judith and Her Maidservant with the Head of Holofernes, 1623-5. Oil on canvas, $6'^{3}/_{8}" \times$ 4'73/4". Detroit Institute of Arts

4.167 (left) Artemisia Gentileschi, Judith Decapitating Holofernes, c. 1620. Oil on canvas, Gallery, Florence, Italy

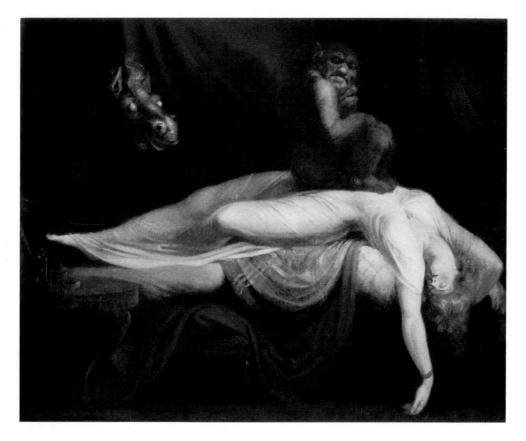

Chiaroscuro: the use of light and dark in a painting to create the impression of volume **Installation:** an artwork created by the assembling and arrangement of objects in a specific location Found object: an object found by an artist and presented, with little or no alteration, as part of a work or as a finished work of art in itself

4.169 Henry Fuseli, The Nightmare, 1781. Oil on canvas, $40 \times 50^{\circ}$. Detroit Institute of Arts

Henry Fuseli (1741–1825), a Swiss-born artist who lived in England after 1779, was inspired by gruesome elements from folklore, horror stories, and the occult to make his own uniquely disturbing paintings. In one of his most famous images, The Nightmare, a woman in white is stretched out on a divan with an incubus on top of her body (4.169). In the background, a fiendish horse peers around the curtain. According to legend, an incubus is a male demon who comes to people, usually women, while they sleep and has sex with them. Fuseli depicts a moment somewhere between sleep and death when the woman's nightmare seems to come to life around her. Fuseli's use of chiaroscuro, or contrasted light and dark colors, enhances the sinister mood created by the expressions on the faces of the incubus and the horse. At the time it was made, the painting's sexual implications were considered scandalous.

The American artist James Abbott McNeill Whistler (1834–1903) used music as the inspiration for an artwork that exemplified an approach known as "Art for Art's Sake." He titled his painting Nocturne in Black and Gold: The Falling Rocket because, like a "nocturne" or a musical composition inspired by the night,

it communicates the rhythm, patterns, and mood of a darkened landscape (4.170).

Nocturne in Black and Gold: The Falling Rocket was controversial in its time. Viewers and critics, unsure of what they were seeing, accused

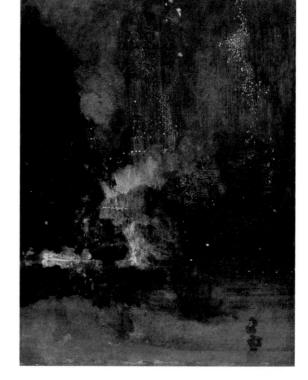

4.170 James Abbott McNeill Whistler, Nocturne in Black and Gold: The Falling Rocket, 1875. Oil on wood panel, $23^{3}/_{4} \times 18^{3}/_{8}$ ". Detroit Institute of Arts

Perspectives on Art: Mona Hatoum

Art, Personal Experience, and Identity

Mona Hatoum is a native of Lebanon (b. 1952) and now lives in London. Her work is exhibited all over the world. Here the art historian Professor Whitney Chadwick, of San Francisco State University, explains some of the connections between Hatoum's art and her personal experiences.

Mona Hatoum's Untitled (Baalbek Bird Cage) (1999) is one of a series of sculptural works on the theme of cages and caging (4.171). An international artist, Hatoum travels extensively and her installations often incorporate found objects that affect her emotionally and/or psychologically. Often her works recall the dislocations of her own life, much of it lived far from her family and the land of her birth. This sculpture originated in a beautiful Victorian birdcage that she discovered in a market while on a trip to Baalbek, Lebanon. Perhaps it reminded her of the loss of her childhood home. Enlarged to ten times its normal size, her sculpture may suggest a giant

4.171 Mona Hatoum, Untitled (Baalbek Bird Cage), 1999. Wood and galvanized steel, 10'2⁷/16" × 9'9" × 6' 5"

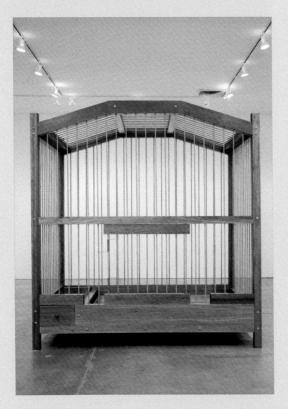

birdcage, or a large wooden bed, or perhaps a house. The work's shifts of scale may feel confusing or threatening to the viewer. Approaching the sculpture, one often feels disoriented, or disconnected. Is this objectso familiar and yet so strange because of its size—a common household object that just happens to suggest a prison? Are its associations friendly or threatening?

The actual dimensions of the birdcage were, in fact, based on the measurements of the cells at Alcatraz Prison in California. The most famous inhabitant of that prison, whose story became the subject of a wellknown Hollywood film, was the so-called "Bird Man of Alcatraz," an incarcerated murderer who raised canaries as a hobby in his cell. In literature, from nineteenth-century English poetry to twentieth-century autobiography, women authors have often identified domestic life with feelings of being a caged bird. Here, as elsewhere in Hatoum's work, the birdcage occupies both a physical and a psychic space that incorporates a wide range of associations—from containment and femininity to liberation.

The feelings of dislocation that accompany the experience of Hatoum's installations and objects, including Untitled (Baalbek Bird Cage), often evoke the artist's own sense of having been "displaced" and "unsettled" by world events. Born in Lebanon of Palestinian parents, who had themselves been uprooted from Haifa in 1948, Hatoum was visiting London when civil war broke out in Lebanon in 1975. The war prevented her return to Beirut and she did not see her family for some years. Much of her work since the early 1980s has been produced in geographically far-flung locations and under conditions of exile that have encouraged her to reconsider what it means to be "settled" or "at home." Baalbek Bird Cage is one among many of Hatoum's sculptures and installations that fuses individual experience and geopolitical reality.

Whistler of trying to deceive the public by presenting a work that was incomplete or carelessly done. The critic John Ruskin wrote that with this painting Whistler was "flinging a pot of paint in the public's face." In reality, Whistler was depicting a fireworks display he had seen in London. He departed from the accepted standards of detailed realism in order to convey his sense of the rhythmic scene with bright sparks in a darkened night sky. About this painting, Whistler said that he was not interested in conveying a story or a recognizable moment, but instead had wanted to focus on line, form, and color. Whistler was also influenced by the way in which music communicates. He appreciated the flow of music and the fact that it does not depend on recognizable words or images.

The Norwegian artist Edvard Munch (1863– 1944) used the realm of his own mind as inspiration for *The Scream* (4.172). As a child he endured the death of his mother and sister and throughout his life suffered from physical illness and depression. These tragic experiences and psychological disturbances motivated his art. Munch reported that he felt psychologically driven to make art. His painting The Scream presents a ghoul-like figure on a bridge with a vibrant red sky in the background. At first glance it appears to be a fictional scene. Entries in Munch's diary, however, indicate that his painting in fact represents his interpretation of an actual event. While walking on a bridge with two friends (the figures looming in the distance), Munch saw the sky turn red, and he froze with anxiety. Scholars have suggested Munch witnessed an incredibly intense sunset caused by the dust thrown into the atmosphere during a volcanic eruption that had occurred years before he made the painting. Others believe he experienced an attack of agoraphobia, or fear of open spaces. Like many **Expressionist** artworks, this painting does not depict what Munch actually saw, but what he felt.

Many artists, like Munch, have found new ways to follow their creative impulses. During the 1940s the American painter Jackson Pollock (1912–56) was undergoing Jungian **psychoanalysis**, a type of therapy that stresses

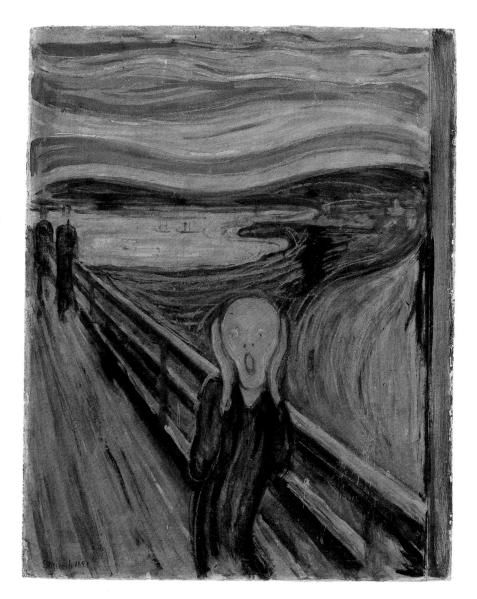

the importance of the collective unconscious and archetypes, or psychological models that we inherit through our unconscious minds. A notably enigmatic work, Male and Female (1942), when interpreted through Jungian analysis, has been understood as an integration of the masculine and feminine elements, and thus a reflection of a balanced psyche (4.173). The female figure, on the left, can be related to the feminine archetype, with its paisley shaped eyes, flowing eyelashes, bright colors, and curving body parts. The male figure, seen on the right, can be connected to the masculine archetype because of its more angular facial features, rigid form, and a mathematical script written on the body. In this painting, Pollock, inspired by **Surrealist** approaches for tapping into the unconscious mind, began to explore unfamiliar

4.172 Edvard Munch, *The Scream*, 1893. Casein and tempera on cardboard, $35\% \times 29\%$. Munch Museum, Oslo, Norway

Expressionism: an artistic style, at its height in 1920s Europe, which aimed to portray the world in terms of vivid extremes of personal experience and feeling Psychoanalysis: a method of treating mental illness by making conscious the patient's subconscious fears or fantasies Paisley: teardrop-shaped motif of Iranian origin, popular on European textiles since the nineteenth century Surrealism: an artistic movement in the 1920s and later, the art of which was inspired by dreams and the subconscious

4.173 Jackson Pollock, Male and Female, c. 1942. Oil on canvas, 6'13/8" × 4'1". Philadelphia Museum of Art

regions of his own psyche in order to access what might be seen as universal ideas about humanity.

The American artist and filmmaker Julian Schnabel (b. 1951) first made his mark on the art world with innovative mixed-media paintings. Schnabel's unconventional approach to painting included attaching broken plates to his canvases and painting on velvet. His work The Exile contains antlers along with a seemingly random assortment of images, both realistic and abstract (4.174). The figure on the left is copied from a portrait of a boy with a fruit basket by the Baroque painter Caravaggio. To the right is a wooden figurine that resembles a kachina doll made by the Native American Hopi. On the upper right is a bearded man with a turban, who is probably a reference to the Ayatollah Khomeini, the political and spiritual leader of the Islamic Revolution in Iran, which was happening about the time that Schnabel made his painting. Through this unlikely collection of imagery, Schnabel blends together influences from art history and current events in order to convey his own experience of life in the present moment.

4.174 Julian Schnabel, The Exile, 1980. Oil, antlers, gold leaf, and mixed media on wood, 7'6" x 12'

Abstract: an artwork the form of which is simplified, distorted, or exaggerated in appearance. It may represent a recognizable form that has been slightly altered, or it may be a completely non-representational depiction Baroque: European artistic and architectural style of the late sixteenth to early eighteenth centuries, characterized by extravagance and emotional intensity

Kachina: carved wooden doll made by the Native American Hopi, representing a supernatural being in human form as a masked dancer

Borrowing an Image

Many artworks are personal statements, and those statements can take many forms. Some artworks are created by borrowing objects, figures, or entire compositions from the work of other artists. This practice, known as **appropriation**, can be traced to the invention by French artist Marcel Duchamp (1887–1968) of **readymades** (see p. 270), which consist of ordinary objects transformed into artworks simply by the decision of the artist.

Duchamp appropriated such objects as urinals, bicycle wheels, snow shovels, and even other artworks as viable material for his art. Over time, other artists followed in his footsteps by continuing to appropriate artworks (including ones by Duchamp). Some also borrowed images from the realms of popular culture, advertising, and even social stereotypes. Thus an artist can make a personal statement by appropriating the work of another.

The American artist Sherrie Levine (b. 1947) is known for her appropriation of famous paintings, sculptures, and photographs from the past. These pieces raise many questions: Who can be an artist? What role does the artist play? How has that role changed over time? What is originality? Who can be original? The pieces Levine appropriates are generally by male artists who worked at a time when there were very few women in the art world, as has been the case throughout most of history. Levine's work leads us to reconsider the structures of art institutions as they existed in the past. Her sculpture Fountain (After Marcel Duchamp: A. P.) (4.175) recalls Duchamp's famous porcelain urinal from 1917. Unlike Duchamp, though, who took an existing urinal and declared it to be art, Levine had a urinal cast in bronze, a material traditionally used for fine art sculptures. Levine encourages the viewer not just to interact with her own piece, but also to consider his or her attitude toward Duchamp's urinal. Her quotation of a past artwork makes Levine's sculpture most meaningful for viewers who are familiar with Duchamp's work.

In the 1960s, **Pop** artists began using appropriation to bring recognizable and familiar

imagery into galleries and museums. Their sources included comic-book characters, movie stars, popular commercial products, and everyday household items. The Brillo Box sculptures by the American artist Andy Warhol (1928–87) exactly copied the design of the product's packaging (4.176). He had the plywood boxes built in his studio, The Factory, and then silkscreened by hand (although they look manufactured rather than hand-made). The square shape of the boxes and the blue, red, and white of the labels recall some of the formal **elements**

in abstract artworks. By combining the practices of what was then considered "high art" at the time with the "low art" of **graphic design**, Warhol was able to bridge the gap between the two and expand the boundaries of acceptable fine art practices to include popular imagery and commercial printing processes.

Even though Warhol's work challenged accepted practices, many people in the art world readily embraced his approach. An even more controversial line was adopted by the Panamanian-

4.176 Andy Warhol, *Brillo Box*, 1964. Synthetic polymer paint and silkscreen ink on painted wood, $17 \times 17 \times 14^{\circ}$. Collection Andy Warhol Foundation

4.175 Sherrie Levine, Fountain (After Marcel Duchamp: A. P.), 1991. Bronze, 26 × 14½ × 14"

Appropriation: the deliberate incorporation in an artwork of material originally created by other artists

Readymade: an everyday object presented as a work of art Pop art: mid-twentieth-century artistic movement inspired by commercial art forms and popular culture

Silkscreen: method of printmaking using a stencil and paint pushed through a screen Elements: the basic vocabulary of art—including line, form, shape, volume, mass, color, texture, space, time and motion, and value (lightness/darkness) Graphic design: the use of images, typography, and technology to communicate

ideas for a client or to a

particular audience

4.177 Richard Prince, Untitled (Cowboys), 1980. Ektacolor print, 27 × 40". edition 1/2. Museum of Contemporary Art, Los Angeles

born American artist Richard Prince (b. 1949). While working for Time Life publications in the 1980s, Prince began to use advertisements as the basis for his artworks. His Cowboys series focused on the Marlboro man from the cigarette company's print ads (4.177). He cropped the images in such a way that the logos were not included, but otherwise, the color, composition, and vantage point of Prince's artworks were predetermined by the advertisements. When the images were enlarged to fit an art gallery wall they became grainy and blurry, revealing that they were copies, not originals. Prince's photographs were considered sufficiently different from the source to have their own artistic merit.

4.178 Nikki S. Lee. Hip Hop Project (25), 2001. Fujiflex print

For her *Projects* series, the Korean artist Nikki S. Lee (b. 1970) joined a number of different communities, from yuppies and tourists to Hispanics and senior citizens, shopping in the stores they frequented and adopting their mannerisms. Lee said, "My goal is not to become black, white, or Hispanic. It's more like becoming an Asian person who really likes that culture." Once she felt she had become a genuine member of the group, she would have a snapshot self-portrait of herself taken with her new peers. For the Hip Hop Project in 2001, Lee went to a tanning salon three times a week to darken her skin, and then immersed herself in the subculture of the hip hop music scene (4.178). Although she told the people in the close-knit group depicted in this image that she was an artist, most of them did not believe her. It is surprising to learn that her interaction with these people is temporary, because there are no clues to suggest that she is not one of them. Such guises as this one become borrowed personalities for Lee, who considers her identity to be very fluid.

Discussion Questions

- 1 Several artists created multiple self-portraits. Select three self-portraits by the same artist and study them closely. What are the differences between your three selections? What do you think the artist was exploring or conveying in each example?
- In this chapter we have studied artists who appropriate imagery. Elsewhere in this book you will see examples of artworks that have been influenced by another artist or culture (see for example 3.76, 3.184, and 4.130). How does influence differ from appropriation? How do the two groups of artwork relate to the earlier work that influenced them or that was appropriated?
- Consider artworks in this chapter that were inspired by the artist's personal experience. Now think of a specific event in your life or a set of circumstances that would be interesting to translate into an artwork. What would you want people to know? What feelings stand out in your mind? What kinds of colors and imagery relate to your experience?

Glossary

NOTE: A few terms have more than one definition, depending on the context in which they are used.

Abstract: (1) art imagery that departs from recognizable images from the natural world; (2) an artwork the form of which is simplified, distorted, or exaggerated in appearance. It may represent a recognizable form that has been slightly altered, or it may be a completely non-representational depiction

Abstraction: the degree to which an image is altered from an easily recognizable subject

Abstract Expressionism: a midtwentieth-century artistic style characterized by its capacity to convey intense emotions using nonrepresentational images

Academies: institutions training artists in both the theory of art and practical techniques

Acropolis: a high place in a Greek city on which a temple is located

Action painting: application of paint to canvas by dripping, splashing, or smearing that emphasizes the artist's gestures

Actual and Implied lines: actual lines are solid lines. Implied lines are impressions of lines created from a series of points that orient our gaze along a visual path

Actual line: a continuous, uninterrupted line

Aesthetic: related to beauty, art, and taste **A-frame:** an ancient form of structural support, made out of beams arranged so that the shape of the building resembles a capital letter A

Afterimage effect: when the eye sees the complementary color of something that

the viewer has spent an extended time viewing (also known as successive contrasts)

Aisles: in a basilica or other church, the spaces between the columns of the nave and the side walls

Altar: an area where sacrifices or offerings are made

Altarpiece: an artwork that is placed behind an altar in a church

Ambulatory: a covered walkway, particularly around the apse of a church

Analogous colors: colors adjacent to each other on the color wheel

Anamorphosis: the distorted representation of an object so that it appears correctly proportioned only when viewed from one particular position

Appropriation: the deliberate incorporation in an artwork of material originally created by other artists

Apse: semicircular vaulted space in a church

Aquatint: an intaglio printmaking process that uses melted rosin or spray paint to create an acid-resistant ground

Aqueduct: a structure designed to carry water, often over long distances

Arabesque: an abstract pattern derived from geometric and vegetal lines and forms

Archaic: Greek art of the period *c*. 620–480 BCE

Arches: structures, usually curved, that span an opening

Architectural order: a style of designing columns and related parts of a Greek or Roman building

Architrave: a beam that rests on the top of a row of columns

Armature: a framework or skeleton used to support a sculpture

Art Brut: "raw art," artworks made by untrained artists, and having a primitive or childlike quality

Articulate: to make smaller shapes or spaces within a larger composition **Artifact:** an object made by a person

Artist's book: a book produced by an artist, usually an expensive limited edition, often using specialized printing processes

Assemblage: artwork made of threedimensional materials including found objects

Asymmetry: a type of design in which balance is achieved by elements that contrast and complement one another without being the same on either side of an axis

Atmospheric perspective: use of shades of color and clarity to create the illusion of depth. Closer objects have warmer tones and clear outlines, while objects set further away are cooler and become hazy Atrium: a central, normally public, interior space, first used in Roman houses Automatic: suppressing conscious control to access subconscious sources of creativity and truth

Avant-garde: early twentieth-century emphasis on artistic innovation, which challenged accepted values, traditions, and techniques

Axis: an imaginary line showing the center of a shape, volume, or composition

Background: (1) the part of a work depicted as behind the main figures; (2) the part of a work depicted furthest from the viewer's space, often behind the main subject matter

Balance: a principle of art in which elements are used to create a symmetrical or asymmetrical sense of visual weight in an artwork

Balustrade: a railing supported by short pillars

Baroque: European artistic and architectural style of the late sixteenth to early eighteenth century, characterized by extravagance and emotional intensity **Base:** the projecting series of blocks

Base: the projecting series of blocks between the shaft of a column and its plinth

Basilica: an early Christian church, either converted from or built to resemble

a type of Roman civic building

Bas-relief: a sculpture carved with very little depth

Bauhaus: design school founded in Weimar, Germany, in 1919

Binder: a substance that makes pigments adhere to a surface

Bohemian: derived from the gypsies of the former Czech Kingdom of Bohemia who moved around; a wanderer; an artist or writer who functions outside the bounds of conventional rules and practices

Boldface: a darker and heavier typeface than its normal instance

Bust: a statue of a person depicting only his or her head and shoulders

Byzantine: relating to the East Roman Empire, centered on Constantinople (modern-day Istanbul) from the fifth century CE to 1453

Calligraphy: the art of emotive or carefully descriptive hand lettering or handwriting

Canon of proportions: a set of ideal mathematical ratios in art used to measure the various parts of the human body in relation to one another

Canopic jar: a jar used by ancient Egyptians to hold the embalmed internal organs removed from the body during mummification

Capital: the architectural feature that crowns a column

Capstone: a final stone forming the top of a structure; on a pyramid, it is pyramid-shaped

Cast: a sculpture or artwork made by pouring a liquid (for example molten metal or plaster) into a mold

Catacombs: an underground system of tunnels used for burying and commemorating the dead

Central-plan church: Eastern Orthodox church design, often in the shape of a cross with all four arms of equal length Ceramic(s): fire-hardened clay, often painted, and normally sealed with shiny

protective coating

Ceramist: a person who makes ceramics **Chevron:** a V-shaped stripe, often reproduced upside down or on its side in decorative patterns

Chiaroscuro: the use of light and dark in a painting to create the impression of volume

Choir: part of a church traditionally reserved for singers and clergy, situated between the nave and the apse

Classical: (1) ancient Greek and Roman; (2) artworks from ancient Greece or Rome; (3) art that conforms to Greek and Roman models, or is based on rational construction and emotional equilibrium; (4) Greek art of the period c. 480-323 BCE

Classical period: a period in the history of Greek art, c. 480–323 BCE

Clerestory windows: a row of windows high up in a church to admit light into the

Coffered: decorated with recessed paneling

Coiling: the use of long coils of clay – rather than a wheel - to build the walls of a pottery vessel

Collage: a work of art assembled by gluing materials, often paper, onto a surface. From the French coller, to glue

Colophon: comment written on a Chinese scroll by the creator, owner, or a viewer

Color: the optical effect caused when reflected white light of the spectrum is divided into a separate wavelength

Color field: a term used by a group of twentieth-century abstract painters to describe their work with large flat areas of color and simple shapes

Color theory: the understanding of how colors relate to each other, especially when mixed or placed near one another

Column: freestanding pillar, usually circular in section

Complementary colors: colors opposite one another on the color wheel Composite view: representation of a

subject from multiple viewpoints at one time

Composition: the overall design or organization of a work

Concentric: identical shapes stacked inside each other sharing the same center, for example the circles of a target

Conceptual: relating to or concerning ideas

Conceptual art: a work in which the ideas are often as important as how it is made

Concrete: a hard, strong, and versatile construction material made up of powdered lime, sand, and rubble

Constructivism: an art movement in the Soviet Union in the 1920s, primarily concerned to make art of use to the working class

Continuous narrative: when different parts of a story are shown within the same visual space

Contour: the outline that defines a form **Contour rivalry:** a design in which the lines can be read in more than one way at the same time, depending on the angle from which it is viewed

Contrapposto: a pose in sculpture in which the upper part of the body twists in one direction and the lower part in another

Contrast: a drastic difference between such elements as color or value (lightness/darkness)

Convention: a widely accepted way of doing something; using a particular style, following a certain method, or representing something in a specific way

Convex: curved inward, like the exterior of a sphere

Corbeled: with a series of corbels architectural feature made of stone, brick, wood, etc.—each projecting beyond the one below

Cornice: molding round the top of a building

Cor-ten steel: a type of steel that forms a coating of rust that protects it from the weather and further corrosion

Course: a single row of stones or bricks forming a horizontal layer of a structure **Cropping:** trimming the edges of an image, or composing it so that part of the subject matter is cut off

Cross-hatching: the use of overlapping parallel lines to convey darkness or lightness

Cubism: a twentieth-century art movement that favored a new perspective emphasizing geometric forms

Curator: a person who organizes the collection and exhibition of objects/artworks in a museum or gallery

Dada: anarchic anti-art and anti-war movement, dating back to World War I, that reveled in absurdity and irrationality **Deposition:** a scene showing the taking down of Christ's body from the cross **Depth:** the degree of recession in perspective

De Stijl: a group of artists originating in the Netherlands in the early twentieth century, associated with a utopian style of design that emphasized primary colors and straight lines

Diagonal: a line that runs obliquely, rather than horizontally or vertically Didactic: with the aim of teaching or educating

Directional line: implied line within a composition, leading the viewer's eye from one element to another

Dissonance: a lack of harmony **Documentary:** non-fiction film based on actual people, settings, and events

Dome: an evenly curved vault **Drypoint:** an intaglio printmaking process where the artist raises a burr when gouging the printing plate

Edition: all the copies of a print made from a single printing

Elements: the basic vocabulary of art line, form, shape, volume, mass, color, texture, space, time and motion, and value (lightness/darkness)

Embroidery: decorative stitching

generally made with colored thread applied to the surface of a fabric

Emphasis: the principle of drawing attention to particular content within a work

Engraving: a printmaking technique where the artist gouges or scratches the image into the surface of the printing plate

Enlightenment: an intellectual movement in eighteenth-century Europe that argued for science, reason, and individualism, and against tradition **Entablature:** the part of a Greek or

Roman building that rests on top of a column

Entasis: the slight swelling or bulge at the midpoint of a column

Etching: (1) a printmaking process that uses acid to bite (or etch) the engraved design into the printing surface; (2) an intaglio printmaking process that uses acid to bite (or etch) the engraved design into the printmaking surface

Eucharist: Christian ceremony that commemorates the death of Jesus Christ **Experimental film:** films the style and content of which are very different from mainstream commercial films

Expressionism: an artistic style at its height in 1920s Europe, aiming to portray the world in terms of vivid extremes of personal experience and feeling

Expressive: capable of stirring the emotions of the viewer

Facade: any side of a building, usually the front or entrance

Fauves: a group of early twentiethcentury French artists whose paintings used vivid colors. From the French fauve, wild beast

Figuration: the portrayal of things in the visible world

Figurative: art that portrays items perceived in the visible world, especially human or animal forms

Figure–ground reversal: the reversal of the relationship between one shape (the figure) and its background (the ground),

so that the figure becomes background and the ground becomes the figure

Firing: heating ceramic, glass, or enamel objects in a kiln, to harden them, fuse the components, or fuse a glaze to the surface

Fixing: the chemical process used to ensure a photographic image becomes permanent

Flint: an object or tool made from the very hard, sharp-edged stone of the same

Flying buttress: an arch built on the exterior of a building that transfers some of the weight of the vault

Focal point: (1) the center of interest or activity in a work of art, often drawing the viewer's attention to the most important element; (2) the area in a composition to which the eye returns most naturally

Foreground: the part of a work depicted as nearest to the viewer

Foreshortening: a perspective technique that depicts a form at a very oblique (often dramatic) angle to the viewer in order to show depth in space

Form: an object that can be defined in three dimensions (height, width, and depth)

Format: the shape of the area an artist uses for making a two-dimensional artwork

Found image: an image found by an artist and presented with little or no alteration as a work of art

Found object: an object found by an artist and presented, with little or no alteration, as part of a work or as a finished work of art in itself

Fresco: (1) a technique where the artist paints onto freshly applied plaster. From the Italian fresco, fresh; (2) paintings made on freshly applied plaster

Frieze: the strip that goes around the top of a building, often filled with sculptural ornamentation

Futurism: an artistic and social movement, originating in Italy in 1909, passionately in favor of everything modern

Gèlèdé ritual: ritual performed in Nigeria's Yoruba society to celebrate and honor women

Genre: categories of artistic subject matter, often with strongly influential histories and traditions

Gestalt: complete order and indivisible unity of all aspects of an artwork's design Glazing: in oil painting, adding a transparent layer of paint to achieve a richness in texture, volume, and form **Golden Section:** a unique ratio of a line divided into two parts so that a + b is to a

Gothic: Western European architectural style of the twelfth to sixteenth centuries, characterized by the use of pointed arches and ornate decoration

as *a* is to *b*. The result is 1:1.618

Graphic design: the use of images, typography, and technology to communicate ideas for a client or to a particular audience

Grid: a network of horizontal and vertical lines; in an artwork's composition, the lines are implied

Ground: the surface or background onto which an artist paints or draws

Guilds: medieval associations of artists, craftsmen, or tradesmen

Gypsum: fine grained, powdery mineral often used to make a smooth plaster

Happening: impromptu art actions, initiated and planned by an artist, the outcome of which is not known in advance

Hatching: the use of non-overlapping parallel lines to convey darkness or lightness

Hellenistic: Greek art from c. 323– 100 BCE

Hierarchical scale: the use of size to denote the relative importance of subjects in an artwork

Hieroglyph: written language involving sacred characters that may be pictures as well as letters

Highlight: an area of lightest value in a work

High relief: a carved panel where the figures project with a great deal of depth from the background

Hue: general classification of a color; the distinctive characteristics of a color as seen in the visible spectrum, such as green or red

Humanism: the study of such subjects as history, philosophy, languages, and literature, particularly in relation to those of ancient Greece and Rome

Hypostyle hall: a large room with a roof supported by a forest of columns

Icon: a small, often portable, religious image venerated by Christian believers; first used by the Eastern Orthodox Church

Iconic: a sign, the form of which directly suggests its meaning

Iconoclast: someone who destroys imagery, often out of religious belief Ideal: more beautiful, harmonious, or perfect than reality

Idealism: elevating depictions of nature to achieve more beautiful, harmonious, and perfect depictions

Idealized: represented as perfect in form or character, corresponding to an ideal **Ideogram:** a symbol that expresses an idea or a thing without representing the sounds in its name (for example, "8")

Illuminated characters: highly decorated letters, usually found at the beginning of a page or paragraph

Illuminated manuscript: a handlettered text with hand-drawn pictures

Illuminations: illustrations and decorations in a manuscript

Illusionism (adjective illusionistic): the artistic skill or trick of making something look real

IMAX: a format for film presentation that records at such high resolution that it allows presentation of films at far larger sizes than the conventional one

Impasto: paint applied in thick layers Implied line: a line not actually drawn but suggested by elements in the work

Implied texture: a visual illusion expressing texture

Impression: an individual print, or pull, from a printing press

Impressionism: a late nineteenthcentury painting style conveying the impression of the effects of light

Incised: cut

Inlay: substance embedded in another, contrasting material

Installation: an artwork created by the assembling and arrangement of objects within a specific location

Intaglio: any print process where the inked image is lower than the surface of the printing plate; from the Italian for "cut into"

Intarsia: the art of setting pieces of wood into a surface to create a pattern

Intensity: the relative clarity of color in its purest raw form, demonstrated through luminous or muted variations **In the round:** a freestanding sculpted work that can be viewed from all sides

Isometric perspective: a system using diagonal parallel lines to communicate depth

Ivory: hard, creamy-colored material from the tusks of such mammals as elephants

Kachina: carved wooden doll made by the Native American Hopi, representing a supernatural being in human form as a masked dancer

Kinetic art: a work that contains moving

Kinetic sculpture: three-dimensional art that moves, impelled by air currents, motors, or people

Kouros: sculpture of a nude Greek youth

Lapis lazuli: bright-blue semiprecious stone containing sodium aluminum silicate and sulphur

Latitude: a point on the earth's circumference measured to the east

Levering: to move or raise an object

using a leverlike action

Line: a mark, or implied mark, between two endpoints

Linear outline: a line that clearly separates a figure from its surroundings **Linear perspective:** a system using imaginary sight lines to create the illusion of depth

Lintel: the horizontal beam over the doorway of a portal

Low relief: carving in which the design stands out only slightly from the background surface

Luminosity: a bright, glowing quality **Lyre:** a stringed instrument that is played by being plucked; the strings hang from a crossbar that is supported by two arms connected to a hollow box, which amplifies the sound

Mandala: a sacred diagram of the universe, often involving a square and a circle

Mannerism: from Italian *di maniera*, meaning charm, grace, playfulness; midto late sixteenth-century style of painting, usually with elongated human figures elevating grace as an ideal

Mantle: sleeveless item of clothing—a cloak or cape

Manuscripts: handwritten texts **Mask:** a barrier, in spray painting or silkscreen printing, the shape of which blocks the paint or ink from passing through

Masquerade: performance in which participants wear masks and costumes for a ritual or cultural purpose

Mass: a volume that has, or gives the illusion of having, weight, density, and bulk

Medieval: relating to the Middle Ages; roughly, between the fall of the Roman Empire and the Renaissance

Medium (plural **media**): the material on or from which an artist chooses to make a work of art, for example canvas and oil paint, marble, engraving, video, or architecture

Metope: a square space between triglyphs, often decorated with sculpture

Mezzotint: an intaglio printmaking process based on roughening the entire printing plate to accept ink; the artist smoothes non-image areas

Middle ground: the part of a work between the foreground and background

Mihrab: a niche in a mosque that is in a wall oriented towards Mecca

Mime: a silent performance work; actors use only body movements and facial expressions

Minaret: a tall slender tower, particularly on a mosque, from which the faithful are called to prayer

Minimalist: a mid-twentieth-century artistic style characterized by its simple, unified, and impersonal look, and often employing geometrical or massive forms Mobile: suspended moving sculptures, usually impelled by natural air currents Modeling: the representation of three-dimensional objects in two dimensions so that they appear solid

Modernist: a radically new twentiethcentury architectural movement that embraced modern industrial materials and a machine aesthetic

Monochromatic: having one or more values of one color

Monolith: a monument or sculpture made from a single piece of stone

Monumental: having massive or impressive scale

Mosaic: a picture or pattern created by fixing together small pieces of stone, glass, tile, etc.

Motif: a distinctive visual element, the recurrence of which is often characteristic of an artist's work

Motion: the effect of changing placement in time

Mural: a painting executed directly on to a wall

Naturalism (adjective **naturalistic**): a very realistic or lifelike style of making

images

Nave: the central space of a cathedral or basilica

Necropolis: cemetery or burial place **Negative:** a reversed image, in which light areas are dark, and dark areas are light (opposite of a positive)

Negative space: an empty space given shape by its surround, for example the right-pointing arrow between the **E** and **x** in **FedEx**

Neutral: colors (such as blacks, whites, grays, and dull gray-browns) made by mixing complementary hues

Non-objective: art that does not depict a recognizable subject

Nude: an artistic representation of the naked human figure

Oculus: a round opening at the center of a dome

Octagonal: eight-sided

Oil paint: paint made of pigment floating in oil

One-point perspective: a perspective system with a single vanishing point on the horizon

Opaque: not transparent

Op art: a style of art exploiting the physiology of seeing to create illusory optical effects

Optical mixture: when the eye blends two colors that are placed near one another, creating a new color

Organic: having forms and shapes derived from living organisms

Origami: the Japanese art of paperfolding

Orthogonals: in perspective systems, imaginary sightlines extending from forms to the vanishing point

Outline: the outermost line of an object or figure, by which it is defined or bounded

Paisley: teardrop-shaped motif of Iranian origin, popular on European textiles since the nineteenth century **Paleolithic:** prehistoric period,

extending from 2.5 million to 12,000 years ago

Palette: (1) the range of colors used by an artist; (2) a smooth slab or board used for mixing paints or cosmetics

Passion: the arrest, trial, and execution of Jesus Christ, and his sufferings during them

Patina: surface color or texture on a metal caused by aging

Patron: an organization or individual who sponsors the creation of works of art Pattern: an arrangement of predictably repeated elements

Pectoral: a large ornament worn on the chest

Pediment: the triangular space, situated above the row of columns, at the end of a building in the Classical style

Pendentive: a curving triangular surface that links a dome to a square space below **Performance art:** a work involving the human body, usually including the artist, in front of an audience

Performance artist: an artist whose work involves the human body (often including his or her own)

Perspective: the creation of the illusion of depth in a two-dimensional image by using mathematical principles

Photomontage: a single photographic image that combines (digitally or using multiple film exposures) several separate images

Physiology: a science that studies the workings of the body and its organs

Pictograph: picture used as a symbol in writing

Picture plane: the surface of a painting or drawing

Piece mold casting: a process for casting metal objects in which a mold is broken into several pieces that are then reassembled into a final sculpture

Pigment: the colored material used in paints. Often made from finely ground minerals

Pilaster: a vertical element, square in shape, that provides architectural support for crossing horizontal elements in postand-lintel construction; also used for decoration

Plane: a flat surface

Planography: a print process lithography and silkscreen printing where the inked image area and noninked areas are at the same height

Plastic: referring to materials that are soft and can be manipulated

Pointed arches: arches with two curved sides that meet to form a point at the apex **Pointillism:** a late nineteenth-century painting style using short strokes or points of differing colors that optically combine to form new perceived colors

Pop art: mid-twentieth-century artistic movement inspired by commercial art forms and popular culture

Portico: a roof supported by columns at the entrance to a building

Portrait: image of a person or animal, usually focusing on the face

Positive: an image in which light areas are light and dark areas are dark (opposite of a negative)

Positive–negative: the relationship between contrasting opposites

Positive shape: a shape defined by its surrounding empty space

Post-and-lintel construction: a

horizontal beam (the lintel) supported by a post at either end

Post-Impressionists: artists either from or living in France, c. 1885–1905, who moved away from the Impressionist style - notably Cezanne, Gauguin, Seurat, and Van Gogh

Postmodernism: a late twentiethcentury style of architecture playfully adopting features of earlier styles

Predella: an artwork designed as a companion piece to a more important work

Prehistoric: dating from the period of human existence before the invention of writing

Pre-Raphaelite Brotherhood: English art movement formed in 1848 by painters who rejected the academic rules of art, and often painted medieval subjects in a naïve style

Primary colors: three basic colors from which all others are derived

Principles: the "grammar" applied to the elements of art—contrast, balance, unity, variety, rhythm, emphasis, pattern, scale, proportion, and focal point

Print: a picture reproduced on paper, often in multiple copies

Profile: the outline of an object, especially a face or head, represented from the side

Propaganda: art that promotes an ideology or a cause

Proportion: the relationship in size between a work's individual parts and the whole

Provenance: the record of all known previous owners and locations of a work of art

Psychoanalysis: a method of treating mental illness by making conscious the patient's subconscious fears or fantasies **Psychology:** a science that studies the nature, development, and operation of the human mind

Pueblos: word meaning "town" that refers to Anasazi settlements throughout the Four Corners area of Utah, Colorado, New Mexico, and Arizona; also the name of groups descending from the Anasazi **Putto** (plural **putti**): a representation of a nude or scantily clad infant angel or boy, common in Renaissance and Baroque art **Pyramid:** ancient structure, usually massive in scale, consisting of a square base with four sides that meet at a point or apex with each side forming a

Qibla: the direction Muslims face when praying

triangular shape

Raku: handmade and fired ceramic, made for a tea ceremony

Readymade: an everyday object presented as a work of art

Realism: nineteenth-century artistic style that aimed to depict nature and everyday subjects in an unidealized manner **Realistic:** artistic style that aims to represent appearances as accurately as possible

Register: one of two or more horizontal sections into which a space is divided in order to depict the episodes of a story **Relief:** (1) a raised form on a largely flat background. For example, the design on

background. For example, the design on a coin is "in relief"; (2) a print process where the inked image is higher than the non-printing areas; (3) a sculpture that projects from a flat surface

Renaissance: a period of cultural and artistic change in Europe from the fourteenth to the seventeenth century **Repoussé:** a technique of hammering metal from the back

Representation: the depiction of recognizable figures and objects **Representational:** art that depicts figures and objects so that we recognize what is represented

Rhythm: the regular or ordered repetition of elements in the work **Rib vault:** an archlike structure supporting a ceiling or roof, with a web of protruding stonework

Romanesque: an early medieval European style of architecture based on Roman-style rounded arches and heavy construction

Romanticism: movement in nineteenthcentury European culture, concerned with the power of the imagination and greatly valuing intense feeling

Rosin: a dry powdered resin that melts when heated, used in the aquatint process

Salon: (1) official annual exhibition of French painting, first held in 1667; (2) a French term for an exhibition of work by multiple artists; (3) the routine gathering of a circle of notable people—often figures from the worlds of art, literature, and politics—at the home of one member of the group

Sand painting: also known as dry painting, a labor-intensive method of painting using grains of sand as the medium

Sarcophagus (plural sarcophagi): a coffin (usually made of stone or baked clay)
Sarsen: a type of hard, gray sandstone
Satire: a work of art that exposes the weaknesses and mistakes of its subjects to ridicule

Saturation: the degree of purity of a color

Scale: the size of an object or an artwork relative to another object or artwork, or to a system of measurement

Secondary color: a color mixed from two primary colors

Sfumato: in painting, the application of layers of translucent paint to create a hazy or smoky appearance and unify the composition

Shade: a color darker in value than its purest state

Shading: the use of gradated light and dark tones to represent a three-dimensional object in two dimensions

Shaft: the main vertical part of a column **Shaman:** a priest or priestess regarded as having the ability to communicate directly with the spiritual world

Shape: a two-dimensional area, the boundaries of which are defined by lines or suggested by changes in color or value

Silhouette: a portrait or figure represented in outline and solidly colored in

Silueta: series of images by Ana Mendieta in which the artist's body is situated in outdoor environments

Silkscreen: method of printmaking using a stencil and paint pushed through a screen

Sketch: a rough preliminary version of a work or part of a work

Slip: clay mixed with water used to decorate pottery

Space: the distance between identifiable points or planes

Span: the distance bridged between two supports, such as columns or walls

Stained glass: colored glass used for windows or decorative applications **Stela:** upright stone slab decorated with inscriptions or pictorial relief carvings **Stencil:** a perforated template allowing ink or paint to pass through to print a design

Stepped pyramid: a pyramid consisting of several rectangular structures placed on top of one another

Stereotypes: oversimplified notions, especially about marginalized groups, that can lead to prejudiced judgments **Still life:** a scene of inanimate objects, such as fruits, flowers, or motionless animals

Stucco: a coarse plaster designed to give the appearance of stone

Style: a characteristic way in which an artist or group of artists uses visual language to give a work an identifiable form of visual expression

Stylized: art that represents objects in an exaggerated way to emphasize certain aspects of the object

Stylobate: the uppermost platform on a Classical temple, on which the columns stand

Subject: the person, object, or space depicted in a work of art

Sublime: feeling of awe or terror, provoked by the experience of limitless nature and the awareness of the smallness of an individual

Subordination: the opposite of emphasis; it draws our attention away from particular areas of a work

Sunken relief: a carved panel where the figures are cut deeper into the stone than the background

Support: the material on which painting is done

Surreal: reminiscent of the Surrealist movement in the 1920s and later, whose art was inspired by dreams and the subconscious

Surrealism: an artistic movement in the 1920s and later, the art of which was inspired by dreams and the subconscious

Surrealist: an artist belonging to the Surrealist movement in the 1920s and later, whose art was inspired by dreams and the subconscious

Symbolism: movement in European art and literature, c. 1885–1910, that conveyed meaning by the use of powerful yet ambiguous symbols

Symmetry: the correspondence in size, form, and arrangement of items on opposite sides of a plane, line, or point that creates direct visual balance

Synesthesia: when one of the five senses perceives something that was stimulated by a trigger from one of the other senses

Tableau: a stationary scene arranged for artistic impact

Tapestry: hand-woven fabric—usually silk or wool—with a non-repeating, usually figurative, design woven into it

Tattoos: designs marked on the body by injecting dye under the skin

Temperature: a description of color based on our associations with warmth or coolness

Tenebrism: dramatic use of intense darkness and light to heighten the impact of a painting

Terracotta: iron-rich clay, fired at a low temperature, which is traditionally brownish-orange in color

Tesserae: small pieces of stone or glass or other materials used to make a mosaic **Texture:** the surface quality of a work, for example fine/coarse, detailed/lacking in detail

Three-dimensional: having height,

width, and depth

Three-dimensionality: the condition of having height, width, and depth

Three-point perspective: a perspective system with two vanishing points on the horizon and one not on the horizon

Throwing: the process of making a ceramic object on a potter's wheel

Tint: a color lighter in value than its purest state

Tipi or **teepee:** portable dwelling used by Plains groups

Tracery: a complex but delicate pattern of interwoven lines

Transept: structure crossing the main body of a cruciform church

Triglyph: a projecting block carved with three raised bands, which alternates with figurative reliefs in a frieze

Triptych: an artwork comprising three painted or carved panels, normally joined together and sharing a common theme

Trompe l'oeil: an extreme kind of illusion meant to deceive the viewer

Tumbling: the use of levers to roll heavy objects over short distances

Twisted perspective, also known as composite view: a representation of a figure, part in profile and part frontally

Two-dimensional: having height and width

Tympanum: an arched recess above a doorway, often decorated with carvings

Typography: the art of designing, arranging, and choosing type

Unity: the imposition of order and harmony on a design

Value: the lightness or darkness of a plane or area

Vanishing point: the point in a work of art at which imaginary sight lines appear to converge, suggesting depth

Vanitas: an artwork in which the objects remind the viewer of the transience of life

Variety: the diversity of different ideas, media, and elements in a work

Vault: an archlike structure supporting a ceiling or roof

Vaulted: arched

Visionary art: art made by self-taught artists following a personal vision

Void: an area in an artwork that seems empty

Volume: the space filled or enclosed by a three-dimensional figure or object **Voodoo:** a religion based on Roman

Catholic and traditional African rituals, practiced in the West Indies and southern U.S.

Watercolor: transparent paint made from pigment and a binder dissolved in water

White space: in typography, the empty space around type or other features in a layout

Woodblock: a relief print process where the image is carved into a block of wood Woodcut: a print created from an incised piece of wood

Ziggurat: Mesopotamian stepped tower, roughly pyramid-shaped, that diminishes in size toward a platform summit

Further Reading

PART 1

- **Chapter 1.1** Art in Two Dimensions: Line, Shape, and the Principle of Contrast
- de Zegher, Catherine, and Cornelia Butler, On Line: Drawing Through the Twentieth Century. New York (The Museum of Modern Art) 2010.
- Ocvirk, Otto, Robert Stinson, Philip Wigg, and Robert Bone, *Art Fundamentals: Theory and Practice*, 11th edn. New York (McGraw-Hill) 2008.
- **Chapter 1.2** Three-Dimensional Art: Form, Volume, Mass, and Texture
- Ching, Francis D. K., *Architecture: Form, Space, and Order*, 3rd edn. Hoboken, NJ (Wiley) 2007.
- Wong, Wucius, *Principles of Three-Dimensional Design*. New York (Van Nostrand Reinhold) 1977.
- **Chapter 1.3** Implied Depth: Value and Space
- Auvil, Kenneth W., Perspective Drawing, 2nd edn. New York (McGraw-Hill) 1996. Curtis, Brian, Drawing from Observation, 2nd edn. New York (McGraw-Hill) 2009.

Chapter 1.4 Color

- Albers, Josef and Nicholas Fox Weber, Interaction of Color: Revised and Expanded Edition. New Haven, CT (Yale University Press) 2006.
- Bleicher, Steven, *Contemporary Color:* Theory and Use, 2nd edn. Clifton Park, NY (Delmar Cengage Learning) 2011.

Chapter 1.5 Time and Motion

Krasner, Jon, *Motion Graphic Design: Applied History and Aesthetics*, 2nd edn.

- Burlington, MA (Focal Press [Elsevier]) 2008.
- Stewart, Mary, *Launching the Imagination*, 3rd edn. New York (McGraw-Hill) 2007.

Chapter 1.6 Unity, Variety, and Balance

- Bevlin, Marjorie Elliott, *Design Through Discovery: An Introduction*, 6th edn.
 Orlando, FL (Harcourt Brace &
 Co./Wadsworth Publishing) 1993.
 Lauer, David A., and Stephen Pentak, *Design Basics*, 8th edn. Boston, MA
- Chapter 1.7 Scale and Proportion

(Wadsworth Publishing) 2011.

- Bridgman, George B., *Bridgman's Life Drawing*. Mineola, NY (Dover Publications) 1971.
- Elam, Kimberly, *Geometry of Design:*Studies in Proportion and Composition,
 1st edn. New York (Princeton
 Architectural Press) 2001.

Chapter 1.8 Emphasis and Focal Point

- Lauer, David A., and Stephen Pentak, Design Basics, 8th edn. Boston, MA (Wadsworth Publishing) 2011.
- Stewart, Mary, *Launching the Imagination*, 3rd edn. New York (McGraw-Hill) 2007.

Chapter 1.9 Pattern and Rhythm

- Ocvirk, Otto, Robert Stinson, Philip Wigg, and Robert Bone, *Art Fundamentals: Theory and Practice*, 11th edn. New York (McGraw-Hill) 2008.
- Wong, Wucius, *Principles of Two-Dimensional Design*, 1st edn. New York (Wiley) 1972.

Chapter 1.10 Content and Analysis

- Barnet, Sylvan, *Short Guide to Writing About Art.* Harlow, UK (Pearson Education) 2010.
- Hatt, Michael, and Charlotte Klonk, Art History: A Critical Introduction to Its Methods. New York (Manchester

University Press; distributed exclusively in the USA by Palgrave) 2006.

PART 2

Chapter 2.1 Drawing

- Faber, David L., and Daniel M. Mendelowitz, A Guide to Drawing, 8th edn. Boston, MA (Wadsworth Publishing) 2011.
- Sale, Teel and Claudia Betti, *Drawing:*A Contemporary Approach, 6th edn.
 Boston, MA (Wadsworth Publishing)
 2007.

Chapter 2.2 Painting

- Gottsegen, Mark David, *Painter's Handbook: Revised and Expanded.* New
 York (Watson-Guptill) 2006.
- Robertson, Jean, and Craig McDaniel, Painting as a Language: Material, Technique, Form, Content, 1st edn. Boston, MA (Wadsworth Publishing) 1999.

Chapter 2.3 Printmaking

- Hunter, Dard, *Papermaking*. Mineola, NY (Dover Publications) 2011.
- Ross, John, *Complete Printmaker*, revised expanded edn. New York (Free Press) 1991.

Chapter 2.4 Visual Communication Design

- Craig, James, William Bevington, and Irene Korol Scala, *Designing with Type*, 5th Edition: The Essential Guide to Typography. New York (Watson-Guptill) 2006.
- Meggs, Philip B. and Alston W. Purvis, Meggs' History of Graphic Design, 4th edn. Hoboken, NJ (Wiley) 2005.

Chapter 2.5 Photography

Hirsch, Robert, *Light and Lens: Photography in the Digital Age.* London (Elsevier) 2007.

- Jeffrey, Ian, How to Read a Photograph. New York (Abrams) 2010.
- London, Barbara, John Upton, and Jim Stone, Photography, 10th edn. Upper Saddle River, NJ (Pearson) 2010.
- Marien, Mary Warner, Photography: A Cultural History, 3rd edn. Upper Saddle River, NJ (Prentice Hall) 2010.
- Rosenblum, Naomi, A World History of Photography, 4th edn. New York (Abbeville Press) 2008.
- Trachtenberg, Alan, ed., Classic Essays on Photography. New York (Leete's Island Books) 1980.

Chapter 2.6 Film/Video and Digital Art

- Cook, David A., A History of Narrative Film, 4th edn. New York (W. W. Norton) 2004.
- Corrigan, Timothy, and Patricia White, The Film Experience, 2nd edn. New York (Bedford/St. Martin's) 2008.
- Monaco, James, How to Read a Film: Movies, Media, and Beyond. New York (Oxford University Press) 2009.
- Wands, Bruce, Art of the Digital Age. New York (Thames & Hudson) 2007.

Chapter 2.7 Alternative Media and **Processes**

- Alberro, Alexander, and Black Stimson, Conceptual Art: A Critical Anthology. Cambridge, MA (MIT Press) 2000.
- Bishop, Claire, Installation Art, 2nd edn. London (Tate Publishing) 2010.
- Goldberg, Rosalee, Performance Art: From Futurism to the Present, 2nd edn. New York (Thames & Hudson) 2001.
- Lippard, Lucy, Six Years: The Dematerialization of the Art Object from 1966 to 1972. Berkeley, CA (University of California Press) 1997.
- Osborne, Peter, Conceptual Art (Themes and Movements). New York and London (Phaidon) 2011.
- Rosenthal, Mark, Understanding Installation Art: From Duchamp to Holzer. New York (Prestel) 2003.

Chapter 2.8 The Tradition of Craft

- Speight, Charlotte, and John Toki, Hands in Clay: An Introduction to Ceramics, 5th edn. New York (McGraw-Hill) 2003.
- Wight, Karol, Molten Color: Glassmaking in Antiquity. Los Angeles, CA (J. Paul Getty Museum) 2011.

Chapter 2.9 Sculpture

- Rich, Jack C., The Materials and Methods of Sculpture, 10th edn. Mineola, NY (Dover Publications) 1988.
- Tucker, William, The Language of Sculpture. London (Thames & Hudson) 1985.

Chapter 2.10 Architecture

- Ching, Francis D. K., Architecture: Form, Space, and Order, 3rd edn. Hoboken, NJ (Wiley) 2007.
- Glancey, Jonathan, Story of Architecture. New York (Dorling Kindersley/Prentice Hall) 2006.

PART 3

Chapter 3.1 The Prehistoric and Ancient Mediterranean

- Alfred, Cyril, Egyptian Art. New York (Oxford University Press) 1980.
- Aruz, Joan, Art of the First Cities: The Third Millennium B.C. from the Mediterranean to the Indus. New York (The Metropolitan Museum of Art); New Haven, CT (Yale University Press) 2003.
- Boardman, John, The World of Ancient Art. New York (Thames & Hudson) 2006.
- Pedley, John Griffiths, Greek Art and Archeology, 5th edn. Upper Saddle River, NJ (Pearson/Prentice Hall) 2007.
- Wheeler, Mortimer, Roman Art and Architecture. New York (Thames & Hudson) 1985.

Chapter 3.2 Art of the Middle Ages

Benton, Janetta, Art of the Middle Ages.

New York (Thames & Hudson) 2002. Camille, Michael, Gothic Art: Glorious Visions. New York (Abrams) 1996.

Lowden, John, Early Christian & Byzantine Art. London (Phaidon) 1997.

Chapter 3.3 Art of India, China, and Japan

Craven, Roy, Indian Art. New York (Thames & Hudson) 1997.

Lee, Sherman, History of Far Eastern Art. New York (Abrams) 1994.

Stanley-Baker, Joan, Japanese Art. New York (Thames & Hudson) 2000.

Tregear, Mary, Chinese Art. New York (Thames & Hudson) 1997.

Chapter 3.4 Art of the Americas

- Berlo, Janet Catherine, and Ruth B. Phillips, Native North American Art. New York (Oxford University Press) 1998.
- Coe, Michael D., and Rex Koontz, *Mexico*: From the Olmecs to the Aztecs, 6th edn. New York (Thames & Hudson) 2008.
- Miller, Mary Ellen, The Art of Ancient Mesoamerica, 4th edn. New York (Thames & Hudson) 2006.
- Rushing, Jackson III, Native American Art in the Twentieth Century: Makers, Meanings, Histories. New York (Taylor and Francis) 1999.
- Stone-Miller, Rebecca, Art of the Andes: From Chavin to Inca, 2nd edn. New York (Thames & Hudson) 2002.

Chapter 3.5 Art of Africa and the Pacific Islands

- Bacquart, Jean-Baptiste, The Tribal Arts of Africa. New York (Thames & Hudson) 2002.
- Berlo, Janet Catherine, and Lee Anne Wilson, Arts of Africa Oceania and the Americas. Upper Saddle River, NJ (Prentice Hall) 1992.
- D'Alleva, Anne, Arts of the Pacific Islands. New Haven, CT (Yale University Press) 2010.
- Willet, Frank, African Art, 3rd edn. New York (Thames & Hudson) 2003.

- **Chapter 3.6** Art of Renaissance and Baroque Europe (1400-1750)
- Bazin, Germain, and Jonathan Griffin, Baroque and Rococo. New York (Thames & Hudson) 1985.
- Garrard, Mary, Artemisia Gentileschi. Princeton, NJ (Princeton University Press) 1991.
- Hartt, Frederick, History of Italian Renaissance Art, 7th edn. Upper Saddle River, NJ (Pearson) 2010.
- Welch, Evelyn, Art in Renaissance Italy: 1350-1500. New York (Oxford University Press) 2001.
- **Chapter 3.7** Art of Europe and America 1700-1900
- Chu, Petra ten-Doesschate, Nineteenth Century European Art. New York (Abrams) 2003.
- Denvir, Bernard, Post-Impressionism. New York (Thames & Hudson) 1992.
- Irwin, David, Neoclassicism. London (Phaidon) 1997.
- Levey, Michael, Rococo to Revolution: Major Trends in Eighteenth-Century Painting. New York (Thames & Hudson) 1985.
- Thomson, Belinda, Impressionism: Origins, Practice, Reception. New York (Thames & Hudson) 2000.
- Vaughan, William, Romanticism and Art. London (Thames & Hudson) 1994.
- **Chapter 3.8** Twentieth and Twenty-First Centuries: The Age of Global Art
- Arnason, H. H., and Elizabeth C. Mansfield, History of Modern Art, 6th edn. Upper Saddle River, NJ (Pearson) 2009.
- Barrett, Terry, Why is that Art?: Aesthetics and Criticism of Contemporary Art. New York (Oxford University Press) 2007.
- Fineberg, Jonathan, Art Since 1940: Strategies of Being, 3rd edn. Upper Saddle River, NJ (Prentice Hall) 2010. Jones, Amelia, A Companion to
- Contemporary Art Since 1945. Malden,

- MA (Blackwell Publishing) 2006.
- Stiles, Kristine, and Peter Selz, Theories and Documents of Contemporary Art: A Sourcebook of Artists' Writings, 2nd edn, revised and expanded. Berkeley, CA (University of California Press) 2011.

PART 4

Chapter 4.1 Art and Community

- Art in Action: Nature, Creativity, and Our Collective Future. San Rafael, CA (Earth Aware Editions) 2007.
- Iosifidis, Kiriakos, Mural Art: Murals on Huge Public Surfaces Around the World from Graffiti to Trompe l'oeil. Vancouver, BC (Adbusters) 2009.
- Kwon, Miwon, One Place After Another: Site-Specific Art and Location Identity. Cambridge, MA (MIT Press) 2004.
- Witley, David S., Cave Paintings and the Human Spirit. Amherst, NY (Prometheus Books) 2009.

Chapter 4.2 Spirituality and Art

- Azara, Nancy J., Spirit Taking From: Making a Spiritual Practice of Making Art. Boston, MA (Red Wheel) 2002.
- Bloom, Jonathan, and Sheila S. Blair, Islamic Arts. London (Phaidon) 1997.
- Fisher, Robert E., Buddhist Art and Architecture, New York (Thames & Hudson) 1993.
- Guo, Xi, Essay on Landscape Painting. London (John Murray) 1959.
- Lyle, Emily, Sacred Architecture in the Traditions of India, China, Judaism, and Islam. Edinburgh (Edinburgh University Press) 1992.
- Williamson, Beth, Christian Art: A Very Short Introduction. New York (Oxford University Press) 2004.

Chapter 4.3 Art and the Cycle of Life

Dijkstra, Rineke, Portraits. Boston, MA (Institute of Contemporary Art) 2005. Gearon, Tierney, The Mother Project

- (DVD). New York (Zeitgeist Films) 2007. Germer, Renate, Fiona Elliot, and Artwig Altenmuller, Mummies: Life after Death in Ancient Egypt. New York (Prestel) 1997.
- Miller, Mary Ellen, and Karl Taube, An Illustrated Dictionary of the Gods and Symbols of Ancient Mexico and the Maya. New York (Thames & Hudson) 1997.
- Ravenal, John B., Vanitas: Meditations on Life and Death in Contemporary Art. Richmond, vA (Virginia Museum of Fine Arts) 2000.
- Steinberg, Leo, The Sexuality of Christ in Renaissance Art and in Modern Oblivion. Chicago, IL (University of Chicago Press) 1996.

Chapter 4.4 Art and Science

- Bordin, Giorgio, Medicine in Art. Los Angeles (J. Paul Getty Museum) 2010.
- Brouger, Kerry, et. al., Visual Music: Synaesthesia in Art and Music Since 1900. London (Thames & Hudson); Washington, D.C. (Hirshhorn Museum); Los Angeles, CA (Museum of Contemporary Art) 2005.
- Gamwell, Lynn, and Neil deGrasse Tyson, Exploring the Invisible: Art, Science, and the Spiritual. Princeton, NJ (Princeton University Press) 2004.
- Milbrath, Susan, Star Gods of the Maya: Astronomy in Art, Folklore, and Calendars. Austin, TX (University of Texas Press) 2000.
- Pietrangeli, Carlo et al., The Sistine Chapel: A Glorious Restoration. New York (Abrams) 1999.
- Rhodes, Colin, Outsider Art: Spontaneous Alternatives. New York (Thames & Hudson) 2000.

Chapter 4.5 Art and Illusion

- Ades, Dawn, In the Mind's Eye: Dada and Surrealism. Chicago, IL (Museum of Contemporary Art); New York (Abbeville Press) 1986.
- Battistini, Matilde, Astrology, Magic and

- Alchemy in Art. Los Angeles, CA (J. Paul Getty Museum) 2007.
- Ebert-Schifferer, Sybille, et al., Deceptions and Illusions: Five Centuries of Trompe L'Oeil Painting. Washington, D.C. (National Gallery of Art) 2003.
- Gablik, Suzi, Magritte. New York (Thames & Hudson) 1985.
- Kemp, Martin, The Science of Art: Optical Themes in Western Art from Brunelleschi to Seurat. New Haven, CT (Yale University Press) 1992.
- Seckel, Al and Douglas Hofstadter, Masters of Deception: Escher, Dali & The Artists of Optical Illusion. New York (Sterling Publishing) 2007.

Chapter 4.6 Art and Rulers

- Berzock, Kathleen Bickford, Benin: Royal Arts of a West African Kingdom. Chicago, IL (Art Institute of Chicago); New Haven, CT (distributed by Yale University Press) 2008.
- Freed, Rita, Pharaohs of the Sun: Akhenaten, Nevertiti: Tutankhamen. Boston, MA (Museum of Fine Arts in association with Bulfinch Press/Little, Brown and Co.) 1999.
- Rapelli, Paola, Symbols of Power in Art. Los Angeles, CA (J. Paul Getty Museum, Getty Publications) 2011.
- Rawski, Evelyn, China: The Three Emperors 1662-1795. London (Royal Academy of Arts) 2006.
- Schele, Linda, The Blood of Kings: Dynasty and Ritual in Maya Art. New York (G. Braziller) and Fort Worth, TX (Kimball Art Museum) 1992.
- Spike, John T., Europe in the Age of Monarchy. New York (The Metropolitan Museum of Art) 1987.
- Zanker, Paul, The Power of Images in the Age of Augustus. Ann Arbor, MI (University of Michigan Press) 1990.

Chapter 4.7 Art and War

- Auping, Michael, Anselm Kiefer Heaven and Earth. Fort Worth, TX (Modern Art Museum of Fort Worth, in association with Prestel) 2005.
- Barron, Stephanie, Degenerate Art. Los Angeles, CA (Los Angeles County Museum of Art) and New York (Abrams) 1991.
- Hughes, Robert, Goya. New York (Alfred A. Knopf) 2003.
- Steel, Andy, *The World's Top Photographers:* Photojournalism: And the Stories Behind Their Greatest Images. Mies, Switzerland, and Hove, UK (RotoVision) 2006.
- Wilson, David, The Bayeux Tapestry. London (Thames & Hudson) 2004.

Chapter 4.8 Art of Social Conscience

- Alhadeff, Albert, *The Raft of the Medusa*: Gericault, Art, and Race. Munich and London (Prestel) 2002.
- Blais, Allison, et al., A Place of Remembrance: Official Book of the National September 11 Memorial. Washington, D.C. (National Geographic) 2011.
- Kammen, Michael, Visual Shock: A History of Art Controversies in American Culture. New York (Alfred A. Knopf) 2007.
- Van Hensbergen, Gijs, Guernica: The Biography of a Twentieth-Century Icon. New York (Bloomsbury) 2005.

Chapter 4.9 The Body in Art

- Clark, Kenneth, The Nude: A Study in Ideal Form. Princeton, NJ (Yale University Press) 1990/1956.
- Dijkstra, Bram, Naked: The Nude in America. New York (Rizzoli) 2010.
- Jones, Amelia, Body Art/Performing the Self. Minneapolis, MN (University of Minnesota Press) 1998.

Nairne, Sandy, and Sarah Howgate, The Portrait Now. New Haven, CT (Yale University Press) and London (National Portrait Gallery) 2006.

Chapter 4.10 Art and Gender

- Broude, Norma, and Mary Garrard, Feminism and Art History: Questioning the Litany. New York (Harper & Row) 1982.
- Hickey, Dave, The Invisible Dragon: Essays on Beauty, revised and expanded edition. Chicago, IL (University of Chicago Press) 2009.
- hooks, bell, Feminism is for Everybody: Passionate Politics. Cambridge, MA (South End Press) 2000.
- Iones, Amelia, Feminism and Visual Culture Reader. New York (Routledge)
- Perry, Gill, Gender and Art. New Haven, CT (Yale University Press) 1999.
- Valenti, Jessica, Full Frontal Feminism: A Young Woman's Guide to Why Feminism Matters. Emeryville, CA (Seal Press) 2007.

Chapter 4.11 Expression

- Dempsey, Amy, Styles, Schools, and Movements, 2nd edn. New York (Thames & Hudson) 2011.
- Doy, Gen, Picturing the Self: Changing Views of the Subject in Visual Culture. London (I. B. Tauris) 2004.
- Evans, David, Appropriation. Cambridge, MA (MIT Press) and London (Whitechapel Gallery) 2009.
- Rebel, Ernst, Self-Portraits. Los Angeles, CA (Taschen) 2008.
- Rugg, Linda Haverty, Picturing Ourselves: Photography and Autobiography. Chicago, IL (University of Chicago Press) 1997.

Sources of Quotations

Introduction

- p. 27: William Wall quoted from http://www.library.yale.edu/beinecke/br blevents/spirit1.htm
- p. 40: Label from Nazi exhibition from Stephanie Barron, Degenerate Art: The Fate of the Avant-Garde in Nazi Germany (New York: Harry N. Abrams, 1991), 390.
- p. 40: Otto Dix from The Dictionary of Art, vol. 9 (Basingstoke: Macmillan Publishers, 1996), 42.

PART I

Chapter 1.1

p. 50: Barbara Hepworth from Abraham Marie Hammacher, The Sculpture of Barbara Hepworth (New York: Harry N. Abrams, 1968), 98.

Chapter 1.2

- p. 62: Vivant Denon from http://www.ancient-egypthistory.com/2011/04/napoleonbonapartes-wise-men-at.html.
- p. 66: Lino Tagliepietra from the artist's website at http://www.linotagliapietra.com/batma n/index.htm.

Chapter 1.3

p. 76: Albert Einstein from Thomas Campbell, My Big TOE: Inner Workings (Huntsville, AL: Lightning Strike Books, 2003), 191.

Chapter 1.4

- p. 92: Vasily Kandinsky from Robert L. Herbert, Modern Artists on Art (New York: Dover Publications, 1999), 19.
- p. 97: Matisse from Dorothy M. Kosinski, Jay McKean Fisher, Steven A. Nash, and Henri Matisse, Matisse: Painter as Sculptor (New Haven, CT: Yale

- University Press, 2007), 260.
- p. 102: Van Gogh quoted in Ian Chilvers, Harold Osborne, and Denis Farr (eds.), *The Oxford Dictionary of Art* (New York: Oxford University Press, 2009), 298.

Chapter 1.5

p. 108: William Faulkner from Philip Gourevitch (ed.), The Paris Review: Interviews, Volume 2 (New York: Picador USA, 2007), 54.

Chapter 1.6

p. 126: Palladio from Rob Imrie and Emma Street, Architectural Design and Regulation (Chichester, UK: Wiley-Blackwell, 2011), section 1.2.

Chapter 1.7

p. 128: Baudelaire from Charles Baudelaire, Flowers of Evil and Other Works, ed. and trans. Wallace Fowlie (New York: Dover Publications, 1992), 201.

Chapter 1.8

p. 137: Mark Tobey from Tate Collection, Northwest Drift 1958 (quoted from the display caption, November 2005).

Chapter 1.9

p. 146: Elvis Presley from Dave Marsh and James Bernard, The New Book of Rock Lists (New York: Simon & Schuster [Fireside], 1994), 9.

PART 2

Chapter 2.1

p.166: William Blake from The Complete Poetry and Prose of William Blake (Berkeley and Los Angeles, CA: Anchor/ University of California Press 1997), 574.

Chapter 2.2

p.183: Andrew Wyeth from William Scheller, America, a History in Art: The American Journey Told by Painters, Sculptors ... (New York: Black Dog & Leventhal Publishers, 2008), 22.

Chapter 2.5

- p. 216: Dorothea Lange from Dorothea Lange, "The Assignment I'll Never Forget: Migrant Mother," in Popular Photography (February 1960); reprinted in James Curtis, Mind's Eye, Mind's Truth: FSA Photography Reconsidered (Philadelphia: Temple University Press, 1989).
- p. 227: Edward Burtynsky from Manufactured Landscapes (U.S. Edition), directed by Jennifer Baichwal (Zeitgeist Films, 2006).

Chapter 2.7

- p. 242: Vito Acconci's description of Following Piece from documentation accompanying the photographs; reprinted in Lucy Lippard, Six Years: The Dematerialization of the Art Object (Berkeley, CA: University of California Press, 1973/1997), 117.
- p.244: Yoko Ono's text accompanying Wish Tree from Jessica Dawson, "Yoko Ono's Peaceful Message Takes Root," Washington Post (April 3, 2007); washingtonpost.com.
- p.247: Kara Walker from "Interview: Projecting Fictions: 'Insurrection! Our Tools Were Rudimentary, Yet We Pressed On," ART21 "Stories" Episode, Season 2 (PBS: 2003); http://www.pbs.org/art21/artists/walker /clip1.html.

Chapter 2.8

- p. 248: Geoffrey Chaucer from The Works of Geoffrey Chaucer, Volume 5 (New York: Macmillan and Co., Limited, 1904), 341.
- p. 257: Tilleke Schwarz from her website: http://mytextilefile.blogspot.com/2011/ 02/tilleke-schwarz.html.

Chapter 2.9

- p. 260: Michelangelo quoted by Henry Moore from Henry Moore and Alan G. Wilkinson, Henry Moore-Writings and Conversations (Berkeley, CA: University of California Press, 2002), 238.
- p. 264: Michelangelo from Howard Hibbard, Michelangelo (New York: Harper & Row, 1985), 119.

p. 273: Ilya Kabakov from H. H. Arnason and Peter Kalb, History of Modern Art (Chicago: Prentice Hall, 2003), 715.

Chapter 2.10

- p. 285: Le Corbusier from Nicholas Fox Weber, Le Corbusier: A Life (New York: Alfred A. Knopf, 2008), 171.
- p. 286: Mies van der Rohe from E. C. Relph, The Modern Urban Landscape (Baltimore, MD: The Johns Hopkins University Press, 1987), 191.

PART 3

Chapter 3.1

- p. 299: Inscription from Assyrian palace from Met Museum website and object
 - http://www.metmuseum.org/works_of_ art/collection_database/ancient_near_e astern_art/human_headed_winged_bull _and_winged_lion_lamassu/objectview. aspx?collID=3&OID=30009052
- p. 304: Protagoras from Kenneth Clark, Protagoras (New York: Harper and Row, 1969), 57.

Chapter 3.2

p. 322: Hildegard of Bingen from Hildegard von Bingen's Mystical Visions, trans. by Bruce Hozeski from Scivias (I,1), 8.

Chapter 3.4

p. 354: David Grove from David Grove, In Search of The Olmec (unpublished work), © David Grove.

Chapter 3.7

- p. 403: Jacques-Louis David from the Revolutionary Convention, 1793, quoted in Robert Cumming, Art Explained (New York: DK Publishing, 2005), 70.
- p. 406: Unspecified critic on Goya from Lucien Solvay, L'Art espagnol (Paris and London, 1887), 261.
- p. 408: Unspecified critic on Frederic Erwin Church from Pierre Berton, Niagara: A History of the Falls (New York: State University of New York,

- Albany, 1992), 119.
- p. 408: Gustave Courbet from Robert Williams, Art Theory: An Historical Introduction (Malden, MA: Blackwell Publishing, 2004), 127.
- p. 414: Unspecified critic on Claudel from Ruth Butler, Rodin: The Shape of Genius (New Haven, CT and London: Yale University Press, 1993), 271.
- p. 416: Paul Gauguin from Charles Estienne, Gauguin: Biographical and Critical Studies (Geneva: Skira, 1953), 17.
- p. 418: Unspecified critic on the Eiffel Tower from Joseph Harriss, The Tallest Tower: Eiffel and the Belle Epoque (Bloomington, Indiana: Unlimited Publishing, 2004), 15.

Chapter 3.8

- p. 424: Henri Matisse from Jack Flam, Matisse: The Man and His Art, 1869-1918 (Ithaca, NY: Cornell University Press, 1986), 196.
- p. 431: Marcel Duchamp from Arturo Schwarz, The Complete Works of Marcel Duchamp (New York: Delano Greenidge Editions, 1997), II, 442.
- p. 434: Filippo Marinetti from his "Manifesto for the Italo-Abyssinian War," (1936), quoted in Walter Benjamin, "The Work of Art in the Age of Mechanical Reproduction," in Walter Benjamin, Illuminations: Essays and Reflections, ed. Hannah Arendt (New York: Schocken Books, 1968), 241.
- p. 438: Mark Rothko from Selden Rodman, Conversations with Artists (New York: Devin-Adair, Co., 1957).
- p. 450: Matthew Ritchie from his interview about Proposition Player, ART21, Season 3, Episode 1 (PBS: 2005); http://www.pbs.org/art21/series/seasont hree/index.html.

PART 4

Chapter 4.1

p. 454: Susan Cervantes from Tyce Hendricks, "Celebrating Art that Draws People Together," San Francisco

- Chronicle (May 6, 2005), F1.
- p. 454: Aliseo Purpura-Pontoniere from Tyce Hendricks, "Celebrating Art that Draws People Together," San Francisco Chronicle (May 6, 2005), F1.
- p. 457: Christo and Jeanne-Claude, "Selected Works: The Gates," The Art of Christo and Jeanne-Claude (© 2005; access date September 7, 2007) www.christojeanneclaude.net
- p. 459: Hilla Rebay (the curator of the foundation and director of the Guggenheim museum) from the Solomon R. Guggenheim website: http://www.guggenheim.org/guggenhei m-foundation/architecture/new-york.
- pp. 460-61: Mark Lehner from "Explore the Pyramids," © 1996-2007 National Geographic Society < access date September 13, 2007>: http://www.nationalgeographic.com/py ramids/pyramids.html
- p. 468: Diego Rivera from Bertram D. Wolfe, The Fabulous Life of Diego Rivera (New York: Stein and Day, 1963), 423.

Chapter 4.2

- p. 473: Betye Saar from Beryl Wright, The Appropriate Object (Buffalo, NY: Albright-Knox Gallery, 1989), 58.
- p. 480: Description of the Mosque of the Imam, Isfahan from The Metropolitan Museum of Art, "Works of Art: Islamic Highlights: Signatures, Inscriptions, and Markings", accessed September 13, 2010: www.metmuseum.org/works_of_art/col lection_database/islamic?art/mihrab/obj ectview.aspx?collID=14OID=140006815

Chapter 4.3

- p. 484: Albert Einstein from "The World As I See It," Forum and Century, vol. 84 (October, 1930), 193-4; reprinted in Living Philosophies, vol. 13 (New York: Simon and Schuster, 1931), 3-7; also reprinted in Albert Einstein, Ideas and Opinions, based on Mein Weltbild, ed. Carl Seeling (New York: Bonanza Books, 1954), 8-11.
- p. 486: Tierney Gearon, from Brett Leigh Dicks, "Tierney Gearon's Mother Project,"

The Santa Barbara Independent (February 14, 2008).

Chapter 4.4

- p. 500: Willard Wigan from The Telegraph article by Benjamin Secher on July 7, 2007:
 - http://www.telegraph.co.uk/culture/art/ 3666352/The-tiny-world-of-Willard-Wigan-nano-sculptor.html.
- p. 502: Jasper Johns from Martin Friedman, Visions of America: Landscape as Metaphor in the Late Twentieth Century (Denver, co: Denver Art Museum, 1994), 146.
- p. 503: Marcia Smilack from Artist's Statement on her own website: http://www.marciasmilack.com/artiststatement.php
- p. 503: Jean Dubuffet from John Maizels, Raw Creation: Outsider Art and Beyond (London: Phaidon, 2000), 33.
- p. 504: Salvador Dali from Dawn Ades et al., Dali (Venice, Italy: Rizzoli, 2004), 559.

Chapter 4.5

- p. 508: Pliny the Elder from Jerome Jordon Pollitt, The Art of Ancient Greece: Sources and Documents (Cambridge: Cambridge University Press, 1990), 150.
- p. 512: Ovid from *Metamorphoses*, trans. A. D. Melville and E. J. Kenney (New York and Oxford: Oxford World's Classics, 2009), 232.
- p. 519: Magritte from Paul Crowther, Language of 20th-Century Art (New Haven, CT: Yale University Press, 1997), 116.

Chapter 4.7

p. 533: Nick Ut from William Kelly, Art and Humanist Ideals: Contemporary Perspectives (Australia: Palgrave Macmillan, 2003), 284.

Chapter 4.8

- p. 545: Picasso from Charles Harrison and Paul Wood, Art in Theory, 1900-2000: *An Anthology of Changing Ideas* (Oxford: Blackwell Publishing, 2003), 508.
- p. 546: Florence Owens Thompson, and one of her children, both from Kiku Adatto, Picture Perfect: Life in the Age of the Photo Op. (Princeton, NJ: Princeton University Press, 2008), 247 and 248.
- p. 548: Mary Richardson from June Purvis, Emmeline Pankhurst: A Biography (London and New York: Routledge, 2002), 255.
- p. 549: Eric Fischl poem from Laura Brandon, Art and War (London: I.B. Tauris & Co Ltd, 2007), 129; and Fischl's remarks from Daniel Sherman and Terry Nardin, Terror, Culture, Politics: Rethinking 9/11 (Indiana: Indiana University Press, 2006), 60.
- p. 552: Maya Lin from Marilyn Stokstad, Art History (place?: Pearson Education, 2008), xliv.
- p. 553: Translation of text on artwork by Wenda Gu from discussion of the exhibition by the Asia Society: http://sites.asiasociety.org/arts/insideout /commissions.html.

Chapter 4.9

p. 554: Willem de Kooning from an interview with David Sylvester (BBC,

- 1960), "Content is a Glimpse..." in Location I (Spring, 1963) and reprinted in David Sylvester, "The Birth of 'Woman I," Burlington Magazine 137, no. 1105 (April, 1995), 223.
- p. 566: Matisse from "Exactitude is not Truth," 1947, essay by Matisse written for an exhibition catalog (Liège: Association pour le progrès intellectuel et artistique de la Wallonie, with the participation of Galerie Maight, Paris); English translation (Philadelphia Museum of Art, 1948); reprinted in Jack Flam, *Matisse on Art* (Berkeley, CA: University of California Press, 1995/1973), 179–181.

Chapter 4.10

p. 571: Cindy Sherman from "Interview with Els Barents," in Cindy Sherman (Munich: Schirmer und Mosel, 1982); reprinted in Kristine Stiles and Peter Selz, eds., Theories and Documents of Contemporary Art: A Sourcebook of Artists' Writings (Berkeley, CA: University of California Press, 1996), 792-3.

Chapter 4.11

- p. 584: John Ruskin, letter 79 (18 June 1877) from Fors Clavigera: Letters to the Workmen and Labourers of Great Britain, vol. 7 (Orpington, Kent: George Allen, July 2, 1877), 201; reprinted in E. T. Cook and Alexander Wedderburn, eds., The Works of John Ruskin, vol. 29 (London: George Allen, 1907), 160.
- p. 589: Nikki S. Lee from Erica Schlaikjer, "Woman's Art Requires Becoming a Chameleon," The Daily Northwestern (February 24, 2006), Campus Section.

Illustration Credits

p. 16 (above) Stanza della Segnatura, Vatican Museums, Rome; (center) Library of Congress, Washington, D.C. Prints & Photographs Division, H. Irving Olds collection, LC-DIG-jpd-02018; (below) Photo Irmgard Groth-Kimball © Thames & Hudson Ltd, London; p. 18 iStockphoto.com; p. 19 Photo Irmgard Groth-Kimball © Thames & Hudson Ltd, London; p. 20 Stanza della Segnatura, Vatican Museums, Rome; p. 21 Galleria degli Uffizi, Florence; p. 22 Museo Nacional del Prado, Madrid; p. 23 Library of Congress, Washington, D.C.. Prints & Photographs Division, H. Irving Olds collection, LC-DIG-ipd-02018; p. 24 Library of Congress, Washington, D.C.. Prints & Photographs Division, FSA/OWI Collection, LC-DIG-fsa-8b29516; p. 25 Teriade Editeur, Paris, 1947. Printer Edmond Vairel, Paris. Edition 250. Museum of Modern Art, New York, The Louis E. Stern Collection, 930.1964.8. Digital image 2012, Museum of Modern Art, New York/Scala, Florence. © Succession H. Matisse/DACS 2012; 0.1 Fitzwilliam Museum, University of Cambridge/Bridgeman Art Library; 0.2 Spencer Collection, New York Public Library, Astor, Lenox and Tilden Foundations; 0.3 Solomon R. Guggenheim Museum, New York, Gift, Mr. and Mrs. James J. Shapiro, 85.3266. Photo David Heald © Solomon R. Guggenheim Foundation. © ARS, NY and DACS, London 2012; 0.4 © Nik Wheeler/Corbis; 0.5 © Ian Dagnall/Alamy; 0.6 © Jeff Koons; 0.7 Indianapolis Museum of Art, Gift of Charles L. Freer/Bridgeman Art Library; 0.8 Musée du Louvre, Paris; 0.9 Kunsthistorisches Museum, Vienna; 0.10 Private Collection; 0.11 Photo © Erik Cornelius/Nationalmuseum, Stockholm; 0.12 © Ian Dagnall/Alamy; 0.13 Mauritshuis, The Hague; 0.14 Photo Marc Quinn Studio. Courtesy White Cube. © the artist; 0.15 Publisher Heinar Schilling, Dresden. Printer unknown. Edition 15. Museum of Modern Art, New York, Purchase, Acc. no. 480.1949. Photo 2012, Museum of Modern Art, New York/Scala, Florence. © DACS 2012; 0.16 Metropolitan Museum of Art, Gift of Mrs. Frank B. Porter, 1922, Acc. no. 22.207. Photo Metropolitan Museum of Art/Art Resource/Scala, Florence; 0.17 Musée du Louvre, Paris; **0.18** André Held /akg-images; **p. 44** (above) Photo Andrew Hawthorne. Courtesy the artists; (center) © 2012 The M.C. Escher Company-Holland. All rights reserved. www.mcescher.com; (below) Museo Nacional del Prado, Madrid; 1.1 Photo Jarno Gonzalez Zarraonandia/iStockphoto.com; 1.2a Slow Images/Getty Images; 1.2b National Gallery of Art, Washington, D.C., Wolfgang Ratjen Collection, Paul Mellon Fund, 2007.111.55; 1.3 © CLAMP/Kodansha Ltd; 1.4 Image courtesy Peter Freeman, Inc., New York; 1.5 @ Bowness, Hepworth Estate; 1.6 © ADAGP, Paris and DACS, London 2012; 1.7

Fondation Dubuffet. © ADAGP, Paris and DACS, London 2012; 1.8 National Gallery of Art, Washington, D.C., Collection of Mr. and Mrs. Paul Mellon, 1983.1.81; 1.9 Ralph Larmann; 1.10, 1.11 British Library, London; 1.12 @ Sauerkids; 1.13 Museo Nacional del Prado, Madrid; 1.14 British Museum, London; 1.15 Private Collection; 1.16 Ralph Larmann; 1.17 © Nike; 1.18 Art Institute of Chicago, Helen Birch Bartlett Memorial Collection, 1926.417; 1.19 Ralph Larmann; 1.20 Courtesy Flomenhaft Gallery, New York; 1.21 Ralph Larmann; 1.22 Courtesy AT&T Archives and History Center; 1.23a © 1996 Shepard Fairey/ObeyGiant.com; 1.23b @ 1996 Shepard Fairey/ObeyGiant.com. Photo © Elizabeth Daniels, www.elizabethdanielsphotography.com; 1.24 © Georgia O'Keeffe Museum/DACS 2012; **1.25** © Big Ten Conference; **1.26** © 2012 The M.C. Escher Company-Holland. All rights reserved. www.mcescher.com; 1.27 Monasterio de las Huelgas, Museo de Telas Medievales, Burgos; 1.28 Ralph Larmann; 1.29, 1.30 Photo Heidi Grassley © Thames & Hudson Ltd, London; 1.31 Photo courtesy the Marlborough Gallery Inc., New York. © Estate of David Smith/DACS, London/VAGA, New York 2012; 1.32 Rheinisches Landesmuseum, Bonn; 1.33 Photo Russell Johnson. Courtesy Lino Tagliapietra, Inc.; 1.34 Museo dell'Ara Pacis, Rome; 1.35 Fine Arts Museum of San Francisco, Museum Purchase, Gift of Mrs Paul Wattis 1999, 42 a-k; 1.36 Ralph Larmann; 1.37a, 1.37b Photo Clements/Howcroft, MA, USA. Courtesy the artists; 1.38 Photo Nationalmuseum, Stockholm; 1.39 Photo Andrew Hawthorne. Courtesy the artists; 1.40 Photo Irmgard Groth-Kimball © Thames & Hudson Ltd, London; 1.41 Photo Sue Ormerod. © Rachel Whiteread. Courtesy Gagosian Gallery, London; 1.42 @ Marisol, DACS, London/VAGA, New York 2012; 1.43 Stedelijk Museum, Amsterdam; 1.44 Museum of Modern Art, New York, Purchase, Acc. no. 130.1946.a-c. Photo 2012, Museum of Modern Art, New York/Scala, Florence. © DACS 2012; 1.45 © Romain Cintract/Hemis/Corbis; 1.46 © Louise Bourgeois Trust/DACS, London/VAGA, New York 2012; 1.47 Los Angeles County Museum of Art (LACMA). Purchased with funds provided by the Mr. and Mrs. William Preston Harrison Collection, 78.7. © ADAGP, Paris and DACS, London 2012; 1.48 Special Collections & Archives, Eric V. Hauser Memorial Library, Reed College, Portland, Oregon; 1.49, 1.50 Ralph Larmann; 1.51 Sterling & Francine Clark Art Institute, Williamstown; 1.52 Contarelli Chapel, Church of San Luigi dei Francesci, Rome; 1.53 Ralph Larmann; 1.54 Musée du Louvre, Paris; 1.55 Library of Congress, Washington, D.C. Prints & Photographs Division, H. Irving Olds collection, LC-DIG-jpd-02018; 1.56 National Palace Museum, Taipei; 1.57 © T. H. Benton and R. P. Benton Testamentary Trusts/DACS, London/VAGA, New York 2012; 1.58 Ralph Larmann; 1.59 Crystal Bridges Museum of American Art, Arkansas; 1.60 Metropolitan Museum of Art, Purchase, The Dillon Fund Gift, 1988. Photo

Metropolitan Museum of Art/Art Resource/Scala, Florence 2012; 1.61 Ralph Larmann; 1.62 The Sims © 2012 Electronic Arts Inc. The Sims and The Sims plumbob design are trademarks or registered trademarks of Electronic Arts Inc. in the US and/or other countries. All Rights Reserved. Used with permission; 1.63 Private Collection; 1.64 Ralph Larmann; 1.65 Santa Maria Novella, Florence; 1.66a, 1.66b Stanza della Segnatura, Vatican Museums, Rome; 1.67 Ralph Larmann; 1.68 @ 2012 The M.C. Escher Company-Holland. All rights reserved. www.mcescher.com; 1.69 Graphische Sammlung Albertina, Vienna; 1.70 Pinacoteca di Brera, Milan; 1.71, 1.72 Ralph Larmann; 1.73 Fine Arts Museum of San Francisco, Gift of Vivian Burns, Inc., 74.8; 1.74 Ralph Larmann; 1.75 @ Mark Tansey. Courtesy Gagosian Gallery, New York; 1.76 Ralph Larmann; 1.77 Museum of Modern Art, New York, Gift of Mr. and Mrs. Ben Heller, Acc. no. 240.1969. Photo 2012, Museum of Modern Art, New York/Scala, Florence. © ARS, NY and DACS, London, 2012; 1.78 The Museum of Fine Arts, Houston, Gift of Audrey Jones Beck. © ADAGP, Paris and DACS, London 2012; 1.79 Ralph Larmann; 1.80 Teriade Editeur, Paris, 1947. Printer Edmond Vairel, Paris. Edition 250. Museum of Modern Art, New York, The Louis E. Stern Collection, 930.1964.8. Photo 2012, Museum of Modern Art, New York/Scala, Florence. © Succession H. Matisse/DACS 2012; 1.81 Cleveland Museum of Art, Mr. and Mrs. William H. Marlatt Fund, 1965.233; 1.82 National Gallery of Art, Washington, D.C., Chester Dale Collection, 1963.10.94; 1.83 @ Howard Hodgkin; 1.84 British Museum, London; 1.85 Ralph Larmann; 1.86, 1.87 Musée d'Orsay, Paris; 1.88 Ralph Larmann; 1.89 Private Collection (color artwork by Ralph Larmann); 1.90, 1.91 Ralph Larmann; 1.92 Courtesy Charles Csuri; 1.93 Yale University Art Gallery, New Haven, Bequest of Stephen Carlton Clark, B.A. 1903, 1961.18.34; 1.94 Albright-Knox Art Gallery, Buffalo, New York, General Purchase Funds, 1946; 1.95 National Gallery of Art, Washington, D.C., Samuel H. Kress Collection, 1939.1.293; **1.96** Photo University of South Florida. © Nancy Holt/DACS, London/VAGA, New York 2012; 1.97 Library of Congress, Washington, D.C.. Prints & Photographs Division, LC-USZ62-536; 1.98 Galleria Borghese, Rome; 1.99 Albright-Knox Art Gallery, Buffalo, New York, Bequest of A. Conger Goodyear and Gift of George F. Goodyear, 1964. © DACS 2012; 1.100 Solomon R. Guggenheim Museum, New York, Partial gift of the artist, 1989, 89.3626. Photo David Heald © Solomon R. Guggenheim Foundation, New York. © ARS, NY and DACS, London 2012; 1.101 Copyright Bridget Riley, 2012. All rights reserved; **1.102** Courtesy the Bill Douglas Centre for the History of Cinema and Popular Culture, University of Exeter; 1.103 Disney Enterprises/Album/akg-images; 1.104 Double Indemnity, © Paramount Pictures; **1.105** © Blaine Harrington III/Alamy; **1.106** Photo © B. O'Kane/Alamy. © 2012 Calder Foundation, New York/DACS, London; 1.107a Library of Congress, Washington, D.C. Prints & Photographs Division,

FSA/OWI Collection, LC-USZ62-58355; 1.107b © The Dorothea Lange Collection, Oakland Museum of California, City of Oakland. Gift of Paul S. Taylor; 1.107c Library of Congress, Washington, D.C. Prints & Photographs Division, FSA/OWI Collection, LC-USF34-9097-C; 1.107d Library of Congress, Washington, D.C. Prints & Photographs Division, FSA/OWI Collection, LC-USF34-9093-C; 1.107e Library of Congress, Washington, D.C. Prints & Photographs Division, FSA/OWI Collection, LC-USF34-9095; 1.107f Library of Congress, Washington, D.C. Prints & Photographs Division, FSA/OWI Collection, LC-DIG-fsa-8b29516; 1.108 Courtesy the artists; 1.109 © the artist. Courtesy Catherine Person Gallery, Seattle, WA; 1.110 Ralph Larmann; 1.111 Library of Congress, Washington, D.C.. Prints & Photographs Division, H. Irving Olds collection, LC-DIG-jpd-02018; 1.112 I. Michael Interior Design; 1.113 Ralph Larmann; 1.114 Courtesy Galerie Berès, Paris. © ADAGP, Paris and DACS, London 2012; 1.115 Galleria Nazionale delle Marche, Urbino; 1.116 Museum of Modern Art, New York, Blanchette Hooker Rockefeller Fund, Acc. no. 377.1971. Photo 2012, Museum of Modern Art, New York/Scala, Florence. © Romare Bearden Foundation/DACS, London/VAGA, New York 2012; **1.117** © The Joseph and Robert Cornell Memorial Foundation/DACS, London/VAGA, New York 2012; 1.118 Photo John Freeman; 1.119 Ralph Larmann; **1.120** © Estate of Robert Rauschenberg. DACS, London/VAGA, New York 2012; 1.121 Private Collection; 1.122 The University of Hong Kong Museum; 1.123 Photo Shimizu Kohgeisha Co., Ltd. Permission Ryoko-in Management; 1.124 pl. XIII, Book II from Wade, I. (ed.) Palladio: Four Books of Architecture, 1738; 1.125 Courtesy Drepung Loseling Monastery, Inc.; 1.126 Photo Attilio Maranzano. Photo courtesy the Oldenburg van Bruggen Foundation. Copyright 1992 Claes Oldenburg and Coosje van Bruggen; 1.127 Courtesy the artist; 1.128 Werner Forman Archive, line artwork Ralph Larmann; 1.129 Gemäldegalerie, Staatliche Museen, Berlin; 1.130 Purchased with assistance from the Art Fund and the American Fund for the Tate Gallery 1997 © Tate, London, 2012. © ADAGP, Paris and DACS, London 2012; **1.131**, **1.132** Ralph Larmann: 1.133 National Museum, Ife, Nigeria; 1.134 Stanza della Segnatura, Vatican Museums, Rome; 1.135 Ralph Larmann; 1.136 National Archaeological Museum, Athens; 1.137 Ralph Larmann; 1.138a George Eastman House, New York; 1.138b Ralph Larmann; 1.139 iStockphoto.com; 1.140 Ralph Larmann; 1.141 Metropolitan Museum of Art, Gift of Nathan Cummings, 1966, 66.30.2. Photo Metropolitan Museum of Art/Art Resource/Scala, Florence; 1.142 Photo @ Museum of Fine Arts, Boston. Courtesy Jules Olitski Warehouse LLC. © Estate of Jules Olitski, DACS, London/VAGA, New York 2012; 1.143 © Estate of Mark Tobey, ARS, NY/DACS, London 2012. Courtesy Sotheby's; 1.144 Musées Royaux des Beaux-Arts de Belgique, Brussels; 1.145 Galleria degli Uffizi, Florence; 1.146 Victoria

& Albert Museum, London; 1.147 Musée du Louvre, Paris; 1.148 James A. Michener Collection, Honolulu Academy of Arts; 1.149 Ralph Larmann; 1.150 Musée National d'Art Moderne, Centre Georges Pompidou, Paris; 1.151 Metropolitan Museum of Art, Louis E. and Theresa S. Seley Purchase Fund for Islamic Art, and Rogers Fund, 1984. Photo Metropolitan Museum of Art/Art Resource/Scala, Florence; 1.152 Ashmolean Museum, Oxford; 1.153a, 1.153b, 1.153c Museum of Modern Art. New York, Gift of Agnes Gund, Jo Carole and Ronald S. Lauder, Donald L. Bryant, Jr., Leon Black, Michael and Judy Ovitz, Anna Marie and Robert F. Shapiro, Leila and Melville Straus, Doris and Donald Fisher, and purchase, Acc. no. 215.2000. Photo Ellen Page Wilson, courtesy The Pace Gallery © Chuck Close, The Pace Gallery; 1.154 © DACS 2012; 1.155 Kunsthistorisches Museum, Vienna; 1.156 iStockphoto.com; 1.157 Collection Center for Creative Photography © 1981 Arizona Board of Regents; 1.158 © WaterFrame/Alamy; 1.159 Museo Nacional del Prado, Madrid; 1.160a Musée d'Orsay, Paris; 1.160b Ralph Larmann; 1.161 iStockphoto.com; 1.162 @ Andia/Alamy; 1.163 Allan Houser archives @ Chiinde LLC; 1.164 Collection University of Arizona Museum of Art, Tucson, Museum purchase with funds provided by the Edward J. Gallagher, Jr Memorial Fund 1982.35.1. © the artist; 1.165 The Art Institute of Chicago, Gift of Arthur Keating and Mr. and Mrs. Edward Morris by exchange, April 1988. © The Estate of Eva Hesse. Hauser & Wirth. Photo Susan Einstein, courtesy The Art Institute of Chicago; 1.166 Musée du Louvre, Paris; 1.167 Courtesy Archiv LRP; 1.168 The Art Institute of Chicago, Friends of American Art Collection, 1942.51; 1.169 Museo Nacional del Prado, Madrid; 1.170 Museo Nacional del Prado, Madrid; 1.171 © Succession Picasso/DACS, London 2012; **1.172** © 2012 Thomas Struth; **p. 164** (above) National Palace Museum, Taipei; (center) Printed by permission of the Norman Rockwell Family Agency. Book Rights Copyright © 1943 The Norman Rockwell Family Entities; (below) © Free Agents Limited/Corbis; 2.1 Biblioteca Ambrosiana, Milan; **2.2** The Royal Collection © Her Majesty The Queen: **2.3a** Biblioteca Ambrosiana, Milan; **2.3b** Stanza della Segnatura, Vatican Museums, Rome; 2.4 Ralph Larmann; 2.5 © DACS 2012; 2.6 Museum of Modern Art, New York, The Judith Rothschild Foundation Contemporary Drawings Collection Gift. Courtesy Daniel Reich Gallery, New York; 2.7 British Museum, London; 2.8 © DACS 2012; 2.9 Photo Peter Nahum at The Leicester Galleries, London/Bridgeman Art Library; 2.10 Metropolitan Museum of Art, Purchase, Joseph Pulitzer Bequest, 1924, Acc. no. 24.197.2. Photo Metropolitan Museum of Art/Art Resource/Scala, Florence; 2.11 Musée d'Orsay, Paris; **2.12** The Art Institute of Chicago, Helen Regenstein Collection, 1966.184; 2.13 San Francisco Museum of Modern Art, Purchased through a gift of Phyllis Wattis. © Estate of Robert Rauschenberg. DACS, London/VAGA, New York 2012; 2.14 Van Gogh

Museum (Vincent Van Gogh Foundation), Amsterdam; 2.15 National Palace Museum, Taipei; 2.16 British Museum, London; 2.17 from Wakoku Shōshoku Edzukushi, 1681; 2.18 Ralph Larmann; 2.19 Musée des Beaux-Arts de Lvon. © Succession H. Matisse/DACS 2012; 2.20 Teriade Editeur, Paris, 1947. Printer Edmond Vairel, Paris. Edition 250. Museum of Modern Art, New York, The Louis E. Stern Collection, 930.1964.8. Photo 2012, Museum of Modern Art, New York/Scala, Florence. © Succession H. Matisse/DACS 2012; 2.21 Museum of Modern Art, New York, Purchase, 330.1949. Photo 2012, Museum of Modern Art, New York/Scala, Florence; **2.22** Ralph Larmann; **2.23** Metropolitan Museum of Art, Gift of Edward S. Harkness, 1918, 18.9.2. Photo Metropolitan Museum of Art/Art Resource/Scala, Florence; 2.24 National Gallery of Scotland, Edinburgh; 2.25 Metropolitan Museum of Art, Purchase, Francis M. Weld Gift, 1950, Inv. 50.164. Photo Metropolitan Museum of Art/Art Resource/Scala, Florence; 2.26 Museum of Modern Art, New York, Purchase, 16.1949. Photo 2012, Museum of Modern Art, New York/Scala, Florence. © Andrew Wyeth; 2.27 Vatican Museums, Rome; 2.28 Philadelphia Museum of Art, Gift of Mr. and Mrs. Herbert Cameron Morris, 1943. © 2012 Banco de México Diego Rivera Frida Kahlo Museums Trust, Mexico, D.F./DACS; 2.29 Photo Steven Ochs; 2.30 Musée du Louvre, Paris; 2.31 Los Angeles County Museum of Art, Gift of Mr. and Mrs. Robert H. Ginter, M.64.49. Digital Image Museum Associates/LACMA/Art Resource NY/Scala, Florence. Courtesy Gallery Paule Anglim; 2.32 Kemper Museum of Contemporary Art, Kansas City. Bebe and Crosby Kemper Collection, Gift of the William T. Kemper Charitable Trust, UMB Bank, n.a., Trustee 2006.7. Photo Ben Blackwell © the artist; 2.33 Galleria degli Uffizi, Florence; 2.34 The Royal Collection © Her Majesty The Queen; 2.35 Kemper Museum of Contemporary Art, Kansas City. Bebe and Crosby Kemper Collection, Kansas City, Missouri. Museum Purchase, Enid and Crosby Kemper and William T. Kemper Acquisition Fund 2000.13. © the artist; 2.36 Photo Austrian Archives/Scala Florence; **2.37** Photo Tate, London 2012. © L&M Services B.V. The Hague 20110512. © Miriam Cendrars; 2.38 Clark Family Collection. Image courtesy The Clark Center for Japanese Art & Culture; 2.39 Courtesy Art Link International, Florida. © the artist; **2.40** Photo Sybille Prou; **2.41** Ralph Larmann; **2.43** British Museum, London; 2.44 Museum of Modern Art, New York. Given anonymously (by exchange), Acc. no. 119.1956. Photo 2012, Museum of Modern Art, New York/Scala, Florence. © Nolde Stiftung Seebüll; 2.45 Library of Congress, Washington, D.C. Prints & Photographs Division, H. Irving Olds collection, LC-DIG-jpd-02018; 2.46 Ralph Larmann; 2.47 Victoria & Albert Museum, London; 2.48 © DACS 2012; **2.49** Kupferstichkabinett, Museen Preussiches Kulturbesitz, Berlin; 2.50 Metropolitan Museum of Art, Harris Brisbane Dick Fund, 1935, Acc. no. 35.42. Photo Metropolitan Museum of Art/Art

Resource/Scala, Florence; 2.51a Museo Nacional del Prado, Madrid; 2.51b Private Collection; 2.52 Print and Picture Collection, Free Library of Philadelphia. Courtesy Fine Arts Program, Public Buildings Service, U.S. General Services Administration. Commissioned through the New Deal art projects; 2.53 Ralph Larmann; 2.54 Private Collection; 2.55 © The Andy Warhol Foundation for the Visual Arts/Artists Rights Society (ARS), New York/DACS London 2012; 2.56 Fogg Art Museum, Harvard Art Museums, Margaret Fisher Fund, M25276. Photo Imaging Department @ President & Fellows of Harvard College. © ARS, NY and DACS, London 2012; 2.57 © Kathy Strauss 2007; 2.58 British Museum, London; 2.59 Tokyo National Museum; 2.60 Koninklijke Bibliotheek, The Hague, Folio 8r., shelf no. 69B 10; 2.61 V&A Images/Victoria & Albert Museum; 2.62 Ralph Larmann; 2.63 Courtesy Ford Motor Company; 2.64 General Motors Corp. Used with permission, GM Media Archives; 2.65 from Works of Geoffrey Chaucer, Kelmscott Press, 1896; **2.66** Printed by permission of the Norman Rockwell Family Agency. Book Rights Copyright © 1943 The Norman Rockwell Family Entities; 2.67 Courtesy Kok Cheow Yeoh; **2.68** The Art Institute of Chicago, Mr. and Mrs. Carter H. Harrison Collection, 1954.1193; 2.69 Taesam Do/FoodPix/Getty. Image courtesy Hill Holiday; 2.70 School of Journalism and Mass Communication, University of North Carolina at Chapel Hill. Photo Eileen Mignoni; 2.71 Gernsheim Collection, London; 2.72 Image appears courtesy Abelardo Morell; 2.73 British Library, London; 2.74 Metropolitan Museum of Art, The Rubel Collection, Purchase, Ann Tenenbaum and Thomas H. Lee and Anonymous Gifts, 1997, Acc. no. 1997.382.1. Photo The Metropolitan Museum of Art/Art Resource/Scala, Florence; 2.75 Ralph Larmann; 2.76 Bibliothèque nationale, Paris; 2.77 Library of Congress, Washington, D.C.. Prints & Photographs Division, FSA/OWI Collection, LC-DIG-fsa-8b29516; 2.78 @ Ansel Adams Publishing Rights Trust/Corbis; 2.79 Collection of the Société Française de Photographie, Paris; 2.80 Collection Center for Creative Photography © 1981 Arizona Board of Regents; 2.81 Library of Congress, Washington, D.C.. Prints & Photographs Division, LC-DIG-nclc-01555; 2.82a, 2.82b Copyright Steve McCurry/Magnum Photos; 2.83 © Hiroko Masuike/New York Times/Eyevine; 2.84 Copyright Steve McCurry/Magnum Photos; 2.85 Royal Photographic Society, Bath; 2.86 Courtesy Yossi Milo Gallery, New York. © DACS 2012; 2.87 The Art Institute of Chicago, Alfred Stieglitz Collection, 1949.705 © Georgia O'Keeffe Museum/DACS, 2012; 2.88 © Estate of Garry Winogrand, courtesy Fraenkel Gallery, San Francisco; 2.89 Nationalgalerie, Staatliche Museen, Berlin. © DACS 2012; 2.90 © Stephen Marc; 2.91 Gernsheim Collection, Harry Ransom Humanities Research Centre, University of Texas at Austin; 2.92 Courtesy Gagosian Gallery © Sally Mann; 2.93 Sandy Skoglund, Radioactive Cats © 1980; 2.94 Photo © Edward Burtynsky, courtesy

Flowers, London & Nicholas Metivier, Toronto; 2.95 Ralph Larmann; 2.96 Library of Congress, Washington, D.C. Prints & Photographs Division, LC-USZ62-45683; 2.97 Star Film Company; 2.98 akg-images; 2.99, 2.100 British Film Institute (BFI); 2.101 M.G.M/Album/akg-images; 2.102 British Film Institute (BFI); 2.103 Disney Enterprises/Album/akg-images; 2.104 Lucasfilm/20th Century Fox/The Kobal Collection; 2.105, 2.106, 2.107, 2.108 British Film Institute (BFI); 2.109 Image copyright of the artist, courtesy Video Data Bank, www.vdb.org; 2.110 Courtesy Electronic Arts Intermix (EAI), New York; 2.111 Image courtesy Dia Art Foundation. Courtesy Tony Oursler, Stephen Vitiello and Constance de Jong; 2.112 Courtesy exonemo; 2.113a Photo Mathias Schormann © Bill Viola; 2.113b, 2.113c Photo Kira Perov © Bill Viola; 2.114 © DACS 2012; 2.115 Photo Betsy Jackson. Courtesy the artist; 2.116 @ Marina Abramović. Courtesy Marina Abramović and Sean Kelly Gallery, New York. DACS 2012; 2.117 © Barbara Kruger. Courtesy Mary Boone Gallery, New York; 2.118 @ ARS, NY and DACS, London 2012; 2.119 Photo Karla Merrifield © Yoko Ono; 2.120, 2.121 Courtesy The Fundred Dollar Bill Project; 2.122 Photo courtesy the Oldenburg van Bruggen Foundation. Photo © Robert McElroy/Licensed by VAGA, New York, NY; 2.123 © Fred Wilson, courtesy PaceWildenstein, New York. Photo courtesy PaceWildenstein, New York; 2.124 Courtesy Sikkema Jenkins & Co., NY; **2.125** (above) Courtesy Trudy Labell Fine Art, Florida. © the artist; 2.125 (below) Photo Trudy Labell; 2.126 Photos Ralph Larmann; 2.127 Cleveland Museum of Art, Gift of the Hanna Fund, 1954.857; 2.128a Metropolitan Museum of Art, New York. The Michael C. Rockefeller Memorial Collection, Bequest of Nelson A. Rockefeller, 1979, Acc. no. 1979.206.1134. Photo Schecter Lee. Photo Metropolitan Museum of Art/Art Resource/Scala, Florence; 2.128b Photo Irmgard Groth-Kimball © Thames & Hudson Ltd, London; 2.129 Palace Museum, Beijing; 2.130 Courtesy Arizona State University Art Museum, photo Anthony Cunha; 2.131 Courtesy the Voulkos & Co. Catalogue Project, www.voulkos.com; 2.132 British Museum, London; 2.133 © Angelo Hornak/Corbis; 2.134 Photo Teresa Nouri Rishel © Dale Chihuly; 2.135 National Archaeological Museum, Athens; 2.136 Kunsthistorisches Museum, Vienna; 2.137 © the artist www.tillekeschwarz.com; 2.138 The Solomon R. Guggenheim Foundation, New York, 88.3620; Faith Ringgold @ 1988; 2.139 © Christie's Images/Corbis; 2.140 Metropolitan Museum of Art, Rogers Fund, 1939, Acc. no. 39.153. Photo Metropolitan Museum of Art/Art Resource/Scala, Florence; 2.141 Seattle Art Museum, Gift of John H. Hauberg and John and Grace Putnam, 86.278. Photo Paul Macapia; 2.142 Museum of Fine Arts, Boston, Massachusetts/Harvard University -Museum of Fine Arts Expedition/Bridgeman Art Library; 2.143a, 2.143b Photo Scala, Florence; 2.144 British Museum, London; 2.145 Photograph

Jacqueline Banerjee, Associate Editor of the Victorian Web www.victorianweb.org; 2.146a, 2.146b © David Hilbert/Alamy; 2.147 Photo Scala, Florence, courtesy Ministero Beni e Att. Culturali; 2.148 Vatican Museums, Rome; 2.149 Photo Scala, Florence, courtesy Ministero Beni e Att. Culturali; 2.150 British Museum, London; 2.151 Museo Nazionale di Villa Guilia, Rome; 2.152 National Museum, Reggio Calabria, Italy; 2.153 Ralph Larmann; 2.154 @ Richard A. Cooke/Corbis; 2.155 Photo Tom Smart; 2.156 Photo Tate, London 2012. The works of Naum Gabo © Nina Williams; 2.157 Photographed by Prudence Cuming Associates. © Damien Hirst and Science Ltd. All rights reserved, DACS 2012; 2.158 © Succession Picasso/DACS, London 2012; 2.159 Philadelphia Museum of Art, The Louise and Walter Arensberg Collection. © ADAGP, Paris and DACS, London 2012; 2.160 Harvard Art Museums, Busch-Reisinger Museum, Hildegard von Gontard Bequest Fund, 2007.105. Photo Junius Beebe, President & Fellows of Harvard College © DACS 2012; 2.161 Photo Jens Ziehe 2004 © 2002 Olafur Eliasson; **2.162** Photo Mark Pollock/Estate of George Rickey. © Estate of George Rickey/DACS, London/VAGA, New York 2012; 2.163a Photograph by Zhang Haier; 2.163b Photo Dai Wei, Shanghai © the artist; 2.164 Courtesy the artists and Sprovieri Gallery, London; 2.165 Maki and Associates. Courtesy Silverstein Properties; **2.166**, **2.167** iStockphoto.com; **2.168** DeAgostini Picture Library/Scala, Florence; 2.169a Ralph Larmann; 2.169b iStockphoto.com; 2.170 Ralph Larmann; 2.171 Bridgeman Art Library; 2.172 Index/Bridgeman Art Library; 2.173 Ralph Larmann; 2.174 © Christophe Boisvieux/Corbis; 2.175 Ralph Larmann; 2.176 Photo Scala, Florence; 2.177 Gianni Dagli Orti/Basilique Saint Denis Paris/The Art Archive; 2.178a, 2.178b Ralph Larmann, 2.179 © Robert Harding Picture Library Ltd/Alamy; 2.180, 2.181 Ralph Larmann; 2.182 © Photo Japan/Alamy; 2.183 Photo Shannon Kyles, ontarioarchitecture.com; 2.185 Photo Sandak Inc, Stamford, CT; 2.186 @ INTERFOTO/Alamy; 2.187 © Robert Harding Picture Library Ltd/Alamy; 2.188 © Bildarchiv Monheim GmbH/Alamy; 2.189 © Richard A. Cooke/Corbis; 2.190 © Free Agents Limited/Corbis; 2.191 Photo courtesy Michael Graves & Associates; 2.192 © Chuck Eckert/Alamy; 2.193a Courtesy Zaha Hadid Architects; 2.193b © Roland Halbe/artur; 2.194 Courtesy CMPBS; p. 292 (above) Egyptian Museum, Cairo; (center) iStockphoto.com; (below) Musée d'Orsay, Paris; 3.1 Drazen Tomic; 3.2 Photo Jean Clottes; 3.3 Images courtesy the Mellaarts/Çatalhöyük Research Project; 3.4 The J. Paul Getty Museum, Villa Collection, Malibu, California; 3.5 Photo Jeff Morgan Travel/ Alamy; 3.6 Archaeological Museum, Heraklion; 3.7 British Museum, London; 3.8 Iraq Museum, Baghdad; 3.9 Metropolitan Museum of Art, Gift of John D. Rockefeller Jr., 1932, Acc. no. 32.143.2. Photo Metropolitan Museum of Art/Art Resource/Scala, Florence; 3.10 Photo Scala, Florence/BPK,

Bildagentur für Kunst, Kultur und Geschichte, Berlin; 3.11 iStockphoto.com; 3.12 Gianni Dagli Orti/Egyptian Museum, Cairo/The Art Archive; 3.13, 3.14 Egyptian Museum, Cairo; 3.15 British Museum, London; 3.16 Peter Connolly/akg-images; 3.17 Nimatallah/akg-images; 3.18 Ralph Larmann; **3.19** British Museum, London; **3.20**, **3.21** Museum of Fine Arts, Boston, Henry Lillie Pierce Fund; 3.22 Metropolitan Museum of Art, Fletcher Fund, 1932, Acc. no. 32.11.1. Photo Metropolitan Museum of Art/Art Resource/Scala, Florence; 3.23 Minneapolis Institute of Arts; 3.24 Vatican Museums, Rome; 3.25 © Altair4 Multimedia Roma, www.altair.it; 3.26 Palazzo Torlonia, Rome; 3.27 Giovanni Caselli; 3.28 Image Source Pink/Alamy; 3.29 @ Atlantide Phototravel/Corbis; **3.30** iStockphoto.com; **3.31** Drazen Tomic; **3.32**, **3.33** Zev Radovan/ www.BibleLandPictures.com; 3.34 Canali Photobank, Milan, Italy; 3.35 Photo Scala, Florence; 3.36 Monastery of St. Catherine, Sinai, Egypt; 3.37 Photo Scala, Florence; 3.38 Cameraphoto/ Scala, Florence; 3.39, 3.40, 3.41 British Library, London; 3.42 Biblioteca Governativa, Lucca; 3.43 British Library/akg-images; 3.44 Musées Royaux d'Art et d'Histoire, Brussels; 3.45 © Hanan Isachar/Corbis; 3.46 Mohamed Amin/Robert Harding; 3.47 Metropolitan Museum of Art, Harris Brisbane Dick Fund, 1939, Acc. no. 39.20. Photo Metropolitan Museum of Art/Art Resource/Scala, Florence; 3.48 © Matthew Lambley/Alamy; 3.49 Ralph Larmann; 3.50 © Rolf Richardson/Alamy; 3.51 Ralph Larmann; 3.52 Hervé Champollion/akgimages; 3.53 Sonia Halliday Photographs; 3.54, 3.55 Galleria degli Uffizi, Florence; 3.56 Drazen Tomic; **3.57** iStockphoto.com; **3.58** © Tom Hanley/Alamy; 3.59 © Susanna Bennett/Alamy; 3.60 © Frédéric Soltan/Sygma/Corbis; 3.61 © Pep Roig/Alamy; 3.62 Freer Gallery of Art, Smithsonian Institution, Washington, D.C., Purchase F1942.15a; **3.63** iStockphoto.com; **3.64**, **3.65**, **3.66** Palace Museum, Beijing; 3.67 Brooklyn Museum, Gift of Mr. & Mrs. Alastair B. Martin, the Guennol Collection, 72.163a-b; 3.68 Hunan Museum, Changsha; 3.69 Courtesy the artist; 3.70 Photo Shunji Ohkura; 3.72 Sakai Collection, Tokyo; 3.73 Horyu-ji Treasure House, Ikaruga, Nara Prefecture, Japan; 3.74 The Tokugawa Art Museum, Nagoya; $3.75\,\mathrm{V\&A}$ Images/Alamy; $3.76\,\mathrm{The}$ Art Institute of Chicago, Robert A. Waller Fund, 1910.2; 3.77 Library of Congress, Washington, D.C. Prints & Photographs Division, H. Irving Olds collection, LC-DIG-jpd-02018; 3.78 iStockphoto.com; 3.79 Drazen Tomic; 3.80 Anton, F. Ancient Peruvian Textiles, Thames & Hudson Ltd, London, 1987; 3.81 Museo Arqueología, Lima, Peru / Bridgeman Art Library; 3.82 Royal Tombs of Sipán Museum, Lambayeque; 3.83 iStockphoto.com; 3.84 American Museum of Natural History, New York; 3.85 Dumbarton Oaks Research Library and Collections, Washington, D.C.; 3.86 Drazen Tomic; 3.87 Richard Hewitt Stewart/ National Geographic Stock; 3.88a Drazen Tomic; 3.88b © aerialarchives.com/Alamy; 3.89 © Ken

Welsh/Alamy; 3.90 @ Gianni Dagli Orti/Corbis; 3.91 Dallas Museum of Art, Gift of Patsy R. and Raymond D. Nasher, 1983.148; 3.92 Peabody Museum, Harvard University, Cambridge, 48-63-20/17561; 3.93 Biblioteca Nazionale Centrale di Firenze; 3.94 Museo Nacional de Antropología, Mexico City; 3.95 Museo del Templo Mayor, Mexico City; 3.96 Drazen Tomic; 3.97 @ Chris Howes/Wild Places Photography/Alamy; 3.98a, 3.98b Peabody Museum, Harvard University, Cambridge, 99-12-10/53121; 3.99 Missouri Historical Society, St. Louis, 1882.18.32; **3.100** American Museum of Natural History, New York; 3.101 Drazen Tomic; 3.102 National Museum, Lagos; 3.103 Linden Museum, Stuttgart; 3.104 Dallas Museum of Art, Foundation for the Arts Collection, Gift of the McDermott Foundation, 1996.184.FA; 3.105 National Museum of African Art, Smithsonian Institution, Washington, D.C.; 3.106 Musée Barbier-Mueller, Geneva; 3.107 © JTB Photo Communications, Inc./Alamy; 3.108 © Chris Howes/Wild Places Photography/Alamy; **3.109** Photo Barney Wayne; **3.110** Drazen Tomic; **3.111** pl. XVI from Parkinson, S., A Journal of a Voyage to the South Seas, 1784; 3.112 Photo Paul S. C. Tacon; 3.113 Bishop Museum, Honolulu, Hawaii; 3.114 iStockphoto.com; 3.115 Musée Barbier-Mueller, Geneva; 3.116 Collected by G.F.N. Gerrits, Vb 28418-28471 (1972). Photo Peter Horner 1981 © Museum der Kulturen, Basel, Switzerland; 3.117 Drazen Tomic; 3.118 from Vasari, G., Lives of the Great Artists, 1568; 3.119 @ Michael S. Yamashita/Corbis; 3.120 Libreria dello Stato, Rome; 3.121 Brancacci Chapel, Church of Santa Maria del Carmine, Florence; 3.122 Refectory of Sta Maria delle Grazie, Milan; 3.123, 3.124 Vatican Museums, Rome; 3.125 Stanza della Segnatura, Vatican Museums, Rome; 3.126 Vatican Museums, Rome; 3.127a, 3.127b National Gallery, London/Scala, Florence; 3.128, 3.129a, 3.129b, 3.129c Gemäldegalerie, Staatliche Museen, Berlin; 3.130 Musée d'Unterlinden, Colmar; 3.131 British Museum, London; 3.132 Museum Narodowe, Poznań/Bridgeman Art Library; 3.133 Galleria dell'Accademia, Venice; 3.134 Cameraphoto/Scala, Florence; 3.135 Capponi Chapel, Church of Santa Felicità, Florence; 3.136 National Gallery of Art, Washington, D.C., Samuel H. Kress Collection, 1946.18.1; 3.137 Photo Scala, Florence, courtesy Ministero Beni e Att. Culturali; 3.138 © nagelestock.com/Alamy; 3.139 Photo Scala, Florence, courtesy Ministero Beni e Att. Culturali; **3.140** The Earl of Plymouth. On loan to the National Museum of Wales, Cardiff; 3.141 Royal Institute for the Study and Conservation of Belgium's Artistic Heritage; 3.142 Galleria Nazionale d'Arte Antica, Palazzo Barberini, Rome; 3.143 Galleria degli Uffizi, Florence; 3.144 Rijksmuseum, Amsterdam; 3.145 © Bertrand Rieger/Hemis/Corbis; 3.146 © Florian Monheim/Arcaid/Corbis; 3.147 Gianni Dagli Orti/Musée du Château de Versailles/The Art Archive; **3.148** The Wallace Collection, London; **3.149**

National Gallery, London/Scala, Florence; 3.150

Classic Image/Alamy; 3.151 Musée du Louvre, Paris; 3.152 Virginia Museum of Fine Arts, Richmond. The Adolf D. and Wilkins C. Williams Fund; 3.153 iStockphoto.com; 3.154 Musée du Louvre, Paris; 3.155, 3.156 Museo Nacional del Prado, Madrid; **3.157** © Tate, London 2012; **3.158** Metropolitan Museum of Art, Gift of Mrs. Russell Sage, 1908, Acc. no. 08.228. Photo Metropolitan Museum of Art/Art Resource/Scala, Florence; 3.159 White Images/Scala, Florence; 3.161 Hampton University Museum, Virginia; 3.162 Musée d'Orsay, Paris; 3.163 © Tate, London 2012; 3.164 Musée Marmottan, Paris; 3.165 Musée d'Orsay, Paris; 3.166 Art Institute of Chicago, Charles H. and Mary F. S. Worcester Collection, 1964.336; **3.167** White Images/Scala, Florence; **3.168** BI, ADAGP, Paris/Scala, Florence. © ADAGP, Paris and DACS, London 2012; 3.169 Musée d'Orsay, Paris; 3.170 Courtauld Gallery, London; 3.171 National Gallery of Scotland, Edinburgh; 3.172 Museum of Modern Art, New York. Acquired through the Lillie P. Bliss Bequest. Acc. no. 472.1941. Photo 2012, Museum of Modern Art, New York/Scala, Florence; 3.173 Private Collection; 3.174 Musée Carnavalet, Paris; 3.175 Private Collection/ © Ackermann Kunstverlag/Bridgeman Art Library; **3.176** Österreichische Galerie Belvedere, Vienna; 3.177 Mark Edward Smith/photolibrary.com; 3.178 Photo Spectrum/Heritage Images/Scala, Florence; 3.179 Metropolitan Museum of Art, Harris Brisbane Dick Fund, 1966, 66.244.1-25. Photo Metropolitan Museum of Art/Art Resource/Scala, Florence; 3.180 The Barnes Foundation, Merion, PA. © Succession H. Matisse/DACS 2012; 3.181 Museum of Modern Art, New York, Mrs. Simon Guggenheim Fund, 8.1949. Photo 2012, Museum of Modern Art, New York/Scala, Florence. © Succession H. Matisse/DACS 2012; 3.182 Teriade Editeur, Paris, 1947. Printer Edmond Vairel, Paris. Edition 250. Museum of Modern Art, New York, The Louis E. Stern Collection, 930.1964.8. Photo 2012, Museum of Modern Art, New York/Scala, Florence. © Succession H. Matisse/DACS 2012; 3.183 Photograph by Hélène Adant/RAPHO/GAMMA, Camera Press, London; 3.184 Museum of Modern Art, New York, acquired through the Lillie P. Bliss Bequest, 333.1939. Photo 2012, Museum of Modern Art, New York/Scala, Florence. © Succession Picasso/DACS, London 2012; 3.185 Kunstmuseum, Bern; 3.186 Mildred Lane Kemper Art Museum, St. Louis, University purchase, Kende Sale Fund, 1946. © Succession Picasso/DACS, London 2012; 3.187 Metropolitan Museum of Art, Bequest of Gertrude Stein, 1946, Acc. no. 47.106. Photo Metropolitan Museum of Art/Art Resource/Scala, Florence. © Succession Picasso/DACS, London 2012; 3.188 Museum Folkwang, Essen; 3.189 Art Institute of Chicago, Arthur Jerome Eddy Memorial Collection, 1931.511. © ADAGP, Paris and DACS, London 2012; 3.190 Museum of Modern Art, New York, Purchase, 274.1939. Photo 2012, Museum of Modern Art, New York/Scala, Florence; 3.192 Museum of Modern Art, New York, The Sidney and Harriet Janis Collection,

595.1967 a-b. Photo 2012, Museum of Modern Art, New York/Scala, Florence. @ ADAGP, Paris and DACS, London 2012; 3.193 © The Heartfield Community of Heirs/VG Bild-kunst, Bonn and DACS, London 2012; 3.194 © DACS 2012; 3.195 Photo Hickey-Robertson, Houston. The Menil Collection, Houston. @ ADAGP, Paris and DACS, London 2012; 3.196 Museum of Modern Art, New York, Gift of Mr. and Mrs. Pierre Matisse, 940.1965.a-c. Photo 2012, Museum of Modern Art, New York/Scala, Florence. © Succession Miro/ADAGP, Paris and DACS, London 2012; 3.197 Photo Francis Carr © Thames & Hudson Ltd, London; 3.198 Philadelphia Museum of Art, The Louise and Walter Arensberg Collection. © ADAGP, Paris and DACS, London 2012; 3.199, 3.200 Stedelijk Museum, Amsterdam; 3.201 © ADAGP, Paris and DACS, London 2012; 3.202 © Romare Bearden Foundation/DACS, London/VAGA, New York 2012; 3.203 Courtesy Center for Creative Photography, University of Arizona © 1991 Hans Namuth Estate; 3.204 The University of Iowa Museum of Art, Iowa City, Gift of Peggy Guggenheim, OT 102. © The Pollock-Krasner Foundation ARS, NY and DACS, London 2012; 3.205 National Gallery of Art, Washington, D.C., Gift of the Mark Rothko Foundation, Inc., 1986.43.13. © 1998 Kate Rothko Prizel & Christopher Rothko ARS, NY and DACS, London, 2012; 3.206 © The Andy Warhol Foundation for the Visual Arts/Artists Rights Society (ARS), New York/DACS, London 2012; 3.207 © The Estate of Roy Lichtenstein/DACS 2012; 3.208 (above) Photo Smithsonian American Art Museum/Art Resource/Scala, Florence; 3.208 (below) Ralph Larmann; 3.209 Collection of the Modern Art Museum of Fort Worth, Museum purchase, The Benjamin J. Tillar Memorial Trust. Acquired in 1970. © Judd Foundation. Licensed by VAGA, New York/DACS, London 2012; 3.210 Photo Hickey-Robertson, Houston. The Menil Collection, Houston. © ARS, NY and DACS, London 2012; 3.211 Museum of Modern Art, New York, Larry Aldrich Foundation Fund, 393.1970.a-c. Photo 2012, Museum of Modern Art, New York/Scala, Florence. © ARS, NY and DACS, London 2012; **3.212** © The Estate of Ana Mendieta. Courtesy Galerie Lelong, New York; 3.213 Photo courtesy John Michael Kohler Arts Center © the artist and Stefan Stux Gallery, NY; 3.214 © EggImages/Alamy; **3.215** Photo courtesy Michael Graves & Associates; 3.216 (left) Museum of Modern Art, New York, Gift on behalf of The Friends of Education of The Museum of Modern Art, Acc. no. 70.1997.2. Photo 2012, Museum of Modern Art, New York/Scala, Florence. Courtesy the artist and Jack Shainman Gallery, New York; 3.216 (right) Museum of Modern Art, New York, Gift on behalf of The Friends of Education of The Museum of Modern Art, Acc. no. 70.1997.5. Photo 2012, Museum of Modern Art, New York/Scala, Florence. Courtesy the artist and Jack Shainman Gallery, New York; **3.217** William Sr. and Dorothy Harmsen Collection, by exchange, 2007.47. Denver Art Museum. All Rights Reserved;

3.218a, 3.218b Courtesy Gladstone Gallery, New York. © Shirin Neshat; 3.219 Museum of Modern Art, New York, Fractional gift offered by Donald L. Bryant, Jr., Acc. no. 241.2000.b. Photo 2012, Museum of Modern Art, New York/Scala, Florence. © 1997 Pipilotti Rist. Image courtesy the artist, Luhring Augustine, New York and Hauser & Wirth; 3.220 Courtesy Gladstone Gallery, New York. Photo Michael James O'Brien. © 1997 Matthew Barney; 3.221 Contemporary Arts Museum, Houston. Photo Hester + Hardaway. Courtesy Andrea Rosen Gallery, NY; **p. 452** (above) Photo David Heald. The Solomon R. Guggenheim Foundation, New York. FLWW-10; (center) Courtauld Gallery, London; (below) Victor Chavez/WireImage/Getty; 4.1 Musée du Louvre, Paris; 4.2 @ guichaoua/Alamy; 4.3 Martin Gray/National Geographic Stock; 4.4 Keith Bedford/epa/Corbis; 4.5 iStockphoto.com; 4.6 Photo David Heald. The Solomon R. Guggenheim Foundation, New York. FLWW-10; 4.7 Silvio Fiore/photolibrary.com; 4.8 iStockphoto.com; 4.9a, 4.9b, 4.9c, 4.9d @ 1991 Ancient Egypt Research Associates ("AERA"). Photographs Mark Lehner; 4.10 @ Taisei Corporation/NHK; 4.11 @ Bob Krist/Corbis; 4.12 Cahokia Mounds State Historic Site, painting by William R. Iseminger; 4.13 David Hiser/National Geographic Stock; 4.14 Erich Lessing/akg-images; 4.15 University of Pennsylvania Museum of Archaeology and Anthropology, Philadelphia B17694; 4.16 @ Peter Arnold, Inc./Alamy; 4.17 Henry John Drewal and Margaret Thompson Drewal Collection, EEPA D00639. Eliot Elisofon Photographic Archives, National Museum of African Art, Smithsonian Institution, Washington, D.C., courtesy Henry John Drewal; 4.18 Photo Anne Chauvet; 4.19 Photo Art Resource/Bob Schalkwijk/Scala, Florence. © 2012 Banco de México Diego Rivera Frida Kahlo Museums Trust, Mexico, D.F./DACS; **4.20** Precita Valley Vision © 1996 Susan Kelk Cervantes. Courtesy Precita Eyes Muralists, www.precitaeyes.org; 4.21 John Hios/akg-images; 4.22a, 4.22b Dom-Museum Hildesheim; 4.22c Ralph Larmann; 4.23 India Museum, Calcutta; 4.24 The Cleveland Museum of Art, James Albert and Mary Gardiner Ford Memorial Fund, 1961.198; 4.25 National Museum of African Art, Smithsonian Institution, Washington, D.C., Museum purchase 90-4-1. Photograph Franko Khoury; 4.26 Smith College Museum of Art, Northampton, Massachusetts. Purchased with the proceeds from the sale of works donated by Mr. and Mrs. Alexander Rittmaster (Sylvian Goodkind, class of 1937) in 1958, and Adeline Flint Wing, class of 1898, and Caroline Roberta Wing, class of 1896, in 1961. Courtesy Michael Rosenfeld, LLC, New York, NY; 4.27 Musée du Louvre, Paris; 4.28 State Tretyakov Gallery, Moscow; 4.29 Photo Scala, Florence/Fondo Edifici di Culto - Min. dell'Interno; 4.30 Gianni Dagli Orti/The Art Archive; 4.31 Norbert Aujoulat; 4.32a Ralph Larmann; 4.32b Colorphoto Hans Hinz, Allschwil, Switzerland; 4.33a Ralph Larmann; 4.33b © Araldo de Luca/Corbis; **4.34** © B. O'Kane/Alamy;

4.35 Courtesy Jingu Administration Office; 4.36 Photo Hickey-Robertson © 1998 Kate Rothko Prizel & Christopher Rothko ARS, NY and DACS, London; 4.37 Rainer Hackenberg/akg-images. © Succession H. Matisse/DACS 2012; 4.38 Teriade Editeur, Paris, 1947. Printer Edmond Vairel, Paris. Edition 250. Museum of Modern Art, New York, The Louis E. Stern Collection, 930.1964.8. Photo 2012, Museum of Modern Art, New York/Scala, Florence. © Succession H. Matisse/DACS 2012; 4.39 University Art Museum, Obafemi Awolowo University, Ife; 4.40 Dumbarton Oaks Museum, Washington, D.C.; 4.41 Courtesy the artist and Marian Goodman Gallery, New York/Paris; 4.42 © Tierney Gearon, Courtesy Yossi Milo Gallery, New York; 4.43 Metropolitan Museum of Art, The Michael C. Rockefeller Memorial Collection, Bequest of Nelson A. Rockefeller, 1979, Acc. no. 1979.206.1611. Photo Metropolitan Museum of Art/Art Resource/Scala, Florence; 4.44 Dallas Museum of Art, The Clark and Frances Stillman Collection of Congo Sculpture, Gift of Eugene and Margaret McDermott, 1969.S.22; 4.45 The Cleveland Museum of Art, Purchase from the J. H. Wade Fund 1930.331; **4.46** © Loren McIntyre/lorenmcintyre.com; 4.47 Pinoteca di Brera, Milan; 4.48 © Andres Serrano. Courtesy the artist and Yvon Lambert Paris, New York; 4.49 Copyright Merle Greene Robertson, 1976; 4.50 Courtesy National Museum of the American Indian, Smithsonian Institution (18/2023). Photo by Photo Services; 4.51 Museo del Templo Mayor, Mexico City, CONACULTA-INAH, 10-220302; 4.52 Dallas Museum of Art, Foundation for the Arts Collection, Mrs John B. O'Hara Fund; 4.53 British Museum, London; 4.54 Photo Heidi Grassley © Thames & Hudson Ltd, London; 4.55 Ralph Larmann; 4.56 © Ivan Vdovin/Alamy; 4.57 Hervé Champollion/akgimages; 4.58 National Gallery of Art, Washington, D.C., Widener Collection, 1942.9.97; 4.59 Photograph K2822 © Justin Kerr; **4.60** National Museum of Anthropology, Mexico City; 4.61 National Maritime Museum, Greenwich, London; 4.62 National Gallery, London/Scala, Florence; 4.63 Gift of the Alumni Association to Jefferson Medical College in 1878, purchased by the Pennsylvania Academy of the Fine Arts and the Philadelphia Museum of Art in 2007 with the generous support of more than 3,600 donors, 2007, 2007-1-1; 4.64 Courtesy the David Lloyd Gallery; 4.65 Courtesy Institute for Plastination, Heidelberg, Germany; 4.66 Art Institute of Chicago, Helen Birch Bartlett Memorial Collection, 1926.224; 4.67 @ Jasper Johns/VAGA, New York/DACS, London 2012; 4.68 Courtesy Marcia Smilack; 4.69 Museum of Modern Art, New York. Benjamin Scharps and David Scharps Fund, 288.1956. Photo 2012, Museum of Modern Art, New York/Scala, Florence. @ ADAGP, Paris and DACS, London 2012; 4.70 Museum of Modern Art, New York. Given anonymously, 162.1934. Photo 2012, Museum of Modern Art, New York/Scala, Florence. © Salvador Dali, Fundació Gala-Salvador Dalí, DACS, 2012; 4.71 High Museum of Art, Atlanta, 1999.93.

Purchase with T. Marshall Hahn Folk Art Acquisition Fund for the T. Marshall Hahn Collection; 4.72 Victor R. Boswell, Jr./National Geographic Stock; 4.73 Photo Vatican Museums, Rome; 4.74 Metropolitan Museum of Art, Rogers Fund, 1903. Inv. 03.14.13a-g. Photo Metropolitan Museum of Art/Art Resource/Scala, Florence; 4.75 Photo Scala, Florence; 4.76 Photo Scala, Florence, courtesy Ministero Beni e Att. Culturali; 4.77 Kunsthistorisches Museum. Vienna; 4.78 National Gallery of Art, Washington, D.C. Gift of Mr. & Mrs. Richard Mellon Scaife in honour of Paul Mellon, 1993.15.1; 4.79 Courtesy Miran Fukuda; 4.80 Photo Anthony d'Offay, London; 4.81a James Green/Robert Harding; 4.81b. 4.81c, 4.81d Ralph Larmann; 4.82 Gianni Dagli Orti/Palazzo del Tè Mantua/The Art Archive; 4.83 Pietro Baguzzi/akg-images; 4.84a, 4.84b Courtesy the artist; 4.85 National Gallery of Art, Washington, D.C., Gift of Lila Acheson Wallace, 1987.2.1. Photo Ellen Page Wilson, courtesy The Pace Gallery. © Chuck Close, The Pace Gallery; 4.86 Courtauld Gallery, London; 4.87 from Kirby, J., Dr Brook Taylor's Method of Perspective Made Easy, 1754; 4.88 National Gallery of Art, Washington, D.C., Gift of the Collectors Committee, 1987.55.1. © ADAGP, Paris and DACS, London 2012; 4.89 Photo Scala, Florence; 4.90 The Palace Museum, Beijing; 4.91a Photo Irmgard Groth-Kimball © Thames & Hudson Ltd, London: 4.91b @ World Pictures/Alamy; 4.92 British Museum, London; 4.93 Musée du Louvre, Paris; 4.94 Musée National de Château de Versailles; 4.95 Ägyptisches Museum, Staatliche Museen, Berlin; 4.96a, 4.96b Egyptian Museum, Cairo; 4.97 Photo Scala, Florence; 4.98 Metropolitan Museum of Art, Gift of Mr. and Mrs. Klaus G. Perls, 1990, Acc. no. 1990.332. Photo Metropolitan Museum of Art/Art Resource/Scala, Florence; 4.99 Musée du Louvre, Paris; 4.100 @ Hubert Stadler/Corbis; 4.101 @ Peter Guttman/Corbis; 4.102 Library of Congress, Washington, D.C. Prints & Photographs Division, LC-B8184-7964-A; **4.103** Photo Scala, Florence; 4.104, 4.105 Museo Nacional del Prado, Madrid; 4.106 Nick Ut/AP/Press Association Images; 4.107 Dallas Museum of Art, purchased with funds donated by the Jolesch Acquisition Fund, The 500, Inc., the National Endowment for the Arts, Bradbury Dyer, III, Mr. and Mrs. Bryant M. Hanley, Jr., Mr. and Mrs Michael C. Mewhinney, Deedie and Rusty Rose, and Mr. and Mrs. William T. Solomon. Courtesy Gagosian Gallery; 4.108 Photograph Luidger; 4.109 National Archaeological Museum, Naples; 4.110 Centre Guillaume le Conquérant, Bayeux; 4.111 Museum of Fine Arts, Boston, Fenollosa-Weld Collection; **4.112** Courtesy the artist; **4.113** © DACS

2012; **4.114** Courtesy the artist; **4.115** © Anselm Kiefer; 4.116 Musée du Louvre, Paris; 4.117 Photo courtesy the artist and Jonathan Ferrara Gallery; 4.118 Museum of Fine Arts, Boston, Henry Lillie Pierce Fund, BJ385; 4.119 © Succession Picasso/ DACS, London 2012; 4.120 Lions Gate/The Kobal Collection; 4.121 Library of Congress, Washington, D.C. Prints & Photographs Division, FSA/OWI Collection, LC-DIG-fsa-8b29516; 4.122a National Gallery, London/Scala, Florence; 4.123 Courtesy Mary Boone Gallery, New York; 4.124a @ Reuters/ Corbis; 4.124b © Ton Koene/ZUMA Press/Corbis; 4.125 Monastery of St. Catherine, Sinai, Egypt; 4.126 Musées Royaux des Beaux-Arts de Belgique, Brussels; 4.127 @ Maurice Savage/Alamy; 4.128 Courtesy the artist; 4.129 Naturhistorisches Museum, Vienna; 4.130 Museum of Modern Art, New York. Purchase, 478.1953. Photo 2012, Museum of Modern Art, New York/Scala, Florence. @ ARS, NY and DACS, London 2012; 4.131a Ralph Larmann; **4.131b** Erich Lessing/akg-images; **4.132** Museo delle Terme, Rome; 4.133 Uffizi Gallery, Florence; 4.134 Kimbell Art Museum, Fort Worth, Texas/Art Resource, NY/Scala, Florence; 4.135 Metropolitan Museum of Art, The Harry G. C. Packard Collection of Asian Art, Gift of Harry G. C. Packard, and Purchase, Fletcher, Rogers, Harris Brisbane Dick, and Louis V. Bell Funds, Joseph Pulitzer Bequest, and The Annenberg Fund Inc. gift, 1975, 1975.268.125. Photo Metropolitan Museum of Art/Art Resource/Scala, Florence; 4.136 Photo Scala, Florence, courtesy Ministero Beni e Att. Culturali; 4.137 Musée d'Orsay, Paris; 4.138 Courtesy the artist and Luhring Augustine, New York; 4.139a, 4.139b © ADAGP, Paris and DACS, London 2012; 4.140 Courtesy the artist and Luhring Augustine, New York: 4.141 © Vanessa Beecroft; 4.142a Victor Chavez/WireImage/Getty; **4.142b** Alessandro della Valle/epa/Corbis; 4.143 Museum of Modern Art, New York. Fractional and promised gift of Malcom Wiener in memory of John Rewald, Acc. no. 183,1994. Photo 2012, Museum of Modern Art, New York/Scala, Florence; 4.144 Teriade Editeur, Paris, 1947. Printer Edmond Vairel, Paris. Edition 250. Museum of Modern Art, New York, The Louis E. Stern Collection, 930.1964.8. Photo 2012, Museum of Modern Art, New York/Scala, Florence. © Succession H. Matisse/DACS 2012; **4.145** Musée National d'Art Moderne, Centre Georges Pompidou, Paris. © Succession H. Matisse/DACS 2012; 4.146 © Tate, London, 2012. Reproduced by permission of The Henry Moore Foundation; 4.147 Museum of Modern Art, New York, Gift of Mrs. John D. Rockefeller III, 678.1954. Photo 2012, Museum of

Modern Art, New York/Scala, Florence. © ADAGP, Paris and DACS, London 2012; 4.148 Courtesy Christie's/Werner Forman Archive; 4.149 Records of the Work Projects Administration, U.S. National Archives and Records Administration; 4.150 © The John Coplans Trust; **4.151** Library of Congress, Washington, D.C. Prints & Photographs Division, FSA/OWI Collection, LC-DIG-fsa-8b29516; 4.152 Courtesy the artist and Metro Pictures; 4.153 Brooklyn Museum, Gift of the Elizabeth A. Sackler Foundation, 2002.10. Photo © Donald Woodman. © Judy Chicago, 1979. © ARS, NY and DACS, London 2012; 4.154 Galleria degli Uffizi, Florence; 4.155 Copyright © by Guerrilla Girls, Inc. Courtesy www.guerrillagirls.com; **4.156** Courtesy the artist; 4.157 Metropolitan Museum of Art, Rogers Fund, 1931, Acc. no. 31.3.166. Photo Metropolitan Museum of Art/Art Resource/Scala, Florence; 4.158 Copyright © 1972 The Estate of Diane Arbus; 4.159 © copyright The Robert Mapplethorpe Foundation. Courtesy Art + Commerce; 4.160 Courtesy Regen Projects, Los Angeles; 4.161 Private Collection; 4.162 Museo de Arte Moderno, Mexico City. © 2012 Banco de México Diego Rivera Frida Kahlo Museums Trust, Mexico, D.F./DACS; 4.163 Gemäldegalerie Alte Meister, Dresden; **4.164** Copyright Duane Michals. Courtesy Pace/MacGill Gallery, New York; 4.165 © Jenny Saville; 4.166a Photo Vladimir Sichov, Sipa-Press. Courtesy the artist and galerie Michel Rein, Paris. © ORLAN; **4.166b** Courtesy ORLAN. © ORLAN; 4.167 Galleria degli Uffizi, Florence; 4.168 Detroit Institute of Arts, Gift of Mr. Leslie H. Green; 4.169 Detroit Institute of Arts, Founders Society Purchase with funds from Mr. and Mrs. Bert L. Smokler and Mr. and Mrs. Lawrence A. Fleischman; 4.170 Detroit Institute of Arts, Gift of Dexter M. Ferry, Jr.; 4.171 Photo Herbert Lotz © the artist. Courtesy White Cube; 4.172 @ Munch Museum/Munch-Ellingsen Group, BONO, Oslo/DACS, London 2012; 4.173 Philadelphia Museum of Art, Gift of Mr. and Mrs. H. Gates Lloyd, 1974. © The Pollock-Krasner Foundation ARS, NY and DACS, London 2012; 4.174 Courtesy Bischofberger Collection, Switzerland. © 2012 Julian Schnabel/ARS, New York/DACS; 4.175 © Sherrie Levine. Courtesy Simon Lee Gallery, London; 4.176 © The Andy Warhol Foundation/Corbis. © The Andy Warhol Foundation for the Visual Arts/Artists Rights Society (ARS), New York/DACS, London 2012; 4.177 The Museum of Contemporary Art, Los Angeles. Purchased with funds provided by the National Endowment for the Arts, a Federal Agency, and Councilman Joel Wachs. © Richard Prince; 4.178 Courtesy the artist and Sikkema Jenkins & Co.

Image Numbering by Part and Chapter

The following list shows in which chapters images appear, cited by figure number:

Introduction

0.1-0.18 inclusive

Part 1

Chapter 1.1: 1.1–1.27 inclusive

Chapter 1.2: 1.28-1.46 Chapter 1.3: 1.47-1.70 Chapter 1.4: 1.71-1.94 Chapter 1.5: 1.95-1.109 Chapter 1.6: 1.110-1.125 Chapter 1.7: 1.126-1.140 Chapter 1.8: 1.141-1.148 **Chapter 1.9: 1.149–1.160(a)** and **(b)** Chapter 1.10: 1.161-1.172

Part 2

Chapter 2.1: 2.1–2.21 inclusive

Chapter 2.2: 2.22-2.40

Chapter 2.3: 2.41-2.57

Chapter 2.4: 2.58-2.70

Chapter 2.5: 2.71-2.94

Chapter 2.6: 2.95–2.113(a) and **(b)**

Chapter 2.7: 2.114-2.124

Chapter 2.8: 2.125-2.141

Chapter 2.9: 2.142-2.164

Chapter 2.10: 2.165-2.194

Part 3

Chapter 3.1: 3.1–3.30 inclusive

Chapter 3.2: 3.31-3.55 Chapter 3.3: 3.56-3.78 Chapter 3.4: 3.79-3.100 Chapter 3.5: 3.101-3.116 Chapter 3.6: 3.117-3.144 Chapter 3.7: 3.145-3.179 Chapter 3.8: 3.180-3.221

Part 4

Chapter 4.1: 4.1-4.20 inclusive

Chapter 4.2: 4.21-4.38

Chapter 4.3: 4.39-4.58

Chapter 4.4: 4.59-4.73

Chapter 4.5: 4.74-4.88

Chapter 4.6: 4.89-4.101

Chapter 4.7: 4.102-4.115

Chapter 4.8: 4.116-4.128

Chapter 4.9: 4.129-4.147

Chapter 4.10: 4.148-4.160

Chapter 4.11: 4.161-4.178

Acknowledgments

The publisher would like to thank the following for their generous advice and feedback during the preparation of Gateways to Art. Special gratitude goes to: John Adelman, Lone Star College Cy-Fair; Fred C. Albertson, University of Memphis; Dan Boylan, Trine University; Andrea Donovan, Minot State University; Kara English, Tarrant County Community College; Trina Felty, Pima Community College; Ferdinanda Florence, Solano Community College; Rebecca Hendrick, University of Texas at El Paso; Bonnie Holt, Contra Costa College; Kathy Holt, Arapahoe Community College; Frank Latimer, Pulaski Technical College; Bridget Lynch, Simmons College; Patrick McNally, Community College of Aurora; Ken Magri, American River College; Erin Morris, South Mountain Community College; Carola Naumer, Truckee Meadows Community College; Kristin Powers Nowlin, Southeast Missouri State University; Elaine O'Brien, Sacramento State University; Margee Bright Ragland, Georgia Perimeter College; Mollie Rushing, Delta State

University; Dennis Sears, Gadsden State Community College; Suzanne Thomas, Rose State College; Li-Lin Tseng, Pittsburg State University; Cathie Tyler, Paris Community College; Kathy Windrow, Eastfield College; Kathy Windrow, Eastfield College; Linda Woodward, Lone Star Community College Montgomery; Susan Zucker, Louisiana State University.

The publisher also gratefully acknowledges the following contributors: Wafaa Bilal, Tracy Chevalier, Mel Chin, Michael Fay, Antony Gormley, David Grove, Zaha Hadid, Zahi Hawass, Mona Hatoum, Hyo-In Kim, Steve McCurry, Melchor Peredo, Martín Ramírez, Colin Rhodes, Howard Risatti, Sonoko Sasaki, Richard Serra, Cindy Sherman, Paul Tacon, Dan Tague, Spencer Tunick, Bill Viola, and Robert Wittman.

Debra J. DeWitte

would like to thank the following for their scholarly assistance: Melissa Bowden, University of Texas at Arlington; Richard Brettell, University of Texas at Dallas; Annemarie Carr, Southern Methodist University; Juilee Decker, Georgetown College; Rita Lasater, University of Texas at Arlington; John McQuillen, University of Toronto; Jenny Ramirez, Virginia Military

Institute; Beth Wright, University of Texas at Arlington; and her warmest thanks go to her family: Bill Gibney, Jaclyn Jean Gibney, and Connie DeWitte.

Ralph M. Larmann

would like to thank the following for their scholarly assistance and support: Ella Combs-Larmann, independent scholar and artist; Dr. Gordon Kingsley, Harlaxton College; Steven Ochs, Southern Arkansas University; Dr. Heidi Strobel, University of Evansville; University of Evansville, Office of Academic Affairs, Office of Alumni Relations, University Library, Department of Art; and for their patience and understanding: Ella, Allison, and Tip.

M. Kathryn Shields

would like to thank the following: Laura M. Amrhein, University of Arkansas Little Rock; Damon Akins, Guilford College; Maria Bobroff, Guilford College; Ingrid Furniss, Lafayette College; Rita Lasater, University of Texas at Arlington; Claire Black McCoy, Columbus State University; Jenny Ramirez, Virginia Military Institute; and express love and gratitude to her family: Barry Bell, Gillian Denise Shields Bell, Alden Emmerich Shields Bell, and Nancy Shields.

Index

Figures in italic refer to pages on which illustrations appear

A-frame construction 481 Abe, Shuya 237

Abelam, the (Papua New Guinea) 373, 374; cult house 364, 374, 374; yam mask 373, 373

Aboriginal rock art 371, 371

Abraham (biblical figure) 316, 324

Abramovic, Marina 242-43; The House with the Ocean View 242, 243

absolute monarchy 398, 523, 524

abstract 59, 66, 113, 136, 137, 163, 203, 205, 218, 219, 259, 338, 366-67, 415, 557, 572, 587

Abstract Expressionism/Expressionists 437-38, 441, 481

abstraction 153-54, 422, 435-36, 450

Academies 34, 35; French 96, 398-99, 400, 410; Royal

Academy, London 404, 411

Acconci, Vito 242; Following Piece 240, 242, 242

Achilles and Ajax Playing Dice (Andokides Painter) 307,

307, 309

acropolis 304, 305; see also Athens; Parthenon

acrylic paints 137, 188, 188, 191

action paintings 241, 437

Adam and Eve (Beckmann) 196, 196

Adam and Eve (Dürer) 196, 196

Adam and Eve (Rembrandt) 197, 197

Adams, Ansel: Sand Dunes, Sunrise-Death Valley National

Monument, California 217, 217

additive colors 92, 93

adobe buildings 275, 275

advertisements 103, 210, 210; see also logos; posters

Aeroplane 1 (Matos) 190, 191

aesthetic 237, 254, 285

Afghan Girl at Nasar Bagh Refugee Camp, Peshawar,

Pakistan (McCurry) 219, 219, 221

Africa 364-65; architecture 368, 368-69, 369; Benin plaque 527, 527; kente 367, 367; map 365; masks 37, 43, 43, 367, 367; notions of beauty 558-59; sculpture 132, 132, 365,

365-66, 366, 369, 369, 472, 472, 487, 487-88, 568-69, 569; spiritual beliefs 472; status symbols 472-73

African Americans 224-25; art 119-20, 120, 436, 436-37, 445, 445-46, 473, 473

afterimage effect 501

Agra, India: Taj Mahal 332, 335, 335-36

aisles 280

ahu'ula cloaks (Hawaiian) 372, 372

Ajanta caves, India: Bodhisattva Padmapani 333, 333

Akhenaten, pharaoh 525; Akhenaten, Nefertiti, and three daughters (relief) 525, 525

Akkadians 298, 299, 474; head of ruler 299, 299

Alberti, Leon Battista: On Painting 86, 87, 379, 509

Alexander, St.: reliquary of the Head of 322, 322-23

Alexander Mosaic (Battle of Issus) 535, 535

Alhazen 86

All the Submarines of the United States of America (Burden) 533, 533-34

Allen, James: The Connectors 53, 55, 55

Along the River during the Qingming Festival (Zhang

Zeduan) 337-38, 338

Altar of Peace, Rome see Ara Pacis Augustae

altarpieces 387

altars 318

alternative media 240-47

Amataerasu Omikami (god) 480

ambulatory 326, 326

Amélie (Jeunet) 234, 234

American Civil War 42, 530, 530, 533

Amitayas mandala (Tibetan Buddhist monks) 126-27, 127

amphora, Greek 307, 307, 309

analogous colors 96, 97, 98-99

analysis of artworks 154; biographical 154, 156-57, 161;

contextual 154, 158-59, 161; feminist 154, 157-58;

formal 154, 159-61, 163; iconographic 154-56, 161; psychological 154, 159

anamorphosis 515

Anasazi, the 359, 360; Cliff Palace, Mesa Verde, Colorado 359, 359-60

ancestor figures, Moai (Easter Island) 372-73, 373

ancestor poles, Asmat (New Guinea) 486-87, 487

Ancestral Spirit Chair (Saar) 473, 473

Andean artworks 348-50, 352; silver llama 352, 352;

textiles 352, 352; see also Chavín, Inca, Moche, Nazca, and Paracas cultures

Andokides Painter: Achilles and Ajax Playing Dice (amphora) 307, 307, 309

Anguissola, Sofonisba 388-89; Portrait of the Artist's Sisters

Playing Chess 389, 389

animation (movies) 111, 232-33, 234

Anthropométries... (Klein) 562, 562

Antoni, Janine: Loving Care 563, 563

Anubis (god) 492, 494

Apollo and Daphne (Bernini) 108, 109

appropriation 270, 588-89

apses 318

aquatints 27, 27-28, 197, 197, 199, 203

aqueducts, Roman 279, 279

Ara Pacis Augustae, Rome 67, 67

arabesques 320, 336

Arabic calligraphy 61, 61, 211, 316, 324

Arbus, Diane 575; Hermaphrodite with a Dog 575, 575 arch construction: corbeled 279; pointed 280, 281, 326,

455, 480; rounded 279, 279, 280, 281; triumphal 312, 312

Archaic period 307, 308, 309

archetypal images 554

architectural orders, Classical 306, 306, 309

architecture 29-30, 274-75, 291; basic construction

methods 276, 278; cast-iron 284-85; Classical see Greece, ancient, and Roman Empire; and engineering 276, 277;

Gothic 130, 254, 281, 281, 285, 315, 327, 454, 455; and

illusionism 513-14; Islamic 148, 324-25, 335-36, 368-69, 480; Mannerist 514; Modernist 285-89, 291, 444-45,

458-59; Neoclassical 30, 404-5; Postmodernist 289, 444,

445; reinforced concrete 288-89; Rococo 399;

Romanesque 280, 281, 315, 325-26; sacred 480-81, 483,

see also Gothic style; steel-frame 285, 287; wooden 282-84; see also arch construction; domes; vaults; and specific

countries

architraves 306, 513, 514, 515 Arles, France: St. Trophime 325, 325

armatures 265-66, 267

Arnolfini Portrait, The (van Eyck) 384, 385, 385

Arnolfo di Cambio: Florence Cathedral 378

Arp, Hans 146; Trousse d'un Da 146, 146

art: definition of 26-29; creators of 30-34; reasons for studying 41-43; value of 34-37

Art Brut 503

Art Dome see Geodesic Dome

"Art for Art's Sake" 584

Art Nouveau 419-20

Artichoke Halved (Weston) 148, 148-49

articulate 288

artifacts 270

artist's books 189

Artist's Studio, The (Daguerre) 218, 218

artivists 191

Ascending and Descending (Escher) 90, 90

Ascent of the Prophet Muhammad on his Steed..., The (miniature) 322, 322

Ashoka, Emperor of India 333

Ashurnasirpal II, of Assyria 299; palace 299, 299-300

Asian Field (Gormley) 272, 272

Asmat ancestor poles (New Guinea) 486-87, 487

assemblages 121, 121, 430, 430-31, 433, 433

Association Mensuelle, L' 200

Assyrians 298, 299-300

astrolabes 496, 498; Safavid 498, 498

astronomy 353, 358, 393, 496-97

asymmetry 125-26, 127, 445

Athens 454-55; Acropolis 304-5, 305, 455; Panathenaic Festival 454; Temple of Athena Nike (Kallikrates) 278,

278; see also Parthenon

Atkins, Anna 214; Halydrys Siliquosa 214, 214

atmospheric perspective 83, 83-84, 379, 416

atrium 459

AT&T logo (Bass) 58, 58

attacks on artworks 546, 547, 548-51

Augustus, Emperor 527; Augustus of Primaporta 527, 527

Australia 370; Aboriginal rock art 371, 371

automatic 51, 146

Automatic Drawing (Masson) 51, 51

Autun, France: Cathedral of Saint-Lazare 30, 494, 494-95

avant-garde 427, 567

Awakening Slave (Michelangelo) 264, 264

axis 69, 126, 282, 326

Aztecs 353, 356, 357, 484; calendar stone (Sun Stone) 497,

497-98; The Dismemberment of Coyolxuahqui 358, 358;

human sacrifice 357, 357-58; The Mother Goddess 358, 358; pictographs 353; pyramids 357, 463, 463; Tlaloc

mask vessel 491, 491–92; Tlazolteotl sculpture 485, 485

Baalbek Bird Cage (Hatoum) 585, 585

Babur, Mughal emperor 140, 140

Baby Blocks (Schapiro) 57, 57

Baby Figure, Olmec 251, 251

Babylon/Babylonians 279, 300; Ishtar Gate 300, 300 background 55, 119, 147, 161, 169, 182, 223, 232, 253, 262,

320

Bacon, Henry 37

Baghdad, Iraq: National Museum 299 Bai-ra-Irrai, Belau 149, 149

Bailey, Xenobia 445; Mothership I: Sistah Paradise's Great

Walls of Fire Revival 445, 445-46 balance 124-25, 127, 161, 391; asymmetrical/dynamic

125-26; radial 126-27; symmetrical 125

Ball, Hugo 430, 430

Balla, Giacomo: Dynamism of a Dog on a Leash 109, 109 ballgames, Mesoamerican 356, 356

balloon framing 283, 283-84

Baltimore album quilts 124, 124

balustrade 510 Bamberg, Germany: Basilica of Vierzehnheiligen

(Neumann) 399, 399

bamboo drawings (Wu Zhen) 176, 176

Bamiyan, Afghanistan: Buddhas 549, 549, 551 Banjo Lesson, The (Tanner) 409, 409

Bank of China, Hong Kong (Pei) 287, 287-88

banner from tomb of Lady Dai (Han Dynasty) 339, 339-40 Banner of Las Navas de Tolosa (Islamic tapestry) 61, 61

Bar at the Folies-Bergère, A (Manet) 517, 517-19

Barney, Matthew: Cremaster cycle 449, 449

Boating Party, The (Cassatt) 98, 98–99 Calling of St. Matthew, The (Caravaggio) 79, 79 Baroque style 186, 377, 393, 398, 477; architecture 289; Boccioni, Umberto: Muscular Dynamism 179, 179; Unique camera obscura 86, 212-13, 213 painting 393, 395, 395, 395-96, 495, 495, see also Camera Obscura Image of the Panthéon in the Hôtel des Forms of Continuity in Space 434, 434 Caravaggio and Gentileschi, Artemisia; sculpture 261, Bochner, Mel: Vertigo 49-50, 50 Grands Hommes (Morell) 213, 213 261-62, 392-93, 393, 475, 475-76 Camera Work (journal) 223 bodhisattvas 333; Bodhisattva Padmapani, Ajanta, India Barricade, rue de la Mortellerie, June 1848, The (Meissonier) Cameraman's Revenge, The (Starewicz) 232-33, 233 333, 333 531, 531, 533 Body Worlds exhibition (Hagens) 500-501 cameras 212, 214; digital 212, 214-15; video 228, 238 base 285 Canaletto (Antonio Canal); The Maundy Thursday Festival bohemians 431 basilica 529 before the Ducal Palace in Venice 48, 49 boldface 206, 207 Basketball Player (Hagens) 500, 501 Cannons (Kandinsky) 428, 428 Bonampak murals, Mexico 356-57, 357 Bass, Saul: AT&T logo 58, 58 canon of proportions 556, 556, 557 Bonheur, Rosa: Plowing in the Nivernais: The Dressing of the Batman (Tagliapietra) 66, 66 canopic jars, Egyptian 302, 302, 494, 495 Vines 150-51, 151 Battle of Issus (mosaic) 535, 535 capitals 285, 306, 307 Book of the Dead (Egyptian papyrus) 492, 492, 494 Battle Scene Hide Painting (Plains Indians) 360, 360-61 capstones 461 Boscoreale, Italy: Villa of Publius Fannius Synistor 508, Baudelaire, Charles 128 Caravaggio, Michelangelo Merisi da 394, 587; The Calling Bauhaus 40,41 of St. Matthew 79, 79; Judith Decapitating Holofernes 394, Botticelli, Sandro 558; The Birth of Venus 558, 558 Bayeux Tapestry 536, 536, 537 Bearden, Romare 436; The Dove 119-20, 120; Three Folk Bourgeois, Louise: Maman 75, 75 Carolina Photojournalism Workshop 211, 211 Brancusi, Constantin 436; Bird in Space 436, 436 Musicians 436, 436-37 Carpenter, Captain Richard: bent-corner chest 259, 259 Branded (Saville) 581, 581-82 Beautiful Woman (Dohan) 559, 559 Carter, Howard 303 Braque, Georges 94, 424-25, 426; Houses at L'Estaque 426, beauty, notions of 557-59 Beckmann, Max: Adam and Eve 196, 196 cartoonists 128 426 cartoons (designs) 168, 168, 183 Breaking Column (Rickey) 271, 271 Bedroom, The (van Gogh) 56, 56 cartoons (movies) 111, 111 Breaking of the Vessels (Kiefer) 541, 541 Beecroft, Vanessa: VB35 563, 563, 565 carving 263, 265 Beever, Julian: Woman in Pool 515, 515-16 "Bridge, The" (movement) 429 Brillo Box (Warhol) 588, 588 Cassatt, Mary 99; The Boating Party 98, 98-99; The Child's Bellows, George: Woodstock Road, Woodstock, New York, Brockville, Ontario: stick-style house 283, 283 Bath 345, 345 1924 51, 51-52 casting 263, 266; lost-wax 266-67, 267; piece mold 338, 339 bronze(s) 266-67, 267; Akkadian 299, 299; Chinese vessels Benin, West Africa 43; brass plaque 527, 527; ivory mask casts 132, 177, 218, 219 125, 125, 339, 339; contemporary 71, 71-72, 154, 154, 43, 43 548, 548–49, 588, 588; Futurist 434, 434; Greek statues catacombs 479; ancient Rome 317, 317, 478-79, 479 Benning, Sadie 236; Flat is Beautiful 236-37, 237 134, 134, 266, 266; Hildesheim doors 471, 471-72; Indian Çatalhöyük, Turkey 296; wall painting 296, 296 Benton, Thomas Hart: The Wreck of the Ole '97 82-83, 83 488, 488; Italian Baroque 392, 392-93; Roman 152, 153 Cataract 3 (Riley) 110, 110 Berlin, Germany: Neue Nationalgalerie (Mies van der cathedrals: Autun, France 30, 394, 394-95; Chartres, France Brooklyn Museum, New York City 39-40 Rohe) 287; Pergamon Museum 300 254, 254-55, 327, 327; Florence, Italy 378, 378; Notre Brown, Joan 186; Girl in Chair 186 Bernhardt, Sarah: portrait (Nadar) 217, 217 Dame, Paris 455, 455 Bernini, Gianlorenzo 393; Apollo and Daphne 108, 109; Brücke, Die ("The Bridge") 429 Bruegel, Pieter, the Elder 386; Hunters in the Snow 146-47, Catholic Church 317, 377, 381, 390, 393, 401, 476 David 392, 393, 393; The Ecstasy of St. Teresa 475, 475-76 cave paintings 204; Cosquer Cave, France 295, 295; 147; Landscape with the Fall of Icarus 138, 138; Bernward, Bishop 471 Lascaux, France 190, 477, 477, 478, 478 Netherlandish Proverbs 386, 386 Beuys, Joseph 113, 241; Coyote, I Like America and America Cellini, Benvenuto: Salt Cellar of Francis I 256, 256 Bruggen, Coosje van see Oldenburg, Claes Likes Me 241, 241-42 Cello Music (Smilack) 502, 503 Brunelleschi, Filippo 87, 379; Florence Cathedral 378, 378 Bible, the 315, 316, 470, 471 cels 233 Bichitr: Jahangir Preferring a Sufi Shaykh to Kings 335, 335 brush and ink drawings 175-76, 176 Buddha (Siddhartha Gautama) 103, 331, 332–33, 340, 343, Cendrars, Blaise 189 Bicycle Wheel (Duchamp) 430, 430-31 472; Bamiyan statues 549, 549, 551; Life of Buddha censorship of art 39-41 Bidri ware huqqa base 143, 143 Center for Maximum Potential Building Systems: model (Gupta period stela) 472, 472; see also Buddhism Big Ten logo (Grivetti) 60, 60 village, Longju, China 291, 291 Buddhism 331, 334, 340; in China 336; in Indian art 332bijinga 344, 344 Central Park Zoo, New York City (Winogrand) 224, 224 Bilal, Wafaa 540; Domestic Tension 540, 540 33, 472, 472; in Japan 282-83, 283, 343, 343, 346 ceramics 33, 248, 250, 250, 259, 572; Aztec 491, 491-92; Bilbao, Spain: Guggenheim Museum (Gehry) 74, 74-75 Bull-leapers (Minoan fresco) 297, 297 Chinese 252, 252; coil method 250, 252; Iznik 100, 100; Bull's Head (Picasso) 270, 270 binder 172, 180, 191 Japanese tea bowls 32, 32, 37, 342, 342; slab method 252-Burden, Chris: All the Submarines of the United States of Bingham, Hiram 353 53; throwing (on wheel) 252; Yoruba 484, 484-85 America 533, 533-34 "bioart" 115 ceramists 248 biographical analysis 154, 156-57, 161 burins 195 Cervantes, Susan 454, 468; Precita Valley Vision 468, 469 Burne-Jones, Edward 208; Works of Geoffrey Chaucer (with Bird in Space (Brancusi) 436, 436 Cézanne, Paul 426, 428; Mont Sainte-Victoire 415-16, 416 Morris) 208, 208 Birren, Faber 103 Burtynsky, Edward 227; Manufacturing #17 227, 227 Chaan Muan, Lord of Bonampak 356-57 Birth of a Nation (Griffith) 230, 230 chairs: Congo 472-73, 473; Ancestral Spirit Chair (Saar) busts 262, 310, 311 Birth of Venus, The (Botticelli) 558, 558 Byzantine Empire 314, 318, 520, 570; art and architecture 473, 473 bis poles, Asmat 486-87, 487 chalk 172; drawings 78, 78-79, 172, 172, 515, 515-16 318-20, 319, 520-21, 521; iconoclasm 550 black-figure vases 309 Champollion, Jean-François 302 Black Letter style 206, 206, 211 Byzantium 314, see Istanbul charcoal 171; drawings 50, 171, 171-72 Black Mountain College, North Carolina 241 Charles V, Holy Roman Emperor 388 Cabinet of Dr. Caligari, The (Wiene) 235, 235 Blake, William 166, 405, 407; Elohim Creating Adam 407, Charlottesville, Virginia: Monticello (Jefferson) 404, 404-5 Cage, John 241; Theater Piece No. 1 241 407 Chartres Cathedral, France 327, 327; stained glass 254, Cahokia, Illinois: Monks Mound 462-63, 463 Blek le Rat (Xavier Prou) 191; David with the Machine Gun 254-55 191, 191 Chaucer, Geoffrey 248; Works (Morris and Burne-Jones) Caillebotte, Gustave 413; Paris Street: Rainy Day 413, 413 Bloch-Bauer, Adele, II: portrait (Klimt) 34-35, 35 Calatrava, Santiago: Quadracci Pavilion, Milwaukee Art Blom, Frans 354 Chavín culture 348, 349, 350; Raimondi Stela 349, 349-50 Museum 289, 289 Blue Dancers (Degas) 415, 415 Calder, Alexander 113; Untitled 113, 113 Chéret, Jules: poster 418, 418 Blue Interior (Tobey) 137, 137 Chevalier, Tracy: Girl with a Pearl Earring 38 calendars 496; Aztec calendar stone 497, 497-98 Blue Man Group 112, 113 Chevrolet logo 207, 207 calligraphy 205; Arabic 61, 61, 211, 316, 324; Chinese 32, Blue Nude II (Matisse) 566, 566 chevron 473 Blue Room, The (Valadon) 142-43, 143 33, 205, 205, 336, 337

Chibinda Ilunga (Chokwe sculpture) 568-69, 569 Chicago, USA 285 Chicago, Judy 572; The Dinner Party 572, 572-73 Chihuly, Dale 255; Fiori di Como 255, 255 Child's Bath, The (Cassatt) 345, 345 childbirth: and art 484-86 Chin, Mel 245; Operation Paydirt 245, 245 China 227, 330, 331; ancestor worship 338; bronze vessels 125, 125, 339, 339; calligraphy 32, 33, 205, 205, 336, 337; chromotherapy 104; Confucianism 331, 336; Daoism 331, 336; ink painting 125-26, 126; landscapes 82, 82, 84, 85, 336-37, 337; literati 337; Mao Zedong portraits 529, 529; map 330; painted banner 339, 339-40; porcelain 252, 252; scroll paintings 82, 82, 84, 85, 336-38, 337, 338, 521, 521; "Terracotta Army" 462, 462; tombs 338, 339 China Monument: Temple of Heaven (Gu) 552-53, 553 Chirico, Giorgio de 431-32; The Melancholy and Mystery of the Street 432, 432 choir (of church) 326, 326 Chokwe people: Chibinda Ilunga 568-69, 569 Chola period: Shiva Nataraja 488, 488 Christ see Jesus Christ Christ in the House of Levi (Veronese) 389, 389-90 Christian Church/Christianity 103, 130, 316-18, 470, 471-72, 474; see also Catholic Church; Eastern Orthodox Church: Protestants Christina's World (Wyeth) 182, 183 Christo and Jeanne-Claude: The Gates Central Park, New York City 456, 457, 457 chromotherapy 104 Church, Frederic Edwin 408; Niagara 408, 408; Twilight in the Wilderness 98, 98 church design 281; aisles 280; altars 318, 319; ambulatory 326, 326; apse 318; central plan 319; choir 326, 326; nave 280, 280 Cimabue: Virgin and Child Enthroned 328, 328 Cincinnati, Ohio: Contemporary Arts Center (Hadid) 290, Circus, The (Seurat) 100, 100-1, 101 Citizen Kane (Welles) 231, 231 CLAMP: Tsubasa RESERVoir CHRoNiCLE 49, 49 Classical (art and architecture) 132, 305, 309, 401, 433 Claude Lorrain: The Tiber from Monte Mario Looking South Claudel, Camille 414; The Waltz 414, 414 clay 248, 250; modeling 265-66 Clement VII, Pope 388, 510 clerestory windows 282 Close, Chuck 516; Fanny/Fingerpainting 516, 516-17; Self Portrait 144-45, 145 Clovis spear points 348 CMYK color 102, 102, 105 Coatlicue 358, 358 Codex Magliabechiano 357, 357 coffered 312 Coffin in the Shape of a Cocoa Pod (Kwei) 93, 93 coffins: Egyptian 26, 26-27, 302; see also sarcophagi coil(ing) method (ceramics) 250, 365 Cole, Thomas 407, 408; The Oxbow 407, 407-8 collages 57, 94, 119-20, 224, 237, 426, 436-37

chiaroscuro 78, 78-79, 91, 379, 584

445; in print 101-2; psychology of 103, 104; revolutionary use of 422; RGB 102, 102, 105; and saturation 95, 95-96, 100; secondary 92, 97; shades of 94; subtractive 92-93; symbolic values 103; and temperature 99, 100; tertiary 97; and value 93-95, 94; vibrating boundaries 97, 97, 110, 110; and see below color field 136, 137 color pencils, drawing with 170, 170 color theory 501 color wheels 92, 93, 96; CMYK 102; RGB 102 Colossal Heads, Olmec 70, 70, 75, 251, 251, 263, 263, 354, 354, 522, 522 Colosseum, Rome 310, 312, 458, 458 columns 285, 513, 513; shafts 285, 306, 307 communicative line 55-56, 56 Communism/Communists 69, 273, 529 community art 454 Company of Frans Banning Cocq and Willem van Ruytenburch, The (The Night Watch) (Rembrandt) 396, complementary colors 96-98, 98, 503 composite view 304, 305, 426 composition 67, 109, 116, 138, 142, 173, 199, 223, 275, 328, 344, 388, 425, 530, 544; and placement of elements 140-41; and unity 116, 116, 117; see also balance; focal point computer games 85, 86, 87 computer-generated art 102-3, 103, 209 concentric shapes 61 conceptual art 49, 174, 240, 243-44, 431, 442-43 conceptual statements 578 conceptual unity 120-21 concrete 458, 459; reinforced 288-89 cone of vision 90, 90 Confucius/Confucianism 103, 331, 336 Congo, Democratic Republic of: kneeling female figure 487, 487-88; Ngombe chair 472-73, 473 Connectors, The (Allen) 53, 55, 55 Conques, France: Sainte-Foy 280, 280 Constantine, Emperor 312, 314, 528; statue of 528, 528-29 Constantinople 314; see also Istanbul Constructed Head No. 2 (Gabo) 269, 269 Constructivism/Constructivists 69, 69, 268-69, 269, 270, Conté crayon 172; drawings 172-73, 173 Contemporary art 422, 443, 448, 449 content 152-54 contextual analysis 154, 158-59, 161 continuous narrative 316, 342, 343, 379 contour drawing 179 contour lines/contours 55, 177, 178, 179, 370, 567 contour rivalry 350, 351 contrapposto 308, 309 contrast 46, 58-61, 140, 142, 172, 203, 207, 254 conventions 557 convex 510 Copernicus, Nicolaus 393 Coplans, John 570; Self-portrait Sideways No. 3 570, 570 Cor-ten steel 467 corbeled arches 279 Corbusier, Le (Charles-Édouard Jeanneret) 286, 287; Villa Savoye, Poissy, France 286, 286-87 Corday, Charlotte 551, 552 Córdoba, Spain: Great Mosque 148, 148 Corinthian order 306, 306, 309, 311 Corn Blue Room (Rickard) 446-47, 447 Cornelia Pointing to Her Children as Her Treasures (Kauffmann) 404, 404, 570 Cornell, Joseph 121; Untitled (The Hotel Eden) 121, 121

Cosby Show 445 Cosquer Cave, France 295; Black horse 295, 295 Count Your Blessings (Schwarz) 256, 257 Counter-Composition V (van Doesburg) 435, 435 Counter-Reformation, the 377, 390 Courbet, Gustave 408; Fox in the Snow 492, 492; Stonebreakers 408, 409 courses, brick 461 Cow with the Subtle Nose (Dubuffet) 503, 503 Cowboys series (Prince) 589, 589 Coyote, I Like America and America Likes Me (Beuys) 241, 241-42 crafts 248, 249, 259 crayon 172; drawings 51-52, 51, 55, 55, 172-73, 173 creation myths 122, 352, 484-85, 496 Creation of Adam (Michelangelo) 381, 381 Creation of the Sun and Moon (Michelangelo) 264, 264 Cremaster cycle (Barney) 449, 449 cropping (of images) 415 "Cross and Carpet" page 320-21, 321 cross-hatching 80, 80, 172-73, 175 Crow, the (group of the Sioux clan) 360 Crystal Palace, London (Paxton) 284, 284-85 Csuri, Charles 102-3; Wondrous Spring 102, 103, 103 Cubi XIX (Smith) 64-65, 65 Cubism/Cubists 94, 118, 275, 425, 426, 427, 429, 433-34, cuneiform writing 298 curators, museum 246-47 cutouts 482, 566 Cut with the Kitchen Knife through the Last Weimar Beer-Belly Cultural Epoch of Germany (Höch) 224, 225 Cycladic sculptures 296, 296 Dada 146, 224, 243, 429-31 Daguerre, Louis-Jacques-Mandé 214; The Artist's Studio 218, 218 daguerreotypes 214, 218 Dalí, Salvador 504; Persistence of Memory 504, 504 Daoism 331, 336 darkrooms, photographic 215, 215 Daumier, Honoré 200; Rue Transnonain 200, 200-201 David (Bernini) 392, 393, 393 David (Donatello) 392, 392, 393 David (Michelangelo) 392, 393, 393 David with the Machine Gun (Blek le Rat) 191, 191 David, Jacques-Louis 403; Death of Marat 551, 551-52; The $Oath\ of\ the\ Horatii\ 400,\ 403,\ 403-4$ Davidson, Carolyn: Nike Company logo 56, 56 Dead Christ (Mantegna) 489, 489 death 484, 487, 489-90; see also human sacrifice; sarcophagi Death of Marat (David) 551, 551-52 De Chirico, Giorgio see Chirico, Giorgio de Defense Worker (Thrash) 199, 199 Degas, Edgar 345, 415; Blue Dancers 415, 415; The Tub 172, Degenerate Art Exhibition (1937) 40, 41 Deir el-Medina, Egypt 30 deities 470, 472, 474 Déjeuner sur l'herbe, Le (Luncheon on the Grass) (Manet) DeJong, Constance, Oursler, Tony, and Vitiello, Stephen: Fantastic Prayers 237, 239, 239

de Kooning, Willem 174; Woman I 554, 555, 555-56

Massacre at Chios 42, 43

Delacroix, Eugène: Liberty Leading the People 405, 405; The

Delaunay, Sonia 189; Prose of the Trans-Siberian Railway

and of Little Jehanne of France 189, 189

colophons 336, 337

color (s) 56, 66, 92, 136, 142, 160, 171, 180, 194, 207, 212,

231, 250, 393, 422; additive 92, 93; analogous 96, 97, 98-

99; CMYK 102, 102, 105; complementary 96-98, 98, 503;

in electronic displays 102-3, 110, 110; and emotions 99,

103, 104, 105; hues 93; intensity of 82–83; and light 92,

92-93; and luminosity 186, 191; neutral 43, 94, 160-61;

optical 100-101, 105; and pigments 92; primary 92, 97,

cornices 285

Demoiselles d'Avignon, Les (Picasso) 425, 425-26, 427 Denon, Vivant: Travels in Upper and Lower Egypt 62 deposition 391 Deposition (Pontormo) 390, 391 depth 160, 270; implied 77, 78, 80, 82, 83, 84, 85, 86, 91 Derain, André: The Turning Road, L'Estaque 96, 96 Deren, Maya, and Hammid, Alexander: Meshes of the Afternoon 236, 236 De Stijl ("The Style") movement 435-36 Destitute Pea Pickers in California. Mother of Seven Children... (Lange) 114, 114 developing films 215, 215 Deventer, Gherard Wessels van: Dutch History Bible 205 Devil Made Me Do It, The (Sauerkids) 53, 53 diagonal lines 344 Diaz, Porfirio 184 Dickson, W. K. see Edison, Thomas didactic 315 digital illustration 209 digital media, interactive 237-38 Dijkstra, Rineke: Mothers series 485, 485-86 Dinner Party, The (Chicago) 572, 572-73 directional line 198, 199 Disasters of War (Goya) 198 Discus Thrower (Discobolos) (Myron) 557, 557 Dismemberment of Coyolxauhqui, Goddess of the Moon (Aztec) 358, 358 Disney (Walt) Pictures: Finding Nemo 111, 111 Disputa (Raphael) 509 dissonance 388 Dix, Otto 40; The War 538, 539, 541; War Cripples (Kriegeskrueppel) 40, 40 Djenné, Mali 368; Great Mosque 368, 368-69 Do the Right Thing (S. Lee) 445 Do Women Have to be Naked to get into the Met. Museum? (Guerrilla Girls) 574, 574 documentary movies 235-36, 239 documentary photography 219, 530-31, 533, 569; see also Lange, Dorothea Doesburg, Theo van 435-36, 439; Counter-Composition V 435, 435 Dogon, the: Kanaga mask 367, 367 Dohan, Kaigetsudô: Beautiful Woman 559, 559 domes 282, 378, 378; coffered 312, 312; geodesic 77, 77; pendentive 282, 282 Domestic Tension (Bilal) 540, 540 Donan, Stanley see Kelly, Gene Donatello 391; David 392, 392, 393 Doric order 306, 306 Doryphoros see Spear Bearer Double Elvis (Warhol) 201, 201-2 Double Indemnity (Wilder) 111-12, 112 Dove, The (Bearden) 119-20, 120 Doyle, Tom 157 Draftsman Drawing a Recumbent Woman (Dürer) 91, 91 drawing 166-67, 177, 179; brush and ink 175-76; chalk 172; charcoal 171-72; color pencil 170; Conté crayon 172–73; contour 179; gesture 179; ink 174; pastel 172; pen and ink 174-75; pencil 169; silverpoint 170 Drawing for Sculpture (with color) (Hepworth) 50, 50–51 "Dreaming," the 371 dry painting see sand painting

drypoint 40, 40, 196, 196, 203

Wheel 430, 430-31; Fountain 243, 270, 270; Nude

Dura Europos, Syria: synagogue 315, 315-16, 317

Descending a Staircase, No. 2434, 434

Dubuffet, Jean 503-4; Cow with the Subtle Nose 503, 503; Suite with 7 Characters (Suite avec 7 Personnages) 51, 51 Eucharist, the 320 Duchamp, Marcel 113, 146, 243, 430, 431, 443, 588; Bicycle

Exodus and Crossing of the Red Sea (Dura Europos fresco) Durand, Asher Brown: Kindred Spirits 84, 84 Durant, Susan 262; Memorial to King Leopold of the Belgians 262, 262 Dürer, Albrecht: Adam and Eve 196, 196; Course in the Art of Measurement... 206, 206; Draftsman Drawing a Recumbent Woman 91, 91; Four Horsemen of the Apocalypse 193, 193-94; The Last Supper 387-88, 388, 391; The Painter's Manual... 206; A Young Hare 189, 189 Dust Storm. Women Take Shelter from Strong Dust-Laden Winds... (McCurry) 220, 220 Dutch History Bible (copied by van Deventer) 205 Dying Lioness (Assyrian relief) 262, 262 Dynamism of a Dog on a Leash (Balla) 109, 109 Eagle Transformation Mask (Kwakiutl) 362, 362 Eakins, Thomas: Portrait of Dr. Samuel D. Gross (The Gross Clinic) 499, 499-500 earthenware 250 earthworks 268, 268, 273; see also mounds, manmade Easter Island 372; Moai ancestor figures 372-73, 373 Eastern Orthodox Church: icons 318, 474-75 Ecstasy of St. Teresa, The (Bernini) 475, 475-76 Edison, Thomas, and Dickson, W. K.: Fred Ott's Sneeze 108, editions (prints) 192, 202 Egypt, ancient 26-27, 30, 132, 300, 526; architecture 278, 278; books of the dead 492, 492; canopic jars 302, 302, 494, 495; chromotherapy 104; coffin painting 26, 26-27; Great Sphinx 63, 63-64, 301, 301, 302; hieroglyphs 204, 204, 302, 302; Palette of Narmer 526, 526–27; pharaohs 301, 302, 525; pyramids 64, 64, 276, 277, 277, 301, 301, 302, 460, 460-61, 493, 493; sculpture 130, 130, 302, 302, 308, 556, 556–57, 575, 575; tomb paintings 183, 304, 304; Tutankhamun's funerary mask 303, 303 Eiffel, Gustave 285 Eiffel Tower, Paris 417-18, 418 Eine Kleine Nachtmusik (Tanning) 131, 131 Einstein, Albert 76, 484, 504 Elderly Peasant, An (Lhermitte) 171, 171-72 elements of art 46, 62, 116, 128, 136, 142, 152, 422, 588 "Elgin Marbles" 307 Eliasson, Olafur: Remagine 271, 271 Elohim Creating Adam (Blake) 407, 407 embroidery 350, 350, 351 Emperor Babur Overseeing his Gardeners, The (Mughal painting) 140, 140 emphasis 79, 136, 140, 141, 150, 159, 169, 207, 280; and subordination 136-38; see also focal point encaustic 180-81, 186, 191; icon 318, 318-19; portraits 181, 181 Encore (Fukuda) 512, 512 engineering: and architecture 276, 277 engraving(s) 195, 196, 196, 203, 401-2, 402, 518 Enlightenment, Buddhist 332-33, 340 Enlightenment, the 498 entablatures 306, 307 entasis 512, 513 Erased de Kooning Drawing (Rauschenberg) 174, 174 Ernst, Max 432-33; Surrealism and Painting 432, 433 Escher, M. C.: Ascending and Descending 90, 90; Sky and Water I 60, 60-61 Este, Isabella d' 34; portrait (Titian) 34, 34 etching(s) 53, 55, 55, 197, 197, 203 Etruscan sarcophagus (from Cerveteri) 266, 266

Evans, Mary: album quilt 124, 124

Ever Is Over All (Rist) 448, 448, 450

Exile, The (Schnabel) 587, 587

316, 317 exonemo: The Road Movie 239, 239 Experiment on a Bird in the Air Pump, An (J. Wright) 498, experimental films 236-37 Expressionism/Expressionists 196, 235, 253, 427-29, 586 expressionistic 393 expressive 171, 186, 211, 227, 267, 288 Eyck, Jan van 185, 385; The Arnolfini Portrait 384, 385, 385; Madonna in a Church 130, 130; The Madonna of Chancellor Rolin 185 facades 49, 67, 126, 149, 289, 311 Fading Away (Robinson) 135, 135 Fairey, Shepard: Obey 58, 59 Fall of the Giants (Giulio Romano) 514, 514 Falling Woman (Fischl) 548, 548-49 Fallingwater, Bear Run, Pennsylvania (F. Wright) 286, 286, False Perspective (Hogarth) 518, 518 Family of Charles IV, The (Goya) 406, 406 Fan Kuan: Travelers among Mountains and Streams 82, 82 Fanny/Fingerpainting (Close) 516, 516-17 Fantastic Prayers (DeJong, Oursler, and Vitiello) 237, 239, Father Damien (Marisol) 71,71-72 Faulkner, William 108 Fauves, the 96, 97 Fay, Michael 538; Storm and Stone 538, 538-39 Favum portraits 181 feather cloaks (ahu-ula), Hawaiian 372, 372 female figurines, prehistoric 554-55 feminism/feminists 568, 572-74; analysis of artworks 154, 157-58 feng shui 288 Fenton, Roger 226; Valley of the Shadow of Death 226, 226 Fertile Crescent 298 fiber art 256-58, 259 Fifth Vision of Hildegard of Bingen, The (illuminated frontispiece) 321, 321-22 figuration 450 figurative 365, 557 figure-ground reversal 61 film noir 77, 112 films see movies fin de siècle 417-19 Finding Nemo (Disney cartoon) 111, 111 Fiori di Como (Chihuly) 255, 255 Fireflies at Uji River (Shonen) 190, 190 firing (ceramics) 365 Fischl, Eric: Falling Woman 548, 548-49 Fisk, Pliny, III 291 fixatives 174 fixing (photography) 212, 213-14, 215 Flack, Audrey: Marilyn Monroe 155, 155-56 Flag (Johns) 502, 502 Flagellation, The (Piero della Francesca) 119, 119 Flat is Beautiful (Benning) 236-37, 237 Flavin, Dan 441-42; Untitled 442, 442 Fleming, Victor: The Wizard of Oz 231, 231-32 flint objects 496 Florence, Italy 262, 379, 392; Brancacci Chapel (Santa Maria del Carmine) frescoes (Masaccio) 379, 379-80; Cathedral 378, 378, 392 Flower Container (Karnes) 252, 252 flying buttresses 280, 281, 327 focal point 69, 136, 138, 139, 140, 141, 147, 161, 173, 379

Following Piece (Acconci) 240, 242, 242

fonts 206, 206-7 Geodesic Dome (Art Dome) (Fuller) 77, 77 Ford Motor Company logo 207, 207 geodesic sphere 77, 77, 78 foreground 67, 119, 146, 161, 173, 183, 217, 395 geometric shapes 57, 57 foreshortening 91, 488, 515 form(s) 62-64, 113, 154, 166, 218-19, 235, 252, 263, 275, 328, 422, 512, 557; geometric 64-65, 74; in relief see relief sculpture; in the round 66; organic 65-66, 74 formal analysis 154, 159-61 format 132 Fort Edward (Wall) 27, 27-28 found images 243 found objects 121, 270, 431, 584, 585 Fountain (Duchamp) 243, 270, 270 Fountain (After Marcel Duchamp: A.P.) (Levine) 588, 588 Four Horsemen of the Apocalypse (Dürer) 193, 193–94 Fox in the Snow (Courbet) 492, 492 Fragonard, Jean-Honoré: The Swing 401, 401 Francesco di Giorgio Martini: studiolo, Ducal Palace, Gubbio 258, 259 Franco, General Francisco 545, 546 Fred Ott's Sneeze (Edison and Dickson) 108, 108 French, Daniel Chester: Lincoln Memorial 37, 37 French Academy of Painting and Sculpture (of Fine Arts) 96, 398-99, 400, 410 frescoes 167, 183, 185, 191, 296, 535; Dura Europos synagogue 315, 315, 316, 317; Minoan 297, 297; restoration of 506, 506-7; Roman 310, 311, 479, 479, 508, 508-9; see also Masaccio; Michelangelo; murals; Raphael Freud, Sigmund 431, 504 friezes 306, 306, 307, 514, 515 Fuii, Mount 346 Fukuda, Shigeo 511-12; Encore 512, 512 Fuller, Loie 418, 418 Fuller, Richard Buckminster: Geodesic Dome (Art Dome) 77, 77 Fundred Dollar Bill Project 245, 245 Funeral of Phocion, The (Poussin) 393, 395, 395 Funeral of St. Bonaventure, The (Zurbarán) 140, 141 Fuseli, Henri 584; The Nightmare 584, 584 Futurism/Futurists 109, 433-34 Gabo, Naum (Naum Pevsner) 269; Constructed Head No. 2 269, 269 gall ink 174 Gallas Rock (Voulkos) 253, 253 Gates, The (Central Park, New York City) (Christo and Jeanne-Claude) 456, 457, 457 Gauguin, Paul 416, 428, 579; The Vision after the Sermon (Jacob Wrestling with the Angel) 416, 416; The Yellow Christ 105, 105 Gautama, Siddhartha see Buddha Ge Zhichuan Moving His Dwelling (Wang Meng) 336-37, Gearon, Tierney 486; Mother Project series 486, 486 Gedö, Ilka: Self-portrait 169, 169 Gehry, Frank: Guggenheim Museum, Bilbao 74, 74-75, 444 geishas 559 Gèlèdé rituals 465, 465 Gemma-Frisius, Rainer: camera obscura 213 gender 568; and art 568-72, 575-77; see also feminism/feminists General Services Administration (GSA) 467 Genghis Khan 335 genres 215, 235, 395, 401 Gentileschi, Artemisia 187, 394, 572, 573, 583; Judith and Her Maidservant with the Head of Holofernes 583, 583; Judith Decapitating Holofernes 139, 139, 187, 187, 394, 394, 573, 573, 583, 583; Self-portrait as the Allegory of

George, Terry: Hotel Rwanda 546, 546 Géricault, Théodore: Raft of the Medusa 542, 543-44 gestalt unity 116, 121-22, 127 gesture drawing 179 Ghana: kente 367, 367 Ghostwriter (Helmick and Schechter) 68, 68 Giacometti, Alberto 565, 567; Man Pointing 567, 567 Giambologna (Giovanni Bologna): Rape of a Sabine 261, 261-62 Giant (Goya) 197, 197 Giotto di Bondone 378; Virgin and Child Enthroned 328, Girl in Chair (Brown) 186, 186 Girl with a Pearl Earring (Vermeer) 38, 38 Girl with Mirror (Lichtenstein) 439, 439 Gislebertus 30; Last Judgment 494, 494-95 Giuliani, Rudolph 39 Giulio Romano: Fall of the Giants 514, 514; Palazzo del Tè, Mantua 514, 514 Giza, Egypt: Great Pyramids 64, 64, 276, 277, 277, 301, 301, 460, 460-61, 493, 493; Great Sphinx 63, 63-64, 301, 301, Glass and Bottle of Suze (Picasso) 426, 426 glassmaking/glassware 66, 66, 253, 253, 255; see also stained glazes/glazing (in oil painting) 186, 385 Global Groove (Paik and Godfrey) 237, 237 Godfrey, John J. see Paik, Nam June Gogh, Vincent van 34, 56, 104, 105, 416; The Bedroom 56, 56; The Night Café 104, 104-5; Self-portrait with Bandaged Ear and Pipe 578–79, 579; Sower with Setting Sun 175, 175; Starry Night 416-17, 417 Going Forth by Day (Viola) 238 Goju-no-To (Five-story Pagoda), Japan 283 gold artworks: Cellini 256, 256; Egyptian 303, 303; Moche 350, *350*; Mycenaean *255*, 255–56 "Golden Rectangles" 134-35 Golden Section, the 134, 134, 135, 135 Good Shepherd (mosaic) 318, 318 Gore, Al 235-36 Gormley, Antony 272, 272; Asian Field 272, 272 Gothic style: architecture 130, 254, 254, 281, 281, 285, 315, 327, 327, 454, 455, 455; stained glass 254, 254-55, 455 gouache paint 50, 188, 189 Goulue at the Moulin Rouge, La (Toulouse-Lautrec) 210, Goya, Francesco: "And There Is No Remedy" (from Disasters of War) 198, 198; Giant 197, 197; The Family of Charles IV 406, 406; The Second of May, 1808 532, 532; The Third of May, 1808 54, 54, 150, 150, 198, 198, 405, 406, 406, 532, 532 graffiti artists 191 Grande Odalisque (Ingres) 157, 157–58 graphic design/designers 55, 60, 204, 206, 588 Graves, Michael 445; Humana Building, Louisville, Kentucky 289, 289; Portland Public Services Building 444, 445 Great Depression, the 199, 216 Great Exhibition (London, 1851) 284-85 Great Serpent Mound, Ohio 267, 267-68 "Great Wave off Shore at Kanagawa, The" (from Thirty-six views of Mount Fuji) (Hokusai) 81, 81, 117, 117, 195, 195, 346, 346 Great Zimbabwe 369, 369 Greco, El (Domenikos Theotokopoulos) 391; Laocoön 391,

Greece, ancient 304; Archaic period 307, 308, 309; architecture 83, 83, 135, 135, 180, 278, 304-6, 454, 513, 513; philosophers 92; sculpture 132, 134, 134, 304, 305, 307, 307, 308, 308, 470, 470-71, 557, 557-58; vases 131, 131-32, 307, 307, 309 Greek Orthodox Church 316 grid 116 Griffith, D. W.: Birth of a Nation 230, 230 Grivetti, Al: Big Ten logo 60, 60 Gross Clinic, The (Eakins) 499, 499-500 ground 100, 171, 417, 435 Grove, David 354 Grünewald, Matthias: Isenheim Altarpiece 387, 387 Gu, Wenda 552; United Nations-China Monument: Temple of Heaven 552-53, 553 Gubbio Ducal Palace, Italy: studiolo (Francesco di Giorgio Martini) 258, 259 Guerin, Jules: Lincoln Memorial murals 37 Guernica (Picasso) 545, 545-46 Guerrilla Girls 573-74; Do Women Have to be Naked to Get into the Met. Museum? 574, 574 Guggenheim, David: An Inconvenient Truth 235-36, 236 Guggenheim Museum, Bilbao (Gehry) 74, 74–75, 444 Guggenheim Museum, New York (F. Wright) 110, 458, 458-59 guilds, medieval 34, 35 Gula, Sharbat: portraits (McCurry) 219, 219, 221 Gutenberg, Johannes 206 gypsum 460, 461 Hadid, Zaha 290; Contemporary Arts Center, Cincinnati, Ohio 290, 290 Hadrian, Emperor 311 Hagens, Gunther von: Basketball Player 500, 501; Body Worlds exhibition 500-501 Hagia Sophia, Istanbul 282, 282, 318 Halydrys Siliquosa (Atkins) 214, 214 Hammid, Alexander see Deren Maya Hammurabi, Stela of 528, 528 Hampton, James 441; The Throne of the Third Heaven of the Nations' Millennium General Assembly 440, 441 Han Dynasty: banner from tomb of Lady Dai 339, 339-40 Hang-Up (Hesse) 156, 156-57 happenings 241 Hardouin-Mansart, Jules: Hall of Mirrors, Palace of Versailles 398, 399 Harlem Renaissance 436 Harnett, William M. 511; The Old Violin 511, 511 Harvest of Death, Gettysburg, Pennsylvania, July 1863 (O'Sullivan) 530, 531, 533 hatching 80, 80, 91, 171, 172-73, 175 Hatoum, Mona 585; Untitled (Baalbek Bird Cage) 585, 585 Hatshepsut 575; Sphinx of 575, 575 Have No Fear, He's a Vegetarian (Heartfield) 431, 431 Hawaii 72, 372; feather cloak 372, 372; war god 265, 265 Hawass, Zahi 303 Hayllar, Edith 87; A Summer Shower 86, 87 Head of a Satyr (Michelangelo) 80, 80 Heads, Olmec see Colossal Heads, Olmec Heads of the Virgin and Child (Raphael) 170, 170 Hearst, William Randolph 231 Heartfield, John 431; Have No Fear, He's a Vegetarian 431, Heiltsuk tribe: bent-corner chest 259, 259 Hellenistic sculpture 308, 309, 309 Helmick, Ralph, and Schechter, Stuart: Ghostwriter 68, 68 Helvetica font 206 Hennings, Emmy 430 Hepworth, Barbara 50; Drawing for Sculpture (with color)

Painting 187, 187

Ise Jingu (Grand Shrine of Ise), Japan 480, 481 Hussein, King of Jordan 323 50, 50-51 Isenheim Altarpiece (Grünewald) 387, 387 Hutu genocide 546 Herculaneum 310 Isfahan, Iran: Madrasa Imami mihrab 324, 324-25; hypostyle halls 278, 279 Here Is New York: A Democracy of Photographs (exhibition) Masjid-i-Shah portal 480, 480 221, 221 Ishtar Gate, Babylon 300, 300 I Like America and America Likes Me (Beuys) see Coyote, I Hermaphrodite with a Dog (Arbus) 575, 575 Like America and America Likes Me Islam/Muslims 61, 103, 316, 331, 335; see also Koran, the; Herschel, John 214 Muhammad, Prophet Icarus (Matisse) 97, 97, 178, 178, 424, 424-25, 482, 483 Hesse, Eva 157; Hang-Up 156, 156-57 Islamic art and architecture 316; Banner of Las Navas do iconic 554 hierarchical scale 130, 130, 298, 299, 304, 324, 325, 526 Tolosa 61, 61; calligraphy 61, 61, 316, 324; huqqa base 143, hieroglyphics/hieroglyphs: Egyptian 204, 204, 302, 302; iconoclasm 550 Maya 353 iconographic analysis 154-56, 161 143-44; kufic script 320, 325; manuscripts 320, 320, 322, 322; mihrabs 324, 324-25; miniature 335, 335; mosque highlights 58, 78, 172 icons 318, 318-19, 474-75, 475, 550, 550, 551 lamp 100, 100; mosques 148, 148, 324, 368, 368-69; Taj Hildegard of Bingen 321; The Fifth Vision of Hildegard of ideal, the 377 idealized 471,557 Mahal 335, 335-36 Bingen 321, 321-22; Scivias (Know the Ways) 321 isometric perspective 84, 85, 86, 537 Hildesheim, Germany: Church of St. Michael's doors 471, identity, in art 571, 573, 585 ideograms 552, 553 Istanbul: Hagia Sophia 282, 282, 318 471-72 Ife, Nigeria: Oni sculpture 132, 132; ritual vessel 484, 484ivory 43 Hill, John 28 Iznik pottery 100, 100 Hill, Holliday, Connors, Cosmopulos agency: Tyco 85; terracotta head 558-59, 559 Iktinos and Kallikrates: Parthenon 135, 135, 305, 305, 513, advertising campaign 210, 210 Jahangir, Mughal emperor 335; Jahangir Preferring a Sufi Hinduism 331, 332; in Indian art 122, 334, 488 Shaykh to Kings (Bichitr) 335, 335 illuminated characters/illuminations 208, 208, 320, 321; see Hine, Lewis Wickes 219; Power House Mechanic Working on Steam Pump 569, 569; Ten Year Old Spinner, Whitnel also manuscripts, illuminated Japan 330, 331-32, 340; architecture 282-83, 283, 342, 342, 480, 481; geishas 559; illusionistic artwork 511-12, 512; illusionism 182, 259, 408, 508; in architecture 511-12, 513-Cotton Mill 219, 219; Work Portraits 569 literature 343; manga 49, 49; map 330; religions 331, 340, 14; in paintings and drawings 508-11, 514-19; in Hip Hop Project (Lee) 589, 589 343, 346; scrolls 343, 343-44, 536-37, 537, 559, 559; sculpture 512 Hiroshige, Ando: "Riverside Bamboo Market, Kyobashi" Imagen de Yagul (Mendieta) 443, 443 shrine panel 343, 343; tea ceremony 32, 32, 37, 340, 342, 141, 141 342; textiles 340, 341; ukiyo-e prints 194, 344, 344, 345; see Hirst, Damien: The Physical Impossibility of Death in the IMAX 228, 229 Mind of Someone Living 269, 269 imitation 162-63; see also appropriation also Hokusai, Katsushika japonisme 345 Immediate Family (Mann) 226 Hitler, Adolf 40, 41, 158, 431 jatakas 333 impasto 186, 417, 503 Höch, Hannah 224; Cut with the Kitchen Knife through the implied line 52-53, 54, 86, 109, 141, 160, 395 Jazz (Matisse) 97 Last Weimar Beer-Belly Cultural Epoch of Germany 224, Jeanne-Claude see Christo implied texture 136, 199 225 Hodgkin, Howard: Interior with Figures 99, 99 Jefferson, Thomas 404; Monticello 404, 404-5; Virginia impression (printmaking) 192 Hogarth, William 401; False Perspective 518, 518; Marriage Impression Sunrise (Monet) 412, 412-13 State Capitol 30, 30 Jerusalem: Dome of the Rock 322, 323, 323-4; mosque Impressionism/Impressionists 99, 234, 344, 345, 411-13, à-la-Mode series 402, 402-3 415, 427, 429 lamp 100, 100 Hokusai, Katsushika 31; "The Great Wave off Shore at Jesus Christ 105, 105, 316, 317, 318, 318-19, 325, 489, 489 Improvisation #30 (Cannons) (Kandinsky) 428, 428 Kanagawa" (from Thirty-six Views of Mount Fuji) 81, 81, Jeunet, Jean-Pierre: Amélie 234, 234 117, 117, 195, 195, 346, 346; Maple Leaves on a River 26, In the Blue (Crest) (Mickett and Stackhouse) 69, 69 in the round 66, 74, 260, 393 Jewish culture 103, 315, 316, 317; and Catacombs, Rome Inca, the 348, 351, 488; Machu Picchu 351, 351, 353; 478, 479; Dura Europos synagogue 315, 315–16, 317 Holocaust, the 541 Johns, Jasper 502; Flag 502, 502 Holt, Nancy 107; Solar Rotary 107, 107 mummified children 488, 488-89; tunic 352, 352 incise, incised (decorative technique) 309 Ionah 317 Holy Virgin Mary, The (Ofili) 39 Inconvenient Truth, An (Guggenheim) 235-36, 236 Journal of a Voyage to the South Seas, A (Parkinson) 370 Holzer, Jenny 109–10; Untitled (Selections from Truisms...) Journey of the Sun God Re, The (Egyptian coffin painting) India 330, 331, 332; architecture 332, 332, 333, 334, 334, 110, 110 Homer, Winslow: Prisoners from the Front 41, 41-43 335, 335-36; Bidri ware huqqa base 143, 143-44; cave 26, 26-27 Joy of Life (Matisse) 423, 423-24 paintings 333, 333; Hinduism 331, 334; map 330; homosexuality 568, 576, 577 Judaism 316 painting 335, 335; sculpture 334, 334-35, 488, 488 Hong Kong: Bank of China (Pei) 287, 287-88 Judd, Donald 441; Untitled 441, 441 Infinity (J. de Rivera) 153, 153 Hopi, the 360; kachinas 490-91, 491 Judith and Her Maidservant with the Head of Holofernes Ingres, Jean-Auguste-Dominique: Grande Odalisque 157, Hopkins, Roger 460 (Gentileschi) 583, 583 Hopper, Edward: Nighthawks 159, 159 Judith Decapitating Holofernes (Caravaggio) 394, 394 Horse in Motion, The (Muybridge) 229, 229-30 inks 174; brush and ink drawing 175-76; paintings 125-26, Judith Decapitating Holofernes (Gentileschi) 139, 139, 187, Hotel Rwanda (George) 546, 546 126, 189-90; see also pen and ink drawings 187, 394, 394, 573, 573 inlay 487 House (Whiteread) 71,71 Julie (Dijkstra) 485, 485-86 House with the Ocean View, The (Abramovic) 242, 243 Inquisition, the 390 Julius II, Pope 381, 388; tomb (Michelangelo) 264-65, 265 insanity and art 104, 416, 503-4, 505 Houser, Allan: Reverie 154, 154 installations 110, 110, 111, 240, 246, 246-47, 533, 533-34, Jurisprudence (Raphael) 509 Houses at L'Estaque (Braque) 426, 426 Justinian I, Byzantine Emperor 318, 319, 320, 520; Houston, Texas: Rothko Chapel 481, 481, 483 584; human bodies as 562, 564, 564-65, 565; and identity Justinian mosaic 520-21, 521 Hudson River School 407 446, 446-47, 447; mixed-media 450, 450; and multiculturalism 445, 445-46; in public spaces 457, 457; hues 92, 93 sculptural 273, 273, 585, 585; video 448, 448, 450 Kaaba, Mecca 324, 324 human body: and notions of beauty 557-59; and Kabakov, Ilya and Emilia: The Man Who Flew into Space Insurrection! (Our Tools Were Rudimentary, Yet We Pressed performance art and installations 562-65; see also nudes On) (Walker) 247, 247 from His Apartment 273, 273 Human Condition, The (Magritte) 519, 519 kachina dolls, Hopi 490-91, 491, 587 human sacrifices 357, 357-58, 463, 488, 488-89 intaglio printmaking 192, 195-97, 199, 203 Kahlo, Frida 579; The Two Fridas 579, 579 Humana Building, Louisville, Kentucky (Graves) 289, 289 intarsia 259 intensity, color 83 Kallikrates: Parthenon (with Iktinos) 135, 135, 305, 305, humanism 376-7, 509 513, 513; Temple of Athena Nike 278, 278 interior design 118, 118 Hummingbirds, The (Lostutter) 129, 129 Interior with Figures (Hodgkin) 99, 99 Kamehameha, King of Hawaii 372 Hunefer (scribe) 492, 494

Interregnum (Hung Liu) 186, 186, 188

Ionic order 306, 306

Irascibles, the 202-3

Hung Liu 186; Interregnum 186, 186, 188

Hungry Tigress (Asuka period) 343, 343

Hunters in the Snow (Bruegel the Elder) 146-47, 147

kami 331, 340, 480

Kandariya Mahadeva temple, Khajuraho, India 334, 334-

Kandinsky, Vasily 92, 428; Improvisation #30 (Cannons) 428, 428 kaolin 250, 251 Karatsu ware 32, 32 Karnak, Egypt: Temple of Amun-Re 130, 130, 278, 278 Karnes, Karen: Flower Container 252, 252 Kauffmann, Angelica 404; Cornelia Pointing to Her Children as Her Treasures 404, 404, 570 Kauffmann House see Fallingwater Kearny, Lawrence 372 Kelly, Gene, and Donan, Stanley: Singin' in the Rain 232, 232 kente (West African textile) 367, 367 Kepler Underneath 1 (Strauss) 203, 203 Khafre, pharaoh 302; Pyramid of see Giza: Great Pyramids; statue 302, 302, 308 Khajuraho, India: Kandariya Mahadeva temple 334, 334-Khufu, Pyramid of see Giza: Great Pyramids Kiddo (Yeoh) 209, 209 Kiefer, Anselm 541; Breaking of the Vessels 541, 541 Kim, Hyo-In 249; To Be Modern #2 249, 249 Kindred Spirits (Durand) 84, 84 kinetic art/sculpture 112, 113, 115, 270-71, 289, 431 Kirchner, Ernest Ludwig 428; Street Berlin 428-29, 429 Kiss, The (Klimt) 418, 419 Kiss, The (Rodin) 414, 414 Klein, Yves 562; Anthropométries... 562, 562 Klimt, Gustav 35, 419; Adele Bloch-Bauer 34-35, 35; The Kiss 418, 419 Knossos, Crete: Bull-leapers fresco 297, 297; Palace 183, 296-97, 297 Koetsu, Hon'ami: teabowl 342, 342 Kollwitz, Käthe: Self-portrait in Profile to Left 171, 171 Kooning, Willem de see de Kooning, Willem Koons, Jeff: Rabbit 31, 31 korai 308 Koran, the 61, 316, 320, 320, 321, 324, 325 Kosuth, Joseph 442; One and Three Chairs 442, 443 kouros 308, 308, 309 Kruger, Barbara 243; Untitled (Your Gaze Hits the Side of My Face) 243, 243 Kyoto, Japan: Taian teahouse 342, 342

Ku Klux Klan 230 kufic script 320, 325 Kwakiutl, the 361-62 Kwei, Kane: Coffin in the Shape of a Cocoa Pod 93, 93

Labbo, Sheikh Amadou 368 Lady's Death, The (Hogarth) 402, 402-3 La Farge, Oliver 354 Lakota, the (group of the Sioux clan) 360 lamassu 299, 299

Lambert, Ron 115; Sublimate (Cloud Cover) 115, 115 Lamentation over the Dead Christ, The (Mantegna) 91, 91 Landscape with the Fall of Icarus (Bruegel the Elder) 138,

landscapes: American 98, 98, 407, 407-8, 408; Chinese 82, 82, 84, 85, 336-37, 337; Claude Lorrain 176, 176; photographic 217

Lange, Dorothea 114; Destitute Pea Pickers in California. Mother of Seven Children... 114, 114; Migrant Mother 114, 114, 216, 216, 547, 547, 570, 570

Lao Zi 331

Laocoön (El Greco) 391, 391, 393 Laocoön and his Sons (Hellenistic sculpture) 309, 309 lapis lazuli 298, 298, 299, 465 Lascaux Caves, France: paintings 191, 477, 477, 478, 478 Last Judgment (Gislebertus) 494, 494-95

Last Judgment (Michelangelo) 381, 383, 383, 507, 507 Last Supper, The (Dürer) 387-88, 388, 391 Last Supper, The (Leonardo) 380, 380-81, 391 Last Supper, The (Tintoretto) 390, 390-91 latitude 498 La Venta, Mexico 355; altar 476, 476-77; see also Olmecs layout design 210 Lee, Nikki S.: Projects series 589, 589 Lee, Spike: Do the Right Thing 445 LEED (Leadership in Energy and Environmental Design)

Leonardo da Vinci 32, 37, 166, 380, 383, 496; The Last Supper 380, 380-81, 391; Mona Lisa 32, 33; studies of the foetus in the womb 166-67, 167; wing of a flying machine

Leopold I, King of the Belgians 262

letterforms 206

levering blocks 460, 461, 461

Levine, Sherrie 588; Fountain (After Marcel Duchamp: A.P.)

Lévy-Dhurmer, Lucien: The Wisteria Dining Room 420,

Lhermitte, Léon Augustin 171; An Elderly Peasant Woman 171, 171-72

Liberty Leading the People (Delacroix) 405, 405 Libyan Sibyl, The (Michelangelo) 183, 183; Studies for the Libyan Sibyl 172, 172

Lichtenstein, Roy 439; Girl with Mirror 439, 439 life drawing 177 Life Magazine 241

Light Prop for an Electric Stage (Moholy-Nagy) 271, 271 Lin, Maya: Vietnam Veterans Memorial 552, 552

Lincoln, Abraham: Memorial statue (French) 37, 37

Lindisfarne Gospels 320-21, 321

line(s) 46, 140, 166; actual 53, 54, 86, 141; communicative 55-56; contour 55, 177, 178, 179, 370, 567; definition and functions 47, 49; diagonal 55, 56, 56, 140, 344; directional 53-55; horizontal 56, 56; implied 52-53, 54, 86, 109, 141, 160, 395; regular and irregular 49-52; vertical 55, 56, 56; see also outline(s)

linocuts 193

lintels 324, 325, 325, 494-95, 523, 523 lithography 192, 199-201, 200, 203, 210, 210

llama, Andean silver 352, 352

logos 207, 211; AT&T 58, 58; Big Ten 60, 60; Chevrolet 207, 207; Ford 207, 207; Nike 56, 56

London 403; Crystal Palace (Paxton) 284, 284-85; Great Exhibition (1851) 284-85; Royal Academy 404, 411

Longju, China: model village (Center for Maximum Potential Building Systems) 291, 291

Lorrain, Claude see Claude Lorrain

Los Angeles: Watts Towers (Rodia) 29, 29

lost-wax casting 266-67, 267

Lostutter, Robert 129; The Hummingbirds 129, 129 Louis XIV, of France (the "Sun King") 398, 400, 419, 524;

portrait (Rigaud) 524, 524

Louis XVI, of France 404, 525

Louisville, Kentucky: Humana Building (Graves) 289, 289 Louvre, Paris 189, 398, 405, 419, 419

Lovers in an Upstairs Room (Utamaro) 194, 194

Loving Care (Antoni) 563, 563

Lucas, George: Star Wars 233-34, 234

luminosity 186, 191

Luncheon of the Boating Party (Renoir) 234

Luncheon on the Grass (Le Déjeuner sur l'herbe) (Manet) 410, 410

Lutherans 388

Lux, Loretta 222; The Waiting Girl 222, 222

lyres 465; Sumerian 464, 464-65

McCurry, Steve 220; Afghan Girl at Nasar Bagh Refugee Camp, Peshawar... 219, 219, 221; Dust Storm. Women Take Shelter from Strong Dust-Laden Winds... 220, 220; Sharbat Gula... 219, 221

Machu Picchu, Peru 351, 351, 353

Madonna in a Church (van Eyck) 130, 130

Madonna of Chancellor Rolin, The (van Eyck) 185 maghribi script 320

Magritte, René: The Human Condition 519, 519; The Treachery of Images ("This is not a pipe") 76, 76, 431 Maids of Honor, The (Velázquez) see Meninas, Las

Maki, Fumihiko: New World Trade Center, New York City 274, 274-75

Male and Female (Pollock) 586-87, 587

Malevich, Kazimir 435; Suprematist Painting (Eight Red Rectangles) 435, 435

Mali, Africa: architecture 368, 368-69

al-Malik, Caliph Adb 323

Maman (Bourgeois) 75, 75

Man, Controller of the Universe (Rivera) 468, 468

Man Pointing (Giacometti) 567, 567

Man Who Flew into Space from His Apartment, The (I. and E. Kabakov) 273, 273

mandalas 126-27, 127, 333

Mandan, the 360, 361; robe 360, 360-61

Manet, Édouard 410; A Bar at the Folies-Bergère 517, 517-19; Le Déjeuner sur l'Herbe (Luncheon on the Grass) 410, 410; Olympia 560-61, 561

manga 49, 49

Mann, Sally: Immediate Family 226; The New Mothers 226, 226

Mannerism/Mannerists 377; architecture 514, 514; painting 388-89, 389, 390, 391, 391, 393

Mantegna, Andrea 489; ceiling of Camera degli Sposi 510, 510; Dead Christ 489, 489; The Lamentation over the Dead Christ 91, 91

mantles 351; Paracas 350, 350

Mantua, Italy: Camera degli Sposi, Ducal Palace (Mantegna) 510, 510; Palazzo del Tè (Giulio Romano)

Manufacturing #17 (Burtynsky) 227, 227

manuscripts 35, 320; Franco-German 52, 53; illuminated 205, 205, 206, 320–21, 321, 384; Islamic 320, 320, 322, 322

Mao Zedong 188; portraits 528, 529, 529

Maori, the: tattoos 370, 370, 372

Maple Leaves on a River (Hokusai) 26, 28

Mapplethorpe, Robert 576; Self-portrait (#385) 576, 576-

Marat, Jean-Paul 551, 551-52

Marc, Stephen 224; Untitled-Passage on the Underground Railroad 224-25, 225

Marcus Aurelius, equestrian statue of 152, 153

Marevna, Marie (Marie Vorobieff-Stebelska) 118; Nature morte à la houteille 118, 118–19

Marie Antoinette, Queen 525, 552; Marie Antoinette and Her Children (Vigée-Lebrun) 524, 525

Marilyn Monroe (Flack) 155, 155-56

Marinetti, Filippo 434

Marisol (Maria Sol Escobar): Father Damien 71,71-72 Marriage à-la-Mode series (Hogarth) 402, 402-3

Marriage Settlement, The (Hogarth) 402, 402

Martini, Pietro Antonio: The Salon 400, 400

Masaccio: Brancacci Chapel frescoes 379-80; Tribute

Money 379, 379; Trinity 88, 88

Mask II (Mueck) 512, 512-13

mask(ing) 190, 201

masks 465; Abelam yam masks 373, 373; Benin ivory mask 43, 43; Eagle Transformation Mask (Kwakiutl) 362, 362; funerary mask of Tutankhamun 303, 303; Gèlèdé 465,

111-12 Agamemnon" (Mycenaean) 255, 255-56 Berlin 287 Moulin de la Galette (Renoir) 412,413 Migrant Mother (Lange) 114, 114, 216, 216, 547, 547, 570, masquerades 465 mounds, manmade 459; Great Serpent Mound, Ohio 267, 570 mass 62, 68, 70-72, 265 mihrabs 324, 324-25 267-68; Monks Mound, Cahokia, Illinois 462-63, 463; Massacre at Chios, The (Delacroix) 42, 43 tomb of Qin Shi Huangdi 462, 462 Milan, Italy: The Last Supper (Leonardo), Santa Maria delle Masson, André 51; Automatic Drawing 51, 51 movies: animated 232-33; black-and-white 230-31; color Grazie 380, 380-81 Master of Osservanza, workshop of the: The Meeting of St. 231-32; contemporary 447-48, 449; documentary 235-Millais, John Everett: Ophelia 411, 411, 417 Anthony and St. Paul 106, 106-7 Milwaukee Art Museum, Wisconsin: Quadracci Pavilion 36, 239; experimental 236-37; horror 235; IMAX 228, Matisse, Henri 97-98, 179, 422-23, 424, 425, 482, 566; Blue (Calatrava) 289, 289 229; propaganda 158-59; silent 230; and special effects Nude II 566, 566; Chapel of the Rosary 482, 482-83; 233-34 Icarus (from Jazz) 97, 97, 178, 178, 424, 424-25, 482, 483, mime 113 Mozi 86 minarets 324, 336, 368, 369 566, 566; Joy of Life 423, 423-24; The Red Studio 424, 424; Ming Dynasty (China): porcelain flask 252, 252 Mueck, Ron 512; Mask II 512, 512-13 Woman Seated in an Armchair 178, 178, 179 Mughal Empire 335-36; gardens 140 Matos, John (a.k.a. "Crash") 191; Aeroplane 1 190, 191 Minimalism/Minimalists 441; installations 441-42, 442; sculpture 441, 442, 466, 466-67 Muhammad, Prophet 316, 322, 322, 323, 324, 331 Maundy Thursday Festival before the Ducal Palace in Venice, multiculturalism 445 Mining the Museum (Wilson) 246, 247 The (Canaletto) 48, 49 Mumtaz Mahal 335-36 Maya, the 353, 356-57, 496-97; ballgame 356, 356; flint Minoan civilization 296-97 Miró, Joan: Object 433, 433 Munch, Edvard: The Scream 586, 586 sculpture 496-97, 497; hieroglyphs 349, 353; pyramids Mistos (Match Cover) (Oldenburg and van Bruggen) 129, mugarnas 480, 480 276, 276; sarcophagus 490, 490; stela 67, 67; temple lintel Muqi: Six Persimmons 125-26, 126 523, 523, 525; vessel 356 Mural (Pollock) 437, 437 Miyazaki, Hayao: Spirited Away 233, 233 meaning see content murals 37; Mayan 356-57, 357; Mexican 184, 184-85, 467-Moai ancestor figures (Easter Island) 372-73, 373 Mecca, Saudi Arabia 324, 325, 331, 498; Kaaba 324, 324 68, 468; see also frescoes medieval 31, 314-15 mobiles 113, 113 Murasaki Shikibu: Tale of Genji 343, 343-44 Moche culture 348, 350; earspool 350, 351 medium (plural media) 27, 80, 102, 106, 116, 169, 180, 204, modeling 265-66, 393 Muscular Dynamism (Boccioni) 179, 179 228, 240, 248, 273, 380, 437, 465, 483, 517, 537, 546, 572 Museo del Prado 7 (Struth) 163, 163 Modernism/Modernist 285, 422, 437; architecture 285-89, Meeting of St. Anthony and St. Paul, The (workshop of the museums 29, 37, 74, 74-75; curators 246-47 444-45; sculpture 565, 567, see also Rodin, Auguste Master of Osservanza) 106, 106-7 Music—Pink and Blue II (O'Keeffe) 59, 59-60 Modersohn-Becker, Paula 428; Self-portrait with Camellia Megerle, Birgit: Untitled 170, 170 Meissonier, Ernest: Remembrance of Civil War, 1848 (The Muslims: in Spain 498; see Islam; Islamic art and 428, 428 Barricade, rue de la Mortellerie, June 1848) 531, 531, 533 Moget, Mark see Sauerkids Muybridge, Eadweard: The Horse in Motion 229, 229–30 Melancholy and Mystery of the Street, The (de Chirico) 432, Moholy-Nagy, László 270–71; Light Prop for an Electric Mycenae/Mycenaeans 279, 297; "Mask of Agamemnon" Stage 271, 271 255, 255-56 Mona Lisa (Leonardo) 32, 33, 438, 439 Melanesia 370; see Papua New Guinea Myron: Discus Thrower (Discobolos) 557, 557 Méliès, Georges 230; A Trip to the Moon 230, 230 Mondrian, Piet 435 Monet, Claude 345; Impression Sunrise 412, 412-13 Melissa & Lake, Durham, North Carolina (Opie) 577, 577 Monks Mound, Cahokia, Illinois 462-63, 463 Nadar (Gaspard-Félix Tournachon) 217; Sarah Bernhardt Memorial to King Leopold of the Belgians (Durant) 262, 262 memorials 551-53 monochromatic 94, 562 Namuth, Hans: Pollock painting in studio 437 Monogram (Rauschenberg) 123, 123 Mendieta, Ana 443; Silueta Works in Mexico series 443, 443 Nara, Japan: Horyu-ji (Horyu Temple) 282-83, 283, 343, monoliths 295, 369, 369 Meninas, Las (Picasso) 162, 162-63 monoprints/monotypes 192, 202, 202-3, 203 Meninas, Las (Velázquez) 159-62, 160, 161, 406 Naram-Sin, Akkadian king 299; Stela of 474, 474 Mont Sainte-Victoire (Cézanne) 415-16, 416 Menkaure, pharaoh: Menkaure and His Wife, Queen Monticello, Charlottesville, Virginia (Jefferson) 404, 404-5 Narmer, Palette of 526, 526-27 Khamerernebty (Egyptian sculpture) 556, 557; Pyramid parrative 227, 401, 433, 541 of see Giza: Great Pyramids Monument to the Third International (Tatlin) 69, 69 monumental scale/monumentality 128, 267, 276, 435 National Gallery of Art, Washington, D.C. 113, 113 Merwyn, Emily: web design 211 Mesa Verde, Colorado: Anasazi Cliff Palace 359, 359–60 Moore, Henry 565, 567; Recumbent Figure 567, 567 Native Americans 216, 359; Anasazi Cliff Palace, Mesa Meshes of the Afternoon (Deren and Hammid) 236, 236 Morell, Abelardo: Camera Obscura Image of the Panthéon in Verde, Colorado 359, 359-60; Great Serpent Mound, Ohio 267, 267–68; Hopi kachinas 490–91, 491; Kwakiutl the Hôtel des Grands Hommes 213, 213 Mesoamerica 353; map 353 Morgue (Gun Murder), The (Serrano) 489, 489-90 masks 361-62, 362; Monks Mound, Cahokia, Illinois Mesopotamian civilizations 298-300 462-63, 463; Navajo sand paintings 465, 465; Plains Morimura, Yasumasa: Portrait (Futago) 561, 561 metalwork 255; aluminum 113, 113; brass 436, 436, 527, Moronobu, Hishikawa: Papermaking in Japan 177, 177 Indians Battle Scene Hide Painting 360, 360-61; tipis 360; 527; casting bronze 266-67, 267, see also bronze(s); gold 255, 255–56, 256, 303, 303, 350, 350; stainless steel 31, 31, Morris, William 208; Works of Geoffrey Chaucer (with Tlingit blanket 258, 258; see also Rickard, Jolene Burne-Jones) 208, 208 naturalism/naturalistic 181, 189, 190, 361, 379, 422 64-65, 65, 153, 153, 441, 441 metopes 306, 307, 307 mosaics 318; Alexander Mosaic (Battle of Issus) 535, 535; nature, in art 490 Nature morte à la bouteille (Marevna) 118, 118-19 Byzantine 318, 318, 319, 319–20, 520–21, 521; Roman 307 mezzotints 199, 199, 203 Moser-Katz, Seth: web design 211, 211 Nauman, Bruce 243-44; The True Artist Helps the World by Michals, Duane: The Return of the Prodigal Son 580-81, Revealing Mystic Truths... 244, 244 Moses (biblical prophet) 315, 316 581 Michelangelo Buonarroti 260, 264, 309, 377, 380, 383; Moses (Michelangelo) 264-65, 265 Navajo sand paintings 465, 465 naves 280, 280, 318, 454 mosque lamp (Iznik pottery) 100, 100 Awakening Slave 264, 264; Creation of Adam 381, 381; mosques 324, 480; Great Mosque, Córdoba 148, 148; Great Nazca culture: Nazca Lines, Peru 46-47, 47 Creation of the Sun and the Moon 264, 264; David 392, Mosque, Djenné 368, 368–69; Madrasa Imami, Isfahan Nazis/National Socialism 35, 40-41, 158, 158-59, 241, 431, 393, 393; Head of a Satyr 80, 80; The Last Judgment 381, 324, 324-25; Masjid-i-Shah, Isfahan 480, 480 381, 383, 383, 507, 507; The Libyan Sibyl 183, 183; Moses Nebamum, tomb of (Thebes): fowling scene 304, 304 (from tomb of Julius II) 264–65, 265; Studies for the Mother Goddess, Coatlicue (Aztec) 358, 358 Nebuchadnezzar II, of Babylon 300 Libyan Sibyl 172, 172; Sistine Chapel ceiling 172, 264, 264, Mother Project series (Gearon) 486, 486 necropolis 351 Mothers series (Dijkstra) 485, 485-86 381, 381, 383, 506, 506-7 Mothership I: Sistah Paradise's Great Walls of Fire Revival Nefertiti 525, 525 Mickett, Carol, and Stackhouse, Robert: In the Blue (Crest) negative, film 212 (Bailey) 445, 445-46 69,69 negative space 58-61, 136, 289 motifs 125, 143-45, 339, 361, 504; see also iconographic Micronesia 370 Neoclassicism 403; in architecture 30, 30, 404, 404-5; in

motion 106, 108; actual 112-13; illusion of 109-10;

Mies van der Rohe, Ludwig 287; Neue Nationalgalerie,

465; Kanaga mask (Dogon) 367, 367; "Mask of

Middle Ages 314-15

middle ground 146

implied 108-9; and photography 228-30; stroboscopic

painting 403, 403-4, 404

Rokeby Venus (Velázquez) 548, 548 Roman Catholic Church see Catholic Church Roman Empire 295, 314, 528; ancestor busts 310; aqueducts 279, 279; architecture 132, 147, 279, 280, 309-10, 311, 311-12, 312; encaustic portraits 181, 181; frescoes 310, 311; sculpture 310, 310, 527, 527; see also Romanesque style: architecture 280, 280, 281, 315, 326, 326; sculpture 325, 325, 494, 494-95 Romanticism 405-8 Rome 309, 310, 314, 388; Ara Pacis Augustae 67, 67; Arch of Constantine 312, 312; Catacombs 317, 317, 478-79, 479; Colosseum 310, 312, 458, 458; equestrian statue of Marcus Aurelius 152, 153; Pantheon 311, 311-12, 312; statue of Constantine 528, 528-29; see also Vatican City Rosetta Stone 302 Rosie the Riveter (Rockwell) 209, 209 Rothko, Mark 438; Rothko Chapel, Houston, Texas 481, 481, 483; Untitled 438, 438 Royal Academy of Arts, London 404, 411 rubbings 205, 205 Rubens, Peter Paul 395; The Raising of the Cross 395, 395-Rue Transnonain (Daumier) 200, 200-201 rulers in art 520-29 Ruskin, John 215, 586 Russian art: abstract 428, 428; Constructivist 69, 69, 268-69, 269; Cubist 118, 118-19; icons 474-75, 475; installation sculpture 273, 273; Suprematist 435, 435 Saar, Betye 473; Ancestral Spirit Chair 473, 473 sacred places 477–83; see also church design 318-19, 550 285

sacrifice (in art) 487-89 Safavid Empire: astrolabe 498, 498 St. Alexander, Reliquary of the Head of 322, 322-23 St. Catherine Monastery, Mount Sinai, Egypt: icons 318, Saint-Denis, Abbey Church of, nr Paris 280-82, 281 Sainte-Foy, Conques, France 280, 280 St. Louis, Missouri: Wainwright Building (Sullivan) 285, St. Sernin, Toulouse, France 326, 326, 327 St. Trophîme, Arles, France 325, 325 Salon, The, Paris 400, 401, 411, 531 Salon, The (Martini) 400, 400 Salon des Refusés, Paris 410 salons 427 Salt Cellar of Francis I (Cellini) 256, 256 San Lorenzo, Mexico: Olmec head 34, 354 Sanchi, India: Great Stupa 332, 333 Sand Dunes, Sunrise—Death Valley National Monument, California (Adams) 217, 217 sand paintings 465; Navajo 465, 465; Tibetan 126–27, 127 sans serif 206, 207 Santiago de Compostela, Spain 280 sarcophagi (sing. sarcophagus) 301; Etruscan (from Cerveteri) 266, 266; Maya 490, 490 Sargon, Akkadian King 299 sarsen stones 456, 457 Sasaki, Sonoko 340, 341, 342; Sea in the Sky 340 satire 518, 518, 519

Sauerkids (Mark Moget and Taco Sipma): The Devil Made

hierarchical 130, 130, 298, 299, 304, 324, 325, 526; and

scale 62, 128, 135, 163, 180, 223, 379; distorted 131;

meaning 128-29; monumental 128, 267, 276, 435 Schapiro, Miriam: Baby Blocks 57, 57 Schechter, Stuart see Helmick, Ralph Schiele, Egon; Portrait of the Artist's Wife, Standing, with Hands on Hips 55, 55 Schnabel, Julian 587; The Exile 587, 587 School of Athens, The (Raphael) 88, 89, 89, 132, 133, 133, 167, 168, 168, 381, 382, 383, 507, 509, 509 Schröder House, Utrecht (Rietveld) 444, 445 Schwarz, Tilleke 257; Count Your Blessings 256, 257 science: and art 166-67, 496-501; of perception 501-3 science-fiction films 233-34, 235 Scientific American (magazine) 230 Scivias (Know the Ways) (Hildegard of Bingen) 321 Scream, The (Munch) 586, 586 sculpture 260, 273; abstract 436; additive methods (casting, modeling) 263, 265-67; Akkadian 299; Asmat 486-87; assemblages 430-31, 433; Assyrian 299-300; Aztec 358, 485; Baroque 261-62, 392-93, 475-76; Buddhist 549, 549, 551; constructing 268-69; Cycladic 296; freestanding (in the round) 260-62; Futurist 434; Hellenistic 308, 309; in installations 272, 273; kinetic 113, 270-71, 289, 431; light 271; Maya 496-97, 497; medieval(German) 65, 65; Minimalist 441-42; modern 50-51, 410, 414, 436, 565, 567; Pop art 588, 588; prehistoric 296, 554-56; Renaissance 264-65, 392-93; 17th-century Italian 108; subtractive methods (carving) 263, 264, 265; Toltec 534-35; Yoruba 132, 366; see also Olmecs; relief sculpture; and under specific countries Sculpture of the Lady Sennuwy (Egyptian) 261, 261 Sea in the Sky (Sasaki) 340, 341 Seated Figure (Zapotec culture) 250, 250, 252 Second of May, 1808, The (Goya) 532, 532 Self (Quinn) 39, 39 self-portraits 427, 578-82; Close 144-45, 145; Gedö 169, 169; Rembrandt 36, 36; and see below Self-portrait as the Allegory of Painting (Gentileschi) 187, Self-portrait in a Convex Mirror (Parmigianino) 510-11, Self-portrait in Profile to left (Kollwitz) 171, 171 Self-portrait (#385) (Mapplethorpe) 576, 576–77 Self-portrait Sideways No. 3 (Coplans) 570, 570 Self-portrait with Bandaged Ear and Pipe (van Gogh) 578-79, 579 Self-portrait with Camellia (Modersohn-Becker) 428, 428 Self-portrait with Saskia in the Scene of the Prodigal Son in the Tavern (Rembrandt) 580, 580 Sen no Rikyu 342; Taian teahouse 342, 342 Senefelder, Alois 199 Senufo people 472; mother-and-child figure 472, 472 serifs 206, 206 Serra, Richard 466; Tilted Arc 466, 466-67 Serrano, Andres: The Morgue (Gun Murder) 489, 489-90 Seurat, Georges 100, 501; The Circus 100, 100-101, 101; Sunday on La Grande Jatte 501, 501-2; Trees on the Bank of the Seine 172-73, 173 sfumato 380 shading 411 shafts (of columns) 285, 306, 307 Shah Jahan 335, 336 shamans 350, 465, 477 Shang Dynasty 338; ritual container 125, 125; ritual wine vessel (guang) 339, 339 shape(s) 46, 57, 62, 80, 142, 166, 223; concentric 61; geometric 57; implied 58; organic 57; position 80, 82;

positive and negative 58-60; size 80

Shimomura, Roger 188; Untitled 188, 188

Sherman, Cindy: Untitled Film Stills 570-72, 571

Shinto 331, 340, 346, 480 Shiva Nataraja (Chola bronze) 488, 488 Shona, the 369 Shonen, Suzuki: Fireflies at Uji River 190, 190 Shotoku, Prince 282 sidewalk art 515, 515-16 silhouettes 247, 512 silkscreen printing 192, 201, 201–2, 203, 438, 439, 588 Silueta Works in Mexico series (Mendieta) 443, 443 silverpoint 170; drawings 170, 170 Simpson, Lorna 574; You're Fine 574, 574 Sims, The (computer game) 84, 85, 86 Singin' in the Rain (Donan and Kelly) 232, 232 Sioux, the 360, 361 Sipma, Taco see Sauerkids Siqueiros, David Alfaro 185 Sistine Chapel frescoes, Rome (Michelangelo) 172, 264, 264, 381, 381, 383; restoration of 506, 506-7, 507 Six Persimmons (Muqi) 125-6, 126 sketches 166, 199, 264, 265, 425 Skoglund, Sandy: Radioactive Cats 226, 226-27 Sky and Water I (Escher) 60, 60-61 skyscrapers 285, 291 slab method (ceramics) 252-53 slip 250, 309 Smilack, Marcia 503; Cello Music 502, 503 Smith, David: Cubi XIX 64-65, 65 Smithson, Robert: Spiral Jetty 268, 268 "snapshot aesthetic" 224 soapstone sculpture 369, 369 social conscience, as expressed in art 542-553 society, in art 528 Solar Rotary (Holt) 107, 107 Song Dynasty 337, 338 Sower with Setting Sun (van Gogh) 175, 175 space 55, 62, 76, 80, 112, 142, 162, 268; negative 58, 69, 75, 289 span 276 Spanish Civil War (1936-37) 545-46 Spanish War of Independence (1808-14) 532 Spear Bearer (Doryphoros) (Polykleitos) 308, 308 special effects (movies) 233-34 spectrum, the 92, 92, 93 Sphinx, the (Great Sphinx of Giza) 63, 63-64, 301, 301, 302 Sphinx of Hatshepsut 575, 575 Spiral Jetty (Smithson) 268, 268 Spirited Away (Miyazaki) 233, 233 spirituality and art 470-77; see also religions; sacred places spray paint(ing) 190-91 Stackhouse, Robert see Mickett, Carol stained glass 254, 254–55, 280, 281, 321, 454, 455 Standard of Ur (Sumerian civilization) 298, 298 Stanza della Segnatura (Raphael) 509, 509, 514; see also School of Athens, The Star Wars (Lucas) 233-34, 234 Starewicz, Wladyslaw: The Cameraman's Revenge 232-33, Starry Night (van Gogh) 416-17, 417 Statue of Liberty (Wigan) 500, 500 Steerage, The (Stieglitz) 223, 223-24 Stein, Gertrude 427; portrait (Picasso) 427, 427 Stein, Leo 427 stele (sing. stela) 348, 473, 529; Buddhist (Gupta period) 472, 472; of Hammurabi 528, 528; Maya 67, 67; of Naram-Sin 474, 474; Raimondi (Chavín) 349, 349-50 stencils/stenciling 190, 201, 204, 425 stereotypes 473, 568 Sterne, Hedda 202-3; Untitled (Machine Series) 202, 203 stick-style house (Brockville, Ontario) 283, 283

saturation 95, 95-96

Saturday Evening Post 209

Saville, Jenny 581; Branded 581, 581-82

Tassi, Agostino 583 toranas 333 Stieglitz, Alfred 223; The Steerage 223, 223-24 Toulouse, France: St. Sernin 326, 326, 327 Tatlin, Vladimir: Monument to the Third International 69, still lifes 119, 215, 400, 401; photographic 218-19 Toulouse-Lautrec, Henri de 210, 345; La Goulue at the Stirling, Matthew and Marion 354, 354 Stonebreakers (Courbet) 408, 409 tattoos, Maori 370, 370, 372 Moulin Rouge 210, 210 tracery 498 tea bowls, Japanese 32, 32, 37 Stonehenge, England 456, 456-57 tea ceremony, Japanese 32, 37, 340, 342, 342 transept 326, 326 stoneware 250 Travelers among Mountains and Streams (Fan Kuan) 82, 82 teepees 360, 361 Store, The (Oldenburg) 246, 246 Treachery of Images, The (Magritte) 76, 76, 431 tempera 91, 106, 137, 140, 181, 181-83, 182, 191, 586 Storm and Stone (Fay) 538, 538-39 temperature, color 99, 100 Trees on the Bank of the Seine (Seurat) 172-73, 173 Stowe, Harriet Beecher 262 temples 30; Egyptian 130, 130, 278, 278; Greek 83, 83, 180, Tribute Money (Masaccio) 379, 379 Strauss, Kathy: Kepler Underneath 1 203, 203 278, 278, 470, 470-71; see also Parthenon; Indian 334, triglyphs 515 Street Berlin (Kirchner) 428-29, 429 334-35; Roman 311, 311-12; Tenochtitlan 358, 491; Trinity (Masaccio) 88,88 Struth, Thomas: Museo del Prado 163, 163 Teotihuacan 356, 356; Yaxchilán 523, 523 Trip to the Moon, A (Méliès) 230, 230 stucco 515 triptych 538, 539, 539 Study for La Source (Prud'hon) 78, 78-79 Ten Year Old Spinner... (Hine) 219, 219 Triumph of the Will (Riefenstahl) 158, 158-59 tenebrism 395, 498 stupas 333; Great Stupa, Sanchi, India 332, 333 trompe l'oeil 508, 510-12 Tenochtitlan, Mexico 358; Great Temple 358, 491 style 51, 77, 95, 111, 118, 162, 171, 186, 194, 217, 231, 425 Teotihuacan, Mexico 353, 355; Pyramid of the Sun 355, Trousse d'un Da (Arp) 146, 146 stylized 182, 267, 289, 301, 328, 348, 475 355, 356; Temple of the Feathered Serpent/of True Artist Helps the World by Revealing Mystic Truths..., stylobate 306, 512, 513, 513 The (Nauman) 244, 244 Ouetzalcoatl 356, 356 subjects 172, 183, 194, 212, 247, 296, 378 terracottas 365; Chinese "Terracotta Army" 462, 462; Ife Tsubasa RESERVoir CHRoNiCLE (CLAMP) 49, 49 Sublimate (Cloud Cover) (Lambert) 115, 115 tsumugi-ori textiles 340, 341 484, 484-85, 558-50, 559; Nok 365, 365 sublime 407 Tub, The (Degas) 172, 173 tesserae 318, 535 subordination 136; and emphasis 136-38 Tula, Mexico: Toltec warrior columns 534, 535 Tewa, the 360 subtractive colors 92-93 tumbling (with levers) 460, 461 Successful Operation (ORLAN) 582, 582 textiles 256-57, 257, 259; African 367, 367; Andean 350, Tunick, Spencer 564; nude installations 564, 564-65, 565 352, 352; Chinese hanging scrolls 82, 82, 84, 85, 336-38, Suffragettes 548 Turner, Joseph M. W.: Slave Ship 544, 544-45 Sugar Cane (D. Rivera) 184, 185 337, 338, 521, 521; Hawaiian 372, 372; Inca 352, 352; Turning Road, L'Estaque, The (Derain) 96, 96 Suger, Abbot 280-82 Japanese 340, 341; Paracas 350, 350; Tlingit 258, 258; see Tutankhamun, King 302; golden mask of 303, 303; tomb of also tapestries Suite with 7 Characters (Dubuffet) 51, 51 texture 62, 72-73, 145, 169, 219, 250, 275, 342, 385, 413; 302, 304 Sullivan, Louis 285; Wainwright Building, St. Louis 285, alternating 82; implied 136, 199; subversive 73 Tutsis, genocide of 546 285 Theater Piece No. 1 (Cage) 241 TV Buddha (Paik) 72,73 Sumerians 298-99; lyres 464, 464-65; see also Ur Thebes, Egypt: tomb painting 304, 304 Twilight in the Wilderness (Church) 98, 98 Summer Shower, A (Hayllar) 86, 87 Two Courtesans (Utamara) 344, 344, 345 Theodora and Attendants (mosaic) 319, 319-20 Sun Stone (Aztec) 497, 497-98 two-dimensional art 46, 49, 62, 76, 270, 508 Third of May, 1808, The (Goya) 54, 54, 150, 150, 198, 198, Sunday on La Grande Jatte (Seurat) 501, 501-2 Two Fridas, The (Kahlo) 579, 579 405, 406, 406, 532, 532 Sung Dynasty: silkscreen printing 201 Thirty Are Better than One (Warhol) 438, 439 Two Lovers (Riza Abbasi) 182, 182 supports 181, 186 Two Ways of Life, The (Rejlander) 222, 222 Thirty-Six Views of Mount Fuji (Hokusai) 81, 81, 117, 117, Suprematism 435 Tyco advertising campaign (Hill, Holliday, Connors, 195, 195, 344, 346, 346 Suprematist Painting (Malevich) 435, 435 Cosmopulos agency) 210, 210 "This is not a pipe" (Magritte) 76, 76, 431 surreal 227 tympana (sing. tympanum) 324, 325, 325, 494, 495 Surrealism/Surrealists 73, 76, 121, 131, 431-33, 504, 567, Thrash, Dox: Defense Worker 199, 199 typography 206-7, 211 three-dimensional/three-dimensionality 62, 75, 76, 179, 586 186, 252, 260, 320, 378, 413, 425, 508 Surrealism and Painting (Ernst) 432, 433 ukiyo-e printmaking 194, 344, 344, 345 Suzuki Shõnen: Fireflies at Uji River 190, 190 Three Folk Musicians (Bearden) 436, 436-37 Swing, The (Fragonard) 401, 401 Throne of the Third Heaven of the Nations' Millennium ultramarine 180 Unique Forms of Continuity in Space (Boccioni) 434, 434 Sydney Opera House (Utzon) 288, 288-89 General Assembly, The (Hampton) 440, 441 Unite NOLA (Tague) 543, 543 throwing (on potter's wheel) 252 symbolism, in churches 325-27 United Nations series (Gu) 552-53, 553 Symbolism/Symbolists 415, 417, 417 Tiber from Monte Mario Looking South, The (Claude unity 116, 127, 128, 142; compositional 116, 116-20; Lorrain) 176, 176 symmetry 125, 127, 391 Tibetan sand painting (mandala) 126-27, 127 conceptual 120-21, 122; gestalt 121-22; and variety 123syncretic religions 331 Tikal, Guatemala: Maya pyramids 276, 276 24 synesthesia 503 Untitled (Calder) 113, 113 Tilted Arc (Serra) 466, 466-67 time 106-8; and motion 106, 108, 112; and natural Untitled (Flavin) 442, 442 tableaux 227, 441 processes 115; symbols of 155-56 Untitled (Judd) 441, 441 Tacon, Paul 371 Untitled (Megerle) 170, 170 Times New Roman 206 Tagliapietra, Lino: Batman 66, 66 Tague, Dan 543; Unite NOLA 543, 543 Tin Lizzie Green (Olitski) 137, 137 Untitled (Rothko) 438, 438 Untitled (Shimomura) 188, 188 Tintoretto (Jacopo Roobusti): The Last Supper 390, 390-91 Taj Mahal, Agra, India 332, 335, 335-36 Untitled (Baalbek Bird Cage) (Hatoum) 585, 585 tints 92, 93-94 Talbot, William Henry Fox: The Oriel Window, South Untitled (The Hotel Eden) (Cornell) 121, 121 Gallery, Lacock Abbey 214, 214 tipis 360, 361 Untitled (La Immaculada) (Ramírez) 505, 505 Titian (Tiziano Vecellio): Isabella d'Este 34, 34; Venus of Tale of Genji (Murasaki Shikibu) 343, 343-44 Untitled (Machine Series) (Sterne) 202, 203 Urbino 560, 560 Tale of the Heiji Rebellion (painted scrolls) 536–37, 537 Untitled (Selections from Truisms...) (Holzer) 110, 110 Tiwanaku culture 348 Taliban, the 549, 551 Untitled (Your Gaze Hits the Side of My Face) (Kruger) 243, Tlaloc (Aztec god) 463; mask vessel 491, 491-92 Tanner, Henry Ossawa 408-9; The Banjo Lesson 409, 409 Tlazolteotl (Aztec goddess) 485; sculpture 485, 485 Tanning, Dorothea: Eine Kleine Nachtmusik 131, 131 Untitled Film Stills (Sherman) 570-72, 571 Tansey, Mark: Picasso and Braque 94, 94-95 Tlingit people: blanket 258, 258 Untitled—Passage on the Underground Railroad (Marc) To Be Modern #2 (Kim) 249, 249 t'ao t'ieh 125 Tobey, Mark 137-38; Blue Interior 137, 137 224-25, 225 Taos, the 360 Ur: bull lyre 464, 464-65; Royal Cemetery 298-99; Taos Pueblo, New Mexico 275, 275 Toilet of Venus, The (Velázquez) 548, 548 Standard of Ur 298, 298; Ziggurat 459, 459 Toltecs, the: warrior columns, Tula 534, 535 tapestries 537; Bayeux 536, 536, 537; Islamic 61, 61 Urbino, Federico da Montefeltro, duke of 259 Torah, the 315, 316

Tar Beach (Ringgold) 257, 257

U.S. Green Building Council: LEED (Leadership in Energy and Environmental Design) 291

Ut, Nick: Vietnamese Girl Kim Phuc Running after Napalm Attack 533, 533

Utamaro, Kitagawa 345; Lovers in an Upstairs Room 194, 194; Two Courtesans 344, 344, 345

Utrecht, Netherlands: Schröder House (Rietveld) 444, 445 Utzon, Jørn: Sydney Opera House 288, 288-89

Valadon, Suzanne: The Blue Room 142-43, 143 Valley of the Shadow of Death (Fenton) 226, 226 value (lightness or darkness) 76, 77-78, 92, 93-95, 142, 169, 183, 197, 214, 259, 438; alternating 82; and emphasis 140; and hatching and cross-hatching 80; and variety 122, 122; see also chiaroscuro

value of artworks 34-37

vanishing point 87, 87, 88, 90, 90, 160, 379, 519

vanitas 156

variety 116, 122-24, 127

Vasari, Giorgio 185; The Lives of ... Painters, Sculptors, and Architects 377, 377

Vatican City: Augustus of Primaporta 527, 527; Sistine Chapel frescoes (Michelangelo) 172, 264, 264, 381, 381, 383, 506, 506-7, 507; Stanza della Segnatura 509, 509, see also School of Athens, The

vaults 280, 454; barrel 280, 280; rib 280, 281, 327

VB35 (Beecroft) 563, 563, 565

vector graphics 209, 211

Velázquez, Diego de Silva y: Las Meninas (The Maids of Honor) 159-62, 160, 161, 406; Rokeby Venus (The Toilet of Venus) 548, 548

Vence, France: Chapel of the Rosary (Matisse) 482, 482-83 Venice, Italy: Ducal Palace 48, 49

Venus of Urbino (Titian) 560, 560

Vermeer, Johannes; Girl with a Pearl Earring 38, 38; Woman Holding a Balance 495, 495

Veronese, Paolo (Paolo Caliari): Christ in the House of Levi 389, 389-90

Versailles, Palace of 398, 399, 419, 524

Vertigo (Bochner) 49-50, 50

Vesperbild (14th-century, Germany) 65, 65, 75

Vesuvius, Mount 310, 508

Vicenza, Italy: Villa Rotonda (Palladio) 126, 127

video artworks 72, 73, 237, 238, 238, 239

video cameras 228

Vidyadhara, King 334

Vierzehnheiligen basilica, nr Bamberg, Germany

(Neumann) 399, 399

Vietnam War 533, 552

Vietnamese Girl Kim Phuc Running after Napalm Attack (Ut) 533, 533

Vietnam Veterans Memorial (Lin) 552, 552

View from Mount Holyoke, Massachusetts, after a Thunderstorm—The Oxbow (Cole) 407, 407-8

Vigée-Lebrun, Élisabeth 525; Marie Antoinette and Her Children 524, 525

Villa of the Mysteries, Pompeii 310, 311

Villa Savoye, Poissy, France (Le Corbusier) 286, 286-87 Viola, Bill 238; Going Forth by Day 238; The Raft 238

Vir Heroicus Sublimis (Newman) 95, 95-96

Virgin and Child Enthroned (Cimabue) 328, 328

Virgin and Child Enthroned (Giotto) 328, 328

Virgin and Child Surrounded by Saints (icon) 550, 550

Virgin and Child with Angels, The (Ferrarese School) 181,

Virgin of Vladimir (icon) 475, 475

Virginia, USA: Monticello, Charlottesville (Jefferson) 404, 404-5; State Capitol (Jefferson) 30, 30

Vishnu Dreaming the Universe (Hindu relief) 122, 122 vision, cone of 90, 90

Vision after the Sermon, The (Gauguin) 416, 416

visionary art 441

Vitiello, Stephen see DeJong, Constance

Vitruvius: On Architecture 132

Vittori, Gail 291

void 211

volume 55, 62, 68, 68-69, 160, 379, 411

vomitoria 458

voodoo 473

Voulkos, Peter: Gallas Rock 253, 253

Wainwright Building, St. Louis, Missouri (Sullivan) 285,

Waiting Girl, The (Lux) 222, 222

Walker, Kara 247; Insurrection! (Our Tools Were

Rudimentary, Yet We Pressed On) 247, 247

Walking Man (Rodin) 565, 565, 567

Wall, William G.: Fort Edward 27, 27-28

wall art 191-92; see also frescoes; graffiti art; murals

Waltz, The (Claudel) 414, 414

Wang Meng: Ge Zhichuan Moving His Dwelling 336-37

Wang Xizhi 205

war: artists and 40, 41-43, 159, 534-41; documenting 226,

530-31,533

War, The (Dix) 538, 539, 541

War Cripples (Dix) 40, 40

Warhol, Andy 438; Brillo Box 588, 588; Double Elvis 201,

201-2; Thirty Are Better than One 438, 439

wash, brush and 175-76, 176

Washington, D.C.: Lincoln Memorial (French) 37, 37;

Vietnam Veterans Memorial (Lin) 552, 552

watercolor painting 29, 129, 129, 188-89, 189, 191

Web design 211

wedging (of clay) 250

Weems, Carrie Mae 446; You Became a Scientific Profile... 446, 446

Welles, Orson: Citizen Kane 231, 231

Weston, Edward 218; Artichoke Halved 148, 148-49; Pepper No. 30 218, 218-19

Whistler, James A. M. 584; Nocturne in Black and Gold: The Falling Rocket 584, 584, 586

white space 210, 211

White Vertical Water (Nevelson) 28, 28

Whiteread, Rachel: House 71, 71

Wibald, Abbot of Stavelot 323

Wiene, Robert: The Cabinet of Dr. Caligari 235, 235

Wigan, Willard 500; Statue of Liberty 500, 500

Wilder, Billy: Double Indemnity 111-12, 112

Wills, Harold: Ford logo 207

Wilson, Fred 246; Portraits of Cigar Store Owners (from Mining the Museum) 246, 247

Winegrad, I. Michael: interior design 118, 118

Winogrand, Garry 224; Central Park Zoo, New York City

Wise, Kirk, and Miyazaki, Hayao: Spirited Away 233, 233 Wish Tree for Liverpool (Ono) 240, 244

Wish Tree for Washington (Ono) 240, 244 Wisteria Dining Room (Lévy-Dhurmer) 420, 420 Wittman, Robert 36 Wizard of Oz, The (Fleming) 231, 231-32

Wo-Haw: Wo-Haw between Two Worlds 361, 361

Woman I (de Kooning) 554, 555, 555-56

Woman from Willendorf 554, 554–55, 556

Woman Holding a Balance (Vermeer) 495, 495

Woman in Pool (Beever) 515, 515-16

Woman Seated in an Armchair (Matisse) 178, 178, 179

Wondrous Spring (Csuri) 102, 103, 103

wood 258-59

woodblock printing/woodcuts 31, 60, 60-61, 91, 91, 141, 193, 193-95, 194, 195, 344, 388, 388

Woodstock Road, Woodstock, New York, 1924 (Bellows) 51, 51-52

wool, importance of in Andean textiles 352

Workhorse Zoo (Zaretsky and Reodica) 115, 115

Works Project Administration 199, 569

Wreck of the Ole '97, The (Benton) 82-83, 83

Wright, Frank Lloyd: Fallingwater, Bear Run, Pennsylvania 286, 286, 287; Guggenheim Museum, New York 110, 458, 458-59

Wright, Joseph, of Derby 498; An Experiment on a Bird in the Air Pump 498, 499

Wright Brothers, the 94, 95

Wu Zhen (Wu Chen): Leaf from an album of bamboo drawings 176, 176

Wyeth, Andrew 182-83; Christina's World 182, 183

Xu Yang: The Qianlong Emperor's Southern Inspection Tour... 84, 85

yam masks, Abelam 373, 373

Yaxchilán, Mexico: temple lintel 523, 523, 525

al-Yazdi, Muhammad Mahdi: astrolabe 498, 498

Yellow Christ, The (Gauguin) 105, 105

Yeoh, Kom Cheow 209-10; Kiddo 209, 209

yin and yang symbol 346

Yomei, Emperor of Japan 282

Yongzheng Emperor, portrait of the 521, 521, 523

Yoruba, the: Gèlèdé rituals 465, 465; ritual vessel 484, 484-85; sculpture 132, 132, 366, 366

You Became a Scientific Profile... (Weems) 446, 446

Young Hare, A (Dürer) 189, 189 You're Fine (Simpson) 574, 574

Zapotec culture: Seated Figure 250, 250, 252 Zaretsky, Adam, and Reodica, Julia: Workhorse Zoo 115,

Zen Buddhism/Buddhists 125-26, 241, 331, 337, 340

Zeus (Greek bronze) 134, 134 Zeuxis 508, 509

Zhang Zeduan: Along the River during the Qingming

Festival 337-38, 338

ziggurats 298, 299, 300, 459; at Ur 459, 459 Zimbabwe: Great Zimbabwe 369, 369

zoetropes 111, 111, 228, 229

Zuni, the 360 Zurbarán, Francisco de: The Funeral of St. Bonaventure

Zürich, Switzerland: Cabaret Voltaire 430, 430